DATE DUE ✐ **P9-DUU-766**

10-29-99

APR 1 2 2010

LIBRARY
COLLEGE of the REDWOODS
DEL NORTE
883 W. Washington Blvd.
Crescent City, CA 95531

114665

PR4836.M67 1999

Keats

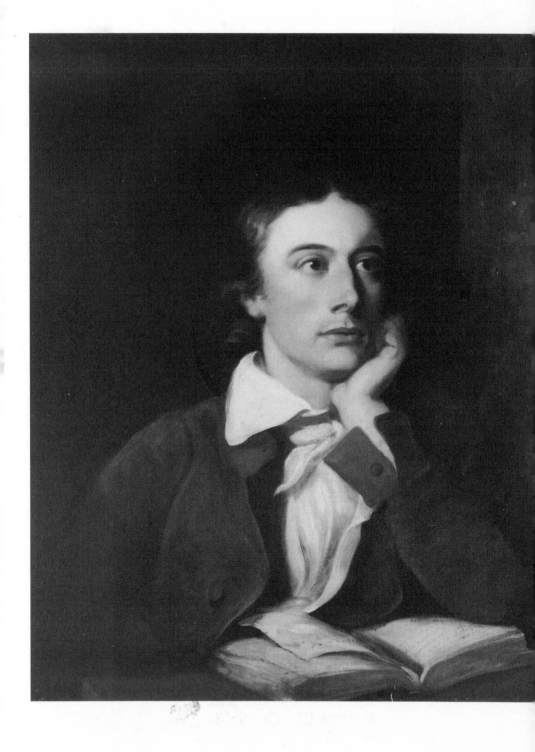

KEATS

ANDREW MOTION

THE UNIVERSITY OF CHICAGO PRESS

LIBRARY
COLLEGE of the REDWOODS
DEL NORTE
883 W. Washington Blvd.
Crescent City, CA 95531

114665

For
Emma Morgan
and her family

The University of Chicago Press, Chicago 60637

Copyright © 1997 by Andrew Motion
Published by arrangement with Farrar, Straus & Giroux, Inc.
All rights reserved. Published in the United Kingdom in 1997
by Faber & Faber Ltd, London. First American edition 1998
University of Chicago Press Edition 1999
Printed in the United States of America

04 03 02 01 00 99 6 5 4 3 2 1

Library of Congress Cataloging-in-Publication Data

Motion, Andrew, 1952–
 Keats / Andrew Motion. — University of Chicago Press ed.
 p. cm.
 Originally published: New York : Farrar, Straus and Giroux, 1998.
 Includes bibliographical references and index.
 ISBN 0-226-54240-8 (alk. paper)
 1. Keats, John, 1795–1821. 2. Poets, English—19th century—
Biography. I. Title.
PR4836.M67 1999
821'.7—dc21 98-41014
 CIP

⊗ The paper used in this publication meets the minimum requirements
of the American National Standard for Information Sciences—Permanence of
Paper for Printed Library Materials, ANSI Z39.48-1992.

Illustrations

ILLUSTRATIONS IN TEXT

[vii]

Picture Acknowledgements

Plates: Athenaeum of Ohio / Mount St Mary's Seminary of the West, Cincinnati, Ohio: plates 55, 57. Avon County Library: plate 35. British Museum: plates 42, 43, 52, 68. Corporation of London Records Office: plate 2. Corporation of London, from the collections at Keats House, Hampstead: plates 7, 10, 14, 15, 16, 17, 21, 26, 27, 28, 29, 30, 31, 34, 36, 37, 40, 54, 59, 60, 62, 67, 70, 71, 73. Robert Goodsell / photo Keats House: plate 58. Guildhall Library, Corporation of London: plates 1, 3, 4, 5, 6, 12, 38, 39, 46, 48. Keats Shelley Memorial House, Rome: plates 44, 72. Musée du Luvre, Paris: plate 41. National Portrait Gallery, London: frontispiece, plates 9, 18, 19, 22, 23, 24, 25, 32, 50, 56, 61, 64. Old Operating Theatre Museum, London: plate 11. Private collections: plates 8, 45, 47, 63, 65, 66. Royal College of Surgeons of England: plate 13. Scottish National Portrait Gallery, Edinburgh: plates 49, 51, 69. David M. Thomas / Corporation of London (Keats House, Hampstead): plate 53. The Wordsworth Trust, Dove Cottage: plate 33.

Illustrations in text: Lord Abinger / photo Keats House, Hampstead: page 528. British Library: page 310. Corporation of London, from the collections at Keats House, Hampstead: pages 473, 514. Fitzwilliam Museum, Cambridge: page 396. Houghton Library, Harvard University: pages 110, 128, 200, 209, 248, 340, 432, 438, 441, 458, 475, 477, 522. Professor Michael Jaye: page 390. Pierpont Morgan Library, New York / photos David A. Loggie: pages 177, 383.

Acknowledgements

I owe a big debt to the three biographies of Keats written in the 1960s: *John Keats* by Walter Jackson Bate (1963), which is a masterpiece of New Criticism; *John Keats: The Making of a Poet* by Aileen Ward (1963), which makes pioneering insights into Keats's psychology; and *John Keats* by Robert Gittings (1968), which skilfully synthesises a great deal of earlier analysis, and adds much important information about Keats's family background, financial affairs, and daily comings and goings. As my own researches diversified, I found myself treating these books not so much as things to read and reread but as subjects to interview. In what follows, I have quoted from them, agreed with them, and disagreed with them, in much the same way that I would want to treat people who had known Keats personally. It is therefore right and proper that I should acknowledge them first. Like everyone else who loves Keats, I am deeply grateful for their original insights and their clarifications.

I am also sharply aware of how much I owe to several editions of Keats's poems and letters. Among the many options available, I have relied most heavily on *The Poems of John Keats*, ed. Miriam Allott (1970, 2nd edn., 1972); *John Keats: The Complete Poems*, ed. John Barnard (Harmondsworth, 2nd edn., 1976); *John Keats*, ed. Elizabeth Cook (1990); *John Keats: Selected Poems*, ed. Nicholas Roe (1995); *The Poems of John Keats*, ed. Jack Stillinger (Cambridge, Mass., 1978); and *The Letters of John Keats 1814–21*, ed. Hyder E. Rollins (2 volumes, Cambridge, Mass., 1958). I have also quoted extensively from *The Keats Circle: Letters and Papers 1816–1878*, ed. Hyder E. Rollins (2 volumes, Cambridge, Mass., 1948), and *More Letters and Poems of the Keats Circle*, ed. Hyder E. Rollins (Cambridge, Mass., 1955). Among the critical studies I have learned most from are: *Romantic Medicine and John Keats* by Hermione De Almeida (1991); *The Uses of Division* by John Bayley (1976); *John Keats* by John Barnard (Cambridge, 1987); *Romantics, Rebels and Reactionaries* by Marilyn Butler (Oxford, 1981); *The Poet-Physician: Keats and Medical Science* by Donald C. Goell-

[ix]

nicht (Pittsburgh, 1984); *Keats's Life of Allegory: The Origins of a Style* by Marjorie Levinson (Oxford, 1988); *The Beauty of Inflections: Literary Investigations in Historical Method and Theory* by Jerome J. McGann (Chicago, 1985); *Keats and Embarrassment* by Christopher Ricks (Oxford, 1976); *Keats and History*, ed. Nicholas Roe (Cambridge, 1995); *Keats: The Religious Sense* by Robert M. Ryan (Princeton, 1976); *Keats the Poet* by Stuart M. Sperry (Princeton, 1973); *The Odes of John Keats* by Helen Vendler (Cambridge, Mass., 1983); and *Keats's Poetry and the Politics of the Imagination* by Daniel P. Watkins (1989). I am also indebted to the essays contained in 'Keats and Politics: A Forum', *Studies in Romanticism* (volume 25, summer 1986), and to the unpublished thesis 'The Life of George Keats' by Naomi Kirk, lodged in the Carpenter Library, Columbia University. A longer though still selective reading list appears on page 606. Nicholas Roe's *John Keats and the Culture of Dissent* (1997), which is included in this list, appeared as my book was going to press. I have referred in my notes to Roe's chapter on Keats's schooling, a part of which was originally published in *Essays in Criticism* (January 1992); his other chapters also explore aspects of Keats's work in ways that are very sympathetic to my own readings.

I am equally but differently grateful to the institutions which have helped me during my researches, in particular: the British Library, the Brotherton Library at the University of Leeds, the Houghton Library at Harvard University, Keats House in Hampstead, the Keats-Shelley Memorial House in Rome, and the Wellcome Institute in London. Their librarians and other staff have been unfailingly helpful and considerate. I also gladly acknowledge my use of material provided by the Berg Collection of the New York Public Library, the London Borough of Camden, the Devon County Record Office, the London Borough of Enfield, the Greater London Record Office, the Guildhall Library, Guy's Hospital, the Hampshire Record Office, the Hunterian Museum, the Centre for Kentish Studies, Lloyd's Register of Shipping, the Corporation of London, the Record Office of North-amptonshire County Council, the Pierpont Morgan Library, the Royal College of Surgeons in England, and the City of Westminster Public Library. I am also very grateful for the encouragement and hospitality shown to me by the Master of Eliot House at Harvard University; by the Friends of Keats House; by the organisers of the John Keats

Bicentennial Conference at Harvard University; and by the Keats-Shelley Memorial Association of America.

Many individuals have also helped me, giving me advice, showing me kindness, and warm-heartedly sharing their knowledge of Keats. I am especially grateful to Bryan Abraham, Bathsheba Abse, Dannie Abse, Alex Alec-Smith, Miriam Allott, Walter Jackson Bate, Lee Brackstone, William T. Buice III, John Bradley, Adrian Casey, Roberta Davis, Hermione De Almeida, Kelvin Everest, Jane Feaver, Doucet Fischer, Roy Foster, Jonathan Galassi, Jean Haynes, Seamus Heaney, Alan Heimert, Richard Holmes, Gerald Isaaman, Pat Kavanagh, Sonia Lane, Hermione Lee, Ian McEwan, Blake Morrison, Roy Park, Tom Paulin, Alison Plouviez, Roy Porter, Christopher Reid, Nicholas Roe, Louise Ross, Robert Ryan, James Runcie, Simon Schama, Grant Scott, Ronald Sharp, Hillas Smith, Stuart Sperry, Judy Stewart, Jack Stillinger, Kevin Van Anglen, Chris Wallace-Crabbe, Aileen Ward, Marina Warner, Richard Wendorf, and Susan Wolfson.

Finally, I want to thank separately the five people to whom I have owed most while writing this book: John Barnard, whose work on Keats has been an inspiration, and whose reading of this book in its penultimate draft was invaluable to me; Jon Cook, whose conversations about Keats have been indispensable; Christina Gee, the Curator of Keats House, who has been abundantly generous with her time and attention; Alan Hollinghurst, whose friendship and advice have been essential; and my wife Jan Dalley, without whom none of what follows could have been written.

I have not given sources for my quotations from primary texts which are generally mentioned in biographies of Keats. My quotations from the poems come from *John Keats: The Complete Poems*, ed. John Barnard (Harmondsworth, 2nd edn., 1976), and my quotations from the letters come from *The Letters of John Keats 1814–21*, ed. Hyder E. Rollins (2 volumes, Cambridge, Mass., 1948). The lines from 'Ego Dominus Tuus' by W. B. Yeats on page 576 are reprinted by permission of A. P. Watt Ltd on behalf of Michael Yeats.

Introduction

Keats: his name releases a flood of familiar images. He is the apostle of 'beauty' and 'truth'. He is the dedicated sensualist, sometimes swooning and softly pillowed, sometimes feasting greedily on luscious fruit and jellies. He is the poor orphan whose 'march of passion and endeavour' is fraught with hardships. He is the lover who loses his life almost as soon as he finds it. He is always pitifully young but full of extraordinary adult wisdom. Suffering and striving combine at every stage of his career. So do selflessness and self-fulfilment. Other writers have seized on him as the embodiment of their own ambitions – and sometimes of their distress and neglect. Readers have made him a byword for the poetic identity. At once pathetic and sublime, his story distils familiar human fears, and realises the most noble ideals. Its fascination is endless; its power to move and inspire is inexhaustible.

And yet, and yet . . . Keats's 'posthumous existence' has blurred his 'reality'. The translation of his life into a legend has distorted or denied important aspects of his achievement. When Richard Monckton Milnes published the first full-length biography of Keats, in 1848, the process was already well advanced. Thanks largely to Shelley's elegy *Adonais* (1821) and Leigh Hunt's memoir *Lord Byron and Some Contemporaries* (1828), Keats had already been enshrined as the archetype of the stricken Romantic: a supersensitive soul, brought to an early grave by the hostile reviewers of *Blackwood's Magazine* and the *Quarterly Review*. He was pre-eminently a poets' poet – at best an exotic marvel, at worst a sad curiosity. (In his lifetime, his poems had sold badly, and in 1834 his publisher had glumly concluded 'the world cares nothing for him'.)

Milnes worked hard to challenge this impression, and to winnow fact from fantasy. But his book did not attempt – and was not adequately equipped – to capture Keats whole. Hampered by conventional morality, Milnes quoted Wordsworth, the Poet Laureate of the day, who insisted that 'Silence is the privilege of the grave, a right of the departed',[1] and made no mention of many important personal

circumstances, including Keats's love affair with Fanny Brawne.[2] His reading was partial in other respects as well. Although Milnes admired the technical subtleties of Keats's poetry, and its delicious intensity, he played down the troublesome political dimension to these things, and entirely ignored the radicalism which had incensed contemporary Tory critics.[3] His Keats, in other words, was a writer whose actions mattered less than his reactions, and who was therefore still likely to seem escapist and effete.

In the aftermath of Milnes's *Life*, the impression that Shelley had given in *Adonais* continued to dominate all others. In the same way that Hazlitt had described Keats in the 1820s as showing 'a prevalence of the sensibility over the will', William Rossetti characterised him in the 1860s as a pitiful outcast, and Oscar Wilde towards the end of the century as 'The youngest of the martyrs'. For them all, Keats had been blighted by the world but lived apart from its harsh realities.

Sidney Colvin, who published the first thorough biography of Keats in 1917,[4] gave a more elaborate defence. He emphasised Keats's pugnacity, discussed his relationship with Fanny Brawne, examined the conditions and effects of his training as a doctor, developed the analysis of his work, and even took the trouble to explain that the word 'Keat' meant 'brave', and had nothing to do with the name 'Kate'. It was a valiant, and in some respects a vain effort. Hard on Colvin's heels came a rush of other biographers who, as they pored adoringly over their subject, continued to wrap him in gentle phrases and soften the outline of his ambition. Amy Lowell in *John Keats* (1925), Dorothy Hewlett in *Adonais* (1938), Betty Asquith in *Keats* (1941), Blanche Williams in *Forever Young* (1943) – all these confirmed the picture of Keats as a beautiful weakling. Apparently the audience for the story was insatiable.

Then the picture altered. Hyder E. Rollins published *The Keats Circle: Letters and Papers 1816–1878* in 1948, *More Letters and Papers* in 1955, and an annotated edition of Keats's letters in 1958. In the 1960s, three important biographies sprang up around this great mass of fresh material: Aileen Ward's *John Keats: The Making of a Poet* (1963, revised 1968), Walter Jackson Bate's *John Keats* (also 1963), and Robert Gittings's *John Keats* (1968).[5] In different ways, these books denied there had been anything irresolute in Keats's character, and gave an apparently comprehensive account of his daily doings. They dealt with his medical training, they investigated his love life, they separated his

sensitivity from his sickness, and they analysed his philosophy as well as his poetics. In fact the attention they paid him was so detailed that one of his subsequent editors has said: 'The accumulation of information from so many sources allows us [now] to know Keats better than most of [his] contemporaries knew him, even those who saw him every day; and modern scholars who [study] the record undoubtedly know Keats better than they do most people that they see every day in their own lives.'[6]

Even these fine studies have their limitations. Scrupulously logging the facts of Keats's life, they imply that his drive to self-realisation was determined by largely personal considerations. By his bad reviews, of course, but also by the early and tragic loss of his parents, the painful death of his brother Tom, his own protracted illness. In other words, they intensify the form of his Romantic alienation by diversifying the sense of him as a victim, and focus attention on his view of life as a 'vale of soul-making'. While this allows them to ask valuable questions about the ways in which his poetry explores the value of suffering, it also means that they – like their forebears – concentrate on his achievement as an aesthetician, propounding notions of the creative 'fancy' and linking them to his ideas about 'negative capability' (though Ward does provide some vivid description of the political background). Wordsworth and Coleridge are shown exploiting, then shrinking away from, their early radicalism. Shelley is a fiery polemicist. Byron is obviously satirical and social. But Keats remains – in Colvin's phrase – someone whose mind is 'naturally unapt for dogma',[7] and who, as Eliot said, 'did not appear to have taken any absorbing interest in public affairs'.

It is easy to see how this came about. Like virtually all Romantic artists, Keats frequently defines himself as an outsider, either to dramatise his wounded sensitivity, or to make an imaginative space in which to develop ideas of transcendence. In one of the letters he sent to his brother George in America he approvingly quotes some remarks by Hazlitt about Godwin's novel *St Leon* (1799) which crystallise the image. The novel's hero, Hazlitt had said in a lecture which Keats saw in manuscript, 'is a limb torn off from Society. In possession of eternal youth and beauty, he can feel no love; surrounded, tantalised, and tormented by riches, he can do no good. The faces of Men pass before him as in a speculum, but he is attached to them by no common ties of sympathy or suffering. He is thrown back into himself and his own thoughts. He lives in the solitude of his own breast, – without wife or

child or friend or enemy in the whole world . . . He is himself alone. His existence is purely intellectual, and is therefore intolerable to one who felt the rapture of affection, or the anguish of woe.'

Echoes of these remarks reverberate throughout Keats's own writing. At one point he undertakes to 'live like a hermit'; at another he says he can 'bear anything – any misery, even imprisonment – so long as I have neither wife nor child'. (His friend Benjamin Robert Haydon revealingly referred to him as 'the only man I ever met with who is conscious of a high call . . . except Wordsworth'.) The emphasis not only suited his appeal to posterity; it licensed his view of writing as a form of divine madness, and his devotion to poetry as a search for a maturer self. Time and again, Keats shows us that he wants to be a poet more than anything else, and proves this by choosing poetry itself as one of his important subjects. Inspired by Classical stories, by translations, by paintings, by engravings, by Tassie gems and by myths, his lines often seem to provide a substitute for experience rather than a realisation of it. Byron recognised this when he said that Keats belonged to 'that second-hand school of poetry' – though his perception was soured with a sneer. Invoked more sympathetically, Keats's world might be described as an in-between creation, a fancy as well as a fact, a cold pastoral as well as a warm and living landscape. It is a place ideally suited to Romantic artists in general and to the 'chameleon poet' in particular – the poet, that is, who has easy, Shakespearean access to whatever situation or character presents itself.

Identifying these things in Keats is essential to any account of his love for 'the principle of Beauty'. A great deal of his imaginative energy, and a large part of his personality, depended on his ambition to create a 'shape' which could resist the flow of time. But while this does justice to his relish for the exclusivity of the artist, it also promotes the idea that he lived in a vacuum, and never described or responded to wider issues. Admittedly, certain individual poems, and some parts of others, have always been cited as exceptions to the rule. It is commonplace, for instance, to speak of 'Hyperion' in terms of the struggle between generations, and to relate this to arguments surrounding the aftermath of the French Revolution. Or to emphasise the attack on money-grubbing in 'Isabella' (Bernard Shaw described the poem as proto-Marxist). Or to draw attention to the passages about those 'who lord it o'er their fellow-men / With most prevailing tinsel' at the beginning of the third book of *Endymion*. Or to follow Aileen Ward in connecting the

sonnet 'Nebuchadnezzar's Dream' with the Tory government's trial of the radical William Hone.

Until recently, however, these and other such episodes have usually been regarded as isolated instances.[8] Little biographical effort has been made to consider how their arguments might be developed through the whole body of his work, and little thought devoted to how they might reflect his experience – not just as a private individual, but socially and politically as well. To point this out, and to try and make good the lack, is not to impose a historicist analysis on work which is designed to resist it. It is to uncover a large and neglected part of Keats's inspiration. The evidence of contemporaries is clear about this. His work was filled, Leigh Hunt said, with 'political opinions [which were] not to be borne by the then government authorities'.[9] Charles Cowden Clarke insisted that 'his whole civil creed was comprised in the master-principle of "universal liberty".' His conservative and soon-discarded friend George Felton Mathew complained that he was 'of a sceptical and republican school'. Reviewers who attacked him did so because he belonged – as *Blackwood's* said – 'to the Cockney School of Politics, as well as the Cockney School of Poetry'.

Even the speediest survey of Keats's writing proves the point. At all times, and in various ways, it tangles with what he called his 'barbarous age', supporting his claim that he 'should have been a rebel angel had the opportunity been mine', and was 'willing to jump down Aetna for any great public good'. He commemorates patriotic heroes such as King Arthur, Robin Hood, John Milton, Algernon Sidney; he criticises the Holy Alliance and all kinds of despotic authority (whether it be of governments over people, or Church over State, or his guardian Richard Abbey over his family); he engages with the issue of military power, with the French Revolution and the Napoleonic Wars, with the repressive effects of the Corn Laws, enclosures and the Six Acts, with radicals such as Cobbett, Kosciusko and his early mentor Leigh Hunt, and with the plight of people working in factories.

Important as these things are, they form merely a part of Keats's neglected story. The forms and idioms of his work also show him responding to a particular historical crisis. The couplets that he used in *Endymion* were, as *Blackwood's* complained, a way of 'lisping sedition'. Sonnets like 'On Seeing the Elgin Marbles' make a similar sort of challenge to conventional ideas of closure. His treatment of myths had the revolutionary purpose of making them seem intimate, and therefore

capable of speaking about contemporary concerns. Even his so-called 'effeminacy' formed a part of the process. The headily opulent language of his work, as *Blackwood's* again realised, was a form of linguistic androgyny – a counterpart to the idea of the 'chameleon poet' – which as it distanced itself from familiar male discourse also commented upon it. Like all other aspects of his Romantic temper which have been treated in purely literary terms, it has an important social dimension.

Inevitably, a biography which wants to explore these aspects of his work must look for their origins in his life – not just in the background to his existence, but in his daily experience and the very foundation of his identity. Milnes nested Keats safely in the comfortable bosom of the middle class, as did most others who decisively shaped his posthumous reputation. His brother George Keats, for instance, protested huffily to Hunt that the family did not come from 'a low origin'. Only William Rossetti, among nineteenth-century commentators, admitted that things might not have been so cut and dried: he said that Milnes's attempts to make Keats respectable were 'a concession to that deadly spirit of flunkeyism in the British people'.[10]

Rossetti was right. Keats was born at a time when pressure created by the Industrial Revolution had blown the pattern of the old order into fragments. The growth of commerce, of international trade, and of the bureaucracies which served these things, meant that a new social configuration had begun to emerge – and Keats was unsure whether he was climbing out of the working class, or likely to slip at any moment from the lower rungs of the middle class. So was George, as his irritation with Hunt and the facts of his own career make plain. Where Keats himself constantly felt that money worries blocked his way upwards through society – even as he tried to work round the problem by becoming a writer and therefore in a sense *déclassé* – his brother took himself off to America to reinvent himself. Their sister Fanny made the same escape: she married a Spaniard – an exiled liberal novelist – and spent most of her adult life abroad.

Keats's writing was profoundly affected by the instability of his origins. Other, less nebulous elements in his early life were just as decisive. His family were dissenters of some kind. His school was not merely an unusually tolerant institution, but run along roughly the same lines as a Dissenting academy. (The years Keats spent at school amounted to nearly a third of his life.) His youthful friendship with Charles Cowden Clarke shows that even as an adolescent he was deeply

engaged with the pressing political issues of the day.[11] His training as a doctor, and especially his contact with Astley Cooper, the senior surgeon at Guy's, encouraged him to see his profession as a liberal and liberalising way of 'doing some good in the world'. When he gave up medicine for poetry, these principles remained intact, underlying and informing his wish to be a 'physician to all men'.

There is good reason to believe that the lives of all important writers need to be reconsidered at regular intervals, no matter how familiar they might be. While the wind of history blows, their stories revolve and alter, offering new attractions and sometimes new difficulties to each successive generation. This might be reason enough for wanting to add another *Life* of Keats to those that already exist, even supposing that his radicalism had already been adequately described. As it is, the justification is more substantial. The Keats that has come down to us is finely figured, yet incomplete. Embedding his life in his times, I have tried to recreate him in a way which is more rounded than his readers are used to seeing. Examining his liberal beliefs, I have tried to show how they shaped the argument as well as the language of his work. At all times, I have tried to illuminate his extraordinary skill in reconciling 'thoughts' with 'sensations'.

My intention is not to transform Keats into a narrowly political poet. It is to show that his efforts to crystallise moments of 'Truth' combine a political purpose with a poetic ambition, a social search with an aesthetic ideal. He is always engaged with the 'Liberal side of the Question', even when sinking most deeply into the imagination. He is fascinatingly 'formed by circumstances', as well as wonderfully self-creative. Yet my account – any such account – needs to be introduced with a note of caution. As the connections accumulate, they inevitably expose separations as well as links between his life and his work. This is something that all biographies must (or should) demonstrate. Art, after all, is never merely a convulsive expression of personality.

The point needs to be made especially forcefully when thinking about Keats – for one obvious reason. He was extraordinarily young when he produced his greatest poetry. Although never prodigious in the sense that Mozart was prodigious, and although his friends recognised this by stressing what Hunt called his 'great promise'[12] rather than his

maturity, the fact remains that he was only twenty-three years old when he wrote 'The Eve of St Agnes', the six odes, 'Lamia' and the two 'Hyperion's. Accounts of his reading, his friendships, his psychological imperatives, his poetic 'axioms', his politics, and his context can never completely explain this marvellous achievement. The story of his life must also allow for other things – things which have become embarrassing or doubtful for many critics in the late twentieth century, but which are still, as they always were, actual and undeniable: inspiration, accident, genius.

KEATS

ONE

I<small>N SEPTEMBER</small> 1820, five months before his death, Keats sailed to
Italy with his friend Joseph Severn. Their journey along the south
coast of England was disrupted by a series of terrible storms and
exasperating calms. Often their boat was driven backwards the way it
had come. Occasionally the captain allowed his passengers ashore
while he waited for a favourable wind. During one of these delays,
they explored 'the splendid caverns and grottos' around Lulworth
Cove, in Dorset. Keats told Severn it was 'a part [of England] he
already knew', but did not say precisely how or why. His reticence was
characteristic. Throughout his life, he made very few remarks about
his early days, and none about his distant ancestors. Even his closest
friends discovered next to nothing about his family, except that both
his parents had died young, and left him with 'a personal soreness
which the world had exacerbated'.

Over the years, biographers have struggled to fill in the details of his
background, some finding out things that Keats was unlikely to have
learned himself, others collecting the scattered facts that emerged after
his death. Sadly, most of these 'facts' derive from an unreliable source –
from Richard Abbey, who became guardian of the four Keats children in
1814.[1] (He was appointed by their maternal grandmother, Alice
Jennings, who made herself their 'discreet Parent' after the death of
Keats's father in 1804.) Abbey was a tea broker in the City of London, a
reactionary northerner who placed an exaggerated value on prudence
and practicality. He disapproved of Keats's parents for what he reckoned
to have been their fast living, and thought their eldest son's poetic hopes
were ridiculous. Keats and his sister came to look on him as a monster.
They thought his administration of their finances was always mean and
sometimes dishonest.

When Abbey was approached by Keats's publisher John Taylor in
1827 to give evidence for a possible biography, he seized the chance to
defend his own part in the story. He concentrated on his bitterest
memories, and retailed gossip as truth. Only Grandmother Jennings
escaped his censure. Her husband was stigmatised as a 'gourmand' who
excessively enjoyed 'the pleasures of the table'. Keats's mother was
'more remarkably the Slave of other Appetites'. Keats's father 'did not
possess or display any great Accomplishments', and 'thought it became

[3]

him to act somewhat more the Man of Consequence than he had been accustomed to do'.

Whether or not Taylor believed Abbey, he ended their conversation thinking: 'These are not Materials for a Life of our poor Friend which it will do to communicate to the World', and made no further effort to get at the truth of things. Others were even less resourceful. The sentimental poet George Felton Mathew, for instance, who befriended Keats in 1815, answered his own question 'O! Where did thine infancy open its eyes?' by saying ''twas the Queen of those regions of air, / The gay fields of Fancy – thy Spirit has blest!' Leigh Hunt, who knew Keats much better than Mathew, said simply that his 'origin was of the humblest description . . . He never spoke of it.' Only Charles Brown and Charles Dilke were more precise, one saying that Keats's father was 'a native of Devonshire' and the other that he was 'a Devonshire man'. Neither of them offered any clues about his family's occupation, or character, or social standing.

More recent research has established that the names Keats, Keat and Keates seem to have originated in Berkshire, but are most common throughout the west of England.[2] Thomas Hardy liked to say that one branch of the family, living in the east Dorset village of Broadmayne, bore a 'facial and temperamental resemblance' to the poet. Others have been discovered in Winterbourne Came, where the dialect poet William Barnes worked as the parish priest, and around Poole, Corfe, Looe Bay and Plymouth. Thomas Keate (1745–1828), who was surgeon to George, Prince of Wales, and shared Keats's looks as well as his professional interests, came from Somerset. Eighteenth-century records also show the name flourishing in and around Madron, in Cornwall.

Keats's only sister Fanny claimed that their father came from this part of the world, and when her daughter Rosa was baptised, she entered her grandfather's name as 'Mr Thomas Keats of Land's End, Cornwall, England'. It is tempting to think that by removing her origins so far from London she was trying to bury her family in obscurity while also giving them a local habitation. Was this done to hide something? Was her father illegitimate, for instance, as some have suggested when pointing out that his baptismal records do not survive? Or was she simply reporting a shadowy truth? If she was, her case can be strengthened by one intriguing piece of evidence. When her grandfather was born, a Thomas Keats was running a small boat called *The Lark* out of Plymouth, hauling bulk commodities between Devon, Dorset and Cornwall.[3] At

the same time, members of the Jennings family were living near Madron, engaged in a similar line of business: they owned a boat called the *Charming Phill* and worked as coastal traders. It is possible that the two families were linked by common interests long before they were joined in marriage.

This boat-owning Thomas Keats moved inland in the 1770s, perhaps elsewhere in Devon, perhaps to Berkshire. In any event, it is likely that memories of his previous life came with him, and possible that in due course these were passed on to Keats himself. His writing often uses images to do with the sea. He describes himself as 'leap[ing] headlong into the sea' when he begins *Endymion*; he refers to 'dead-drifting' and to casting an anchor 'stiff'; and all manner of tides and currents run between his earliest 'Imitation of Spenser' and his epitaph: 'Here lies one whose name is writ in water'.[4]

Keats could have learned more about his father's family if he had wanted: he had relatives in London who could have advised him when he was working at Guy's Hospital in 1815 and 1816, and afterwards when he was living in Hampstead. There was Thomas Keats the surgeon. There was Elizabeth Keats, possibly his aunt, who swam briefly into his ken after his father's death. There was a 'coffee-German' he once met with his brother George at Covent Garden in 1819.[5] But he did not seek out these people, and neither did they make any effort to contact him. Although this occasionally led him to complain about feeling isolated, it could also produce a sense of freedom. Writing to his sister-in-law in 1818 he said awkwardly but proudly that his name had been 'Enchanted . . . the Lord knows where', and even the letters he sent to those he loved best were often signed simply 'Keats'. The signature encapsulated feelings which shaped his whole existence. Forgetting or concealing his origins, he longed to turn himself from a private citizen into a poetic landmark.

The family history of Frances Jennings, Keats's mother, is much clearer – and so is the role her forebears played in his life. Her father John, the son of Martin Jennings and Mary Cleminson, was baptised in St Stephen's, Coleman Street, on 13 October 1730. (He had a sister, also Mary, whose first husband died young and who later married Charles Sweetinburgh, a victualler who worked near Bishopsgate.) Details of the first part of his life are obscure, but in 1774, when he was in his mid-fifties, he made a number of significant appearances in public records. He became the leaseholder of a stables called the Swan and Hoop at 24

The Pavement, Moorgate, which is now a main street running into the City of London, but then stood close to the eastern edge of the capital. The same year, he also bought his Freedom of the City, and joined the Innholders' Company.

Initially, John Jennings took a short lease on the Swan and Hoop; ten years after moving in, he renewed it for a further twenty-one years and also began renting the inn which lay adjacent. The following year he extended his little empire by acquiring the lease on 22 The Pavement, subletting it and earning £46 per annum. At around the same time, he began dealing in mortgages, acting as a moneylender, and investing in Government Funds and East India stock. Keats's brother George said these wheelings and dealings made John Jennings 'very well off', but added that his grandfather was also 'extremely generous and gullible'. Even if his household did not spend 'four days out of the week roasting and baking for the Sunday dinner', as Abbey said it did, he evidently enjoyed life too much to become securely 'affluent'. Once the stabling and the inn sections of the Swan and Hoop had been combined, they catered for a large number of businessmen and visitors travelling into the City from the expanding eastern suburbs – people who looked for good company as well as good service.

The building itself was impressive; its frontage was 117 feet long, lying between Little Moorfields (now Moorfields) and Moorfields (now Finsbury Pavement), just to the north of London Wall. The original plan, dated 1753, shows two coach houses, a spacious yard, stabling for some fifty horses and also room for several carriages. When Jennings took over the lease, he spent the large sum of £670 on repairs and alterations, turning premises that had been merely functional into one of the area's most hospitable ports of call. Yet it remained a bustling rather than a stylish place, as Keats emphasised when, in his unfinished satire 'The Cap and Bells' (1819–20), he recalled the time he had spent there as a child. He made no mention of fashionable demi-landaux or wealthy clients, and concentrated instead on the hungry coachmen making faces which said 'eat, eat, eat', and the 'Polluted Jarvey' (driver) 'Whose springs of life are all dried up and dead, / Whose linsey-woolsey lining hangs all slack, / Whose rug is straw, whose wholeness is a crack'.

It is not surprising that Keats's memories should have settled as they did. Ever since Moorfields had first been developed, it had become more and more sharply differentiated from the respectable suburbs of Bethnal

[6]

Green, Stepney, Hackney, Walthamstow, Enfield and Edmonton – which Jennings relied on for his business. It was distinguished by the new Square and Circus at Finsbury, renowned for the new Bethlem Hospital which was opened in 1815, and ornamented by the houses of rich physicians working at the two sites of St Luke's Hospital. But much of it was poverty-stricken, its maze of overcrowded streets lined with meagre shops, and its few surviving patches of green busily overrun. One was used by the Honourable Artillery Company as their parade ground; in Tub Field the Clerkenwell Volunteers regularly met and marched. The Swan and Hoop was a refuge from such places and also reflected their variety. It belonged to a part of London which showed the wide world of Georgian England in miniature: higgledy-piggledy, riven with inequalities, and eager to promote its commercial interests – and to defend them with force if necessary.

On 25 FEBRUARY 1774, three weeks after John Jennings moved into the Swan and Hoop, he got married. His wife was Alice Whalley, a thirty-eight-year-old woman who had been born at Colne, in Lancashire, but who had lived in London for several years. Little is known about her background, and nothing about how she met her husband – though it is possible that her family, like the relatives of another and more famous Lancastrian, Robert Peel, were customers at the inn.[6]

The wedding took place in St Stephen's, Coleman Street. Although it was an ordinary Anglican church, the couple were in fact associated with dissenting stock (which denomination is not clear). Records in the Guildhall Library[7] show that several members of the Jennings family – including another John Jennings, who died in 1778, and Keats's great-aunt Mary Sweetinburgh and her husband Charles – were buried in Bunhill Fields, just to the north of Moorgate by the City Road. Ever since 1665, when Bunhill was denominated 'Tindale's, or the Dissenters' burial ground', it had been preferred as the final resting place for Nonconformists. (Robert Southey referred to it as the 'campo santo' of all kinds of rebels and outsiders.) John Bunyan, Isaac Watts and Daniel Defoe were buried there, and in time they would be joined by William Blake, the radical Joseph Cartwright, and Thomas Hardy the co-founder of the London Corresponding Society.

These dissenting allegiances are reflected in the way that John and Alice Jennings brought up their three children: Frances, who was baptised on 29 June 1775; Midgley John, who was baptised on 21

November 1777 (his unusual first name was then common in the Colne region of Lancashire[8]); and Edward, who was baptised on 4 January 1782 and died aged fourteen. When they were six years old, the boys were dispatched as boarders to Clarke's School in Enfield – the same 'liberty-loving' establishment that Keats and his brothers would eventually attend. Nothing is known about Edward. Midgley volunteered for the Navy soon after leaving Enfield, was taken on board HMS *Leopard* as an able seaman at Deal, and in August 1799, after serving briefly as a clerk and acting purser, became a first lieutenant. Abbey's judgement that John Jennings behaved like a 'tyrant' at home implies that Midgley volunteered because he could not wait to get away. The ethos of Clarke's academy, however, and the fact that Midgley rose so quickly through the ranks, makes it just as likely that he was doing something he believed in. (At the Battle of Camperdown in 1797 he was temporarily in command of the marine attachment on board the 74-gun HMS *Russell*.) He was eager to oppose a much more threatening kind of tyrant than his father, and to exemplify the values that his family and school espoused. The stories that his nephew would later hear about Camperdown, where Midgley bravely showed himself on deck to distract fire from his admiral Duncan, set a standard of heroic determination that Keats hoped to match by other means.

Frances Jennings had no such public arena in which to prove the effect of her upbringing. Reports of her 'singular character' suggest that she had the same spirit as her brother. Nothing is known about her education – presumably she went to a local dame school where she learned the 'talents, sense and deportment' for which she was later praised – and little about her looks and personality from any source except Abbey. Predictably, he was disparaging – so much so that it is difficult not to suspect his hostility masked all sorts of opposite feelings. 'At an early age', he told Taylor, Frances decided 'that she must & would have a Husband; and her passions were so ardent . . . that it was dangerous to be alone with her. – She was a handsome, little woman – Her features were good & regular, with the exception of her Mouth which was unusually wide. A little Circumstance was mentioned to me as indicative of her Character – She used to go to a Grocers in Bishopsgate Street, opposite the Church, probably out of some Liking for the Owner of the Shop, – but the man remarked . . . that Miss Jennings always came in dirty Weather, & when she went away, she held up her Clothes very high in crossing the Street, & to be sure, says the Grocer, she has

[8]

uncommonly handsome legs. – He was not however fatally wounded by Cupid the Parthian.'

Abbey's bias is obvious when his account is compared to others. Charles Cowden Clarke, for instance, the son of Keats's schoolmaster, agreed that Frances had a 'good figure and large oval face' but called her 'sensible'. And George Keats insisted that 'She was a most excellent and affectionate parent and as I thought a woman of uncommon talent.' These reports make Frances seem less like the flirt that Abbey described, and more like an obviously pretty, capable and vivacious woman, someone who was naturally strong-willed, and who throughout her childhood had been encouraged to think and act for herself. She was clearly frustrated by the lack of opportunities that life offered so long as she remained single. Marriage would mean sacrificing her property and inheritance to her husband, but it would also give her a role – certainly within her family, and possibly in business as well.

Thomas Keats thought so, anyway. It is not known when he began working at the Swan and Hoop, nor whether in applying to the inn he was exploiting old connections between his family and the Jenningses. But his quickness and energy made him welcome. He was a short, thickset man with brown hair and dark hazel eyes, generally reckoned to be 'of good sense and very much liked', and with 'a total freedom from vulgarity and assumption'. Charles Cowden Clarke was very particular about this when recalling Thomas's visits to the school in Enfield, saying that he was 'a man so remarkably fine in common sense, and native respectability, that I perfectly remember the warm terms in which his demeanour used to be canvassed by my parents after he had been to visit his boys'. Although he seems originally to have been employed in the Swan and Hoop as an ostler ('a principal servant', Charles Cowden Clarke says), he was well-off enough to keep a 'remarkably fine horse' for 'his own Riding', and there is no reason to suppose that the assets of £2,000 he had acquired by the time he was thirty were 'solely' the result of his 'fortunate'[9] marriage.

The wedding of Thomas and Frances took place on 9 October 1794 in St George's, Hanover Square: he was barely twenty, she was nineteen. Because the church had no previous connection with either of their families, and because none of their relatives acted as witnesses, it is sometimes assumed to have been 'a hasty affair'. There is no corroborating evidence for this, but the location says something about their characters. St George's was (and still is) a fashionable church in the

middle of London, a good distance from the parish where the young couple were known. It allowed them to state their independence as well as show their social intentions. John Jennings, at least, seems to have approved of the match. Once the wedding was over, he continued to employ his new son-in-law and – according to Leigh Hunt – let him and Frances use his house as their own.

Others suggest that Thomas and Frances in fact spent the first year and more of their marriage in a neighbouring parish – exactly where is not known. This in turn means that it is not clear where Keats was born, only when: on 31 October 1795. He was baptised on 18 December in St Botolph's Without, a church in the City. It was not in the same parish as the Swan and Hoop but had connections with the Jennings family. Mary had been baptised there in 1733. Two years later, when their second child George was born on 28 February 1797, Thomas and Frances had left their first home and were living north of the City Road in Craven Street, about three-quarters of a mile away from the Swan and Hoop. A little over two years later, when a third son, Thomas, was born on 18 November 1799, they were still there.

The first few years of Keats's life are obscure. In later life he mentioned that he felt afflicted by 'even earlier misfortunes' than the deaths of his parents, but what he meant remains a matter for speculation. Perhaps he was referring to the death of a third brother Edward, aged one, in 1802. (Like several of his relatives, Edward was buried in Bunhill Fields.) Perhaps his father's continuing employment at the Swan and Hoop was not as easy-going in fact as it seems in outline. Perhaps his mother was as flighty as Abbey made out. On the other hand, Keats may have meant something more general. Securely employed, living close to open country, steadily improving his prospects, Thomas Keats provided well for his family: his wife, his three surviving sons, and his daughter Fanny (christened Frances Mary) who was born on 3 June 1803. Yet the times in which they were living were perilous. Overseas, Napoleon rose from the flames of the French Revolution, smashing the familiar shape of Europe and threatening to invade England itself. At home, the Tory government treated dissenters ruthlessly, and main-tained its authority by introducing a series of vicious repressive measures. It was, as Keats would later say, in many respects a 'barbarous age', and its dangers flickered round him continually.

TWO

Two DAYS BEFORE Keats was born, George III drove in state to open Parliament in Westminster. When his coach reached the Mall it was surrounded by an angry mob shouting 'No war! No King! No Pitt! Peace! Peace! Peace! Bread! Bread!' Fists were raised threateningly, loaves of bread were hoisted on sticks. When someone threw a stone and shattered a window in the coach, the King gasped to one of his companions: 'My Lord! I, I, I have been shot at!'

The protest had a long history. As the Industrial Revolution picked up speed in the mid-eighteenth century, new kinds of economic activity had proliferated, stimulated by advances in iron production, in clay manufacture, in cotton spinning, in steam power, in road and water communication. The population increased rapidly; markets boomed; 'private profit and economic development' became 'the supreme objects'[1] of unbroken Tory government; and England underwent 'the greatest transformation in human history since the remote times when men invented agriculture and metallurgy, writing, the city and the state'.[2]

The changes created many hardships as well as chances for self-improvement. In the countryside, enclosures were displacing or destroying time-honoured communities with increasing rapacity. In the overcrowded cities, conditions were often desperate. Social divisions widened and deepened. A series of bad harvests drove up the price of bread (a family which paid six pence for a 4lb loaf in 1793 paid one shilling and four pence for it in 1800). Parliament did nothing to alleviate the miseries of a large part of the population; it did not want to disturb the status quo, and was frankly terrified that the Revolution in France – let alone other popular uprisings in America, Holland, Poland and Ireland – might lead to similar turmoil at home.

This of course is exactly what the leading radicals wanted to foment. There was never a mass uprising in England such as occurred in Paris, but by the 1790s the working classes had been thrust into 'a state of apartheid',[3] and their objections had acquired a distinctly revolutionary edge. (The word 'class' as a means of defining social divisions had already come into existence by the middle of the eighteenth century.) Demonstrations were commonplace in the industrial cities of the Midlands and North. Lobbyists in London joined forces with protesters

elsewhere to link 'agitation from town to town and [plan] their own shadowy government, the Convention'.[4] Food riots erupted across the country in every year between 1792 and 1796, and at the end of the century they were 'very extensive indeed'.[5] In 1795 2,000 people gathered in Copenhagen Fields in East London to denounce their rulers. In 1796 dozens of women in Nottingham 'went from one baker's shop to another, set their own price on the stock therein, and putting down their money, took it away'.[6]

Figures at the centre of this unrest were demonised by the government: Horne Tooke, who won nearly 2,000 votes when he stood as an independent Reformer in Westminster in 1790; Thomas Paine, whose *Rights of Man* appeared in two parts in 1791 and 1792; Thomas Hardy, a shoemaker who was secretary to the London Corresponding Society, founded in 1792; Major Cartwright, who organised a Society for Promoting Constitutional Information; Earl Grey, who set up an Association of the Friends of the People which by 1794 had 5,000 paying members and was condemned by Burke as 'the Mother of all Mischief'. These men and others (such as John Thelwall, William Cobbett, Henry Hunt, and Francis Place) were hounded for their beliefs, frequently arrested, and silenced wherever possible. In what became known as the 'White Terror', Prime Minister Pitt issued a Proclamation against Sedition in 1792, held treason trials in 1793 and 1794, suspended Habeas Corpus in 1794 and 1798, passed the Treason and Sedition Act in 1795 and the Unlawful Oath Act in 1797, and in 1799 banned Corresponding Societies – the Societies, that is, which had originally met merely to debate the question 'Have we, who are Tradesmen, Shopkeepers and Mechanics, any right to obtain a Parliamentary Reform?'

The more harshly Parliament acted, the more fervent its opponents became, and the more eager to associate with other kinds of dissenters. Nonconformist religions, for instance, grew enormously in size and number through the last decade of the century, and became closely allied to those arguing for political change. (Not only the larger bodies such as Baptists, Unitarians, Methodists and Congregationalists – whose numbers had swollen from 15,000 in 1750 to 35,000 by 1800 – but also smaller groups such as the Sandemanians, Muggletonians and Swedenborgians.) Although these organisations had in some senses a restraining influence – Methodists, in particular, were strongly anti-intellectual – their scriptural message was directed clearly at the deprived, the poor, and the overlooked. They consistently challenged the establishment,

appealing to 'the pure in heart' for sympathy, and diversifying political rage.

The result was more than simply a general atmosphere of fragmentation and anger. It was a world fraught with actual violence. In the factories and the fields, where the conditions of everyday life were routinely shaped by appalling levels of suffering, the danger of rioting was a constant threat. There was a 'distinctly Sturm und Drang quality' about political life too. 'Think of the Earl of Chatham', one recent historian has urged, 'collapsing in the House of Lords as he made his last manic and incoherent speech against war with America in 1778, or of Edmund Burke flinging a dagger into the floor of the House of Commons in December 1792 as a symbol of his departure from the Foxite Whigs, and of Charles James Fox bursting into tears as a result.'[7] Think too of the Prime Minister Perceval, assassinated in the House of Commons in 1811, or of the startling statistic that nineteen Members of Parliament committed suicide between 1790 and 1820, and that a further twenty lapsed into insanity, as did their king.

Why did the country not convulse in some more united way? The answer has something to do with deep memories of the Civil War, something to do with the confused response to the aftermath of the French Revolution, something to do with the large numbers of the bourgeoisie who profited in the upheaval, and a great deal to do with the fact that dissenters in the 1790s and 1800s had to compete with the stabilising effects of England's long-drawn-out European war. When there were periods of particular hardship, such as during the hunger crises of 1795/6 and 1800/1, radicals were able to play upon the misery of those they spoke for. During times of national emergency (such as in 1798 when the French were massing across the Channel), or national celebration (in 1805 after Trafalgar), they lost the attention of their audience.

In fact the fortunes of the war made little difference to the plight of the oppressed. It was the running costs which caused most of their grievances. In the first phase of hostilities – from their outbreak in 1793 until the Peace of Amiens in 1802 – these were continuously high, partly because the country's finances had barely recovered from the recent war with America, partly because European trade came to a virtual standstill. When Napoleon attacked the Austrian armies in 1796 he enlisted Spain as an ally and forced England to leave the Mediterranean. By the following year, Pitt had no allies on the Continent, and only Duncan's

triumph at the Battle of Camperdown – where Midgely Jennings distinguished himself – helped to contain the military as well as the domestic crisis.

Naval victories at Cape St Vincent and Aboukir Bay, and the annihilation of the Danish fleet in the Baltic, improved things considerably. But the expense of keeping France at arm's length remained enormous. When the war began, the army numbered 50,000 men (the French army was 500,000 strong), and numerous Militia Acts were passed to swell the number of recruits. (A Supplementary Act of 1796, for instance, required 60,000 militiamen from England and 4,000 from Wales.) This added to the government's already large economic burden. Direct Income Tax was introduced. In 1797 gold payments were suspended and the 'paper pound' was born. One-off revenues were repeatedly levied.[8]

Their cumulative effects hurt people badly: in 1800 less than 15 per cent of the population had an income of over £50 a year, and of these only a quarter earned more than £200 a year.[9] It also made military expenditure, and military business, part of everyone's life. As a child, Keats would often have seen men training on open ground near the Swan and Hoop and thought it nothing unusual. In 1806 George Cruikshank described 'Every town' in England as 'a sort of garrison – in one place you might hear the "tattoo" of some youth learning to beat the drum, at another place some march or national air being practised upon the fife, and every morning at 5 o'clock the bugle horn was sounded through the streets, to call the volunteers to a two-hour drill . . . and then you heard the pop pop pop of the single musket, or the heavy sound of the volley, or the distant thunder of the artillery'.[10]

The cost of these manoeuvres far outstretched the national income. The fact that the government never flinched shows that they were as determined to defend the old order as they were to defeat the enemy abroad. Pitt himself, like Burke, openly wished that 'the example of successful pillage'[11] in France would encourage orthodoxy at home, and although the incomes of most people suffered as the National Debt increased, his hopes were in many respects fulfilled. (The Debt rose from £228 million in 1793 to just under £876 million in 1815.) They remained fulfilled for many years after his death, too – during the second phase of the war between 1804 and 1815. The heroics of Moore and the young Wellesley in the Spanish Peninsula; the alarms and excursions following the collapse of Russia's alliance with France; the now-

legendary set-piece battles which took place across mainland Europe – all these drew people together. When peace was finally restored, even a radical speaker in unrepresented Manchester admitted that 'The great importance of trade and manufacture in this country has been fully evinced during the period of the late war.'[12]

This 'trade and manufacture' blossomed in the years following Waterloo, helping to transform the old feudal order into a social structure organised around 'money, property, talent, secular belief, parliament, the middle class, and an industrial class of labourers'.[13] Although these changes were obviously divisive in some ways, they were also binding. They turned the country into a self-conscious nation. They encouraged a cult of heroes (ranging from Spenser and Shakespeare to Nelson and Wellington), and cultivated a sense of shared values. They provoked rage against injustice at home while promoting exploitation elsewhere. (The years between 1760 and 1820 saw the colonisation of Canada, the discovery of Australia and New Zealand, the annexation of the West Indies, and the final subordination of India.) In the process, one writer has shrewdly said, the English 'fell in love with themselves'[14] for the first time in their history, smothering differences and difficulties in order to create the image of a united nation. Southey – surprisingly, in view of his later views about such matters – realised that the price of coherence was a grievous self-deception. 'The English love to be at war, but do not love to pay for their amusement . . . There is not a people upon earth who have a truer love of the royal family than the English, yet they caricature them in the most open and insolent manner. They boast of a freedom of the press, yet as surely and systematically punish the author who publishes anything obnoxious.'[15]

These paradoxes run from the top to the bottom of the Georgian and Regency worlds in which Keats lived. They are evident in the figure of the King himself, who was sometimes regarded amiably as Farmer George, sometimes pityingly as a lunatic, and sometimes derided as the patriarch of a drab, vindictive and remote court. They are even more obvious in the relationship between Parliament and the people. During the seven Tory administrations which governed during Keats's life-time,[16] the number of representatives in the Commons rose to 558, but many of these bought their places or traded on inherited privileges. Only property owners were allowed to vote, and large parts of the country, notably the industrial boom towns, had nobody to speak for them in Westminster. These facts alone are enough to counter any report of the

[15]

period as a paradigm of high living and high style, of Beau Brummell and the Brighton Pavilion, of striped wallpaper and stucco, of Nash terraces and Carlton House – the Prince Regent's London home. Coleridge comes closer to the truth when he describes the period as 'an age of *anxiety* from the crown to the hovel, from the cradle to the coffin; all is an anxious striving to maintain life, or appearances – to *rise*, as the only condition of not falling'.[17]

Occasionally government threw the people scraps of comfort. In 1795 the Duke of York introduced some military reforms to prevent the army mutinying as the navy would do at the Nore two years later; in 1803 the administration of the War Office was overhauled; and in 1809 an Act was passed which banned the sale of government offices. More widespread changes were ruled out – though a few efforts were made to remedy the plight of the poor. The best-known of these was the ill-conceived and counterproductive Speenhamland System for Poor Relief, introduced in the year of Keats's birth, which guaranteed labourers a minimum wage by subsidising them out of the Poor Rates. (The effect was to encourage farmers to lower wages.) Otherwise, charities performed the work that government refused to undertake: the Society for Bettering the Condition of the Poor, for instance, which was set up in 1796, and which like many other such organisations relied on the support of dissenting religions, especially Methodism.

Doctors also stepped into the breach, beginning a slow change in attitudes to health and medical training which would affect Keats deeply. There was a rapid expansion in the size and workload of Founders' Hospitals: St Bartholomew's and St Thomas's were both ancient foundations, but six others, including Guy's where Keats studied, were established in London during the eighteenth century. Mercifully, they had an effect. Of the patients admitted to Bart's and St Thomas's in 1775, one in thirteen died; of those admitted to the General Dispensary (founded in 1770), only one in thirty-three died in 1800. This represented a 'revolutionary development, a first step towards wresting the indigent sick from the clutches of the parish workshops',[18] and also led to a new respect for doctors, and new estimates of their social status. It also produced the first serious research into demographics: Malthus published his *Essay on the Principle of Population* in 1798, and three years later the first census was carried out. The population of England was found to be a little over 8 million.

London, in which nearly a million people lived in 1801, was the

swollen epitome of England's problems, and a forcing house for reform. Some western and central districts paraded the country's new wealth and sophistication, glittering with private palaces. Other areas typified its misery and injustice: poverty darkened labyrinthine alleyways; refuse steamed uncollected at roadsides; the Thames reeked (around the turn of the century, the stench twice forced the Commons to interrupt debates); the air was so thickly polluted that a contemporary guidebook warned 'if the increase of London proceeds as far as it may, the inhabitants must at last bid adieu to all hopes of seeing the sun'.[19] In between these opposites were the thousands scrabbling to keep or improve their place in the middle class – people building the new estates in Camden or St John's Wood; people funding and filling new theatres, clubs, churches and assembly rooms; people shopping in Regent Street or thronging in Vauxhall Gardens as Keats did himself, paying a shilling for entrance, then passing through its groves 'pleasantly surprised by the sudden appearance of statues of the most renowned English poets'.[20]

Sweatshops and pleasure gardens, smog and scintillation: the contradictions made London a cruel and violent place, as well as a bewildering one. Prostitutes 'plied their trade in the streets with almost no interference'[21] – there were almost 10,000 working in London by 1800. Assaults were common. (Keats was never attacked, but he did on one occasion fight a butcher's boy for bullying a kitten, and Charles Cowden Clarke once escaped being mugged only by sprinting away from his assailants 'at cricketing speed'.) Punishments were harsh. Although there was no equivalent of the modern police force, the rule of law was enforced by aldermen and small private armies of vigilantes. Those arrested faced a battery of harsh reprisals. In 1800 there were more than 200 capital offences on the statue books. A person could be executed or transported for pickpocketing goods valued at more than one shilling, or appearing at night with a blackened face, and many main thoroughfares were the sites of pillories: Norris Street in the Haymarket, for instance.

All the same, the capital prided itself on the development of 'morals, manners, and social amenities'.[22] In 1778 Joseph Bramah patented his superior ballcock lavatory – he had marketed 6,000 by 1797. In 1807 the Gas Light and Coke Company began illuminating parts of Pall Mall and the West End. Scientific discoveries confirmed the sense of progress. Davey published his *Researches* in 1800, Linnaeus his *Elements of Natural History* in 1801, and Lussac his *Law of Gases* and Paley his *Natural Theology* in 1802. Current electricity was invented. The Royal

[17]

Institution was established, and so were the Zoological, Horticultural and Astronomical Societies, and the Mineralogical Foundation.

Although it was only the rich who benefited from some of the changes, many affected the country at large. The increase in export trade led to the creation of vast new docks: West India Dock started business in 1797, and London, East India and Surrey Commercial Docks followed within the next five years. Canals wriggled across the landscape – by 1815 £20 million had been invested in their development. 'Turnpike mania', which raged from the 1770s for at least the next fifty years, cut travelling times by huge margins – by a quarter between 1750 and 1815, according to one source. 'We heard our speed!' Thomas de Quincey wrote exuberantly at the end of one journey. 'We saw it! We felt it as thrilling!'[23]

Thrilling they may have been, but these examples of progress intensified divisions as well as gilding them. Keats implied as much when writing about Godwin, and his friend Charles Dilke. His contemporary Thomas Love Peacock was one of many who debated the issue more thoroughly. (Keats knew Peacock a little; he spent the evening with him, for instance, at Leigh Hunt's house on 11 February 1818.) Mr Foster, in *Headlong Hall* (1816), says that 'Everything we look to attests the progress of mankind . . . and demonstrates their gradual advancement towards a state of unlimited perfection', only to hear Mr Escot reply: 'These improvements, as you call them, appear to me only so many links in the great chain of corruption, which will soon fetter the whole human race in irreparable slavery and incurable wretchedness.'[24] Peacock closed this conversation by accepting that the new distribution of wealth was bound to affect every aspect of society. He understood, in particular, that for some it would produce new opportunities for leisure, and that these would in turn create different styles and fashions. The rich at play in their grand houses, with their 'seasons' and their preferred artistic forms, were by 1800 only a part of the audience which needed to be entertained – and as entrepreneurs and artists realised this, England developed for the first time a culture trade as brisk as the commercial business which supported it.

Interest in the theatre broadened, clearing the way for a generation of great actors and actor-managers (Kean, Macready, Mrs Siddons, and Mrs Jordan). Aristocratic collectors and art speculators opened galleries decked with old masters, and with patriotic scenes from Shakespeare and English history. The British Museum expanded, and a National Gallery

was planned. Musical life flourished, and was augmented not just by famous names like Handel, but also by lesser-known performers like Keats's friend Vincent Novello. Opera began to occupy the same sort of place in middle-class life that it had long enjoyed in Italy, with Drury Lane, Covent Garden and the King's Theatre all playing to packed and enthusiastic houses. (The King's Theatre was the only one to present Italian language productions, introducing *Don Giovanni* into its repertoire for twenty-three performances in 1817.) The size of the reading audience also increased enormously – even though books were expensive: a new novel cost at least seven shillings and six pence and a work of history or *belles-lettres* a guinea. The success of James Lackington, whose colossal shop in Finsbury Circus, 'The Temple of the Muses', was only a stone's throw from Keats's birthplace, gives a clear picture of the new market. He modernised the book trade by standardising prices, issuing catalogues and pioneering cut-price selling, and through most of the 1790s sold 100,000 books a year.

Authors benefited as well as readers, and some notched up spectacular sales. Scott's *Lay of the Last Minstrel* sold 44,000 copies in 1805, and his *Lady of the Lake* 20,300 copies in 1810 (it cost forty-two shillings). Byron's *Corsair* sold 10,000 copies on the day of its publication in 1810, and Keats himself tells us that in February 1819 Murray shifted 4,000 copies of the Fourth Canto of *Childe Harold*. It is no wonder that in the wake of such triumphs, a mass of new publishers sprang up all over London, among them Taylor and Hessey, who published *Endymion* in 1818 and the *Lamia* volume in 1820. Nor is it surprising that newspapers and journals also prospered. During the early 1790s, no fewer than fourteen daily morning papers and one evening paper appeared in London alone; on Sundays there were eight to choose from, including the *Observer*. (In 1812 Southey announced that 'everyone who reads at all, reads a Sunday newspaper'.) There were weekly and monthly magazines as well, some long established such as the *Strand*, appealing to fashionable readers, some like the *Westminster Magazine*, the *Macaroni* and the *Sentimental Magazine* aimed at particular sections of the public. One has only to remember Keats's friend Leigh Hunt to see how diverse and popular these could be. As well as co-founding the radical journal the *Examiner*, which soon after it had been launched in 1808 sold as many as 2,000 copies a week, Hunt also edited a number of other and less successful publications, among them the *Indicator* and the *Reflector*.

[19]

LEIGH HUNT NEVER intended his magazines to serve as complete historical surveys – least of all the *Examiner*. Yet in a sense he did manage to summarise the period as a whole. Linking liberal politics with cultural appreciation, and combining gossip with straightforward reporting, he mirrored both the connectedness and fragmentation of the entire Regency period. Keats himself greatly appreciated this. He read the *Examiner* enthusiastically from adolescence to the end of his life, sometimes published in its pages, and often discussed the issues it raised.

Inevitably, some aspects of the age influenced him more than others, and some hardly affected him at all. This means that distinctions have to be made, as well as associations emphasised, in placing his story within its context. But even when his poems struggled to overrule time, they reflected his particular circumstances. He was born with the City at his back, among clamorous commercial interests, Volunteers training, radicals protesting, hospitals expanding, and suburbs spilling into open country. He spent his adult life paying very deliberate attention to these things, and to other national and international issues as well. In some respects they persuaded him that he was an outsider. In others they gave him confidence. He could insist on independence because he knew that he belonged nowhere precisely. He looked beyond everyday events because he understood how they might confine and disappoint him. And he realised that in striving to achieve various sorts of cohesion in his work, he could never ignore the stubborn facts of paradox and contradiction.

THREE

FAMOUS MEN AND WOMEN are often described as having been sweet and precocious when children. The most celebrated early story about Keats fits the pattern. While his family were still living in Craven Street at the end of the 1790s they had a neighbour, a Mrs Frances Grafty, who later remembered that as a small boy 'instead of answering questions put to him, he would always make a rhyme to the last word people said, and then laugh'.

Other anecdotes paint a more complicated picture. A servant of his brother Tom once said that when Keats was five he was 'violent', and most of his contemporaries also emphasised his quick temper. This moodiness seems to have been connected with his feelings about his

mother. According to Benjamin Robert Haydon, the young Keats 'once got hold of a naked sword and shutting the [front] door swore nobody should go out. His mother wanted to do so but he threatened her so furiously she began to cry, and was obliged to wait till somebody through the window saw her position and came to the rescue.' Haydon was notoriously prone to exaggeration, but more reliable sources confirm that Frances and her eldest son were especially close. Even though Keats shared some characteristics with his father 'in person and feature', his face was his mother's – reddish-haired, high-browed, wide-mouthed – and she obviously indulged him. George Keats admitted in 1828 that while she had a 'doting fondness for [all] her children' which amounted to 'prodigality', it was 'particularly John' that she loved. The remark is hardly substantial enough to serve as the foundation for a psychological portrait of Keats as an adult, but when combined with Haydon's story it is at least suggestive. There was something passionate and unstable about Keats as a little boy, and something about his relationship with his mother which mingled love with anxiety. In his later relationships with women, and especially with Fanny Brawne, this mixture grew much more pronounced. In his treatment of female characters in his poems, it is unmistakable.

If Frances dominated him at home, her family shaped his life away from it. Until 1802, his father continued to travel from Craven Street to work in the Swan and Hoop, and at some time during that year became even more closely involved with the business. John Jennings, feeling that he had worked long and hard enough, decided to retire outside London. He found a 'nice house' at Ponders End near Enfield, ten miles north of Moorfields, rented it for £30 a year, and moved there with his wife Alice and their maid Christian Findlayson. He asked Thomas Keats to take over management of the inn. Although there were only three years of the existing lease left to run, it was secure and profitable. The recent peace in Europe, and the replacement of Pitt by Addington as Prime Minister, seemed to herald a new era of expansion.

Nothing is known about Thomas's long-term plans. Did he, for instance, mean to renew the lease on the Swan and Hoop when it expired in 1805? His short-term arrangements are clearer. He paid his father-in-law an annual rent of £44, moved his young family to live above the premises, and early in 1803 was admitted into the Innholders' Company. All these things suggest that he responded eagerly to his new life, and intended to make a success of it. Later in 1803, he consolidated his

position by becoming a Freeman of the City. By this time, however, his circumstances had altered dramatically. War had broken out again in Europe. At home, the death of Edward in infancy had been followed within a few months by the birth of Fanny. It was a pattern which Keats, who was now aged seven, would find repeating throughout his life, each fresh opportunity bringing a setback, each moment of happiness matched by one of sorrow. 'This is the world', he wrote to George in March 1819. 'We cannot expect to give away many hours to pleasure – circumstances are like Clouds continually gathering and bursting – While we are laughing the seed of some trouble is put into the wide arable land of events – while we are laughing it sprouts [it] grows and suddenly bears a poison fruit which we must pluck.'

Keats's mother, who in her strong-willed youth had always been keen to seize any social advantage, continued to try and turn the family's mixed blessings into simple good fortune. While they were still infants, she had sent John and George to a local dame school; now that they were old enough to begin their education proper, she wanted them to go to the public school at Harrow. It is unlikely that her husband would have had any objections to this on class grounds. Although Harrow was popular with the aristocracy and the upper classes (Peel and Perceval went there, as well as Byron), it was 'still regarded by the trading classes of Middlesex as the local county school'.[1] He might, however, have felt that its academic reputation was inflated. Pupils there were given a basic grounding in Greek and Latin, played a lot of games, and were subject to vicious bullying and a harshly disciplinarian regime.[2] One contemporary complained of being 'lashed into [leaving] by the tingling rod'.[3]

For the privilege of receiving this patchy and painful education, parents were expected to pay nearly £50 a year. Cost is usually given as the reason why Keats never went to Harrow. Richard Monckton Milnes, for instance, said that the school 'had been at first proposed but was found to be too expensive'. Considering the amount of money that Thomas Keats was now making as manager of the Swan and Hoop, and the savings that his parents-in-law had accumulated, it seems likely that other considerations in fact settled the question – considerations about what type of education he and Frances wanted for their children. Frances's brother Midgley had already passed through a school in Enfield which was not merely less brutal than Harrow, but distinctly progressive. Its headmaster, John Clarke, was noted for providing his pupils with a home away from home, and even if his roll-call of alumni

featured fewer well-known names than a great public school might be able to boast, its social atmosphere was by no means lowly. Keats and his brother George were enrolled there in the summer of 1803, both of them in the uniform that all junior boys were required to wear: a frilled collar, a short jacket with pearl buttons, and a tasselled cap.

Enfield was as much a model of respectable home-counties civility as Moorfields was typical of urban mix and mêlée. Until it was joined to London by rail in 1849 (the school was converted into the station) it was an unspoiled and self-contained place, flanked by the river Lea and the New river, clustered round a market square and church, and proud of a local history which linked it to national events. (Two battles had been fought near by during the Wars of the Roses, and the local manor house had once belonged to Henry VIII.) In 1800 the population stood at a little under 4,000, and they lived well. The centre was filled with elegant houses built in the Queen Anne style; there was an annual fair; there was a grammar school which had been founded in 1558; and there were two Nonconformist chapels – evidence of the dissenting tendency to subdivide rather than insist on consensus. Charles Lamb, who lived in Enfield after Keats's day, valued it for being 'cut off [from London] by country lanes', and Henry Crabb Robinson described it as 'a singularly beautiful picture'. Keats himself found it accessible but sheltered, full of news from town but surrounded by woods and elm-bordered fields, and comfortably close to his grandparents in Ponders End.

The school occupied a handsome three-storey building of dark red brick. It had been constructed by Edward Helder, a West India merchant, in 1672, and decorated with pedimented gables and a pillared façade 'wrought by means of moulds into rich designs of flowers and pomegranates, with heads of cherubim over two niches in the centre of the building'. (This central section is now preserved in the Victoria and Albert Museum, towering over the postcards in the shop.) It stood opposite a bend in the New river and close to the remnant of Enfield Chase, which had recently been much reduced by enclosures, but for children at least was still a place 'peopled with dragons, lions, ladies, knights, dwarfs and giants'.[4] Clarke had opened the school in 1786 with a Baptist minister called John Ryland. They made room for sixty-odd pupils (Harrow had over 300), filling the bedrooms with six or eight beds, and building a forty-foot schoolroom where there had formerly been a coach house and stabling. This still left space for a playground between the schoolroom and the house. Beyond it stretched a 100-foot

garden, part of which was given over to small plots to be cultivated by the pupils themselves. Clarke's son described the setting as a rural paradise: 'A magnificent old morello cherry tree' grew against the house 'well exposed to the sun'; beyond the garden lay 'a sweep of grass, in the centre of which was a pond sometimes dignified as a lake' where the boys learned to swim; 'round the pond there were strawberry beds' that 'assiduous' boys were allowed to water on summer evenings; beyond the pond was an iron railing across which the 'songs of nightingales' drifted from nearby woods; and built against this railing was 'a rustic arbour' where, towards the end of his time at the school, Keats sat reading Spenser's *The Faerie Queene*.

Clarke hoped that Nature would function as a teacher – and Keats evidently found this congenial. The few specific references he makes to the school imply that when not swimming in the New river, or playing cricket in the fields near by, he spent his time gardening (on his deathbed he told Severn that his 'greatest pleasure had been watching the growth of flowers'), or catching fish and transporting them to Ponders End to store in his grandmother's 'washing tubs three', 'in spite / Of the might / Of the maid' – Miss Findlayson.

Most accounts of Keats's schooling have been content to call it 'liberal'[5] and let it go at that. Charles Cowden Clarke encouraged this by summarising his father's philosophy as 'independent far in advance of his time', and other friends confirmed the same vaguely humane impression. Although one of them regarded Keats's ignorance of Greek as 'a *want* of education', they agreed that 'his rare quality of purifying himself' owed much to John Clarke's stress on individuality. A much clearer image of the school emerges when it is compared to an actual Dissenting academy. By the time Keats began his education, these academies were well established – and some, like the ones at Warrington, Daventry and Mile End in London, were widely respected. Administered by those whose beliefs kept them outside the old Anglican grammar schools and universities, they were defiantly forward-looking. They paid close attention to scientific subjects, they mixed Classical learning with 'modern' subjects such as geography and mathematics, and they explored rational teaching methods that emphasised the value of doubt and questioning. To place Clarke's school in the same league as the Warrington Academy (one of the radical 'Nonconformist univer-

sities') would be misleading: it was too interested in promoting solidly middle-class values. But it did share the same broad aims.

Because Clarke never published anything – not a single pamphlet – it is impossible to render his beliefs in his own words. John Ryland, however, with whom Clarke founded the school at Enfield, published as though his life depended on it, and his work speaks eloquently for his colleague.[6] Ryland was born in Bourton-on-the-Water, Gloucester-shire, on 12 October 1723, the son of a grazier, and was educated in the great dissenting crucible of Bristol. He combined a simple and passionate Calvinist faith with a tormented sense that God must always remain elusive, and spent his life pursuing Him as though he were tracking a heavenly yeti. 'If there is ever a God in heaven or earth,' he wrote once, 'I vow and protest, in his strength, or that God permitting me, I shall find him out.'

Four years after his (adult) baptism, Ryland was called to the ministry in Bourton, was soon ordained, and opened his first school in Warwick. He remained there for nine years before moving to Northampton, then a centre of Nonconformist education, where he formed another school and worked as a minister in the College Street chapel. In Warwick he had been 'recognised far and near as a man of true spiritual force, with the originality, the enthusiasm and daring which common minds call eccentricity and extravagance'.[7] In Northampton his reputation rose still further. Looming from his pulpit in a huge five-tier wig, and speaking in a voice like 'the roaring of the sea',[8] he developed a style of preaching which 'could send ladies into ecstasies of religious fervour merely by the way in which [he] rolled out the sonoroties of the word Mesopotamia'.[9] His classroom manner was just as impressive. Although he took no part in public agitation, he spoke out loudly in favour of civil and religious freedom. He was 'intense in his desire to implant patriotic and Protestant feelings in the bosoms of his scholars'.[10] He sprinkled their calendar with the anniversary dates of events he thought they should celebrate (the Gunpowder Plot, the Revolution of 1688). He 'strongly defended the cause of the Americans, and condemned the measures taken against them'.[11] He advertised himself as 'an ardent friend of liberty' and identified, as Keats would later do, Alfred the Great as the originator of English constitutional liberties.[12] The great Baptist writer Robert Hall (1764–1831), who also attended the academy in Bristol, warmly admired this 'constellation of excellences'. Ryland 'had walked in all the fields of knowledge', Hall said, 'and it seemed to

[25]

me . . . that he knew everything that was fit to be known, and could do everything that was fit to be done.'[13]

Ryland was less impressive when it came to organising practical matters, as he realised himself. Before his twenty-seven-year stint at Northampton came to an end, he hired two assistant masters to help him with his teaching and administration. One was George Dyer (1755–1841), a young Baptist scholar and poet whose habits were gentle and hesitant (he had a bad stammer), but whose liberal principles were rock-like.[14] He published an analysis of *The Complaints of the Poor People* (1795) which celebrated – as Keats would do – heroes of freedom such as Milton and Algernon Sidney, the author of *Discourses Concerning Government*; he wrote several stridently radical poems, including one on 'The English Revolution' which advocated 'equal laws'; he expected that schools should practise the same degree of tolerance that he demanded from governments; he fiercely opposed capital punishment; and he objected to flogging.[15]

Clarke, the other assistant master hired by Ryland, was better equipped than Dyer to help with the day-to-day running of the school. A squarely built and imposing man, with a large balding head, a jutting chin, and a protruding lower lip, he had previously worked in a solicitor's office in Northampton, where he had acquired a reputation for being conscientious and compassionate. One day, in his capacity as Deputy Sheriff of the town, he was ordered to hang a condemned prisoner in the local jail. Feeling the task was against his principles, he resigned his post and applied to Ryland for a job. He was immediately put in charge of science, arithmetic and penmanship – Dyer taught the Classical languages. Ryland did not have to explain his radical beliefs to his new recruit. Clarke already shared them, even if he did not have precisely the same sort of religious faith. He disapproved of corporal punishment, and he based his teaching on the 'revolutionary hypothesis that education is designed primarily to develop the good in boys rather than in exposing the evil'.[16] To this end, and to reward them for conduct as well as work, he marked his pupils in a range which ran from O (optime) to X (unsatisfactory), and drilled into them his maxim 'Do not come into a room like a pig; but begin and end with a special affecting grace in all company.'[17] He also understood the value of practical demonstration. He gave lessons in basic anatomy by dragging a skeleton into his classroom, illustrated theories of migration by taking his pupils outside during the autumn and pointing out the swallows gathering on

the roof of the schoolhouse, explained centrifugal force by twirling mop heads, taught the configurations of the solar system by forming his pupils into a human orrery, and wielded 'a fire-shovel, tongs and a poker [to] show the foundation of the mechanic powers, especially the action of levers'.[18] It is possible that these exercises, which he repeated at Enfield, left their lasting impression on Keats in particular as well as general ways: helping to shape the cosmology of the two 'Hyperion' poems, and the final image of 'To Autumn'.

While Ryland's school developed its reputation for combining 'pleasure with improvement',[19] his home became renowned as a meeting place for reformists. The best-known of these was Joseph Priestley, famous in his day not only for the discovery of oxygen, but as a radical teacher with 'a basic commitment to the capacity of human beings to understand the world through investigation'.[20] Priestley was born in 1733, the son of Calvinist parents, and became a dissenting minister in 1767. He was a tireless opponent of monarchical politics, a passionate enthusiast for the original principles of the French Revolution, anticipated Paine in his *Essay on the First Principles of Government*, and steadfastly connected his professional work with his ideological beliefs. Once he had identified the Anglican hegemony as a kind of perversion (he called the established church 'a fungus upon the noble plant of Christianity'),[21] his demands for reform stopped only a little short of calls for rebellion. He published and experimented energetically, he befriended other radicals such as Jeremy Bentham and Richard Price, he proposed a vision of patriotism as 'manly freedom',[22] and he elaborated Locke's view that the way to human perfectibility lay through education. Wesley called him 'one of the most dangerous enemies of Christianity'; Coleridge hailed him as 'patriot, and saint, and sage'; friends and enemies alike recognised that he distilled the revolutionary mood of the moment.

Priestley left England for America in 1794, but not before he had strongly influenced Ryland, and also become a friend of Clarke's – whom he introduced to militant sympathisers such as Cartwright and Richard Warburton Lytton. While Ryland and Clarke were less developed politicians than Priestley, they made his thinking a vital part of their own educational programme, promoting his views and using his publications wherever possible.[23] If some Northampton parents were put off by this, their feelings were not reflected in the school's register: pupil numbers held steady at just under one hundred. Ryland's benevolence did create a

[27]

different sort of problem, however. His fees, Dyer said, 'were not only low, but his hand was apt to be liberal beyond his means, [and] his peculiar situation as a very popular preacher in a particular time, rendered his academy a sort of open house "to all the vagrant strain" '.[24] Eventually and inevitably the school went bust – though rather than accept defeat, Ryland persuaded Clarke that they should transfer their work to a different place. In 1785 they left the Midlands, and after a year spent casting about for a new and suitable location, settled on Enfield.

George Dyer did not come with them. In the months before leaving Northampton he had tried to pluck up courage to propose to Ryland's stepdaughter, Ann Stott, only to find that Clarke also loved her. When she accepted Clarke, Dyer left for Cambridge. This, combined with Ryland's old age, meant that the new school in Enfield was effectively run from the first by Clarke, while his partner concentrated on 'the religious improvement of the pupils', and on preaching in the local chapel. Although Ryland's new congregation regarded him as 'attractive [and] of much humour and resource',[25] his Calvinism and his politics both soon got him into trouble. He was denounced by a local poet, Sherwin, and widely accused of preaching to the elect and spurning others. In time, these difficulties faded. The people of Enfield found, as those in Warwick and Northampton had done, that Ryland's sincerest passion was for tolerance. According to Charles Cowden Clarke, his 'pulpit eloquence'[26] became a legend, and the sight of him driving to preach every Sunday in the stage coach (and once, because the coach was not running, in a wheelbarrow) was a welcome part of village routine. When he died on 24 July 1792, he was mourned as a friend as well as a teacher.

Clarke continued to work in the school as his father-in-law had encouraged him. Less strenuously Bible-thumping, he made religious instruction a vital part of everyday life.[27] Keats's Christian faith later dwindled and mutated, but he never forgot his earliest lessons: the daily worship, the hours spent 'in reading the scriptures',[28] the constant reference to such texts as Watts's *Divine Songs* and Dodderidge's *Principles of Christian Teaching* – and of course to Ryland's writings, which formed an especially important part of the school library. There are more than ninety allusions to the Bible in his poems, and a letter written to his sister Fanny in 1819 shows a deep and intricate knowledge of Christian teaching.[29] Neither did he neglect Clarke's advice that the basic tenets of Christianity, when stripped of their 'parsonical'

trappings, could be related to other kinds of commitment. Throughout the two long terms which made up each year (one running from August to Christmas, one from January to July), Clarke stressed the humanising virtues of studying the Classics – even though he did not teach Greek. He encouraged his pupils to develop an interest in music (he and his wife both played the piano). He gave them a great deal of poetry to read, and praised 'the consideration of verse. – Not a skill of composing, – so much as a just taste and a grand imagination; so as to relish a fine composition'.[30]

In the process, he invited them to share his liberal politics. His son said that he had 'to the full the political tendencies which were so intimately associated with religious dissent',[31] always referring his pupils to the opinions of friends like Priestley and Cartwright, and employing the exiled radical Abbé Béliard as his French master. (Keats objected to the French method of cramming boys 'like young jackdaws' but he learned the language easily, and was later grateful to be able to read Voltaire and to translate Ronsard.) When John and Leigh Hunt founded the *Examiner* in 1808, Clarke immediately became a subscriber, and the journal's 'liberty-loving, liberty-advocating, liberty-eloquent' articles were made freely available to all pupils in the school. Whereas many other people who had espoused the radical cause in the 1790s had since 'gone down the long bitter path of disenchantment',[32] Clarke remained true to his first principles. He was a practical idealist, unassuming but stalwart, and able to satisfy the desire for bourgeois self-improvement as well as to stimulate liberal sympathies.

FOUR

JOHN AND ALICE JENNINGS, living in Ponders End close to Clarke's school, often called on their two eldest grandsons during their first long spell away from home. So did Thomas and Frances Keats, and it says a good deal about Thomas's character that his visits were later remembered vividly by Charles Cowden Clarke, who was only fifteen when the boys (themselves aged seven and a half and five) first arrived in Enfield. 'I have a clear recollection of [Thomas's] lively, and energetic countenance,' he said, 'particularly when seated in his gig, and preparing to drive his wife home, after visiting his sons.'

This makes it sound as though the Keats parents knew their children

were bound to be homesick. The fact that George often defended his smaller but elder brother suggests that John missed them especially badly. In fact George, who was 'a child of rather pacific nature', was often mistaken as the eldest of the boys, looking after Tom when he eventually joined them at the school, helping his siblings with their reading, and showing an affection towards John in particular which was 'really more remarkable than even his brother's poetic genius'.

From the outset, John Clarke also made John his 'favourite . . . with a generous placability'. There was soon reason to show him even greater concern. On 15 April 1804, when Keats had only been at Enfield for nine months, his father was killed. He was returning from a visit to the school, and after stopping for supper in Southgate on his way home to the Swan and Hoop, was thrown from his 'remarkably fine horse' as he travelled down the City Road at one in the morning. (Abbey, with no justification, said he was 'most probably very much in liquor'.) John Watkins, a night watchman, saw the riderless horse clattering back to the stables, and found Thomas Keats lying unconscious outside the gates to Bunhill Fields. He carried the body to a surgeon in a side street, but nothing could be done. Thomas Keats was taken back to the Swan and Hoop; he died the same morning.

Frances Keats was twenty-nine and coping with an eleven-month-old daughter. In the last two years her uncle Charles Sweetinburgh and her son Edward had both died, and she had seen her two eldest children sent away to boarding school. This latest and most grievous loss seems to have driven her half out of her mind. Shortly after her husband had been buried in the Jennings family vault in St Stephen's, Coleman Street, on 23 April, she disappeared from the Swan and Hoop, probably taking Fanny with her. When a Poor Rates collector visited the inn later in the summer, he was received by an Elizabeth Keats, possibly Thomas's sister.

Frances's absence is surprising for business as well as domestic reasons. Her financial situation was precarious; her husband had died intestate, and the lease on his business was due to expire in just under a year's time, on 25 March 1805. But when she returned to the inn during the summer, she did not devise a general rescue plan. She merely took out a short lease in her own name in the stables (not the inn), and waited for the wheels of the law to turn until she gained control of Thomas's estate. This would eventually happen a year or so later, bringing her some £2,000 – not enough to pay the rent on her property and to support

her family for long.

Perhaps Frances knew that her father was ill, and that the organisation of the business was bound to change soon whatever she did. Perhaps she was simply not thinking straight. In any event, her single most decisive act (in a time long before the Married Women's Property Act) made her just about as powerless as she could be. On 27 June 1804, a little over two months after her first husband's death, she got married again, in the same church where she had married Thomas ten years previously. Neither of the Jenningses came to the ceremony, though since they had not come to her first wedding either, this should not be taken as proof that they were both hostile to the match: only Alice is reported as having 'actively disapproved'[1] of it.

Frances must have trusted that her new husband would help her care for the children, win her father's support, manage the business well, extend the lease in due course, and make her a partner in all but name. She made a bad choice. The little that is known about her new husband, William Rawlings, shows that at one time he had been briefly employed as a stable keeper, but when he met Frances was working as a minor clerk in the banking firm of Smith, Payne and Company in George Street. He had 'no property of any kind', and a very modest salary. As soon as he got married, he abandoned his existing work and became proprietor of the inn.

There is not enough evidence to brand Rawlings an adventurer, but he was obviously an unsuitable husband for Frances in several ways, not least because he was ignorant about inn-keeping. All through the hot summer and foggy autumn of 1804, it was Frances who organised the running of the Swan and Hoop, paying rent to her father in Ponders End. Because it is not known whether John Jennings shared his wife's dislike of Rawlings, it is also not clear whether he helped with the business. He was unlikely to have been actively involved. He had been in poor health since his retirement, receiving regular visits from the local doctor, Thomas Hammond, and on 1 February 1805 he made a hasty will. His total savings amounted to £13,000. He left half to his wife, a third to his son Midgley, and annuities of £50 to his daughter and sister. His grandchildren were bequeathed £1,000, to be divided among them equally.

Five weeks after signing his will, John Jennings was buried in St Stephen's, Coleman Street, and Frances became even more seriously at a loss. The lease on the Swan and Hoop was due to expire in a fortnight,

and her father's executors, still critical of her second marriage, kept the terms of his will obscure. The more powerful of these executors was her younger brother Midgley. At first he told his sister nothing at all about her legacy; he just sent her a peremptory demand for the last quarter's rent on the inn. She responded by demanding 'various sums owed to the inn by her father'.[2] The exchange marked the beginning of a long and complicated legal battle that made Frances financially insecure for the remainder of her life, even though in April she inherited the £2,000 deriving from her first husband.

Within three months – in the early summer of 1805 – Frances and Rawlings had filed a Bill of Complaint in Chancery against her brother, her mother, and the second executor of her father's will (Charles Danver, a neighbour in Ponders End). She accused them of interpreting the will to their own advantage, and registered her rights to a third of the unwilled part of the estate – some £3,500. It was a gamble, and it damaged the few remaining ties which bound the family together. So much so, in fact, that as Chancery began its slow deliberations, her life with Rawlings collapsed. He remained briefly in charge of the Swan and Hoop, then 'disposed of the lease to [a] new occupier'[3] and sank back into the shadows. (When he died a few years later, he was apparently still grieving 'greatly' for his wife.) Frances – for the second time in a little over a year – simply vanished. According to Abbey she went to live with a Jew called Abraham in Enfield, and began drinking heavily. Alice Jennings, who had moved from Ponders End to a house in Church Street, Edmonton, shortly after her husband's death, had no choice but to take responsibility for her grandchildren – even though she was sixty-nine years old.

EDMONTON WAS TWO miles away from Enfield, roughly the same size (the population was 5,000 in 1801), and had a history which was less impressive but more charming: William Cowper had made it famous in his poem about John Gilpin, celebrating its small hotel the Bell (now the Angel). Like its sister village, it was at once cut off from and in touch with London – surrounded by meadows and elm clumps, and adjacent to Pymme's Brook, which Charles Lamb would later commemorate. A local history of 1819 says it was 'a place possessing . . . many local advantages[;] the beauty of the scenery, the variety of the views, and its vicinity to the metropolis, would not be overlooked by those whose rank and fortune enabled them to select a suitable residence'.[4] Such seclusion

was extremely welcome to the Keats children, and if Alice Jennings resented her daughter's behaviour she never took it out on them. She was always loving, tolerant and considerate, and they were quickly drawn to her – even as they clung to each other in their sudden abandonment. (George would later remember how he and his brothers were 'always devising plans' to amuse their little sister Fanny, bringing her presents of mice and fish, 'jealous lest [she] should prefer either of us to the others'.) Yet however comforting Alice was, she could not undo the damage that had been done. Keats had seen his family broken apart by a quarrel about money. In all his later financial dealings, he showed an embarrassment, and sometimes an incompetence, which reflects this early experience. More painfully still, he had watched his mother change from an ideal figure into a focus for scandal and dislike.

In the late summer of 1805, when the holidays ended and the new school term began, the Clarke family took it upon themselves to act like a second set of surrogate parents. Charles Cowden Clarke, who was eight years older than the now nearly ten-year-old Keats, was especially protective. He was bluff but sensitive – widely read in the Greek and Latin classics, a passionate theatre-goer, an accomplished singer and pianist, and a productive poet. His political opinions were sophisticated as well. Sharing his father's tolerant curiosity, he had worked his way through the enlightened reading in the school library, and listened to Priestley and other radicals in his father's home.

To start with, such tastes did not attract Keats. At least until his early teens, he 'gave no extraordinary indications of intellectual character', and spent more time idling, playing games, and enjoying 'extraordinary gesticulations and pranks' than he did concentrating on his lessons. (One friend said that he was 'noted for his indifference' to them.) It made him seem an aggressively normal child: if he had any sort of popular reputation, it was as a fighter. Even the charitable John Clarke admitted that Keats had 'a highly pugnacious spirit', and Charles Cowden Clarke said that Keats's fits of rage produced 'the most picturesque exhibition – off the stage' that he had ever seen. It reminded him, he said, of 'the transports of that marvellous actor Edmund Kean', whom Keats later idolised and resembled 'in face and figure'. One particular episode stuck in Charles Cowden Clarke's memory. 'An usher [in the school], on account of some impertinent behaviour, had boxed Tom [Keats's] ears[.] John rushed up, put himself in the received posture of offence, and, I believe, struck the usher, – who could have put him in his pockets.

[33]

His passion at times was almost ungovernable; his brother George, being considerably the taller and stronger, used frequently to hold him down by main force, when he was in "one of his moods" and was endeavouring to beat him. It was all, however, a wisp-of-straw conflagration, – for he had an intense tender affection for his brother, and proved it upon the most trying occasions.'

Another boy in the school, Edward Holmes (1797–1859), whose precocious skills as a musician endeared him to Charles Cowden Clarke, felt that Keats's belligerence made it likely that he would end up serving in 'some military capacity'. He also sensed that such hot temper was the result of troubled family circumstances, and displaced differently 'ardent and imaginative' characteristics. Like several other boys – the 'lively, brisk' Edward Cooper, for instance, who later became a distinguished inventor, and Thomas Richards, who was also the son of a successful livery-stable keeper – Holmes did what he could to calm Keats's anxieties, and steer him into peaceable ways. In particular, and although he was 'some years his junior' and therefore 'obliged to win his friendship . . . [in] several battles', Holmes began persuading Keats to take an interest in music.

Holmes was an attractive, good-natured boy, and an excellent mimic – which no doubt made his enthusiasms more acceptable to Keats. In later life, like Keats, he became a friend of Leigh Hunt and Vincent Novello, who regarded him as his 'most eminent pupil'. In the 1830s he would write regularly for the *Atlas*, and in 1845 he published the first biography of Mozart in English. Its stress on the 'spirituality' of music is a mature expression of the lessons he had learned at school: the Clarkes believed that art should be a transfiguration of life, not an escape from it. When not ragging with Keats in 'a sort of grotesque and buffoon humour', Holmes would occasionally play for him, sing to him, and discuss musical composition. So did Charles Cowden Clarke. In 1819, when Keats read Clarke his 'The Eve of St Agnes', he told him that the passage in which Porphyro listens to the music in the castle 'came into my head when I remembered how I used to listen in bed to your music at school'. (Holmes would get out of bed and stand at the top of the stairs.) Keats's letters are dotted with references to music which reflect this early experience. Sometimes they merely comment on performances he has heard – on the musician, for instance, he described as 'pegging and fagging away' at an overture. Sometimes they register a simple social function – asking his sister about learning the flageolet, or for advice

about dancing. Sometimes they pay tribute to music's power, as when he describes meeting a beautiful woman who kept him awake as a tune of Mozart's might do. Sometimes they make more profound connections, as in the great letter to Benjamin Bailey of 17 September 1817, when he asks 'Have you never been surprised with an old Melody' while explaining how 'the simple imaginative Mind may have its rewards in the repetition of its own silent Working coming continually on the spirit with a fine suddenness?' If these and other references were not enough to show that Keats eventually saw poetry and music as linked, rather than merely as sister arts, we have Bailey's own word for it. 'One of [Keats's] favourite topics of discourse', he said, 'was the principle of melody in Verse, upon which he had his own notions, particularly in the management of open & closed vowels. I think I have seen a somewhat similar theory attributed to Mr Wordsworth, but I do not remember his laying it down in writing. Be this as it may, Keats's theory was worked out by himself.'[5]

DURING THIS MIDDLE period of Keats's school life, the political situation abroad deteriorated steadily. Nelson's victory at Trafalgar in October 1805 was followed by severe restrictions on British trade in Europe, and as Spain revolted against Napoleon in 1808, England was drawn into an exhausting conflict on the Peninsula, emerging triumphant at Vimiero in 1808, but crushed at Corunna. There was continuing unrest at home as well. When Pitt died in January 1806, the same month that Nelson was buried, the so-called Ministry of All the Talents was formed under Grenville and Fox, then shortly afterwards collapsed when Fox also died. The Duke of Portland became Prime Minister until 1809, when Perceval took over, and both men continued to justify their hostility to any Parliamentary reform by deflecting attention away from national to international issues.

Keats often heard these things discussed by the Clarkes, but paid more attention to the dramas of his family life. In May 1806, when he was ten and a half, Chancery finally delivered its verdict on the claim brought by his mother and William Rawlings against the executors of John Jennings's will. Alice and Midgley were granted all the cash they had claimed; Frances was only allowed her £50 annuity – and even this was withheld until all the successful claimants had received their dues. Frances was already a remote figure to her children. The court's decision drove her even further away. While Rawlings remained alone at the

Swan and Hoop, she continued to live her veiled half-life, possibly with Abraham as Abbey stated. Three years passed before she surfaced again, drawn out of obscurity by yet another financial crisis. In 1808 her brother Midgley at last received the money settled on him by Chancery, and was instructed to pay the arrears of Frances's annuity. Even though he died shortly afterwards (or perhaps because he knew that he was dying and wanted to settle outstanding difficulties), the rift between them narrowed. By this stage, though, Frances was 'in great distress', suffering for whatever life she had lived in isolation, poverty-stricken by the delay in receiving her dues, and still hoping that Chancery would find in her favour when it came to consider the remaining aspects of her claim. In the early part of 1809, as an 'immense quantity of snow' fell over London and Middlesex, and gales blustered for weeks on end, she made a cautious approach to her mother, asking whether she might return to live once more with her children, who were now aged thirteen (John), eleven (George), nine (Tom), and five (Fanny).

When Alice Jennings agreed, she found Frances woefully unlike the vivacious and independent spirit she had known five years previously. Her daughter was only thirty-four years old, but careworn, depressed, and ill – suffering from 'a rheumatism' according to George, and also showing signs of the tuberculosis which had recently killed her brother. She was not so much a guest in her mother's house as a patient, and the resemblance she had once shown to her eldest son was hard to discern. During her absence, Keats had grown into an 'active, athletic and enduringly strong' boy, 'well-knit' and with 'a fine compactness' like his father. He was short for his age (he had nearly reached his full adult height of five feet and a fraction of an inch), but his red-brown hair, darting gestures, and eager expression gave an impression of 'extraordinary vivacity and personal beauty'. He may have been noted at school for his 'indifference to be thought well of . . . as a "good boy" and to his tasks in general'; he was also reckoned to have a fine, if latent 'sensibility'.

From the first moment that Keats was reunited with his mother, this 'sensibility' showed more and more clearly. He appointed himself her principal nurse, caring for her with a passionate possessiveness. 'Before his mother died,' Haydon wrote many years later in his diary, 'during her last illness, his devoted attachment interested all. He sat up whole nights in a great chair, would suffer nobody to give her medicine but himself, and even cooked her food; he did all, & read novels in her

intervals of ease.' His nursing forged the first connection between literature and healing which would eventually become a dominant theme in his poetry. It had a wider effect as well. It taught him that the contemplation of suffering contained the possibility of greater knowledge – not just knowledge of the self, but of the whole human condition. Pleasure, he began to realise, was inseparable from pain; gain could not be separated from loss. This is what he meant when he later said that 'Difficulties nerve the Spirit of a Man – they make our Prime object a Refuge as well as a Passion.'

When keats went back to Clarke's school after his brief summer holidays, his worry about his mother continued to galvanise him. He attacked his work with 'a new resolve', quickly transforming himself from a boy who had been distinctly 'not literary'[6] into a voracious reader. Charles Cowden Clarke remembered that he began studying well before seven o'clock in the morning, when lessons began, had to be driven 'out of the classroom for exercise', and would even read during meals. (This picture of Keats as a 'hungry' reader is reminiscent of the way that 'hunger and fancy' combined in the young Coleridge – and also of David Copperfield, who in his heartless stepfather's house would read 'as if for life'.)

John Clarke's library was large and well stocked, and Keats's teachers let him range as he chose. (William Newman, an assistant master at Enfield before Keats arrived, said that boys at the school had 'greater advantages of seeing, reading and hearing of good books than thousands of youths of [their] age'.) Sometimes Keats fell on popular classics like the *Arabian Nights* and (according to Holmes) '*Robinson Crusoe* and something about Montezuma and the Incas of Peru'. Sometimes he devoured Gothic thrillers such as Beckford's *Vathek*, or the novels of Monk Lewis, Mrs Radcliffe, and Maria Edgeworth. But it was Latin authors and mythological keys which became his staple diet. 'The books that were his constantly recurrent sources of attention,' says Charles Cowden Clarke, 'were Tooke's *Pantheon*, Lemprière's *Classical Dictionary* [*Bibliotheca Classica*], which he appeared to *learn*, and Spence's *Polymetis*.'

All these made a lasting impression. The *Pantheon*, for instance, provided him with a good deal of material for his later writing, and was still among his books when he died. (It gave him ideas about the festivities honouring Pan in the opening scenes of *Endymion*, as well as

[37]

details for episodes in 'Hyperion'. Tooke has one chapter on 'The More Ancient Gods' and another on 'The War of the Titans'.) *Polymetis* – a large, well-illustrated volume – was similarly useful. It now seems a charming, slightly dotty concoction – Casaubonish in its search for connections. Like Lemprière's *Dictionary*, however, it offered Keats a key to classical culture, containing brief portraits of the gods and goddesses he would later transform into emblems of modern anxiety and virtue. Apollo, for instance, who has 'a certain brightness beaming from his eyes', and Psyche, Endymion, Hyperion and Saturn, who appears 'very old, and decrepit, as well as chained . . . in all respects, like one that must go extremely slowly'.

In the short term, these books drew Keats away from everyday life into fairyland; others that he studied had the opposite effect. Many of them reflected the continuing influence of Ryland on the school. Charles Cowden Clarke says that as Keats worked his way along the shelves he concentrated on 'voyages and travels of any note' and also on histories, particularly 'Robertson's histories of Scotland, America and Charles the Fifth'. This last book is a study of how 'the powers of Europe were formed into one great political system' during Charles V's reign as Holy Roman Emperor during the first half of the sixteenth century, and in all three of his volumes Robertson is at pains to stress that 'the great events which happened then have not hitherto spent their force. The political principles and maxims then established still continue to operate.'

Gilbert Burnet's *History of his Own Time* also left Keats in no doubt that he was learning about the social structures of his own life while he studied the conflicts of the past. This is the book Charles Cowden Clarke remembers seeing propped between Keats 'and the table, [with Keats] eating his meal from beyond it', and which, he said, 'laid the foundation of his love of civil and religious liberty'. (Clarke once referred to Burnet as 'so fine a Scholar and so great a man'.[7]) An enormous, highly subjective work, it is not so much 'a formal history' as a 'running commentary'[8] on the years 1640–1713, consistently placing its emphasis on 'the Principle of . . . *Toleration*' as well as devotion, and showing less interest in explaining doctrinal disputes than in identifying religion as the 'spring of a new nature'. Fired by a 'long experience' of 'baseness . . . malice and . . . falsehood', Burnet places his hope for the future on the example of those who challenge 'the worst of both men and of parties'. Milton (who in *Paradise Lost* had produced 'the beautifullest and

[38]

perfectest poem that ever was writ') and Algernon Sidney ('a republican of most extraordinary courage') are singled out for special praise. Both immediately became heroic figures for Keats, confirming his faith in the value of noble action.

There was a third element in Keats's reading, which Charles Cowden Clarke may have encouraged by confiding his own literary ambitions. In most respects, his poetic tastes were typical of his time – typical, that is, of an eighteenth-century writer who believed in the value of learning by example. As he introduced his protégé to what he habitually referred to as the 'riches' of the past, he delighted in his discriminating judgement. When Keats finished Virgil's *Aeneid*, for instance (of which he translated a large part into prose before leaving school), he 'hazarded the opinion that there was feebleness in the structure of the work'. He showed the same mixture of excitement and discipline in his classroom studies, too – and a similar sort of ambition. Although his ostentatious reading won him the generally good opinion of his headmaster, he wanted a more precise kind of reward, and set himself to win first prize of the three that John Clarke awarded every term for translations from Latin and French. He succeeded at his first attempt, and was awarded C. H. Kauffman's *Dictionary of Merchandise* – 'a very reasonable choice', as one of his biographers says, 'for the headmaster of a school which catered for the sons of the trading and business classes'.[9] The following year 'there may [also] have been another book awarded',[10] and in 1811 he received Bonnycastle's *Introduction to Astronomy*.

Keats evidently hoped that his work would please his mother and keep thoughts of their difficulties at bay. It gave only temporary shelter. Although Frances had relinquished her claim to any money from her brother's estate soon after arriving in Ponders End, she was still persevering with her appeal for the capital from her own annuity, and for the legacy to her children. As she did so, her sister-in-law Margaret Jennings created yet another obstacle. She petitioned Chancery that all Midgley's capital still held by the court should be allotted absolutely to her three children, Keats's cousins. Frances's original dealings with Chancery had been upsetting enough. This new appeal made matters even worse. It meant that when Keats returned home for Christmas at the end of 1809, the house where he should have been prized was a place where he felt oppressed. Once again life seemed determined to prove that success was only the prelude to failure. 'I have never known any unalloy'd Happiness for many days

[39]

together', he said later. He decided to behave as he had done during the summer. He turned himself into his mother's nurse, grateful to have at least this much contact with the person he loved best in his family, but had seen the least.

FIVE

EARLY IN THE new year, 1810, Chancery finally reached the end of its deliberations: the claim that Margaret Jennings had lodged on behalf of her children was dismissed on 13 February, and she was allocated one half of her late husband's capital (the other half eventually went to the Keats children). In the same judgement, £1,666 3s 4d was ordered to be set aside for Frances – which meant that her annuity of £50 was at last secure, and that her children would inherit whatever remained at the time of her death. Chancery also decreed that the £1,000 willed by John Jennings to his Keats grandchildren should be invested in 3 per cent Consols, and put in trust until they reached the age of twenty-one.

As soon as this peace had been achieved, it was shattered, Frances died during the second week of March, and on the 20th was buried in the family vault of St Stephen's, Coleman Street. The cause of her death was given simply as a 'decline': it was almost certainly tuberculosis. The news of his loss reached Keats at school, and when he returned there after the funeral, his teachers and friends were shocked by the violence of his sorrow. Nursing his mother, he had felt energised and even a little ennobled by his 'difficulties'. Once his battle to save her had been lost, he gave way to 'impassioned and prolonged grief', often taking himself off to suffer in solitude, sometimes so overcome during his lessons that he had to leave his desk and hide in the alcove beneath the raised platform on which his teacher sat.

While the miserable spring turned into summer, Keats immersed himself even more deeply in his books. The small child became in the eyes of his school-fellows a kind of miniature man: reserved and preoccupied where only a short while before he had been rumbustious and full of jokes. He was deprived of both his parents, and surrounded by an extended family which was indifferent or hostile: he did not see his aunt Margaret or his cousins again.

Keats never whined about being an orphan, but he did later admit that his greatest misfortune had been that he 'had no mother', and realised

that this powerfully influenced the growth of his personality. It gave him an unshakeable sense that because life was precarious it must be lived fully and fast. 'It runs in my head we shall all die young,' he said at the end of his life, remembering that before he was fifteen years old he had lost both his parents, a brother, and two uncles.[1] Every attempt that he would later make to explain the conditions of human existence sprang from his conviction that suffering was its only reliable component. The question was not whether it might be greater or less, but how it might best be 'undergone'. In letter after letter, and poem after poem, he would admit that there was 'nothing stable in the world', that life was full of 'all sorts of troubles and disagreeables', that 'existence' was 'pain', that 'aching Pleasure' turned 'to poison while the bee-mouth sips'. The point of confronting these difficulties was not simply to learn a lesson in realism. It was to school the self for a 'great human purpose'. He came to believe that the batterings and abrasions which take 'the fine point off a Man's soul', were also the means by which people attain some more resilient philosophical dimension, leading them from the 'thoughtless chamber' to the 'chamber of Maiden Thought' and beyond. There is never any sense that this is an easy progression, but Keats does not doubt – until the very end of his life – that it comprises the only proper response to experience.

All these ideas, forming cautiously at first, and later developed with wonderful zest, were a way of achieving control of experience through explanation. But Frances's death also produced many other less manageable thoughts – some of which caused Keats grave personal difficulties, and some of which helped to shape the images and patterns upon which his work depended. At the same time as they depressed him, they allowed him to invent himself by stimulating a powerful belief in the compensatory role of the imagination. When he began writing poetry, he devised strategies for making it seem a parallel universe in which loss and gain could both be examined with equal clarity. The half-real, half-statuesque existence of his mythical figures allows this, and so do characters such as Porphyro, Madeline, Isabella, Lamia and Lycius in his narrative poems. Part familiar and part allegorical, they prove their breathing humanity while insisting they are deliberately created things.

This duality is strengthened by the context Keats creates for them. Their universe is made up of recognisable trees, flowers, landscapes and buildings, and also decorated with images which are patently confected – bowers and caves, underwater panoramas, lonely towers, bare hillsides,

mythological forests. These are symbols which declare themselves as such, and like the gods or narrative characters who tangle with them, they show how often and how deeply Keats's work as a poet is driven by his desire to transform absence into something substantial. He never wrote a poem simply and directly about his parents, but their loss, and especially the loss of Frances, is evident everywhere.

This connection can also be made precisely. The traumatic, broken shape of Keats's relationship with his mother – losing her first to Rawlings, then recovering her, then losing her again to death – created a pattern of possession and abandonment which runs throughout his poems. In 'La Belle Dame Sans Merci' and 'Lamia' it is altogether exposed. In his play *Otho the Great* he suggests that any sort of loving union amounts to death itself. In *Endymion* the hero repeatedly wakes from dreams of loving companionship to a solitude in which his 'appetite' for 'love immortal' confuses sexual longing with the wish to be mothered: it repeatedly describes love as a nourishing drink, and spends a good deal of time gazing at women's breasts – those 'tenderest, milky sovereignties'.

Keats eventually showed extraordinary self-knowledge about the origin of these themes, especially in the letter he wrote to his friend Benjamin Bailey in July 1818, where he admitted that he did not have 'a right feeling towards Women', and was prone to think of them in crudely divided ways: as either perfect or corrupt. (The split was reinforced by his having had effectively two mothers – one a young fallen angel, the other an elderly nurse.) In the short term, he was more concerned by his responsibility for his siblings. During his earliest schooldays, George had usually behaved as the eldest and most protective. Now Keats took charge in whatever ways he could. He encouraged his brothers by his example as a pupil, he dictated the tempo of their time together, and he altered his role as nurse into one of adviser – particularly of the quiet, slightly built Tom and their sad, sallow-faced sister Fanny. In 1819, when she was sixteen, he told her: 'I feel myself the only Protector you have.' The 'happiness' of his family, he said, was 'sacred'; his love for his brothers was 'an affection passing the Love of Women'.

There were many things which Keats was too young to administer, in fact and in law. One of these was his finances. In different circumstances his grandmother would have controlled them, but her old age (she was now seventy-four) made her uncertain. Her daughter's legacy to the children was clear enough – Chancery had finally seen to that. So were

her own affairs. In August of this year, 1810, she had at last received all that she had been left by her husband: stock valued at a little over £8,500. This meant that Keats's inheritance could now be finalised as well. She willed him some £2,000 (roughly a quarter of the money she divided between her four Keats grandchildren). In addition, Chancery had allotted him just over £800 capital – and when he reached the age of twenty-one he would also be able to claim his mother's legacy and the amount left to him by his grandfather. All in all, it came to a very respectable amount, and should certainly have spared him any pressing financial worries. In fact, and disastrously, difficulties continued to beset him.

Keats himself was partly to blame. In later life, his reluctance to delve into his own monetary affairs meant that he often lived beyond his means, and lent to his friends when he could not afford to. In other respects he was an innocent victim. For one thing, he simply did not receive everything that was his due. William Walton, Frances's lawyer, was the only person who knew about the Chancery inheritance, and it did not come to light until after Keats had died. For another, he suffered at the hands of those to whom Alice Jennings turned for help: John Nowland Sandell and Richard Abbey. When Alice asked them to draw up her will, she also appointed them the children's trustees and guardians. It was a decision taken with the best intentions, but led to problems which blighted Keats's entire life.

Sandell, who had run an office near the Swan and Hoop in the 1790s and now worked as a merchant in Broad Street Buildings, is a shadowy figure. He took 'a very small part, if any, in the trusteeship',[2] but one piece of surviving evidence suggests that he was at least solicitous. In January 1816, when Fanny was twelve, Sandell and his wife Ann entertained her at home in Dalston – a village to the east of London – and when she left, Sandell gave her a note saying: 'This is to certify to whom it may concern, that Frances Mary Keats during the time she was on a Visit to Mrs Sandell, was a very good girl.' Shortly after this encounter, Sandell died aged forty-six; he was buried in St John's Church, Hackney, and the register of his death duties shows that he had prospered: he left an estate worth over £20,000.[3]

Abbey is an altogether more significant character, one whose gossiping about Keats's parents has already marked him out as malicious. It is generally agreed that his handling of the estate was also stingy and incompetent. Although it seems highly unlikely that he

intended to do the children harm when he first accepted the role Alice created for him, the way in which he performed his duties meant that he often let them suffer. This was perhaps partly because he saw certain similarities between their present situation and his own past. His 'father and grandfather had died leaving him ample provision, with care and foresight, to make good in the world',[4] and he could not stomach the idea that his charges might not follow his 'sensible' example. The effect was to make him stern when he might have been kind, furtive when he needed to be open, stubborn when he should have been imaginative. Although he never lost his affection for Alice Jennings, he felt that the Keats children were tainted by the weaknesses of their parents, attended a dangerously subversive school (he said that if he had fifty children he would not have sent one of them to Enfield), and held views which implicitly criticised his own beliefs. Keats reserved for him some of the harshest words he ever wrote – and so did his sister Fanny. In 1826 she referred to him as 'that consummate villain'.

Alice Jennings knew nothing about Abbey's faults. But the question remains: why did she choose him? For many years Keats's biographers accepted John Taylor's impression that Abbey shared with her 'a common County and birthplace' (Colne, in Lancashire), and that this formed a bond between them. In fact, Abbey was a Yorkshireman not a Lancastrian.[5] He was the eldest son of farmers from Healaugh in the Vale of York, inherited substantial sums from his family, and was able to buy his own tea-broking business at 6 Size Lane, off Budge Row in the City, when he first came to London in 1786. It seems likely that he met Alice when she was living at the Swan and Hoop, rather than earlier, and that she was attracted by his worldly success and by the fact that he was apparently charitable at home. He had married an illiterate woman, Eleanor Jones, for love, and, being childless, they adopted the daughter of a north-country woman who had been murdered by her husband.

As Abbey had grown more prosperous, he had also begun flaunting his old-fashioned values. He wore 'white cotton stockings and Breeches and half boots – when for a long Time there had been no other Man on the Exchange in that Dress'. Now forty-five years old – he had been baptised on 13 August 1765 – he was a partner in the firm of Abbey, Cock and Co. (tea brokers), based at 4 Pancras Lane in the Poultry, and had a large house four miles away from Edmonton in the pretty village of Walthamstow ('Pindars', in Marsh Street), where he was a warden in the local church. He also held a number of influential public offices. He

was a member of the Port of London Committee and the Honourable Company of Guilders; Steward of the City of London National Schools Examinations; and was twice the Master of the Honourable Company of Pattenmakers. These things undoubtedly impressed Alice Jennings, and if she knew that he fulfilled his various roles with a heavy-handed severity, there is no record of her objecting. When he became Chairman of the Walthamstow Sunday School he insisted that poor children, who were entitled to receive a guinea if they remained in employment for a year after leaving school, only got their money if they produced the Bibles and Prayer Books they had been given as leaving presents to prove they had not sold them. As Master of the Pattenmakers he reduced the number of company dinners and banned the serving of wine.

Cautious and captious, hard-working and high-achieving, Abbey never inspired any trace of the affection associated with a father-figure: he was ushered into the children's lives as a type of masculine rectitude such as they had never previously known. And as soon as Alice Jennings had signed her will, he began trying to fashion his young charges in his own image. No doubt it had already occurred to Alice that the midsummer term, 1810, should be Keats's last at Clarke's school. In July he was fourteen years and nine months old, at that period a perfectly usual age for children like him to end their formal education and begin training for a career. But Abbey obviously helped her reach a final decision, since when Keats prepared for the next stage of his life, George was also taken away from Enfield and put to work as a clerk in Abbey's business in the Poultry. George seems to have lodged with the Abbeys in London, and worked alongside Cadman Hodgkinson, Abbey's seven-teen-year-old apprentice, who was the son of a City druggist. For the time being, Tom, who was only ten, stayed at the school, and Fanny remained at home in Edmonton with her grandmother. In 1814 she went to an 'academy for young ladies' in Walthamstow High Street run by a Miss Caley and a Miss Tuckey and continued there until she was fifteen, when she went to live with the Abbeys.

It is not known whether Abbey influenced Keats while he considered which career to pursue. As an orthodox and socially ambitious man, he would certainly have approved any choice which meant joining the professional classes. In the early autumn, when it was decided that Keats should begin training as a surgeon-apothecary,[6] Abbey willingly gave whatever support was necessary. So did Alice Jennings. Her grandson's prospective career offered the chance of long-term security, and also

meant that Keats would be able to remain within easy reach for the next few years. This is not to say that Alice and Abbey made Keats's decision for him. In later life, when he had abandoned medicine and was prone to disparage the conditions of his apprenticeship, he often suggested that his career was thrust upon him. Charles Cowden Clarke, however, remembered that it was 'his own selection'. Becoming a doctor was a natural development of the role he had played at home for the past eighteen months. Attending his mother's sickbed, he had been son and nurse. The care he had shown, and the sorrow he had endured, coalesced into a sympathy with suffering which, in the aftermath of his mother's death, naturally sought wider and more formal expression. There were other motives, too. During the years that Keats had spent in Enfield, he had been taught that liberal convictions should be applied as widely as possible. As he ended his life with John Clarke, he may not have suddenly felt 'the growth of an intellectual passion' as (for instance) Lydgate did in *Middlemarch* when he first clapped eyes on 'an old Cyclopedia' in a 'small home-library'. But he knew that the next 'chamber' of his existence was a logical extension of everything that preceded it.

He realised, moreover, that medicine itself was at a revolutionary stage in its development. Scientific discoveries of the past several years had greatly developed the understanding of certain diseases, and the European war had sharply increased the need for and prestige of doctors, while also giving them enormous opportunities for observation and research. The Army Medical Service (for which Keats's doctor relation Thomas worked as Inspector of Regimental Infirmaries) had been overhauled; monthly reports had begun to appear on 'The Diseases of London' in 1796; and in 1805 Pitt had tried to establish a Board of Health (a kind of proto Health Service). Although it only survived a year, it showed that a new attitude to medicine was beginning to emerge, reflecting the pioneering spirit within it.

One of the clearest signs of this change was the Apothecary Act of 1815. When Keats began his apprenticeship in 1810 he could not have known that this Act would be passed almost exactly as he qualified – but even at the time, there was enough evidence that the medical world was in turmoil to suggest that it was ripe for reorganisation. Throughout the eighteenth century, doctors had fallen into one of three categories: apothecaries ('the lowest rank of the medical hierarchy'[7] who were forbidden by law to dispense medical advice as well as drugs, but were in

effect the doctors to the poor); surgeons (who were licensed by the Royal College and 'had to do with the simpler functions of the general practitioner of medicine and dentistry');[8] and physicians (who were university-trained at Oxford, Cambridge or Edinburgh, entitled to be called 'Doctor', had a highly developed sense of their own importance, and charged extremely large fees). As the growing body of medical knowledge complicated these distinctions, and the health needs of the population increased, relations between the three categories became increasingly tense. A Doctor Barlow (1779–1844), for instance, who was a physician at the General Hospital in Bath, complained in 1813: 'The surgeon exclaims against the apothecary, the apothecary retorts, and thus they go on mutually exasperating each other by every vilifying epithet and opprobrious insinuation until they have rendered life such a scene of heart-burning animosity and contention, that the strongest feeling of every liberal mind must be a desire to escape for ever from the profession and its bickerings.'[9]

The purpose of the 1815 Act was to stabilise the profession in general and to define the role of apothecaries in particular. In their earliest days, apothecaries had been associated with the Company of Grocers, but since receiving their first independent charter in 1617 had grown steadily in number and responsibility. By the end of the eighteenth century they were no longer simply dispensing and selling drugs, but practising too – effectively working as the equivalents of modern general practitioners. This expansion of their role inevitably prompted a wish for recognition: to exchange their function as individual entrepreneurs for something more definite and dignified. In 1812 they formed an association of some 200 members (this had increased to 3,000 by 1815), and stepped up their campaign for government reform. In 1813 a bill 'for regulating the practice of Apothecaries, Surgeon-Apothecaries and Practitioners in Midwifery . . . throughout England and Wales' was brought before Parliament, but judged to be 'careless and ill thought out'.[10] Two years later it was revised to propose that 'A Court of Examiners, consisting of twelve persons, [should be] chosen by the Society to examine the candidates for the Society's licence and [to grant] a certificate to those who satisfied the Examiners.'[11] The fee for this examination was fixed at ten guineas for people intending to practise in London or within a ten-mile radius, and at six guineas for those further afield. All candidates were required to have reached the age of twenty, to have spent a minimum of five years as an apprentice, to

produce testimonials of having received 'a sufficient medical educa-tion',[12] and to do at least a year of course work and clinical training at a major teaching hospital ('walking the wards') if they wanted to qualify as surgeons.

Although the Act was generally approved once the fuss surrounding its introduction had died down, it was in fact a muddled piece of legislation. It provided no clear definition of an apothecary; it preserved the existing hierarchical system; and it failed to outlaw irregular practitioners. It did, however, acknowledge the need to establish the terms of a modern medical education, and recognised that apothecaries were legitimate practitioners, not merely quacks. In 1817, writing in the *Examiner*, Hunt said that while he had 'no sort of regard' for 'apothecaries in general', there were at least some who 'may take rank in our estimation as physicians, sometimes above them, if they are good surgeons also; and if such an apothecary as this happens to have the whole weight of his profession upon him, as in a village for instance, where there is no physician, he may undoubtedly be one of the most valuable members of society.'[13]

Many would-be doctors were compelled to move away from home in order to serve their five-year apprenticeship. Keats was more fortunate. One of his grandmother's neighbours in Edmonton was Thomas Hammond, who had looked after John Jennings and Frances in their final illnesses and was a frequent visitor at Clarke's school. In August 1810 Hammond had apprenticed one of his sons to another doctor, and was ready to take on a pupil of his own, provided the necessary fees of £210 were paid. Even though it was a bad time to sell stock (Wellington's campaign in the Spanish Peninsula was foundering, and government funds were performing badly), Abbey made no objection. He was satisfied that both the career and the connection with Hammond were suitable, and promptly sold over £300 of Keats's inheritance.

Keats in turn paid what was owing to Hammond, made the vows demanded of every apprentice (not to marry, gamble, or visit taverns and playhouses during his incumbency), and removed his small hoard of books and other possessions from his grandmother's house. He was not yet fifteen, but his boyhood was over. The traumatic insecurities of his childhood were about to be replaced by the less hurtful but equally baffling uncertainties of adolescence – and of the apprenticeship itself.

W‍RITING TO HIS brother George in September 1819, Keats briefly discussed the change and re-formation of bodily tissues. 'Seven years ago', he said, 'it was not this hand that clench'd itself against Hammond.' His remark is usually taken as proof that his apprenticeship, which began happily enough, ended in disillusionment and recrimination.[1] It would be more accurate to say that when Keats began work, he regarded it as the necessary prelude to the life he had chosen. He may have been often bored, sometimes 'nervous and morbid', and occasionally deeply depressed; but he was always able to put the beliefs he valued into practice.

This helps to explain why Charles Cowden Clarke described the 'arrangement' with Hammond as 'the most placid time in [Keats's] painful life'. The doctor was a trusted friend of the family, and also an eminently respectable figure in the community. His father and grandfather had both practised in Edmonton, he and his two brothers had all studied at Guy's – where, like his elder brother William, Hammond had been dresser to the surgeon William Lucas senior – and he had worked locally since qualifying in the late 1780s. In 1790, aged twenty-five, he had married Susannah Bampton, the widow of a wealthy London confectioner, and two of their six children also became surgeons. If the family had a fault it was 'habitual intemperance', and this might have led to problems with the equally quick-tempered Keats. But disparaging remarks about all the Hammonds are heavily outnumbered by others which praise the 'excellent'[2] care they gave, and their progressive methods. Hammond himself was a Member of the Corporation of Surgeons, and conscientiously maintained his connections with the hospital where he had trained, and where he eventually advised Keats to study.

Hammond's house in Edmonton was a monument to his reputation. 7 Church Street, within hailing distance of Alice Jennings, was a handsome, two-storey, slate-roofed building, known in Keats's day as 'Wilston', shielded from the road by a brick wall, and opposite a Charity School decorated with a little figure in a blue uniform holding a book. An orchard stretched away behind the house, and in the garden on the east side stood a small detached cottage which was used as the surgery. Keats took most of his meals in the house – his apprenticeship fee covered the

cost of his board and lodging – but slept in the attic above the surgery. It was a cramped space with two windows, and, according to one source,[3] he shared the room with another apprentice for part of his time there. (The house and cottage were both demolished in the 1930s and replaced with a row of boxy shops; their names have an appropriate resonance: 'The Candy Shop'; 'Booze and Co'; 'Keats Chemist'; and 'M. D. Cooper' – an optician.)

Hammond was a conspicuous figure in his time, but has become vague in history. Little evidence survives about his daily doings with Keats, and only a few anecdotes give them any vivid colouring. In one we find Keats buying a pocket watch which he had engraved 'John Keats Edmonton 1813'. In another we have to rely on the unreliable memories of Richard Hengist Horne: 'Mr Hammond driving on a professional visit [to Clarke's school] one winter day [left] Keats to take care of the gig. While Keats sat in a brown study holding the reins, young Horne, remembering his school reputation as a boxer, in bravado threw a snowball at him and hit, but made off into safety before Keats could get at him to inflict punishment.'[4] (This was perhaps during the notoriously bad winter of 1810, when snow and fog were so dense that 'even in the open streets and squares it was necessary to use candles'.)

Such details hardly shed enough light to illuminate a day, let alone five years. But their sparsity is relieved by other information about the time – about the duties Keats would have had to perform, for instance. To start with, these would not have been much more than accompanying Hammond on his rounds, sweeping and cleaning the surgery, taking notes on cases, and helping with such standard procedures as cupping, leeching, poulticing and blistering. As his experience grew, they would have become more demanding. He would have begun formal studies in anatomy, physiology and materia medica, made up pills and potions under Hammond's supervision, attended post mortem examinations, and learned how to identify the symptoms of some diseases, as well as how to bleed and vaccinate, dress wounds, pull teeth, lance abscesses and deliver babies. Various contemporaries protested that these duties could 'weigh too heavily upon the health and sanity'[5] of a child younger than sixteen, but if Keats felt disgusted or overburdened, no evidence survives either in letters to his family, or in complaints which patients were entitled to lodge under By-Law 12 of the Society of Apothecaries.

When we read Charles Cowden Clarke saying that these duties left

Keats with copious 'leisure hours [to indulge] his passion for reading and translating', we need to allow for his being overwhelmingly interested in the literary life of his friend. Yet while Keats's routines as an apprentice were particular and pressing, there is no reason to doubt that he devoted himself to his books with exceptional energy whenever he was free from Hammond – not just to his medical texts, but to the plays and poems that Clarke borrowed for him from the school library. It is, in fact, no exaggeration to say that as Keats set out on his career as a doctor, he also began his life as a poet. 'Five or six times a month', Clarke said, Keats visited him 'on my own leisure afternoons. He rarely came empty-handed; either he had a book to read, or he brought one to be exchanged. When the weather permitted, we always sat in an arbour at the end of a spacious garden' – the garden belonging to the school where father and son Clarke still taught, and where Keats sometimes took his meals. In one of his most successful early poems, an Epistle to Charles Cowden Clarke written in September 1816, Keats remembered these meetings gratefully:

> Since I have walked with you through shady lanes
> That freshly terminate in open plains,
> And revelled in a chat that ceasèd not
> When at night-fall among your books we got:
> No, nor when supper came, nor after that –
> Nor when reluctantly I took my hat;
> No, nor till cordially you shook my hand
> Mid-way between our homes. Your accents bland
> Still sounded in my ears, when I no more
> Could hear your footsteps touch the gravelly floor.
> Sometimes I lost them, and then found again;
> You changed the footpath for the grassy plain.

At this stage, Keats made no conscious effort to combine the two halves of his existence. In his Epistle to Clarke, for instance, he did not mention his professional training, and concentrated instead on literary enthusiasms – and on literary debts. He praised Clarke for his 'classic ear', crediting him with all the knowledge that he had 'never known', and admitting that his 'dull, unlearned quill' discovered from Clarke 'all the sweets of song':

Spenserian vowels that elope with ease,
And float along like birds o'er summer seas;
Miltonian storms, and more, Miltonian tenderness;
Michael in arms, and more, meek Eve's fair slenderness.
Who read for me the sonnet swelling loudly
Up to its climax and then dying proudly?
Who found for me the grandeur of the ode,
Growing, like Atlas, stronger from its load?
Who let me taste that more than cordial dram,
The sharp, the rapier-pointed epigram?
Showed me that epic was of all the king,
Round, vast, and spanning all like Saturn's ring?

As this implies, Clarke was by now not simply conducting Keats on a tour through the whole landscape of literature, but directing him towards especially sympathetic poets: towards Tasso, whose account of the Crusades he no doubt believed would appeal to Keats's 'military capacity', and to Spenser, whom Clarke felt had fired 'the train of [his own] poetical tendencies'. In the spring of 1813, Clarke read Spenser's 'Epithalamium' aloud to Keats 'in [the] hallowed old arbour', and immediately afterwards loaned him his copy of *The Faerie Queene*. The poem impressed Keats as nothing had done previously. He 'went through it', Clarke said later, 'as a young horse would through a spring meadow – ramping! Like a true poet, too – a poet "born, not manufactured", a poet in grain, he especially singled out epithets, for that felicity and power in which Spenser is so eminent. He *hoisted* himself up, and looked burly and dominant, as he said, "what an image that is – *sea-shouldering whales*!" '

Clearly, the high temperature of *The Faerie Queene* fomented Keats's own sensuality; its scope also struck him deeply. Convincing him that the epic form 'was of all the king', it laid the basis of a life-long ambition. 'Did our great Poets ever write short Pieces?' he once asked, and when struggling with *Endymion* he reassured himself by insisting that it was a necessary 'test of Invention'. He did not simply mean that length was a self-sufficient virtue. He believed (and was further encouraged in this by Hunt and Wordsworth) that the epic was the only form which could adequately display ancient ideal virtues. It gave the chance to create an entire imaginative world, a world which existed as a counterpart to modern times, offering a release from their pressures by seeming to

stand at one remove, but at the same time commenting on them, and lamenting the disappearance of virtues associated with Classical antiquity.

In later life, Keats became increasingly doubtful about Spenser's politics; he wrote a snatch of 'antique' verse at the end of Book 5 of his copy of *The Faerie Queene* which attacked the Elizabethan regime in Ireland by having a giant Typographus blind Artegall and Talus, the defenders of the established order. In his earliest reading, though, he looked on Spenser as someone who set the standard by which all his other reading with Charles Cowden Clarke had to be judged. Shakespeare passed the test triumphantly – indeed, he immediately became a part of the test. The dramatic physicality of 'sea-shouldering whales' was a quality that Keats found on every page of the plays. It vitally developed his sense that the most powerful poetry does not make its effects by hectoring, or even by candidly expressing the author's personal opinion, but by creating a self-sufficient imaginative universe – a universe in which readers are invited to make independent critical decisions and moral judgements. In the fullness of time, this sense would evolve to the point at which he came to share many of Shakespeare's own characteristics, as Matthew Arnold recognised when he said Keats 'is: he is with Shakespeare'. Arnold understood that the 'younger poet's' work was 'not imitative, indeed, of Shakespeare, but Shakespearean because its expression has that rounded perfection and felicity of loveliness of which Shakespeare is the great master'. This remark deserves to have become famous for more than its affectionate warmth. It is the foundation of Arnold's belief that Keats's affinity with Shakespeare depends on thoughts about poetic identity: about the overriding need for it to remain fluid, to have no trace of the egotistical sublime, to have in its extreme suppleness and empathy 'no character at all'.

However well the young Keats learned these things in theory, he was not able to act on them. As his reading broke over him in wave after wave – sometimes returning him to writers he had known at school like Mary Tighe, Gray, Thomson, Cowper and Milton (he first owned a copy of *Paradise Lost* in 1810), and sometimes introducing him to others that he had not encountered before, like James Beattie – he was too overwrought by the wealth of influences, too hungry for new sensations. Yet for all their profusion, they did focus in a single ambition. Beattie's *The Minstrel*, for instance, with its Spenserian stanzas and its warnings that no one 'can tell how hard it is to climb / The steep where Fame's proud

temple shines afar', illustrates the point. The 'plan of the poem'[6] (and of Keats's reading as a whole) describes a pilgrimage which leads a 'man of low degree' from 'fancy' to wisdom as his imagination matures. Its pre-Wordsworthian ethos confirmed Keats's sense that flowery luxury was a distraction from the 'real' world of suffering. It provided a way of distinguishing between true poets and mere dreamers – as Keats would do throughout his own writing life, from early poems like 'Sleep and Poetry', to 'The Fall of Hyperion'.

Charles Cowden Clarke has often been given the credit for helping to shape these thoughts. His contribution to other aspects of Keats's thinking has been neglected. A commonplace book that Clarke kept during the period of the apprenticeship (most of its entries were made between 1810 and 1814) suggests that in his youth Clarke was very unlike the rather bufferish figure he became in later life – when he wrote his reminiscences of Keats. It shows, in fact, that he held 'libertarian political views which formed a continuum with his poetical beliefs',[7] and was closely involved with his father's dissenting friends. His published writing only occasionally admits this. At one point in his *Recollections* he says that his father 'took me himself to see his distinguished acquaintances, [and] he favoured my making my own early friendships and fostered my cultivating an intimacy with such superior men as our own village neighbourhood supplied'. At another, he lets on that his allegiances were reflected in his looks – something that seems astonishing to anyone familiar with the respectable figure who appears in his later portraits. With his 'long, light-brown curls reaching below the shoulders', he was 'so obviously provocative and artistic' that when he was once spotted by the pupils of Westminster School during a visit to London, he provoked a chorus of ' "Oh, my eye! What a quiz! I say, do look at that Miss Molly!" '

The commonplace book proves these sympathies in a number of ways: in its selection of poems by Clarke himself, in its quotation from Chatterton and others (including Chatterton's 'Ode to Freedom'), and in its reference to history books and polemical writings. There are extracts from Selden, Russell and Penn which deal with issues of constitutional liberty and religious toleration; passages from Bolingbroke on 'the real *Patriot*' who 'bends all the forces of his understanding . . . to the good of his country';[8] sections from Burnet on the need to oppose war and violence; and many pieces celebrating radical heroes such as King Alfred and Milton. (Clarke wonders 'What Eulogy does

Alfred the great require?' and answers himself: 'Almost every Act he performed exalts him in our Esteem & Veneration . . . A simple narrative of Facts would have been sufficient to have established his fame till every event be cancelled in the Book of Time.'[9]) He is even more fulsome about Milton. As well as transcribing Wordsworth's sonnet 'Milton! thou shouldst be living at this hour', he includes his own poem 'Left upon Milton's Tomb in Westminster Abbey'. It begs for 'one ray' of 'that meridian blaze / Which o'er thy pure and steadfast mind did shine', and praises him as someone who 'of rebel Angels sung and taught our sires / How best foul earth-born tyranny to tame'.[10] In the Epistle he later wrote to Clarke, Keats echoes these tributes, thanking his friend for pointing out 'the patriot's stern duty; / The might of Alfred, and the shaft of Tell; / The hand of Brutus, that so grandly fell / Upon a tyrant's head'. Elsewhere he records other debts. Two of his poems adapt lines from verses by Clarke ('Sunset' and 'The Nightingale', both of which were included in the commonplace book), and many others develop Clarke's opinion that the search for immortal 'Fame' depends on grappling with the issues of the day. In an unpublished poem that Clarke wrote on his twenty-fifth birthday (15 December 1812), for instance, he says:

> O lead me forth
> Celestial Guide,
> To ev'ry spring that flows down
> Parnassus' hill, and let me quaff
> In extasy
> Of ev'ry wave . . .
> Then shall another brilliant wreath
> Entwine thy brow
> Seraphic Bard!
> Nor would I fail
> To deck thy lyre,
> Delightful Author of the Task!
> But ever will I sing of HIM
> For this his prime, his choicest gift
> Vouchsaf'd to Man –
> Sweet LIBERTY! –[11]

THE LANGUAGE OF Clarke's poetry was strongly influenced by writers that Keats later referred to as 'the mighty dead' – and by the not so

[55]

mighty dead, as well. Its arguments were particularly indebted to Leigh Hunt. Clarke did not meet Hunt until the summer of 1812 (he lent him one of his commonplace books in 1816[12]), but as he developed and directed Keats's reading, he constantly discussed the *Examiner*, knowing that Keats had admired it since school. Although mentioning the journal here means interrupting the narrative of Keats's apprenticeship, it casts a very revealing light on his aims and preoccupations during this time.

It also raises a troubling question. Why, when the opportunity eventually arose, was Clarke not immediately willing to introduce Keats to Hunt? In his *Recollections of Writers* (1878) Clarke implies he did just that: he makes no mention of his own ambitions, and quotes several letters to prove that he felt nothing but admiration for Keats. The original texts of these letters, however, tell a different story. They show that Clarke was 'more than half thinking of a poetic career himself',[13] and made 'persistent efforts to win favour'[14] with Hunt. This is important – and not just because it reveals tensions in Clarke's friendship with Keats that are usually overlooked. It suggests that while drawing Keats forward into adult life, in one respect at least he held him back. He was jealous as well as affectionate. He was eager to endorse Hunt's ideas, but anxious to reserve his editorial patronage for himself.

By today's standards, the *Examiner* seems bravely but not sensationally liberal. Contemporaries knew that it was dangerously subversive, and occupied a distinguished place among other like-minded journals. William Cobbett's *Register* (which ran under various titles between 1802 and 1835), Richard Carlile's *The Republican* and T. J. Woolner's *Black Dwarf* were just a few of the many publications which surrounded and supported it, all sparked into life by the efforts of successive Tory governments to maintain the old order and its privileges. Although the *Examiner* shared many opinions with these radical counterparts, it differed from them in having a wider range of interests, and a tone which was just as likely to be raffish or flippant as it was aggrieved and outraged. Its attacks on reactionary government jostled for space with reports of executions and business deals, with essays and poems, with legal dramas, with reviews of exhibitions, books and concerts. For the early part of its life, this mixture brought Hunt a steady commercial success, as well as notoriety. Its sales reached 2,000 within a year of its first appearance, and eventually peaked at three times that figure – though by the late 1810s sales had started to decline. (Hunt tried to

compensate for this by starting another magazine, the *Indicator*, in 1819.)

The *Examiner* had originally been proposed by Leigh Hunt's brother John in 1807, with the suggestion that another brother, Robert, should cover fine arts while Leigh dealt with politics. Leigh Hunt had previously thought of himself as a poet and theatre reviewer, so he greeted the proposal with some suspicion. But he was braced by his brother's confidence in him (John had a much graver personality), and by the advice to transfer to politicians 'the attitudes he took to actors'. When the first issue appeared on Sunday 3 January 1808, running to sixteen pages and costing eightpence halfpenny, he emerged as the star turn. He wrote fast, chattily, and with unfettered enthusiasm or rage as appropriate, feeling as he said later that 'common sense' was 'the moral part of my business', and knowing that simply what he observed as a citizen 'enabled [him] to detect the most wretched errors'.[15] The advantages were passion, panache and a witty directness. The drawbacks were occasional wild judgements (dismissing Blake as 'an unfortunate lunatic', and Coleridge's 'Christabel' as evidence of insanity), hasty conclusions (initially undervaluing Wordsworth), and outbursts of preciousness (not always summoning 'the strength to tackle big subjects'[16]).

The *Examiner* was founded on the principle of humane impartiality – the Hunt brothers refused to ally themselves specifically with Wilberforce, or Burdett, or any other individual radical. They did, however, have a particular programme to promote. So far as the artistic content was concerned, Leigh Hunt wanted to advance 'the happiness of his kind, to minister to the more educated appreciation of order and beauty, to open more widely the door of the library and more widely the window of the library looking out upon nature'. Politically, the Proposal promised 'an humble attempt . . . to encourage an unprejudiced spirit of thinking in every respect, or, in other words, to revive an universal and *decent philosophy with truth for its sole object.*'[17] It is possible that Leigh Hunt, who wrote this Proposal when he was new to the job, hoped that mere washy liberalism would satisfy his readers. As the *Examiner* aged, and the emergencies of the period became more acute, his criticism became harder and sharper. In editorial after editorial, he pressed the case for Parliamentary reform; he lampooned the King and chastised the extravagances of the Prince Regent; he repeatedly urged the need for religious tolerance, and he demanded better leadership of the war in

Europe. When the Duke of York was appointed Commander-in-Chief of the army in October 1808, for instance, Leigh Hunt denounced him as 'one of the worst generals existing', and a fortnight later fiercely attacked the barbaric punishments for military offenders:

God forbid I should persecute any set of men, who are merely politically injudicious. I leave them to the throne. But when want of political judgement is united with want of virtue, when private vice becomes a public curse, and when a man's fireside, for want of common care, bursts out into a conflagration, and threatens everything with destruction, it then becomes my duty to break into the domestic walks, to climb up into the secret recesses, to defy the blazing rubbish about me, and to endeavour to quench the fire, even though it rises from a lady's chamber.

Just as Hunt vilified figures he felt were cruel or repressive, so – like Charles Cowden Clarke and Keats – he hero-worshipped champions of liberty. The names of King Alfred (who 'stands at the head of all great freemen that England has produced',)[18] Sidney, Milton, and other 'patriots' of the past are sprinkled through his prose, prized for their emblematic virtues and for the inspiration they give to such contemporary reformers as Burdett and Samuel Whitbread ('one of the most useful, indefatigable, and free-spirited public characters which even England herself has ever produced'[19]). They embodied qualities which needed defending from enemies without – Napoleon, pre-eminently – and from the Tory regime at home. Their role was to expose and resist what Hunt and fellow liberals saw as a double jeopardy.

Milton had an especially important part to play. When, in one of his editorials, Hunt said that Milton 'may be placed at the head of all [England's] poets and others, who have loved liberty as well from the loftiness of imagination and from the sense of patriotic duty',[20] he reminded readers that he considered the twin interests of the *Examiner* – the political and the literary – not as separate things but as two edges of the same sword. This idea influenced Keats more powerfully than any other he derived from the magazine. It encouraged him to think that poetry should advance a specifically liberal argument, and reinforce it by cultivating an appropriately subversive idiom. Hunt reiterated his point insistently, attacking the 'cuckoo-song' regularity of Pope, who he thought had 'little imagination of a higher order',[21] criticising 'the French school of poetry', stressing that 'the book was a sacred object [because] . . . it was the key by which the feelings could be unlocked',

[58]

and demanding that any discussion of poetry should be linked to an appreciation of painting, drama and music. The greatest and most durable art, he insisted, scorned narrow ideas of use. Even when it seemed to escape the world, its transcendence implied a criticism of existing circumstances. (He later praised a moment in Keats's poetry for being 'a fancy founded, as all beautiful fancies are, on a strong sense of what really exists or occurs'.)

Hunt's own practice as a poet lagged a long way behind his preaching, though for most of his years with the *Examiner* he worked hard to promote his reputation. He had started young – in 1802, when his father edited and successfully published his *Juvenilia* – and by 1811, in the first edition of *The Feast of the Poets*, he was confident enough to create a pantheon of writers who exemplified the virtues he defended in the *Examiner*. He recommended Moore and Campbell, accepted Scott, and attacked Southey, Coleridge and Wordsworth. (Wordsworth was much less fiercely criticised in the second edition of 1814, and praised in the third edition of the following year.) All these early works – even *The Feast of the Poets*, which is more concerned with an argument than its poetic augmentation – have some of the weaknesses that appear in his prose. They often mistake sentiment for strong emotion, daintiness for delicacy, and lushness for density. The same is true of later works like *The Story of Rimini* (1816) and *Foliage* (1818) – but while this means that the example Hunt offered to Keats could be damaging, it should not obscure the value of his influence as an essayist and editor. Keeping Keats in touch with the world at large, Hunt helped to define private convictions.

As the war in Europe rumbled forward, Hunt intensified his analysis of national and international issues, switching from issue to issue as crisis followed crisis. Napoleon's retreat from Moscow in 1812 raised hopes of an eventual English victory, but when conflict broke out again with America shortly afterwards, a new period of unrest began at home. During the months running up to the Peace of Paris, the abdication of Napoleon, and the Congress of Vienna, many industrial centres were riven by Luddite riots and by protests about high food prices and taxation. One dramatic measure of the turmoil was the assassination of the Prime Minister, Spenser Perceval, on 11 May 1811 (he was replaced by Lord Liverpool, who held the position until 1827). That same year, the face of government was changed even more profoundly when the

King finally declined into insanity, and the Regency was made permanent. George III had suffered his first bout of illness in 1788, and when he came to celebrate fifty years on the throne in 1809 it was widely understood that his son would take charge sooner rather than later. Hunt anticipated this in the earliest issues of the *Examiner*, and had never believed that because the Prince had Whig friends he would encourage more liberal policies when he gained power. He had first vilified him in 1808, urging 'A little prudence, a little self-command, a little self-respect'[22] as he complained about the Civil List and royal salaries. Through the next several years he took every chance to press home the attack, concentrating on the Regent as someone who had 'the finest opportunity of becoming nobly popular', but who was persistently extravagant and illiberal, and sometimes actually corrupt. Three times the magazine was taken to court by the government – once for discussing the sale of army promotions by the Duke of York's mistress, once for an especially passionate attack on the cabinet, and once for campaigning against military punishments. On each occasion the Crown intended to silence Hunt; every time he emerged with his reputation (and sales) enhanced, and his determination reinforced. In March 1812, goaded by an outpouring of praise for the Regent from the Tory *Morning Post* on St Patrick's Day, he launched an even more dangerous assault. He wrote:

What person, unacquainted with the true state of the case, would imagine, in reading these astounding eulogies, that this *Glory of the People* was the subject of millions of shrugs and reproaches! That this *Protector of the Arts* had named a wretched Foreigner his Historical Painter in disparagement or in ignorance of the merits of his own countrymen! That this *Maecenas of the Age* patronised not a single deserving writer! That this *Breather of Eloquence* could not say a few decent extempore words – if we are to judge at least from what he said to his regiment on its embarkation for Portugal! That this *Conqueror of Hearts* was the disappointer of hopes! That this *Exciter of Desire* (bravo, Messieurs of the *Post!*) this *Adonis in Loveliness* was a corpulent gentleman of fifty! In short, that this *delightful, blissful, wise, pleasurable, honourable, virtuous, true*, and *immortal* PRINCE, was a violator of his word, a libertine over head and ears in debt and disgrace, a despiser of domestic ties, the companion of gamblers and demireps, a man who has just closed half a century without one single claim on the gratitude of his country or the respect of posterity.[23]

Although the Hunt brothers had previously published several similar articles, they must have suspected that this would bring their charmed editorial life to an end. It is possible that they even courted disaster,

knowing that it would add to their radical prestige. When the government duly charged them with the 'intention to traduce and vilify' the Regent, and bring him into 'hatred, contempt and disgrace', they went to meet their fate with a sense of outrage rather than surprise. Their trial was delayed until September 1812, so that the jury could be packed with civil servants who were likely to convict them, and on 3 February 1813 Leigh and John were sentenced to two years each in separate prisons, fined £500, and bound to pay a further £500 security for their good behaviour in the five years following.

The punishment was harsh, but Leigh Hunt, at least, was determined to suffer in style. While his brother John was taken off to begin his sentence in Coldbath Fields, he hired a Hackney coach to Horsemonger Lane Gaol, put on his smartest clothes, flourished a copy of the neo-Latin poet Erycius Poteanus, and took his wife and two children with him. Once installed, he accepted the financial help of supporters (including the young Shelley, whom he had not yet met) and began turning his two prison rooms into an elegant apartment. He had them decorated with wallpaper covered in a pattern of trellised roses, hung Venetian blinds over the windows to conceal the bars, put a picture of his brother over the fireplace, installed a piano and busts of his favourite poets, painted blue sky and woolly clouds on his ceiling, and began cultivating a garden in the prison yard.

Hunt sold 10,000 copies of the *Examiner* on the day his sentence was passed, and his cell immediately became a shrine for all the leading radicals of the day: intellectuals like James Mill, Jeremy Bentham and Hunt's own lawyer Henry Brougham; painters like Haydon; writers such as William Hazlitt, Charles Lamb, Tom Moore and Byron (who called Hunt 'the wit in the dungeon' and referred to him in his journal as 'an extraordinary character, and not exactly of the present age. He reminds me more of the Pym and Hampden times – much talent, great independence of spirit, and an austere, yet not repulsive aspect.')[24] Since Hunt was allowed to continue editing his magazine, their suggestions were put to immediate use. This made the *Examiner*, in what the government hoped would be its doldrums, the most popular liberal journal of the time. Although Hunt was careful to avoid further libel actions (in February 1814, for instance, he cut short a discussion of whether his incarceration had altered public opinion about the Regent), he continued to press for Parliamentary reform, and to challenge the extravagances of the ruling elite.

[61]

Hunt enjoyed his notoriety, and often thanked his supporters in his editorials. Charles Cowden Clarke was not well known enough to deserve a mention, but it is clear from surviving letters that he had first got to know Hunt while the trial was pending, and visited Horsemonger Lane at least once a week after sentence had been passed. He brought fruit and eggs from Enfield, and frequently stayed late into the evening to 'chat'. These meetings were among several important elements in Hunt's routine.[25] For Clarke they were exceptional, and when he returned home he eagerly passed on everything he had heard. His reports made Keats impatient with his apprenticeship. Listening to stories about 'Libertas' was not enough. He wanted closer contact.

It was impossible for Keats to cut short his time with Hammond if he intended qualifying as a doctor. But late in 1813 or early in 1814[26] he did the next best thing. He moved out of his attic above the surgery and found separate lodgings. Possibly these were with his grandmother; more likely they were elsewhere in Edmonton – and, according to George, he shared them with Tom (who had by now left school, worked briefly with Abbey, and abandoned the job unhappily). Even if his brother shared the rent, it was an audacious step for Keats to have taken. He had already spent a sizeable portion of his inheritance to pay his fees to Hammond, he was not entitled to any rebate, and the interest due from his remaining investments was diminished by the international situation. Yet it was not the only sign of his developing independence. As he made his move, he asserted himself in an even more significant way. He began to write poems.

SEVEN

KEATS'S FIRST SURVIVING poem is an imitation of Spenser – the poet Charles Cowden Clarke had praised above all others, and whom he had seen Keats 'ramp[ing] through . . . like a young horse turned into a spring meadow'. Its four lush stanzas were written early in 1814, when he was nineteen, and while they perform their act of devotion to writing itself, they pay homage to his hero as well as his friend. Rising 'from her orient chamber', the 'Morning' slants across 'woven bowers' such as the one that Keats and Clarke sat in, then picks out a small island and gilds it with Spenserian colours:

> all around it dipped luxuriously
> Slopings of verdure through the glossy tide,
> Which, as it were in gentle amity,
> Rippled delighted up the flowery side;
> As if to glean the ruddy tears, it tried,
> Which fell profusely from the rose-tree stem!
> Haply it was the workings of its pride,
> In strife to throw upon the shore a gem
> Outvying all the buds in Flora's diadem.

Keats's borrowings are obvious here. So is his authenticity: the sumptuous details, Classical references and painterly gestures would all become trademarks. And there is something else too – something that again anticipates his mature work. The 'beauties' of the 'Imitation' are not merely a lovely escape from the world; they enact a form of engagement with it. By setting his 'emerald' island 'in the silver sheen / Of the bright waters', Keats describes a miniature England that belongs in a specific historical context. Its seclusion is an emblem of peacefulness in general, and the result of a particular Peace – the Peace between England and France, which was signed in Paris at the time it was written, and which Hunt also celebrated in an 'Ode for Spring' published in the *Examiner* in April 1814. Keats referred to it again – and this time quite candidly – in another poem he wrote shortly afterwards: 'On Peace'. It bristles with opinions about monarchy and power that he had learned from Hunt, and shared with Charles Cowden Clarke:

> O Europe! let not sceptered tyrants see
> That thou must shelter in thy former state;
> Keep thy chains burst, and boldly say thou art free;
> Give thy kings law – leave not uncurbed the great;
> So with the horrors past thou'lt win thy happier fate!

The polemics of 'On Peace' give it a certain intensity, but inhibit Keats's gift for transformation. In this sense, the 'Imitation of Spenser' seems the richer of his first two efforts. While not seeming in the least confrontational, it allegorises its times. To judge by his next poem, 'Fill for me a brimming bowl' (August 1814), his life away from Hammond now allowed him to enjoy these times more fully than ever before. Yet the song-like stanzas show him distinctly troubled by pleasure – and especially by the pleasure of seeing or meeting women. Hitherto his

society had been entirely made up of his family and the enclosed male world of Clarke's school. Now, on his walks into London (to see the Naumachia, for instance – a mock water-battle organised by the Prince Regent), or on visits to his brother George at Abbey's office in Pancras Lane, he discovered things and people that he had previously only seen briefly, or imagined: grand buildings in the Classical style; dandified men-about-town; women wearing the fashionably low-cut and high-waisted dresses which had appeared 'overnight' after the Peace of Paris. Although they belonged in a realm beyond his reach, they became a part of his substitute existence – like the mythological figures he lingered over in his books. He could make a 'soft nest' for them in his imagination, even if he could not engage with them on equal terms.

The inspiration for 'Fill for me . . .' seems to have been a visit that Keats made to Vauxhall Gardens on the banks of the Thames during the celebrations which marked the Peace of Paris in August 1814. Like the Ranelagh Gardens, which had been closed in 1805, the Vauxhall Gardens epitomised the style as well as the tawdriness of Regency London. Their spacious avenues teemed with entertainments, side-shows, fountains and meeting places, but were also crowded with pickpockets and prostitutes. In the mêlée, Keats glimpsed a woman he immediately felt was 'The Image of the fairest form / That e'er my revelling eyes beheld, / That e'er my wandering fancy spelled'. Rather than wanting to pursue her, he immediately felt threatened. The woman overwhelmed his 'delight' in 'The Classic page, the Muse's lore', and he decided that she was therefore best forgotten:

> Fill for me a brimming bowl
> And let me in it drown my soul:
> But put therein some drug, designed
> To banish Woman from my mind:
> For I want not the stream inspiring
> That heats the sense with lewd desiring,
> But I want as deep a draught
> As e'er from Lethe's waves was quaffed.

These couplets are clumsy and overdetermined but they lay hold of a theme which dominates much of Keats's later writing. In the most general terms, they anticipate his struggle to reconcile a longing for escape with the knowledge that difficulties cannot and should not be

ignored. (This reaches a climax in the 'Ode to a Nightingale', which contains a much more famous mention of Lethe.) They also make a very intimate connection between these broad issues and his feelings about women. When he wrote the poem, his strongest emotional ties bound him to his brothers, to his work as an apprentice, and to literature. His wish to 'banish' women is a measure of that devotion to writing, but it is also a sign of how attractive and therefore potentially destructive he found them. In the 'Imitation of Spenser' he had already begun to explore these tensions, speaking about imaginative fervour in terms of sexual excitement. In 'Fill for me . . .' he is much more explicit. He longs to push women to the side of his mind; he cannot resist pulling them towards the centre.[1]

IT IS UNLIKELY that Keats saw in his earliest poems the seeds of conflicts which would preoccupy him throughout his life. The sheltering influence of Charles Cowden Clarke, and the widespread support for Hunt among everyone he knew, suggest that most of his apprenticeship was truly a 'placid time'. It was a calm that could not last. In December 1814 George wrote to their sister Fanny while she was staying with the Abbeys in Walthamstow, and told her that their 'poor Grandmother has been very ill indeed'. Within a few days Alice Jennings was dead: she was buried beside her husband in St Stephen's, Coleman Street, on 19 December, aged seventy-eight.

Although Keats had not lived under the same roof as his grandmother for some time, he had never been far beyond her reach, or ceased to look on her as a surrogate mother. Her death finally confirmed the dividedness of his family. George continued to labour in the Pancras Lane office where the fifteen-year-old Tom soon returned to join him.[2] Fanny, still only eleven years old, became a permanent lodger with the Abbeys in Walthamstow. Keats would always show a deep concern for Fanny's welfare, and in years to come he would write her touchingly affectionate letters offering advice, sympathy and support. But partly because Abbey frowned on close contact between them, partly because of the difference between their ages, and eventually because Keats's poverty and ill health made it difficult for him to visit Walthamstow regularly, he never had the chance to get to know her as well as he did George and Tom. At the end of his life he would tell her 'My Conscience is always reproaching me for neglecting you for so long a time.'

Keats remained alone in Edmonton, and if the sonnet he soon wrote

to his grandmother's memory is anything to go by, he comforted himself in his grief by refusing to doubt that a virtuous existence would be rewarded in heaven: 'As from the darkening gloom a silver dove / Upsoars, and darts into the Eastern light, / On pinions that naught moves but pure delight, / So fled thy soul into the realms above, / Regions of peace and everlasting love'. Keats would never again give such an accepting account of Christian faith, and although this makes his sonnet untypical, it is in one sense very revealing. He had been 'tenderly attached' to his grandmother, and her death confirmed his sense that if he was to enjoy any future he must make it for himself. It is a mark of this determination, and of the deep anxieties which underpinned it, that he 'never told anyone, not even [George], the occasion on which [the poem] was written'.

It has sometimes been suggested that the upheavals following Alice Jennings's death formed a part of Keats's difficulties with Hammond, and may even have led to him shortening his apprenticeship.[3] This seems unlikely, in view of the tenure demanded by the College of Surgeons. But it is certainly possible that his grief quickened his longing for independence. Saying this, however, is not the same as suggesting that Keats now began to turn against medicine. The fact that John Taylor (repeating Abbey's unreliable evidence) argued that Hammond 'did not . . . conduct himself as . . . he ought to have done to his young pupil', and that Keats acquired a reputation with someone in the village as 'an idle loafing fellow',[4] indicate turmoil but not antipathy. When his grandmother died, Keats had nine months of his apprenticeship left to run. If he had ducked out of his duties in any significant way, and if he had been at loggerheads with his master, Hammond would hardly have supported his application to Guy's Hospital the following year.

All the same, the last stretch of Keats's time in Edmonton was clearly less contented than his first few years had been. He was living a good distance away from his remaining family, and he was more obviously a prey to what he later called his 'horrid Morbidity of Temperament'. (The phrase adapts a remark that Hazlitt made about Wordsworth's *Excursion* in 1817, when describing the 'restless morbidity of temperament' suffered by 'those persons who have been devoted to the pursuit of any art or science'.) He responded as he had done during his mother's last illness: by trying to lose his depression in work. Nearly a dozen short poems were finished during the spring and summer of 1815, and they all show evidence of new reading and new thinking – in particular, new

thinking about how to reconcile the burgeoning world of his imagination with events in the wider world.

As far as Keats was concerned, the most significant of these events was the release of Leigh Hunt from prison on 2 February, which he commemorated in a sonnet: it was the first of his own poems that he showed to Charles Cowden Clarke. The lines link Hunt to earlier writers they all admired (Spenser, for instance), and to heroes of Liberty ('daring Milton'), before rounding on the government in its closing couplet: 'Who shall his fame impair / When thou art dead, and all thy wretched crew?' In two other poems written during the same month, 'To Hope' and 'Ode to Apollo', he makes the same connections. Both poems generate their emotional heat by invoking the 'hateful thoughts' which afflict him as he sits by his 'solitary hearth', and by emphasising his wish to 'let me not see our country's honour fade'. In 'To Hope' he borrows from a recent editorial by Hunt to condemn 'the base purple of a court oppressed'. In the 'Ode to Apollo' he associates 'Heroic deeds' done in the name of Liberty with the work of particular ancient and Renaissance poets: Homer, Tasso, Virgil, Spenser, Shakespeare, and Milton. As the title implies, patriotic actions and patriotic writing are fused in the figure of Apollo. But because Apollo is the god of medicine, as well as poetry and music, his name has other resonances. Like 'To Hope', the 'Ode' is a poem about personal ambition as well as fine principles. It modestly but firmly insists that Keats's chosen career and his writing have the same end in view:

> In thy western halls of gold
> When thou sittest in thy state,
> Bards, that erst sublimely told
> Heroic deeds, and sung of fate,
> With fervour seize their adamantine lyres,
> Whose chords are solid rays, and twinkle radiant fires.

Keats wrote these two poems in the same month that Napoleon began his 'One Hundred Days' of freedom before Waterloo, and they obviously feed off the mood of alarm which gripped England at the time.[5] As volunteers enlisted and troops embarked for the Low Countries, a fresh wave of discontent swept through the streets at home (in March riots broke out in London protesting about the Corn Laws). Until Wellington defeated Napoleon on 18 June, the need to appeal to

'Great Liberty' seemed more urgent than ever – and even when victory finally came, many liberals realised that it was more likely to reinforce the status quo than introduce a new era of reform. Hunt, enjoying his new-found freedom, complained in the *Examiner* that the Allies had betrayed their people at the Congress of Vienna; Hazlitt called Waterloo 'the sacred triumph of kings over mankind'; Keats, in May, wrote an attack on the absolute monarchy of Charles II. Once again, he was following a lead that had been given by Hunt: on 22 May the *Examiner* had responded to a speech given by the liberal Duke of Sussex, in which Charles had been accused of 'trampling on the rights of the people';[6] in his 'Lines' Keats attacked 'Infatuate Britons' who 'still proclaim / His memory, your direst, foulest shame'.

The same mixture of fear and hope lies behind another poem Keats wrote around this time: a sonnet 'To Chatterton'. Keats's interest in Chatterton is usually treated as an example of his enthusiasm for a currently fashionable literary figure. Even though Chatterton's medievalising 'Rowley' poems had already been exposed as fakes, he was – like Ossian – highly regarded by many readers who felt that his work captured the spirit of the writing it imitated. Haydon, for instance, insisted that Chatterton 'did not deserve the appellation of an impostor', and Hazlitt, who once spoke of him slightingly in a lecture, was persuaded by Keats to moderate his opinion. 'What I meant', he explained, 'was less to call into question Chatterton's genius, than to object to the common mode of estimating his magnitude by its prematureness.'

It is easy to believe that Keats – young, bereaved and lonely – would have identified with Chatterton's tragic story: he had committed suicide, penniless and discredited, in Holborn on 24 April 1770, aged seventeen. Several other poets, notably Wordsworth, Coleridge and Shelley, apostrophised him as a 'marvellous boy' who had died for poetry, a victim of the world's indifference, and someone whose 'animal' impulse filled his language with an alert sensuality. But there were other reasons why Keats valued him so highly. Chatterton had applied to become a surgeon's apprentice (on a slave ship: he was refused). More complicatedly, the 'ruling passion' of his short life was the 'pride' with which he responded to adversity. He had been born into poverty in Bristol in 1752 – his father was a sexton who died three months before his son was born – his schooling had been harsh, and his apprenticeship to an attorney dull. He seized on writing 'medieval' poems as a refuge from 'the philistinism

of [his] mercantile city'.[7] They involved him with a time which he believed to be free from the taint of capitalism, and full of ancient virtue – an era of 'pure' English. His style, that is to say, combined literary with political motives, and several of his poems speak as baldly about the connection as Keats does in his own early work. In 'The Whore of Babylon', for instance, Chatterton justifies the opinion of one of his first biographers that 'Before he quitted Bristol, he had entered deeply into politics'.[8] He was, in Keats's view, an exemplary poet 'of the Patriotic party' – stranger and slighter than Milton, but representing similar virtues:

> The Composition of my Soul is made
> Too great for servile, avaricious Trade;
> When raving in the Lunacy of Ink
> I catch the Pen, and publish what I think.

As SPRING TURNED into summer, and Keats's long apprenticeship at last drew to a close, his duties with Hammond slackened. He had more time to spend with Charles Cowden Clarke in Enfield, and with George in London. Whereas Clarke tended to keep Keats to himself, talking bookish talk, George felt that his brother's 'sad Despondency' could best be shifted by appealing to his gregarious instincts. Taller and still older-looking than Keats, with darker and thinner hair, but the same high-bridged nose and full mouth, he was already acting as mentor to his second brother Tom. When he took Keats under his wing, he invited him to card parties and dances after work, and introduced him to other young writers. Later, and a little pompously, he described himself as showing his brother 'continual . . . explanation, and inexhaustible spirits and good humour'.

It was a new world for Keats but, in certain important respects, an extension of the one he was leaving behind. Just as his school life had been exclusively male, and his friendships at home dominated by his feelings for Charles Cowden Clarke and his own brothers, so his adult life was spent largely in a bachelor environment. He lodged with other men (including, of course, George and Tom themselves); he often attended all-male parties; his artistic milieu had little enthusiasm for 'bluestockings'. At the same time, however, he had already been drawn to families (such as the Clarkes) who were prepared to act as surrogates. In years to come, he would often be attracted to other families who

[69]

fulfilled a similar role, but which differed in one crucial respect: they often included daughters. Keats's reactions to these young women were contradictory. Sometimes he felt tender-hearted; more often, he treated them as honorary men, or regarded them with suspicion. Would they despise him for being short and poor? Would they appreciate his poetic ambitions? More seriously, would they awaken the fear of betrayal that his mother had created in him? In other words, it was perfectly natural for young men of Keats's age and class to proclaim the superiority of living in 'a man's world', and to bond closely with one another. In Keats's case, though, purely social conventions were underwritten by strong psychological requirements.

This pattern of behaviour is clear in the most important new contact that Keats made through George. Caroline and Anne Felton Mathew were daughters of a wine merchant who lived with their parents and siblings in Goswell Street, north-west of the City. They held regular 'at homes' for 'minor poets and poetical young ladies',[9] and one frequent visitor to these parties was their cousin George Felton Mathew. This cousin, who lived with his father, an Oxford Street mercer, was himself the leader of a small literary set, and although he might not have shared the Keats brothers' liberal opinions, or their sense of fun, he played the part of a young poet-about-town with impressive dedication. Much of his verse was tamely derivative from eighteenth-century models and Gothic romances. (His sister Mary copied most of his work into an album which was called *The Garland*.) He hoped that its lowering shadows and Gothic ruins would make him seem 'languid and melancholy' and 'thoughtful beyond [his] years', but in fact his thoughtfulness was very strictly circumscribed by his family's evangelical background. In years to come, his 'gloom' turned out to have less to do with Romantic longings than with various kinds of repression: religious, emotional, and ideological.

When Keats first met Mathew, he assumed that they shared similar tastes. They had already learned to value many of the same authors (Tasso and Spenser), and soon began trading enthusiasms: Keats now read for the first time William Sotheby's translation of Wieland's *Oberon*, Mary Tighe's *Psyche or the Legend of Love*, and probably the oriental tales of Robert Southey as well. It is a measure of his previous isolation – and of his receptivity – that he succumbed to the influence of these works immediately, and accepted his new friend as the leader in a shared poetic enterprise. He abandoned his attempts to reconcile

lyricism with worldliness, and opted for an altogether sweeter and more glutinous style. Judging by a later account of their first meetings, Mathew obviously approved the change, but felt that it did not go far enough:

I always considered him a young man of promise, like a tree covered with a profusion of blossom – He was rather below the middle stature, but made up of fair proportions, with regular and good features, and a complexion rather light but not florid. A painter or a sculptor might have taken him for a study after the Greek masters, and given him 'a station like the herald Mercury, new lighted on some heaven-kissing hill'. His eye was more critical than tender, and so was his mind. He admired more the external decorations than felt the deep emotions of the Muse. He delighted in leading you through the mazes of elaborate description, but was less conscious of the sublime and the pathetic. He used to spend many evenings in reading to me, but I never observed the tears in his eyes nor the broken voice which are indications of extreme sensibility. These indeed were not the parts of poetry which he took pleasure in pointing out. Nevertheless he was of a kind and affectionate disposition, and though his feelings might not be so painful to himself, they would perhaps be more useful to others.[10]

However glad Keats felt to have discovered a fellow poet, it is clear that even his first contacts with Mathew were marked by reserve as well as responsiveness. (The remark about 'tears in his eyes' is revealing; his better friend Charles Cowden Clarke remembered that when Keats read aloud from Shakespeare's *Cymbeline* 'I saw his eyes fill with tears, and his voice faltered'.) But for the first few months of their acquaintance, Keats and Mathew were caught in a mutual excitement which swept everything before it. Each saw the other reflecting his own poetic pretensions. They went to 'little domestic concerts and dances together', they read and discussed together – and Keats met more young women than he had ever encountered before. Not surprisingly, one of them found a way through his defences: Mary Frogley, a 'dark-haired bright-eyed beauty' who had already met and been admired by his brother George. Over the next few months Keats wrote her so many poems that she was later referred to as his 'old flame', and in other poems written simultaneously, his elation produced a new kind of energy in his work. Although they sentimentalise the 'vulgarity' for which he would become notorious and celebrated, their sweet solutions give a dilute version of the 'fine excess' of his maturity.

Saying this makes the poems sound better than they are. In fact, 'To Some Ladies' (which he sent to Anne and Caroline Mathew when their

cousin was on holiday in Hastings), 'On Receiving a Curious Shell', 'To Emma',[11] and 'Song', all weaken the creative tensions he had begun to form in his earliest work. The Mathew sisters and other women appear in them as 'sylphs' who have 'elegant, pure, and aërial minds' and are suspended in 'moon-beamy air'. The men who court them are knights who loll in 'voluptuous' vacancy. In a sense, this suggests a real conflict in Keats – he wanted to write poems which were seductive, and was embarrassed by physical intimacy ('I will press thy fair knee,' he says at one point, 'And then thou wilt know that the sigh comes from me'). But whereas in poems like 'Had I a man's fair form', written only a short while later, he would incorporate and explore these difficulties, here he surrenders to the conventions he had learned from Mathew. There is no dramatising of sexual problems, only a sighing over women as 'fluttering thing[s]' and 'emblem[s]'.

The failure is most damaging in the sequence of three sonnets beginning 'Woman! when I behold thee flippant, vain', where Keats coos over 'Light feet, dark violet eyes, and parted hair, / Soft dimpled hands, white neck, and creamy breast' before rising to the dire climax: 'God! she is like a milk-white lamb that bleats / For man's protection'.[12] Sickly as the poems are, however, they do contain at least one passage which shows that Keats knew he was neglecting his true subject. The lines 'In truth there is no freeing / One's thoughts from such a beauty' refer to his conviction that love and writing were incompatible. Before his friendship with Mathew was six months old, he had already begun to recover his balance.

A new direction in his reading proved the point. Wordsworth had no place in Mathew's pantheon, but in the autumn of 1815 Keats bought the recently published two-volume edition of his poems, and at once fell under their corrective influence. His response shows considerable independence of mind, both in opposing Mathew's taste, and also in extending the boundaries that Charles Cowden Clarke had set. Among those Keats regarded as the arbiters of his taste, only Hunt, in successive editions of *The Feast of the Poets*, had begun to value Wordsworth; elsewhere his reputation was generally at a low ebb. In the next poem that Keats wrote, a sonnet 'O Solitude!', he made no secret of his allegiance, openly imitating Wordsworth's cadences, identifying with his philosophy, and mingling both with attitudes he had learned from Hunt. 'Nature's observatory' is not a remote Lake District peak but a suburban hillock:

O Solitude! if I must with thee dwell,
 Let it not be among the jumbled heap
 Of murky buildings; climb with me the steep –
Nature's observatory – whence the dell,
Its flowery slopes, its river's crystal swell,
 May seem a span; let me thy vigils keep
 'Mongst boughs pavilioned, where the deer's swift leap
Startles the wild bee from the foxglove bell.
But though I'll gladly trace these scenes with thee,
 Yet the sweet converse of an innocent mind,
 Whose words are images of thoughts refined,
Is my soul's pleasure; and it sure must be
 Almost the highest bliss of human-kind,
When to thy haunts two kindred spirits flee.

EIGHT

By the time Keats wrote 'O Solitude!' he had finally left Hammond and moved to London. The 'jumbled heap / Of murky buildings' was the new world he had impatiently anticipated, but which now filled him with alarm and nostalgia. And also with a sense of purpose. In spite of his difficulties with Hammond, and although he would later 'not like to be reminded' of his training, he felt fully committed to the life in medicine that awaited him. He looked upon it as 'practical but intellectually creative, socially responsible, and altruistic'.[1]

Before the passing of the Apothecary Act (in July 1815, exactly as his time with Hammond came to an end) Keats could have set up in practice as soon as his apprenticeship finished. Now he had to work in a hospital in order to gain the minimum qualification required for him to become a Licentiate of the Society of Apothecaries. When he followed in Hammond's footsteps and registered at Guy's Hospital on Sunday 1 October, he opted to study there for a full year, which meant that in due course he would be entitled to apply for membership of the Royal College of Surgeons. Once again, Abbey made no complaints about the expense involved: he handed over enough money to buy books and instruments, to rent lodgings, to cover the preliminary office fee of £1 2s, and to allow Keats to register as a surgical pupil and to attend lectures.

Trainees at Guy's worked in the hospital for two terms in every year,

one running from October to mid-January, the other from 21 January to mid-May. Between leaving Hammond and starting his course, it is likely that Keats stayed with his brothers in Pancras Lane, but as his new routine started, he looked around for somewhere nearer the hospital which he could share with fellow students. Before long he was informed by Astley Cooper, the senior surgeon at Guy's, of a vacancy at 28 St Thomas Street, close to the main gates, in a house belonging to a tallow chandler named Markham. Markham regularly let three or four of his rooms as study-bedrooms, and one as a communal sitting room. It was adequately comfortable, and convenient for work, but a goodish distance from George and Tom, and in an area (Southwark, or the 'Borough') which was badly congested and run down. Close to the southern end of London Bridge, which carried the main road to Kent, it was crammed with coaches ferrying passengers and wagons laden with food. Its open ditches, full of stinking waste, were 'considered the worst in England'.[2] Its streets were violent. Its skyline showed not only the silhouette of hospitals – Guy's and St Thomas's faced each other across the street in which Keats lived – but also the grim outline of the ruined Clink, which had been burned by rioters in 1780, the old Marshalsea Prison, and the new Marshalsea (which appears in *Little Dorrit*) that had been begun in 1811. Beyond these the ground sloped away to a slum district known as the Mint, which sprawled along the flank of a shallow valley above yet another prison: the King's Bench Prison. Keats himself referred to the area as a 'beastly place in dirt, turnings and windings', and one of his biographers describes it as 'a neighbourhood still almost Elizabethan in its lack of what a guide-book called "the progress of refinement" '.[3] Prostitution was rife. Body snatchers and grave robbers haunted its cemeteries. Cockfights were commonplace and so was bear-baiting. (Keats later told Charles Cowden Clarke about a visit he made to watch bear-baiting – imitating the bear and the snarling dogs.)

Keats's fellow lodgers in St Thomas Street were both considerably older than he, and a good deal higher up in Guy's complicated hierarchy. One was George Cooper, aged twenty-three, who worked in the hospital as a contemporary dresser to Astley Cooper (no relation). The other was Frederick Tyrrell, the twenty-two-year-old son of the City Remembrancer, who was already a surgeon's apprentice. Neither would have had much time to advise him about the routines and rituals of his new life. To learn these, he had to rely on his contemporaries, and on what Hammond had told him.

Guy's was the more recently founded of the two 'United Hospitals'. St Thomas's had been established by monks (and named after St Thomas of London and Canterbury) in 1553, and ever since opening its doors had struggled to cope with the needs of the area, let alone of the capital in general. Throughout the eighteenth century, with the massive increase in the population, it had become even more overburdened, often turning patients away, and releasing others before their treatment was complete. Daniel Defoe, in his *Tour through the Whole Island of Great Britain* (1724–7), says that in 1718 alone the hospital had 'cured or discharged 3,608 patients' and retained 566 'under cure' – many in cramped and unhygienic conditions. Almost exactly as Defoe collected these statistics, one of the governors of the hospital, the wealthy bookseller and philanthropist Thomas Guy (1644?–1724) began discussing the possibility of founding a second hospital near by. He had already subscribed towards the building of a schoolhouse in Tamworth, Staffordshire, which he represented in Parliament (he supported the Whig party), but his new proposal was much more ambitious. He persuaded his fellow governors to lease him a plot of land adjacent to St Thomas's, on which slum houses had been demolished in 1721, and began building a hospital which was 'far in advance of its time'. Guy specified that a central colonnade should run through the whole range of his building, giving covered access to thirteen wards on the ground floors and upper storeys. This gave a coherence of design which St Thomas's lacked (being built in a series of quadrangles), and allowed for a little over 400 patients to receive their treatment in reasonable space and privacy. (St Thomas's at this stage had eighteen wards and 430 beds.) In addition, Guy also created a separate building to accommodate twenty 'incurable lunatics', and provided enough funding to employ three surgeons, three physicians, and one apothecary. On average, this staff – helped by the assistants they employed and trained – treated 2,200 patients a year.

Guy died in 1724, the year before his hospital was completed, celebrated as 'a patron of liberty, and of the rights of his fellow-subjects'.[4] But even the huge contribution he made to the health of the capital was unable to meet its growing needs. By the end of the eighteenth century, his hospital was as crowded as St Thomas's – and although its administration was vastly improved and its site enlarged by Benjamin Harrison, who took over as Treasurer in 1797, its doctors were still overworked, and its system overloaded. It was Harrison who founded the medical school at Guy's, which from 1768 to 1825 was

linked to the existing school at St Thomas's. Educational responsibilities were divided between the two sites: anatomy, dissection and surgery were taught in St Thomas's, chemistry and materia medica at Guy's. The courses were 'so arranged that no two of them interfere[d] in the hours of attendance; and the whole [was] calculated to form a complete . . . medical and chirurgical instruction'.[5]

The arrangements reflected Guy's original generosity and Harrison's efficiency. They also made the United Hospitals a magnet for the most enterprising medical practitioners of the day, and a focus for recent developments in medicine. These amounted to nothing less than a revolution in attitudes to health care – and in the discussion of life itself. Gall and Spurzheim's diagram of the nervous system had been published in 1810; Charles Bell's pioneering conception of the anatomy of the brain appeared the following year; important new insights into poisons and fossils had been published shortly afterwards; in 1815 Laënnec invented the stethoscope (though it was not widely used for several years); doctors John Abernethy and William Lawrence had sparked a wide-ranging interdisciplinary debate about the nature and meaning of existence, a debate which coincided with the publication of Lamarck's *Histoire Naturelle*, and 'the ensuing controversy over the notion of . . . evolution'.[6]

St Thomas's and Guy's (particularly after the passing of the Apothecary Act) were better placed than any hospitals in England to further these advances. Their surgeons and physicians 'not only collaborated but also shared information with the best medical researchers in Britain and Europe'.[7] They founded and stocked an important medical library. They regarded their patients with a sympathy we now take for granted but which at the time seemed exceptional. ('The comfort and well-doing of our patients [are] paramount', one surgeon said. '[We are] never [to] lose sight of the primary object of this, and all other hospitals, which is – the relief of the suffering of humanity.')[8] In all these respects, and in the experiments conducted in their operating theatres, they gave a practical dimension to the radical forces so often suppressed in the country at large. Guy's was a Whig foundation, and a centre of humane liberalism.

No information survives about which courses Keats took in anatomy and physiology. In every other respect, his routines can be clearly established. His day began at seven-thirty, with lectures on such subjects as midwifery, experimental philosophy, and dentistry, though these

were not required for his qualifying exam, and are not mentioned on his final certificate. On Tuesday, Thursday and Saturday mornings he attended chemistry lectures for an hour before beginning his hospital attendance – in Guy's on Monday, Wednesday and Friday, and at St Thomas's on the other three days of the working week. These lasted for an hour and a half, and consisted of two courses, taught variously by William Babbington, Alexander Marchet, and William Allen. In the afternoons, he went to anatomy lectures from two o'clock until four, then spent at least an hour dissecting and studying morbid anatomy with Joseph Henry Green. After this, for two evenings a week, he was lectured for an hour on the practice of medicine by Babbington and James Curry, and for a further hour on the principles and practice of surgery by Astley Cooper and Henry Cline. On two other evenings, he attended a course on physiology; the first twelve lectures were also given by Cooper. In addition, he took during his first year a course on the theory of medicine and materia medica taught by Curry and James Cholmely, and a course in medical botany with William Salisbury which included instruction in the Society of Apothecaries' 'working labora- tory', the Chelsea Physic Garden.

The aim of the courses, for which Keats paid a total of thirty-two guineas attendance fee, was to give 'a comprehensive knowledge of discipline connected with medicine (not only of the physical or life sciences, but of mathematics, optics, mechanism, and natural history)', and to teach him 'to use this knowledge in . . . practice'.[9] Even if Keats did not attend all the lectures – and there is evidence in his one surviving notebook that he missed several[10] – they were detailed enough to give him a thorough grounding. They were also demanding enough to make us sympathise with his occasional absence, both in the sense that they required long hours of concentration, and because the conditions in which they were delivered were often not much short of chaotic.

John Flint South, the son of a druggist in the Borough who began attending the United Hospitals two years before Keats, and was an apprentice to Henry Cline junior, said the pupils 'packed . . . like herrings in a barrel' to watch surgery being performed in St Thomas's small operating amphitheatre. At the foot of steeply rising seats was a sawdust-covered space where the surgeon stood while his patient lay on a wooden table. Even though the scene was obviously dramatic and compelling, no one was able to watch in silence. The pupils, South says, were 'not so quiet, as those behind were continually pressing on those

before, often so severely that several could not bear the pressure, and were continually struggling to relieve themselves of it, and had not infrequently to be got out exhausted. There was also a continual calling out of "heads, heads" to those about the table whose heads interfered with the sightseers, with various appellatives, in a small way resembling the calls in the Sheldonian Theatre during Commemoration . . . I have often known even the floor so crowded that the surgeon could not operate till it had been partially cleared.'[11] The discomforts of the students were as nothing compared to the agonies of the patients. Lecture by lecture, week by week, their bones were broken for resetting, their bodies opened, and their limbs amputated, all without any anaesthetic except alcohol. Even the sturdy South found it hard to bear. 'So long as the patient did not make much noise I got on very well,' he says; 'but if the cries were great, and especially if they came from a child, I was quickly upset, had to leave the theatre, and not infrequently fainted.'[12]

Keats had to endure equally distressing sights in the hospital wards during the second part of the morning. New patients were admitted at a weekly 'taking in' on Thursdays, allocated a bed, acquainted with the 'Rules and Orders' drawn up by Harrison, cleaned of vermin, then visited by the surgeon with his entourage. No history of their case was taken, but a diet was prescribed, orders for further treatment were passed to the surgeon's dresser and the ward sister, and details of surgery were arranged where necessary. (Friday was operating day.) Twice a week, the surgeon also visited wards containing those who had been previously admitted – wards where scenes of misery were commonplace. Keats's previous experience had prepared him for such things; nevertheless, it is obvious from his later remarks that he found them profoundly upsetting. As they deepened his sense of the need to alleviate pain, they also made him wonder more intensely about the nature of suffering: whether it served any purpose in the formation of an identity, whether it 'nerved' people to deal with other difficulties in their lives.

IN HIS FRIENDSHIPS with Charles Cowden Clarke and (differently) Mathew, Keats had already showed his quick sensitivity. In his belligerence at school he had also proved that he was fiery and forthright. As he settled into his lodgings and his new routines, he sought out people who appealed to both sides of his personality. Several of them are now only names: Charles Butler, who entered Guy's the day before he did;

Frederick Leffler, who was the son of a Surrey music master and apprenticed to an apothecary in Soho Square; Charles Severn, an apprentice in Harlow; and Daniel Gosset, a fellow student from Edmonton, and therefore possibly someone he had known since childhood. One other colleague – John Spurgin, who had completed a two-year course at St Thomas's and was about to enter Caius College, Cambridge, to train as a physician – overlapped with him by only a fortnight or so, but formed a closer link. Spurgin was an excitable young man, and a committed follower of Swedenborg. As he showed Keats round the Borough, and told him about the details of Guy's training and personalities, he 'attempted to convert [him] to the doctrines'[13] of the Swedish philosopher, and continued to write him letters and lend him books after he had left London.

Judging by the sonnet written after the death of Alice Jennings, the only religion that Keats had previously followed with any degree of devotion was orthodox Christianity. If his parents' dissenting sympathies had complicated his thinking, and if the ethos of his school had challenged it, respect for his grandmother's principles had demanded that he keep his doubts to himself. The friendship with Spurgin, though, suggests that his new freedom allowed him to speculate more adventurously – and in particular to develop his thoughts about the connections he might make between medicine and writing. In the one surviving letter Spurgin wrote from Cambridge, he responded to Keats's admission that he felt in 'a mazy Mist' by saying that he must acquire knowledge of 'the Life which activates and animates Nature' if he wanted to judge 'what can give the brightest and most Lucid Flame to the fire of Poetry, even, and wander in Paths amid the Geniuses of old which I know you so much admire'. This was the kind of opinion which, thirty years earlier, had made Swedenborg so important for a while to William Blake. Although there is no reason to believe that Keats accepted the whole of Swedenborg's philosophy, his willingness to keep in touch with Spurgin at least suggests that he was interested in its broad outline. By tightening the links which bound him to his dissenting background, Swedenborg helped to give his life coherence at a brief but crucial stage. Right at the start of his career at Guy's, Keats entered into the radical spirit of the place.

This helps to correct the received impression of Keats as a half-hearted student. Most of the evidence for this comes from two sources: his surviving notebook – a small pocket-sized affair, bound in limp

brown leather – and the testimony of a few contemporaries. When his notes are compared to those made by Joshua Waddington, a contemporary at Guy's, they sometimes seem 'sketchy and disjointed',[14] and show that his concentration lapsed as time passed. Many of them, though, are full and detailed.[15] Some are written out neatly. Others are notes he would probably have amplified later. The doodles of skulls, fruits and flowers which illustrate their margins are just as likely to be anatomical or botanical subjects as signs of inattention. The range of subjects runs from anatomy to the absorption of poisons, from pathology to the structure of the lympathic system. It is not, in other words, the notebook of a lazy or distracted student. It is the notebook of someone who found certain topics more interesting than others, who may well have supported its information with work done elsewhere, and who evidently thought that he was doing enough to pass his qualifying examinations.

It is harder to defend Keats from the charges made against him by various contemporaries. One of them, Walter Cooper Dendy, said that he had often seen Keats during lectures 'in a deep poetic dream', and later produced a 'quaint [Spenserian] fragment' which he claimed Keats had written 'while the precepts of Sir Astley Cooper fell unheeded on his ear'. Even Charles Cowden Clarke, who was adamant that Keats had chosen his profession in the first place, admitted that he now 'could not knit his faculties to the study of anatomy. He attended the lectures; and he did not retain a word he had heard: they all ran from him like water from a duck's back.' Other voices support this view of Keats as a dreamer, always (in his own words) winging his way 'to fairyland' when he should have been concentrating on practical matters. But while they have an indisputable authority, they make no allowance for the fact that Keats saw his two callings as closely linked. They cannot, combined with the evidence of the notebook, be allowed to cancel the opinion of a later and much closer friend, Charles Brown, who said that to start with, at least, Keats was 'indefatigable in his application to anatomy, medicine, and natural history'.

The most solid proof of this, and the one least distorted by hindsight, is the fact that within a month of entering Guy's Keats was accepted for the next vacant dressership in the hospital. This would become available early in the new year, 1816, and represented a very rapid and significant promotion. (Only twelve dressers were picked from approximately seven hundred pupils to serve the three surgeons at Guy's.) His

biographers have always been puzzled by his elevation. He did not, after all, come from a distinguished medical family. Neither did financial considerations appear to have anything to do with it. The post entitled him to a small rebate – the Guy's office returned to him the six guineas difference between his year's fee of twenty-four guineas and the half-yearly fee of eighteen guineas – but involved longer-term expenses. When he re-registered as a dresser in the spring he had to pay his surgeon £50.

The usual explanation given for Keats's success is simply that he had a 'vivid physical presence'.[16] It is worth considering another possibility, which connects his training with his schooldays and his apprenticeship. During this time, the social life of Enfield had been dominated by a handful of conspicuous locals, among them John Abernethy. Abernethy was the son of dissenting parents who lived in Fenchurch Street, near the Swan and Hoop, and had been baptised on 3 April 1764 in St Stephen's, Coleman Street, where the Jennings family had worshipped and were buried. After an itinerant childhood, during which he was educated at Wolverhampton Grammar School, he returned to Coleman Street in 1787, became an apprentice to Sir Charles Blicks in St Bartholomew's Hospital, and subsequently began practising and lecturing there. He was a man of 'unconquerable shyness',[17] but his reputation as an exceptional surgeon and teacher was soon widespread. John Flint South remembered 'there was an originality, a quaintness, and sometimes even a drollery [about him] which fixed the attention'; a favourite trick was to dramatise the sufferings of his patients by harumphing, slouching, and contorting himself. His earliest publications, including his *Surgical and Physiological Essays* (Part One, 1793), quickly brought him to the attention of Astley Cooper, the senior surgeon at Guy's, who was soon on 'quite friendly terms with him'.[18] Cooper especially admired his recommendations for the treatment of lumbar abscess, and – like everyone else at Guy's – valued his entanglement with what has been called 'the preoccupation of the age':[19] John Hunter's radical theories of life. Abernethy's main contribution to his subject was a prolonged public debate with another doctor, William Lawrence, which began in 1814 when Abernethy published his *Enquiry into the Probability and Rationality of Mr Hunter's Theory of Life*, and continued throughout the period of Keats's training. Hunter had argued that the foundations of life were 'the result of subtile particles comixed with the visible fabric of living beings', from which Abernethy developed the idea that people did

[81]

not merely produce thoughts and sensations mechanically, but super-imposed 'mind or intellect . . . in the form of consciousness'.[20] He advocated, in other words, a form of vitalism which Keats – and Coleridge, among others – found fascinating because it embodied an attempt to place consciousness at the centre of existence.

By the time Abernethy had become eminent as a polemicist, he had also distinguished himself in other walks of life. He was, for instance, a committee member of the Medical Society of London, and after serving as an assistant surgeon at Bart's for twenty-eight years he eventually became senior surgeon there. Before taking up his appointment, he had already decided to capitalise on his success by buying a house in the country: Field Manor, in Enfield, where he lived at the weekends and during holidays with his wife Anne (who was from Edmonton) and their nine children. It was an impressive, three-storeyed, stuccoed building, somewhere that suited his reputation, and allowed him to become an admired part of village life. A contemporary remembered how 'many a time have we seen [his favourite mare Jenny] jogging along on a fine summer afternoon', and how Abernethy himself 'used to doff the black knee breeches, silk stockings, and shoes, sometimes with, sometimes without, short garters, and refresh one's rural recollections with drab kerseymores and top-boots'.[21] When Abernethy died in 1831, he was as well regarded in Enfield as he was in the London hospitals where he worked. In recognition of this, his colleagues erected a large black marble monument to his memory on the south wall of the nave in the village church.

It is not known exactly when Abernethy first visited Enfield, and there is no firm evidence that he ever met Keats, his family, or even Hammond. But considering the small size of the village, and the fact that his wife had been brought up near Hammond (perhaps had even been delivered by him or his father), it is likely that his family and the Jenningses – and their grandchildren – would have been aware of each other. They were linked by more than medicine. Abernethy's London childhood and his religious background also formed a connection, one that was particularly likely to bear fruit when Keats went to Guy's. Why? Because of the senior surgeon Astley Cooper. Cooper, the friend and admirer of Abernethy, was the person best placed to influence Keats's career at the hospital. The care he had shown in finding Keats lodgings with his own dresser suggests that he took a special interest in him. That he should so soon afterwards have promoted him to a

dressership confirms this. Was his concern fired by a recommendation from Abernethy? If it was, it suggests once again that the course of Keats's life was decisively shaped by allegiances which have not previously been noticed. The general admiration that Cooper felt for Abernethy's professional views reflected a deep political sympathy. In his own youth, Cooper had not merely been nonconformist, but controversially radical.

Cooper was forty-seven years old in 1815. He was the fourth son of the rector at Brooke, in Norfolk, and in 1784, at the age of sixteen, had come to London to work as apprentice to his uncle William Cooper, who was the senior surgeon at Guy's, and to lodge with a distinguished member of staff at St Thomas's, Henry Cline. William Cooper was a cautious man, old-fashioned by the standards of the time. Cline held firmly progressive views, and as he took responsibility for his young charge, he began introducing him to like-minded friends, one of whose daughters Cooper would marry in 1791. Through Cline, Astley Cooper 'not only [came] into constant communication but into the closest intimacy with such men as Horne Tooke, Thelwall, and indeed, with all the chief of those who, glorying in the rise of the democratic spirit which at that time was spreading itself over Europe, were not only watching with interest the progress of the French Revolution, but were anticipating similar events with unconcealed anxiety or expectations in our own country'.[22]

Cooper's professional enthusiasm led some of his colleagues to hope for great things from him. Others were disturbed by his militant politics. William Cooper was especially put off, but at this stage nothing seemed likely to stop the young star rising. Astley Cooper soon switched his articles from his uncle to Cline; in 1786 he was appointed his demonstrator; in 1791 he began sharing lectures on surgery with him; and in that same year he also set up a lecture series of his own. He would later become renowned for his work in arterial surgery, and would pioneer operations on the carotid artery, on the amputation of the leg at the hip joint, and on the ligation of the abdominal aorta.

Cooper made no effort to disguise his radicalism. When he visited Edinburgh in 1787 (his indentures required that he spend one session studying medicine at the university there), he became a member of the Speculative Society, a group of reformist thinkers, and at one of their debates spoke against the motion: 'Has Britain derived any benefit from her territorial possessions in the East Indies?' Back in London the following year, he continued to develop his friendship with Jacobins,

joining the Revolution Society and the Physical Society (of which 'citizen' Thelwall was a member), and in 1792 he visited Paris, partly to study medical practice, partly to breathe the political air. He attended meetings of the National Assembly, heard Danton, Marat and Robespierre speak, and discovered 'at first hand something of the workings of the political principles which had long engaged his interest since being at Cline's house'.[23]

When these 'principles' were inflamed by the September Massacres, and the sight of the 'Gardens of the Tuilleries . . . full of dead men',[24] Cooper offered his services to local hospitals, working alongside others 'wearing some democratic badge'. Although the experience 'produced in his mind a horror',[25] it did nothing to temper his opinions when he returned to London. One contemporary said: 'If [Paris] had in any degree diminished his democratic zeal, he has not acknowledged on paper any change of political feeling'[26] – and nearly forty years later he was still prepared to admit that 'A revolution may sometimes be a good thing for posterity', even if it is 'never [good] for the existing generation for the change is always too sudden and too violent'.[27]

By the time Cooper wrote this, he had long ceased to campaign for rebellion. His change of heart had something to do with disillusionment about the later stages of the French Revolution; it was more obviously the result of professional expediency. In 1800, when the time came for his uncle to retire as senior surgeon at Guy's, he was advised that his own candidacy for the post was likely to be damaged by his beliefs, and his supporters in the hospital set about persuading him to tone down his opinions, or better still to abandon them altogether. When Harrison, the Treasurer at Guy's, received an anonymous letter, signed 'CAUTION', which complained that Cooper was 'a Jacobin, friend of Horne Tooke, and an associate of the celebrated Thelwall',[28] he went to see him and explained the problem. Cooper's ambitions triumphed with striking suddenness. He told Harrison that he had recently decided 'to think more of paying obedience to the laws of the country than of disputing their justice and propriety', and had 'determined to relinquish the companionship and intimacy of our late democratical friends, and abandon for the future all participations in the strife of politics and party'.[29]

Cooper was duly appointed senior surgeon at Guy's, and began the stage of his career which made him one of the most admired doctors in the country. Eventually, among numerous other honours, he was made

Hunterian Professor of Comparative Anatomy by the Council of the Royal College. But it would be wrong to suggest that his success was achieved entirely at the expense of his former convictions. Although, after his meeting with Harrison, he continued to argue that 'unsettled discontented views' did more harm than good, he transformed his previous beliefs rather than neglecting them. The freethinking he had preached in debating rooms became the foundation of his practice as a doctor. It was radicalism by other means.

When Keats first encountered him, Cooper was 'the idol of the Borough school'[30] – a large and athletic man, who spoke in a thick Norfolk accent, and had 'an habitual air of bonhomie and a good-natured mirthfulness'.[31] He earned a great deal of money (sometimes as much as £20,000 a year),[32] but continued to see non-paying patients in the early mornings before leaving for work at the hospital. He treated those in his care with 'a tenderness of voice and expression, and with an interest so clearly depicted in his manner, that he at once acquired [their] confidence, respect and gratitude'.[33] On his ward rounds he was accompanied by 'hundreds of students . . . listening with almost breathless anxiety to catch the observations which fell from his lips', and at the bedside 'his *name* was a host'.[34]

He was also greatly admired as a lecturer. Dry facts were broken up by his 'irresistible temptation to perpetrate a pun',[35] and by his fondness for aphorisms ('A surgeon should have an eagle's eye, a lady's hand, and a lion's heart.'). According to John Flint South, 'he was so simply truthful, so clear and distinct in his conveyance of his own knowledge and experience to others, that the stupidest pupil, if only he would attend, could scarcely fail of comprehending the instruction offered to him.'[36] But it was more than his skills as a communicator which endeared him to his students. He also impressed them by giving 'the results of his own experiences and observation, the latter of which was most diligently maintained throughout his long and laborious life'.[37] It was this truth to experience, this idea that knowledge can only be gained by observation, that formed the basis of all his teaching – and which Keats would later encounter in a different guise when he read Hazlitt using 'the word "sensation" in its empirical sense'.[38] 'Nothing is known in our profession by guess,' Cooper said; 'and I do not believe that from the first dawn of medical science to the present moment, a single correct idea has emanated from conjecture alone.'[39]

This emphasis was his greatest legacy to Keats. No matter how often

Keats creates an alternative universe in his poems, he never doubts that the only true test of belief is that it should be proved upon the pulses. The various appeals he makes for 'a life of sensations rather than thoughts' do not represent a wish to escape from the intellect to the imagination, but to weigh what the head says to be true against what the heart feels to be true. Cooper influenced him in other ways as well. The 'rough commonsense and concrete examples' which filled his lectures find an echo in the 'homely similes with which Keats illustrates [his] profound philosophical and aesthetic ideas'.[40] Both men distrusted rigid systems and abominated rank materialism. Both set the need for compassion at the centre of their work. Both were especially distressed by illness in children and women ('women have cancers', Keats later expostulated in a letter). In everything he did, Cooper pressed the need for medical advance and experiment, but at the same time realised that his profession would not suit everyone. 'Surgery requires certain qualities, without which no man can arise to celebrity,' he said. 'These are a good eye, a steady hand, and above all a mind which is not easily ruffled by circumstances which may occur during the operation.' In due course, this advice would also have its deep effect on Keats.

Other lecturers at Guy's complemented Cooper's example, but none of them had the same impact. Babbington (who taught the practice of medicine) was a 'good-tempered, kindly' Irishman who placed a similar weight on the value of 'experience and practical good sense'.[41] The foppish and fair-faced Curry (who was also Irish, and also taught the practice of medicine) 'told of all that had been said and written by everyone who had handled the subjects in which he treated, but he dearly loved theorising and criticising'.[42] Green (a friend of Coleridge, and the anatomy demonstrator) demanded that his pupils' knowledge 'be articulate and even minute'.[43] Henry Cline junior made a special point of being 'extremely kind and attentive to his patients . . . and carefully attended to little matters which added greatly to [their] comforts'.[44] Working with others like Marcet, Cholmely, Haighton and Chandler, they created an atmosphere in the hospital which diversified the example of its senior surgeon. Dynamic but considerate, they embodied a philosophy which dignified Keats's profession, and developed attitudes which he would continue to elaborate throughout his life as a poet.

KEATS'S FIRST FEW MONTHS at Guy's were bewildering but decisive. He was excited by London, challenged by the chance to prove his convictions, and horrified by the sight of 'chaps . . . at work, carving limbs and bodies, in all stages of putrefaction, & of all colours'. Perhaps he might be too squeamish to become a successful surgeon? The question made him doubt his long-term future, and also convinced him that his recent writing had been misdirected. In the past he had been able to indulge easy 'luxuries', and to control his troubling 'speculations' by appealing to a more or less orthodox religious faith. Now, with his mind full of new images of pain, his scepticism increased. The convictions he had suppressed during the early days of his friendship with Mathew began to surface again.

As he rediscovered his old loyalties, he turned back to his old advisers. Once his days at Guy's had fallen into a pattern, he sought out Charles Cowden Clarke, mulling over the ideas they shared, and hearing the latest news about Leigh Hunt. In the first week of November, during a brief holiday from Guy's to mark the Lord Mayor of London's annual procession down the Thames, Clarke showed Keats three volumes he had just received from Hunt, each of them bound in 'blushing' red: a revised edition of *The Feast of the Poets*, a polemical masque called *The Descent of Liberty*, and *Politics and Poetics*. Even though these books were written in what Byron criticised as 'a kind of harsh and yet colloquial compounding of epithets, as if to avoid saying common things in a common way', and weakened their realism by indulging in fits of sentimentality, their aim was clear. Like Spenser, Milton and Dryden before him, Hunt wanted to 'lead the poets of the present age [back] to that proper mixture of sweetness and strength'. Keats was enthralled, sensing more strongly than ever that his recent work had taken a wrong turning. In the poem he wrote this same month, a verse epistle to Mathew, he wrenched himself back on course. His lines were a reply to Mathew's own address 'To a Poetical Friend', responding affectionately to the idea that a 'brotherhood in song' can promote 'a feeling / Of all that's high, and great, and good, and healing'. They also point out that Mathew is 'Too partial'. 'Lydian airs', 'white Naiads' and 'rapt seraphs', Keats says, have no place amid the 'contradictions' of 'this dark city': their fascinations are merely a form of escape from adult responsibilities.

At least, they are so unless each 'flowery spot, sequestered, wild, romantic' becomes a kind of chamber of thought – somewhere to 'moralise' on Chatterton and Milton, to 'mourn the fearful dearth of human kindness' in 'the pitiless world', and to honour the heroes of freedom – Alfred, William Tell, William Wallace and Robert Burns.

It is not only the argument of the Epistle that measures how suddenly Keats was turning away from Mathew. The style of the poem, which combines a debt to Elizabethans such as Browne and Drayton with borrowings from Wordsworth and Hunt, is also a sign of their difference. (The 'whole idea' of the poem is based on *Politics and Poetry*, according to one of Keats's critics.[1] Mathew's initial reaction was to revise his own poem, adding a stanza which tried to justify his romanticism by pointing out traces of the same thing in several of Keats's heroes – including Shakespeare and Milton. Keats was not impressed, and although he continued to see Mathew over Christmas and into the new year, he realised that their intellectual companionship could not survive for long. Mathew had no wish to use poetry as a form of social criticism; Keats felt it was 'vain' for him to 'tease the niggard muse' without some larger purpose. Writing to Richard Monckton Milnes after Keats's death, Mathew insisted a little plaintively that he had 'aided' Keats 'to the utmost of my powers' during their friendship, but admitted that they had always been at odds on all 'the gravest subjects of human interest'. Keats, Mathew said, 'was of the sceptical and republican school. An advocate for the innovations which were making progress in his time. A fault-finder with everything established. I, on the contrary, hated controversy and dispute – dreaded discord and disorder – loved the institutions of my country – believed them founded in nature and truth – best calculated to uphold religion and morality – harmonising on the one hand with the Theocracy of heaven, and on the other with the paternal rule at home. But I respected Keats's opinions, because they were sincere.'

Shifting away from Mathew inevitably meant losing touch with his circle; it was not a separation that Keats could make cleanly. There was at least one mutual friend who still held his interest: the 'lovely' Mary Frogley. It is impossible to say just how warmly Keats felt about her, partly because the one poem in which he addressed her by name – on Valentine's Day, 1816 – was in fact written at the request of his brother George. In certain respects, this lyric returns Keats to the sentimental world he had first rejected in his Epistle three months earlier. It

fantasises about 'days of old' and half smothers its human subject by comparing her to goddesses and Spenserian heroines. But whereas these things were treated with a straight face in the poems Keats had sent to the Mathew sisters, here they are lightly mocked:

> Hadst thou lived in days of old,
> O what wonders had been told
> Of thy lively countenance,
> And thy humid eyes that dance
> In the midst of their own brightness,
> In the very fane of lightness,
> Over which thine eyebrows, leaning,
> Picture out each lovely meaning:
> In a dainty bend they lie,
> Like to streaks across the sky,
> Or the feathers from a crow,
> Fallen on a bed of snow.

This joking shows Keats recovering his more robust personality; it also suggests that he was still uncertain about how to respond to women. Where it is most playful it has a displaced sexual excitement; where it is most direct it becomes voyeuristic (identifying with 'the little loves that fly / Round about with eager pry'). Some of the reasons for this unease are evident in another poem he wrote around the same time: 'Had I a man's fair form'. This, as its opening phrase indicates, is driven by a sense of physical inadequacy, and its rejection of chivalric symbols ('I am no knight') becomes a means by which Keats conveys his vulnerability. Like 'Fill for me . . .', it records both the delights and the dangers of desire – dangers he tried to dismiss in the squib 'Give me Women, Wine, and Snuff', written later in the same year. Its laddish tone reflects the ebullience of his personality; poetically speaking, it is touchingly unconvincing.

All these poems show that Keats's confusion was due partly to lack of experience. One of his colleagues, indicating that it made Keats seem exceptional, said that at Guy's he was 'never inclined to pursuits of a low or vicious character', even though living in the Borough gave him ample opportunity. Another argued that 'He would have been pleased to find himself admired by the Fair Sex, for his Genius, but not for his person.' This remark, which closely echoes the opening of 'Had I a man's fair

form', suggests that his reserve – as well as emphasising his devotion to the noble calling of literature – contained a good deal of self-dislike, caused by his height, among other things. (Years later he would angrily write 'I do think better of Womankind than to suppose they care whether Mister John Keats five feet hight likes them or not.') It was also connected to his memories of his mother. Her repeated abandonments had bred in him a corresponding wish to assert his independence. By lowering his guard with Mary Frogley (she kept his poems and defended his reputation for the rest of her life), he combined past with present anxieties – and the result was dramatic. After he had given up writing her 'shyly amorous lyrics'[2] in the early months of 1816, he produced almost no more love poetry for nearly a year.

Keats busily found ways of making it seem as though his rejection of Mathew's circle was nothing but a relief. While continuing to insist that his commitment to poetry was unwavering, he threw himself into the social life of Guy's, accentuating the 'tough-skinned level-headed' side of his personality. (Significantly, he had never introduced Mathew to his friends at the hospital.) He developed a taste for claret, snuff and cigars; he learned how to play billiards and whist; he went to boxing matches, cockfights, and bear-baitings. His sense of fun, which he had often shown with his brothers, and which would often bubble through his most sombrely thoughtful letters, made him a popular companion.[3] At Christmas 1815, when his fellow students in St Thomas Street finished their courses (George Cooper went to work in Brentford, and Frederick Tyrrell moved to Edinburgh) he asked two others staying in the same house, Henry Stephens and George Wilson Mackereth, whether they might move in with him, knowing that they 'represented, far more closely than the company [he] had kept so far, the average type of medical student'.[4] (They also helped him to pay for his lodgings: the rent was at least £63 a year, and his allowance for rent was £20 at most.)

Little is now known about Mackereth. He planned to take his Licentiate exams at the end of July, and when he eventually passed them, at the second attempt, he entirely disappeared from Keats's life. Stephens is a stronger presence, and less 'average', too. He had been born in London, was two years younger than Keats, and combined his work in the hospital with an interest in the theatre and poetry. (He later wrote a tragedy called *Edwi and Elgiba*.) He was also a committed freethinker, eventually becoming friends with the radicals Robert Owen, Benjamin Richardson and Robert Stephenson, and had a gift for

invention which later made him famous as the inventor of Stephens Ink. He liked Keats enough to want to share rooms with him, but found him a problematic friend. He was jealous of Keats's imminent promotion, disliked the way his brothers hero-worshipped him, and considered him unstable – sometimes full of 'practical jokes and pranks', sometimes 'steady, quiet and well-behaved', sometimes distracted and morbid. Moreover, he thought Keats was pretentious, and resented the way he 'seemed to think it a presumption in me to attempt to tread along the same [poetic] pathway as himself at however humble a distance'. (One of their mutual friends said that at this time Keats habitually 'went about . . . à la Byron', with his shirt collar turned down and his neck bare, and 'let his mustachios grow occasionally'.) All these criticisms show plainly in the memoir Stephens later wrote about Keats:

[Keats] attended lectures and went through the usual routine, but he had no desire to excel in that pursuit . . . In [our sitting room] he was always at the window, peering into space, so that the window-seat was spoken of by his comrades as Keats's place . . . In the lecture room he seemed to sit apart and be absorbed in something else, as if the subject suggested thoughts to him which were not practically connected with it. He was often in the subject and out of it, in a dreamy way.

He never attached much consequence to his own studies in medicine, and indeed looked upon the medical career as the career by which to live in a workaday world, without being certain that he could keep up the strain of it. He nevertheless had a consciousness of his own powers, and even of his own greatness, though it might never be recognised . . . Poetry was to his mind a zenith of all his Aspirations: the only thing worth the attention of superior minds: so he thought: all other pursuits were mean and tame . . . The greatest men in the world were the poets and to rank among them was the chief object of his ambition. It may readily be imagined that this feeling was accompanied with a good deal of pride and conceit, and that amongst mere medical students he would walk and talk as one of the gods might be supposed to do when mingling with mortals. This pride exposed him, as may readily be imagined, to occasional ridicule, and some mortification.

Not all Keats's new friends found his 'pride' as tiresome as Stephens did. Henry Newmarch and William Haslam, for instance. Newmarch was a 'lighthearted & merry' friend of his grandmother's family, who was a student at Bart's, and confident enough to challenge George's 'idolatry' of his brother by criticising Keats's poems. Haslam was the son of a grocer in the City, had trained as a solicitor, and five years later

would be among those who saw Keats aboard the *Maria Crowther* for his journey to Italy – telling a friend: 'I, for one, cannot afford to lose him. If I know what it is to love, I truly love John Keats.' This indicates that soon after first meeting Keats in late 1815 or early 1816, Haslam became one of his closest companions. Yet the quality of their friendship is difficult to measure, since hardly any of their meetings are documented, and Haslam eventually lost all his letters from Keats.[5] Their intimacy only survives in silhouette: throughout their early days, he helped to guide Keats round London, and was always conscientious and selfless. In the summer of 1818 he earned Keats's unfading gratitude by looking after his sickly brother Tom. Until his death in 1851, Haslam never ceased to cherish the memory of his 'noble friend'.

George (or possibly Edward Holmes, according to Charles Cowden Clarke) also introduced Keats to Joseph Severn during this period. The story of their affection is much better preserved. Born in Hoxton to the east of London on 7 December 1793, Severn was the son of a music master who had later moved to Goswell Street. As an adolescent, Severn had been separated from his family (he had three sisters and two brothers) and sent to work as an apprentice to William Bond, an engraver in North London with whom he stayed for seven or eight years 'stabbing copper'. Like Keats, he hungered to make his name as an original artist, and to further his ambitions he attended classes at the Royal Academy, painting miniatures and watercolours in his spare time to earn money for his fees and materials. He was often overwhelmed by lack of confidence, and by the need to idolise those he regarded as his superiors. His uncertainty showed in his features: he was nervously thin, with a narrow face, a wide mouth, and a mop of curly brown hair which he wore girlishly long. It was several months before he and Keats began to see much of each other, but they soon laid the foundation of a mutual respect. They were both torn between creative hopes and practical demands. They were both interested in thinking how their work might be linked to the aims of the sister arts. They both enjoyed walking outside London, especially beyond Highgate and across Hampstead Heath. Keats was the more powerful personality of the two, and Severn could seem irritatingly adhesive, but Keats never lost patience with him. For his part, Severn felt 'a new world was opened to me, and I was raised from the mechanical drudgery of my art to the hope of bright and more elevated courses'.

In all his previous friendships, even with his brother George, Keats

had taken the role of gifted junior partner. With Severn he became more dominant. This was partly due to Severn's self-doubt. When we read of his initial 'astonishment' at Keats's powers of observation during their walks together (leaping on to a stile and shouting 'The tide! The tide!' as he watched the wind sweeping through a cornfield), we hear the same note of slightly abject adoration that sounds in his many later references. Just before his death in 1879 he said to a friend, 'I may say that of all I have done with brush and pen, as artist and man, scarce anything will long outlast me . . . yet through my beloved Keats I shall be remembered.' It also has a great deal to do with Keats's own very rapid maturing. During his first few months in London, he acquired a much stronger sense of himself, and a greater feeling of purpose. Even if he was troubled by conflicting loyalties, even if he sometimes sank into gloomy introspection, he was also vitalised. He felt part of a wider society that was at once boisterous and high-minded. He was learning to accept that his turbulent childhood contained general truths about life. He was discovering that the distinct parts of himself were not proof of a hopelessly fractured personality, but of a possible strength in diversity. History was not something to dread or distantly admire, but – as Severn records him saying – 'a real living Spirit . . . an immortal youth . . . just as there is no *Now* or *Then* for the Holy Ghost'.

As soon as Keats took up his dressership in March 1816, the tensions between his work and his writing became more difficult to reconcile. He paid fees for a full twelve months, intending to become a member of the Royal College of Surgeons at the end of his training. But instead of being assigned to Astley Cooper, as had originally seemed possible, he was appointed to the post left vacant by William Everest under William Lucas junior.[6] Lucas had a reputation as a cack-handed butcher. John Flint South described him as 'a tall ungainly man, with stooping shoulders and shuffling gait, as deaf as a post, [and] not overburdened with brains of any kind'. He was 'very good natured and easy', but his operations were 'very badly performed and accompanied by much bungling if not worse'. Even Cooper broke the rules of etiquette to agree. Lucas, he said, was 'neat-handed but rash in the extreme, cutting amongst most important parts as though they were only skin, and making us all shudder from the apprehension of his opening arteries or committing some other horror'.

When not assisting at Lucas's ghastly rituals, holding down patients

and helping to stifle their cries, Keats endured other and equally gruesome new duties. He changed bandages, and found 'almost every wound was or quickly became a foul-smelling, festering sore'.[7] He took his weekly turn in the out-patients department, acting as 'a kind of house-surgeon *pro tempore*'.[8] On Wednesdays (taking-in day) he accompanied Lucas on his rounds, carrying the plaster box which was his badge of office, and receiving orders about forthcoming operations. And he attended to emergencies during his periods of night duty. Any sense of privilege he might have felt about his preferment was soon swallowed by the sheer laboriousness and misery of his work.

It is hardly surprising that he tried to keep these 'horrors' at bay by continuing to dress 'à la Byron' and by drifting 'into fairyland'. But no amount of poetic fantasising could stop the depression he had suffered during his time with Hammond from returning, and quickly building up. Charles Cowden Clarke once referred to his fits of melancholy as 'irreversible'. This might seem like an exaggeration, were it not for the corroborating evidence of George, who said that during his apprentice-ship in Edmonton Keats had occasionally felt wretched enough to contemplate suicide. As the burdens of his dressership increased, he now began 'complaining' bitterly once again – sometimes about other people's suffering, and sometimes about the 'agony' he felt at being denied time to write. 'He feared', his brother said, 'that he should never be a poet, & if he was not he would destroy himself.' He added that while 'no one in England understood his character perfectly but poor Tom', not even their youngest brother had 'the power to disturb his frequent melancholy' and 'many a bitter fit of hypochondriasm' during this time. Severn was certainly incapable of curing it. His encouragement was valuable, but it also helped Keats to see that he had set himself a dauntingly enormous task. He wanted to write poems which were nothing less than 'a Remedy against . . . wrongs within the pale of the world'.

As KEATS'S SELF-QUESTIONING grew more intense, the example of Leigh Hunt became more important to him. Hunt, on the evidence of *Politics and Poetry*, understood just how difficult it was to be pulled in two directions, yet his weekly *Examiner* articles repeatedly discussed the ways in which contradictions could be resolved. A literary sensibility, he insisted, could include a social sense. When Hunt published his new long poem *The Story of Rimini* in February 1816, Keats fell on it hoping for

further enlightenment. What he found was a romantic retelling of the Paolo and Francesca story from Dante's *Inferno* – a version which, for all its accelerated storytelling and emotional frankness, was closely akin to the sentimental work of Mary Tighe. The 'idiomatic spirit' of Wordsworth that it purported to emulate was everywhere subdued or diffused.

Keats's respect for Hunt was so great that he initially took *Rimini* at its own estimation, and shared the opinion of those like Byron who had been consulted about the poem in its early stages, and reckoned it 'devilishly good'. He persuaded himself that it did indeed contain 'the proper mixture of sweetness and strength', and believed that its apparently modern idiom was an acceptable way of reconciling 'fine doing' with 'fine writing'. This made him slow down the development he had recently envisaged, adapting the style he had evolved with Mathew rather than rejecting it altogether. He became mesmerised by the 'rapid slipper-shuffle'[9] of Hunt's versification, by his plethora of adjectives ending in '-y' and adverbs in '-ly' ('fledgy', 'rushy', 'lawny', 'pippy', 'peely'), by his feminine rhymes, and by his feebly decorous treatment of women and Nature. The impact on his practical ambitions was equally powerful. Regretting, perhaps, that Charles Cowden Clarke was still showing no signs of introducing him to Hunt, he decided to take matters into his own hands and sent three poems to the *Examiner* anonymously, asking for them to be considered for publication. When Hunt printed 'O Solitude!' on 5 May, Keats had the first positive proof that his aspirations were not as ridiculous as Mackereth and Stephens sometimes found them. He immediately began spending more and more time 'scribbl[ing] verses' and less concentrating on the revision necessary for his exams in the summer.

The two poems that Keats began soon after reading *Rimini* – the 'Specimen of an Induction to a Poem' and 'Calidore', both of which he wrote between February and May – are also stamped with Hunt's hallmarks, especially the first of them. Its 'chatty cosiness',[10] its chivalric doodlings and dabblings, all form part of the invocation to 'Libertas' with which it closes. 'I will follow', Keats says, 'with due reverence, / And start with awe at mine own strange pretence'. 'Calidore', which takes its subject from *The Faerie Queene*, is a little more energetic, at least as far as its natural descriptions are concerned. The 'black-winged swallow' which dips 'so refreshingly its wings, and breast / 'Gainst the smooth surface' of a stream, and the fir trees 'dropping their hard fruit upon the ground' have the same sharp-edged clarity as the 'dark-leaved

Writer says, it has been given out that hard drinking oc-
casioned Hegg's death ; but this he strongly denies; and
he adds, that the Sister of the deceased was refused admit-
tance to see the remains, till the body was so changed that
she with difficulty recognised it to be her brother's, and
the blood was then oozing through the shroud.

TO SOLITUDE.

O SOLITUDE! if I must with thee dwell,
　　Let it not be among the jumbled heap
　　Of murky buildings ;—climb with me the steep,
Nature's Observatory—whence the dell,
Its flowery slopes—its rivers crystal swell,
　　May seem a span : let me thy vigils keep
　　'Mongst boughs pavilioned ; where the Deer's swift leap
Startles the wild Bee from the Fox-glove bell.
Ah ! fain would I frequent such scenes with thee;
　　But the sweet converse of an innocent mind,
　　Whose words are images of thoughts refin'd,
Is my soul's pleasure ; and it sure must be
　　Almost the highest bliss of human kind,
When to thy haunts two kindred spirits flee.
　　　　　　　　　　　　　　　　　J. K

ament of Lima,
ains a dispatch
army of Upper
ned a complete
ie army of the

n Council was
RCH moved an
dating him on
vith the Prince
r nature to the
ulations of the
the Prince of
s unanimously

ACKSON," rela-
Appointment of
nd upon Colo-
e something to
e, that the sys-
on, corruption,

1 'To Solitude', Keats's first published poem, appeared in the *Examiner* on 5 May 1816. It had
no title when collected in *Poems* (1817).

laburnum's drooping clusters' in the Epistle to Mathew. But its
celebrations of 'knightly deeds', like the 'tale of chivalry' in the
'Specimen', means that it can never be as realistic as it wants.

Later in the summer, Keats wrote three sonnets which show Hunt's
influence beginning to moderate, while still aligning themselves with his
liberal ideals. The first, 'To one who has been long in city pent' (which
was 'written in the fields' in June), opens with a Wordsworthian fanfare,
praising the same hidden-away 'bliss' that he had described in 'O
Solitude!' The 'Fatigued' speaker sinks into 'some pleasant lair', reading
'a debonair / And gentle tale of love and languishment', conscious that it
can bring him no more than a brief respite from his gruelling everyday
life. The next, 'O! how I love, on a fair summer's eve', also cherishes a
'sweet reprieve / From little cares'. Here, though, the immersion in
'Nature's beauty' is not an end in itself; it is a chance to stand apart from
'meaner thoughts' and ponder 'patriotic lore', 'musing on Milton's fate
– on Sidney's bier – / Till their stern forms before my mind arise'.
This may not amount to the brave connection between doing and
thinking which he was formulating as his ideal, but – like some parts of

the Epistle to Mathew – it at least keeps the possibility in sight.

The third sonnet, 'To a Friend who Sent me some Roses' (29 June) manages the same modest achievement. The 'Friend' in question was Charles Wells, who was four years younger than Keats, had been a schoolboy in Edmonton, and was now living in London where he was training as a solicitor. He was especially close to Tom Keats, who had recently introduced him to his brothers: they found him a 'bright, quick, piquant lad, overflowing with wit and humour'. The roses mentioned in the poem may have been what has been called a 'peace offering' sent after some minor disagreement (Keats later had a much more serious falling-out with Wells) – but whatever the cause, it is forgotten as the flowers 'whisper [. . .] of peace, and truth, and friendliness unquelled'. This conclusion is not concerned to draw any obvious parallel between private behaviour and public responsibility, but the point is there to be taken. By celebrating cut flowers rather than wild ones, Keats links tokens of 'friendliness' to suburban values in general, just as he had done when climbing a modest look-out (not a Wordsworthian mountain) in 'O Solitude!'

FLAWED AS THEY are, these spring and summer poems continued to feed Keats's ambition and to reflect his humanitarian beliefs. He was writing fluently, he had been published for the first time, and he had brought himself to the fringe of the literary society he most admired. As he weighed these things, his life at Guy's grew more uncomfortable. He 'made no secret of his inability to sympathise with the science of anatomy', complained to Charles Cowden Clarke and his brothers about Billy Lucas, and worried about the money that had already been spent on his training. If he failed his examination, or, more dramatically, decided to abandon medicine altogether, he would not only be cancelling the work which had so far given his life its structure, but would be betraying the expectations of others. The prospect was alarming, especially since the stern-minded Abbey had recently become his sole trustee and guardian. (Sandell, the other minder appointed by Alice Jennings, had died unexpectedly on 5 May. After his death, Abbey seems to have enlisted another trustee, as he was entitled to do. This man, whose name appears to have been Fry, was worse than useless. Some time after agreeing to co-operate with Abbey he went to live in Holland, thereby creating difficulties Keats would have to confront later.) £1,500 had already been invested in his training, and the bulk of his grandmother's

inheritance was gone. If he were to turn aside from medicine, he knew that Abbey would make the waste of money seem criminal. If he persevered, he would be denying what he now considered the more important part of himself, and would also run up further expenses that he could ill afford.

He decided to take the middle course. By mid-summer he had fulfilled the minimum requirements of apprenticeship, lecture attendance and hospital work, and had announced that after qualifying he eventually wished to work in the country outside London. The date for his examination was set for 25 July in Blackfriars, with Everard Brande presiding. Keats's colleagues and companions feared the worst for him. Cooper himself had recently said that the Apothecary Act made a 'certain course of education indispensable', and standards were high in all four of the papers he was expected to sit: a translation of the pharmacopoeia and physician's prescriptions, the theory and practice of medicine, pharmaceutical chemistry, and materia medica.

He passed – but when Mackereth (who failed) brought the news back to St Thomas Street, Stephens immediately protested that it was only because Keats was good at Latin. When Stephens himself failed the examination a few weeks later, he became even more incredulously disparaging. He complained that Keats had not done enough work, and pointed out that he was only half serious about his career. At no time did he give Keats the credit he deserved for his success. Keats was not yet twenty-one years old, but had become an apothecary 'in the shortest time possible and at the earliest possible age'.[11] Before his new term at Guy's began in the autumn, he decided to reward himself by taking time off and sharpening the definition of his other self.

TEN

LONDON WAS 'MUGGY'[1] during the early summer of 1816, and especially unpleasant for those lodging in St Thomas Street. One of the former residents, George Cooper, had asked the 'Resurrection Men' – who supplied cadavers to Guy's for anatomy lessons – to deposit a corpse in the house so that he could continue his studies in London while practising in Brentford. Keats was understandably keen to leave, and although Friday operations continued in the hospital, he persuaded two other dressers to cover for him.

He did not want to leave London simply for his own sake. He was keen to give some help to his younger brother Tom. While George had grown up into a tall, affable and confident young man-about-town, Tom – now aged sixteen – had suffered in the polluted atmosphere of the City ever since beginning to work for Abbey. The previous winter he had visited Lyon, ostensibly on some hat-making business associated with Abbey, but also to try to improve his health. The journey had not done him much good, and when Keats looked at him now, he saw worrying signs of weakness: a pale and pinched face, a listless manner, a persistent anxiety. They could be, he knew, the early signs of consumption. He decided that when he came back from his holidays he should set up home with Tom to keep an eye on him – and, saying that he would soon follow, sent him on ahead to the south coast while he looked for somewhere they might rent together in the autumn. (George had struck out on his own and was lodging for free with Abbey's head clerk Mr Swan, whom Keats nicknamed Mr Wagtail.)

Their destination was Margate, a resort recommended to him by Charles Cowden Clarke,[2] and described in a guidebook of the time as 'the capital of the Isle of Thanet' on the north coast of Kent. Originally it had been 'of good repute for the fishing and coasting trade'. By the beginning of the nineteenth century it was more renowned for its 'sea air and bathing': it had been one of the first places in the country to introduce bathing machines. The indigenous population was a little over 5,000, but every summer some 20,000 visitors descended on its sandy beaches and gently climbing terraces. Most came from London, some travelling down the Thames by boat (the fare was five shillings for a 'common cabin'), others by coach (which cost £1 2s from the Golden Cross at Charing Cross).

First Tom and then his brother probably went by coach, but judging by the evidence of one contemporary, the greater expense was hardly a guarantee of comfort. 'You get your breakfast at Rochester, which is thirty miles, where your luggage is knocked about, and often materially injured, by being translated into another coach that meets you from Canterbury . . . At Canterbury you dine, and change coach again, experiencing the same scene and species of abuse and impertinence from the coachmen and waiters . . . Then a coach or diligence meets you, and twists you over to Margate, which is seventeen miles; you arrive there about nine o'clock at night, an hour which renders it necessary that you should take up your abode at an inn, and submit to the consequences of

such a situation until you may be lucky enough to get a lodging some forlorn day.'[3]

It is not known where the Keats brothers stayed in Margate – probably in rooms overlooking Hawley Square in the centre of the old town, for which they would have paid about five guineas a week. From here it was a short walk to the beach and the Pier, which had been built in 1799, and the handsome Assembly Rooms, which boasted 'a good billiard and a Coffee-room, several Dining-parlours, and a Piazza supported by a range of duplicated Doric columns'.[4] These assembly rooms were a measure of how Margate had changed in recent years. Although its promenade was a 'lounging place' for 'a more heterogeneous group than at any place in England',[5] the town also catered for fashionable and well-to-do visitors. Its main streets were paved and lit, it had three libraries, it had a theatre (opened in 1787), and elegant walkways leading to a fort on Hooper's Hill. Keats, who was always quick to feel a sense of inferiority, enjoyed its easy mixture of differences.

He may have first explored the town with a fellow medical student, Joshua Waddington, who according to some sources also spent a part of July in Margate. It is also possible that he went to visit his former schoolmaster John Clarke, who this year retired from Enfield to Ramsgate, a little further round the coast.[6] If he did, he would no doubt have been given advice about his career – Clarke was a practical man, and knew from his apothecary brother-in-law John Towers (whom Keats had met through Charles Cowden Clarke) what pressures a doctor had to face. He certainly spent a good deal of time with Tom, walking and lolling on the grassy clifftops, seeing plays, and reading – he had taken with him his two-volume edition of Wordsworth. Although his brother's health was poor, it did not dampen their high spirits – and neither did their confusion when, soon after arriving, Tom began to receive a series of love letters from a preposterously pseudonymous French woman, 'Amena Bellafilla'. (She claimed to know Charles Wells, who may also have visited Margate briefly this summer.) Tom kept his admirer's name to himself, and did not show Keats her letters, but he hoarded them carefully, and took them with him when he eventually returned to London.

Keats spent most of his time writing. His greatest wish was to produce more – and more ambitious – poems, but his Margate holiday also marks the beginning of his life as a correspondent. Although none of his letters from this time survives, George indicates that his brother kept in touch,

using envelopes provided by Wells, who had managed to wangle some which were already 'franked', and could therefore be used for free. It is clear from the two verse Epistles Keats soon completed that this new opportunity had a dramatic effect on his style. His letters are not simply a wonderful adjunct to his poems, but a vital and valuable part of them: they often serve as testing grounds for his theories and ideas, and always blend spontaneity and calculation in a way which allows us to see him in the round.

In his poems Keats cultivates a language which is carefully distanced from normal discourse. In his letters he writes with brilliant directness. No matter how deeply he is immersed in his own thoughts, he never loses sight of the person he is addressing, nor his sense of an intimate contact. There is no strain in them, no anxiety about audience (though they often agitate about the audience for his poems), no nervous struggle to capture beauty and truth, no stressful sense of blockage or contra-diction. Instead, there is freely associating inquiry and incomparable verve and dash – a headlong charge in which jokes, anecdotes, 'little bits of news', snatches of bawdy, imitations of comic Shakespearean garrulity, mockery and gossip are swirled together with poetic 'axioms' and subtle deliberations. When facetious and mercurial he draws on the same energies which nourish his high seriousness. When 'bandying a pun or two',[7] or sinking into voluptuous luxury, or brimming with ridiculous stories, he is 'touched' with the same 'ardency' that fired his ambitions. Page by page – and often line by line – he proves that 'eve[r]y point of thought is the centre of an intellectual world', 'lifting a little time from [the] shoulders' of his correspondents by asserting the full weight of his personality. Even on the threshold of his final illness, when he was bowed by worry about his brother and his own future, he was still able to send his sister-in-law a letter which 'pleased' her with 'nonsense' while squaring up to sombre responsibilities:

T wang dillo dee. This you must know is the Amen to nonsense. I know many places where Amen should be scratched out, rubb'd over with pou[n]ce made of Momus's little finger bones, and in its place 'T wang-dillo-dee,' written. This is the word I shall henceforth be tempted to write at the end of most modern Poems – Every American Book ought to have it. It would be a good distinction in S[o]ciety[.] My Lords Wellington, Castlereagh and Canning and many more would do well to wear T wang-dillo-dee written on their Backs instead of wearing ribbands in their button holes – how many people would go sideways along walls and quickset hedges to keep their T wang dillo dee out of sight, or

wear large pigtails to hide it. However there would be so many that the T wang dillo dee would keep one another in countenance . . .

Although they were usually written pell-mell, and are often full of inadvertent omissions and rashly spelt, Keats's letters are invariably conscious of their createdness. We can see this simply by looking at the way they draw attention to their own physical forms – as when he describes 'cross-writing' as resembling a 'Rat-trap', or points out 'I can only write in scraps and patches', or complains about interruptions, or chafes at the ways in which writing cannot be like speaking. He says at one point: 'One cannot write a wink, or a nod, or a grin, or a purse of the Lips, or a *smile – O law!* One cannot put one's finger to one's nose, or yerk ye in the ribs, or lay hold of your button in writing.' All such remarks, like the many others in which he biographises himself (telling us how he is sitting, what he can see, how his room is arranged), do more than produce a powerfully immediate sense of occasion. They explore the very mechanics of letter writing, and link its freedom to the distrust of consecutive reasoning which he asserts in his poems. While his early poetic mentors – Spenser, Milton, Wordsworth, Hunt – encouraged him to think of his poetic calling as something lofty, his correspondence links him to quite different models: to Hazlitt, and (as Gittings pointed out) to Sterne, whose *Tristram Shandy* he admired. 'I have constructed the main work,' Sterne once said, in terms which are equally appropriate to Keats's letters, 'and the adventitious parts of it with such intersections, and have so complicated and involved the digressive and progressive movements, one wheel within another, that the whole machine, in general, has been kept a-going.'[8]

THE FIRST POEM Keats worked on – and then abandoned – in Margate was 'Calidore': its fairyland gave him no space in which to practise the new freedom he was preaching. He followed it with a much more direct address to his brother George, a sonnet in which he describes his reaction to the 'ocean' he had never seen before – 'its vastness, its blue green, / Its ships, its rocks, its caves, its hopes, its fears – / Its voice mysterious, which whoso hears / Must think on what will be, and what has been.' These lines are excited by newness, but full of uncertainty about his poetic future, and end by suggesting that the material for poetry ('the wonders of the sky and sea') and even his talent itself, depend on the 'social thought' of his brother. 'Social' here obviously

means 'sociable', but in the loose-limbed Epistle he wrote to George soon afterwards, the word appears again, and this time it revives his questions about the purpose and value of poetry. Remembering the 'many a dreary hour' he has recently spent in London, struggling to reconcile his work with his ambition to 'hear Apollo's song', he again rehearses the Huntian wish 'to unfold / Some tale of love and arms in times of old', and the Wordsworthian hope that Nature will redeem him 'from all suffering'. There is a fresh toughness about his deliberations. He accepts that to enter a 'trance' can mean denigrating the here-and-now (' 'Twould make the Poet quarrel with the rose'). Rather than risk this, he rejects romantic pleasures for 'posterity's award':

> The patriot shall feel
> My stern alarum, and unsheathe his steel;
> Or, in the senate thunder out my numbers
> To startle princes from their easy slumbers.
> The sage will mingle with each moral theme
> My happy thoughts sententious; he will teem
> With lofty periods when my verses fire him,
> And then I'll stoop from heaven to inspire him.

No sooner has Keats outlined his ambitions than he sinks back into sighing sensuality, only to rouse himself once again by stating 'Ah, my dear friend and brother, / Could I, at once, my mad ambition smother, / For tasting joys like these, sure I should be / Happier, and dearer to society'. Such unsteady risings and fallings weaken the poem's progress, but its purpose remains definite. It is driven by the same motives he had first shared with Charles Cowden Clarke, and which now formed the foundation of his sympathy with Hunt.

The poem ends with a criticism of the military that Keats knew Hunt would find especially sympathetic: the 'scarlet coats' of the poppies in the fields on the clifftops 'bring to mind / The scarlet coats that pester human-kind'. In his next effort (another Epistle, which he finished in September), he makes the same connection. Celebrating his friendship with Charles Cowden Clarke, and thanking him for explaining how certain kinds of poetry are associated with particular degrees of social involvement, he introduces 'wronged Libertas' (Hunt) as the dominant figure in their relationship, then adds:

Ah! had I never seen,
Or known your kindness, what might I have been?
What my enjoyments in my youthful years,
Bereft of all that now my life endears?

Hunt influenced the form, language and situation of these poems as much as he did their argument. (Keats makes a point, for instance, of saying that his poems are written outside, as Hunt had recently done in his first Epistle to an imaginary 'cousin', Thomas Brown.) The same is true of the other long poem that occupied Keats during his holiday. This was one he had started in June with a description of Hampstead Heath, which contained more precise and evocative physical descriptions than any he had previously managed: 'sweet peas, on tip-toe for a flight: / With wings of gentle flush o'er delicate white, / And taper fingers catching at all things, / To bind them all about with tiny rings'. But it was Wordsworth, rather than Hunt, who provided the context for this more accurate kind of writing. Remembering a sonnet by Wordsworth about Endymion and Cynthia, perhaps even reading it again on the 'clift top', Keats began considering how he might develop its story. He sensed for the first time that he had discovered a subject which might significantly enlarge the frame of his writing. His deliberations about poetry could take their place in a narrative which diversified his attention, and thereby allow him to remain true to his notion of a poet's necessary progress.

This new sense of audience offsets the loneliness which shows elsewhere in the Margate poems. They are, for all their affection and exuberance, full of disappointment – disappointment which increased throughout the two-month holiday. He felt cut off from a literary milieu, as well as from George. He enjoyed Tom's ragging and joking, but missed his more boldly iconoclastic friends. He struggled to find a subject other than poetry itself. He veered wildly between faded styles and fierce hopes. Even as he regretted these things, however, he knew that he was developing a fuller sense of potential. As the summer ended, and the depressing prospect of work and London crept up on him, he felt that he had learned to discipline his attraction to the mere 'sweets of song'. He had for a while shaken off his feeling that 'there was now nothing original to be written in poetry; that all its riches were already exhausted, & all its beauties forestalled'.[9] By removing himself from the world, he had seen how to take his place in it more easily, and more 'usefully'.

ELEVEN

WHEN THE TWO brothers returned to London in late September, Keats moved into the new lodgings he had found before leaving for Margate. Their holiday had deepened his dislike of the crowds and chaos of the Borough, but he needed to remain close to Guy's. 8 Dean Street, in a narrow road which joined St Thomas Street and Tooley Street and is now buried under London Bridge Station, was at least convenient. Originally he had intended to share the house with Tom; for reasons which are now obscure, their plans changed. Tom went to live with George, and Keats became once again a 'house-keeper and solitary'.

He hardly had a moment to feel alone. He had to begin a new series of lectures in surgery, so that he could apply for membership of the Royal College the following year. He was also expected to take more responsibility as he assisted Billy Lucas during his operations. In what little time he had to himself, he sought out his brothers and old friends with an even greater sense of their value, especially Charles Cowden Clarke, who had recently left Enfield and was staying with his sister Isabella Towers in Little Warren Street in Clerkenwell. (It was news of this move which had spurred him to write Clarke the Epistle.) At the first opportunity, he travelled across the City to visit him. Clarke was disturbed to hear that Keats was still worrying about his career, but the writing he had done in Margate proved that his other ambitions were now clearer. So much clearer, that Clarke finally decided to take the step he had long postponed, and offered to show three of Keats's poems to Hunt. (He was no doubt encouraged by the recent publication of 'O Solitude!'.) One of these was the Epistle itself; the other two were sonnets, including 'How many bards gild the lapses of time', which Keats had written shortly after returning to London.

When Hunt had been released from prison twenty months earlier, he had taken a house in the Vale of Health, on the edge of Hampstead Heath, four miles north of London. It was a place apart from the city, but somewhere he could feel in touch with everyday metropolitan affairs. It allowed him to maintain the contacts that he needed for the *Examiner*, and to cultivate his reputation as a new kind of pastoral poet. The ancient Middlesex forest which had once covered Hampstead Hill survived in dense clumps, wild flowers grew in profusion, and nightingales were commonplace.

In the harvest season, haymakers from the Fens would come down for casual labour, and in fine weather the gipsies camped near the willow plantations. A host of local washerwomen, who had lived longer than memory in shacks on the Heath, washed Hampstead's laundry and spread it out on the hills round the Vale of Health; the donkey-drivers took their stand on the Heath wherever they chose, and speculative lace-makers in their short red cloaks, frilled with black lace, and . . . carrying cushions with varicoloured bobbins swinging from them, would sell thread lace to chance customers and take orders from others. Foreign-looking women, from Holland or the Savoy, peddled their miniature brooms of poplar wood and cried: 'Buy a broom! buy a broom! A large one for a lady, a small one for a baby! Buy a broom! buy a broom!'[1]

By the middle of the nineteenth century, Hampstead was widely regarded as what Wilkie Collins called 'a suburban Nirvana'. In Hunt's day, its connotations were less fixed and more complex. Contemporary guidebooks refer to it as 'very happy in its situation, being somewhat romantick',[2] as 'abound[ing] in delightful vales and elegant mansions',[3] as 'extremely picturesque' and 'rank[ing] high for the number and variety of its medical waters'.[4] An elegant set of Assembly Rooms stood in Well Walk; the impeccable white façade of Caen Wood House glistened through the trees beyond an artificial lake; officers often visited from the nearby St John's Wood Barracks; famous ghosts haunted its streets and pathways (Pope and Steele, Richardson, Johnson and Goldsmith). In all these respects, it was somewhere that mirrored the landscapes Hunt had always celebrated in his poems, and which Keats described throughout his writing life. Rather than evoking wild nature as a pure alternative to cities, as Wordsworth and the first generation of Romantic writers had done, they presented it as a set of enclosed and sheltered spaces – somewhere to visit but not to stay, a source of picturesque pleasure rather than moral clarity. It is this aspect of 'suburban' writing which would later infuriate the Tory critics who attacked Keats and Hunt as 'Cockneys'. They were pot-gardeners whose poetry betrayed 'the *shibboleth* of low birth and low habits'. They were parvenus who preferred brief rural excursions and cunning examples of artifice (such as 'bowers') to anything more craggy, sublime, and permanently apart.[5] Keats's verse letters, like the sonnets he had written to Wells and on 'Solitude', prove the point. So does the great mass of Hunt's writing – his Epistle to Thomas Moore, for instance:

And yet how can I touch, and not linger awhile,
On the spot that has haunted my youth like a smile?
On its fine breathing prospects, its clump-wooded glades,
Dark pines, and white houses, and long-allied shades,
With fields going down, where the bard lies and sees
The hills up above him with roofs in the trees?
Now too, while the season, – half summer, half spring, –
Brown elms and green oaks, – makes one loiter and sing;
And the bee's weighty murmur comes by us at noon,
And the cuckoo repeats his soft indolent tune,
And little white clouds lie about in the sun,
And the wind's in the west, and hay-making begun.

Hunt, to do him justice, lived in the least touched-up part of the Heath: the Vale of Health was surrounded by patches of undrained marsh, its low hills dotted with claypits and scored with scrub. When Charles Cowden Clarke walked there on the first weekend in October 1816, taking the route from London that Keats himself would often follow in months to come, he left 'smoky London' fuming in its wide basin, passed the villages of Kentish Town and Islington to the east, and Kilburn and Paddington to the west, and entered a landscape of open fields, small ponds, and scattered farms. Hunt's house stood in a hollow surrounded by a number of other white-painted cottages. He kept it, with his wife and sister-in-law Elizabeth Kent, in a state of artful confusion – something which reflected his situation in more ways than one: he was at this time £1,400 in debt. His notoriously rowdy children charged from room to room. Books were heaped on the floor, on tables, chairs and sofas, and on the piano. Manuscripts, mementoes and trinkets were piled everywhere. Busts of his heroes peered among them: Alfred, Sappho, Petrarch, Kosciusko. The walls were thickly hung with engravings of work by Poussin, Claude and others. Hunt may have claimed, in one of his editorials, that he wanted to 'promote . . . the more educated appreciation of order and beauty' in his readers, but in his home he was more concerned to allow the unhindered 'happiness of his kind'.[6]

Hunt formulated his ramshackle liberality as a 'philosophy of cheer', idealising hearthside scenes as the epitome of decent human behaviour. Playing and singing music, poring over prints, writing and reading poems, all formed a part of the same emphasis – as he later made clear in

his long poem *Foliage* (1818). In the 'Preface, Including Observations on Poetry and Cheerfulness', he argues that 'cheerful' beliefs are more likely to spawn poems than 'unattractive . . . opinions which make humanity shudder'.[7] Over the years, this had led him to take an increasingly blinkered view of the world in his poetry, and to a style which was more cosy than companionable. ('Oh!', he once wrote to his friend Vincent Novello, 'what a disappointing, wearisome, vexatious, billowy, up-&-downy, unbearable, beautiful world it is!') But in theory it equipped him still to defend the radical causes he espoused in the *Examiner* – by appealing to the transfiguring effects of the greatest poets and mythologies (the Greeks, in particular). It is this contradiction which lies at the core of his personality, and which makes him such an engaging, as well as such an exasperating figure. In his views on all the arts, he insists that matters of taste are inherently political, that the corruption and lethargy of Regency England must be challenged, and that a creator's power depends on the ability to refract and diversify immediate circumstances. In his practice, and often in his conversation, he chose soft options, trivial interpretations, easy escapes.

When Charles Cowden Clarke arrived with Keats's poems, and explained they were by the author of a sonnet that had already appeared in the *Examiner*, Hunt was instantly generous. After reading twenty lines of the Epistle to Clarke, he 'broke into expressions of open admiration', and when he had finished reading he passed the manuscript to his friend Horace Smith, who also happened to be visiting. Smith, 'a wealthy stock-broker, who had become rich through a shrewd gamble in Government Loans at the time of Waterloo',[8] was widely known in literary circles as the author of the parodic *Rejected Addresses*. He was immediately impressed by 'How many bards . . .', repeating the penultimate line – 'That distance of recognizance bereaves' – and saying 'What a well-condensed Expression for a youth so young'. Hunt, who only that week had published Shelley's first contribution to the *Examiner*, and had recently admired a volume called *The Naiad* by another young writer, John Hamilton Reynolds, felt that a wish he had often expressed in his magazine was suddenly coming true. A new generation of poets was appearing, one that shared and validated his own beliefs.

Clarke hurried back to London and told Keats that Hunt wanted to meet him. Keats was delighted, but too busy to respond at once. On 9 October, however, as soon as he had settled into Dean Street and

established his new routines at Guy's, he wrote to his friend (it is his first surviving letter) and said: 'The busy time has just gone by, and I can now devote any time you may mention to the pleasure of seeing Mr Hunt – 't will be an Era in my existence.' After closing with instructions about how Clarke might find him among the 'turnings and windings' of the Borough, he began preparing for his ascent to Hampstead. He looked through everything he had written, burning or setting aside poems which seemed unworthy, and copying out others, including the Epistle to Mathew, which he felt would meet Hunt's standards and suit his taste.

When Clarke came to the Borough to settle their plans, he mentioned a book he had on loan from Thomas Alsager, a friend of Hunt's who ran the financial and musical sections of *The Times*. It was the 1616 folio edition of George Chapman's translation of Homer, a work that Hunt had praised for its skill in bottling the 'fine rough old wine' of the original in an Epistle he published in the *Examiner* on 25 August. Keats was exhilarated, and within a few days called on Clarke at the Towerses' house in Clerkenwell to examine it. Clarke and Keats sat up all night reading the book, which contained both the *Iliad* and the *Odyssey*, and when Keats returned to Dean Street at six o'clock the next morning, he wrote out the sonnet that he had begun to frame on the journey home. He was tired, and even though he had used the Petrarchan form during the summer, he reminded himself of the rhyme scheme by jotting it down in the right-hand margin. Then he wrote easily, making only one alteration (he changed 'low' to 'deep' in the sixth line):

> Much have I travelled in the realms of gold,
> > And many goodly states and kingdoms seen;
> > Round many western islands have I been
> Which bards in fealty to Apollo hold.
> Oft of one wide expanse had I been told
> > That deep-browed Homer ruled as his demesne;
> > Yet did I never breathe its pure serene
> Till I heard Chapman speak out loud and bold:
> Then felt I like some watcher of the skies
> > When a new planet swims into his ken;
> Or like stout Cortez when with eagle eyes
> > He stared at the Pacific – and all his men
> Looked at each other with a wild surmise –
> > Silent, upon a peak in Darien.

On the first looking into Chapman's Homer

Much have I travell'd in the Realms of Gold,
And many goodly States, and Kingdoms seen;
Round many Western islands have I been,
Which Bards in fealty to Apollo hold.
Of one wide expanse had I been told,
Which deep brow'd Homer ruled as his Demesne:
Yet could I never judge what Men could mean,
Till I heard Chapman speak out loud and bold.
Then felt I like some Watcher of the Skies
When a new Planet swims into his Ken,
Or like stout Cortez, when with wond'ring eyes
He star'd at the Pacific, and all his Men
Look'd at each other with a wild surmise
Silent upon a Peak in Darien

2 'On First Looking into Chapman's Homer', drafted by Keats early one morning
in October 1816.

Keats wrote this sonnet remarkably fast – but while this shows how urgent and exalted he felt, it also reminds us that he had written all his previous poems very quickly, and anticipates the rate at which he would continue to compose for the rest of his healthy life. Often working at night, when his (usually) cramped lodgings had fallen quiet, he habitually stirred himself into a 'fever', demonstrating in the process his allegiance to the Romantic idea of creation as a 'spontaneous overflow'. When writing *Endymion*, for instance, he sometimes produced fifty lines in a single sitting, and even though his later poems, with which he took more deliberate 'pains', often required many laborious 'compositions and decompositions', they change direction, correct and continue, at the same breathless pace. (The heavily revised manuscript of 'The Eve of St Agnes' is a good example.) Sometimes this made him repetitive and neglectful about verse quantities, as his friend Richard Woodhouse would discover when he helped revise 'Lamia'. More often, it gave his work the sense of forward rush, of imaginative heat and emotional thraldom, which formed a part of his self-image and his subject. The same is true of his letters, in which his pen races across the page, frequently misspelling or conflating similar-sounding words. This has led some people to suspect that Keats was a weak speller (and others to suppose that his frequent omission of the letter 'r', as in 'affod', 'gieved', 'poof', and 'sping', meant that he had difficulties in pronouncing it). In fact the fair copies he prepared for his publishers show that he could spell perfectly well when he wanted to; his spelling, like his grammar and his handwriting itself, is not proof of his 'want of education' but of his 'Character'. His manuscripts are written in a generally large and well-formed script, ventilated with open loops in the uprights, and ornamented with twirly capitals, proceeding evenly and spaciously as he puts down lines he had already formed in his head, then crouching into a flattened and compact sprint as his imagination takes hold. It gives a compelling picture of his intensity.

Keats found a messenger to take 'On First Looking into Chapman's Homer' to Clerkenwell as soon as he had finished writing. It was on Charles Cowden Clarke's breakfast table by ten o'clock, and he read it with an admiration which remained with him for the rest of his life. He recognised at once that the lines addressed themes which had always preoccupied Keats, but which were now suddenly developed to greatness. Earlier in the same month, in 'How many bards . . .', Keats had 'brood[ed]' over writers who had 'ever been the food / Of my delighted

fancy', but here his thoughts had more than a merely personal reference. Clarke would also have recognised some of the sources for the poem: Robertson's *History of America*, which was in the library at Enfield, and which describes the discovery of the Pacific; William Gilbert's commentary on his poem 'The Hurricane', which Wordsworth quotes in one of his notes to *The Excursion*, and which describes how contemplation of 'the distant, vast Pacific' produces 'imperial' exaltation;[9] Bonnycastle's *Introduction to Astronomy*, which Keats had been given in 1811, and which tells how Herschel found the new planet Uranus. He knew, too, how many phrases from Shakespeare and Wordsworth – let alone from Chapman himself – filled Keats's mind as he wrote. In the past, Keats's reading had often snared and cloyed him; now it helped him to turn the past into the future. The geographical sweep of the lines, their sympathetic amazement, were a part of the achievement they valued.

This sense of forward-looking is one of the sonnet's most important themes, as well as one of its greatest strengths. It shows Keats discovering, possessing, and authorising himself. But at the same time, it qualifies its excitement. It is a poem about exclusion as well as inclusion. Its title suggests that Keats felt he had come late to high culture (it is 'On *First* Looking'). It draws attention to the fact that he could not read Homer in the original Greek. It mistakes Balboa (whom Robertson rightly credits as the discoverer of the Pacific) for Cortez, and so undermines its air of learning. It even, for all its wonderfully bold energy, succumbs to a moment of awkward translationese ('pure serene') which creates a sense of Keats standing apart from the main event. In other words, the poem's exceptional and suddenly found maturity depends not on Keats escaping the tensions which shaped his personality, but on incorporating them. It is the first of his poems to secure him a place among 'the mighty dead', but one which feels challenged or even edged aside by history. There is no jealous anger in these contradictions, no resentment or chippiness, but there is both a well-managed and an involuntary sense of difference. It is a poem written by an outsider who wants to be an insider – on his own terms.

To be an insider with Hunt meant joining a circle of artists who shared the same ambivalent feelings. Safe in each other's good opinion, they knew their backgrounds and beliefs set them at odds with the establishment. To this extent, the thrill of discovery that Keats shows in his sonnet may be linked to his pleasure at knowing he would soon meet

Hunt. In the poem Cortez's men 'Looked at each other with a wild surmise'. In Clarke's description of his walk towards the Vale of Health with Keats he says: 'The character and expression of [his] features would arrest even the casual passenger in the street; and now they were wrought to a tone of animation that I could not but watch with interest . . . As we approached the Heath, there was the rising and accelerated step, with the gradual subsidence of all talk.'

KEATS AND HUNT had arrived at their similar beliefs by very different routes. Hunt's father Isaac was descended from 'Tory cavaliers' who many generations previously had settled in Barbados, and he had been raised and educated in Philadelphia before training as a lawyer and taking Holy Orders. He had left America in a hurry, hounded by a mob which objected to his views on Britain retaining its colonial interest. His wife Mary, whom he had met in Philadelphia, was by all accounts a nervous and retiring woman, but when she emigrated to England in 1776 with her husband and their four children, she did a great deal to stabilise her family and secure their future. She persuaded friends – including Benjamin West the painter, who was her uncle by marriage – to lend them money. She arranged for her children to be sent away to charity schools. She organised her husband's preaching life around the Home Counties. And by the time her fifth son Leigh was born on 19 October 1784, she was able to 'reclaim' her family in a 'parental home'[10] in Southgate, then a village in Middlesex to the north of London.

Her problems did not end there. Isaac Hunt was sanguine and hospitable (he liked to drink claret and read Horace) but liable to let his virtues turn into vices. He was often out of work, and occasionally in prison for debt. When Leigh described himself as 'a man of mirth and melancholy', he did more than hint at the exotic mixture of Celtic and Creole strains in his background. He indicated that his entire early experience had been unstable. His family, he said, 'struggled in between quiet and disturbance, between placid readings and frightful knocks at the door, and sickness and calamity; and hopes which hardly ever forsook us'.[11]

Mary Hunt responded to these uncertainties by providing what her son called 'an ultra tender and anxious rearing',[12] turning him into an 'anxious speculative'[13] child even before he was sent away to school – to Christ's Hospital, which then stood in Newgate Street, in London. Here his fearfulness transmuted into a resolute 'spirit of martyrdom'.[14] This

was partly because he was bullied by other boys, partly because his headmaster, James Boyer, was 'suspicious of him for looking American and suggesting that he might harbour Jacobinical feelings'.[15] These suspicions were justified. Since moving to England, his father Isaac had got to know Horne Tooke and other radicals, and their arguments had complicated his existing views. While still willing to publish, in 1791, the *Rights of Englishmen: an Antidote to the Poison now Vending by the Transatlantic Republican, Thomas Paine*, he was also alive to more dissenting opinions – which he combined with an interest in poetry, music, and painting. When Leigh Hunt 'threw off his [school] blue coat'[16] at the age of fifteen, and went to work for his brother Stephen, who was an attorney, his personality had already acquired its adult focus. He was widely read in the Classics and modern literature, wrote poems and essays with prodigious ease, had a 'zeal for liberal politics',[17] and was prepared to suffer for his beliefs.

These beliefs formed the backbone of the *Examiner*, which he founded with another brother, John, after leaving his job at the attorney's and working briefly in the War Office. As his confidence grew, his style acquired the insouciant flair he admired in his father. He was determined that his youthful apprehensions should be transformed into an 'invincibly sunny temperament',[18] and worked hard to diagnose his lingering neuroses by reading deeply in Voltaire, Godwin, Bentham and others. (Haydon said that the 'beauties' of his poetry were 'the product of a painful, hypochondriac Soul that struggles by dwelling on the *reverse* of its own *real* thoughts'.) He turned optimism into a religion, and hid the conviction that he was 'deficient in physical courage',[19] repeatedly subjecting himself to all kinds of tests. One of these was the risk of imprisonment that he knew he courted in his editorials – and when eventually incarcerated in Horsemonger Lane Gaol, he repeatedly played down its effects. He never let on, for instance, that for months after his release he would not or could not leave his house.

Coventry Patmore later said that when he met Hunt for the first time he was greeted by the exclamation 'This is a beautiful world, Mr Patmore!'[20] When Keats first stepped into the cottage in the Vale of Health he received a similar impression of unchangeable good will. Hunt was a little under six foot tall, 'dark and vivid with the exotic flavour of Creole descent', and 'remarkably straight and upright in his carriage with a short, firm step, and a cheerful, almost dashing approach – smiling, breathing, and making his voice heard in articulate

ejaculations'.[21] His black hair fell thickly from a central parting to frame his large but delicately featured face and short-sighted eyes; his mouth was large and 'hard in the flesh' with a long upper lip; and his forehead was 'singularly upright, flat, [and] white'.[22] According to some friends he looked 'gentle like a woman', but although occasionally seeming 'lackadaisical' and 'dandified', he was generally full of vigorous enthusiasm: 'brilliant, reflecting, gay, and kind, with a certain look of observant humour, that suggested an idea of what is called shyness when it is applied to children or to a girl'.[23]

Keats shared many of the same physical characteristics, as Hunt himself realised. Years later, Hunt remembered that his 'every feature was at once strongly cut and delicately alive. If there was any faulty expression, it was in the mouth, which was not without something of a character of pugnacity. The face was rather long than otherwise; the upper lip projected a little over the under; the chin was bold, the cheeks sunken; the eyes mellow and glowing, large, dark, and sensitive; his hair, of a brown colour, was fine, and hung in natural ringlets. His head was a puzzle for the phrenologists, being remarkably small in the skull, a singularity which he had in common with Byron and Shelley, whose hats I could not get on.'[24] Like most other descriptions of Keats, this suggests that he looked at once 'feminine' and robust. (When it was later suggested that he had been incapable of withstanding the attacks in *Blackwood's*, his friends rallied to deny that there had been anything effeminate about him: Barry Cornwall said that he had 'never encountered a more manly and simple young man', and Charles Brown made a point of stressing that he was 'though thin, rather muscular'.) Yet it does so without mentioning the single most striking fact about his appearance: his height. This is partly due to the fact that Keats's smallness was less exceptional then than it would be today.[25] It is also probable that Hunt made no mention of his size because Keats compensated for it by seeming extraordinarily urgent, dynamic and large-spirited. All these things were reflected in his 'Byronic' dress (loose collar and flowing neckerchief) which others outside Hunt's circle admitted was 'singular',[26] and in what Severn called his 'peculiarly dauntless expression' – wide-eyed and with a trembling eagerness. In due course, other new friends would be similarly impressed. Haydon, for instance, who said he 'had an inward look, perfectly divine, like a Delphian princess who saw visions'; or Benjamin Bailey:

[Keats] bore, along with the strong impress of genius, much beauty of feature & countenance . . . His hair was beautiful – a fine brown, rather than auburn, I think; & if you placed your hand upon his head, the silken curls felt like the rich plumage of a bird. I do not particularly remember the thickness of the upper lip, which is so generally described, & doubtless correctly; – but the mouth struck me as too wide, both in itself, & as out of harmony with the rest of the face, which, with this single blemish, was eminently beautiful. The eye was full & fine, & softened into tenderness, or beamed with a fiery brightness, according to the current of his thoughts & conversation. Indeed the form of his head was like that of a fine Greek statue: – & he realised to my mind the youthful Apollo, more than any head of a living man whom I have known.

Elsewhere in this letter, Bailey says that the miniature Severn painted in 1819 is the portrait which catches Keats most accurately. But Severn's image – like the one promoted by remarks about Keats's 'Titian red hair',[27] his hazel eyes 'like the eyes of a wild gypsy maid',[28] and his mouth which 'quivered at the realisation of any tale of generosity or benevolence or noble daring, or at sights of loveliness or of distress'[29] – obviously contains elements of idealisation. It confirms that Keats was startlingly beautiful, while denying that his face bore the marks of uncertainty and anxious striving. It does not show that his hair was already beginning to recede a little from his forehead. That his hands (he is obsessed with hands in his poems) looked old beyond his years. That his favourite posture (Charles Cowden Clarke remembers him 'cherish-ing one leg over the knee of the other, smoothing the instep with a palm of his hand') suggested a coiled reserve, as well as contemplativeness.

Hunt said that during his first meeting with Keats – which soon 'stretched' into a series of 'morning calls'[30] – they became 'intimate on the spot'.[31] This is often mentioned to prove how willing Keats was to become his disciple. Yet it is fairer to both men to say they became friends so quickly because they were already compatible. Keats had independently evolved ideas which echoed Hunt's, and had been marked by experience in ways that Hunt recognised: they both 'sympathised with the lowest commonplace'.[32] Within days Hunt began introducing him to other friends in his circle – and was gratified, but not surprised, when many of them 'pronounced his poems . . . as extraordinary as I thought them'. Keats met Thomas Barnes, the editor of *The Times*; and Godwin; and Charles Lamb; and John Scott, the liberal journalist who would later edit the *London Magazine*; and (with Charles Cowden Clarke in attendance) Vincent Novello, the conductor

and organist at the Portuguese Church in the City; and Charles and James Ollier, who had recently started a publishing firm in Welbeck Street, and who immediately began asking him about his own publishing plans. Listening as the talk ranged from 'Wordsworth's merit to the principles of punning, from the life of Petrarch to the latest *Political Register*',[33] and watching Hunt 'read' his prints of Poussin and Claude, Keats was (as Severn said) 'intoxicated . . . with an excess of enthusiasm'. If he seemed sometimes 'shy and embarrassed, as of one unused to society', it was not because he felt uncertain about the turn his life had taken, or because he was self-conscious about his Cockney accent and his lack of university education. The praise he earned from all sides made him feel accepted. He was not merely a struggling medical student any more, he was 'Junkets', Hunt's trusted favourite.

Inevitably Keats was more strongly drawn to some of Hunt's friends than others. The first to become more than an admired acquaintance was the painter Benjamin Robert Haydon, who early in October had left his studio in 42 Great Marlborough Street, in central London, and taken rooms for a brief period in Hampstead at 7 Pond Street. He was suffering from eye strain and had been ordered to rest, but his idea of rest was most people's idea of strenuous exertion. He had known Hunt ever since the early days of the *Examiner* (he had been introduced to him by David Wilkie, a fellow art student), often publishing articles in its pages, and using the magazine as a platform to campaign for the government to buy the Elgin Marbles, which had begun arriving in London from Greece during the first years of the century. Now he visited Hunt regularly, criticising and cajoling, beseeching and boasting. When he met Keats during one of these calls, he was instantly taken with him.

Keats was similarly overwhelmed. Haydon was his senior by nine years, a bull-necked, wide-browed, balding man whose large flustered face was pincered by little round spectacles, and whose laughter, Hunt said, 'sound[s] like the trumpets of Jericho, and threaten[s] to have the same effect'. His explosive energy was a byword among all who knew him. This produced violent antagonisms as well as fierce friendships, and even though Hunt had always supported him, Haydon's unquench-able demand that everyone should be 'sensible of what talent I had' meant that relations between them were often strained. He was excessive in everything he did, scornful of narrow ambitions, and fuelled by hopelessly impractical desires, by fervent Christian faith and by simplistic Tory jingoism. He made Hunt – who also valued intensity –

seem willowly by comparison. Even when acting generously, his ramp-ant self-belief made him exhausting and competitive.

Today Haydon's reputation as a painter has almost entirely faded; he is best known for his friendships and the sprawling but spectacular diary he kept for much of his life. In his own time, though, his achievement seemed significant, his ambitions important, and his dedication exemplary. (He knelt every morning in his studio to invoke God's blessing on his efforts.) Early in life he had decided that the best vehicle for his self-styled genius was historical painting, and although one of his first major works, 'The Assassination of Dentatus', was indifferently reviewed, he never abandoned its themes and techniques. In paintings like 'Macbeth', 'The Judgement of Solomon', 'The Agony in the Garden', and 'The Death of Eucles after Announcing the Victory of Marathon', his aim was always to present an archetype of heroic effort and heroic suffering. Unfortunately his ability to make his subjects vivacious was extremely limited (though he did make a successfully brooding portrait of Wordsworth on Helvellyn). Strenuous but rigid, his paintings show him trying to capture a monumental Classicism and make it the means of reviving British art. He wanted to see a similar sort of revolution in painting to that which Hunt hoped to foster in poetry.

When he met Keats, Haydon had already begun work on the canvas which would preoccupy him for most of their friendship – 'Christ's Entry into Jerusalem'. He meant it to be a justification of all his beliefs, Christian as well as Classical, and also a demonstration of how past virtues could survive in the present. Around the central figure of Christ astride the donkey, he intended to include portraits of those contempor-aries he judged to be the apostle-martyrs of 'High Art'. It would, he hoped, be a painting which absorbed the lessons he had learned from his study of the Elgin Marbles, uniting their perfect and time-sanctioned forms with the humane teachings he had also taken passionately to heart.

These ambitions struck a resonant chord in Keats, even though he was more sceptical, and entirely without jingoism. He soon started to learn from Haydon's example. He began to read Shakespeare more attentively (Haydon once said he had 'enjoyed Shakespeare with John Keats more than with any other human creature'). He plunged back into Words-worth, whom Haydon already knew personally. He reaffirmed his sense of poetic progress as a noble struggle ('I hope for the support of a High Power', he told Haydon the following spring, 'while I climb the little eminence and especially in my Years of more momentous Labour'). He

confirmed his sense of the epic poem as the ideal form for his ambitions. He felt inspired to see the 'mighty dead' as his 'presiders'. He developed his belief that the only reliable judge of his work was posterity. 'Where we think the truth least understood', he wrote in one of his sonnets to Haydon, 'Oft may be found a "singleness of aim", / That ought to frighten into hooded shame / A money-mongering pitiable brood'.

Keats, in turn, had a strong effect on Haydon – not so much on his work as his personality. Keats emphasised Haydon's generosity, as well as his possessiveness and his distrust of Hunt. ('I love you like my own Brother,' Haydon told Keats once; 'Beware for god's sake of the delusions and sophistications that [are] ripping up the talent & respectability of our Friend – he will go out of this World the victim of his own weakness & the dupe of his own self-delusion.') Within a few days of their first meeting, Haydon decided it was not enough simply to bombard Keats with ideas when they happened to come across each other in the Vale of Health. On Sunday 20 October he therefore invited Keats to dinner (the meal was taken in the early afternoon) with another young and frequent visitor to Hampstead, John Hamilton Reynolds.

Reynolds was the son of a schoolmaster teaching at Christ's Hospital, and lived with his parents and four sisters at 19 Lamb's Conduit Street in Holborn. Even as a boy at St Paul's School he had shown a precocious poetic talent. His *Safie, an Eastern Tale* (published in 1814 when he was nineteen) had been praised by Byron, two subsequent books had been well received, and his most recent, *The Naiad*, which was dedicated to Haydon, was the volume admired by Hunt shortly before Keats first met him. He had also begun to make his mark as a liberal commentator (at the end of his life he referred to himself as 'an unitarian & bitter Radical'). He had joined the Zetosophian Society – a group of friends which included Benjamin Bailey and James Rice – that met regularly to discuss social and literary matters, and had published reviews of books and plays in the liberal Sunday paper the *Champion*. Everyone he knew reckoned that he showed exceptional promise, and also unusual charm. He was strikingly good-looking, with dark brown eyes and almost black hair, and a quizzical smile. In later years, his expression would become more resolutely sardonic. Now it seemed intelligent and amused. John Clare, for instance, who met him in 1823, described him as 'the most good-natured fellow I ever met with. His face was three in one of fun, wit and punning personified. He would punch you with his puns very keenly

without ever hurting your feelings, for if you looked in his face you could not be offended.'[34]

Although only a year older than Keats, Reynolds seemed much more assured – and was obviously much more successful. In fact he had a clear sense of his limitations. A great deal of his work had been highly derivative (from Byron and Hunt, pre-eminently), and his wit was more remarkable than his wisdom. His skill as a parodist was later to flower in a brilliant send-up of Wordsworth's *Peter Bell*. In the same year that he met Keats he said, 'I am one of those unfortunate youths to whom the Muses have glanced a sprinkling of [their] light - one of those who pant for distinction but who have not within them that immortal power to command it.' It was this modesty, combined with a willingness to give credit where it was due, that made him such an important friend to Keats. Even though Keats would sometimes borrow his phrases and cadences (in the 'Ode to a Nightingale', for instance, there is an echo of a passage in 'The Romance of Youth', which Reynolds was writing when they met), there was never any doubt who was the better poet. It was Keats who led and Reynolds who followed, offering an affectionate companionship which boosted Keats's self-esteem. They shared the same literary tastes, the same irreverent vitality, the same love of painting, the same dislike of authoritarianism, the same religious doubts, and the same enjoyments – which ranged from walking in the country to going to boxing matches.

Most of Keats's early meetings with Reynolds took place under the watchful gaze of Haydon or Hunt. As their friendship ripened, they also visited each other's lodgings. Keats got on well with Reynolds's family. His father George was an unassuming but cultivated man, his mother Charlotte dabbled in literature (she later wrote a novel that Lamb admired), and their daughters were all sympathetic – especially the twenty-three-year-old Jane, who shared her brother's romantic good looks. Keats once ended a letter to Jane, 'Your affectionate brother'. As this implies, their house in Lamb's Conduit Street, with its elegant spaciousness, its books and music, and its 'artistic' collections of china, soon became the kind of home-from-home that Keats always found congenial. It was somewhere he could feel petted, have fun, and freely develop his thoughts. 'You know,' he told Reynolds a little over a year later, 'I never have any speculations without associating you in them', and elsewhere told him that one of his 'chief layings-up' was the 'pleasure' he had in showing him poems as he finished them.

TWELVE

REYNOLDS HAD RECENTLY stopped working as a clerk in the Amicable Insurance Company – now the Norwich Union – to earn his living entirely by writing. As things turned out, his freelance life did not last for long: by November 1817 he was articled to a lawyer named Frank Fladgate, who lived and worked in West London. In the short term, however, his example encouraged Keats to think he should give up his work at Guy's. But while Reynolds and his other new friends believed that he could afford to do this, the reality of his finances suggested otherwise. When he reached the age of twenty-one at the end of October in 1816 he was entitled to come into possession of his two trust funds – his grandmother's and his grandfather's. The former, administered by Abbey, had been reduced by his hospital expenses to a few hundred pounds. The latter, controlled by the Accountant General in Chancery, stood at around £800 plus some cash interest. Abbey did not know that this larger fund existed – and although Alice Jennings had told her grandson that he had 'financial expectations', Keats's 'morbid reluctance to inquire more closely into his inheritance'[1] meant that he never found out about it either. As a result, any decision he made to abandon medicine for poetry meant embarking on a course that could not be sustained – unless he wrote something that was a commercial success. Throughout the autumn, he pondered the alternatives without knowing how to resolve them.

His main concern was to press ahead with the long lyric he had begun in June – the lyric which began 'I stood tip-toe . . .', and which he now referred to as 'Endymion'. He had added to it in Margate, but since returning to London, and reading Wordsworth's *Excursion* (1814), he had discovered a new direction in which it might be developed. In Book Four of his poem, Wordsworth interpreted the origins of ancient Greek mythology to promote a patrician version of Classicism.[2] Keats seized on them as a chance of framing a radical alternative. The core of his 'Endymion' reinforces ideas he had been discussing with Hunt and others; it is an eroticised hymn to 'the fair paradise of Nature's light', and celebrates Greek pantheism in characteristically lush, un-Wordsworthian language:

at our feet, the voice of crystal bubbles
Charms us at once away from all our troubles:
So that we feel uplifted from the world,
Walking upon the white clouds wreathed and curled.
So felt he, who first told, how Psyche went
On the smooth wind to realms of wonderment;
What Psyche felt, and Love, when their full lips
First touched; what amorous, and fondling nips
They gave each other's cheeks; with all their sighs,
And how they kissed each other's tremulous eyes;
The silver lamp – the ravishment – the wonder –
The darkness – loneliness – the fearful thunder;
Their woes gone by, and both to heaven upflown,
To bow for gratitude before Jove's throne.
So did he feel, who pulled the boughs aside,
That we might look into a forest wide,
To catch a glimpse of Fauns and Dryadès
Coming with softest rustle through the trees,
And garlands woven of flowers wild, and sweet,
Upheld on ivory wrists, or sporting feet:
Telling us how fair, trembling Syrinx fled
Arcadian Pan, with such a fearful dread.
Poor nymph – poor Pan – how he did weep to find,
Naught but a lovely sighing of the wind
Along the reedy stream; a half-heard strain,
Full of sweet desolation – balmy pain.

As Keats drove his poem forward he also wrote a number of sonnets which are more powerfully influenced by Hunt than Wordsworth. 'On Leaving some Friends at an Early Hour', and its partner 'Keen, fitful gusts are whispering here and there', were both actually written at Hunt's cottage in the Vale of Health, and a third, 'To a Young Lady who sent me a Laurel Crown', refers to Hunt's liking for this kind of coronation. They are all slight and posturing pieces, but they convey how grateful Keats felt to be accepted into the Hampstead set, and how its atmosphere fed the flame of his ambition. This pleased and alarmed Haydon in equal parts, and as he watched Hunt's influence strengthen, he increased his efforts to control it. On 3 November, only a fortnight after their first dinner together, he invited Keats and Charles Cowden Clarke to his studio in Great Marlborough Street to see the work he had decided would be his masterpiece – 'Christ's Entry into Jerusalem'.

Keats wrote a playfully exhilarated note to Clarke confirming the arrangements, calling him 'my daintie Davie', promising that he would be 'as punctual as the Bee to the Clover', and saying 'very glad am I at the thought of seeing so soon the glorious Haydon and all his Creation'. His skittishness was a sign of confidence, as well as excitement. He had spent the previous day in Hampstead looking 'into some beautiful Scenery – for poetical purposes', and had almost certainly begun another long self-analytical lyric to serve as a partner to 'Endymion': 'Sleep and Poetry'.

Haydon also had good reason to feel full of optimism and authority. In the hours before Keats arrived to see him, he had read an article by Hazlitt in the *Examiner* which attacked the Royal Academy – Haydon's *bête noire* – as a 'mercantile body, like any other mercantile body, consisting chiefly of manufacturers of portraits'.[3] Haydon had known Hazlitt for several years, and took his words as further proof of their affinity. In recent weeks he had arranged for Hazlitt to sit for him, so that his portrait could appear among the crowd of faces in 'Christ's Entry', and it is 'probable'[4] that when Keats eventually reached his studio, he met Hazlitt for the first time.

William Hazlitt was thirty-eight, the second son of a radical Unitarian minister who, after a childhood in Shropshire, had attended the famous Dissenting college at Hackney, to the east of London. Since his time there he had come into contact with most of the leading liberal thinkers of the day – philosophers as well as poets – and though he planned a career as a painter, soon abandoned it to concentrate on writing. Even before 1812, when he began working as a political reporter for the *Morning Chronicle*, he regularly published journalism, reviews of art, literature and drama, essays and lectures, all of which championed the radical cause, and earned him a reputation as a critic of exceptional brilliance and acuity. This reputation was consolidated by the 'Round Table' articles which he published in the *Examiner* and collected in 1817, his *Characters of Shakespeare's Plays* (also 1817), *Political Essays* (1819), *Table Talk* (1821), and *The Spirit of the Age* (1825). Wordsworth and Coleridge were, for a while, his close friends and intellectual allies, and the self-definition of the early Romantic poets in general owed a great deal to his opinion and comment. To this extent, he became a part of the period's central and most important literary movement, but he never lost his sense of its necessary liberalism, and when he felt it beginning to falter, he challenged the failure fiercely. He continually set himself at an acute angle to conservative authority, insisting on the need

for reform in all political matters, and demanding that art should speak truth to power with the quality he possessed in abundance: gusto. He was, as E. P. Thompson said, 'one of the few intellectuals who received the full shock of the experience of the French Revolution, and, while rejecting the naiveties of the Enlightenment, reaffirmed the traditions of liberté and égalité. His style reveals, at every point, not only that he is measuring himself against Burke, Coleridge and Wordsworth (and, more immediately, against *Blackwood's* and the *Quarterly Review*), but that he was aware of the strength of their positions and shared some of their responses. Even in his most engaged radical journalism . . . he aimed his polemic, not towards the popular, but towards the polite culture of his time.'[5]

Hazlitt could be daunting as well as delightful – Coleridge once called him 'brow-hanging, shoe-contemplative, *strange*', and others referred to him as 'lean, slouching, splenetic, an Ishmaelite full of mistrust and suspicion, his habitual action of the hand within the waistcoat apt in his scowling moments to suggest a hidden dagger'.[6] But when Reynolds met him only a few months after Keats, he found him 'Warm, lofty & Intelligent – breathing out with us the peculiar & favourite beauties of our best Bards, – Passing from grand & commanding argument to the gaieties & graces of Wit & Humour, – and the elegant and higher beauties of Poetry. He is indeed *great* company, and leaves a weight on the mind, which "it could hardly bear". He is full of what Dr Johnson terms "Good talk". His countenance is also extremely fine: – a sunken & melancholy face, – a forehead lined with thought and bearing a full & strange pulsation on exciting subjects, – an eye, dashed in its light with sorrow, but kindling & *living* at intellectual moments, – and a stream of coal-black hair dropping round all.'

Keats was never close to Hazlitt, in the sense that he never spent long hours in his company, trading opinions and intimacies, but few people had a more powerful impact on his thinking, or on how he expressed himself. It was an influence that he embraced freely, and was supported by the good opinion of all his other friends. The *Examiner* followed Hazlitt's doings almost reverentially, saying that 'he yields only to some of the greatest poets and novelists, and he is at the head of the class in which our most ambitious wits are anxious to be enrolled'.[7] Charles Cowden Clarke, remembering that Hazlitt had originally studied as a painter, noticed something 'naturally impetuous' in him, but was nevertheless deeply impressed by his dynamic restlessness, his dark

and brooding expression, his 'finely intellectual head . . . its square potential forehead, massive mouth and chin, and eyes full of earnest fire'.[8] Haydon repeatedly echoed or paraphrased his thoughts in his own writing – particularly his thoughts about the imagination which, in his lecture on 'The English Comic Writers', Hazlitt characterised in one of his great, spiralling sentences as 'Another mightier world'. It was, he said, 'raised above the ordinary world of reality, as the empyrean surrounds this nether globe, into which few are privileged to soar with mighty wings outspread, and in which, as power is given to them to embody their aspiring fancies, to give to airy nothing a local habitation and a name, to fill with imaginary shapes of beauty or sublimity, and make the dark abyss pregnant, bringing that which is remote home to us, raising themselves to be lofty, sustaining themselves on the refined and abstracted, making all things like not what we know and feel in ourselves, in this "ignorant present" time, but like what they must be in themselves, or in our noblest idea of them, and stamping that idea with reality'.

Hazlitt not only gave Keats phrases to borrow and ideas to develop, but mapped the whole landscape of his intentions. Keats, in turn, regarded Hazlitt's 'taste' as one of the 'wonders of the age', and sprinkled his letters with inquiries about his health, with fond imitations of his mannerisms, with tributes to his intellectual powers, and with comments on his writing. Even when disagreeing with him – as when he writes from the Lake District that he 'cannot think with Hazlitt that these scenes make man appear little' – it is obvious that he regarded the opinion of the 'dark-haired critic' as a touchstone.

His views on poetic identity were especially influential. Hazlitt's favourite doctrine, and the subject of his first book (which Keats later owned), was 'the natural disinterestedness of the human mind', a concept which dealt with the issue of how writers reconcile their commitment to the external and political world with their immersion in the imagination. 'It cannot be concealed,' Hazlitt said, 'that the progress of knowledge and refinement has a tendency to circumscribe the limits of the imagination, and to clip the wings of poetry.' Keats developed this into a faith in the 'self-annulling character'[9] of the poet. It shapes his definition of 'Men of Genius', it informs his notion of negative capability, it governs his understanding of the 'egotistical sublime', it motivates his many discussions of the relationship between 'thought' and 'sensation', and underwrites his belief in 'the chameleon poet'.

Keats also allowed Hazlitt to affect the very fabric and movement of his writing. His letters blaze with the 'fiery laconicism' he prized in Hazlitt's prose, and their pacing shows a similarly 'variable speed of uncommon thoughts',[10] as well as a similar tendency to ingest a rich mass of quotation. (Hazlitt described Milton as a writer of 'centos', meaning that his works were often a collage of references. He might equally well have been speaking of himself.) Keats's mature poems are energised by the same spirit: 'lively, swift to digress and return, and at home in all the possible roles of a narrator'.[11] Even when most eloquently exotic, they embody the principles that Hazlitt exemplified and analysed in his essays on 'The Conversation of Authors' and 'On Familiar Style'. The essence of his style, he said, 'is not to take the first word that offers, but the best word in common use; it is not to throw words together in any combination we please, but to follow and avail ourselves of the true idiom of the language. To write a genuine familiar or truly English style, is to write as any one would speak in common conversation who had a thorough command and choice of words, or who could discourse with ease, force, and perspicuity, setting aside all pedantic and oratorical flourishes.'

Keats's first meeting with Hazlitt marked a turning point in his mental life. He enjoyed it exuberantly. Haydon would later remember how he walked up and down the studio 'spouting Shakespeare', only breaking off when he realised that he was meant to be on duty at Guy's. Shortly afterwards, by way of giving thanks and showing honour, he sent Haydon a sonnet which pictures the painter as a 'stout unbending champion', a heroic pioneer (like 'stout Cortez') who has established new territories for him to explore, and whose 'steadfast genius, toiling gallantly' is an inspiring challenge to the 'money-mongering, pitiable brood' that Hazlitt had attacked in his recent piece about the Royal Academy. It is a high-minded tribute, but misses the dynamism which it admires and to which it aspires. On the other hand – and like the letters that Keats had recently written – it also lacks the note of uncertainty that had weakened the poems he had produced earlier in the year. Even though Keats's medical chores had cut short his visit to Great Marlborough Street, they no longer tortured him with a sense of division. Throughout the autumn and early winter he continued to attend lectures and to function as a dresser, but he did so knowing that it was only a matter of time before he would reach a final decision about his future.

In November he decided on a change which would reflect this shift in

his feelings. He left his lodgings in the Borough and went to live with George and Tom in rooms they had recently taken at 76 Cheapside, on the second floor of a house which stood to the west of Bird-in-Hand court. (It was two doors away from a hat-making business run by one Joseph Keats, who later claimed to be a relative: there is no evidence they had anything to do with each other.) The new address meant that he was still within easy walking distance of Guy's, across London Bridge; more importantly, he was reunited with his family and closer to Hampstead. In a sonnet written a few weeks later, to mark Tom's seventeenth birthday in mid-December, Keats celebrated his household of 'fraternal souls' in more frankly Wordsworthian phrases than any he had yet used. But it is not just his growing sense of security that is contained in their gentle unfoldings. The poem also reflects the fact that he knew his responsibilities had grown in recent weeks – responsibilities towards his brothers (Fanny continued to live at her boarding school or with the Abbeys in Walthamstow), and towards the world in which he hoped his poems would do 'some good'.

The move to Cheapside inaugurated an 'extremely social'[12] time of his life, partly because George continued to introduce him to new friends. Among these were Mrs Wylie, the widow of an infantry officer, and her three children Henry, Charles, and Georgiana, who lived in Westminster. George was already smitten with Georgiana, a dark-haired nineteen-year-old whose mixture of shyness and warm-heartedness made her seem at once mysterious and approachable. Keats himself immediately admired her, and when, also in December, George asked him to write her a sonnet on his behalf, he undertook the task as more than a mere duty. Although he would later emphasise that he valued Georgiana for her 'mind and friendship alone', and links her in his sonnet to the ideal figure of womanhood that he had recently included in 'Endymion', he could not disguise a more intimate kind of attraction:

> Nymph of the downward smile, and sidelong glance,
> In what diviner moments of the day
> Art thou most lovely? – When gone far astray
> Into the labyrinths of sweet utterance?
> Or when serenely wandering in a trance
> Of sober thought? – Or when starting away,
> With careless robe, to meet the morning ray,
> Thou spar'st the flowers in thy mazy dance?

Nov 20th

My dear Sir,

Last Evening wrought me up, and I cannot forbear
sending you the following – Yours unfeignedly John Keats –

Great Spirits now on Earth are sojourning
He of the Cloud, the Cataract the Lake
Who on Helvellyn's summit wide awake
Catches his freshness from Archangel's wing
He of the Rose, the Violet, the Spring
 The social Smiles, the Chain for freedom's sake:
 And lo! – whose stedfastness would never take
A Meaner Sound than Raphael's Whispering
And other Spirits are there standing apart
 Upon the Forehead of the Age to come;
 These, These will give the World another heart
 And other pulses – hear ye not the hum
Of mighty Workings in a distant Mart?
 Listen awhile ye Nations and be dumb.!
 Nov 20 –

Removed to 76. Cheapside

Before writing these poems, Keats had continued to make frequent visits to Hunt, Reynolds and Severn – and to Haydon as well. Within a week of his first visit to the studio, he was invited for another get-together on 13 November, and when this was cancelled because Haydon wanted to see *Timon of Athens* at Drury Lane, they rearranged for the 19th. Once again, Haydon's ebullient friendliness fired Keats to thank him with a sonnet – and this realises its aims more successfully than his previous effort. Identifying Wordsworth, Hunt, and Haydon as 'Great spirits', it suggests that they are all proof of Hunt's faith in the dawning of a new Renaissance, and in human progress in general:

> And other spirits there are standing apart
> Upon the forehead of the age to come;
> These, these will give the world another heart,
> And other pulses. Hear ye not the hum
> Of mighty workings in a distant Mart? –
> Listen awhile ye nations, and be dumb.

Keats sent the sonnet to Haydon by messenger on 20 November,[13] saying that 'Last Evening wrought me up'. He immediately received back the suggestion that he cut the words 'in a distant Mart' from the penultimate line to give it an appropriate suspense. Even without this revision, Haydon was sufficiently impressed and flattered by the poem to offer to show it to Wordsworth, and when Keats sent him a copy for this purpose, he added that 'The idea . . . put me out of breath – you know with what Reverence – I would send my Wellwishes to him.' In fact he had to wait a month before Haydon was as good as his word, and the delay is suggestive of their friendship as a whole. Although the 'wild enthusiasm' Haydon felt for the poem was genuine, and although he decided to prove the depth of his admiration by saying that he wanted to include a portrait of Keats among the crowd of faces in 'Christ's Entry', he could not help squeezing their friendship – trying to keep Keats to himself and away from Hunt. In the coming months, the struggle for control of his loyalty would become increasingly intense. Both men believed they had the best interests of their protégé at heart; neither would willingly accept that he was unlikely to commit himself to one or other of them exclusively.

While Haydon urged Keats to keep his eye on 'the horizon', raining down on him opinions about Shakespeare, about the nature of 'future

greatness', and the need for high ambition, Hunt offered more practical assistance. On 1 December he published an essay in the *Examiner* on 'Three Young Poets' – Shelley, Reynolds, and Keats – which although it 'promise[d] more than it fulfils',[14] included the whole of the sonnet on Chapman's Homer, and predicted great things to come. Keats, Hunt said, 'has not yet published any thing except in a newspaper, but a set of his manuscripts was handed to us the other day, and fairly surprised us with the truth of their ambition and ardent grappling with Nature.' The same day that the article appeared, Hunt also sent Keats a sonnet in which he said that he would soon be crowned with a 'flowering laurel'. The combined effect was all that Keats could hope for. He was now established in the eyes of the world as a member of what Hunt called 'a new school of poetry'. When he later showed the *Examiner* article to Stephens, his former fellow lodger, he did so with the pride of someone who knew that he had reached a decisive stage in his life. Stephens realised that Hunt's praise 'sealed [Keats's] fate'. The battle to combine poetry with a career in medicine was nearly at an end.

KEATS STILL HAD to confront Abbey. Their meeting, some time around the turn of the year,[15] was predictably wounding – but while this inevitably makes Abbey sound unsympathetic, it is easy to see why he behaved as he did. Very little of Keats's work had appeared in magazines, and he was talking to the Olliers about publishing a collection that was far from complete. He had spent a good deal of his grandmother's money. His 'set' held political views that Abbey found extremely disagreeable, and behaved with a blithe irreverence that he deplored. For these reasons, the show-down between them seems less remarkable for what it tells us about Abbey than what it shows about Keats. His sense of his true self was adamant. When Abbey proposed that he should set up in practice somewhere near Edmonton while he completed his training, Keats merely brushed the suggestion aside:

[Abbey] communicated his plans to his Ward, but his Surprise was not moderate, to hear in Reply, that he did not intend to be a Surgeon – Not intend to be a Surgeon! Why what do you mean to be? I mean to rely on my Abilities as a Poet – John, you are either mad or a Fool, to talk in so absurd a Manner. My mind is made up said the youngster very quietly. I know that I possess Abilities greater than most Men, and therefore I am determined to gain my Living by exercising them. – Seeing nothing could be done Abby [sic] . . . called . . . him a Silly Boy, & prophesied a speedy Termination to his inconsiderate Enterprise.

In years to come, Keats would indicate that his revulsion from surgery was the main reason for his decision. His 'last' operation, he told Charles Brown, 'consisted in opening a man's temporal artery. I did it with the utmost nicety, but reflecting on what had passed in my mind at the time, my dexterity seemed a miracle – I never took up the lancet again.' When other friends confirmed his story (Severn, for instance, said that he 'disliked the surgery'), they implied that Keats's career as a whole had been forced upon him 'against his will'. This is misleading. Keats's original commitment had been carefully considered, and his six-year training had included many elements he found fascinating and fulfilling. Had he not been appointed dresser to someone as clumsy as Lucas, the more upsetting aspects of his life in Guy's might have been easier to endure. As it was, his daily experience of suffering made him pay special attention to Cooper's warning that no one should become a surgeon unless he had the temperament for it.

Quitting the hospital did not mean rejecting medicine altogether. Hitherto, Keats had been directed to heal the body. Henceforth he would heal the mind – by addressing the nature and purpose of suffering, by developing the Wordsworthian idea that 'poetry depended upon a condition of positive health in the poet',[16] and by regarding poetry itself as a salubriously redemptive force – 'a friend / To soothe the cares, and lift the thoughts of man'. While we read his work and notice its consoling luxuries, its healthy and unhealthy airs, its medicinal flowers, its systems of nervous sensibilities, its working brains, its ethereal flights, its emphasis on 'sensation', its fluctuating temperatures, its marvellous chemical transformations, and its restorative sleeps, we realise that these things are not just incidental details, but the components of a selfless and moral imagination. They distinguish all his poems, shaping his progress from uncertain beginnings like the verse epistles to late masterpieces like 'The Fall of Hyperion', where the narrator asks 'Sure a poet is a sage; / A humanist, physician to all men', and hears the answer: 'The Poet and the dreamer are distinct, / Diverse, sheer opposite, antipodes. / The one pours out a balm upon the world, / The other vexes it.' In so far as these references have been celebrated by his readers, their function has generally been valued as a way of 'soothing pain'. In truth they are a much less simply emollient, and a much more dynamic, force in his work. They are designed to emphasise 'how necessary a world of Pains and troubles is to school an Intelligence and make it a soul. A Place where the heart must feel and suffer in a thousand diverse ways!' Throughout

literary history there have been many other doctor poets,[17] but few apart from Chekhov have made their apparently divided lives as whole as Keats did. By one means or another, he was always a practitioner. Apollo was always his tutelary spirit.

THIRTEEN

Keats never entirely gave up the idea that he might one day return to medicine. He kept his textbooks and his notebooks, he advised his friends about their health, in 1818 he devotedly nursed his brother Tom through the final stages of his illness, and as his money dwindled almost to nothing at the end of his life, he contemplated working as a surgeon on a ship trading with the East Indies. But once the painful interview with Abbey was over, his wish to convert all that he knew into a different form became more urgent.

In December he wrote four poems. The most successful, 'Written in Disgust of Vulgar Superstition', is an attack on the 'melancholy round' of orthodox religion. He blames its 'black spell' for withering the 'fresh flowers' and 'many glories of immortal stamp' that grow from more liberal ideologies. At least one biographer[1] has suggested that the poem shows an indifference to the ideas fostered at Clarke's school. In fact much of what Keats had read there, and especially the histories by Robertson, had already prepared the ground for his defiance. More specifically, it shows him marking the start of his new life by identifying even more closely with Hunt – sharing his scepticism, and reaching beyond him to the frank anti-clericalism Hunt was beginning to admire in Shelley. Although Hunt's attitude to religion was unstable, veering between the sentimental Unitarianism in which he had been brought up, and the mocking scornfulness he discovered in Voltaire, he consistently argued that 'the right way' to 'praise Heaven' was not 'with slavery', or with 'fears' of damnation, 'But with a face as towards a friend, and with thin sparkling tears'.[2]

The same fresh commitment shines in Keats's other three poems. In 'On the Grasshopper and Cricket' (which he wrote in fifteen minutes in competition with Hunt, and which incorporates ideas from Tom Moore's translation of Anacreon, which they had recently read together), he commemorates a conventionally Romantic ideal of mutuality. In a sonnet to the Polish patriot Tadeusz Kosciusko (1746–

1817), who had spearheaded his country's resistance to Russia and Prussia, and whom Hunt had recently praised in the *Examiner*, he honours the fact of liberal heroism and its role in poetic inspiration. And in 'Happy is England!' he relishes the sights and achievements of his own country while admitting that he 'burn[s] to see' the 'Beauties of deeper glance' that he associates with 'skies Italian' and a culture of high ideals. Hunt's impact on the language of these poems is as pronounced as his effect on their arguments. The cricket which 'rests at ease beneath some pleasant weed', like the 'whitest arms in silence clinging' in 'Happy is England!', have a merely decorative value that Hunt was too ready to admire. But at the same time as Keats adopted these faults, he also completed two longer poems which show him rejecting Hunt's techniques, or at least adapting them. One was 'Endymion', which he soon renamed after its first line, 'I stood tip-toe upon a little hill'. It had been first suggested the previous June, Hunt said, 'by a delightful summer-day, as he stood beside the gate that leads from the Battery on Hampstead Heath in a field by Caen Wood', and its most recent additions – some written in Margate, some in London – had brought the narrative towards a description of Endymion's wedding to Cynthia. As Keats turned to it again, asking for 'three words of honey, that I might / Tell but one wonder of [their] bridal night', the surface of the poem opened to reveal obsessions which had motivated him from the outset:

> The breezes were ethereal, and pure,
> And crept through half-closed lattices to cure
> The languid sick; it cooled their fevered sleep,
> And soothed them into slumbers full and deep.
> Soon they awoke clear-eyed: nor burnt with thirsting,
> Nor with hot fingers, nor with temples bursting:
> And springing up, they met the wondering sight
> Of their dear friends, nigh foolish with delight;
> Who feel their arms, and breasts, and kiss and stare,
> And on their placid foreheads part the hair.

This extraordinary passage combines erotic release with physicianly anxiety, turning love from a purely personal pleasure into a generally healing and liberating force. The previous two hundred lines of the poem immediately refocus. Beneath their invocation of the pantheistic ideal, and their elaborations of myth, lies a deep but unspoken concern

about the function of poetry. How can work which does not make a direct approach to political subjects – work unlike the sonnet to Kosciusko, for instance – embody the spirit of humane liberalism? How can a celebration of love and nature, and especially one written in a densely allusive and sensual style, do the world some good? Keats's medicinal emphasis obviously provides one sort of answer, but for the time being, at least, he is unable to keep it clearly in view:

> Cynthia! I cannot tell the greater blisses,
> That followed thine, and thy dear shepherd's kisses:
> Was there a Poet born? – but now no more,
> My wandering spirit must no further soar. –

In the other long poem completed around the same time, 'Sleep and Poetry' (which he had begun in October), the same questions return much more forcefully. Once again, Keats opens his 'strange assay . . . in gentleness' by invoking the blessings of nature, and moving so easily between the details of an actual landscape and the Classical or literary figures he admired, that they all seem part of the same world, at once real and imaginary. As he enjoys them, though, he realises that there is something 'higher beyond thought than these' – something he eventually identifies as 'Poesy' itself. This immediately provokes a longing to 'die a death / Of luxury' – to welcome poetry as a 'sanctuary' in which he can contemplate ideals of 'solemn beauty', and hope that this might foster his wish to 'find out an immortality'.

Up to this point in the poem, as for most of 'I stood tip-toe . . .', Keats has given no impression of wanting to construct an argument. His lines have beautifully admired their own elegance. But he is gradually overtaken by the knowledge that time will not allow him to rest on his laurels. 'Life is but a day', he says, 'A fragile dew-drop on its perilous way / From a tree's summit'. Asking for 'ten years, that I may overwhelm / Myself in poesy', he maps a journey from the 'realm' of 'Flora and old Pan', where he can 'sleep in the grass, / Feed upon apples red, and strawberries, / And choose each pleasure that my fancy sees' before bidding 'these joys farewell' and approaching 'a nobler life, / Where I may find the agonies, the strife / Of human hearts'.

Most accounts of 'Sleep and Poetry' take this proposed journey as its whole subject. In fact Keats is only a quarter of the way through his poem when he describes it, and although its terms dominate everything

that follows, they are significantly developed. He becomes increasingly concerned that his growing sense of 'real things' will 'like a muddy stream . . . bear along' / My soul to nothingness', and as he considers this possibility, he responds in a way that he knew Hunt would applaud. Wondering whether 'the present state of manhood' is such that 'the high / Imagination cannot freely fly / As she was wont of old', he blames Boileau and the Augustans (who 'swayed about upon a rocking horse, / And thought it Pegasus') for creating a 'schism / Nurtured by foppery and barbarism'. His complaint is not merely a formal one. He also felt that the 'French school' of poetry was associated with a pre-Revolutionary age of oppression, and had neglected 'the great end / Of Poesy' – that it should be 'a friend / To soothe the cares, and lift the thoughts of man'. This point follows easily from the argument sketched in the earlier part of the poem: Keats interprets writing as a humanitarian mission, and wants to ensure that his sensuous language is not merely an ornament to the endeavour, but an essential part of it. In the poem's affectionate judgement, Hunt had already started to do this, and can therefore be 'accounted' one of the 'poet-kings / Who simply tell the most heart-easing things'. Although Keats appreciates that his own youth and inexperience make his efforts 'presumptuous', he dedicates himself to the same task:

> What though I am not wealthy in the dower
> Of spanning wisdom; though I do not know
> The shiftings of the mighty winds that blow
> Hither and thither all the changing thoughts
> Of man: though no great minist'ring reason sorts
> Out the dark mysteries of human souls
> To clear conceiving – yet there ever rolls
> A vast idea before me, and I glean
> Therefrom my liberty; thence too I've seen
> The end and aim of Poesy.

Keats's doubts (including those about money and education) are a powerfully motivating force here. They also undermine his confidence: for the last third of the poem he suffers 'an inward frown / Of conscience' at 'speaking out what I have dared to think'.[3] This leads him away from the realm of abstraction into somewhere more sheltered - specifically, into Hunt's house, where he wrote much of the poem on a sofa Hunt let

him use when he stayed overnight 'in a parlour no bigger than an old mansion's closet'. Many people have regarded this short scene as a diminution, and there are certainly moments in the closing lines which seem merely pretty, weaving 'soft' fingers and 'luxuriant' curls into a soppy picture of amity. Keats's larger effort is to create an intimate version of the general ideals he has just outlined. What Charles Cowden Clarke called the 'art garniture' of Hunt's bower-like study – its books and busts, its engravings and trinkets – is the domesticated aspect of a social virtue. High ambitions are embodied in its forms and faces, ambitions which connect great art with great deeds:

> Sappho's meek head was there half smiling down
> At nothing; just as though the earnest frown
> Of over-thinking had that moment gone
> From off her brow, and left her all alone.
>
> Great Alfred's too, with anxious, pitying eyes,
> As if he always listened to the sighs
> Of the goaded world; and Kosciusko's worn
> By horrid sufferance – mightily forlorn.

'Sleep and Poetry' (from its title onwards) seems built round a series of contrasts. In fact it is concerned to find different ways of saying the same thing. It looks for evidence at home of the ideals it seeks in the world at large, and shows that poetic 'progress' depends not on suppressing one side of the personality to release the other, but on allowing both to exist equally. It appreciates that 'thought' needs 'sensation' to become vivid, and as it predicts a visionary ideal which might 'burst our mental bars', it understands that such a thing can only be achieved by a deliberate accumulation of what Hazlitt referred to as 'knowledge'. Two years later, in 'Hyperion', Apollo explains that 'knowledge enormous makes a god of me'. In 'Sleep and Poetry', Keats anticipates that if he is to 'get' wisdom himself, he must remain a fully committed 'citizen of the world', even as he longs to transform its miseries by the healing power of the imagination.

'I stood tip-toe . . .' ends in radical inconclusiveness, drawing attention to the gulf which exists between its hopes and its achievements. 'Sleep and Poetry' is resolved in a bond of mutual friendship: rising after his 'sleepless' but poetry-filled night, Keats leaves his poem 'as a father does his son'. The phrase is eloquent about his orphan relationship with

Hunt, and also about the role envisaged for poetry itself. Among the family of his friends, he was becoming the parent to himself, at once poised in stillness and confidently expansive as he made a whole world of the inspirational 'parlour':

> See, in another picture, nymphs are wiping
> Cherishingly Diana's timorous limbs –
> A fold of lawny mantle dabbling swims
> At the bath's edge, and keeps a gentle motion
> With the subsiding crystal, as when ocean
> Heaves calmly its broad swelling smoothness o'er
> Its rocky marge, and balances once more
> The patient weeds, that now unshent by foam
> Feel all about their undulating home.

WHILE KEATS HURRIED to finish his two long poems, the balance of friendships in Hunt's circle was powerfully disturbed. Shelley had admired Hunt almost as long as Keats had: he had been an avid reader of the *Examiner*, he had made a generous donation to Hunt in prison, and he had also submitted poems, including his 'Hymn to Intellectual Beauty', for publication. When Hunt had praised him alongside Keats and Reynolds in his article on 'Three Young Poets', he already suspected that he might find him the most congenial of them all. As he welcomed Shelley from his temporary lodgings in Marlow (where he was staying with Thomas Love Peacock) to spend the day in the Vale of Health on 11 December, his hopes were confirmed.

Shelley was twenty-four, and in a recent letter to Hunt had described himself as an 'outcast from society' whose faith in writing to 'interest or improve mankind' had been revived by the prospect of meeting 'you, and perhaps some others (though in a less degree I fear)'. In this respect he resembled Keats, but Shelley's excitement related to a much more dramatic personal history. The brilliant schoolboy at Syon House and Eton, the undergraduate who had been expelled from Oxford for refusing to admit that he was the author of a pamphlet outlining 'The Necessity of Atheism', the heir to a baronetcy who had eloped at the age of nineteen with the daughter of an innkeeper, then run off again three years later with the daughter of William Godwin and Mary Wollstone-craft: Shelley was rich in experience, and a potentially resourceful ally. There had always been something faintly condescending in Hunt's

attitude to Keats; with Shelley he felt certain of being led on to greater glory, and treated him (even though Shelley was eight years younger) like 'an ancient and wrinkled, but rather good-natured grand-uncle'.[4]

Eventually Hunt would come to believe that even the chaos of Shelley's private life had its advantages: it would go some way towards licensing Hunt's sexual promiscuity. (Haydon complained in particular about Hunt's flirtation with his sister-in-law Elizabeth Kent,[5] saying that he liked to 'shut . . . his eyes [and] tickle the edge of her stockings that his feelings may be kept tingling by imagining the rest', and Hazlitt said that his obsession with sex was 'always coming out like a rash. Why doesn't he write a book about it and get rid of it?'). At the beginning of their friendship, though, its confusions seemed merely wretched. The day after meeting Hunt, Shelley returned to his home in Bath and discovered that Harriet, the wife he had abandoned two years previously, had drowned herself in the Serpentine in London. He travelled back to Hunt immediately, enlisting his support as he battled with the claims and counterclaims which followed her death, and finally announcing that he had 'little to regret' about the tragedy beyond 'the mere shock of so hideous a catastrophe having fallen on a human being once so nearly connected with me'. It was a chilling conclusion, even allowing for the fact that he was protecting more sensitive feelings. It also indicated how Hunt had sustained Shelley while he pondered 'the vice and folly and hard-heartedness' of Harriet's family. For the last two weeks in December they were rarely out of each other's company – walking across the Heath, sailing paper boats on the ponds, echoing each other's views on God, the monarchy, and morality. As Shelley fought to gain custody of his children, as he married Mary (on 29 December), as he lent Hunt money to ease the burden of his debts (he had given him £1,500 by the end of the following year), the two men forged a more complicated friendship than any Hunt had previously known. It was made urgent by turmoil, and intense by shared ideals. Hunt thought Shelley a dazzlingly gifted poet and the 'finest character he had ever met' – someone who combined 'everyone he had ever loved and everything he had ever craved to find in one human being: the strong reformer, the sensitive poet, the loving friend, the eager scholar, the nonconformist, the lover of earthly living and the spiritual and ascetic being'. Several in his circle would eventually ask that the phrase 'Friend of Keats' be engraved on their gravestones; Hunt's proudest title was 'Friend of Shelley'.

Few in his circle felt as enthusiastic. Horace Smith admired Shelley's Etonian self-confidence, and was impressed by his knowledge of Plato. Lamb, Haydon, Reynolds and Crabb Robinson tempered their respect for his evident gifts with doubts about his character. Hazlitt, speaking for them all, said that he reckoned Shelley had 'a fire in his eye, a fever in his blood, a maggot in his brain, a hectic fluttering in his speech, which mark out the philosophic fanatic'. Keats was more ambivalent than hostile. His beliefs resembled Shelley's in essence, but were less radically formulated, and much less inclined to issue in polemics. Whereas Shelley liked to wear his political heart on his sleeve, and to versify whole ideologies in his poems, Keats was beginning to commit himself to a more organic style. It was this difference which led, four years later, to their famous exchange about the nature of poetry, in which Shelley gave faint praise to *Endymion*, and Keats replied by saying of Shelley's work that 'There is only one part of it I am judge of; the Poetry, and dramatic effect . . . You I am sure will forgive me for sincerely remarking that you might curb your magnanimity and be more of an artist and "load every rift" of your subject with ore.'

These divergent views reflected other kinds of difference. Keats – small, softly spoken, and brimming with eager sensitivity – was as clearly the product of one kind of background as Shelley was of another. Shelley was 'a fair, freckled, blue-eyed, light-haired, delicate-looking person', who according to Horace Smith made it 'impossible to doubt, even for a moment, that you were gazing upon a *gentleman*'. Others agreed that he had natural authority, even though his voice (Lamb said) 'was the most obnoxious squeak', and his 'figure' was 'of delicate constitution, which appeared the rather from a lounging or waving manner in his gait, as though his frame was compounded barely of muscle and tendon; and that the power of walking was an achievement with him, and not a natural habit'. Everything about him seemed to embody privileges from which Keats felt excluded, as Hunt realised when he admitted that 'Keats did not take to Shelley as kindly as Shelley did to him . . . [and] Keats, being a little too sensitive on the score of his origin, felt inclined to see in every man of birth a sort of natural enemy'. The fact that Shelley was so soon and so obviously preferred by Hunt made Keats feel even more threatened, especially since his own reading of Shelley's poems led him to agree about their quality. The 'Hymn to Intellectual Beauty' might have described a 'dim vast vale of tears' too abstract for Keats to feel on his pulses, but the recently printed *Alastor* told the story of a

poet's difficult and often frustrated search for ideal beauty in terms that came very close to embodying his own feelings. Reading it, he was confirmed in his wish to translate the arguments of 'Sleep and Poetry' on to a larger canvas.[6]

Keats's other dealings with Shelley were just as provocative. When he showed him the collection of poems that he was intending to send to the Olliers, Shelley took him for walks on the Heath and tried to persuade him not to publish. Even though Shelley believed that he was acting in Keats's best interests, and pointed out that he had suffered at the hands of Tory reviewers when printing his own early work, the effect was painful. It convinced Keats that Shelley meant to behave as his superior, and to diminish his reputation with Hunt. At the same time, it forced him to define his separate aims more clearly. He realised that what Hunt called Shelley's 'Archimedean endeavours to move the globe with his own hands' were bound to seem theatrical in ways that he did not want to emulate. His own ambitions demanded that he become more sensuously engaged with the world, and write about its politics more obliquely. He knew that if he were to have a chance of realising his hopes, he would have to loosen his ties with Hampstead. He might, he began to think, even have to leave London altogether for a while.

As HUNT's INTEREST in him wavered, Keats turned to Haydon. On Saturday 14 December, he went to Great Marlborough Street with Reynolds to discuss the contents of his forthcoming volume. He wanted, in particular, to hear their views on how he might eliminate the signs of immaturity that Shelley had spoken about. After listening to them, he decided he should drop several poems – including 'O Come, dearest Emma', in which Hunt's softness combined with the even grosser sentimentality of George Felton Mathew. Before he left, however, Haydon celebrated his plans in a way that he had not anticipated. He persuaded Keats to submit to the painful business of having a mask taken of his face, as he had also done with other friends he intended to include in 'Christ's Entry'. While Reynolds watched, a cloth was wound round Keats's forehead, protecting his hair, and straws were poked up his nostrils so that he could breathe while the plaster hardened. When the cast was removed, it showed the high cheekbones protruding, the mouth wide and full (with its overhanging top lip pressed flat), the expression serene and almost smiling.

When Keats parted company with Haydon and Reynolds in the

afternoon, he walked to Vauxhall to see a friend of Charles Cowden Clarke's: Thomas Richards. During their time together in Enfield, Richards had been to Clarke as Clarke had been to Keats – an inspirational teacher and a kindred liberal spirit. But Keats did not merely want to see him to talk over old times. Richards's younger brother Charles worked as a printer with the Olliers, and was soon to become responsible for Keats's poems. It is a connection which shows Clarke, who had been so crucially involved in Keats's early poetry, continuing to influence its progress towards a wider public. It also reminds us how clearly Keats's choice of publisher advertised his radical allegiances. Like Shelley, who was himself published by the Olliers, he would pay dearly for his choice. The Tory press would know what to expect even before they opened the book.

The discussions that Keats had begun earlier in the day continued into the evening – and then later still, when a storm blew up, and he decided to stay the night with Richards rather than tramp back to Cheapside. By Monday he was home again, still thinking about the arrangement of his collection, this time with Severn. According to some sources,[7] Severn may also now have responded to the moment as Haydon had done, producing a charcoal drawing of Keats which captures him on the threshold of what all his close friends believed would be a triumphant career. In years to come, before and after Keats's death, Severn created many portraits of Keats, but this is one of the most arresting. Keats's jaw, as in the plaster cast, is not weakened by the wide gash of his mouth, and his face wears a dauntlessly determined expression. It was appropriate, as well as accurate. When Severn left him at the end of the day, Keats finally resolved to abandon 'I stood tip-toe . . .', and to reserve his energy for the longer poem he was contemplating.

Although Keats was trying to prove his independence of Hunt, he neither wanted nor was able to distance himself decisively. As the preparations for his book went ahead, he continued to visit the Vale of Health regularly, often meeting Shelley there, and to call on Hunt's other friends as well. If he felt that he should keep his friendship with Haydon separate, he soon found that this was impossible. In early January Horace Smith organised a dinner party with Hunt, at which the explosive painter met Shelley for the first time. Haydon later wrote about the encounter – at which he arrived late, irritated to see that Hunt was ignoring his wife Marianne and flirting with his sister-in-law Elizabeth, and sat down 'right opposite Shelley himself, as I was told

after, for I did not then know what hectic, spare, weakly yet intellectual-looking creature it was carving a bit of broccoli or cabbage in his plate, as if it had been the substantial wing of a chicken . . . In a few minutes Shelley opened the conversation by saying in the most feminine and gentle voice, "As to that detestable religion, the Christian – ." I looked astounded, but, casting a glance round the table, easily saw . . . I was to be set at that evening *vi et armis*. No reply, however, was made to this sally during dinner, but when the dessert came, and the servant was gone, to it we went like fiends . . . I felt exactly like a stag at bay, and resolved to gore without mercy . . . We said unpleasant things to each other, and when I retired to the other room for a moment I overheard them say, "Haydon is fierce." "Yes" said ——, "the question always irritates him." '

Keats did not speak during the argument, and Haydon had good reason for believing that his silence was supportive. A few days previously, he had not only sketched Keats's head into the background of 'Christ's Entry', but had finally got around to sending Wordsworth the sonnet 'Great spirits . . .'. Wordsworth had replied appreciatively on the very morning of the party with Smith, raising Keats to a new pitch of gratitude to Haydon, and to a keener sense that the atmosphere round Hunt was 'smuggering'. Yet his not saying a word also suggests a certain sympathy with Shelley's views, and as the month drew on, he remained on friendly terms with him. He enjoyed his passionate political conversation, and joined with him in condemning the recent Thanksgiving which had followed a demonstration against the Prince Regent, and the suspension of Habeas Corpus which had been its sequel. Hitherto his radicalism had been more theoretical than demonstrative. Now for the first time he felt close to a centre of purposeful dissent.

The effect – which is clear in the sonnet 'Written in Disgust of Vulgar Superstition' – was briefly to reintroduce a note of stridency into his work. Hunt was much more thoroughly influenced by Shelley's blasts and blazes. During the previous several months, and partly as a result of his experience in prison, he had softened the impact of his editorials by publishing poems (often his own) which seemed more concerned to escape the turbulent life of his times than to engage with it. But once it became clear that the end of the war in Europe had done nothing to encourage more tolerant government at home, and as public protest again became commonplace, Shelley encouraged him to reaffirm the principles which had been upheld in the early numbers of the *Examiner*.

'The transition from war to peace', Hunt wrote, 'was not only accompanied with its usual difficulties: it brought upon the nation all those long-hoarded difficulties, which grew out of the sophisticated means by which the war was kept up.'[8] Like other radical editors – Woolner of the *Black Dwarf*, White of the *Independent Whig* – he was scathing about English politicians such as Castlereagh, and their European counterparts such as Metternich, who were attempting to shore up the law of heredity, to limit suffrage, and to defend the security of absolute monarchs. He returned to the attack on 'borough-mongering', on harsh taxes and fiscal abuses, and on clerical pluralism. He reported (not always favourably) on the speeches of militant orators like Henry Hunt, and on outbreaks of popular rioting such as that in Spa Hill Fields in December 1816. He exposed the miserable extent of parish aid to the poor. He argued against the government's repressive Seditious Meetings Act. 'We do not believe that there is any necessity for revolution in this country,' he said, 'though we are more and more of the opinion, if possible, that there is much for Reform.'[9] Throughout the new year, 1817, his rage continued unabated. In April he vilified the monarchy (those 'carousing Belshazzars'), and lambasted people like Coleridge and Southey who supported them. He protested vehemently against the trial of Thomas Woolner for alleged libel in his radical periodical the *Black Dwarf* in June, and of William Hone for publishing satirical political parodies of the litany, the creed and the catechism the following September. He was outraged by a second suspension of Habeas Corpus. In November he grieved for the death of Princess Charlotte, believing that it allowed conservative elements in Parliament (who had always regarded her as a liberal sympathiser) a chance to defend their 'embattled dynasty'. In the same month that she died, he also wrote vitriolically about the suppression of the Pentridge Riots in Yorkshire, and the execution of their leaders. 'There is nothing but pauperism and desolation throughout the country',[10] he said, and a little later, in spite of his opposition to anything so extreme as a civil war, he warned that such a conflict was possible:

The public aspect is certainly becoming warmer and more decisive every day: there are open disturbances in several parts of the country, Wales now included; and it is allowed, that those who proceed to unlawful acts of violence are in many instances suffering severely, themselves and their families, – and without the prospect of relief. But then they should not cry out, it seems; they should not suffer their feelings to run into excesses of any kind, even of speech. Oh no; *they,*

the people, should be perfectly patient and well bred, and say nothing to inflame; and in the meantime [while] kings . . . carve out the world as they please abroad, the people at home are to be enormously taxed without a proper representation, and a single individual is not to bear the diminution of a sinecure for twenty-four thousand a year, but to heap up riches and increase his land, while his fellow creatures are dropping with grief and hunger round about him.[11]

SINCE KEATS HAD moved to Cheapside, his 'social time' had often been spent in London. He had been to recitals and to the theatre with his brothers. (Kean, whose performances he admired so much, was now appearing regularly at Drury Lane.) He had called on Reynolds and Edward Holmes. He had frequently visited Haydon, and on one occasion asked him to arrange a pass for the British Library. Friends noticed that the shyness he had originally shown in the Vale of Health was beginning to wear off, and were amused by his sporadic 'rhodomontades', and by his tendency to 'uphold . . . the worse side of an argument for the intellectual drama that ensued'.

But it was Hunt who remained the focus of his attention. The revitalised arguments of the *Examiner* invigorated him, exciting his political ideals and also his commitment to writing itself. Early in 1817, when his former colleagues Stephens and Newmarch qualified to become members of the Royal College of Surgeons, Keats decided not to sit the examination. It marked the formal end of his career as a would-be doctor. A sonnet he wrote soon afterwards, 'After dark vapours . . .', celebrates his new sense of purpose. Referring to January as an 'anxious month' which closes 'a long dreary season' and 'Takes as a long-lost right the feel of May', he looks ahead to a season of fruition and fulfilment. By ending the poem with a breathless rush of impressions, he demonstrates his loyalty to the open-ended forms associated with 'Cockney' writers; anticipating the mood and imagery of 'To Autumn' he gives a miniature summary of how he would adapt them to suit his own needs:

> And calmest thoughts come round us – as of leaves
> 　Budding – fruit ripening in stillness – autumn suns
> Smiling at eve upon the quiet sheaves –
> Sweet Sappho's cheek – a sleeping infant's breath –
> 　The gradual sand that through an hour-glass runs –
> A woodland rivulet – a Poet's death.

Proofs of *Poems* arrived during the first week of February, and as

Keats corrected them he followed up the implications of his sonnet – concentrating on Hunt, seeking his reassurance. On the 5th he and Reynolds dined at the Vale of Health with Shelley and his wife Mary; on the 12th he and George met Mary Shelley again; and on the 15th he was back with Hunt once more. When, during one of these meetings, the last proof-sheets of his poems were delivered, with a note from Charles Richards saying that if the book was to have a dedication he must send it as soon as possible, Keats had no hesitation in deciding to whom he owed most. Surrounded by friends, he 'drew to a side-table, and in the buzz of a mixed conversation' sat down and wrote a sonnet 'To Leigh Hunt, Esq.'. It is a jog-trot piece, full of the mere expertise that he had shown in sonnets written in competition with Hunt, but it records a deep debt, and a shared ambition to restore the 'Glory and loveliness' they felt was missing from contemporary poetry:

> And I shall ever bless my destiny,
> That in a time, when under pleasant trees
> Pan is no longer sought, I feel a free,
> A leafy luxury, seeing I could please
> With these poor offerings, a man like thee.

As Keats passed these lines to Charles Ollier, he added a prefatory note for his collection: 'The short Pieces in the middle of the Book,' he wrote, 'as well as some of the Sonnets, were written at an earlier period than the rest of the Poems.' It is a sentence which suggests that for all his faith in Hunt's good opinion, his real feelings about his poems were closer to Shelley's. Between the suddenly finished 'I stood tip-toe . . .', which opened the volume, and 'Sleep and Poetry', which ended it, were sonnets too occasional to seem substantial, and other pieces ('Calidore', 'To George Felton Mathew') which showed their obligations too nakedly. They overshadowed the achievement of his single greatest success, 'On First Looking into Chapman's Homer', and at the very least made him vulnerable to charges of writing derivatively. More seriously, they were a bait to critics who wanted to attack his political ideas.

This is what Shelley had warned him about, and before leaving London to set up house in Marlow on 27 February, Shelley returned to the subject once more. He suggested that they should both write a long poem to silence their enemies, and regard the enterprise as a form of friendly competition. This time his advice was well taken. Keats, after

all, had been considering writing an 'epic' for the past several months, and as the 'anxieties' of January fell behind him, his fluency returned. In early February he had arrived at his lodgings in Cheapside one day to find Charles Cowden Clarke 'asleep on the sofa', with a volume of Chaucer open at 'The Flower and the Leaf'.[12] (The poem was only later discovered to have been written by someone else.) Keats explained that he had recently been reading the poem himself, and pointed out that he had written 'an extempore effusion' at 'the close of it'. This may have been produced as quickly as his dedication to Hunt, but it brings together his preoccupations in much more energetic ways. It restates his belief that the 'wandering melody' of verse is a vital part of its meaning, as he had previously said in his sonnet to Kosciusko; it registers the 'power' of 'white simplicity' (the liberal values associated with the ancient greenwood that it celebrates); and it is braced with his larger ambitions ('I that do ever feel athirst for glory'). When he showed the sonnet to Reynolds a few days later, he was rewarded with a poem which praised him in exactly the terms he wanted to hear: 'Thy genius weaves / Songs that shall make the age be nature-led, / And win that coronal for thy young head'.

As Keats discussed 'The Flower and the Leaf' with Clarke, he noticed a resemblance between the lines beginning 'Upon a certain night' and a passage in 'Sleep and Poetry'. Rushing to the Olliers with yet another late addition, he asked that an extract from Chaucer's poem be inserted before the beginning of his own. When this was done, a half-line was omitted, making a nonsense of his plan, but his intentions are nevertheless clear.[13] He wanted to link his poem – as he had said in the dedicatory sonnet – to the native tradition which he felt had been interrupted by the Augustans. He made the same point on the title page of the book itself, which carried an epigraph from Spenser's 'Muiopotmos: or the Fate of the Butterfly' ('What more felicity can fall to creature, / Than to enjoy delight with liberty'), and, just below, an engraving of an unnamed laurelled head. Most commentators believe this to be a portrait of Spenser, though it also resembles Shakespeare. In either case, the purpose is the same: to show the book's literary loyalties at the outset, and to declare that its style is of a piece with its ideas. Its declared dedication is to Hunt; its simultaneous devotion is to Liberty.

FOURTEEN

The first copy of *Poems* reached Keats on Saturday 1 March 1817, exactly a year after he had paid his fees for the medical career he had abandoned. It was bound in grey boards, and priced at six shillings. He at once took it from Cheapside to the Vale of Health, and as he walked up Millfield Lane towards the Ponds, he met Hunt coming towards him. Hunt excitedly invited Keats back to his cottage to celebrate. It was a warm day, and after dinner they sat outside drinking. Had Shelley been there, the talk would easily have turned to other matters. Left alone together for the first time in several weeks, they succumbed to what Haydon – speaking of a different occasion – called 'The excessive mad anticks of people of real Genius when they meet after hard thinking'.[1] Hunt cut some laurel from a bush growing in his garden and wound it round Keats's head; Keats found some ivy and placed it on Hunt. So adorned, they then began writing sonnets to each other, Hunt producing two in a remarkably short time, and Keats struggling through one, in which he first thanked 'the kind poet who has set / Upon my ambitious head a glorious gain', then slipped into a commemoration of themes they had recently debated with Shelley:

> Still time is fleeting, and no dream arises
> Gorgeous as I would have it; only I see
> A trampling down of what the world most prizes,
> Turbans and crowns, and blank regality –
> And then I run into most wild surmises
> Of all the many glories that may be.

The feebleness of the last two lines suggests that Keats felt awkward to be addressing important subjects while so frivolously decorated, and as the evening wore on he began to hope their 'anticks' might soon be forgotten. But when visitors were suddenly announced (possibly Reynolds's sisters), events ran out of his control. Hunt snatched off his own crown; Keats continued to wear his in embarrassed defiance, producing a second sonnet 'To the Ladies who Saw Me Crowned', as if a confession of his unease might diminish it.

His strategy did not work. In the next few days he kept the events of the evening to himself, only showing the sonnet to Reynolds (who may

lmi-
ons,
the
ing,
the
it of
his
rl of
t, of
ОHN
tice,
rt of
60l.
r of
for
&c.
e of
ious
not
e of
ears,

now
hich
part
and
can-
n in
end
hful

ecu-
e of
.ible

ORIGINAL POETRY.
TO HAYDON,
WITH A SONNET WRITTEN ON SEEING THE ELGIN MARBLES.

HAYDON! forgive me that I cannot speak
 Definitively on these mighty things;
 Forgive me that I have not Eagle's wings—
That what I want I know not where to seek:
And think that I would not be overmeek
 In rolling out upfollow'd thunderings,
 Even to the steep of Heliconian springs,
Were I of ample strength for such a freak—
Think too, that all those numbers should be thine;
 Whose else? In this who touch thy vesture's hem?
For when men star'd at what was most divine
 With browless idiotism—o'erwise phlegm—
Thou hadst beheld the Hesperean shine
 Of their star in the East, and gone to worship them.

ON SEEING THE ELGIN MARBLES.

My spirit is too weak—Mortality
 Weighs heavily on me like unwilling sleep,
 And each imagined pinnacle and steep
Of godlike hardship, tells me I must die
Like a sick Eagle looking at the sky.
 Yet 'tis a gentle luxury to weep
 That I have not the cloudy winds to keep,
Fresh for the opening of the morning's eye.
Such dim-conceived glories of the brain
 Bring round the heart an undescribable feud;
So do these wonders a most dizzy pain,
 That mingles Grecian grandeur with the rude
Wasting of old time—with a billowy main—
 A sun—a shadow of a magnitude. J. K

4 Keats's two sonnets on the Elgin Marbles were published in the *Examiner* on 9 March 1817.

have heard about it anyway from his sisters). Hunt, however, circulated both his own poems widely, and the following spring published them, thereby handing his enemies a powerful weapon with which to attack him and his protégé. Keats was troubled by Hunt's indiscretion; he also felt that by fooling with the paraphernalia of poetry he had betrayed the calling he had embraced in 'Sleep and Poetry'. His shame prompted a series of guilty compensations. Returning to Cheapside, he wrote an apologetic 'Ode to Apollo', castigating himself as 'a blank idiot', 'a worm', and 'a pitiful germ', and dedicating himself once more to his

'Delphic' task. Immediately afterwards he sought out Haydon, expecting that contact with his high-mindedness would refill his 'ambitious head' with the ideals he had compromised.

Haydon's reaction to *Poems* was just as enthusiastic, but much more dignified than Hunt's. 'Sleep and Poetry', he declared, was 'a flash of lightning that will sound men from their occupations, and keep them trembling from the crash of thunder that *will* follow'. It was not just his praise that heartened Keats. On Sunday 2 March[2] Haydon took him to see the Elgin Marbles, believing there was nothing finer for his 'genius-loving heart' to contemplate. Once again Keats responded by sonneteering. Whereas his recent poems had been fluent, his new 'effusions' were stricken with a sense of inadequacy – which Haydon signally failed to notice. In the first poem (which elevates the self-criticism of the 'Ode to Apollo') he admits that the beauty of the Marbles had overwhelmed him, producing a sense of 'mortality' which 'Weighs heavily on me like unwilling sleep'. This was the opposite of what Haydon had intended, nothing like the receptive trance that he believed great art was capable of generating. In other ways it fulfilled his aims. By reminding Keats of the gulf between his ambitions and his achievement, the Marbles showed him that his future as a writer depended on his undertaking a hard struggle. In the sonnet's tantalised final lines he sketches the 'undescribable feud' between earth and ethereality, between mortality and permanence, which became the subject of his greatest poems, and of the 'Ode on a Grecian Urn' in particular:

> Such dim-conceivèd glories of the brain
> Bring round the heart an undescribable feud;
> So do these wonders a most dizzy pain,
> That mingles Grecian grandeur with the rude
> Wasting of old Time – with a billowy main –
> A sun – a shadow of a magnitude.

These lines are full of frustrated longing; their consolation is having a clear idea of what they hope to achieve. Keats was too conscious of his failure to feel comforted, and immediately produced a second sonnet asking Haydon to 'forgive me that I cannot speak / Definitively on these mighty things'. This time, he suggests that his only recompense is knowing that Haydon could see the Marbles for the things they are. To understand what he meant, his poems need to be linked to the ideas he

had already learned about Classical civilisation. The influence of Neo-classical taste, based on a revival of interest in Greek and Roman history, had dominated English cultural life since the early eighteenth century. The discovery of Herculaneum in 1738 and Pompeii in 1748 'sustained [a] deep reverence for antiquity' and 'organisations like The Society of Dilettantes, founded in 1732, and publications such as James Stewart and Nicholas Revett's *The Antiquities of Athens* (1762) [had] consolidated this process'.[3] So had J. J. Winckelmann's idealistic praise for the 'noble simplicity' and 'quiet grandeur' of antique sculpture, which he said 'blends the grandeur of man with the charms of youth . . . Here sick decay, and human flaws dwell not, blood palpitates not here . . . Peace dwells in blest tranquillity.' These writers – and others such as Gibbon – developed a notion of the Classical world as a realm of cool, chaste, monumental and clearly structured forms – a site of spiritual excellence which guaranteed the authority of its modern imitators. The results were evident in everything from Wedgwood's vases to public buildings, from dresses and furniture design to entire systems of education. Even though, at the end of the century, certain writers (Richard Holds and Frederick Sayers, for instance) were complaining that its mythologies had become 'trite and insipid',[4] by Keats's day the general inclination was not to reject them altogether, but to bend their principles to fit modern uses.

Shelley, for instance, in his Introduction to *Hellas* (1821), declared that 'The human form and the human mind attained a perfection in Greece which has impressed its image on these faultless productions, whose very fragments are the despair of modern art, and has propagated impulses which cannot cease.' Byron, who like Haydon's adversary Richard Payne Knight refused to accept that the Elgin Marbles were authentic, filled his stanzas with laments for the vanished glory of the antique world. Godwin, in *The Pantheon: Or Ancient History of the Gods of Greece and Rome* (1808, published under the pseudonym Edward Baldwin), said that Greek religion 'gave animation and life to all existence'.[5] Hazlitt, although he appreciated that Greek statues were historically remote and 'marble to the touch and to the heart', accepted that 'By their beauty they are raised above the frailties of passion or suffering'.[6] Hunt, who in the *Examiner* in 1815 had described 'the study of the Classics' as 'a description in humanism', said in the Preface to *Foliage* that Shakespeare 'felt the Grecian mythology not as a set of schoolboy common-places which it was thought wrong to give out, but

as something which it requires more than mere scholarship to under-stand – as the elevation of the external world . . . to the highest pitch of the graceful, and as embodied essences of all the grand and lovely qualities of nature. His description of Proserpine and her flowers in *A Winter's Tale*, of the characteristic beauties of some of the gods in Hamlet and that single couplet in *The Tempest* – "Ye nymphs called Naiads of the wandering brooks / With your sedged crowns and ever harmless looks" – are in the deepest taste of antiquity, and show that all the great poets look at themselves and the fine world about them in the same clear and ever-living fountains.'

Keats's first biographer Richard Monckton Milnes realised that Hunt might as well have been talking about Keats as Shakespeare in this passage, just as Hazlitt might have been discussing the 'Ode on a Grecian Urn' when speaking about Greek sculpture in general. Keats had begun to admire the Greek spirit (the 'religion of Joy', he called it in conversation with Severn) when he read Tooke and Lemprière at school, feeling that his efforts at assimilation must be all the greater for his not knowing the Greek language. This later led some critics to feel that he overcompensated: Byron sneered at him for 'versifying' Lemprière, and even Hunt said he 'never beheld an oak-tree without seeing the Dryad'. Others felt that his sympathy was simply prodigious. Haydon described how he 'loved to take him to the British Museum and [hear him] expatiate . . . on the glories of the antique'; Reynolds referred to his 'genius' as 'peculiarly Greek', and Mathew said that he 'invited comparison with the Greeks in that one of the main endeavours of his poetic career was to grow more Grecian'.

By the time Keats joined Hunt's circle, his sense of the Neo-classical tradition was already sophisticated. He looked upon it as a 'maze of fictions'[7] he could adapt to his particular aims. It was a way of combining vision with revision. Even in the early work in *Poems*, and especially in 'Chapman's Homer' and the two longest 'assays', he invokes ancient sonorities as a support in time of present trouble. Their deliberately artificial world is a compensation for and a criticism of real conditions. There may be contradictions here and there in the volume (the dedicatory sonnet regrets the loss of Classical mythology, while 'I stood tip-toe . . .' invokes Apollo as a 'potent god'[8]) but these become part of a steadily expanding theme. Keats's received stories are all aspects of a subject that he treats openly in his political poems, and enacts in his freely flowing couplets. They are not merely 'pagan' witnesses to his

faith in 'the beautiful'; they are components in a 'humane happy, politically enlightened society [which has no] recourse to Biblical religion'.[9] In due course, he would pay the price for his candour: *Blackwood's*, which regularly used 'Greek religion' as a 'touchstone to reveal moral and theological flaws in contemporary [liberal] ortho- doxy',[10] dubbed him the 'Cockney Homer' in 1818, condemning him for borrowing from 'his prototype Hunt . . . a sort of vague idea that . . . no mythology can be so finely adapted for the purposes of poetry as [the Greeks']'.

Keats's Elgin sonnets contain these beliefs in a distilled form, contributing to the battle about the Marbles' authenticity. On the one hand stood conservatives like the watercolourist Joseph Farington, the painter Ozias Humphry, and Knight (the 'arbiter of fashionable virtue' according to the Tory *Quarterly Review*), who thought they were not produced during the ancient period; on the other were those like Hazlitt, Haydon, and the *Champion* who defended their 'political importance'[11] as well as their antiquity. Ever since the Marbles had first been shown in a private exhibition organised by Lord Elgin, who had brought them from Greece, in London in June 1807, Haydon had kept up a continual barrage in their defence, and in the spring of 1816, when a Select Committee of the House of Commons had debated whether the government should buy them from Lord Elgin, his evidence had been considered alongside that given by other admirers like Benjamin West, Thomas Lawrence and John Flaxman. They paid little attention to the fragmentariness of the pieces, and even less to the terms on which they had arrived in England. They were emblems of a culture that Haydon, like Hunt and the rest of his circle, felt England was lacking, and which was likely to spur a second Renaissance. By writing about them as admiringly as he did, Keats was identifying himself with a cause in which artistic considerations were inextricably involved with liberal issues.

So why does he feel defeated and baffled by their grandeur? In one sense the answer is simple: as he admits himself, he was overfaced by what Hunt called their 'embodied essence'. It amounted to a concentra- tion that he could not immediately digest. It is also possible that his liberalism, being more developed than Haydon's, led him to worry about their context in a way that his mentor never did. The staccato conclusion of his first sonnet alludes to the fragmentariness of the Marbles while perhaps also raising questions about how and why they had been

removed from their original site. Haydon, needless to say, did not notice this. He took the poems as a tribute to his campaign for their purchase, and as a sign that he had scored a victory over Hunt in the contest for Keats's loyalty. But it is a proof of the perturbation in the poems that, as soon as they were finished, Keats immediately turned back to Hunt. He offered him both the sonnets to publish in the *Examiner* (they also appeared in the *Champion*); in mid-March he wrote a eulogistic sonnet 'On the Story of *Rimini*'; and a few days later he produced an effusion 'On a Leander Gem, which Miss Reynolds my Kind Friend, Gave Me', which clearly shows his debts to Hunt.

KEATS WAS NOT SO much ignoring Haydon as marking time, still wondering whether to leave London and begin his 'longer sort of poem of Diana and Endymion'. He nervously sent out copies of *Poems* to interested parties – including one to Wordsworth 'with the Author's sincere Reverence' – and waited to hear what Charles Cowden Clarke called 'the cheers and fond anticipation of all his circle'. His brothers, Hunt, and Haydon had already delivered their verdict, and so too had his publisher Charles Ollier in a sonnet beginning 'Keats I admire thine upward daring soul, / Thine eager grasp at Immortality'. In the wider world, however, the book seemed to be creating virtually no interest whatsoever. Clarke said later 'it might have emerged in Timbuktoo with far stronger chance of fame and approbation . . . The whole community, as if by compact, seemed determined to know nothing about it.'

In all, only six reviews of *Poems* were published, and those which were most favourable were all by friends. By Reynolds, for instance, who a week after publication wrote in the *Champion* that Keats would one day eclipse Byron, Moore, Samuel Rogers and Campbell, likened his aims to Chaucer's and Shakespeare's, and insisted that some of the later sonnets were worthy of comparison with Wordsworth and Milton. These were the words of a staunch supporter, but as Reynolds wrote them he also admitted the defects of the book and, implicitly, its debts to Hunt. 'The author,' he said, 'from his natural freedom of versification, at times passes to an absolute faultiness of measure: – this he should avoid. He should also abstain from the use of compound epithets as much as possible.'[12]

For journals with no special interest in Keats, such weaknesses were reason enough to ignore the book. However, as other reviews trickled in during the next few weeks, it became increasingly obvious that he was

not being judged by purely literary criteria. In June an anonymous 'Observator' (Christopher North), writing in the staunchly conservative *Anti-Gallican Monitor* said: 'this dress is made by a great-grandchild of Milton, after the poet's mode; but the white crepe in his buttonhole, a token of grief for the loss of his liberty, is on the ground of Milton's political principles – Poor youth!'[13] Elsewhere even those who might have identified with his aims were complaining that Hunt had blurred his originality. In September Josiah Conder, a Nonconformist preacher and proprietor of the *Eclectic Review*, wrote: 'We regret that a young man of vivid imagination and fine talents should have fallen into so bad hands, as to have been flattered into the resolution to publish verses, of which a few years hence he will be glad to escape from the remembrance.'[14] The following month even the liberal *London Magazine* repeated the charge: 'If Mr Keats does not forthwith cast off the unkeenness of this school [of Hunt], he will never make his way to the truest strain of poetry in which, taken by himself, it appears he might succeed.'[15]

It is surprising that Hunt did not come more quickly to Keats's support – for political-poetical reasons, as well as friendly ones. In his defence, it can be pointed out that he published five poems by Keats in the four issues of the *Examiner* that preceded or followed the appearance of *Poems*; but his own response did not appear until three months after publication, on 1 June. It was, Hunt told his readers, the first part of an appreciation which would be 'concluded next week' – though in fact the second instalment did not appear until five weeks later on 6 July, with a third part following on 13 July. It is possible to explain this delay by arguing that Hunt wanted to spare Keats the embarrassment of a precise connection. Since the first article does not even mention Keats by name, and concentrates instead on the idea that 'poetry has of late years undergone a very great change', this seems unlikely. It was more probable that he was simply distracted. (He told Charles Cowden Clarke that 'the press of matter' had prevented him from printing his review for 'some weeks' after it had been written.[16]) In early April, his financial problems had reached crisis point. Bailiffs were threatening to invade his house, and when Shelley had suggested that he leave Hampstead for Marlow, he had jumped at the chance to escape. No sooner was Hunt installed in his refuge than his original commitment to Keats seemed part of a different, less important life – and when he finally addressed the poems themselves, his treatment was perfunctory. He praised them for

'strong evidence of warm and social feeling', he emphasised their links with Milton's radical politics and Wordsworth's stress on 'simplicity' (Reynolds had also mentioned 'childishness'), and he identified 'I stood tip-toe . . .' and 'Sleep and Poetry' as the most distinguished things in the collection. But nowhere did he give the strong approval that his patronage might have licensed, and everywhere his endorsements are hedged around with qualifications. He said that Keats had 'a tendency to notice every thing too indiscriminately and without an eye to natural proportion and effect', and described his intensities in deflatingly 'domestic language'.[17]

These disappointments lay a few months in the future. In the immediate backwash of publication, Keats thanked Reynolds for his review in a few 'mono-sentences', saying 'Your Criticism only makes me extremely anxious that I shod not deceive you. It's the finest thing by god – as Hazlitt wod say However I hope I may not deceive you.' He might just as well have said that he hoped he had not deceived himself. Instead of provoking thunder and lightning, his book had produced little more than a sorry self-appraisal. He felt that he had let down his friends and further alienated Abbey – who when given a copy of the book responded: 'Well, John, I have read your book and it reminds me of the Quaker's horse – hard to catch and good for nothing when he was caught.' (Ten years later Abbey told Taylor 'I don't think [Keats] ever forgave me for uttering this Opinion.') Keats realised, too, that he had antagonised Tory critics who were already eager to chastise him.

Not that Hunt seemed to care. As he made his hurried departure for Marlow, he asked Keats to supervise the second edition of *Rimini*, and to sort out papers he intended leaving behind in the Vale of Health. Although Keats obligingly concealed evidence from the bailiff ('old Wood', as Keats called him, 'A very Varmant – sharded in Covetousness'), he felt their original trust had been broken. He was repelled by Hunt's domestic difficulties, and saddened by their differences. He could no longer 'talk about Poetry [to Hunt] in the way I should have liked', he told Haydon, 'for I was not in a humour with either his or mine. His self delusions are very lamentable[;] they have inticed him into a situation which I should be less eager after than that of a galley Slave.'

These reservations grew steadily through the late spring and early summer, and as they undermined what had become the centre of his life as a poet, they forced him to look elsewhere for companionship. He turned back to Charles Cowden Clarke, to Haydon, and to Reynolds,

who was about to start his legal training. There were new friendships, too. Stung by their lack of success with *Poems*, the Olliers had quickly indicated to Keats that they did not wish to persevere with his work, and Keats, like all disappointed authors, was keen to believe that he might fare better elsewhere. With Reynolds's publishers, in fact: John Taylor and James Augustus Hessey, who for ten years had worked at 93 Fleet Street, first as booksellers, and more recently as an educational and literary firm. They had brought out Reynolds's *The Naiad* in the autumn of 1816, the same year that they planned and failed to publish the verse Epistles that Hunt had printed in the *Examiner*, and were widely acknowledged to be exceptionally enterprising and considerate. They had not, for instance, seemed unduly worried when *The Naiad* failed to sell; they still lived in hope of finding a young poet who would do for their company what Byron had done for Murray.

Although Keats at this stage seemed unlikely to prove such a gold mine, Taylor and Hessey showed a firm faith in his potential.[18] In late March, only three weeks after *Poems* had appeared, they were discussing the possibility of publishing his next book, and within a month Taylor had agreed to 'keep him in funds for the refusal of his future works'. (It is a sign of the distance now opening between Keats and Hunt that as Keats left the Olliers, Hunt went to them with the new edition of *Rimini*: they were, after all, Shelley's publisher.) When, on 15 April, Taylor wrote to his father to tell him that he had taken on Keats, he said 'I cannot think he will fail to become a great Poet, though I agree with you in finding much fault with the Dedication [to Hunt] &c. These are not likely to appear in any other of his Productions.'

Hessey was thirty-two, a Yorkshireman with 'very genteel and wealthy connexions' who had come to London in 1803 to work for Lackington's the bookseller in Finsbury Square, near the Swan and Hoop. He was studious, pragmatic, conventionally religious, and always kept on friendly terms with Keats, who called him 'Mistessy'. But he relied on Taylor to make the decisive literary choices for the firm. (Their list eventually included work by Coleridge, Hazlitt, Clare, Lamb, de Quincey, Hogg and Carlyle, as well as Keats.) Taylor was four years older, had been born in East Retford in Nottinghamshire, and met Hessey when he too worked in Lackington's. Since starting business he had lodged briefly in Hampstead, then moved to Fleet Street, where he had made his rooms a popular meeting place for young writers. He had tried his hand at poems as a young man, published some learned books

inquiring into the authorship of the famous 'Junius' letters to Sir Philip Francis, and later wrote on currency, educational and antiquarian subjects. Slightly built and attractive, with short dark hair, rimmed glasses, and a smiling, bony face, he was a reliable as well as an inspiring friend – able to steady Keats when necessary, and also to share his love of life. Many of his authors trusted him with their personal troubles as well as their work, and he carried their burdens affectionately. It made him, he once told his father, 'pale and poorly when I feel disturbed at anything', but this sensitivity never became self-regarding. When he first met Keats he was struck by his sense of dedication – as well as his 'singular style of dress'; over the years he developed 'a strange personal Interest in all that concerns him'.

So did Richard Woodhouse. Woodhouse was seven years older than Keats, and from an altogether different background. He had been born in Bath, the oldest of fifteen children, was educated at Eton, and since travelling in Spain and Portugal (after which he published a *Grammar of the Spanish, Portuguese and Italian Languages* in 1815), had studied law and become legal adviser to Taylor and Hessey. Taylor valued him for his literary as well as his professional opinion, describing him as 'about my own size but thinner, [with] red hair and florid complexion . . . the character of the face is that of gravity and deep thought more than genius'. It is not known exactly when he met Keats, but he was greatly impressed by *Poems*, writing a clumsy celebratory sonnet which credits their young author with 'Waking, long dormant sounds', and soon established himself as an avid collector of Keatsiana. He knew that Keats could be 'wayward, trembling, easily daunted', yet never doubted his 'original genius'. His experience of the world, his education and his relative security might easily have led him to seem patronising. Instead, he listened and leant to Keats with what he called a 'more than brotherly interest in [his] welfare'.

Keats, in turn, prized Woodhouse as 'a good person' who 'likes my Poetry – conclusive'. He was a kind of unambitious Boswell. In letters to Keats, Woodhouse would deliberately put questions designated to elicit 'axioms' he then cherished and explicated; in conversations he raised issues which would allow Keats to develop his thinking; in an interleaved copy of Keats's work that he later ordered from Taylor, he entered biographical observations and critical comments; in his dealings with Keats's friends he ceaselessly pleaded his cause. Eventually he was one of the few to accompany Keats downriver to Gravesend at the beginning of

his final voyage to Italy. The brief journey is evidence of their closeness, a closeness which Woodhouse maintained so assiduously after Keats's death that even Severn, who usually appropriated the role of 'best' friend for himself, said that Woodhouse was 'active and discriminating'.

Joining Taylor and Hessey encouraged Keats to begin the long poem he was planning; it could not annul the awkwardness of breaking with the Olliers. Meaning to spare his brother an argument, George Keats decided to handle them. He did so, however, in a way which shows that his protectiveness could make him seem crass. He wrote to the Olliers in late April as if they had let Keats down. For his pains, he received a letter from James Ollier, Charles's brother, which only compounded the disappointment surrounding *Poems*:

Sir, – We regret that your brother ever requested us to publish his book, or that our opinion of its talent should have led us to acquiesce in undertaking it. We are, however, much obliged to you for relieving us from the unpleasant necessity of declining any further connexion with it, which we must have done, as we think the curiosity is satisfied, and the sale has dropped. By far the greater number of persons who have purchased it from us have found fault with it in such plain terms, that we have in many cases offered to take the book back rather than be annoyed with the ridicule which has, time after time, been showered upon it. In fact, it was only on Saturday last that we were under the mortification of having our own opinion of its merits flatly contradicted by a gentleman, who told us he considered it 'no better than a take in'. These are unpleasant imputations for any one in business to labour under, but we should have borne them and concealed their existence from you had not the style of your note shewn us that such delicacy would be quite thrown away. We shall take means without delay for ascertaining the number of copies on hand, and you shall be informed accordingly.

As the spring advanced, Keats made other new friends besides Taylor and Hessey. The Novello family, for instance. He had occasionally met Vincent Novello on visits to the Vale of Health during the previous winter; now he took to calling on him at his house, 240 Oxford Street, by the Tyburn Gate, sometimes meeting Charles Cowden Clarke there, as well as his schoolfriend Edward Holmes. Novello was the son of a Piedmontese who had come to London in 1771 and worked as a pastry cook. In 1798, when he was seventeen, he had become organist of the Portuguese Embassy chapel – a post he held for twenty-five years. He was widely renowned for the brilliance of his playing, and also for his related musical activities. He was a founder member of the Philharmonic

Society, and publisher and editor of Mozart, Haydn and Purcell. Civilised and sociable, he organised regular evening music parties at which his rose-coloured drawing room, with its grey carpet embroidered with leaves, was transformed into what Lamb called 'a chapel'. Every Sunday its mood was elevated still further, becoming a 'minor heaven' when songs were sung round the piano, and dinner was served by his wife, sister, and many children (including Mary, whom Charles Cowden Clarke would later marry). These gatherings were more than proto-Victorian family jollities, at which the Pickwickianly bald, short-sighted, and florid Novello padded about in shoes several sizes too large (to disguise his small feet), throwing off 'fantasies, buses and acrostics, doggerel and nonsensical discussion'. They also gave Keats a chance to share in 'political argument' and to watch 'a lofty ideal of living . . . put into practice'.[19] The Novellos 'always endeavoured to introduce into their everyday life those beauties of poetry, art, music and natural surroundings'. Like Hunt, they practised 'a sort of bourgeois epicurean-ism'.[20]

Keats had already learned a good deal about music at school and with Hunt. With the Novellos his knowledge increased rapidly, as he propped himself 'against the side of the organ, listening with rapt attention', or sat in his 'favourite position – one foot raised on his other knee' – while Novello played ditties, love songs and traditional ballads, as well as recently published scores by Haydn, Mozart and Beethoven. Each new composer, Keats found, was recommended for more than aesthetic reasons. Novello was a Catholic whose 'simple undogmatic idealism'[21] led him to appreciate 'the liberal movements . . . towards which the Church was politically antagonistic', and as a teacher and performer he did more 'than any single individual towards spreading a love and cultivation of the best music amongst the less wealthy classes in England'.[22] This was his daughter's judgement and possibly an exaggeration, but her point is clear. Novello interpreted music as Hunt interpreted literature. It was an art which had the potential to embody and disseminate progressive values.

Hunt had also preached the same lesson about the painters he admired – especially Claude and Poussin – and so in his different way had Haydon. Two other artists that Keats now began to meet occasionally, Peter de Wint and John Hilton, reinforced it. De Wint was originally from America, and had come to London in 1812, aged fourteen, to study under the eminent mezzotint engraver John Raphael Smith. He was a

slender, dark-complexioned man whose 'strong will' combined with a modest cautiousness: his 'vigour of impulse was held in check by distrust of strange people and new ideas'.[23] While working with Smith he had met Hilton, who was two years younger than himself and the son of a painter in Newark, Nottinghamshire. They immediately became friends, studied together at the Royal Academy and, after de Wint married one of Hilton's sisters, set up home together. Hilton first made his name as a historical and mythological painter (his subjects included 'The Raising of Lazarus', 'Una with the Satyrs' and 'Ganymede'), and eventually became Keeper of the Academy, parting from his friend and moving into Somerset House.

De Wint was renowned for producing watercolours which were 'neither fragments nor impressions', yet had an evocative 'incompleteness'.[24] This appealed to Keats, partly because it suggested humility about the relationship between artist and subject. After Keats's death, John Clare commended the same virtue when asking for the original of a title-page design that de Wint had done for him in 1827. 'I don't know how it is', he said, 'but nothing in the Royal Academy, & other exhibitions, struck me as favourably as those studies of yours.'[25] Although de Wint's style could not compare with Clare's own rugged vernacular, or with Keats's wrought Neo-classicism, a common cause glows in his sepia lowlands and wooded retreats. He is a painter who speaks as plainly about the wish to withdraw from the world as he does about the need to engage with its daily conditions.

In their various ways, all these friends helped Keats to focus on the new task that he had set himself – for the time being, at least. They demonstrated how lyric descriptiveness could be allied to 'knowledge'. Haydon, as ever, was especially forceful, urging him to immerse himself again in Shakespeare so as to discover how 'thoughts' and 'sensations' might be most powerfully linked. Keats took the advice immediately: reading Shakespeare intensively by himself and with Reynolds (who liked to begin his letters with a panegyric on the bard), cramming his correspondence with Shakespearean echoes, allusions, quotations and even parodies, and buying a new duodecimo seven-volume edition of the works edited by George Steevens, who had used Samuel Johnson's edition as his model. (Later this summer he bought a facsimile of the first folio edition of Shakespeare, which he shared with Reynolds.) By mid-March his ideas for his new poem, which he now thought of calling *Endymion*, were well developed. His plans about how best to work on it

were clarifying, too. On the 17th he wrote to Reynolds: 'My brothers are anxious that I sho^d go by myself into the country – they have always been extremely fond of me; and now that Haydon has pointed out how necessary it is that I sho^d be alone to improve myself, they give up the temporary pleasure of living with me for a great good which I hope will follow – So I shall soon be gone out of town.'

Soon but not immediately. Before his arrangements were finalised, he made an impatient start on the poem – one that threw a bridge from his new life to his old. Although he had failed to collect a final certificate from Guy's, and had broken most of his connections with the hospital, he still kept in touch with his former fellow lodger Henry Stephens, who was continuing to study for the Licentiate which Keats himself had gained the previous summer. As Stephens prepared to sit his examinations, he sometimes visited Cheapside, poring over his medical texts while Keats, as he had done in St Thomas Street, concentrated on poems. At one of these meetings Keats jotted down a few lines, then read the first aloud: 'A thing of beauty is a constant joy'. Stephens later said that he told him, 'It has the true ring, but is wanting in some way.' Keats immediately revised it and continued writing:

> A thing of beauty is a joy for ever:
> Its loveliness increases; it will never
> Pass into nothingness; but still will keep
> A bower quiet for us, and a sleep
> Full of sweet dreams, and health, and quiet breathing.
> Therefore, on every morrow, are we wreathing
> A flowery band to bind us to the earth,
> Spite of despondence, of the inhuman dearth
> Of noble natures, of the gloomy days,
> Of all the unhealthy and o'er-darkened ways
> Made for our searching: yes, in spite of all,
> Some shape of beauty moves away the pall
> From our dark spirits. Such the sun, the moon,
> Trees old, and young, sprouting a shady boon
> For simple sheep; and such are daffodils
> With the green world they live in; and clear rills
> That for themselves a cooling covert make
> 'Gainst the hot season; the mid forest brake,
> Rich with a sprinkling of fair musk-rose blooms:
> And such too is the grandeur of the dooms

We have imagined for the mighty dead;
 All lovely tales that we have heard or read –
 An endless fountain of immortal drink,
 Pouring unto us from the heaven's brink.

 Nor do we merely feel these essences
For one short hour; no, even as the trees
That whisper round a temple become soon
Dear as the temple's self, so does the moon,
The passion poesy, glories infinite,
Haunt us till they become a cheering light
Unto our souls, and bound to us so fast,
That, whether there be shine, or gloom o'ercast,
They always must be with us, or we die.

Whether or not Stephens helped Keats to produce the first line here, the revision has an authority which reverberates through the entire length of the passage. It has done more than anything else Keats wrote to identify him as someone dedicated to 'the beautiful' – someone for whom sensuous pleasures exist without any kind of context. There is a great deal in his letters and other poems which supports this view. 'What the imagination seizes as Beauty must be truth'; 'Beauty is truth, truth Beauty'; 'I cannot conceive any beginning to such a love as I have for you [Fanny Brawne] but Beauty'; 'I have loved the principle of beauty in all things'. But in the first thirty-odd lines of his new poem, it is clear that his sense of what constitutes a 'joy for ever' entails other and more pragmatic elements. 'Beauty' is not an escape but a medicine (promoting 'a sleep / Full of sweet dreams, and health, and quiet breathing'). It is a general salvation rather than a merely personal pleasure. It is not a way of arresting the destructive flow of time, but of criticising corrupt power ('the inhuman dearth / Of noble natures, of the gloomy days, / Of all the unhealthy and o'er-darkened ways / Made for our searching').

In so far as these remarks have attracted any comment from Keats's readers, they have usually been related to a broad humanist philosophy. In fact – and this is important for the poem as a whole – they have a quite specific origin and aim, and a particular debt to Hunt. In the early spring of 1817, Hunt had attacked the excesses of the restored Bourbon regime in France, and the support given to it by the British government. Kings, he had said in April, 'by the modern received theory of Legitimacy, have a right like God to do what they will . . . to waste provinces, to persecute

individuals, to nourish superstition, to gorge their favourites with the fat of the soil.'[26] Elsewhere he blamed Parliament for taking 'our eatables, our drinkables, wearables' only to enable 'the King of FRANCE to keep a good table',[27] pointing out that bad harvests had recently made this especially hurtful, and later writing in detail about the disturbances they created: riots in manufacturing towns, an assault on the King's coach which led to the 'Gag Acts', the trial and acquittal of William Hone.

These articles, which helped to focus Keats's sense of living in 'gloomy days', were not the only writings by Hunt which affected his plans for *Endymion*. He was also affected by *Rimini*.[28] His obligations to this poem have often been measured in terms of style and language. Hunt's theme also affected him deeply, helping him to focus the argument for his own poem. *Rimini* differs from its source, Dante's *Inferno*, in sympathising with Paolo and Francesca rather than emphasising their sinfulness, criticising a society which is indifferent or hostile to individual development. Early in *Endymion*, a similar association is made between 'beauty' and liberalism in the appearance of a 'goodly company' which demonstrates that respect for the holiness of the heart's affections can 'wipe away all slime / Left by men-slugs and human serpentry'. The seeds of this idea are present in the opening lines, announcing what Keats calls elsewhere a 'voyage of conception'. This is not to say that the poem's structure is an exercise in consecutive reasoning, which Keats distrusted and associated with rigid conventions. His emphasis on 'beauty' links its opportunities for self-forgetting to its role in promoting intellectual and human growth. As the imagination treats what the senses absorb or feel, it organises a journey from subjectivity to objectivity, from internal workings to a 'mature philosophy'. The effect is not just a transformation but a redemption. Like Wordsworth in the Preface to the *Lyrical Ballads*, and Shelley in the *Defence of Poetry*, Keats offers the opening lines of his poem as an article of faith in the power of poetry to function as a distinctly liberalising force. It casts 'a cheering light / Unto our souls'.

FIFTEEN

KEATS PUT THE opening lines of *Endymion* to one side as soon as he had completed them. There were practical matters he needed to sort out before he began work on the poem proper. He and his brothers had

[163]

become increasingly fed up with their Cheapside lodgings. The rooms were damp, Tom's health seemed to be deteriorating, and Keats himself was suffering from occasional colds and aches. George, too, was unhappy with London. Like Tom before him, he disliked clerking for Abbey in Pancras Lane, and after a quarrel with the junior partner in the office, Cadman Hodgkinson, he had resigned. Keats, still smarting from Abbey's insulting response to *Poems*, sympathised with George's irritation, and swore eternal loathing of Hodgkinson.

Hampstead was an obvious choice for their new home. It was a healthy distance from London, and in spite of his growing doubts about Hunt, he had grown fond of the place over recent months. When the brothers heard in early April that the local postman, Bentley, was letting the first floor of his house at 1 Well Walk, they soon came to terms. The sitting-room-cum-study overlooked a pretty avenue of lime trees which led on to the Heath; the one bedroom was small, but dry and airy. The only disadvantage was the Bentleys' carrot-haired children, whose racket disturbed Keats, and whose more or less continual presence indoors during the following winter made the house seem cramped. He complained about having to 'breathe worsted stockings'.

Haydon disapproved of their choice because he associated Hampstead with Hunt. But Hunt began his intimate incarceration with Shelley in Marlow almost exactly as Keats arrived, and showed no signs of returning to his cottage. Other neighbours soon proved more congenial. A few days after the brothers had moved in, Reynolds introduced Keats to Charles Wentworth Dilke, his 'chatty' wife Maria, and their adored only son, who lived down the hill from Well Walk. Dilke was seven years older than Keats (he had been born in the year of the French Revolution), the son of an ambitious and family-minded Admiralty clerk who worked for much of his life at Portsmouth. After studying at Cambridge, where he distinguished himself as a scholar and radical – he was deeply committed to the philosophy of William Godwin – he began clerking in the Naval Pay Office at Somerset House, simultaneously establishing a reputation as a man of letters. He edited several supplementary volumes to Robert Dodsley's *Select Collection of Old English Plays*, and also wrote on the Junius controversy[1] (as Taylor had done), Elizabethan drama, and Pope. He was a solidly built, serious man, pale-faced with short black hair and long sideburns, whose friends respected his advanced ideas but chided him for propounding them too rigidly. Charles Lamb once categorised an 'obstinate blockhead' as a

'*Dilkish* blockhead', and Keats himself said that Dilke's too-tidy conception of human progress made him a 'Godwin-perfectability man' – someone 'who cannot feel he has a personal identity unless he has made his mind up about everything'.

Like his father before him, Dilke took a slightly self-important interest in his family's pedigree, and was keen to live in a manner which suited what he believed was his station in life. In 1816 he had arranged with a schoolfriend, Charles Brown, to follow the patterns of successful men by moving out of London to the suburbs – to the recently built villa in Hampstead where Keats first encountered him: Wentworth Place. It was in effect two semi-detached houses – a white Regency box which stood in its own garden, faced directly on to the Heath, and had separate entrances for its incumbents. The atmosphere in Hunt's cottage had been exhilarating and hectic. Everything in Dilke's house was amiable and orderly – but in its way just as likely to appeal to Keats. Dilke's literary tastes coincided with his own, and his politics, though sternly expounded, were essentially sympathetic. His passion for fair dealing eventually led him to become Fanny Keats's trustee, quarrelling with his friend Brown in the process, and to make the *Athenaeum*, which he edited later in life, staunchly egalitarian. One of his colleagues on the magazine, Charles Horley, said 'it is impossible to know and not respect him, however so many were his prejudices (and they were limited)'.[2] He wrote passionately against the Corn Laws, in favour of Parliamentary and economic reform, in defence of his notions of progress, and about what he called in a letter to his son 'self-responsibility'.[3] Looking back in middle age on the time when he first met Keats, he made clear that he abhorred its corruptions and inequalities: 'The great battle which [the Radicals] had to fight, was against the prejudices of society. Disputes *now* respect questions on which honest men may conscientiously differ; but *then*, it was whether the one party were entitled to offer an opinion at all. Twenty years ago reformers were hunted down in society as vulgar unwashed mechanicals, and any man who desired to live quietly and pleasantly, was obliged to be silent if he entertained opinions that now pass current all England over.'[4]

To start with, at least, this friendship had to remain tentative. Fearing that Keats's pleasure in his new lodgings might weaken his resolve to leave town and concentrate on his poem, Haydon took him for a long walk through Kilburn Meadows, a mile north of Oxford Street, and told him to stick to his plans. He cited the recent disagreeable business with

'old Wood' as a proof of Hunt's continuing 'delusions', and of the likelihood that he would try and snare Keats once more when he returned to London. The effect, according to Haydon himself, was to make Keats round on Hunt more violently than he had ever done before. 'What a pity', Haydon reported him saying, 'there is not a human dust hole' into which he might sweep 'the mean people' who disappointed him. Keats added, blushing, that 'Byron, Scott, Southey & Shelley think they are to lead the age, but – '. Haydon deleted the final words from his diary, but their meaning is clear.

Although Keats had been considering his escape from London for several months, he still had no firm idea about where he might go. Margate was a possibility, but when Dilke suggested the Isle of Wight, it seemed preferable: more truly removed, a kind of ready-made bower. (Dilke had often visited the island as a child; his married sister still lived on the mainland opposite.) As Keats weighed its advantages, he heard that Taylor would definitely publish him in the future. It was the final encouragement he needed. With George agreeing to stay in Well Walk and look after Tom, he packed his few belongings and, as Haydon advised, the props he needed for his writing. He took some prints that he especially liked – one of Mary Queen of Scots and another of Milton with his daughters – and his seven-volume, pocket-sized edition of Shakespeare. (Within a few weeks he would be telling Haydon that he was 'very near agreeing with Hazlitt that Shakespeare is enough for us'.) In the evening of 14 April, wrapped in a woollen scarf, and travelling for economy's sake on the outside of the coach, he left Holborn for Southampton seventy-five miles away. It was the first time he had ever planned to live and write alone.

KEATS DID NOT THINK he would be coming back to London until his poem was finished; indeed, he intended that its structure would in part depend on matching the growth of his narrative to the cycle of the seasons. As his coach travelled through the open country of Surrey and Hampshire, past hedges powdered with white dust, 'sometimes Ponds – then nothing – then a little Wood . . . then . . . houses which died away into a few struggling Barns', his enormous task began to press on him. What had he already produced to justify this new effort? How would he cope with the unaccustomed solitude? He told himself that these questions were linked to themes he already had in mind. *Endymion* was to be a 'trial of invention', as well as a summary of long-held beliefs.

When darkness fell the air became frosty, and Keats paid extra to move inside the carriage, where he fell asleep. He woke at dawn on the borders of West Sussex and Hampshire, wondering how he might best pass on what he saw to his brothers. As he reached Southampton, he missed them so badly that he 'unbox'd a Shakespeare' from his luggage, and quoted *The Tempest* to himself: 'There's my comfort.' Then, when he had eaten breakfast and 'enquired for a boat' from Southampton Water, he sent them news of his journey, and messages to the friends who had been 'pushing each other out of my Brain by turns'.

By the early afternoon he was on the dockside, looking down Southampton Water towards the place he imagined would be his home for the next several months. He would soon say that 'the Island ought to be called Primrose Island', but he already knew it would be beautiful. He had read the Elizabethan poet Michael Drayton saying that 'Of all the southern isles [Wight] holds the highest place, / And ever since hath been the great'st in Britaine's grace'; if he had looked at contemporary guidebooks, he would have found them agreeing that 'few places of equal extent possess greater variety and beauty of scenery than this far-famed island; comprehending, as it does, within the space of a few miles, sublime coastal views, terrific chasms formed by the convulsions of nature, richly cultivated plains, and romantic wooded seclusions'.[5] In recent years this 'seclusion' had lessened disastrously. Timber which had once been so plentiful that 'a squirrel might . . . have travelled on the tops of the trees for many leagues together',[6] had been felled for ship building, and the barracks built in 1798 near Newport to house 3,000 soldiers had given the area a 'military character'. But in villages such as Ventnor and Shanklin, and in favourite tourist spots like Blackgang Chine, it was still possible to find traces of the old world. The total population of the island was small (approximately 23,000), the pace of life leisurely, and the climate famously healthy. Even in prospect, it seemed ideally suited to his needs. It was a hideaway and a vantage point. He would be able to contemplate his self and also the surrounding world of which he was so consciously a 'citizen'.

The three o'clock ferry (a wherry or rowing boat which charged one shilling and eight pence) landed Keats at Cowes, directly over the water from Southampton; from there he took a short coach ride to Newport, almost in the centre of the island, and before settling in for the night he walked round the village. According to a contemporary description, it was a 'very convenient' and 'commodious' place, with 'well-paved'

streets and 'modern . . . respectably built houses', but as soon as Keats settled into his lodgings, he was perturbed. Scratched on the window pane in his room was the phrase 'O Isle spoilt by the Milatary [sic]' – a reference to the barracks near by, which echoed his own thoughts about 'The scarlet coats, that pester human kind'. The next morning he packed his bags once more. Newport was a 'Nest of Debauchery' he said, adding more forgivingly that the local girls were 'a little profligate'. He decided to investigate Shanklin in the south-east corner, but when he got there he found it too expensive (though 'most beautiful'), and rattled back to Newport again. On the way, he passed the massive and ivy-covered battlements of Carisbrooke Castle. It was a 'specimen of Ruins' such as he had often admired in engravings of Classical scenes, and he decided to take rooms near by – with a Mrs Cook, who ran a boarding house on the Newport road. Writing to Reynolds shortly afterwards, he described the castle as though it were a Piranesi etching, rich in history and redolent of myth: 'I dont think I shall ever see [a ruin] to surpass Carisbrooke Castle,' he declared. 'The trench is o'ergrown with the smoothest turf, and the walls with ivy – The Keep within side is one Bower of ivy – a Colony of Jackdaws have been there many years – I dare say I have seen many a descendant of some old cawer who peeped through the Bars at Charles the first, when he was there in confinement.'

It was not only the castle which enchanted Keats. The small village which huddled in its shadow was also very appealing. It had a Guildhall, built by John Nash, a new public library, two assembly rooms, and five inns. None of these things, nor the nearby barracks, compromised the ancient spirit of the place. Its church, thatched roofs and winding lanes had a medieval look, and Keats warmed to this as he would later do in Chichester and Winchester. He felt that he was looking at a picture which could easily be absorbed into the painterly world of his imagination. In his lodgings, too, he immediately found something to inspire him: a print of Shakespeare which hung in the passageway, and which he persuaded Mrs Cook to let him put in his room with his other engravings. (It came, he said, 'nearer to my idea of [Shakespeare] than any I have seen'.)

At last, with his stage set, he was ready to begin work. It was the moment he had anticipated for months, the chance to make good his promises to his friends and himself, but just as he had anticipated, he found that he could not simply 'leap in'. He began to digress, writing to Reynolds with comic gravity to say that he felt 'narvus', and then setting

aside his own papers to read Spenser and *King Lear*. As he hoped, this helped to unlock him – though not in the way he had expected. Instead of making a smooth resumption of *Endymion*, he wrote a sonnet which began by trying to convey his recent excitement at seeing 'the sea, Jack, the sea', and ended by concentrating on his frustration:

> Oh ye! who have your eye-balls vexed and tired,
> Feast them upon the wideness of the Sea –
> Oh ye! whose ears are dinned with uproar rude,
> Or fed too much with cloying melody –
> Sit ye near some old cavern's mouth and brood,
> Until ye start, as if the sea-nymphs quired!

'To the Sea' (which Reynolds admired and arranged to be published in the *Champion*) is both a self-reproach and an exhortation, like the sonnet Keats had written to George from Margate the last time he had taken himself off to write. Part of his purpose in composing it had been to steady his nerves; after it was done, he found he was still 'all of a Tremble'. He turned back anxiously to Reynolds, insisting that his faith in his own calling was still as great as his devotion to Shakespeare: 'I find that I cannot exist without poetry,' he said, '– with eternal poetry – half the day will not do – the whole of it – I began with a little, but habit has made me a Leviathan.' The longer he continued, the more sharply he realised that he was protesting too much. Immediately after signing off to Reynolds as his 'Sincere Friend', he picked up the manuscript he had begun in Cheapside, and began work.

His original idea for *Endymion* had sounded simple enough: to 'make 4000 Lines of one bare circumstance and fill them with Poetry'. The circumstance was Endymion's discovery of immortal youth through the love of the moon goddess Diana; Keats intended his hero to pursue her through earth, water and air, elaborating 'some idea of a spiritual development',[7] and dramatising his faith in the fundamental 'truth' of the imagination. His plan was nowhere near as radical as that proposed by Shelley in *Alastor* and *Prometheus Unbound*, but the ambition was similar. He meant to credit natural theology, and condemn institutionalised Christianity and all kinds of repressive power; he wanted to praise beauty and prize human love (in its physical and spiritual forms); he hoped to define the immortality of the soul and thereby transcend the tyranny of the present. Transcend but not escape. Keats's version of the

Endymion myth, which he knew from Lyly, Drayton and others, constructs a visionary alternative to existing circumstances, while always remaining alert to their pressures. It mourns that loss of 'antiquity's sublime language'[8] as it promotes a deliberately excessive alternative. It seeks to reconcile individual desire with familiar experience. It presents a choice between the ideal and the real, and only renounces the former when it turns out to be inseparable from the latter – when the Indian Maid and the moon goddess turn out to be one and the same person at the end of Book IV.

These themes entwine through the whole, palpitating length of *Endymion*. They do not so much chronicle the growth of a poet's mind, as Wordsworth did in the *Prelude*, as the growth of an imagination. This means that anyone complaining about the lack of linear development in the poem is likely to have missed the point. What seems wayward about it – sometimes by design, sometimes by virtue of an instinctive retrieval from the unconscious – is its greatest triumph. 'Weaknesses' (digressions, for example) become part of its grand design: their proleptic freedom enacts the liberalism which lies at the heart of Keats's philosophy. They make it a poem as much concerned with contradiction as conviction.

The critical response to *Endymion* has always depended on its readers' willingness to accept these ambivalences. For those who cannot, it is a poem in which mastery is prey to muddle. For those who do, it is a fascinatingly luxurious hot-house in which poetic and political ideals are urgently developed. Keats realised that his method would present difficulties, and in the introductions to his four Books, he took pains to spell out his main concerns. In the lines written with Stephens in Cheapside he had given a commentary on 'heart-easing' beauty. In Book II he refines this to describe the humanising effects of love. In Book III he attacks the tyrannies which oppose his argument. In Book IV he outlines the role that he expects English poetry to play in realising his liberal ideals. Each section, in a variety of ways, 'den[ies] the possibility of an innocent reading of the narrative as a simple account of a mythic poet'.[9]

Partly because Keats relied more heavily on spontaneous creation than on clear forward planning, these themes tend to transmute from philosophic to imaginative terms as soon as they are announced. This is one reason why he so often struggled unhappily with the poem. His wish to mediate between the individual and the world depended on nothing

but his inner workings. For the first few days in Carisbrooke, sometimes breaking off to read Shakespeare and Spenser, sometimes exploring the deep lanes and gentle hills around the village, he wrestled to link his opening lines to the story of Endymion, reinforcing the connection by invoking the loveliness of the seasons, then sinking into a 'mighty forest' on 'the sides of Latmos' where he discovers 'a marble altar' in 'the middle of this pleasantness':

> therein
> A melancholy spirit well might win
> Oblivion, and melt out his essence fine
> Into the winds: rain-scented eglantine
> Gave temperate sweets to that well-wooing sun,
> The lark was lost in him; cold springs had run
> To warm their chilliest bubbles in the grass;
> Man's voice was on the mountains; and the mass
> Of nature's lives and wonders pulsed tenfold,
> To feel this sun-rise and its glories old.

Keats does not try to 'fade' from familiar life into 'Oblivion' in these lines. He wants to associate the pressures of the present with an ancient cultural ideal. When the priest and his 'goodly company' arrive to make a sacrifice to Pan, their 'glee' and 'old piety' suggest that for them, at least, the reconciliation is fully achieved. Young and old, children and shepherds, 'chieftain' and 'common lookers-on', form a harmonious tableau which is both democratic and natural. Baskets brim with 'April's tender younglings', inequality is eradicated (people 'shar'd their famished scrips'), and 'simple times' are celebrated in a vision of order which is obviously Classical but also plainly patriotic and partisan. (The word 'our' appears seven times in ten lines as the priest gives his address.[10])

Things are not so settled for Endymion himself. When he appears for the first time, following in the wake of this 'company', he is vexed with a 'lurking trouble'. 'Ah, well-a-day', Keats sighs, 'Why should our young Endymion pine away?' The answer emerges through the remainder of the poem, but at this point, sobered by the thought of how many more 'lines' he must 'fill', and eager to diversify his argument, Keats steps back from his narrative and writes a 'Hymn to Pan'. It is, self-evidently, a piece of Paganism, a self-dedication to the

principles he had admired in the Elgin Marbles and elsewhere. It is also a tribute to purely natural forces. The five long verses shift gradually from a quasi-Elizabethan manner to one which is obviously indebted to Wordsworth. 'Be still the unimaginable lodge / For solitary thinkings', the chorus says to Pan:

> such as dodge
> Conception to the very bourne of heaven,
> Then leave the naked brain; be still the leaven,
> That spreading in this dull and clouded earth
> Gives it a touch ethereal – a new birth;
> Be still a symbol of immensity;
> A firmament reflected in a sea;
> An element filling the space between;
> An unknown – but no more! we humbly screen
> With uplift hands our foreheads, lowly bending,
> And giving out a shout most heaven rending,
> Conjure thee to receive our humble paean,
> Upon thy Mount Lycean!

In this final stanza Keats brings his poem to a premature climax, and stalls it. The blend of romantic rhetoric and medical reference (the images of diffusion and refraction, the 'touch ethereal' and the 'naked brain') bewilders him at the same time as it validates his quest, making him reel away – 'but no more!' – when he approaches the synthesis he admires. In the letters he began writing as he finished the Hymn, he shows the same mixture of excitement and exhaustion. He says that soon after overcoming his difficulties in restarting the poem, he became 'not capable in my upper stories'. His problems were partly to do with the demands of concentrated writing; they were also a result of the solitude in which he was working. His loneliness without his brothers and friends made him keen to move on from Carisbrooke.

Keats felt he would be admitting failure if he acknowledged these things openly. He turned instead to blaming the island. There were fewer sympathetic souls than he had expected. (Reynolds, who had said he might join him, was too busy to leave London.) Worse still, it was a 'treeless affair'. Considered as a purely aesthetic objection, this seems curious. But when we remember that much of the woodland on the island had recently been cut down to build ships, we realise that Keats was making a different sort of point. The bare downs and stripped-out

valleys marked the destruction of everything he held dear. His bower had been desecrated by the very forces he was criticising or trying to transcend in *Endymion*.

AT THE END OF the first week in May, Keats 'set off pell mell for Margate, at least 150 miles', where he had stayed ten months earlier and where Tom once again joined him. Initially he feared that he would have to 'do without Trees' once again, but within days he was planning 'to get among some', surrounding himself with what he later called the 'mighty senators' which provided the landscape and iconography of his interrupted poem.[11] His move did the trick. After a few days spent sightseeing and acclimatising to his new lodgings (Mrs Cook allowed him to take the portrait of Shakespeare from his room at Carisbrooke), he settled into a routine of reading and writing for eight hours a day. He told Hunt in an awkward letter of 10 May that it was still 'continual uphill Journeying', but his enthusiasm for his task was returning. During the previous week, he had sent his 'Hymn to Pan' to Haydon, who had told him that he had been 'quite right to leave the Isle of Wight if you felt no relief in being quite alone after study', and saying that he had read his 'delicious Poem with exquisite enjoyment[.] [I]t is the most delightful thing of the time – You have taken up the great trumpet of nature and made it sound with a voice of your own.'

Haydon ended his letter with a gust of typically friendly advice. 'God bless you My dear Keats go on, don't despair, collect incidents, study characters, read Shakespeare and trust in Providence.' His encouragement was shrewd as well as heart-easing. Referring to the 'great trumpet of nature', he had focused on the theme of natural unity which lies at the heart of the Hymn. As Keats worked on the next section of his poem, he extended its argument to prove that Pan embodied a form of thinking, as well as a type of sensuous responsiveness. He invented the figure of Peona (Endymion's sister and guide: her name is perhaps derived from 'Paean', physician to the gods – or from the fact that Lemprière says Endymion had a son called Paeon). He devised a pattern of waking and sleeping which would dramatise his investigation of ideal and real states, and 'the fragile bar / That keeps us from our homes ethereal, / And what our duties there'. He dotted his hero's wanderings with signs that kept his ultimate purpose in mind: to discover, as he pursued 'Cynthia bright', that his 'endearing love' was not merely a personal desire but a means of defining a broadly social good.

As Keats worked, anxieties slowly gathered round him. Letters he wrote to Hunt and Haydon show him torn by conflicting loyalties, at one moment congratulating Hunt on a recent article attacking religious intolerance and signing himself affectionately 'John Keats alias Junkets', at another complaining to Haydon that 'Libertas' was self-deceiving. His correspondence with George contains different kinds of confusion. After leaving Abbey, George had worked briefly for a linen draper, and then borrowed some £50 from his brother to launch a business scheme of his own. Keats now found himself short of funds, possibly because Abbey was hesitating to pay interest due on his capital, possibly because George's business plans had swiftly collapsed, preventing him from repaying the money he had borrowed. Even though the crisis soon passed (in the third week of May Taylor and Hessey forwarded him £20), the 'bill-pestilence' left Keats feeling that life was conspiring to distract him from his work. His excitement at returning to Margate faded. The recent past felt tainted, and the immediate future disappointing.

His ebullience did not entirely desert him. Even when thwarted by his poem, he continued to read with his usual hungry intensity, concentrating on the seven-volume Shakespeare that he had brought from Hampstead. His marginal comments, many of them written in mockery of quotations that the editor Steevens had selected from Samuel Johnson,[12] tell us as much about his gusto as they do about his impatience. He crossed out several of Johnson's notes, slightingly ignored others, and deliberately misquoted Shakespeare to provide apt criticisms ('such tricks hath *weak* imagination'). In the process, he echoed the remarks about Augustan taste that he had made in 'Sleep and Poetry', and continued to develop the analysis of Shakespeare which formed part of his drive towards a complete poetic identity. Although his one straight-faced annotation lacks the penetration of his later remarks ('How much more Shakespeare delights in dwelling upon the romantic and wildly natural than upon the monumental'), it nevertheless shows him groping towards perceptions which would eventually become 'axioms' about negative capability and the chameleon poet.

Baiting Johnson could not lift his spirits for long. When Keats next wrote to Haydon, whose enthusiasm for Shakespeare reinforced his own, he indicated that rereading the plays had aggravated his self-doubt. Reminding him of how far he still had to travel on his poetic journey, they awoke miserable feelings of inferiority and wounded pride:

So now I revoke my Promise of finishing my Poem by the Autumn which I should have done had I gone on as I have done – but I cannot write while my spirit is fe[a]vered in a contrary direction and I am now sure of having plenty of it this Summer – At this moment I am in no enviable Situation – I feel that I am not in a Mood to write any today; and it appears that the loss of it is the beginning of all sorts of irregularities. I am extremely glad that a time must come when every thing will not leave a wrack behind. You tell me never to despair – I wish it was as easy for me to observe the saying – truth is I have a horrid Morbidity of Temperament which has shown itself at intervals – it is I have no doubt the greatest Enemy and stumbling block I have to fear – I may even say that it is likely to be the cause of my disappointment. How ever every ill has its share of good – this very bane would at any time enable me to look with an obstinate eye on the Devil Himself – ay to be as proud of being the lowest of the human race as Alfred could be in being of the highest. I feel confident I should have been a rebel Angel had the opportunity been mine.

WITHIN A WEEK of finishing this letter to Haydon, Keats decided to make yet another bid for the right kind of solitude. He left Margate and travelled with Tom the short distance inland to Canterbury.[13] Clustered round its cathedral, the town had an even more obviously medieval feel than Carisbrooke, and a similar picturesqueness that suited the mood of his poem. Its associations with Chaucer meant that he could add another 'Presider' to the one whose works and portrait he carried in his luggage. In his letter to Taylor and Hessey thanking them for their advance, he said that he hoped 'the Remembrance . . . will set me forward like a billiard-Ball'. It is not known exactly what stage of Book I of *Endymion* Keats had reached when he arrived in Canterbury. It is clear, however, that during the time he spent there (possibly one week, possibly three), he devoted himself to poetry more completely than he had yet managed to do. He stopped sending letters. He found ways of combining his circumstantial worries with the grand themes he had set himself. This resulted in two further set pieces. The first is the dream vision Endymion describes to Peona – the vision in which he remembers his first sight of Cynthia, and which has troubled him ever since with knowledge of 'things mysterious, / Immortal, starry'. It has often been celebrated as the first, dynamic moment in which Keats's erotic imagination reconciles worldly desires with transcendent longings, even though it contains a good deal of awkwardness about its subject:

> Ah! see her hovering feet,
> More bluely veined, more soft, more whitely sweet
> Than those of sea-born Venus, when she rose
> From out her cradle shell.

The sequel to this vision is an anti-climax even more remarkable than the climax itself. It is a 'stupid sleep' which plunges Endymion into the merely real (the real which is nothing without a sense of its opposite), where everything natural is corrupted:

> all the pleasant hues
> Of heaven and earth had faded: deepest shades
> Were deepest dungeons; heaths and sunny glades
> Were full of pestilent light; our taintless rills
> Seemed sooty, and o'er-spread with upturned gills
> Of dying fish; the vermeil rose had blown
> In frightful scarlet, and its thorns out-grown
> Like spiked aloe.

Like the 'Hymn to Pan', these two passages address the question of unity – the coherence of the individual, and the integration of the self with society. As Peona responds to them, flushing Keats's philosophy into the open, she brings the poem to one of its most vital and critically disputed episodes:[14] an adumbration of the pleasures which lead 'Men's being mortal' to immortality. Eight months later, when Keats was revising the poem in January 1818, he added a passage which he hoped would spell out the terms of his argument. Sending it to Taylor, he said that the first draft of *Endymion* 'must I think have appeared to you, who are a consequitive Man, as a thing almost of mere words – but I assure you tha[t] when I wrote it, it was a regular stepping of the Imagination towards a Truth. My having written that Argument will perhaps be of the greatest service to me of any thing I ever did – It set before me at once the gradations of Happiness even like a kind of Pleasure Thermometer – and is my first Step towards the chief Attempt in the Drama – the playing of different Natures with Joy and Sorrow.' These are the lines he meant:

> Wherein lies happiness? In that which becks
> Our ready minds to fellowship divine,
> A fellowship with essence; till we shine
> Full alchemized and free of space. Behold

To fret at myriads of earthly wrecks.
Wherein lies Happiness? In that which becks
Our ready minds to fellowship divine,
A fellowship with essence, till we shine
Full alchemized & free of space. Behold
The clear Religion of Heaven! Fold

5 *Endymion*, Book I, lines 77–81. A fragment of the section added when Keats revised the poem, and sent to Taylor on 30 January 1818.

The clear religion of heaven! Fold
A rose leaf round thy finger's taperness,
And soothe thy lips; hist, when the airy stress
Of music's kiss impregnates the free winds,
And with a sympathetic touch unbinds
Aeolian magic from their lucid wombs;
Then old songs waken from enclouded tombs;
Old ditties sigh above their father's grave;
Ghosts of melodious prophesyings rave
Round every spot where trod Apollo's foot;
Bronze clarions awake, and faintly bruit,
Where long ago a giant battle was;
And, from the turf, a lullaby doth pass
In every place where infant Orpheus slept.
Feel we these things? – that moment we have stepped
Into a sort of oneness, and our state
Is like a floating spirit's. But there are
Richer entanglements, enthralments far
More self-destroying, leading, by degrees,
To the chief intensity: the crown of these
Is made of love and friendship, and sits high
Upon the forehead of humanity.
All its more ponderous and bulky worth
Is friendship, whence there ever issues forth
A steady splendour; but at the tip-top,
There hangs by unseen film, an orbèd drop
Of light, and that is love: its influence,
Thrown in our eyes, genders a novel sense,
At which we start and fret; till in the end,
Melting into its radiance, we blend,
Mingle, and so become a part of it –
Nor with aught else can our souls interknit
So wingedly. When we combine therewith,
Life's self is nourished by its proper pith,
And we are nurtured like a pelican brood.
Ay, so delicious is the unsating food,
That men, who might have towered in the van
Of all the congregated world, to fan
And winnow from the coming step of time
All chaff of custom, wipe away all slime
Left by men-slugs and human serpentry,
Have been content to let occasion die,

Whilst they did sleep in love's elysium.
And, truly, I would rather be struck dumb,
Than speak against this ardent listlessness:
For I have ever thought that it might bless
The world with benefits unknowingly,
As does the nightingale, up-perchèd high,
And cloistered among cool and bunchèd leaves –
She sings but to her love, nor e'er conceives
How tip-toe Night holds back her dark-grey hood.
Just so may love, although 'tis understood
The mere commingling of passionate breath,
Produce more than our searching witnesseth –
What I know not: but who, of men, can tell
That flowers would bloom, or that green fruit would swell
To melting pulp, that fish would have bright mail,
The earth its dower of river, wood, and vale,
The meadows runnels, runnels pebble-stones,
The seed its harvest, or the lute its tones,
Tones ravishment, or ravishment its sweet,
If human souls did never kiss and greet?

Knowing that Keats distrusted consecutive reasoning, some readers have found his 'thermometer' hard to read clearly. As elsewhere in *Endymion*, he is creatively divided between an evident Truth and an organic Beauty. But as he rises through his calibrations, climbing from physical enjoyment to the pleasures of music and poetry, to friendship, to the passionate love of couples, he is in fact spelling out a progress that he had already announced in the opening lines of his poem. The Hymn to Pan is a hymn to mutuality; Endymion's dream of Diana is a vision of perfect 'commingling'; the 'pleasure thermometer' is a plan for spiritual fulfilment – not just the fulfilment of gratified desire, but of achieved liberty. Obviously this includes ideas that Keats derived from Plato. Equally obviously it embraces themes that he admired in Shakespeare and Spenser. It also refers to the responsibilities he had shouldered in Guy's and discussed with Hunt. At the very beginning of his poem he framed these in what has become one of literature's most famous aphorisms. After he had finished it, he described them in another and equally well-known formula: 'I am certain of nothing but the holiness of the Heart's affections and the truth of Imagination – What the imagination seizes as Beauty must be truth – whether it existed before

[179]

or not – for I have the same Idea of all our Passions as of Love they are all in their sublime, creative of essential Beauty.'

As PEONA LED Endymion away for the next and underground stage of his quest, Keats suddenly grew more confident. The 'trial' which had begun by dismaying him now seemed self-justifying. To have made even a thousand lines of 'one bare circumstance' proved that he had been right to trust 'my Powers of Imagination and chiefly of my invention'. He could see that his freely spawning couplets were an act of self-possession and a sign of expansiveness, a formal journeying which matched the description he gave to his brother of 'Invention' being 'the Polar Star of Poetry, as Fancy is the Sails, and Imagination the rudder'.

He allowed himself a breathing space, sending Tom back to Well Walk, where George and Mrs Bentley would keep an eye on him, and travelling south to the quaintly named coastal village of Bo Peep, near St Leonards. (It had been recommended to him by Haydon.) Although he only stayed there a few days, it was long enough for him to make one of his most mysterious and provocative friendships: with Isabella Jones. Much of what we know about her, and even more of what we might suppose to be true, was unearthed by Robert Gittings as he prepared his biography of Keats. She was not a woman 'in the first flight of society, for her name was not listed among the fashionable visitors'[1] to the area during May, but for the past several summers she had stayed in the nearby resort of Hastings 'with an elderly member of a listed Whig family, Donat O'Callaghan, to whom she was attached in some undefined way'.[2]

Isabella Jones was beautiful, amusing, well read, and sexy; Keats soon 'warmed with her and kissed her', and incorporated the feelings she provoked into his writing. When he began the second Book of *Endymion*, he opened with a paean to romantic love which is set in a landscape closely resembling the Fishponds, a well-known Hastings beauty spot they presumably visited together, and during the following summer he wrote three love lyrics which are tense with sexual desire and remembered pleasure. Their descriptions of women often hark back to his whimsical earlier poems ('languid arms' and 'faery lids'), but the lover himself is demanding, eager to 'feed and feed' until he finds

fulfilment: 'Hither, hither, hither, / Love this boon has sent – / If I die and wither / I shall die content'.

During the whole of their friendship, Keats never hesitated to say that he felt strongly attracted to Isabella Jones. Her reaction to him is less certain. In one of the short poems probably written for her, he later suggested that after their first encounter she held back from him. 'You say you love', he complained, '– but then your lips / Coral tinted teach no blisses / More than coral in the sea – / They never pout for kisses – / O love me truly!' There are various possible explanations for Isabella's hesitation. Maybe she was a flirt and no more. Maybe she felt that her involvement with O'Callaghan (and, later, with John Taylor) created practical difficulties which prevented her from becoming involved with Keats. Maybe, because she was more experienced in the ways of the world, she soon found him disappointing company. Whatever the reasons, and in spite of the continuing intimacies that Gittings implies, their relationship is characterised more by circlings than commitments. While this obviously tantalised Keats, it also suited him. It allowed him to live within the pale of his creative self-doubts, and to develop his imagination as an alternative to familiar experience. In this sense, Isabella Jones's restraint was her greatest gift to him. It created a charged friendship which was not merely supportive (she often gave him and Tom presents) but inspiring (she suggested the subjects for 'The Eve of St Agnes' and 'The Eve of St Mark', and may even have added indefinably to his imaginative excitement in 'Isabella'). In 1821 she was amongst the first to be told the news of his death.

KEATS WAS BACK IN Well Walk by early June, in time to read the first and disappointing instalment of Leigh Hunt's article about *Poems*. This alone was enough to destroy his optimistic holiday mood, and the anxieties which rushed to replace it were soon compounded by continuing money worries. Within a matter of days, after consulting with Reynolds in Lamb's Conduit Street, he wrote once again to Taylor and Hessey for help, receiving a further £10, and thanking them in a letter which was meant to sound jolly but only seemed 'narvus'. Since beginning *Endymion* he had climbed laboriously on to a narrow ledge of self-esteem. Now he toppled back into self-doubt, seeking out his friends and relying on their support, when he knew that he should be working in Well Walk. He tried to contact Charles Cowden Clarke but

found that he was staying with his parents in Kent. He borrowed books from Taylor. He socialised with the Dilkes and the Reynoldses, and walked on Hampstead Heath with Severn. He fretted about his sister Fanny. He visited Haydon but made no effort to contact Hunt, who had recently returned from Marlow and moved into 13 Lisson Grove North, in London. At the end of the month, Hunt wrote a letter to Clarke, which Clarke later edited for his *Recollections*. Part of it has since become well known; the suppressed remainder is very revealing about the impatience and competitiveness in their three-cornered relationship. 'What has become of Junkets I know not,' Hunt says; 'I suppose Queen Mab has eaten him. If not, I have no doubt that he will appear before us all again very penitent, & poetical, and really sorry. He wants a little more adversity perhaps to make him attend to others as much in reality as he wishes to do in theory; and all that we can hope at present is, that a growth of his ardour may not bring too much upon him too soon.'[3]

Book I of *Endymion* had taken Keats a month to complete. Book II was to take him three, and much of it lacks the digressive vigour of its predecessor. It begins promisingly enough, with the address to the 'sovereign power of love' that had probably been prompted by Isabella Jones. It has sometimes been claimed that this amounts to an abandonment of his original effort to reconcile personal and political forces. In fact, though, Keats is careful only to reject the history 'of martial conflict and powers'[4] – the 'woes of Troy' and the adventures of Alexander. When he calls history 'a gilded cheat', and a 'Wide sea' which transforms wrecks into 'goodly vessels' (perhaps remembering the Naumachia of August 1814), he means to show that it repels him only if it is defined by exclusively political interests. In other words, an idea of history which does not allow for the 'sovereign power' of love is misconceived. The purpose of his poem remains to 'uprear / Love's standard on the battlements of song' for large social reasons, as well as to energise the intimate story of his hero.

Soon after making this brave start, Keats shifted away from 'the universe of deeds'. At one point he criticises himself for his retreat, desperate to combine imaginative wanderings with a definition of actual 'human life', but stumbling as he does so, and then collapsing between choices. The passage is spoken by Endymion, who for the previous 150 lines has been toiling through the underworld, following the fickle track of a butterfly (which turns into a nymph), and rehearsing the idea that

[182]

suffering is valuable. It is something he understands yet cannot take to heart:

> But this is human life: the war, the deeds,
> The disappointment, the anxiety,
> Imagination's struggles, far and nigh,
> All human; bearing in themselves this good,
> That they are still the air, the subtle food,
> To make us feel existence, and to show
> How quiet death is. Where soil is men grow,
> Whether to weeds or flowers; but for me,
> There is no depth to strike in. I can see
> Naught earthly worth my compassing; so stand
> Upon a misty, jutting head of land –
> Alone? No, no; and, by the Orphean lute,
> When mad Eurydice is listening to't,
> I'd rather stand upon this misty peak,
> With not a thing to sigh for, or to seek,
> But the soft shadow of my thrice-seen love,
> Than be – I care not what.

In the next several lines, Endymion links these ideas to others familiar from Book I: the plight of the solitary 'habitual self', the necessity of 'fellowship', the ambition to emulate 'The mighty ones who have made eternal day / For Greece and England'. But like the pursuit of love itself, these remain ideals or questions, not things he can confidently possess. Only when he begins to pray blindly to Diana does he find any sense of release.

Narratively speaking, Diana allows a way forward: she encourages Endymion to move quickly to the bower of Adonis, whom he finds being woken by Venus from his half-year sleep. In other respects, this only deepens the problems Keats has recently encountered. Even though Endymion finds parallels between Adonis's situation and his own (they are both incapable of reconciling ideal and real), he speaks in language which aims at rapturous sensuality but merely sounds gooey. 'Here is wine, / Alive with sparkles – never, I aver, / Since Ariadne was a vintager, / So cool a purple'; 'and here, undimmed / By any touch, a bunch of blooming plums / Ready to melt between an infant's gums'. Such phrases, like 'lips, O slippery blisses' and 'white deliciousness', have been defended by some Keatsians on the grounds that they

combine pleasure with distaste in a way which reflects the larger scheme of the poem. But while it is possible to accept what has been called their 'vulgarity'[5] as a theoretical strength, much of Book II is embarrassing in a weak and uncreative sense. As Endymion winds on his subterranean journey, meets Cybele, hears the love song of the river Alpheus for Arethusa, and finally emerges to find 'the great sea above his head', his emphasis on the need to combine pleasure with pain becomes repetitive, and the descriptive language only feebly metaphorical. Obviously this has something to do with his sudden return to a style he learned from Hunt. Possibly it is also a legacy of his recent experience with Isabella Jones. Keats was both bewitched and at a loss. The love he had placed at the heart of his poem, which is designed to resist the tyrannies surrounding it, is something he had found easier to celebrate in theory than in fact. It is not so much a vindication of his imaginative principles as a challenge to them. The poet and the lover are distinct, and as Keats struggles to understand and remedy this, he self-critically consigns himself to precisely the silver age of poetry that he was determined to rise above:

> Yet, oh yet,
> Although the sun of poesy is set,
> These lovers did embrace, and we must weep
> That there is no old power left to steep
> A quill immortal in their joyous tears.

ONE SUNDAY IN late June, Keats broke his vow to keep silent about his poem until it was half finished; he read his 'Hymn to Pan' and his description of the bower of Adonis to Severn and Charles Cowden Clarke, who had recently returned from his visit to the south coast. He needed to collect himself. A short while previously, Mathew had published a review of *Poems* in the *European Magazine* which scorned his liberalism, his radical friends, and his 'mere luxuries of the imagination'. When it had been followed by the first part of Hunt's article, Keats had felt stranded between an old life that he no longer wanted, and a new one in which he was neglected. After Hunt had eventually persuaded him to visit his new house in Lisson Grove North, Keats reported on the meeting doubtfully, admitting that Hunt's 'makes-up are very good'. (Keats had arrived wearing 'some sort of naval costume' – presumably a variation on his Byronic costume of the previous year.)

As he had done so often in the past, Keats consoled himself by spending time with his brothers. Even their company raised difficulties. Tom, whose health had improved in Margate and Canterbury, now seemed weaker again, and Keats proposed that he visit France during the summer – using money that he had originally hoped to spend on himself. George, too, was preoccupied. Since the failure of his business, he had been compelled to apply once more to Abbey for work, injuring his pride in the process, and limiting his independence. Furthermore, he now told his brother that he was in love – with Georgiana Wylie. Keats did not know her well, but he approved of her, and was happy to see the principles of his poem applied in practice. He appreciated, however, that she was likely to create different loyalties in his family.

The same mixed feelings coloured his relationship with Reynolds. As a young man, Reynolds had fallen in love with a girl who had died young. While on holiday at Sidmouth in Devon the previous autumn, 1816, he had met Mary, Sarah and Thomasine Leigh, three sisters who lived at Salcombe Regis with their mother. They had introduced him in turn to a neighbour, Eliza Drewe, whom Reynolds now described as 'the maiden of my bosom': he hoped to marry her once he had qualified as a lawyer. Like George's news, this encouraged Keats to court Isabella Jones in several poems, one of which Reynolds quoted in the *Champion* on 17 August. At the same time, it stirred his suspicions about the fickleness of women and the dangers of marriage.

It also suddenly increased his sense of isolation, and made him more responsive than ever to any new 'kindred spirits' he happened to meet. Earlier in the summer he had come across two of Reynolds's friends, both of whom he had immediately liked. One was James Rice, the consumptive son of an attorney who had offices near Haydon in Great Marlborough Street. Rice was now training to be a lawyer himself – he would eventually go into partnership with his father – and living in Poland Street, from where he regularly took holidays for his health in the West Country. (It was on one of these trips, in 1814, that he had first met the Leigh sisters, shortly afterwards introducing them to Reynolds.) Like William Haslam, he is someone about whom very little information survives, but who was obviously close and valuable to Keats. Within a short time of their meeting, Keats called him the 'wisest' of 'three witty people' in his set: he 'makes you laugh and think'. Dilke echoed this judgement, referring on one occasion to 'dear generous James Rice', and saying that 'in his quaint way' he was 'one of the wittiest and wisest men I

ever knew'. It was the same with Reynolds. 'Rice', he said, 'was a *very* dear friend of mine . . . He was a true wit – extremely well read – had great taste & sound judgement. For every quality that marks the sensible companion – the valuable friend – the Gentleman and the Man – I have known no one to surpass him.'

Rice's independence had a special appeal for Keats. Although he was good-looking and appreciative of women (of Jane Reynolds, in particular), his ill health kept him at a distance from the world. The fact that his consumption was evidently terminal (he eventually died in 1832 aged forty) meant that he was unlikely ever to get married. Yet for all this, much of what is known about his personality depends on his contact with the Leigh sisters. On his visits to Sidmouth he collaborated with them and other friends in creating commonplace books which reflect his renowned 'taste' and intelligence. Writing in a clear, strong hand, he transcribed poems from a variety of authors, including a long extract from Reynolds's 'The Eden of the Imagination', and at least thirteen short poems of his own. Some of them appear to be addressed to Jane Reynolds; in all of them, sentimental feeling is kept at bay with a melancholy nonchalance, a refusal to submit to the sense that his 'youth' had been 'withered by sickness' and by 'haunting and deformed thoughts and feelings'. In one, for instance, he writes: 'Though I have sometimes in my outward seeming / Worn an aspect unseemly, churlish, rude / And stung thee in my wanton way with mood; / Yet little of offence my heart was deeming, / And even then I bore a "mind subdued / E'en to the very quality" thou ow'st / And when I crost, then chance I loved thee most.' When Keats himself became ill, he sometimes felt irritated and depressed to see his weakness reflected in Rice; more often, he looked upon his stoicism and lack of self-pity as exemplary.

On one of his earliest visits to Devon, Rice met the second new friend to enter Keats's life in the summer of 1817: Benjamin Bailey. Bailey had been brought up in Lincolnshire – he was born in 1791, the same year as Rice – and in 1816 had matriculated at Oxford, to read for Holy Orders. According to Severn he was 'rather stern', and most subsequent biographers have agreed, usually referring to him as 'stuffy' and 'pompous'.[6] This is not surprising. With his big rectangular head, and pursed, opinionated mouth, he could seem severe and orthodox: he was 'fully and gravely determined to his sacred profession', passionately interested in philosophy – especially works by Joseph Butler – and an ardent admirer of Dante, Milton, and Wordsworth. In other respects,

though, he was far from forbidding. he was a skilful light-versifier and a concerned friend. His imperious manner disguised a compulsive emotionalism – something which made him large-hearted at best, tactless at worst, and which attracted him to the free spirits who made up Keats's 'set'.

Once again, the Leigh commonplace books are revealing. Bailey had relatives in Colyton, near Sidmouth, and it is probable that he first met Rice on one of his holiday visits there. In the spring of 1815, Rice introduced him to the Leigh sisters, and he at once joined them and Reynolds in composing and anthologising. During March alone, Bailey transcribed over a hundred poems, and when staying near them over Christmas the following year, he and Reynolds presented Thomasine Leigh with a manuscript entitled 'Poems by Two Friends', of which he had composed thirty-two. Like Reynolds and Rice, he was clearly in a state of mild infatuation, but whereas Reynolds protected his feelings with formal skills, and Rice guarded his heart with ironies, Bailey was more open. In one poem he describes himself as 'the slave of passion' and in others he sympathises with the fatherless girls in their 'time of suffering', or indulges in unrestrained melancholy.

Bailey's contributions also have a more sober interest. He seems to have been largely responsible for shaping and organising the sisters' anthologies, and the work they contain is punctuated by his prose comments about the value of 'friendship, love, and countless other abstractions'.[7] 'Memory softens sorrow long past and brightens the wings of pleasures as they diminish in the distance', he says at one point; and at another 'Pleasure and pain are so intimately connected that the sweets of the one cannot be tasted without a dash of the bitters of the other.' These sentiments struck a deep chord in Keats, endorsing his recent conversations with George and Rice, and complementing the theme of *Endymion*. Although he would later repudiate Bailey for juggling with women's affections, his first impressions persuaded him that they shared a similar attitude to friendship. They both believed (in Bailey's words) that 'Affection's heart-drops are the divinest cordials to human ills', and they both shared 'the Wordsworthian faith that memory, fed with virtue, poetry and the vitality of youthful imagination would nourish them all in later years'.[8] During their intimacy, Keats sent Bailey some of the most important letters he ever wrote, praising his 'philosophic mind' and powerfully developing his own 'moral sense'.

There was something protective as well as admiring in Bailey's

treatment of Keats, just as there had been with Clarke and Hunt. Almost as soon as they met, Bailey took charge of Keats's reading, urging him to make good his lack of a Classical education by reading Plato and others, and to range more widely in Dante, Milton, Wordsworth and Hazlitt. (His emphasis on 'disinterestedness' was given extra weight by his enthusiasm for Hazlitt's *Principles of Human Action*.) He also offered practical help. By the second week of August, Keats had reached the end of Book II of *Endymion*, and was once again thinking that a change of scene might do him good. The Dilkes, Haydon, and the Reynolds sisters were all on holiday, and so were George and Tom – taking the break in France that he had planned for himself. Reynolds was ill. Hunt was still preoccupied with Shelley (he depressed Keats by telling him that Shelley had written 4,000 lines since April). When Bailey said that he would soon be returning to Oxford for the second half of the long vacation, and asked Keats to come with him, it seemed an ideal solution both to his loneliness and to his lack of confidence. Earlier in the summer Haydon had visited Oxford and admired its atmosphere of peaceful learning. 'Everybody shewed you Latin & Greek books to explain any question,' he said, 'as if they had been English.'[9] More obviously than Carisbrooke or Canterbury, it promised to shelter and stimulate Keats's orphan mind.

SHORTLY BEFORE LEAVING Hampstead, Keats walked on the Heath with Charles Cowden Clarke. At one point they encountered a bull which had broken its tether and was threatening to charge them. They pacified it by staring directly into its eyes. As always before beginning a new task, Keats was alert to anything that might be construed as an omen. By the time he was packed and ready to leave Well Walk, his sense of purpose had returned. He had convinced himself that a steady gaze at his subject would redeem his poem from the slackness into which it had recently fallen.

He and Bailey travelled to Oxford together by coach, arriving outside the Mitre Hotel in the High Street in the early morning of Wednesday 3 September. From there it was a short walk to Bailey's rooms overlooking the main quadrangle of Magdalen Hall – a small group of medieval buildings in the shadow of Magdalen College. They soon settled into a routine, as Bailey later explained: '[Keats] wrote, & I read, sometimes at the same table, & sometimes at separate desks or tables, from breakfast to the time of our going out for exercise, – generally two or three o'clock . . .

When we had finished our studies for the day we took our walk', sometimes wandering 'among Colleges, Halls, Stalls', sometimes following the shaded banks of the Isis, sometimes hiring a boat and becoming 'naturalized riverfolks'. Away from the agitations of London, Keats wrote more fluently than he had done for weeks, often producing as many as fifty lines a day.

The main narrative of Book III is concentrated on Glaucus, whom Endymion meets after crossing the sea bed, brooding on his obsession with the moon. The scenery of this passage – 'Old rusted anchors, helmets, breast-plates large / Of gone sea-warriors; brazen beaks and targe; / Rudders that for a hundred years had lost / The sway of human hand' – is the most compellingly strange he had created. Its eerie uselessness describes a nowhere which is nevertheless a precise place: the colossally decayed theatre in which Glaucus can dramatise his story. He says that as a young fisherman he fell in love with the nymph Scylla, tried to persuade Circe to intercede on his behalf, and was enslaved by the 'arbitrary queen of sense' before Circe killed Scylla and condemned him to 'a thousand years of senility before death'.[10]

This tale (which Keats knew from Sandys's translation of Ovid) is a watery reflection of Endymion's own quest, and an elaborate condemnation of ideas of legitimacy that Keats had already attacked in his first two books. Like earlier parts of the poem, it also contains specific contemporary references. Long before Keats began writing *Endymion*, Hunt and others had identified 'legitimacy, in the person of Louis XVIII . . . with Circe';[11] the poem makes the same connection as it pleads for action to break the oppressive power of the sorceress. Glaucus and Endymion are 'twin brothers in this destiny' – Endymion as the poet-redeemer, and Glaucus, with his wand, book and priestly 'stole', as the member of a 'Paphian army' (not a soldier of 'haughty Mars') who is keen to defend the liberating power of sexual love. Even when first subjugated by Circe, he has the means to realise its potency. As he begins his sentence, he discovers from a scroll in the hands of a shipwreck victim that if he collects all the bodies of lovers drowned at sea, 'a youth elect' (Endymion) will eventually appear and release him.

As Glaucus describes his tender but laborious existence, Keats comes close to over-emphasising sensuous and aesthetic values. (Cupid is 'empire sure' in a world where 'pleasure reign'd' and citizens are 'smother'd' in a 'Fresh crush of leaves'.) The exaggeration is further evidence of his eagerness to combine ideas about personal salvation with

a notion of general good. When Glaucus recovers his health, and Scylla and the other drowned lovers revive, the Book ends with a Hymn to Neptune which enshrines him as a natural monarch whose security does not depend on absolute power but on a form of 'fellowship with essence', a feeling of mutuality between ruler and ruled. 'Newly come of heaven', Keats says, 'dost thou sit / To blend and interknit / Subduèd majesty with this glad time'.

'Subduèd' is the key word here, and its echoes mingle with others that Keats has already struck in the first section of his third Book. He had in fact written these opening lines immediately before leaving London, and when several of the first people to read them – including Bailey himself – disapproved of their politics, they missed the poem's point by making them seem exceptional. (Bailey objected to their anti-clerical views, in particular.) Many later readers have made the same mistake, referring to them as a 'false start',[12] and blaming Hunt for their failure. It is certainly true that the passage refers to ideas that Hunt had recently discussed in the *Examiner*. In early August, for instance, he had attacked the government as 'dull and insolent usurpers of the constitution', and later in the month he criticised the French clergy for accepting 'the Roman purple' of Cardinals' hats. But these opinions, far from seeming new to Keats, were merely a repetition of views that he had always held, and had formed the foundation of *Endymion* from its inception. That is to say: the beginning of Book III is nothing like an intervention; it is the plain statement of beliefs which are dramatised throughout the poem. Keats later told Richard Woodhouse 'It will easily be seen what I think of the present Ministers by the beginning of the 3rd Book':

> There are who lord it o'er their fellow-men
> With most prevailing tinsel: who unpen
> Their baaing vanities, to browse away
> The comfortable green and juicy hay
> From human pastures; or – O torturing fact! –
> Who, through an idiot blink, will see unpacked
> Fire-branded foxes to sear up and singe
> Our gold and ripe-eared hopes. With not one tinge
> Of sanctuary splendour, not a sight
> Able to face an owl's, they still are dight
> By the blear-eyed nations in empurpled vests,
> And crowns, and turbans. With unladen breasts,
> Save of blown self-applause, they proudly mount

To their spirit's perch, their being's high account,
Their tip-top nothings, their dull skies, their thrones –
Amid the fierce intoxicating tones
Of trumpets, shoutings, and beAlaboured drums,
And sudden cannon. Ah! how all this hums,
In wakeful ears, like uproar passed and gone –
Like thunder clouds that spake to Babylon,
And set those old Chaldeans to their tasks.
Are then regalities all gilded masks?
No, there are thronèd seats unscalable
But by a patient wing, a constant spell,
Or by ethereal things that, unconfined,
Can make a ladder of the eternal wind,
And poise about in cloudy thunder-tents
To watch the abysm-birth of elements.
Ay, 'bove the withering of old-lipped Fate
A thousand Powers keep religious state,
In water, fiery realm, and airy bourne,
And, silent as a consecrated urn,
Hold sphery sessions for a season due.
Yet few of these far majesties – ah, few! –
Have bared their operations to this globe –
Few, who with gorgeous pageantry enrobe
Our piece of heaven – whose benevolence
Shakes hand with our own Ceres, every sense
Filling with spiritual sweets to plenitude,
As bees gorge full their cells.

KEATS GREATLY ENJOYED Oxford. It was, he said in a letter to his sister
Fanny, 'no doubt . . . the finest City in the world', adding that he hoped
he might soon become more 'intimately acquainted' with her. His
affection, clearly, was bolstered by new feelings of security and trust. It
was the same when he wrote to the Reynolds sisters, gently ribbing and
reprimanding them (and sending them two songs: 'Think not of it', and
'Apollo to the Graces'). And the same again when he contacted Reynolds
himself, dropping into a facetious imitation of Wordsworth's 'Written in
March', in which he teased himself by saying that as well as 'plenty of
ease / And plenty of fat deer for parsons', Magdalen Hall also had 'plenty
of trees'. His London worries – about money and his brothers' well-
being – were swallowed by his pleasure in the place, in his work, and in
'so real a fellow as Bailey'.

Many years later, Bailey said that during their time together 'There was no reserve of any kind between us' – insisting that he was able to 'throw light upon [Keats's] youthful genius and character' because 'the dew and freshness of youthful trustfulness was upon each of us'. As well as deepening his knowledge of Wordsworth, Milton, Dante and Shakespeare,[13] he listened to him 'recite, or chant' Chatterton 'in his peculiar manner', reintroduced him to writers he barely knew, like Jeremy Taylor, and recommended others he had not read at all, such as 'beautiful Mrs [Katherine] Philips . . . "the matchless Orinda" '. (Keats copied out one of her lyrics in a letter to Reynolds.) Bailey also encouraged him to read the Bible, focusing particularly on passages which were to benefit *Endymion* by combining a literal with a 'figurative'[14] truth, and making him 'promise' that 'he would never scoff at religion' as Hunt and Shelley had recently encouraged him to do. His aim was not to convert Keats to Christianity in any orthodox form; rather, he wanted to explore the connection between his own faith and Keats's more humanistic philosophy. Everything he knew about Keats's existing poems, and everything that Keats now read him from *Endymion* – including a passage about Glaucus – persuaded him that deep affinities lay beneath their apparent differences. He understood they were both people who accepted that 'belief' depended on a willingness to accept contradictions.[15] Far from impeding Keats's developing thoughts about his own intellectual identity, and the identity of the poetic character in general, their religious discussions strengthened them enormously.

Bailey nourished *Endymion* at a crucial point in its development. He helped Keats to toughen the language that Hunt had taught him, reducing its fuzzy compounds and gassy locutions, and also encouraged him to experiment with prosody. (Bailey's description of how Keats balanced open and closed vowel sounds in his work is – though brief – 'the only valuable account we have of one of Keats's purely stylistic principles'.[16] In addition, Bailey confirmed Keats's interest in writing poetry which had a 'direct applicability to human life'[17] – especially after he had lent him Hazlitt's *Principles of Human Action* and (possibly) the recently published *Characters from Shakespeare's Plays*. Pressing on rapidly through the thousand-odd lines of his Book, Keats felt that all the previous disappointments he had suffered with his poem were at last being resolved. He had, he believed, finally discovered a manner which could unite the direct approach of his opening with the

sensuality of his later descriptions, and show how they served a common purpose.

In late September, when he was writing the final lines of the Book and beginning to read over what he had done, his disappointment flooded back. The new ideas he had been discussing with Bailey made him suspect that the whole plan of his work was misguided. The loose couplets, which had once seemed an essential part of his radical intent, struck him as feeble. The integration of 'thought' with 'sensation' seemed strenuous and unsatisfactory. When he wrote to Haydon on 28 September, he was overwhelmed by a sense of failure. 'My Ideas with respect to *Endymion*', he said, 'I assure you are very low – and I would write the subject thoroughly again.' There was little comfort for Keats in realising that he had suffered a similar mood swing when finishing the first and second Books. In the past, he had felt that he could recover his poem without beginning a wholly 'new romance'. Now his 'trial' was three-quarters done, and when he looked ahead to the autumn in London, all he could see was further discontent. He had become embroiled in a troublesome plan to raise funds for a young painter, Charles Cripps, whom Haydon had met on his recent visit to Oxford, and proposed to employ as an apprentice, if others would pay his fees. He felt awkward about spending more time with Hunt. Within a month, Keats's fears that their relationship was fatally damaged were borne out when Reynolds passed on some gossip to the effect that Hunt had heard *Endymion* was sprawling out of control, and would have been twice as long again 'without his restraining influence'.[18] 'If he will say this to Reynolds,' Keats wondered, 'what would he to other People?' In his later published remarks about the poem, Hunt continued to strike an ambivalent note, criticising the 'exuberance' of its rhymes, and saying it 'was not a little calculated to perplex the critics. It was a wilderness of sweets, but it was truly a wilderness: a domain of young, luxurious, uncompromising poetry', where 'the weeds of glorious feature' hampered 'the pretty legs accustomed to the lawns and trodden walks, in vogue for the past hundred years'.

These worries overshadowed the last few days that Keats and Bailey spent together – but before they parted, they decided to pay homage to the presiding genius of their friendship. They took a coach forty miles north to Stratford-upon-Avon. First they visited Shakespeare's birthplace, and wrote their names on the bedroom wall among the 'numbers numberless' who had done the same thing. 'If these walls have not been

washed,' Bailey wrote many years later, 'or our names wiped out to find a place for some others, they will still remain together.' Then they looked round Holy Trinity church, admiring the plump statue of the Bard more than most visitors feel it deserves, and once again wrote their names, this time in the visitors' book. It was a simple yet significant act. The signatures were marks of their devotion to the spirit of the place, and of their mutual sympathy. In less than a month, Bailey had helped Keats to discover books, ideas and feelings which clouded his present, but enormously enlarged his ambitions for the future.

SEVENTEEN

WHEN KEATS RETURNED to Hampstead on 5 October, he put on a brave face, eagerly making plans to see his friends again. Within twenty-four hours he had walked down to Lamb's Conduit Street, delivering a parcel to Reynolds from Bailey, and saying that he was pleased to see the sisters 'greatly improved' by their holiday in Littlehampton. In the afternoon he went to see Haydon, who had recently moved from Great Marlborough Street to 22 Lisson Grove North, a 'cursed cold distance' from Well Walk, and in the same street as Hunt.

Why had Haydon moved so close to the person he was constantly warning against, especially since Shelley was also staying there, and was bound to stir up arguments? Keats was surprised and dismayed, listening to Hunt continue his efforts at reconciliation (he had published 'On the Grasshopper and Cricket' in the *Examiner* while Keats was away in Oxford), to Haydon telling him 'don't show [*Endymion*] to Hunt on any account or he will have done half for you', and to Shelley boasting that he had already finished his own long poem. Writing to Bailey shortly afterwards, Keats rounded on the lot of them, saying they were 'at Loggerheads', that Hunt was 'infatuated', that Haydon was obsessed by 'Christ's Entry', that Horace Smith was quarrelsome. 'I am quite disgusted with Literary Men,' he exclaimed, continuing angrily that he would 'never know another except Wordsworth', whom he hoped to meet later in the year.

Just as he had done before leaving for Oxford, he tried to cheer himself by seeking out those who stood at a distance from Hunt – such as Charles Cowden Clarke, Severn, Reynolds and Rice (who was 'very ill' and not able to see him) – or by rapidly forging new friendships. On 7 October,

for instance, he had dinner with Charles Brown. Brown was the last close friend that Keats made, and one of the most important. They had first met through Dilke, with whom Brown had taken Wentworth Place, and in half of which he lived. Whereas Dilke was unyielding in his Godwinian beliefs, Brown was expansive and adventurous. He was eight years older than Keats – he had been born on 14 April 1787 – the son of a Scottish broker and his Welsh wife, and since leaving school had worked briefly in London before travelling to Russia to join a business that his brother John had started in St Petersburg. After five years this enterprise failed, and Brown returned to London, becoming a part-time book-keeper and tutor, and writing a comic opera, *Narensky*, which drew heavily on his experiences abroad. This was produced at Drury Lane in 1814, and moderately well received. When his brother James died the following year, he inherited enough money – more than £10,000 – to devote himself to what he called a 'life of literary pursuits', though these in fact consisted more of schemes than achievements. He never repeated the success of *Narensky*, but planned and abandoned a novel, read widely, sketched skilfully, and enjoyed the company of writers. Tall and balding, he had a thoughtful face which made him look older than his years, though his appearance was contradicted by his youthful zest for life. He was vehemently devoted to liberal principles, and fierce in his condemnation of aristocratic pretensions. He was also restlessly energetic, highly sexed, and gregarious: someone whose enthusiasm for everyday pleasures was as great as his relish for deep thinking.

Soon after Brown had first met Keats, walking on the Hampstead Road in the summer of 1817, he realised that he was someone who would achieve more than he dared hope for himself. He immediately 'inwardly desired [Keats's] acquaintanceship, if not his friendship', and became 'very thick' soon after they had first dined together. Like many of the other, older men that Keats counted amongst his nearest friends, Brown looked on him with an almost parental affection, and was seen by Keats as a protector as well as an ally. With his comfortable income, his secure home, and his large experience of the world, Brown seemed dependable as well as daring. He had a streak of stubbornness which in the years to come would create difficulties with others in his circle, but for Keats himself – even when Brown proved unwilling to travel to Italy – he was never less than 'capital'.

Brown reminded Keats that London could offer new opportunities, even as it reminded him of old disappointments, and this helped to

restore his faith in *Endymion*. Soon after their dinner, Keats told himself that while the poem was less good than he had hoped, it was at least 'independent'. To prove the point, on 8 October he copied out for Bailey some remarks he had sent George the previous spring, when he had spoken of his ambition to 'make 4000 Lines of one bare circumstance and fill them with Poetry'. Although this re-established his first principles, it could not altogether solve his more recent problems – not only the problems of his poem's direction, but of his daily existence. At home in Well Walk, trying to work his way into Book IV, he was continually distracted. His landlord's children made 'a horrid row'. George interrupted him with worries about his future. Tom was visibly ailing. His own health bothered him, too. At the beginning of his letter to Bailey he admitted to feeling only 'tolerably well', and at the close he said, 'The little Mercury I have taken has corrected the Poison and improved my Health – though I feel from my employment that I shall never be again secure in Robustness.'

In fact Keats was more seriously ill than he let on: for the two weeks after his visit to Brown (until 22 October) he was confined to his room in Well Walk, seeing no one except his brothers. The only clue about the nature of his illness is his reference to 'Mercury', and it has alarmed and perplexed generations of his biographers. For most of the early part of this century, the idea that he might have been treating himself for some kind of venereal disease was simply ignored. This was due partly to propriety (how could such a noble spirit have such an ignoble affliction?), partly to a reluctance to believe that Keats could have contracted his disease while staying with the devout and high-minded Bailey, and partly to the fact that mercury was prescribed for a wide range of illnesses, not just sexual ones. (Mercury was either taken orally, in the form of pills, or rubbed on to the skin as an ointment. It is unlikely that Keats's condition was so severe that he had to insert a dribble of mercury into his penis – as Boswell did when suffering from the clap.)

The propriety argument is not worth bothering with. The medical objections need more careful appraisal. It is true that during the eighteenth century mercury was administered to alleviate widely different kinds of suffering – but as Gittings was the first to point out,[1] expert opinions had changed by the time Keats arrived at Guy's. Astley Cooper advised against its indiscriminate use, especially in the case of tubercular patients,[2] and another lecturer, James Curry, recommended that it be prescribed 'with extreme caution, if at all, and usually only

when [the illness] was venereal'.[3] The doctor who probably attended Keats during this time – Solomon Sawrey, of 22 Bedford Row, who was also caring for Tom – was likely to have agreed with Curry, even though he was ignorant about the pathology of the disease. Like many of his contemporaries, Sawrey believed that gonorrhea was an early stage of syphilis, and he regularly prescribed mercury as a means of preventing what he assumed would be an inevitable progress. Even allowing for this misundersanding, his intentions were clear. Sawrey was not treating Keats for syphilis but for gonorrhea[4] – a less serious infection that needed scrupulous treatment, but was not regarded as a grave threat to health, or as a matter of much social significance. Gittings valuably quotes Curry as saying: 'Without accusing the male youth of the present day of greater laxity than those of former generations, it may be asked – how many arrive at the adult age without having occasion to use mercury? . . . Few escape the necessity of using it.'[5]

This leaves the question of Bailey's influence. During their month in Oxford, Bailey had prompted an extraordinary flowering of Keats's intellect: he clarified ideas about poetic form and about the link between social virtue and the imagination, and he had reaffirmed the value of male friendship. But on their evening walks and their boating expeditions they also spent a good deal of time discussing more intimate matters. It is not known whether Keats went into details about his sexual experiences in London, on the Isle of Wight or at Bo Peep. It is clear, however, that he supposed Bailey was suffering the pangs of unrequited love for Thomasina Leigh (in fact he had already started courting Marianne Reynolds 'with the bible and Jeremy Taylor under his arm'), and probable that they exchanged confidences. Keats, after all, was writing a poem which celebrated physical passion, and identified it as the means by which daily conditions could be transfigured into an ideal state.

Saying all this might help to establish his disease as a painful but undeniable fact, and to identify Bailey as someone who – in spite of his religious orthodoxies – was not likely to be fazed by stories of sexual adventuring. (Later in the year he was probably one of the two 'parsons' present when Keats spent an evening discussing 'the derivation of the word C—t'.) It does nothing to answer questions about the extent and variety of Keats's experience. His colleagues at Guy's had reckoned that he behaved with unusual restraint during his time at the hospital, and the coy eroticism of his early poems tends to support their view. But while it

is unwise to try to distinguish between yearning fantasies and remembered encounters in his poems – since much of their erotic charge depends on his blurring the distinction between what is imagined and what is actual – it is evident that his sexual behaviour changed significantly while his commitment to medicine loosened. During his early freelance life – and in spite of his dislike for the way that Hunt and Shelley treated their wives – he cheerfully acknowledged that most of his friends did not think twice about visiting prostitutes, and later joked that a couple of them (Severn and Rice) had illegitimate children. When living with Brown in Wentworth Place in 1820, he made no objection to the fact, only to the consequences, of Brown's sexual relationship with their maid. These things suggest that, once his student days were over, Keats also bought sex as and when he wanted it – which is only what one would expect of someone of his nature, living in his particular time. He admitted as much in a letter to Tom the following year. 'With respect to Woman,' he said, fretting about his health, 'I think I shall be able to conquer my passions hereafter better than I have yet done.'

In the short time that remained to Keats after making this remark to Tom, his attitude to sex altered yet again. His worries about his health became acute, he fell in love with Fanny Brawne, and he worked the 'gordian complication' of his feelings about women into a vehemently defensive distrust – often using Burton's *Anatomy of Melancholy* as a goad. Throughout the early part of his independent adult life, however, and especially around the time in which he wrote to Bailey about dosing himself with mercury, he openly and easily considered himself a man of sufficient sexual experience. He may have gone to brothels in Oxford and London. He enjoyed the 'profligate' girls on the Isle of Wight. He chased flirtatiously 'over the hill and over the dale' in Devon when staying in Teignmouth with Tom in the spring of 1818. And he admitted to 'warming' with Isabella Jones (though it seems unlikely that this 'warming' involved intercourse). The texture of his poetry changed accordingly, as *Endymion* itself proves. While it lacks both the frankness of later lyrics like 'Unfelt, unheard, unseen' and 'O blush not so' (which one of his friends described as being about 'the mystery of the maidenhead'), and the supple detailing of 'The Eve of St Agnes' and 'Lamia', it is a poem in which the erotic focus gradually sharpens as the quest for ideal love intensifies. It is a change which the critics in *Blackwood's* and the *Quarterly* would decry as supremely vulgar, but which in time has been generally recognised as the foundation and

definition of a large part of his genius. His 'fine excess' is a means of generalising particular pleasures into a criticism of 'sovereign' power. The temperature he measures on his pleasure thermometer is the heat of a 'thoughtful' ideal, as well as a 'blissful' individual 'sensation'.

Even though Bailey had raised no objections to Keats's ideas or his behaviour during their time together in Oxford, and made no censorious response to the news that he was taking mercury the following month, he later found it difficult to condone what Keats wrote and did. After *Endymion* had been published, by which time Bailey was preoccupied by urgent ecclesiastical ambitions, he complained about the 'indelicacy' of the poem, and seemed content when Keats wished him the happiness of 'a little Peona Wife' rather than anything more passionate. Yet while insisting that the mingling of spiritual 'essences' was inseparable from the mingling of bodies, Keats retained views about the 'character' of women that Bailey shared. Views about intellectual 'bluestockings', in particular. Expounding his ideas in a letter to Reynolds from Oxford, Keats had spoken with exceptional ferocity. 'The world,' he said, 'and especially our England, has within the last thirty year's been vexed and teased by a set of Devils, whom I detest so much that I almost hunger after an acherontic promotion to a Torturer, purposely for their accommodation; These Devils are a set of Women, who having taken a snack or Luncheon of Literary scraps, set themselves up for towers of Babel in Languages Sapphos in Poetry – Euclids in Geometry – and everything in nothing.' Distinguishing between writers like Elizabeth Montague and Mary Tighe on one hand, and Katherine Philips on the other, he appealed for 'some real feminine Modesty in these things'.

The passage is important for more than what it tells us about the limits to Keats's liberalism.[6] It also shows him rejecting some of his early models (Mary Tighe had influenced several of his apprentice poems), and suggests a growing fretfulness about the likely audience for his work. Ever since childhood he had felt consciously damaged by a woman who had commanded his strong feelings and then betrayed them. In his adult life, his resentments were gradually recast as a wish to do without women altogether – except as sexual objects. Fearing their rejection of him, as a man and as a writer, he repeatedly denounced them so as to insist on his independence before it could be threatened. When he fell in love with Fanny Brawne, his devotion to her clashed painfully with his dislike of her authority over him. When he revised some of his final and greatest poems, he was tormented by the thought

Muse of my Native Land! loftiest Muse!
O first born of the Mountains, by the hues
Of Heaven on the spiritual air begot.
Long didst thou sit alone in northern grot
While yet our England was a wolfish den;
Before our forests heard the talk of Men;
Before the first of Druids was a child—
Long didst thou sit amid our regions wild
Wrapt in a deep prophetic Solitude.
There came a hebrew voice of solemn Mood
Yet wast thou patient: then sang forth the Nine,
Apollo's garland; yet didst thou divine
Such home-bred Glory that they cried in vain
Come hither Sister of the Island" Plain

6 *Endymion*, Book IV, lines 1–29; included in a letter Keats wrote to Bailey
on 28–9 October 1817.

that popular success depended in some degree on the tastes and tolerance of women readers.

As KEATS'S CONFINEMENT ended, any kind of readership felt depressingly remote, obscured by the demands of more immediate difficulties. Tom was declining so fast that Keats thought of 'shipping him off to Lisbon' and possibly accompanying him; when he began visiting friends again, he found them argumentative and embattled. The progress he had made on Book IV of *Endymion* did little to console him. Its 'long-deferred climax'[7] – the union of his hero with Cynthia – was something that his own condition, and his brother's, seemed actually to mock. This perhaps helps to explain why the final part of the poem seems so full of stops and starts. After an opening invocation to the 'muse of my native land', in which he appeals for the Classical age to revive the present as it had done the Elizabethan period, he sinks into despondency, often using terms reminiscent of Coleridge's 'Dejection Ode', which had recently appeared in the collection *Sibylline Leaves*.[8] His mood is intended as a comment on the times; it comes across as a personal regret about the 'sandy' foundations of his own poem:

> Great Muse, thou know'st what prison,
> Of flesh and bone, curbs, and confines, and frets
> Our spirit's wings. Despondency besets
> Our pillows, and the fresh tomorrow morn
> Seems to give forth its light in very scorn
> Of our dull, uninspired, snail-pacèd lives.
> Long have I said, how happy he who shrives
> To thee! But then I thought on poets gone,
> And could not pray – nor could I now – so on
> I move to the end in lowliness of heart.

Keats drags himself back to his narrative by making Endymion hear these words, then moves quickly to a different voice. It is the Indian Maid, whose 'roundelay' is a variation on the same theme – an attempt to show that pleasure and pain combine in human development – but which soon succumbs to the idea that sorrow dominates everything. This confirms the book's sense of distraction. For one thing, it means that Keats temporarily neglects the social aims he has pursued elsewhere in the poem, in order to contemplate a more individualistic and 'psychic'[9]

solution. For another – and this is more seriously troubling – he treats the Indian Maid in ways which challenge his presiding notion of ideal 'harmony'. Elsewhere in his writing (notably in 'Isabella', lines 113–15) he criticises the exploitative and dehumanising effects of the British Empire. When creating the Indian Maid, however, he shows no respect for her 'otherness'[10] even while recognising her 'strangeness',[11] and delivers her voice to his readers as 'the unquestioning vehicle of [his] unwitting but definite imaginative consumption, and entrepreneurial representation, of the Orient'.[12] She is, in other words, proposed as a cohesive force in *Endymion*; in fact her treatment is reactionary and divisive:

> 'Come then, Sorrow!
> Sweetest Sorrow!
> Like an own babe I nurse thee on my breast:
> I thought to leave thee
> And deceive thee,
> But now of all the world I love thee best.
>
> 'There is not one,
> No, no, not one
> But thee to comfort a poor lonely maid:
> Thou art her mother,
> And her brother,
> Her playmate, and her wooer in the shade.'

Keats shows no sign of acknowledging these contradictions: he is too thoroughly preoccupied by other questions. Even before Endymion has been touched by the pitifulness of the Maid's song, he has been in thrall to her beauty – groaning when he sees her 'Sweet as a musk-rose upon new-made hay; / With all her limbs on tremble, and her eyes / Shut softly up alive'. Rather than filling him with a self-sufficient happiness, this has led him to doubt the whole purpose of his quest. How, in his devotion to Cynthia, can he now 'Thirst for another love'? The narrative expects a reconciliation, but when the song ends Keats can no longer let 'disagreeables evaporate' as easily as he has done in the past. In lines which are at once ominous and perfunctory, he makes Endymion ask the Maid 'Wilt fall asleep?', whereupon Mercury appears and the lovers are swept into the air by winged horses.

The flight of fancy has an air of inventive desperation, but at least

fulfils Keats's argumentative intentions, refocusing the central debate of his poem. As Endymion sleeps, he dreams of holding a 'brotherly' conversation with 'divine powers' who at last identify the goddess he has been pursuing. This returns him to the main theme of his poem by reminding him that Endymion is divided between an available human love and a distant ideal one. It is a crisis of commitment which crystallises Keats's thoughts about his human, social and sexual identity. Endymion says to the 'swan of Ganges':

> Can I prize thee, fair maid, all price above,
> Even when I feel as true an innocence?
> I do, I do. – What is this soul then? Whence
> Came it? It does not seem my own, and I
> Have no self-passion or identity.

As this speech sharpens the poem, it also brings it to a new pitch of distress. Only when the scene shifts once more, and Endymion is carried to the Cave of Quietude, does it begin to look as though he might be able to plan some kind of resolution. At least, it does until he realises that this latest 'bower' only recreates the disappointment he felt when listening to the song of the Indian Maid. The Cave is a place 'beyond sorrow or joy', where 'anguish does not sting; nor pleasure pall'.[13] It is a 'den' which resembles a hospital ward:

> Happy gloom!
> Dark Paradise! where pale becomes the bloom
> Of health by due; where silence dreariest
> Is most articulate; where hopes infest;
> Where those eyes are the brightest far that keep
> Their lids shut longest in a dreamless sleep.

These lines (537–42) come more than halfway through Book IV, but they summarise the thoughts which had both inspired and demoralised Keats as he worked on the earlier sections (he completed the first three hundred lines by the end of October). They show that as his final book crept forward, the difference between himself and his hero gradually became less distinct. Both felt at a loss: Keats in a maze of self-doubt, Endymion in his 'Dark Paradise'. Looked at from one point of view, this was deeply disturbing – the poem was losing faith in its original

humanitarian purpose. From another angle, it represented the beginning of a final and triumphant development. Hitherto Keats had made Endymion a perpetual outsider; now he had the chance to turn him into a daring insider. If this meant that he became merely escapist, it would be a disaster – a contradiction of everything the poem had argued previously. In the concluding lines, which Keats would soon write, he determined that Endymion's instincts for self-preservation should affirm his own wish to criticise the interventions of the world.

THE STUBBORN SURVIVAL of *Endymion*'s liberal ambitions has often been neglected. As Keats worked on Book IV, he had troubling proof that his sympathies were all too obvious to his contemporaries. In late October, *Blackwood's* carried the first of what threatened to be a series of articles 'On the Cockney School of Poetry'. The magazine had been founded in Edinburgh the previous April by William Blackwood, a Tory bookseller opposed to the Whig principles upheld by Archibald Constable in his *Scots Magazine*, and by the *Edinburgh Review*. Early sales had been disappointing, and after a few months Blackwood had reorganised his operation, appointing John Wilson and John Lockhart as his assistant editors, warning that henceforth he would show no mercy to political enemies. Wilson was the 'Beserker' of the new recruits – the thirty-year-old son of a rich Glasgow manufacturer who had studied at Oxford and published some undistinguished poems of his own. Lockhart was seven years his junior, and from an even more solidly Tory background. He was the 'scion of an ancient Lanarkshire house', had also been educated at Oxford, and had 'rotated' briefly in Goethe's circle in Weimar before returning to Scotland.

The attack on the 'Cockneys' took as its epigraph some gauche lines by one of Hunt's acolytes, Cornelius Webb. Lockhart, abetted by Wilson, signed his piece 'Z' and warned that while 'Libertas' was his immediate target, in time the whole Hampstead entourage would be dealt with – including Keats, whom Webb had referred to as 'The Muses' son of promise'. Lockhart's title summarised his objections. As far as he was concerned, a 'Cockney' was excluded at birth from the lofty realms of poetry, which were reserved for those who had received a Classical education. Hunt and his circle were therefore impertinent arrivistes. Worse than this, they were politically offensive. Their suburban effusions were a threat to the old poetic order, their 'effeminate' diction was a repudiation of familiar restraints, and their themes were as

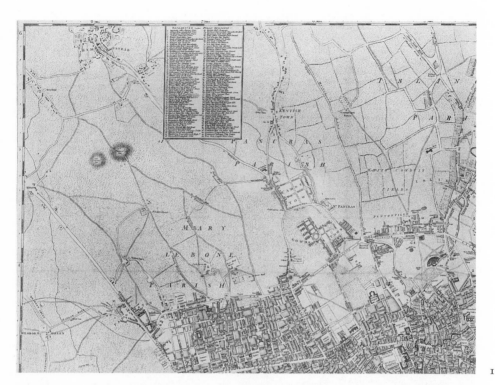

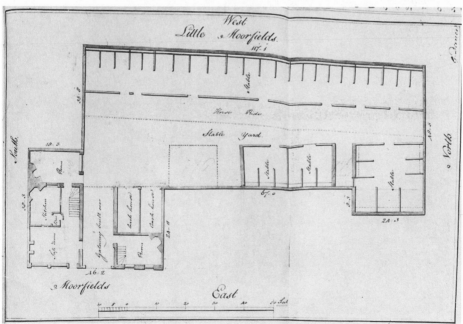

1 Hampstead and part of London, 1797. 2 The ground-plan of The Swan and Hoop,
24 The Pavement, Moorfields, where Keats's maternal grandparents lived.

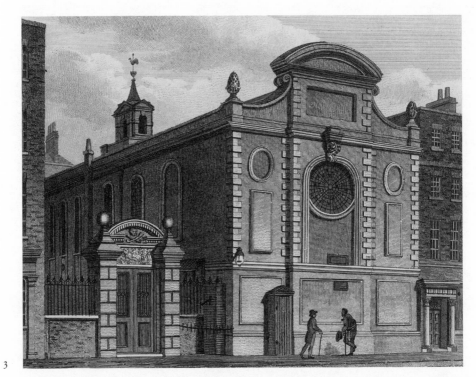

3

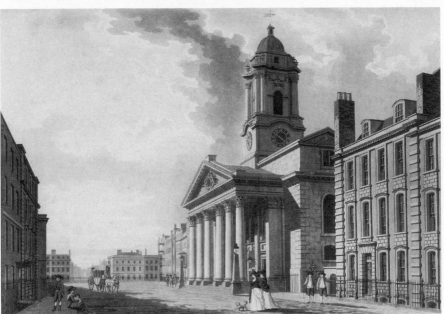

4

3 St Stephen's, Coleman Street, 1820; the 'Keats family church'. 4 St George's, Hanover
Square, c. 1820, where Keats's parents were married on 9 October 1794.

5

6

5 The market square, Enfield, 1806. Keats was at school in Enfield for almost a third of his life. 6 Edmonton, 1806. Keats was an apprentice to Dr Thomas Hammond of Edmonton before beginning his studies at Guy's Hospital in October 1815.

7

8

9

7 A drawing of Clarke's School, Enfield, c. 1840. The central section of the building is now preserved in the Victoria and Albert Museum, London. 8 John Clarke (1757–1820), Keats's headmaster, c. 1815. 9 Charles Cowden Clarke (1787–1877), the son of John Clarke, c. 1834, by an unknown artist.

10

MISERATIONE NON MERCEDE

11

10 Dr Hammond's surgery in Edmonton; the photograph was taken in about 1920, and the building has since been demolished. 11 The Operating Theatre of Old St. Thomas's Hospital, 1821, the only nineteenth-century English operating theatre which has not been destroyed or converted.

LONDON
LIBRARY

12

13

12 The north front of Guy's Hospital, c. 1816; Keats studied at Guy's between October
1815 and the end of the following year. 13 Sir Astley Cooper (1768–1841), by Sir
Thomas Lawrence; Cooper was Senior Surgeon at Guy's during Keats's time there.

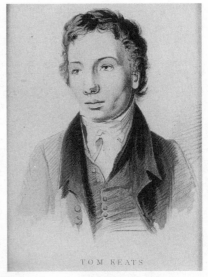

TOM KEATS

14 15

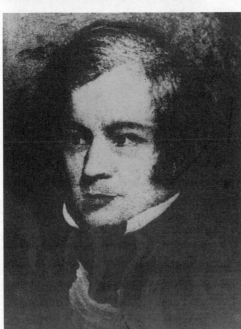

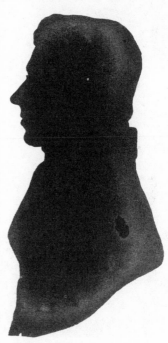

16 17

14 George Keats (1797–1841), Keats's younger brother. This watercolour miniature was painted by Joseph Severn. 15 Tom Keats (1799–1818), Keats's youngest brother, by Joseph Severn. This miniature was painted the year Tom died of tuberculosis, aged nineteen. 16 Henry Stephens as a young man. Stephens and Keats lodged together when they were studying at Guy's Hospital, and later met briefly in June 1818, when Keats was on his way north to walk round Scotland. 17 George Felton Mathew, c. 1815. Mathew later told Keats's first biographer: 'My intimacy with [Keats] was not of long duration', and disapprovingly described him as belonging to a 'sceptical or republican school'.

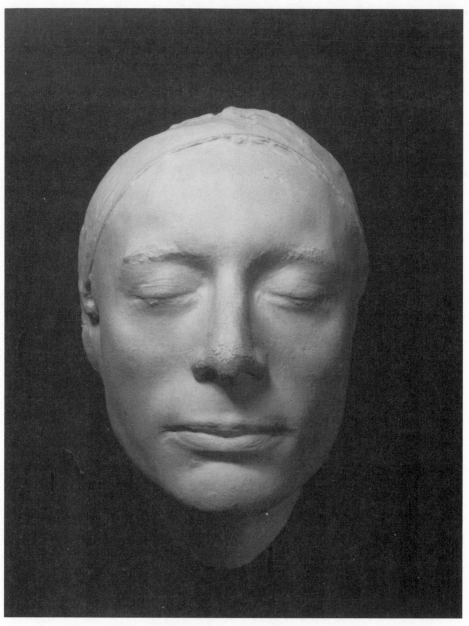

18 The life-mask of Keats, made by Haydon in the autumn of 1816. Keats's sister Fanny later described it as 'a perfect copy of the features of my dear brother . . . except for the mouth, the lips being rather thicker and somewhat more compressed which renders the expression more severe than the sweet and mild original'.

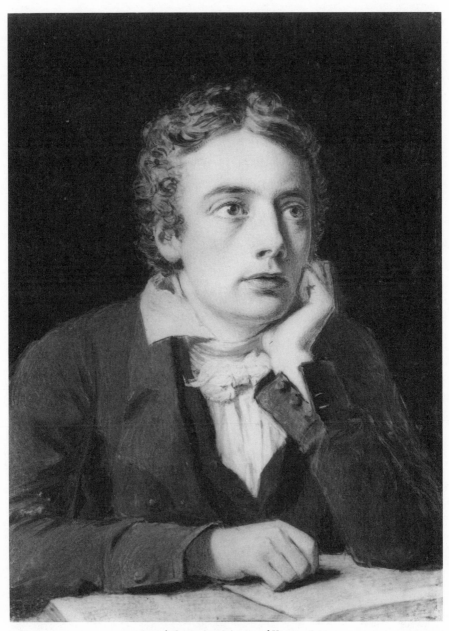

19 Joseph Severn's miniature of Keats, 1819.

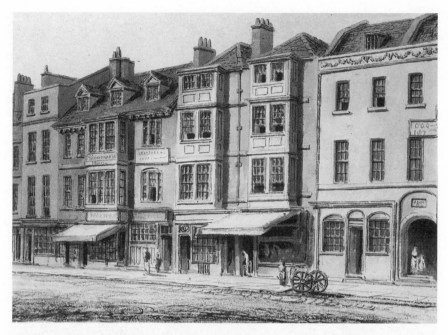

20

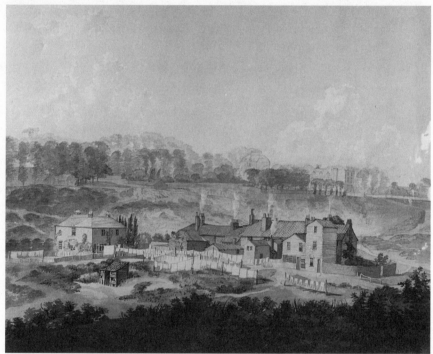

21

20 Southwark-Borough High Street, 1820, showing the houses on the west side, which were demolished in the 1830s. Keats lived in the Borough when he first moved to London, and described it as 'a beastly place in dirt, turnings and windings'. 21 The Vale of Health, Hampstead Heath, c. 1800. This is where Leigh Hunt lived after leaving prison in 1815, and where Keats first met him.

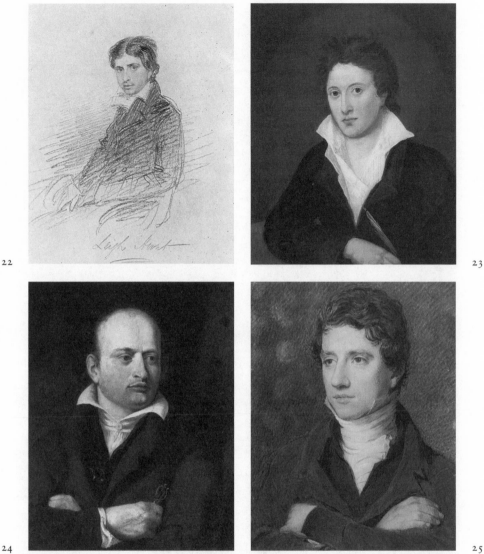

22

23

24

25

22 Leigh Hunt (1784–1859) by Thomas Wageman, 1815. 23 Percy Bysshe Shelley
(1792–1822) by Amelia Curran, 1819. 24 Benjamin Robert Haydon (1786–1846) by
Georgina Zornlin, 1825. 25 John Hamilton Reynolds (1794–1852) by Joseph Severn, 1818.

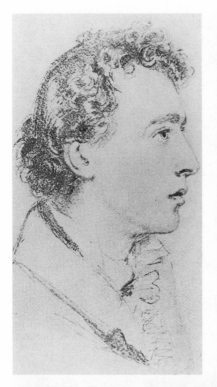

26

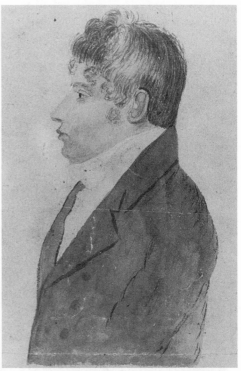

27

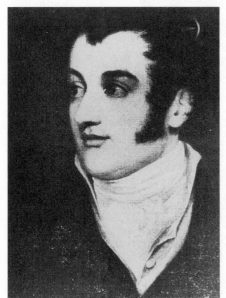

28

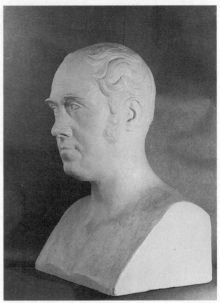

29

26 Joseph Severn (1793–1879); a self-portrait drawn the year after Keats's death, when Severn was twenty-nine. 27 Benjamin Bailey (1791–1853); the portrait shows him as a young man, and is by an unknown artist. 28 Charles Wentworth Dilke (1789–1864); this portrait by an unknown artist was painted c. 1825. 29 Charles Armitage Brown (1787–1842); this bust is the only likeness of Keats's 'capital friend', and was done in Florence by Andrew Wilson in 1828.

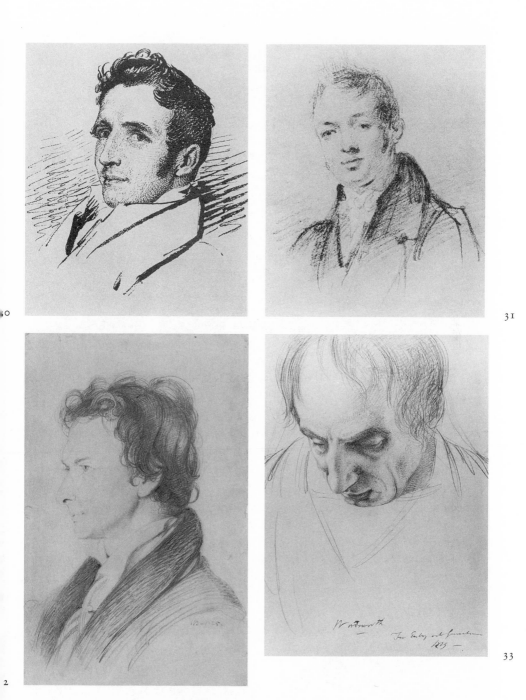

30 John Taylor (1781–1864) by an unknown artist. 31 James Augustus Hessey
(1785–1870); the drawing is probably a sketch for a portrait painted by William Hilton in
1817. 32 William Hazlitt (1788–1830) by William Bewick, 1825. 33 William
Wordsworth (1770–1850) by Haydon; a sketch for the portrait of Wordsworth which
Haydon included in 'Christ's Entry into Jerusalem'.

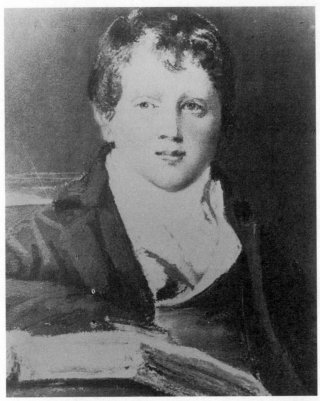

35

34

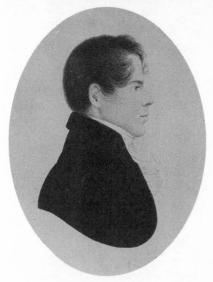

36

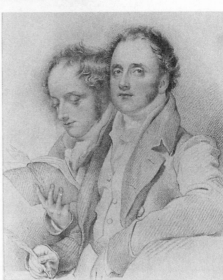

37

34 Richard Woodhouse (1788–1834); the only known portrait, showing him as a boy.
35 Jane Reynolds (1791–1846); a silhouette by an unknown artist. 36 James Rice
(1792–1832); a miniature by an unknown artist, c. 1820. 39 Horatio (Horace) Smith
(1779–1849) and his brother James Smith (1775–1839).

38 The Pier at Margate, 1823, by William Daniell; Keats first visited Margate in August 1816.

39 Blackgang Chine, the Isle of Wight, 1823, by William Daniell; Keats stayed on the island in 1817 and 1819 when he visited the Chine.

40 A view of Teignmouth from the Ness, August 1817, by D. Havell. Keats stayed in Teignmouth with his brother Tom in the early spring of 1818.

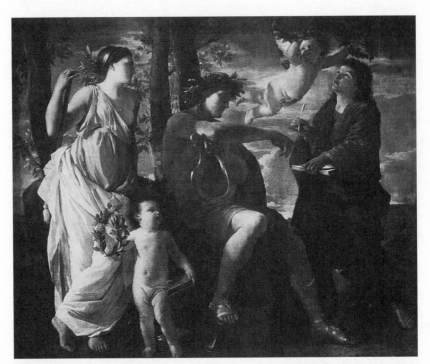

41

42

41 'The Inspiration of the Poet' by Poussin: 'To see the laurel wreath, on high suspended /
That is to crown our name when life is ended.' 42 'The Enchanted Castle' by Woolett
and Viares, after Claude (1782): 'You doth know the Enchanted Castle – it doth stand /
Upon a rock, on the border of a lake, / Nested in trees, which all do seem to shake /
From some old magic-like Urganda's sword'.

despicable as anything that might appear in one of the *Examiner*'s editorials.

Even by the standards of the time, 'Z's assault was violent. It branded Hunt 'profligate', 'underbred', a 'modern tuft-hunter', and 'as completely a Plebeian in his mind as he is in his rank and station in society'. It complained that *Rimini* described a trivially picturesque world where 'Everything is pretence, affectation, finery and gaudiness. The beaux are attorney's apprentices . . ., fiddlers, harp teachers, and clerks of genius: the belles are faded fan-twinkling spinsters, prurient vulgar misses from school, and enormous citizen's wives.' Understandably, Keats was shocked: soon after reading the article, he said that he had never read anything 'so vicious', and added that he feared the sequel was 'intended for me'. But his alarm should not be confused with surprise. Throughout his life as a writer, he had always conflated stylistic and political elements in his work, and realised that Tory reprisals were inevitable. For this reason, he felt able to tell Bailey 'I don't mind the thing much'. Even as he said this, however, he knew that 'abuse' would hurt him more than it might damage someone whose reputation was more secure. His precarious financial situation meant that he had to worry about the effect on his sales.

Keats's worries were fed by everyone around him. Hunt publicly demanded that 'Z' reveal his identity, and Reynolds arranged a meeting with his friend John Christie, who was the London agent of *Blackwood's*, hoping to deflect the coming trouble. In the short term, this seemed to do some good; when the second attack appeared in November, it continued to concentrate on Hunt. By this time, Keats had decided that the best form of defence was to admit where his debts lay. He praised Hunt in several letters, and dined with him on a number of occasions before the year ended, once versifying with him as they had done in their earliest days together. This suggests that he learned to breathe more easily after the first onslaught, and occasionally he even persuaded himself that it might do him some good: his reputation would of course suffer in some quarters, but he would be jolted into cultivating a greater 'disinterestedness'.

All the same, he began to think that if he wanted to reach the end of *Endymion* in peace, he should leave London once again. Realising this was one thing; managing it another. Tom relied on him. Haydon nagged him about funds for Cripps. Other friends troubled him for advice about their careers and love lives. 'In this world,' he told Bailey, 'there is no

quiet – nothing but teasing and snubbing and vexation' – then attempted to philosophise the arguments he had rehearsed after first reading the *Blackwood's* attack. 'There is no Man so thoroughly wicked', he wrote, quoting Wordsworth, '– so as never to be self-spiritualized into a kind of sublime Misery – but alas! 't is but for an Hour – he is the only man "who has kept watch on Man's Mortality" who has philanthropy enough to overcome the disposition [to] an indolent enjoyment of intellect – who is brave enough to volunteer for uncomfortable hours.'

This letter recaptures the intimacy of his conversations with Bailey in Magdalen Hall. In the past, Keats had looked on his friend as an expert in the ways of the world – well read and widely experienced. Almost at once, his confidence in him was challenged. On 2 November Keats heard from Rice and Reynolds that Bailey had been rejected for the post of curate in Lincoln, where he had confidently expected to be preferred. (George Tomaline, the recently elected Bishop of Lincoln, had been raised to the episcopacy by Tory influence, and was seeking to justify his appointment by expressing dismay at 'the great deficiency with respect to professional knowledge which he discovered in candidates for Holy Orders'.[14] Keats wrote to Oxford furiously, using the 'disappointment' as an excuse to unburden himself of all the other injustices which had recently weighed on him:

I am glad to hear there was an hindrance to your speaking your Mind to the Bishop: for all may go straight yet – as to being ordained – but the disgust consequent cannot pass away in a hurry – it must be shocking to find in a sacred Profession such barefaced oppression and impertinence – The Stations and Grandeurs of the World have taken it into their heads that they cannot commit themselves towards and [sic] inferior in rank – but is not the impertinence from one above to one below more wretchedly mean than from the low to the high? There is something so nauseous in self-willed yawning impudence in the shape of conscience – it sinks the Bishop of Lincoln into a smashed frog putrifying: that a rebel against common decency should escape the Pillory! That a mitre should cover a Man guilty of the most coxcombical, tyrannical and indolent impertinence! I repeat this word for the offence appears to me most especially *impertinent* – and a very serious return would be the Rod – Yet doth he sit in his Palace. Such is this World – and we live – you have surely in a continual struggle against the suffocation of accidents – we must bear (and my Spleen is mad at the thought thereof) the Proud Mans Contumely – O for a recourse somewhat human independent of the great Consolations of Religion and undepraved Sensations. of the Beautiful. the poetical in all things – O for a Remedy against such wrongs within the pale of the World! Should not those things be pure

enjoymen[t] should they stand the chance of being contaminated by being called in as antagonists to Bishops? Would not earthly thing do? By Heavens my dear Bailey, I know you have a spice of what I mean – you can set me and have set it in all the rubs that may befal me you have I know a sort of Pride which would kick the Devil on the Jaw Bone and make him drunk with the kick – There is nothing so balmy to a soul imbittered as yours must be, as Pride – When we look at the Heavens we cannot be proud – but shall stocks and stones be impertinent and say it does not become us to kick them?

The 'pride' that Keats talks about here is the dignity of self-belief; the anger springs from knowing that his own chances of realising a 'Remedy' for the world in *Endymion* were continually being thwarted. His time was still being frittered away on 'little two penny errands', his friends were acrimonious, and London itself was boring – on 16 November, the Regent's daughter Princess Charlotte died,[15] and all the theatres closed as a mark of respect. He lingered for a few more days, warily visiting Hunt and Shelley, meeting Godwin and Rice, and dining with Reynolds, with whom he met Christie the *Blackwood's* agent, who later remembered Keats reciting some lines from Chatterton 'with an enthusiasm of admiration such as could only be felt by a poet'. Finally, he reached a decision which would lift him clear of his difficulties. Since Lisbon was too expensive, Tom must go with George to Teignmouth in Devon: Rice, Reynolds, Haydon and Bailey had all recommended its healthy sea air. He would once more set out on his own.

EIGHTEEN

THE REFUGE KEATS found was the Fox and Hounds at Burford Bridge, in Surrey – a place rich in sympathetic picturesque associations. It had possibly been recommended to him by Hazlitt, who knew it well, or by Reynolds, who was attracted by its links with Nelson. (Nelson had spent his last night in England there before joining the *Victory* and leaving for Trafalgar.) When he climbed down from the Portsmouth coach on the evening of Saturday 22 November,[1] he immediately liked what he saw: a low, white-washed building fronted with a row of elms; the river Mole winding nearby; woodland stretching to the horizon. Renting a small room overlooking the stable yard, he climbed the twilit hill – Box Hill – beyond the garden, then returned to write 'some lines', and letters to Reynolds and Bailey. Not even the sense that Shakespeare 'has left

nothing to say about nothing and any thing' could stem his sudden rush of enthusiasm. Not even the bitterness of recent troubles would stop him thinking how they might be turned to advantage. He told Bailey 'I scarcely remember counting upon any Happiness – I look not for it if it be not in the present hour'.[2]

Keats begins this letter to Bailey by making a distinction between 'Men of Genius' and 'Men of Power', once again using an image appropriate to his medical training. 'Men of Genius', he says, 'are great as certain ethereal Chemicals operating on the Mass of neutral intellect – b[ut] they have not any individuality, any determined Character. I would call the top and head of those who have a proper self Men of Power.' Within a few lines, this has led to his thrilling statement of faith in the imagination. 'I am certain of nothing but the holiness of the Heart's affections and the truth of Imagination – What the imagination seizes as Beauty must be truth – whether it existed before or not – for I have the same Idea of all our Passions as of Love they are all in their sublime, creative of essential Beauty . . . The Imagination may be compared to Adam's dream – he awoke and found it truth.'

In obvious ways, this recapitulates ideas which had recently engrossed Keats – ideas about combining a personal with a social quest. It immediately brings him to the threshold of another 'favorite Speculation':

we shall enjoy ourselves here after by having what we called happiness on Earth repeated in a finer tone and so repeated – And yet such a fate can only befall those who delight in sensation rather than hunger as you do after Truth – Adam's dream will do here and seems to be a conviction that Imagination and its empyreal reflection is the same as human Life and its spiritual repetition. But as I was saying – the simple imaginative Mind may have its rewards in the repeti[ti]on of its own silent Working coming continually on the spirit with a fine suddenness – to compare great things with small – have you never by being surprised with an old Melody – in a delicious place – by a delicious voice, fe[l]t over again your very speculations and surmises at the time it first operated on your soul – do you not remember forming to yourself the singer's face more beautiful that [sic] it was possible and yet with the elevation of the Moment you did not think so – even then you were mounted on the Wings of Imagination so high – that the Prototype must be here after – that delicious face you will see – What a time!

No sooner had Keats written this than he said, 'I am continually running away from the subject'. He was wrong. For all its mercurial quickness,

7 The opening page of the letter Keats wrote to Bailey on 22 November 1817.

his letter is urgently logical. Its initial purpose is to define a vision of art that is highly subjective and yet absolutely without self-centredness. By the close, he has described a state of creation which allows the lack of a fixed identity to become a means of entering the world. 'The setting sun will always set me to rights – or if a Sparrow comes before my Window I take part in its existence and pick about the Gravel. The first thing that strikes me on hea[r]ing a Misfortune having befalled another is this. "Well it cannot be helped. – he will have the pleasure of trying the resources of his spirit["], and I beg now my dear Bailey that hereafter should you observe any thing cold in me not to [p]ut it to the account of heartlessness but abstraction.'

It is often said that the achievement of Keats's poems lags behind the theoretical advances he makes in his letters. These lines to Bailey certainly have an authority lacking in *Endymion*; nevertheless, they are intimately linked to his poem. The prose investigates the character of the 'chameleon poet'; the moonstruck couplets seek to reconcile ideal longings with actual conditions. As Keats brought his 'trial' to a close, writing hard for the next six days, he hurried his narrative to make the connection explicit. At first it seemed doomed to fail. Leaving the Cave of Quietude, Endymion berates himself, convinced that his ambition is beyond the 'natural sphere' of man:

> I have clung
> To nothing, loved a nothing, nothing seen
> Or felt but a great dream! O I have been
> Presumptuous against love, against the sky,
> Against all elements, against the tie
> Of mortals each to each.

His conclusion is to settle for life with the Indian Maid in the realm of Pan, where the 'breathing' is not 'too thin'. But the poem's argument will not allow this: it demands a rapprochement between ideal and real, not a compromise. In order to achieve this, Keats reintroduces Peona, who finds her brother sitting where he had received his first vision of ideal love. After listening to the story of his misfortune, she arranges to meet him that evening near Cynthia's temple. Here, in the poem's flurried closing section – which was completed on 28 November – the longed-for reconciliation takes place. The Indian Maid and Cynthia turn out to be one and the same person, and the poem rushes to a close:

> Next Cynthia bright
> Peona kissed, and blessed with fair good-night:
> Her brother kissed her too, and knelt adown
> Before his goddess, in a blissful swoon.
> She gave her fair hands to him, and behold,
> Before three swiftest kisses he had told,
> They vanished far away! – Peona went
> Home through the gloomy wood in wonderment.

In several previous poems – 'I stood tip-toe . . .', for instance, or the sonnets on the Elgin Marbles – Keats had produced creatively inconclusive conclusions. The final pages of *Endymion* leave no room for ambiguity. Darting from incident to incident, they assemble the bare bones of an argument rather than continuing to flesh it out. Judging by the letters Keats wrote shortly afterwards, he regretted this haste, and realised that he had done nothing to solve his earlier difficulties with the poem. As he revised it over the next few months, adding the section describing the 'gradations of Happiness' to Book I, he saw that he had failed to accommodate the changes he had undergone while composing the first draft. He had begun with a hero looking for 'happiness' beyond 'the pale of the World'. He had ended feeling preoccupied by the value of sorrow and suffering. He had begun with a detailed story line. He had ended by presenting a general philosophic framework of belief. He had begun by insisting on the difference between his self and Endymion. He had ended by indicating they were as interchangeable as Cynthia and the Indian Maid.

These shifts have severely damaged the reputation of *Endymion* over the years. Even the most sympathetic efforts to describe its possible coherence – as a Platonic quest poem, as a gargantuan love lyric, as a celebration of first imaginative principles, or as an amalgam of all these things – have been haunted by a sense of breakdown. A socially conscious reading immediately makes it seem more focused and impressive. The hero's digressive wanderings, and the various forms of writerly flexibility, are all aspects of a single, unwavering aim: to define a community which rejects the conditions of the present 'barbarous age', which idealises an antique sense of order, which is intensely 'liberty-loving', democratic, and untrammelled. Keats does not suffer a change of political heart in the poem; rather, he develops his thoughts about how politics and poetry can be most potently combined. He realised that

patches of didacticism (like the beginning of Book III) might have the value of announcing his theme clearly, but discovered that they – like the polemical sonnets he had written at the start of his career – limited their impact by buttonholing the reader. They had too much intellectual striving in them, and too little of what he admired in Shakespeare above all others.

In this sense, the chief value of *Endymion* lies less in what it achieves than in what it allows Keats to find out. Splashed with passages of gorgeous writing, dotted with rhythmical ingenuities, lit with the blaze of a fierce ambition, it is a giant 'chamber of thought'. Not, at its most successful, a place where thoughts are simply delivered, but where they are groped-for and then sensuously extrapolated. It is a lengthy proof of his conviction that 'That which is creative must create itself': a training school, a high-temperature forcing house. Even though his strongest feeling on finishing was one of disappointment, he knew that it represented an essential stage of his growth to maturity.

KEATS HAD ORIGINALLY intended to return to Well Walk as soon as *Endymion* was done. When he finished and dated his manuscript, he decided to spend a few more days at Burford Bridge, reading in his room, and strolling on Box Hill or under the bare trees along the banks of the river Mole. Briefly, he entered a mood which he would later call 'creative indolence', writing a short lyric, 'In drear-nighted December'. Its three gently gliding stanzas show none of the strain he had suffered in the past few months, yet they summarise all their effort – they are a miniature *Endymion*. Reflecting on the river, Keats says that it neither remembers 'Apollo's summer look' nor 'pet[s] / About the frozen time'; he interprets it as an image of the ideal artistic personality:

> Ah! would 'twere so with many
> A gentle girl and boy!
> But were there ever any
> Writhed not of passèd joy?
> The feel of not to feel it,
> When there is none to heal it,
> Nor numbèd sense to steel it,
> Was never said in rhyme.

The confidence of this poem still glowed in Keats when he reached

Hampstead in early December. The threat of *Blackwood's* might still be hanging over him, Tom's health might still be troubling him (he and George had delayed their departure for Devon: they eventually left on 13 December), but with *Endymion* finished he was once again 'the coming poet'³ – and set about proving it to his friends. Later he would refer to these as 'cavalier days', crammed with invitations, brimming with 'fresh-hatched' jokes, and crowded with talk. Over the next month or so he visited Wentworth Place virtually every day. He held a dinner for Severn and Tom's friend Charles Wells, drinking port and playing 'a concert from 4 o'clock till 10' by imitating musical instruments (Keats took the part of the bassoon). He attended a 'Saturday Club' that Rice had recently organised. He saw Reynolds and Horace Smith, and other friends like Horace Twiss and Haydon's pupil William Bewick, who jostled in the margins of his set. He visited Haydon, and heard that he would soon be able to meet Wordsworth. (Wordsworth was staying with his brother, the rector of Lambeth, before moving with his wife Mary and her sister Sarah Hutchinson to lodgings in Mortimer Street in the West End.) He went to see Hunt, who was fulminating about the forthcoming trial of William Hone, the radical pamphleteer who had recently been arrested for attacking the government in parodies of the Catechism, the Creed and the Litany. Keats, like Hunt, admired the brilliance with which Hone defended himself at his trial, and when it ended with an acquittal on 20 December, he joined in the general liberal rejoicing. He wrote the sonnet 'Nebuchadnezzar's Dream' – using, as Hone himself had done, a biblical reference to castigate the Tory ministry (that 'most valiant crew / Of loggerheads and chapmen'). Suspecting a more direct approach would be imprudent, Keats never steps outside the confines of his little allegory, but his sympathies are clear and so is his elation.

At the same time as he wrote this sonnet, Keats found a way of continuing its argument by different means. Reynolds, who wrote regular theatre reviews for the *Champion*, took himself off to Devon to spend Christmas with his fiancée Eliza Drewe, and suggested that Keats act as his temporary replacement. Ever since leaving school and first moving to London, Keats had been to the theatre regularly, most often to see plays by Shakespeare, but also enjoying less 'mighty' writers. His visits were not just a part of his pleasure-seeking metropolitan life, but of his self-education. Edmund Kean, the most renowned actor of his day, was especially important to him. Kean's gifts were phenomenal, and his

person and technique embodied the principles that Keats admired. Although several actors of the old school – Garrick, in particular – had been praised for their naturalism, Kean represented a new and revolutionary spirit. He 'brought back nature and impulse,' said Hunt, 'something genuine and unconscious, something that moved, looked and spoke solely with the impulse of the immediate idea.'⁴ Hazlitt, who described Kean's appearances more vividly than anyone, agreed. Fascinated by his powerful physical presence (wiry frame, coal-black eyes, and rasping voice), and insisting on his social difference (Kean was popularly reckoned to be part gypsy, but himself claimed to be the bastard child of the Duke of Norfolk), Hazlitt made him an archetype of the outsider genius, saying 'the rapidity of his transitions from one tone and feeling to another, [his] propriety and novelty of action, . . . [his] succession of striking poses . . . [gave] perpetually fresh shocks of delight and surprise'.⁵

When Keats discovered that his first task for the *Champion* was to mark Kean's return from illness in a new production of *Richard III* at Drury Lane, he was exhilarated, and determined to make political as well as dramatic points. His review appeared on 21 December, the day after Hone's release, and clearly links the champion of liberty to his theatrical counterpart. ' "In our unimaginative days," ' he began, '*Habeas Corpus*'d as we are, out of all wonder, curiosity and fear; – in these fireside, delicate, gilded days, – these days of sickly safety and comfort, we feel very grateful to Mr Kean for giving us some excitement by his old passion in one of the old plays. He is a relict of romance; – a Posthumous ray of chivalry, and always seems just arrived from the camp of Charlemagne.' While this praise echoes articles about Kean that Keats had read in the *Examiner*, its reference to 'fireside' days is a sign that he wanted to establish a distinction between himself and Hunt (for whom the word was a touchstone). He is more obviously aligned with Hazlitt, whom he invokes when describing the 'undescribable gusto' of Kean's voice, and with the self he had projected in *Endymion*. 'The spiritual', he says, 'is felt when the very letters and prints of charactered language show like the hieroglyphics of beauty; – the mysterious signs of an immortal freemasonry!'

He also, towards the end of the review, introduced yet another name to support his case. Kean 'feels his being', Keats says, 'as deeply as Wordsworth, or any other of our intellectual monopolists'. It is a ringing reference. Keats had admired the two-volume 1815 edition of Words-

worth's poems ever since reading them during his first few months in London. *The Excursion* had impressed him even more deeply. Its emphasis on the idea that poets should be healers, and its arguments about the potency of classical culture, had stimulated his own thoughts about these things. As the prospect of meeting Wordsworth drew closer, he welcomed the chance to pay a public homage.

Haydon, however, warned Keats that the encounter was likely to be difficult: Wordsworth was famously touchy. Provided he was shown the respect he felt was owing to him, he would probably behave graciously; if not, he would be cantankerous. On this present visit to London, he had already shown how demanding he could be, refusing to meet Hazlitt, and complaining to Haydon – while sitting for inclusion in 'Christ's Entry', his head 'bending down in awful veneration'[6] – about the work and criticism of various others. Keats felt he stood a good chance of being well received. He had already shown Wordsworth his 'reverence' in the dedication copy of *Poems* that he had sent to the Lake District, and in his many borrowings and adaptations. Moreover, he trusted Haydon as a mediator, knowing that the painter had written respectfully to Thomas Monkhouse, Mary Wordsworth's cousin, asking where the meeting might best take place. Monkhouse had suggested his own house, in Queen Anne Street, and when the day came for Keats to walk there with Haydon from Lisson Grove North, he felt only 'the greatest, the purest, the most unalloyed pleasure'.

First impressions were contradictory. The twenty-two-year-old Keats was nervous, 'ardent' and impetuous – his clothes and manner indicative of his background and milieu. Wordsworth was more than twice his age, withdrawn, grave and opinionated. As Hunt said, 'He had a habit of keeping his left hand in the bosom of his waistcoat; and in this attitude, except when he turned round to take one of the subjects of his criticism from the shelves . . ., he sat dealing forth his eloquent but hardly catholic judgements.'[7] After the introductions had been dealt with, Wordsworth asked Keats what he was writing. Haydon is the only source for what followed:

I said he has just finished an exquisite ode to Pan – and as he had not a copy I begged Keats to repeat it – which he did in his usual half chant, (most touching) walking up & down the room – when he had done this I felt really, as if I had heard a young Apollo – Wordsworth drily said
 'a very pretty piece of Paganism' –
This was unfeeling, & unworthy of his high Genius to a young Worshipper like

Keats – & Keats felt it *deeply* – so that if Keats has said anything severe about our Friend [since]; it was because he was wounded – and though he dined with Wordsworth after at my table – he never forgave him.

This famous account was produced nearly thirty years after the event, and at a time when Haydon's excitability had turned into something like megalomania: a few months after writing it, he committed suicide. We might, therefore, suspect that while his memory of Wordsworth's remark is probably accurate,[8] his judgement of its effect is doubtful. For one thing, Keats had been prepared to find Wordsworth prickly: the difference between their political views can be conveniently measured by the fact that Keats first published his 'Hymn to Pan' in the radical journal the *Yellow Dwarf*. For another, Wordsworth may not have used either 'pretty' or 'Paganism' in the sense that Haydon understood. 'Pretty' was often used at the time to mean 'admirable'[9] rather than slight or decorative, and 'Paganism' was not something that Wordsworth dismissed automatically. At regular intervals in his poetry, and especially in Book IV of *The Excursion*, he had condoned the 'grand simplicity and beauty'[10] of the Greeks. If he did intend to wound Keats, it was less likely to have been because his 'puling Christian feelings were annoyed', than because he felt Keats's lines did not do adequate justice to the Classical ideal.

Nothing in Keats's behaviour with Wordsworth over the next few weeks suggested that he thought he had been snubbed. In fact, he seems to have been tickled – as he was again later in their meeting. 'During that same interview,' he told Charles Cowden Clarke, 'someone having observed that the next Waverley novel was to be "Rob Roy", Wordsworth took down his volume of Ballads, and read to the company "Rob Roy's Grave"; then, returning it to the shelf, observed "I do not know what more Mr Scott can have to say upon the subject." ' Shortly after leaving Queen Anne Street, Keats wrote a letter to his brothers in Devon which confirms his loyalty to Wordsworth's poetic principles. Beginning with news of the Hone trial, and criticising himself for being 'out too much lately', he then reports on a visit he has made with Wells to see 'Death on the Pale Horse' [sic], a new painting by Benjamin West exhibited at 126 Pall Mall under the patronage of the Prince Regent. West (1738–1820) was the President of the Royal Academy, an establishment figure described by Hunt – whose father had once benefited from West's generosity –

as a 'wretched foreigner'. He was American. Although Keats reckoned the new work 'wonderful . . . when West's age is considered', he felt that it lacked the weighted passion he had recently admired in Kean and re-evaluated in Wordsworth. (Hazlitt said much the same thing when he reviewed it in the *Edinburgh Magazine* the same month.) 'There is nothing to be intense upon,' Keats wrote. 'No women one feels mad to kiss; no face swelling into reality.' Then he widened his thoughts to connect them with the idea of Beauty that he had pursued in *Endymion*, and with the issues of identity he had raised in 'In drear-nighted December'. 'The excellence of every Art is its intensity,' he said, 'capable of making all disagreeables evaporate, from their being in close relationship with Beauty & Truth – Examine King Lear & you will find this exemplified throughout; but in this picture we have unpleasantness without any momentous depth of speculation excited, in which to bury its repulsiveness.'

It is typical of Keats's letters that this opinion, which seems like the conclusion to a thought, should in fact be a staging post. As soon as he has reached it, he gathers himself again, giving more details of his socialising, and saying that a recent dinner with Horace Smith had only served to convince him 'how superior humour is to wit in respect to enjoyment'. Making this distinction, he once again combines aesthetic with social values. Smith and friends, he says, embody a version of the mannered fashionability he dislikes in West's painting, and when describing how they spoke disparagingly of 'Kean & his low company', he blurts out, 'Would I were with that company instead of yours I said to myself.'

This torrential rush of impressions and anecdotes reproduces wonderfully well the process of a mind actually engaged in the act of thinking – continually discovering links between apparently disparate things as it drives speedily forward. It means that when Keats goes on to describe how, after a recent 'disquisition' with Dilke, 'several things dovetailed in my mind', the word 'dovetailed' affects us as something felt, not merely reported. 'At once it struck me,' he continues, using language which is again strongly influenced by Hazlitt, 'what quality went to form a Man of Achievement especially in Literature & which Shakespeare pos[s]essed so enormously – I mean *Negative Capability*, that is when man is capable of being in uncertainties, Mysteries, doubts, without any irritable reaching after fact & reason – Coleridge, for instance, would let go by a fine isolated verisimilitude caught from the

Penetralium of mystery, from being incapable of remaining content with half knowledge. This pursued through Volumes would perhaps take us no further than this, that with a great poet the sense of Beauty overcomes every other consideration, or rather obliterates all consideration.'

This letter marks the high point of an extraordinary year of self-development for Keats, and Hazlitt's contribution to the process has often and rightly been stressed. In many essays, and throughout the *Principles of Human Action*, Hazlitt explores the naturally unselfish and 'disinterested' nature of the imagination in ways that anticipate Keats's thoughts very closely.[11] Yet the role played by Wordsworth, and to a lesser extent by Coleridge,[12] is also vital, and gives further proof that Haydon was wrong to say Keats 'never' forgave the older poet after their first meeting. The two central premises of the letter – that the mind contributes to direct impressions, and that consecutive reasoning violates natural processes – are both ideas that Wordsworth had inherited from Locke and Hume, and form the backbone of many poems (the 'Immortality Ode', for instance). Here and elsewhere Keats develops them into a series of statements about the fusion of object and mind, and about the awakening of external reality into a 'Truth' which is embodied as 'Beauty'. This 'Beauty', he insists, is not the coherence of a thing in itself, but a union of the observable and the interior world, a synthesis which depends on the interplay of senses, on 'gusto', and on imaginative drama. 'As Tradesmen say,' he pointed out to Bailey in March the following year, 'every thing is worth what it will fetch, so probably every mental pursuit takes its reality and worth from the ardour of the pursuer – being in itself a nothing – Etherial thing[s] may at least be thus real, divided under three heads – Things real, things semireal – and no things – Things real such as existences of Sun Moon & Stars and passages of Shakespeare – Things semireal such as Love, the Clouds, &c which require a greeting of the Spirit to make them wholly exist – and Nothings which are made Great and dignified by an ardent pursuit – Which by the by stamps the burgundy mark on the bottles of our Minds, insomuch as they are able to "consec[r]ate *whate'er they look upon*".'

As CHRISTMAS APPROACHED, Keats's 'cavalier' life reached a kind of apotheosis. Between the start of the holidays and the early new year, he dined with Haslam 'very snugly' and often with Brown and Dilke, with whom he now felt 'capital friends'. He saw two more plays for the

Champion – a pantomime called *Harlequin's Vision* with Brown on Boxing Day, and the tragedy *Retribution* (which he refers to as *Don Giovanni*) with Wells on 2 January. (After the performance he proved his point about 'low company' by going backstage and talking to 'a little painted Trollop' who had taken the part of a Quaker.) He bumped into Lamb and Godwin. He dropped in on Rice, Severn and Haydon. Only twice did the smooth round of visiting stick: once on Christmas Day itself, when he saw the Reynoldses and had to listen to Jane complaining about George; and then again when he saw his sister with the Abbeys. Abbey was his usual censorious self, and his wife irritated him with her 'ignorant and unfeeling gabble'. She said that in her opinion all the Keats family were 'indolent'.

On 28 December he made up for this grim perversion of family life by attending a spectacular party given by Haydon – a party which has since become known as the 'Immortal Dinner'. It began at three o'clock in the studio at the back of Haydon's house in Lisson Grove, with the guests seated at a long table beneath the still unfinished 'Christ's Entry': Keats and Wordsworth, Monkhouse and Lamb, and Haydon presiding. The conversation opened with a discussion of Homer, Shakespeare, Milton and Virgil – with Wordsworth, who was 'in high good humour', reciting 'Milton with an intonation like the funeral bell of St Paul's & the music of Handel mingled'. (His high spirits were perhaps partly a reaction to the fact that on the previous day he had seen Coleridge for the first time in several years: it had been an awkward and stressful encounter.) Lamb, who invariably got tiddly very quickly, soon started to chide Wordsworth for criticising Voltaire in *The Excursion*. He proposed a toast to 'Voltaire, the Messiah of the French nation, and a very fit one', and attacked Haydon for including Newton in the canvas that hung above them. Keats joined in. In his recent review of Kean he had praised 'the sensual life of verse'; now he agreed that Newton had 'destroyed all the Poetry of the rainbow by reducing it to a Prism'. He drank with Lamb to 'Newton's health and confusion to Mathematics' – with Wordsworth enthusiastically supporting him.

After three or four hours (during which Keats declaimed a section of *Endymion*), they moved to a front room and met other guests, among them the engraver John Landseer and a young surgeon named Joseph Ritchie, whom Tom had met in France, and who was soon to be sent by the government on an ill-fated expedition to find a new route to the Niger. (Ritchie later praised Keats as likely 'to be the great poetical

luminary of the age to come'; history does not relate whether he fulfilled a promise he made Keats to take a copy of *Endymion* to the Sahara desert and 'throw it in the midst'.) By this stage the company had stopped drinking wine and were sobering up with tea, but this did not prevent the evening from ending in farce. The reason was the late arrival of John Kingston, the deputy Comptroller of the Stamp Office, an old Etonian, and a friend of Horace Smith. Since 1813, Wordsworth had been helping to make ends meet by working as Distributor of Stamps for Westmorland and part of Cumberland. He had never met Kingston, but knew that he was his immediate superior in the London office. Haydon takes up the story:

When we retired to tea we found the comptroller. In introducing him to Wordsworth I forgot to say who he was. After a little while the comptroller looked down, looked up and said to Wordsworth, 'Don't you think, sir, Milton was a great genius?' Keats looked at me, Wordsworth looked at the comptroller. Lamb, who was dozing by the fire turned round and said, 'Pray, sir, did you say Milton was a great genius?' 'No, sir; I asked Mr Wordsworth if he were not'. 'Oh', said Lamb, 'then you are a silly fellow'. 'Charles! My dear Charles!' said Wordsworth; but Lamb, perfectly innocent of the confusion he had created, was off again by the fire.

After an awful pause the comptroller said, 'Don't you think Newton was a great genius?' I could not stand it any longer. Keats put his head into my books. Ritchie squeezed in a laugh. Wordsworth seemed asking himself, 'Who is this?' Lamb got up, and taking a candle, said, 'Sir, will you allow me to look at your phrenological development?' He then turned his back on the poor man, and at every question of the comptroller he chaunted –

Diddle diddle dumpling, my son John
Went to bed with his breeches on.

The man in office, finding Wordsworth did not know who he was, said in a spasmodic and half-chuckling anticipation of assured victory, 'I have the honour of some correspondence with you, Mr Wordsworth.' 'With me, sir?' said Wordsworth, 'not that I remember.' 'Don't you, sir? I am comptroller of stamps.' There was a dead silence; – the comptroller evidently thinking that was enough. While we were waiting for Wordsworth's reply, Lamb sung out

Hey diddle diddle,
The cat and the fiddle.

'My dear Charles!' said Wordsworth, –

Diddle diddle dumpling, my son John,

chaunted Lamb, and then rising, exclaimed. 'Do let me have another look at that gentleman's organs.' Keats and I hurried Lamb into the painting-room, shut the

door and gave way to inextinguishable laughter. Monkhouse followed and tried to get Lamb away. We went back but the comptroller was irreconcilable. We soothed and smiled and asked him to supper. He stayed though his dignity was sorely affected. However, being a good-natured man, we parted all in good humour, and no ill effects followed. All the while, until Monkhouse succeeded, we could hear Lamb struggling in the painting-room and calling at intervals, 'Who is that fellow? Allow me to see his organs once more.'

Haydon's judgement that 'no ill effects followed' was not quite accurate. Although Wordsworth left the party with a good grace, he had obviously been embarrassed, and so had Keats. When Kingston invited him to meet Wordsworth again at his house the following weekend, Keats preferred to go elsewhere. On the last day of the year, however, he happened to meet Wordsworth walking on Hampstead Heath in a fog, and agreed to call on him before his date with Kingston. The result was a more serious disillusionment than any he had suffered after reciting the Hymn to Pan. Arriving at Mortimer Street, where Wordsworth was now staying, he was first kept waiting and then confronted by Wordsworth wearing formal evening dress: a frilled shirt, stiff collar, knee-breeches, and silk stockings. Even though Wordsworth's wife and Sarah Hutchinson received him kindly, and invited him to dine two days later, Keats was put out. He felt that Wordsworth was demeaning himself by pandering to Kingston.

Dilke said that Keats later spoke of this meeting 'with something of anger'. His impatience tells us a good deal about how he now saw himself in relation to authority. Just as he came down 'on the liberal side of the question' in his poems, so his everyday life challenged social orthodoxies. Everything about his connection with Hampstead proved this, as *Blackwood's* realised. If Wilson and Lockhart had been able to follow him round the circle of his friends this Christmas, he would have convinced them that he was indeed dangerously *déclassé* – someone whose suburban 'vulgarity' was a sign of independence, and whose ambitions were inherently subversive. The aftermath of his latest meeting with Wordsworth confirmed it. Leaving the great man bound in the fine clothes of officialdom, he set off to a party given by an old family friend, George Reddell, who ran a sword-cutlery business in Piccadilly. Reddell was an 'innocent, powdered' little man who was not used to entertaining, and 'supplied too much drink'.[13] Surrounded by friends like Rice and acquaintances like the lawyer Frank Fladgate (with whom Reynolds was working), Keats joined in the teasing of another

guest, a 'younger brother' of William Squib, who 'made him self very conspicuous after the Ladies had retired from the supper table by giving Mater Omnium – Mr Redhall [sic] said he did not understand any thing but plain english where at Rice egged the young fool on to say the Word plainly out. After which there was an enquirey about the derivation of the word C—t when while two parsons and Grammarians were setting together and settling the matter Wm Squibs interrupting them said a very good thing – "Gentlemen says he I have always understood it to be a Root and not a Derivative." On proceeding to the Pot in the Cupboard it soon became full on which the Court door was opened Frank Floodgate bawls out, Hoollo! here's an opposition pot – Ay, says Rice in one you have a Yard for your pot, and in the other a pot for your Yard – .'

Because relatively few detailed descriptions of Keats in company have survived, this evening with Reddell – and the 'Immortal Dinner' itself – have struck some of his biographers as unusual. In fact they were typical, especially during this 'cavalier' time of his life. A few days later, for instance, he went to a similar get-together, this time with Horace Twiss and Horace Smith. Shortly afterwards he described it to his brothers – in a letter which has only recently been rediscovered, and which gives a marvellously clear sense of his love of life: 'Horace Twiss dined the other day with Horace Smith', he says. 'Now Horace Twiss has an affectation of repeating extempore verses – which however he writes at home . . . Horace T. was to recite some verses and before he went aside to pretend to make on the spot verses composed before hand. While H.T. was out of the room H.S. wrote the following and handed it about, when H. Twiss had done his spouting:

> "What precious extempore verses are Twiss's
> Which he makes ere he waters and vows as he pisses,
> 'Twould puzzle the Sages of greece to unriddle
> Which flows out the fastest his verse or his piddle,
> And 'twould pose them as much to know whether or not
> His piss or his poems go quickest to pot!" '[14]

All such evenings – and especially the one spent with Reddell discussing slang rather than bowing to an employer – measure the differences which divided Keats from Wordsworth. This does not mean that he suddenly and completely turned against him. Their meetings may have undermined his original 'reverence', but in years to come he

carefully distinguished between his feelings about Wordsworth the man, and his admiration for the work. When he made a final visit to Mortimer Street, he was exasperated by having Mrs Wordsworth lay a hand on his arm at one point and say 'Mr Wordsworth is never interrupted'. Yet within a week he was telling Haydon that *The Excursion* – along with 'Your pictures and Hazlitt's depth of Taste' – was one of 'three things to rejoice at in the Age'.[15]

NINETEEN

IN THE EARLY DAYS of the new year 1818, Keats started to think about revising *Endymion*. He was repeatedly interrupted. A letter from George in Devon told him that Tom had been spitting blood. In discussions with Dr Sawrey, Keats could no longer deceive himself that his brother was merely suffering from some minor ailment, or from the pangs of unrequited love for his mysterious French admirer. Conversations with Haydon about the money for Cripps's training made him feel obligated and guilty, even though (or especially because) Haydon continued to reassure him, and to remind him that he was welcome in the studio for dinner 'every Sunday at three'. As he had done before, Keats tried to calm himself by turning to those friends who made the fewest demands on him – Dilke, Brown, Rice and Woodhouse. Yet even these contacts brought difficulties. Reynolds, back from Devon, was quarrelling with Haydon because he had ignored Haydon's invitation to meet Words-worth at the 'Immortal Dinner'. Haydon, once again, was at odds with Hunt, protesting that Mrs Hunt had not returned some silverware she had borrowed.

When Keats finally started work on his poem, he felt overwhelmed by how much attention it needed. Only a few weeks old, it already seemed like the creation of a different and much younger writer. One possibility was simply to suppress it altogether and let 'this youngster die away'. But this was never a realistic option. He had invested too much in it, too publicly, and he had been advanced money he could not afford to return. He gritted his teeth and pressed on, and by 19 January had reached the end of Book I, incorporating changes which (apart from the 'pleasure thermometer' section, which he added shortly afterwards) were mostly 'of incidental importance'.[1] The following day he took the manuscript to Taylor in Fleet Street. If the publisher had any reservations about what

[223]

he read, he kept them to himself. He told Keats that he would publish the poem in quarto, if Haydon could be persuaded to draw a scene for the frontispiece.

It is a measure of Haydon's self-absorption that nothing came of this plan, and also of Keats's own doubts about what he had written. After listening to Haydon suggest that he might do something for a later edition, or alternatively might provide an engraving of 'the author', Keats decided that he would rather wait until he had finished an entirely new poem. This, he said, was something he had already started to envisage: a recasting of the myth of Hyperion. When this was 'done', he went on, then 'there will be a wide range for you – in Endymion I think you may have many bits of the deep and sentimental cast – the nature of *Hyperion* will lead me to treat it in a more naked and grecian Manner – and the march of passion and endeavour will be undeviating – and one great contrast between them will be – that the Hero of the written tale being mortal is led on, like Buonaparte, by circumstance; whereas the Apollo in Hyperion being a fore-seeing God will shape his actions like one.'

Keats finished revising Book II more quickly, beginning on 25 January and reaching the end on 5 February. Taylor's encouragement had helped him accelerate, and for the first time in weeks he felt genuine pleasure in his work, even though he realised it was not likely to make him the money he needed. In the recently rediscovered letter to his brothers, written on 30 January, he said: 'I am convinced now that my poem will not sell. Hope they say; so I will wait about three Months before I make my determination – either to get some employment at Home or abroad, or to retire to a very cheap way of living in the country.'[2] Although Keats was alarmed by the sense of time running out, it did nothing to put him off thinking about the poems which lay in the future. In the third week of January he had produced two light pieces for the Reynolds family – a ditty for the sisters called 'Apollo to the Graces', and a sonnet 'To Mrs Reynolds's Cat'. This had been followed by another occasional poem, prompted by a visit to Hunt on which he had been shown a lock of Milton's hair, and by another sonnet, 'On Sitting Down to Read *King Lear* Once Again'. Keats never thought this worthy of publication but, like the Milton poem, it shows him renewing the contact between his liberal themes and his sense of personal progress. (*King Lear* was banned from the London stage at this time; its depiction of a mad monarch was thought to be unacceptable, in view of George

III's lunacy.) Speaking of Milton, Keats says 'Pangs are in vain, until I grow high-rife / With old Philosophy, / And mad with glimpses of futurity'; writing about *King Lear*, he bids 'Adieu' to 'golden-tongued Romance', knowing that 'once again, the fierce dispute / Betwixt damnation and impassioned clay / Must I burn through'. In both cases, he seeks to distance himself from *Endymion*, yet continues to explore one of its main themes. His sonnets aspire to 'The bitter-sweet' of Shakespeare in much the same way that *Endymion* hankers to reconcile pleasure with pain. In this sense, they are less like poems marking a fresh start than ones which celebrate continuity, but continuity that Keats realises must include new terms, new forms, and a new version of the 'deep eternal theme'. Shortly after completing them, he told his brothers: 'I think a little change has taken place in my intellect lately. I cannot bear to be uninterested or unemployed, I, who for so long a time, have been a[d]dicted to passiveness.'

Keats was loath to admit it, but his sense of recommitment had something to do with his recent visit to Hunt. However compromised their friendship had become, the meeting reminded him of common sympathies. Predictably, though, Hunt upset him as well as heartening him. Before leaving Lisson Grove North, Keats handed over the fair copy of the first book of *Endymion*, and instead of treating it with respect, Hunt whipped through it carelessly, criticising its language as 'high-flown' (he meant it did not have the chattiness of *Rimini*), and saying that in the scenes between Endymion and Peona 'it should be simple forgetting do ye mind, that they are both overshadowed by a Super-natural Power'. By the time Keats reported this to his brothers a short while afterwards, he could appreciate that Hunt '& Shelley are hurt & perhaps justly, at my not having shown them the affair officiously', but the damage had been done. Another veering towards Hunt had resulted in another recoil.

The criticisms worried Keats, and were still troubling him at the end of January when he began a new poem. The first line strikes a more ringing note than any Hunt was capable of producing – but only to dramatise his self-doubt:

> When I have fears that I may cease to be
> Before my pen has gleaned my teeming brain,
> Before high-pilèd books, in charactery,
> Hold like rich garners the full-ripened grain;

[225]

> When I behold, upon the night's starred face,
> Huge cloudy symbols of a high romance,
> And think that I may never live to trace
> Their shadows, with the magic hand of chance . . .

Like 'On First Looking into Chapman's Homer', this poem shows that Keats felt his success as a poet depended on his acquiring material, rather than on using what was his by birthright. But it tackles the theme with a different kind of authority. Whereas the earlier sonnet projected many of its themes against a historical background, here they are more immediately personal. Although 'When I have fears . . .' is concerned with the threat of failure, its powerful rhetoric creates an undeniable sense of fulfilment. Although the first line anticipates the shocking brevity of Keats's existence, it opens the way for an appreciation of 'high-pilèd books' which reaffirms the durable consolations of art itself.

In the last six lines of the sonnet, Keats returns to the theme of disappointment, perhaps remembering the woman he had seen in Vauxhall Gardens during the summer of 1814, perhaps recalling some other brief encounter:

> And when I feel, fair creature of an hour!
> That I shall never look upon thee more,
> Never have relish in the faery power
> Of unreflecting love! – then on the shore
> Of the wide world I stand alone, and think
> Till love and fame to nothingness do sink.

These last two and a half lines have sometimes been criticised for sounding banal in their bewilderment. In fact their candour is their strength – the heavy-footed desolation is a kind of dead march, a funeral beat. At the same time, they refer to Keats's developing plans. They conclude what is in effect a formal experiment: the first Shakespearean rather than Petrarchan sonnet that he had written. They also describe an emptying of the self which anticipates a fresh start. The resolved steadiness of their tone, so unlike what Keats called the 'ranting' of his *King Lear* sonnet, looks forward to the 'naked and grecian' manner he wanted to cultivate in 'Hyperion'.

'WHEN I HAVE FEARS . . .' is doubtful as well as determined; Keats still felt he needed guidance.[3] Accepting that Hunt was likely to do him more

harm than good, he turned with revitalised interest to Hazlitt. On 18 January, the day before he visited Hunt, he had met Hazlitt in Haydon's studio and heard that he had recently begun lecturing every Tuesday at the Surrey Institution in Blackfriars. Two days later he went to hear the second talk in the series, 'On Chaucer and Spenser' (the first had been 'On Poetry in General'), but arrived at the wrong time – at eight o'clock, not seven - and found the audience already leaving. The following week, however, he turned up on time to hear Hazlitt discuss Shakespeare and Milton, and over the next month or so also heard him talk about nature poetry, about Dryden, about Swift, Collins and Gray, about Chatterton (delivering an opinion which Keats later persuaded him to revise),[4] about Burns, and 'On the Living Poets'.

In the pillared circle of the lecture theatre, Hazlitt spoke nervously but dramatically, often incorporating passages from existing articles, sometimes expanding them to include new material. His audience was 'a mixed lot – Quakers, dissenters, and mind-improvers, along with Keats's set and a sprinkling of Hazlitt's enemies. They gave him an assortment of prejudices to set on edge with his inimitable skill.'[5] The theme of the first lecture was Shakespeare's universality, the very thing Keats had been exploring in recent weeks. Discussing it with friends later, he heard that Hazlitt had insisted Shakespeare 'was just like any other man, but that he was like all other men. He was the least of an egoist that it was possible to be. He was nothing in himself; but he was all that others were, or that they could become. He not only had in himself the germs of every faculty and feeling, but he could follow them by anticipation, intuitively, into all their conceivable ramifications, through every change of fortune, or conflict of passion, or turn of thought . . . When he conceived of a character, whether real or imaginary, he not only entered into all its thoughts and feelings, but seemed instantly, and as if by touching a secret spring, to be surrounded with all the same objects.'

Keats had already personalised these ideas in his letters. During the months to come, his understanding of them deepened enormously. When he evolved the notion of the 'chameleon poet', he relied on Hazlitt's conviction that Shakespeare was 'the least of an egoist'. When he adapted a concept of the 'egotistical sublime', he embraced Hazlitt's judgement that in *The Excursion* Wordsworth's 'intense intellectual egotism swallows up everything'. When he told Bailey in January 1819 that 'Men should bear with each other', he converted what Hazlitt offered as a literary argument into social terms. Many other passages

show the same sort of connection, and all, as Woodhouse realised in some notes he made about Keats later in the year, prove that he grew increasingly determined to make his address to history imaginative and reflective, rather than polemical or overt. 'The highest order of Poet,' Woodhouse interpreted Keats as saying, '. . . will have so high an imagn that he will be able to throw his own soul into any object he sees or imagines, so as to see, feel, be sensible of, & express, all that the object itself wod see feel be sensible of or express – & he will speak out of that object so that his own self will with the Exception of the Mechanical part be "annihilated". – and it is of the excess of this power that I suppose Keats to speak, when he says he has no identity.'

As Hazlitt's lectures continued, Keats followed up the hints he gave about other writers who were likely to inspire the latest stage of his self-invention. In his lecture about Swift and others on 17 February, for instance, Hazlitt praised Voltaire. Keats already knew a good deal about Voltaire from conversations with Hunt and Haydon, who had included his portrait in 'Christ's Entry'. Now he began reading him again. Like Hazlitt, he resented the attack on 'the laughing Sage of France' that Wordsworth had made in *The Excursion*, not only because he recognised the social importance of Voltaire's struggle against superstition and ignorance, but because it implied a notion of progress that endorsed his own. In the *Essai sur les Moeurs*, he read passages describing the cycles of history as evidence of mankind's recurring heartlessness; this confirmed his strengthening wish to confront the 'misery' of life. In the biography of Charles XII, he found Voltaire echoing his belief that this misery had as much to do with state authority as it did with personal responsibility. 'If any Prince or minister of State shall meet with unwelcome truths in this book,' Voltaire said, 'they must consider, that they are in a public capacity, and obliged to give accompt to the public for their actions; that is the price they pay for their greatness; that history is to tell the whole truth, and nothing but the truth; and that if they would have men speak well of them, it concerns them to do well.'[6] Some time later, when visiting Haydon's studio, Keats stood in front of the portrait of Voltaire in 'Christ's Entry', put his hand on his heart, and said, 'There is the being I will bow to.'

As Keats discussed these ideas with his friends, he found that no one responded to them more helpfully than Reynolds. Like Keats, he had recently detached himself from Hunt, continuing to write profitably for the *Champion* and, since January, for a radical weekly called the *Yellow*

Dwarf which had recently been founded by John Hunt. This aroused Keats's own ambitions in an amiably competitive way, but he was also excited for more complicated reasons. Reynolds had been told by his fiancée Eliza Drewe that he must give up writing poetry and establish himself as a lawyer before she would consent to marry him. As things turned out, their marriage did not in fact take place for several years, but in the short term, at least, Reynolds seemed to Keats like someone who needed as much support as he could get.

This made Keats feel even more obviously like the senior partner in their relationship, and encouraged him to extend the reach of his poems. Once again, Hazlitt played an important part. In his lecture on 3 February, talking about Dryden's translations of Boccaccio, Hazlitt had said that a treatment of some of the other tales in *The Decameron* 'could not fail to succeed in the present day', prompting Keats immediately to lay hands on a prose translation and scan it for possibilities. He did not have to look far. In the first tale that Hazlitt had suggested – the story of Isabella – he found a narrative which gripped him so powerfully that within hours of reading it he had drafted a few stanzas of a poem on the same subject. When he mentioned this to Reynolds, they decided to collaborate on a whole book of verse adaptations from Boccaccio.

Before starting work in earnest, they concentrated on a smaller joint venture. During the first week of February, Reynolds sent Keats two sonnets on Robin Hood – 'The trees in Sherwood forest are old and good', and 'With coat of Lincoln green and mantle too' – which were intended to celebrate the republican spirit of Hood's rebellion, and praise signs of its continuance into the present day. Thanking him for the 'dish of Filberts', Keats included two poems of his own. Before transcribing them, however, he returned once more to the question of identity. Criticising Wordsworth and Hunt for 'teasing' their readers with 'grandeur & merit', he promotes the idea that all writing – and especially writing which seeks to win support for an argument – should be 'uncontaminated & unobtrusive'. 'We hate poetry that has a palpable design upon us,' he tells Reynolds, '– and if we do not agree, seems to put its hands in its breeches pocket. Poetry should be great & unobtrusive, a thing which enters into one's soul, and does not startle it or amaze it with itself but with its subject. – How beautiful are the retired flowers! how would they lose their beauty were they to throng into the highway crying out "admire me I am a violet! dote on me I am a primrose!" Modern poets differ from the Elizabethans in this.'

In the second of his two poems, 'Lines on the Mermaid Tavern', which Keats had written after spending an evening at the Tavern in Cheapside, he invokes 'the Elizabethans' specifically. (He obviously had a special fondness for this poem, copying it to no fewer than seven of his friends.[7]) He treats the famous meeting place of Shakespeare, Jonson, Beaumont and Fletcher as a 'Paradise' of free and liberal imagining. 'Bold Robin Hood' and 'his maid Marian' are honorary members of their society – for reasons that are implicit in the very title of the first poem, 'Robin Hood' itself. Contemporaries would have been alert to its radical reference. In 1765, Percy had attempted to lift Hood from popular broadsheets and make him a part of mainstream literature in his *Reliques of Ancient English Poetry*. In 1795, however, he had been rehabilitated as a political hero by the republican Joseph Ritson in his *Robin Hood: A collection of all the ancient poems, songs and ballads now extant, relative to that celebrated English outlaw*. It seems likely that Keats knew this book, since in one of his letters he quotes a phrase from the introduction in which Ritson describes Hood as a man who 'in a barbarous age [this is the phrase that Keats adopts], and under a complicated tyranny, displayed a spirit of freedom and independence, which has endeared him to the common people, whose cause he maintained (for all opposition to tyranny is the cause of the people) and, in spite of the malicious endeavours of pitiful monks, by whom history was consecrated to the crimes and follies of titled ruffians and sainted idiots, to suppress all record of his patriotic exertions and virtuous acts, will render his name immortal'.[8]

Whereas Reynolds had cheerfully celebrated the democratic spirit of Sherwood, Keats laments its disappearance. 'No!', he begins, chiding his friend for undue optimism:

> No! those days are gone away,
> And their hours are old and grey,
> And their minutes buried all
> Under the down-trodden pall
> Of the leaves of many years . . .

In the sixty-odd 'Thrumming' lines that follow, Keats details what has been lost. By maintaining an apparently light tone (the poem is a kind of extended hunting ditty), and embedding matters of opinion in actual sights and sounds, he manages to make his purpose 'unobtrusive' in just

[230]

the way that his accompanying letter recommends. Conflating images from Shakespeare with others from the 'old oak forest' of 'Albion' that he had mentioned in his *King Lear* sonnet, he turns Hood into an ideally patriotic figure who embodies all the virtues of the Classical golden age. This makes him much more than a sentimental hero of folklore. He exemplifies moral rather than legal authority (the implication that Reynolds should stick to writing and not becoming 'limed' in the law is clear). He is a 'Man of Power' who is also a 'Man of Genius'. He is the representative of all those who are oppressed but defiant in the present day – resisting government greed and military exploitation. As Keats glances back to his complaints about the 'treeless' Isle of Wight, and forward to the cash concerns of Isabella's brothers, he astutely separates use from value, and at the same time insists that Hood's forest rebellion represents valuable writerly qualities while making its political statement. No wonder he told Reynolds that he had written the poem in 'the Spirit of Outlawry':

> if Robin should be cast
> Sudden from his turfèd grave,
> And if Marian should have
> Once again her forest days,
> She would weep, and he would craze.
> He would swear, for all his oaks,
> Fallen beneath the dockyard strokes,
> Have rotted on the briny seas;
> She would weep that her wild bees
> Sang not to her – strange! that honey
> Can't be got without hard money!

The day after Keats sent the two poems to Reynolds, he visited Hunt. The meeting only served to dramatise how different their lives had become: they spent the afternoon writing (with Shelley) feebly competitive sonnets about the Nile. Keats left them as darkness fell, and sought out Reynolds again. Another sonnet that Keats wrote the following day shows they spent part of the evening discussing Spenser, but the themes of his Hood poem still burnt in him fiercely. He refers to Reynolds as a 'forester', and stresses his own commitment to producing 'some English' which will revive the Classical ideal. 'Be with me', he asks Spenser in the closing couplet: 'Be with me in the

summer days and I / Will for thine honour and his [Reynolds's] pleasure try'.

This same day or the previous one, Keats also wrote a more authoritative sonnet, 'Time's sea . . .', referring yet again to the woman he had seen in Vauxhall Gardens. He admits that her beauty's 'web' still has him 'tangled', and that her ungloved hand has him 'snared'. At first glance, the subject seems a far cry from Sherwood Forest and Reynolds. In fact it is closely linked. Brooding on political freedom, Keats triggered thoughts about more personal kinds of liberty, for himself and his engaged friend. In 'Robin Hood' he had deplored authoritarian state rule; in 'Time's sea . . .' he regards love as a danger to his autonomy and a distraction from his 'nobler life' as a writer. But because the woman in the sonnet is unobtainable (almost, in fact, non-existent) Keats is able to respond to her with more complicated feelings. She 'dost eclipse / Every delight with sweet remembering, / And grief unto my darling joys dost bring' – demanding, in other words, that he recognise the simultaneity of pleasure and pain. It is this which connects the poem to the Spenser sonnet, and beyond it to 'Robin Hood'. In everything Keats wrote at this time, in everything he did and deliberated, he recovers from *Endymion* and prepares for the next stage of his drive towards self-fulfilment.

Although he sometimes saw Hunt (for dinner on 11 February, for instance, with Shelley, who was about to leave for Italy), and Haydon (on 1 March, when he again played at imitating the bassoon), Keats refused several other invitations so that he could continue to concentrate on Reynolds. Even when Reynolds fell ill during the middle part of February, Keats visited and wrote to him, sending him poems (among them 'Blue! 'Tis the life of heaven . . .', which is an 'answer' to one of Reynolds's own sonnets) and relying on him to nurture the 'very gradual ripening' of his 'intellect'. His main purpose was still to discover ways of pursuing arguments in his poems without seeming 'ostentatious' – as he explained in the great letter he wrote to Reynolds on 19 February. He began by describing the ideal creative state as a paradoxical 'delicious diligent Indolence' and by condoning 'the Benefit done by great Works to the "Spirit and pulse of good" by their mere passive existence'. (The reference is to Wordsworth's 'The Old Cumberland Beggar'.) Then he spoke more openly about the relationship between poetic identity and social obligations:

The points of leaves and twigs on which the Spider begins her work are few and she fills the Air with a beautiful circuiting: man should be content with as few points to tip with the fine Webb of his Soul and weave a tapestry empyrean – full of Symbols for his spiritual eye, of softness for his spiritual touch, of space for his wandering of distinctness for his Luxury – but the Minds of Mortals are so different and bent on such diverse Journeys that it may at first appear impossible for any common taste and fellowship to exist between two or three under these suppositions – It is however quite the contrary – Minds would leave each other in contrary directions, traverse each other in Numberless points, and all [sic] last greet each other at the Journeys end – A old man and a child would talk together and the old Man be led on his Path, and the child left thinking – Man should not dispute or assert but whisper results to his neighbour, and thus by every germ of Spirit sucking the Sap from mould ethereal every human might become great, and Humanity instead of being a wide heath of Furse and Briars with here and there a remote Oak or Pine, would become a grand democracy of Forest Trees.

This dramatises thinking in a way that is at once tentative and bold. Keats's mind races and pauses, reaching out to Reynolds for sympathy, then tearing forwards again as it discovers and refines its theme. 'It has been', he continues, 'an old Comparison for our urging on – the Bee Line – however it seems to me that we should rather be the flower than the bee – for it is a false notion that more is gained by receiving than giving – no the receiver and the giver are equal in their benefits – The f[l]ower I doubt receives a fair guerdon from the Bee – its leaves blush deeper in the next spring – and who shall say between Man and Woman which is the most delighted? Now it is more polite to sit like Jove tha[n] to fly like Mercury – let us not therefore go hurrying about and collecting honey-bee like, buzzing here and there impatiently from a knowledge of what is to be arrived at; but let us open our leaves like a flower and be passive and receptive.'

By now the letter has come almost full circle, returning to its opening remarks about 'delicious diligent Indolence' with a deeper sense of what it involves. It is nothing to do with inertia, everything to do with openness; nothing to do with self-effacement, everything to do with immersion. Turning from the relation between writers and their subjects to the relation between men and women, from 'beautiful circuiting' to 'grand democracy', Keats associates his aesthetic with his political principles. He broadens the notion of negative capability to admit issues of responsibility as well as responsiveness.

This is reinforced by the poem with which Keats ends his letter. Telling 'dear Reynolds' that he was 'led into these thoughts by the beauty of the morning operating on a sense of Idleness', he imagines what a thrush might have been 'saying' as it sang outside his room. The bird's message encapsulates all that he has just written, and does full justice to its paradoxes:

> 'O fret not after knowledge – I have none,
> And yet my song comes native with the warmth.
> O fret not after knowledge – I have none,
> And yet the Evening listens. He who saddens
> At thought of idleness cannot be idle,
> And he's awake who thinks himself asleep.'

ON 30 JANUARY Keats had sent Taylor the 'pleasure thermometer' passage he wanted to add to Book I of *Endymion*. Climbing towards 'ardent listlessness', it climaxes in precisely the same kind of 'indolence' that he hears in the song of the innately knowledgeable thrush. In a covering letter to Taylor he hinted at these connections, saying that his revision represented his 'first Step towards the chief Attempt in the Drama – the playing of different Natures with Joy and Sorrow'. It is a revealing remark, not just because it looks ahead to his writing for the theatre, but because it emphasises assimilation and reconciliation. A little under a month later, in a letter written after he had sent the finished manuscript of Book II, his thoughts were still tending in the same direction. Taylor had responded to *Endymion* by wondering whether its sensuality might not offend some readers. Keats needed to consider this for obvious reasons: his financial situation demanded that his work appeal to a large audience. But the integrity of his poem mattered more to him than his sales. Realising that some readers would have to 'overcome Prejudices', and that some of Taylor's suggested cuts were 'a great improvement', he avoided commenting on them in detail by turning to general issues. The same general issues, in fact, that he had been considering while listening to Hazlitt and writing to Reynolds, and which he now formulated as 'a few Axioms'. 'I think Poetry should surprise by a fine excess and not by Singularity,' he urged at one point – and then added: 'if Poetry comes not as naturally as the Leaves to a tree it had better not come at all.'

When Keats wrote this letter to Taylor, he was expecting to complete

his revision of *Endymion* in the near future. 'I have coppied the 3rd book and have begun the 4th', he said. No sooner had the end come in sight than progress once again became difficult. On 21 February a letter arrived at Well Walk from Georgiana Wylie which said that she was soon expecting to see George in London. He arrived in time for his twenty-first birthday, on 28th, when he was entitled to claim the inheritance left him by his grandmother. Keats was naturally pleased to see his brother, and to discover that the sale of his government stock raised 25 per cent more money than he had been able to realise himself a little over two years previously. It meant that George could plan confidently for his future – both in business, and with Georgiana. On the other hand it created worries about Tom, who was threatening to leave Devon for London shortly. The recent episode of blood-spitting warned Keats that this would be extremely unwise.

Keats understood there was no question of George returning to the West Country. With no one else to call on for help, he would have to go to Devon himself – and soon, before Tom acted impetuously. Accordingly, he asked George to deliver Book III of *Endymion* to Taylor, and arranged for Charles Cowden Clarke to correct proofs as they returned from the printers. He sent messages to Reynolds and other friends, telling them he was leaving town. He cancelled a meeting with Peter Moore, one of the managers at Drury Lane, with whom he had hoped to discuss his theatrical ambitions.

Keats never complained that Tom's needs were ruining his own plans, but he knew that another period of his life was over. Even though he had lived like a 'cavalier' since completing the first draft of *Endymion*, his 'racketing' had cleared his mind. Thanks largely to Reynolds and Taylor, he had proved his independence of Hunt and Haydon. He had significantly deepened his thoughts about poetic identity. Hazlitt's lectures had been the single most decisive influence on these ideas, and also on the 'many songs & Sonnets' he had recently written. On 3 March, immediately before leaving town, he went to the last lecture in the series: 'On the Living Poets'. Its harsh judgement of Wordsworth may not have precisely echoed his own more subtle evaluation, but its endorsement of Shakespeare confirmed everything that he had been thinking about. In the space of a few weeks, he had woven thoughts about the nature of the imagination, and about its relationship to 'power', into the delicate, durable fabric of a mature philosophy.

[235]

Keats left home on 4 March, catching a coach at seven-thirty in the evening. He knew that his journey ahead would be long and tiring. After rattling south-west through Salisbury, Dorchester, Bridport and Hinton, he would change coaches at Exeter, boarding the Royal express or cheaper 'diligence' which would take him down to Teignmouth on the coast. If things went well, the trip would last twenty-seven hours. It could hardly have gone worse. Before he was clear of London, a strong wind sprang up and rain drenched him. (He was sitting on the roof, to save money.) By the time he reached open country, the storm had developed into a hurricane: the *Examiner* later reported uprooted trees, roofs blown off, carriages overturned, and at least half a dozen people killed.

On 14 March, from the safety of his lodgings, Keats ruefully told Reynolds he had 'escaped being blown over and blown under', adding that even though the wind had now dropped, rain was still pelting down. 'Being agog to see some Devonshire,' he said, 'I would have taken a walk the first day, but the rain wod not let me; and the second, but the rain wod not let me; and the third; but the rain forbade it – ditto 4 – ditto 5 – ditto.' It was the same when he wrote to Bailey in Oxford. He could see there was something farcical about the 'abominable Devonshire weather', but was so fed up that he decided it was no better than the locals deserved. His letter brilliantly catches the energy of his conversation:

you may say what you will of devonshire: the t[r]uth is, it is a splashy, rainy, misty snowy, foggy, haily floody, muddy, slipshod Country – the hills are very beautiful, when you get a sight of 'em – the Primroses are out, but then you are in – the Cliffs are of a fine deep Colour, but then the Clouds are continually vieing with them – The Women like your London People in a sort of negative way – because the native men are the poorest creatures in England – because Government never thought it worth while to send a recruiting party among them. When I think of Wordswo[r]th's Sonnet 'Vanguard of Liberty! ye Men of Kent!' the degenerate race about me are Pulvis Ipecac. Simplex a strong dose – Were I a Corsair I'd make a descent on the South Coast of Devon, if I did not run the chance of having Cowardice imputed to me: as for the Men they'd run away into the methodist meeting houses, and the Women would be glad of it – Had England been a large devonshire we should not have won the Battle of Waterloo –

The comedy here has a serious side. It acts as a safety valve for Keats to release his frustrations about leaving London, about interrupting his work, and about breaking contact with his friends. When he says later in the letter that he fancies 'the very Air of a deteriorating quality' he comes close to revealing his true feelings. The weather sluiced away his brother's reasons for being in Teignmouth, making a mockery of its reputation as a kind of spa for consumptives. As Keats well knew, contemporary guidebooks to the area all recommended its 'very beneficial climate',[1] and advised patients to drink 'that fashionable purging draft, sea water', to take hot and cold sea-water baths, and to make bracing expeditions to the neighbouring villages of Dawlish, Babbacombe Bay and Bishops Teign. James Clark, who would later become Keats's doctor in Rome, wrote that on this coast 'the invalid will be exposed to less rigorous cold, and for a shorter season, – will have more hours of fine weather, and, consequently, more exercise in the open air, – he gives himself a better chance of passing the winter here than he could have in any more northern part of our Island'.[2]

According to George, Teignmouth had already had the desired effect on Tom, in spite of his blood-spitting. Keats was dismayed by what he found. Tom was a shadow of himself, and his lodgings were depressing – a set of dark, airless rooms in the Strand, which runs alongside the harbour and ends in a knob of land known as the Den. Characteristically, Tom himself was determined to seem cheerful, and whenever the weather permitted, he showed Keats round as though they were simply out-of-season holidaymakers. In the thriving port, they watched boats coming and going continually, exporting clay, and women dressed *à la hollandaise* helping to unload the fishing fleet. In the centre, they walked round a labyrinth 'augmented by the fanciful disposition of different architects':[3] there were Assembly Rooms, completed in 1792, and a theatre modelled on 'old Covent Garden', where Kean had appeared in 1812. Close to the long sandy front, they saw a cave decorated with shells, and stables for donkeys which gave rides to summer visitors. Everything was peaceful and unpretentious. It was also muddy and dispiriting. A few years after Keats had left, the poet Winthrop Mackworth Praed visited Teignmouth and got the same impression:

> A little town was there
> O'er which the morning's earliest beam
> Was wandering fresh and fair.

No architect of classical school
Had pondered there with line and rule –
The buildings in strange order lay
As if the streets had lost their way:
Fantastic, puzzling, narrow, muddy,
Excess of toil from lack of study.
Where Fashion's very latest tangles
Had no conception of right angles.

Once the excitement of arrival had faded, Keats had trouble maintaining his 'customary eagerness to be pleased'.[4] The weather made him feel trapped; he worried about his brother's chances of recovery; he missed the solitude in which to work comfortably. Yet work he did, pressing on with his revisions to Book IV, thinking about the Preface that he had promised Taylor he would write for *Endymion*, hatching plans for new poems. Before leaving London, and encouraged by conversations about the theatre with Brown, he had produced six lyrical 'Extracts from an Opera'.[5] They were slight, sketchy pieces, and only one ('Song', with its shadowy anticipation of 'La Belle Dame Sans Merci') made a coherent effort to deal with the themes that were preoccupying him. Now, in a sonnet written between 7 and 13 March, he meditated on the 'four seasons in the mind of man'. It is autumn and winter which get his closest attention:

Quiet coves
His soul has in its Autumn, when his wings
He furleth close; contented so to look
On mists in idleness – to let fair things
Pass by unheeded as a threshold brook.
He has his Winter too of pale misfeature,
Or else he would forego his mortal nature.

These lines return Keats to ideas that had recently filled him with enthusiasm – ideas about indolence and the inseparability of pain and pleasure. But they sound resigned rather than intrigued. The sonnet is fixated by 'pale misfeature'; its mood is tense; and its praise for self-creation is implied rather than actual. The same feelings of doubt and recrimination creep into the letter he wrote to Bailey when he sent him the poem. After its energetic opening attack on Devon weather, and its similarly vigorous appeal to the patriotic ideals of Alfred and Shake-

speare he finds so lacking in the West Country, he lowers his voice to describe a sudden loss of confidence. 'I am sometimes so very sceptical', he says, 'as to think Poetry itself a mere Jack a lanthern to amuse whoever may be struck with its brilliance.'

It is typical of Keats that once he has hit this low point, he should settle at once into a speculation which challenges it. Rather than allowing 'scepticism' to harden into a permanent shape, he reinterprets it as proof that the value of anything in life is not fixed. ('Every thing is worth what it will fetch.') This perception, which leads into his remarks about 'Things semireal' needing 'a greeting of the spirit to make them wholly exist', is offered as what he calls 'collateral' to his sonnet. Just as he had done in recent correspondence with Reynolds, he presents it as a kind of inspired accident, a consequence of his pell-mell and freely associating style. (Later in this same letter he reminds Bailey that 'it is an old maxim of mine . . . that eve[r]y point of thought is the centre of an intellectual world . . . We take but three steps from feathers to iron.')

Keats's flash of insight could not change his mood. Whichever way he turned, circumstances conspired against him. He developed a cold – the result of his soaking on the journey from London. He went to the theatre and 'got insulted' by a member of the audience. (In what way we do not know.) He visited the library to read the latest *Examiner* and was infuriated to see that the government was introducing an Indemnity Bill designed to 'protect magistrates, Ministers and informers from the consequence of any actions resulting from the suspension of habeas corpus'.[6] Teignmouth could offer very little sympathetic company to distract him. 'Bartlet the surgeon, Simmons the Barber, and the Girls over at the Bonnet Shop say we shall now have a month of seasonable weather', Keats sighed to Reynolds, giving a tactfully restrained but clear idea of how bored he felt.

Only one family appealed to him: his landlady, Margaret Jeffery,[7] and her two daughters Mary-Ann and Sarah (also known as Fanny), who had previously befriended Tom and found a doctor to look after him – William Turton. (Turton lived in a street called Myrtle Hill, and was generally reckoned to be 'friendly' though 'really occupied with his conchological researches'.) George had already flirted with the Jeffery girls, and taken a lock of hair from 'laughing thoughtless Sarah' back to London. He now wrote the sisters a playful letter asking 'how do you like John? Is he not very original?', as though he expected his brother to take up where he had left off. In later years, a legend grew up that Mary-Ann

had fallen in love with Keats. She eventually published a collection of sentimental poems, some of which might have been addressed to him. There is no evidence to suggest that he felt anything more than friendly towards her.

KEATS AT LAST FINISHED his revision of *Endymion* on 14 March. His depression, like the clouds, refused to lift. Within a few days, a letter arrived from George which made him even more apprehensive. It was full of fears about Tom ('who could have imagined such a change?'), worrying news about Reynolds ('he has a bad rheumatic fever, and suffers constant pain'), and niggles about money. Almost as soon as Keats had read it, he received a second, and even more unsettling letter. George said that Mrs Wylie had agreed to let him marry her daughter Georgiana, who was not yet twenty-one; he planned to emigrate with her to America.

While Keats dreaded[8] losing a brother who was his close friend, he sympathised with his motives. His own decision to give up medicine had reflected his impatience with authority. George was also turning his back on a system that had failed him. Toiling ignominiously with Abbey, or drudging as a clerk elsewhere in the City, George had contemplated a life of small returns. Transplanting himself to America meant taking larger risks, but it allowed him to become his own man. This is what Keats understood when he said, 'I would sooner [my brother] should till the ground, than bow to a customer.' They both felt impelled by the same 'burden of society'.

Keats knew that George's decision had been shaped by his reading as well as his needs. The book which had influenced him most strongly was Morris Birkbeck's *Notes on a Journey in America*, which Taylor and Hessey had recently published. It is a hastily written but beguiling work – an account of how Birkbeck, a liberal English farmer who was the son of a Quaker preacher, had bought 1,440 acres of prairie land in Illinois at two dollars an acre the previous August, and intended to sell off some portions and develop others in ways which would prove his high-minded ideals. Part-tract, part-guide and part-advertisement, it rails against slavery as 'that broadest, foulest blot'[9] on the American landscape; it insists that settlements should have common land; it demands that even the poorest emigrants should have 'a cabin, a garden, a cow and a pig';[10] and it expects that many of its readers will want to leave home because they feel rejected or disgusted by living in 'a nation with half its

population supported by alms, or poor rates, and one fourth of its income derived from taxes'.[11] 'Having no elective franchise,' Birkbeck writes, 'an English farmer can scarcely be said to have a political existence.'

This was the sort of opinion that had fired Southey and Coleridge when they planned Pantisocracy a few years earlier. George shared their idealistic hopes, but was in no doubt about the hardships that lay ahead. Even as a schoolboy he had read about these in William Robertson's *History of America*, a book Keats remembered well, and had relied on when writing his sonnet on Chapman's Homer. Compared to Birkbeck – and to fellow colonists like his friend George Flowers, or Henry Feardon – Robertson was gloomy and cautious. His America was not a land of opportunity but a wilderness.

Keats never admitted openly how much he would miss his brother. However, his worries about him showed everywhere in his writing – including the long-deferred Preface to *Endymion*, which he began soon after hearing from George. It opens with an elaborate Dedication: 'Inscribed, with every feeling of pride and regret, and with "a bowed mind", to the memory of the most English of poets except Shakespeare, Thomas Chatterton.' This is only remarkable for its extravagance. Throughout his poems and letters, Keats had often used both poets as emblems of the literary and political 'Albion' he most admired. Now he introduced them as the advance guard in a campaign waged on behalf of 'the individual' in 'a great nation'. They stand at the head of a Preface which is as mindful of George's decision to invent a new 'way of life' as it is concerned with the reception of his own work.

Keats begins his Preface by describing the claims of 'an individual' in very ambiguous terms. 'About a twelve month since,' he says, 'I published a little book of verses; it was read by some dozens of my friends who lik'd it; and some dozens whom I was unacquainted with, who did not.' This show of realism is obviously designed to bolster his confidence. In fact it has the opposite effect, and within a few lines he is admitting that he has 'fought under disadvantages' and hopes for more from his future work than he does from *Endymion* itself. 'Before I began [it],' he writes, 'I had no inward feel of being able to finish; and as I proceeded my steps were all uncertain. So this Poem must rather be considered an endeavour than a thing accomplish'd; a poor prologue to what, if I live, I humbly hope to do. In duty to the Public I should have kept it back for a year or two, knowing it to be so faulty: but I really

cannot do so: – by repetition my favorite Passages sound vapid in my ears, and I would rather redeem myself with a new Poem – should this one be found of any interest.' In the few remaining lines of the Preface, Keats retreats still further, apparently not caring that he contradicts and compromises himself. 'I have written', he continues, 'to please myself and in hopes to please others, and for a love of fame.' Before finally blustering to a close, he admits that his Dedication will seem 'affected' to some readers, but can do no more to defend himself than say, 'Were I dead, sir, I should like a Book dedicated to me.' It is a remark which sounds half in love with the idea of a posthumous existence, even as it shrinks from it.

Keats hesitated over his Preface for two days, then posted it to Taylor with Book IV on 21 March. He was desperate to win readers, but determined to reproach them if they showed any signs of resisting him. When Taylor and others responded to what he had written, his confusion deepened. Reynolds, in particular, stung him by telling him plainly that the Dedication was indeed 'affected', and that his attempt to be flippant about serious subjects in the Preface was reminiscent of Hunt. In reply, Keats began compliantly enough, saying that 'since you all agree that the thing is bad it must be so', then became more defensive. 'I am not aware there is any thing like Hunt in it,' he said, '(and if there is, it is my natural way, and I have something in common with Hunt).' When he moved on to clarify his feelings about the audience for his work, he grew actually angry. 'I have not the slightest feel of humility towards the Public,' he said, '– or to any thing in existence, – but the eternal Being, the Principle of Beauty, – and the Memory of great Men – When I am writing for myself for the mere sake of the Moment's enjoyment, perhaps nature has its course with me – but a Preface is written to the Public; a thing I cannot help looking upon as an Enemy, and which I cannot address without feelings of Hostility.'

Had Keats ended there, his complaint might have sounded merely chippy, his rage a pre-emptive blast against people he suspects he has not written well enough to please. In the remainder of his letter he becomes more measured. Yet the fact that he has 'no feel of stooping', and hates 'the idea of humility' to the 'Multitudes of Men', keeps him on edge. Friends are one thing ('I wod be subdued before my friends, and thank them for subduing me'), and so are worthy causes ('I would jump down Aetna for any great Public good') – but what he calls 'a Mawkish Popularity' is beneath his contempt. 'My glory would be to daunt and

dazzle the thousand jabberers about Pictures and Books,' he says. 'I see swarms of Porcupines with their Quills erect "like lime-twigs set to catch my Winged Book" and I would fright 'em away with a torch – You will say my preface is not much of a Torch. It would have been too insulting "to begin from Jove" and I could not [set] a golden head upon a thing of clay – if there is any fault in the preface it is not affectation: but an undersong of disrespect to the Public. – if I write another preface it must be done without a thought of those people – I will think about it. If it should not reach you in four – or five days – tell Taylor to publish it without a preface, and let the dedication simply stand "inscribed to the memory of Thomas Chatterton".'

Keats did produce another Preface, sending it to Taylor on 10 April and loosening the connection between his circumstances and his writing. Like its predecessor, however, this second Preface is remarkably self-critical. Warning that 'it is not without a feeling of regret that I make [the poem] public', insisting that what he writes next will be superior, it gathers to make a resounding statement about poetic progress, and about the dangers of succumbing to 'mawkishness' instead of rising to Shakespearean disinterestedness.

The imagination of a boy is healthy, and mature imagination of a man is healthy; but there is a space of life between, in which the soul is in a ferment, the character undecided, the way of life uncertain, the ambition thick-sighted: thence proceeds mawkishness, and all the thousand bitters which those men I speak of must necessarily taste in going over the following pages.

'Those men I speak of' have previously been defined as 'men who are competent to look, and who do look with a zealous eye, to the honour of English literature'. They are the same people as those he has in mind at the end of the Preface, when he says 'I hope I have not in too late a day touched the beautiful mythology of Greece, and dulled its brightness: for I wish to try once more, before I bid it farewell.' Like everything he had written in his first draft, it is a sentence brimming with contra-dictions – self-deprecating as well as proud, aesthetically minded as well as idealistic, bound by the present yet looking to the future. Plainly, as he revised the Preface, Keats found ways of controlling his 'doubts and uncertainties'. Equally obviously, he had not solved them.

IN THE FORTNIGHT between writing the first draft and completing the final text of the Preface, Keats began to enjoy Devon for the first time. A

few days of fine weather meant that he could escape his lodgings. He walked along the sea shore and clambered along the clifftops as he had done in Margate. He watched the men and women working in the harbour. He wrote two flirtatious songs ('For there's Bishop's Teign' and 'Where be ye going, you Devon maid'). And on Easter Monday, 23 March, he visited Dawlish Fair, commemorating it in five verses of doggerel – or 'bitcherell', as he called it to Rice and Haydon, both of whom had evidently talked with him about the local 'profligates':

> O who wouldn't hie to Dawlish fair,
> O who wouldn't stop in a Meadow?
> O [who] would not rumple the daisies there,
> And make the wild fern for a bed do?

In his letter to Haydon (and it is a sign, paradoxically, of the slight coolness which now existed between them) Keats never deviates from his carefree holiday tone. With Rice he is less cheerful and therefore more intimate.[12] Saying 'it would be a happy thing' if he and his friend could 'settle our thoughts, make our minds up on any matter in five Minutes and remain content', he acknowledges that he cannot help reaching irritably after facts and reasons. This is tantamount to repeating that he feels isolated from poetry itself, and it helps to explain why he should then spend a page discussing the question 'Did Milton do more good or ha[r]m to the World?' Calling him a 'delectable' writer, and 'an active friend to Man', he means to confirm his own ambitions. In his present mood even this becomes problematic. 'That which is contained in the Pacific [cannot] lie in the hollow of the Caspian – that which was in Miltons head could not find Room in Charles the seconds – he like a Moon attracted [the] Intellect to its flow – it has not ebb[e]d yet – but has left the shore pebble all bare – I mean all the Bucks Authors of Hengist and Castlereaghs of the present day – who without Milton's gormandizing might have been all wise Men.'

The day after Keats finished this letter to Rice, the weather broke again. He and Tom returned to their dark lodgings and shut the windows – bored, thwarted and low-spirited. In his letters to London, he struggled to seem his usual ebullient self. He turned to the still sickly Reynolds 'in the hopes of cheering [him] through a Minute or two' with a verse Epistle. But as he began writing, his depression got the better of him, and the Chattertonian rhythms of his recent ditties gave way to

sombre pentameters. His lines are dominated by 'shapes, and shadows, and remembrances' – by 'visitings' which begin with a scene of sacrifice (reminiscent of similar scenes in works by Titian), then abruptly cut to a memory of Claude's 'Landscape with the Father of Psyche', and eventually melt into an evocation of Claude's 'The Enchanted Castle':

> You know it well enough, where it doth seem
> A mossy place, a Merlin's Hall, a dream.
> You know the clear lake, and the little isles,
> The mountains blue, and cold near-neighbour rills,
> All which elsewhere are but half animate;
> Here do they look alive to love and hate,
> To smiles and frowns; they seem a lifted mound
> Above some giant, pulsing underground.

While it is difficult to speak precisely about Keats's aim in transforming painted scenes into poetical ones, his broad purpose is clear. His landscapes are gorgeously plausible, but evidently allegorical; they are concentrations of private virtue and public good. Hazlitt, once again, wrote better about this than any of his contemporaries, focusing on Poussin. Much of what he said could equally well apply to Claude, or at least to Keats's feelings about Claude, including his remarks about the way in which Poussin and Milton resemble each other. They have, he says, 'something of the same pedantry, the same stiffness, the same elevation, the same grandeur, the same mixture of art and nature, the same richness of borrowed materials, the same unity of character. Neither the poet nor the painter lowered the subjects they treated, but filled up the outline in fancy, and added strength and prominence to it: and this not only satisfied, but surpassed the expectations of the spectator and the reader.'

This combination is similar to the one Keats summarised in his Preface when referring to 'the beautiful mythology of Greece'. It is striking, though, that as he describes 'The Enchanted Castle' he makes it more gothic than noble. He points out, for instance, the 'little wing . . ./ Built by a Lapland witch turned maudlin nun'. This owes something to Keats's wish to cheer up Reynolds; it is the kind of grotesque joke they both enjoyed.[13] It also accelerates the poem's movement from doubt to dissatisfaction, and opens the way for its final, fearsome vision. As this unfolds, Keats confronts a baffling question. If the imagination is lost in

a half-world when it moves outside its 'proper bound', how can it adjust itself to the laws of ordinary existence?

> Things cannot to the will
> Be settled, but they tease us out of thought.
> Or is it that imagination brought
> Beyond its proper bound, yet still confined,
> Lost in a sort of purgatory blind,
> Cannot refer to any standard law
> Of either earth or heaven? It is a flaw
> In happiness, to see beyond our bourne –
> It forces us in summer skies to mourn;
> It spoils the singing of the nightingale.

Like the previous reference to Claude, this passage recalls 'Sleep and Poetry'. In the earlier poem Keats had felt confident enough to see various poetic states as the map of an evolution. Here he cannot be certain of progress.[14] He is too heavily oppressed by his own experience, too troubled by Tom's condition, and too uncertain about the future his brother faced in America. Using ideas and images from Robertson's *History* – which he also quotes a good deal in letters written during this time – he imagines a world full of menace, a place where 'great unerring Nature' (as he calls it in one of his last poems) loses its healing powers and becomes the site of an 'eternal fierce destruction':

> Dear Reynolds, I have a mysterious tale,
> And cannot speak it. The first page I read
> Upon a Lampit rock of green seaweed
> Among the breakers. 'Twas a quiet eve;
> The rocks were silent, the wide sea did weave
> An untumultuous fringe of silver foam
> Along the flat brown sand. I was at home
> And should have been most happy – but I saw
> Too far into the sea, where every maw
> The greater on the less feeds evermore. –
> But I saw too distinct into the core
> Of an eternal fierce destruction,
> And so from happiness I far was gone.
> Still am I sick of it; and though, today,
> I've gathered young spring-leaves, and flowers gay
> Of periwinkle and wild strawberry,

Still do I that most fierce destruction see –
The shark at savage prey, the hawk at pounce,
The gentle robin, like a pard or ounce,
Ravening a worm.

Keats would never again lose his faith in progress so absolutely – until the onset of his final illness. In this sense, the Epistle to Reynolds might seem like an aberration, a 'horrid' mood 'of one's mind' that he abruptly dismisses with a brief parody of Wordsworth. Before it fades, however, it lets us see 'far into' his imagination, clearly showing the 'pain' that he usually counterbalanced with 'pleasure'. Stripping away illusions surrounding the ideology of progress, Keats reminds himself that he is vulnerable socially. And not just socially. The poem also gives the strong impression that Keats feels trapped – as a suffering individual in the most general sense, and also as someone who might develop his brother's 'destructive' illness. He has only his poetry between himself and the world – poetry which, as he admitted in his two Prefaces, was more likely to attract derision than praise.

KEATS POSTED HIS letter to Reynolds apologising for 'the unconnected subject, and careless verse'. He wanted to make light of its seriousness, and to suggest that the Epistle, like others he had written, was merely the prelude to his next and more sustained effort. This was to be the 'new romance' he mentioned in the closing lines – the story from Boccaccio that he had already started before leaving London. (Reynolds himself may by now also have begun the two narratives he later collected in *The Garden of Florence* in 1821.)

Hazlitt's recommendation had been enough to fire 'Isabella' in the first place, and not even the knowledge that Hunt had already written several Italian love dramas, including *Rimini*, could put Keats off. (He did admit that 'It is a great Pity that People should by associating themselves with the fine[st] things, spoil them – Hunt has damned Hampstead [and] Masks and Sonnets and "Italian tales".') Since then, his thoughts about the poem had been almost continuously interrupted, though he had still managed to reach some conclusions about its form – he would write it in *ottava rima* – and its narrative: he had decided to move the setting from Messina to Florence, and to give his heroine two brothers not three. This left him with the task of recreating a gruesome tale of impossible passion. Isabella lives in the house of her brothers,

who are merchants, and is secretly in love with her young clerk, Lorenzo. When the brothers discover this, they lure Lorenzo to a forest, murder him and bury him. His ghost then appears to Isabella in a dream and tells her what has happened, whereupon she digs him up, cuts off his head, and plants it in a pot of basil. Rooted in his brain and watered by her tears, the basil thrives lustily until it is removed by the brothers, leaving Isabella to die broken-hearted.

8 'Isabella,' lines 49–56; a fragment of Keats's draft.

Although Keats enjoyed gothic extravagances, his poem is dominated by various kinds of distancing. Much of what he writes has a distinct air of pastiche. The verse form creates a prevailingly stylised mood. The frequent use of antithesis and repetition confirms it. So do the large number of moments at which Keats draws attention to the fact that he is telling a story. When Lorenzo first kisses Isabella, for instance, we hear that 'his erewhile timid lips grew bold, / And poesied with hers in dewy rhyme', and at other points Keats frequently turns aside to address 'eloquent and famed Boccaccio', asking 'forgiving boon' for plundering his work. As a result, the poem has acquired a reputation for being more interested in its digressions than its main narrative. It is certainly true that many of its most urgent moments attend to something other than (or in the margins of) disappointed love. To the theme of individuality, for example. Isabella's relationship with Lorenzo is an attempt to love according to values which are diametrically opposed to her brothers'. Or to the associated theme of money. In stanzas XV and XVI there is an attack on 'money-mongering' which rings more angrily than anything

else in the poem. By depriving their sister of her independence, by brutalising her world and overriding her withdrawal from it, her brothers create the same kind of cruelties they also enact and sponsor in the public arena. They are capitalists[15] who seek to impose their regime on every aspect of the world:

> For them the Ceylon diver held his breath,
> And went all naked to the hungry shark;
> For them his ears gushed blood; for them in death
> The seal on the cold ice with piteous bark
> Lay full of darts; for them alone did seethe
> A thousand men in troubles wide and dark:
> Half-ignorant, they turned an easy wheel,
> That set sharp racks at work to pinch and peel.
>
> Why were they proud? Because their marble founts
> Gushed with more pride than do a wretch's tears? –
> Why were they proud? Because fair orange-mounts
> Were of more soft ascent than lazar stairs? –
> Why were they proud? Because red-lined accounts
> Were richer than the songs of Grecian years?
> Why were they proud? again we ask aloud,
> Why in the name of Glory were they proud?

Anxieties about the connection between love, self-hood, and materialism lie at the heart of 'Isabella' – sometimes showing themselves plainly, sometimes linking with questions about conventionality. Time and again, the poem invites us to consider how orthodoxies are invented. What do they depend on? How can they be broken and at what cost? Because Keats poses these questions in formal as well as thematic ways, asking himself how best to recast Boccaccio's story in 'syllables that ill beseem / The quiet glooms of such a piteous theme', he raises points of poetic procedure which parallel his thoughts about Isabella herself. In order to realise his ambitions as a writer, he must challenge 'the gentleness of old Romance', turning it into a story which has obviously contemporary references. In order to fulfil herself as a woman, Isabella must love transgressively (Lorenzo is merely a clerk), grieve subversively (cutting off and concealing the head), and continually resist all the orthodoxies which imprison her (doubting the story that her brothers tell her about Lorenzo).

Keats tackles these issues in ways which are always ingenious and self-conscious. However, it is impossible to do justice to the peculiar mood of 'Isabella' – the sense it gives of living its most intense life outside the main narrative – without considering other and less calculated subjects. One arises from Keats's decision to reduce the number of the brothers from three to two. He no doubt did this for practical reasons, restricting and therefore tightening his narrative. The effect was to place Isabella in a similar relation to her family as his to George and Tom. There is no question that he was anything but deeply fond of them both; there is also no doubt that (without meaning to) they made his life more difficult. Tom's illness tied Keats down; George's American ambitions threatened him with emotional as well as financial losses. When we say that the potency of 'Isabella' has something to do with dismay at the brothers' control over the structure of life in general, we cannot ignore the possibility that this depends on private resentments which Keats could not or would not admit openly.

This connection between self and subject is probably unconscious, and not in the least developed. It is never disruptive enough to sabotage – or significantly to enlarge – Keats's deliberate intentions. The poem's focus on registers and ways of speaking, and its examination of social codes and fiscal conventions, amount to an inquiry into the definition of identity and 'truth', and into the ways in which 'truth' can be combined with 'beauty'. Over the past few weeks, Keats had approached these issues as he debated the nature of poetic character. In the next few months he would develop them still further – to the point at which he felt that by treating his ostensible themes so openly in his poem, he had broken faith with the tenets of the 'chameleon poet'. When Taylor, Woodhouse and Lamb first read 'Isabella', they all praised it. Keats himself disparaged what he had written as being 'too smokeable' – too easily mocked. The phrase comes from a letter he wrote to Woodhouse on 22 September 1819, by which time he had written other narrative romances which left him impatient with his earlier effort:

I shall persist in not publishing The Pot of Basil – It is too smokeable – I can get it smoak'd at the Carpenters shaving chimney much more cheaply – There is too much inexperience of li[f]e, and the simplicity of knowledge in it – which might do very well after one's death – but not while one is alive. There are very few would look to the reality. I intend to use more finesse with the Public. It is possible to write fine things which cannot be laugh'd at in any way. Isabella is

what I should call were I a reviewer 'A weak-sided Poem' with an amusing sober-sadness about it.

Keats eventually relented, and included 'Isabella' in his 1820 volume. He remains its shrewdest critic. On the one hand, it anticipates the voice of his mature narrative genius. Moving excitedly through the comparatively large spaces of its stanzas, Keats follows arguments to their logical conclusions, and at the same time explores the full stretch of his sensuality. On the other hand, he tells a story in which the skeleton of his thought is often disconcertingly visible inside the body of his descriptive writing. As he said to Woodhouse: 'in my dramatic capacity I enter fully into the feeling: but in Propria Persona I should be apt to quiz it myself'.

THE GHOULISH HAUNTINGS of 'Isabella' enlarge the nightmare vision which looms at the end of the Epistle to Reynolds. Developing one from the other, Keats associated his fears about the future with 'morbidities' which lay in the past. The anti-materialist drive of the poem depends on feelings which had become better informed since meeting Hunt. Much of its narrative fabric includes material from his days with Hammond and at Guy's – sometimes for short periods, as when he describes Isabella's dream of Lorenzo coming 'like a fierce potion, drunk by chance, / Which saves a sick man from the feathered pall / For some few gasping moments'; more obviously in the exhumation scene, where Keats becomes a sort of poetic Resurrection Man, working 'through the clayey soil and gravel hard, / To see skull, coffined bones, and funeral stole', gazing 'into the fresh-thrown mould', and even 'turn[ing] up a soilèd glove, whereon / Her silk had played in purple phantasies'. Boccaccio had originally described Lorenzo's body as miraculously intact: the corruption is Keats's invention.

It is easy to suppose that his brooding on such things was coloured by his long confinement with Tom. Yet as he worked on 'Isabella' – from late February to 27 April – his brother's health seemed to pick up a little. At the same time, the weather improved, and good news came from London. George had taken charge of his financial affairs and discovered that the post-war boom in stock prices would benefit him even more than he had first thought. Instead of realising £1,400, as he had expected, he found that he would get between £1,600 and £1,700.

Before reading the letter in which George explained this, Keats had been unable to make any plans which involved more than minimal

expense. He had used up most of the money left to him by his grandmother. Now he reviewed his plans to go abroad – plans he had set aside the previous summer when Tom had first fallen seriously ill. As he did so, Charles Brown wrote to him with a more modest suggestion. Every summer, Brown let his half of Wentworth Place in Hampstead and took a holiday in Scotland, from where his father's family originated. Would Keats like to go with him? They would set off from the Lake District, Brown suggested, and ramble north for four months or so – until the summer was over. Keats accepted at once, telling Haydon that he saw the trip as 'a sort of Prologue to the Life I intend to pursue – that is to write, to study, and to see all Europe at the lowest expense'.

At last, after long weeks of frustration, Keats began thinking once more of his life as a journey. Elsewhere in his letter to Haydon he spoke of the 'innumerable compositions and decompositions which take place between the intellect and its thousand materials before it arrives at that trembling delicate and snail-horn perception of Beauty'. Just a fortnight later, in a letter to Taylor, he returned to the same subject more deliberately. His remarks come in the course of thanking Taylor for sending an advance copy of *Endymion* (which would be published on 19 May, costing nine shillings, in an edition of five hundred copies):

I was purposing to travel over the north this Summer – there is but one thing to prevent me – I know nothing I have read nothing and I mean to follow Solomon's directions of 'get Wisdom – get understanding' – I find cavalier days are gone by. I find that I can have no enjoyment in the World but continual drinking of Knowledge – I find there is no worthy pursuit but the idea of doing some good for the world – some do it with their society – some with their wit – some with their benevolence – some with a sort of power of conferring pleasure and good humour on all they meet and in a thousand ways all equally dutiful to the command of Great Nature – there is but one way for me – the road lies th[r]ough application study and thought. I will pursue it and to that end purpose retiring for some years. I have been hovering for some time between an exquisite sense of the luxurious and a love for Philosophy – were I calculated for the former I should be glad – but as I am not I shall turn all my soul to the latter.

This passage has an element of youthful pomposity. It has a more remarkable sense of purpose. While Keats's interest in the 'dramatic' imagination was leading him away from poems which spelt out their political purposes (as he had done in Book III of *Endymion*, and in the passage about the money-grubbing brothers in 'Isabella'), he was still

determined to do 'some good for the world' by other means. This meant reappraising, yet again, the relationship between 'sensation' and 'thought'. The bleak vision of the Epistle to Reynolds, and the straight look he had aimed at what was 'weak-sided' in 'Isabella', were hardening into a conviction that he could not longer trust in his 'invention' alone. In the letters from Devon which follow his peroration to Taylor, he steadily expands his sense of what is necessary. Even when most melancholy (the weather soon worsened again, and Keats described himself lying awake at night 'listening to the Rain with a sense of being drown'd and rotted like a grain of wheat'), he is anxious to find new ways of 'getting knowledge'. Writing to Reynolds on 27 April he says: '[I] shall learn Greek, and very likely Italian – and in other ways prepare myself to ask Hazlitt in about a year's time the best metaphysical road I can take. – For although I take Poetry to be the Chief, there is something else wanting to one who passes his life among Books and thoughts on Books.'

A few days later he wrote to Reynolds again: a long letter which is more thoughtful about thinking than any he had previously written. It begins with some reflections on how professional life (that is, life not spent 'among Books and thoughts on Books') can threaten writing as well as enrich it. Keats is remembering Reynolds's commitments as a lawyer, and the possibility that he might himself be driven to 'study physic or rather medicine again'. He says: 'I feel it would not make the least difference in my Poetry [to return to medicine]; when the Mind is in its infancy a Bias is in reality a Bias, but when we have acquired more strength, a Bias becomes no Bias. Every department of knowledge we see [as] excellent and calculated towards a great whole. I am so convinced of this, that I am glad at not having given away my medical Books, which I shall again look over to keep alive the little I know thitherwards.'

As Keats raises this idea, he clarifies it by mentioning Wordsworth and Milton, both of whom he had been reading extensively since arriving in Teignmouth. Wordsworth appears first, in the form of a reference to 'Tintern Abbey', when Keats tells Reynolds that 'An extensive knowledge is needful to thinking people – it takes away the heat and fever; and helps, by widening speculation, to ease the Burden of the Mystery.' This is the most explicit connection that Keats had so far made between his career as a doctor and his life as a poet. But as he emphasises their common concerns, he admits 'it is impossible to know how far knowledge will console us for the death of a friend and the ill "that flesh is heir to" '. During the last months of his life, when he was exhausted by

his own illness, this 'speculation' would torment Keats hideously. Here it is a way of defining the humanitarian role he wants art to perform. This is where Milton comes in. Because Milton has 'apparently less anxiety for Humanity' than Wordsworth, Keats suggests that he is a lesser writer – though no sooner has he said this than he qualifies his judgement, adding that we can only properly judge others when we have shared their experience. Maybe, he wonders, not even Wordsworth 'has in truth epic passion', then continues: 'Axioms in philosophy are not axioms until they are proved upon our pulses: We read fine – things but never feel them to thee [sic] full until we have gone the same steps as the Author.'

As Keats reaches this point in the 'labyrinth' of his thought, he includes the first verse of an 'Ode to May'. The poem never became more than a fragment, perhaps because as he began work on it he discovered that Hunt had written on the same subject in the *Examiner*. It nevertheless sketches the course he intends to take in his writing as a whole. Referring to the 'Bards' in 'Grecian isles' he asks:

> O, give me their old vigour, and unheard
> Save of the quiet primrose, and the span
> Of Heaven and few ears,
> Rounded by thee, my song should die away
> Content as theirs,
> Rich in the simple worship of a day.

IMMEDIATELY AFTER TRANSCRIBING this eloquent scrap, Keats emphasised that its argument was proof of his recent development. Referring briefly to his uncertainties about Wordsworth ('whether or no he has an extended vision or a circumscribed grandeur – whether he is an eagle in his nest, or on the wing'), he rises to a magnificent conclusion. It is a great prose hymn to the idea of progress, to what he calls 'the general and gregarious advance of intellect', and the 'grand march of intellect':

I compare human life to a large Mansion of Many Apartments, two of which I can only describe, the doors of the rest being as yet shut upon me – The first we step into we call the infant or thoughtless Chamber, in which we remain as long as we do not think – We remain there a long while, and notwithstanding the doors of the second Chamber remain wide open, showing a bright appearance, we care not to hasten to it; but are at length imperceptibly impelled by the awakening of the thinking principle – within us – we no sooner get into the second Chamber, which I shall call the Chamber of Maiden – Thought, than we

become intoxicated with the light and the atmosphere, we see nothing but pleasant wonders, and think of delaying there for ever in delight: However among the effects this breathing is father of is that tremendous one of sharpening one's vision into the heart and nature of Man – of convincing ones nerves that the World is full of Misery and Heartbreak, Pain, Sickness and oppression – whereby This Chamber of Maiden Thought becomes gradually darken'd and at the same time on all sides of it many doors are set open – but all dark – all leading to dark passages – We see not the ballance of good and evil. We are in a mist – *We* are now in that state – We feel the 'burden of the Mystery'[.] To this point was Wordsworth come, as far as I can conceive when he wrote 'Tintern Abbey' and it seems to me that his Genius is explorative of those dark Passages. Now if we live, and go on thinking, we too shall explore them.

There is heroic determination in this letter, as well as modesty. Ever since arriving in Devon, Keats had felt that his life was stalled or drifting. For virtually every day of his stay, rain had confined and depressed him, washing at his identity. Tom had shown no significant, stable improvement. Apart from Brown's offer, all the news from London had rattled him (the latest instalment told him that Shelley had now reached Italy, which he longed to see himself). He could not even look upon his writing as he wished. 'Isabella' showed a great increase in his control of poetic tone, but it was 'too smokeable'; the 'Ode to May' was unfinished. Two other poems which had crept into the sodden light of day were also focused on frustration, and the possibility of dispelling it by showing an extended imaginative reach. One was a sonnet to Rice[16] which broods on the separations of time – as he would later do in the 'Ode on a Grecian Urn' – and yearns for a state of suspension in which 'The flush of welcome [is] ever on the cheek: / So we could live long life in little space'. The other and more successful piece was an address to Homer. In his previous response to Chapman's translation, Keats had admitted and overcome his feelings of exclusion (not knowing Greek, not feeling a part of dominant culture). This time he again presents himself as 'Standing aloof in giant ignorance', but identifies with the processes of the blind poet rather than his productions. The lines are at once forlorn and emphatic. Keats knew that if he wanted his poems to travel further into the world, embracing more of its miseries as well as its pleasures, he must make himself a more 'naturally'[17] knowledgeable writer. He would have to descend further into his own self:

Ay, on the shores of darkness there is light,
 And precipices show untrodden green;
There is a budding morrow in midnight;
 There is a triple sight in blindness keen;
Such seeing hadst thou, as it once befell
To Dian, Queen of Earth, and Heaven, and Hell.

TWENTY-ONE

FOR MOST OF his eight and a half weeks in Devon, Keats had fretted
about not being in London. By the first week of May his mood had
changed. Ahead of him, darkening his plans for Scotland, lay the hostile
critics of *Blackwood's*, and friends who were sick or quarrelsome. Behind
him lay proof that he could turn even the most profound depression into
a new sense of dedication. The spring had finally come. George had
promised to send the opening stanzas of 'Isabella' (which Keats had
drafted before leaving Well Walk) so that he could start making a fair
copy of the whole poem.

It was Tom who took the final decision to leave. He had suffered
another attack of blood-spitting in the past few days, and knew the
journey would be risky, but felt that he had been away from London too
long. He was bored; he missed the wider world. Keats had no choice
other than to 'stoop'. They caught the coach to Exeter, then boarded the
express for London. At first, it seemed that Keats had no reason to worry
about his brother. When the coach reached Honiton he sent a brief note
to Mrs Jeffery, who was also full of 'anxiety', saying 'My brother has
borne his Journey thus far remarkably well.' Almost immediately
afterwards, disaster struck. As they jolted onwards from Dorchester to
Bridport, Tom began to haemorrhage from his lungs so badly that he
and Keats had to climb down from the express and continue in brief,
careful stages. By the time they eventually reached London, they were
both exhausted. It was a dismal return to their old life.

Tom soon rallied, writing blithely to Mary-Ann Jeffery from Well
Walk on 17/18 May: 'I found myself much better at the end of the
journey than when I left *Tarterey* alias Teignmouth – the Doctor
[Sawrey] was surprised to see me looking so well, as were all my Friends
– they insisted that my illness was all mistaken Fancy and on this
presumption excited me to laughing and merriment which has deranged

me a little.' The recovery cheered Keats, too. Even if he found it hard to believe that Tom was not consumptive, he knew the progress of the disease was affected by the mood of the patient. He encouraged Tom to think of the future, and in particular of how he might travel to Italy in the autumn.

Memories of their journey paled as George outlined his American plans. During their absence, he had completed his financial arrangements with Abbey, and had decided to buy a 1,400 acre settlement in Illinois – one of the plots Birkbeck had advertised in his book. He was planning to marry Georgiana Wylie within ten days, and would leave England almost immediately afterwards. This was all much more precipitate than Keats had expected. Ever since childhood, he had relied on his younger brother to shoulder many of the burdens that he, as the eldest orphan, might have been expected to carry. George was self-confident. He was socially adept. He was financially lucky. Keats knew that he would miss him badly for all these reasons, and for others as well. George was an unshakeably loyal defender of his poems. Without his support during the publication of *Endymion*, Keats would be especially vulnerable.

Once again, Keats turned to Bailey, explaining and justifying. (Bailey had recently missed Keats in town and written to offer a second stay in Oxford before he left for Carlisle, where he was now due to be ordained deacon in July, following his disappointment at Lincoln.) Keats said that George was 'of too independent and liberal a mind to get on in trade in this country', and pointed out that his wife-to-be was 'of a nature liberal and high-spirited'. It was a courageous effort, but could not be maintained for long. As his letter continued, Keats admitted, 'I feel no spur at my Brothers going to America and am almost stony-hearted about his wedding.' It was the stoniness of repressed tenderness, rather than indifference. In the days before the wedding took place on 28 May, with Keats signing the register as a witness in St Margaret's, Westminster, he lived in a weary trance. 'I am in that temper', he told Bailey, 'that if I were under Water I would scarcely kick to come to the top', adding that he was as always throwing himself 'on the charity of friends for relief'. Bailey himself was too far away to be much help, and too preoccupied with cultivating the affections of his new room-mate at Magdalen Hall, who was the son of the influential Primate of the Scottish Episcopalian Church. But there were others he could count on. Haydon, for instance, whom he saw twice for dinner over the next ten days;

Hazlitt, with whom he also dined and discussed his plans for 'getting knowledge'; Rice; Reynolds; and of course George himself. They went to the theatre together (and at the Lyceum bumped into Isabella Jones, who unbeknown to Keats had recently become 'a close friend'[1] of Taylor). They eked out their last hours together in Well Walk.

Discussing the tour of Scotland with Brown, Keats realised that he could prolong his farewell to George by accompanying him to Liverpool before continuing his own journey north. His poems offered a less certain kind of 'relief'. When the publication day for *Endymion* arrived – 19 May – there was none of the excited optimism that had greeted his first book, just a tense silence in which he imagined *Blackwood's* preparing to strike. In fact, in the whole of the first month after publication, only two reviews appeared, neither influential and one (in the *Oxford University and City Herald*) by Bailey. Bailey concealed his doubts about the poem, which were not so much structural (he thought the conclusion was '*rather* but not too *much* abrupt'), as ethical (he felt that its depiction of sensual love was 'false, delusive, and dangerous'). But his 'charity' was a cold comfort to Keats. He told Bailey that 'the world is malignant enough to chuckle at the most honourable simplicity – and that idea also makes me sick of it'.

Every time Keats tried to 'bear up' and recover his sense of fun, the thought of his imminent loss, or of some other problem, pressed him down again. On 4 June he wrote a teasing letter to Mary-Ann and Sarah Jeffery; two days later he felt so exhausted that Doctor Sawrey told him he 'mustn't go out'. A short while later he was more energetic again, admitting to Bailey that his sister-in-law was 'the most disinterested woman I ever knew', and that this made him 'like her better and better'. Immediately afterwards, however, he plunged back into depression. His fears for *Endymion* colour everything he says, but he makes no mention of why they should suddenly have grown acute. The explanation was simple. At the same time as he was writing to Bailey, *Blackwood's* had reviewed Hunt's *Foliage*, mocked Keats for taking part in the ivy-crowning episode, and referred to him as an 'amiable but infatuated bardling'. While trying to make amends, Hunt had only succeeded in raising the stakes. He had responded to an equally savage review of his book in the *Quarterly Review* by anonymously attacking its editor in the *Examiner*, and advertising a forthcoming review of *Endymion*. (In fact it never appeared.) Keats knew that the stage was set for a similarly ferocious assault on his own work, even though Taylor had tried to head it off by contacting the *Quarterly*'s editor, William Gifford.

Keats is more candid about his fears for George in America – but as so often before, he quickly turns from his own problems to worry about other people. In previous letters, this had often made him sound settled and expansive. Here, in his unhappy confusion, he launches himself on a brief switchback ride – swooping between particular anxieties and general impressions, between present pressures and formative influences. 'You', he tells Bailey, 'have all your Life (I think so) believed every Body – and although you have been so deceived [in the business with the Bishop of Lincoln] you make a simple appeal – were it my choice I would reject a petrarchal coronation – on accou[n]t of my dying day, and because women have cancers.' This remark, echoing the question he had posed to Bailey on 20 January ('Why should Woman suffer?') is a proof of the concerns which had sustained him as a doctor. It is also a reminder that one effect of his mother's illness and early death was to create a complicated overlap between his feelings about women and his thoughts about suffering. As the letter continues, these things coalesce in a brief summary of his ideas about human progress in general:

Now I am never alone without rejoicing that there is such a thing as death – without placing my ultimate in the glory of dying for a great human purpose[.] Perhaps if my affairs were in a different state I should not have written the above – you shall judge – I have two Brothers one is driven by the 'burden of Society' to America the other, with an exquisite love of Life, is in a lingering state – My Love for my Brothers from the early loss of our parents and even for earlier Misfortunes has grown into an affection 'passing the Love of Women' – I have been ill temper'd with them, I have vex'd them – but the thought of them has always stifled the impression that any woman might otherwise have made upon me – I have a Sister too and may not follow them, either to America or to the Grave – Life must be undergone, and I certainly derive a consolation from the thought of writing one or two more Poems before it ceases.

Welcoming his sister-in-law into his family, Keats insists on her 'disinterestedness', and at the same time denies some other aspects of her personality. As he does so, he goes to the heart of his contradictory feelings about women and sinks down bewildered. 'To see an entirely disinterested Girl quite happy is the most pleasant and extraordinary thing in the world,' he says; 'it depends upon a thousand Circumstances – on my word 'tis extraordinary. Women must want Imagination and they may thank God for it – and so m[a]y we that a delicate being can feel happy without any sense of crime. It puzzles me and I have no Logic to

[259]

comfort me – I shall think it over.' Keats's self-analysis stops here, and he returns to his worries about being '*smothered* in *Foliage*' before signing off with his brothers' 'remembrances'. But his letter shows that he realised George's departure would open the wound of earlier abandonments – and also that he was still determined to heal them by 'doing some good'. Originally this had meant practical good: becoming a doctor. Now it meant literary good: 'writing one or two more Poems'.

THE BROTHERS' LAST FEW days together seemed both sluggish and rushed: Keats complained to the Jeffery sisters that he felt lethargic, yet, 'They say we are all (that is our set) mad at Hampstead.' He was certainly surrounded by busy-ness, even when not busy himself. On 10 June a General Election was called, and the whole of Hunt's circle immediately began campaigning for the radical cause. Reynolds, now recovered, was frantically making up for lost time as a would-be lawyer. Taylor was keenly concerned with the Keatses' wellbeing, concealing from Keats himself that '*Endymion* does not by any means please me as I expected', sending Birkbeck's new book, *Letters from Illinois*, to George, and also presenting a parcel of books to Tom.

George was engrossed by last-minute details – buying provisions for his journey, saying goodbye to friends, tidying his affairs. In the past, he and Keats had always managed to sort out their finances amiably. For the first time, difficulties began to appear between them. George deposited £500 with Abbey meaning to safeguard his brothers for the foreseeable future. Keats immediately found that he had to withdraw £190 to pay George's outstanding debts, and to provide a nursing wage for Mrs Bentley during his absence. Keats made no complaint at the time, though according to Brown he in fact reckoned that George also owed him money to repay past loans. On the way to Liverpool, George would give Keats £70 or £80 in respect of these loans, which Keats did not think was enough. He had to ask Abbey to forward a further £30 before the Scottish tour was over.

Compared to George's grand schemes, Keats's own plans seemed modest. Even so, he found it difficult to rediscover the sense of momentum he had felt towards the end of his time in Teignmouth. The reaction to *Endymion* continued to disappoint him. He had received friendly congratulations from Monkhouse and other friends, but reviews were still sparse, and often made irritating references to Hunt. On 7 June the *Champion* carried the first of a warm two-part

appreciation. The same month, however, the *British Critic* said: 'This is the most delicious poem, of its kind, which had fallen within our notice, and if Mr Hunt had never written, we believe we might have pronounced it to be sui generis without fear of contradiction.' The *Literary Journal* made the same point. 'This poem', it said, 'frequently reminds us of Mr Hunt's *Rimini*, though many of the faults so justly attributed to that author, have been avoided in the present work.'

On the other hand, Keats's thoughts about Scotland encouraged him. Provided he had recovered from what he described to Bailey as 'a little indisposition of my own' (presumably a recurrence of the venereal infection he had suffered after leaving Oxford), he was set to begin his tour at the end of the month. Haydon was especially supportive, telling him that he must study landscape and 'gorge on wonders', and saying he felt confident 'you will feel the effects of it as long as you live'. He believed that Keats would not simply discover 'new sensations' as he travelled, but find ways of incorporating them into what they both believed was the noblest form: the epic. It was for these reasons that Keats decided to reread Dante during his tour. Ever since Bailey had first encouraged him to look deeply into *The Divine Comedy*, Keats had prepared a place for Dante in his pantheon beside Shakespeare, Milton and Wordsworth. Realising that his two-volume edition of Cary's translation of the *Inferno* was too large to fit in a knapsack, he bought the three-volume pocket-sized edition, which Taylor and Hessey had recently taken over and published on Coleridge's recommendation. Like the portrait of Shakespeare he had discovered on the Isle of Wight, and which now hung in Well Walk, Dante's 'Book full of vowels' – as he described it to his sister – was a talisman as well as source of 'knowledge'. He felt that he needed the blessing of the past, if he was ever to produce a poem which would live into the future.

TWENTY-TWO

At last the time came to depart. On Monday 22 June, less than a month after George and Georgiana had got married, the young couple left their lodgings at 28 Judd Street, near Brunswick Square, and met Keats and Brown at the Swan with Two Necks in Lad Lane near the Guildhall. The inn was very close to where the Keats brothers had once lived in Cheapside, and as they boarded the coach and set off, they

moved through the scenery of their shared past. Although he did not know it, Keats also came close to touching the life that lay ahead of him. In the days before leaving Wentworth Place, Brown had arranged to let his half of the house to a widow, her two daughters, and young son, who had recently come to live in Hampstead. The family's name was Brawne. The elder daughter was Fanny Brawne.

The four adventurers made a bizarre group. George was smartly suited, his luggage bulging with as much of his life as he could carry – including some of the books that Keats had won at school. Georgiana was dressed as though she was about to make a social call rather than cross the Atlantic. She was only twenty years old, and still 'ignorant', but her self-possession filled Keats with a 'tenderness' and 'admiration' as 'great and more chaste than I can have for any woman in the world'. To a large extent, George and Georgiana's composure depended on their innocence: their New World had been shaped in their imaginations by books and a few conversations with returned emigrants. Their companions knew better what to expect. Brown considered himself a seasoned traveller – he had visited Russia, and over the last ten years or so he had 'footed' across large parts of the British Isles. In 1808, for instance, he had walked from London to Bath, Liverpool, York, Hull, Derby, Nottingham and Leicester, then back to London again. His practical good sense, combined with his ambitions as an artist and writer, made him resilient as well as appreciative. He was well equipped to support Keats through the demanding physical trials ahead, and to sympathise with its discoveries. Many years later, his son described him as 'Methodical, hospitable, kind hearted, and very cool in the presence of danger'.[1]

Moreover, the literature which inspired Brown and Keats was more reliable than anything George and Georgiana had read. The first section of their proposed journey, through the Lake District, had been a happy hunting ground for travellers in pursuit of the sublime even before Thomas West published his influential guide to the Lakes in 1778. By the time Keats and Brown arrived there, the book was in its tenth edition and had been complemented by others such as William Gilpin's *Observations Relative chiefly to Picturesque Beauty* (1795). The second stage of their journey, through Scotland, was also celebrated. In the years since Boswell and Johnson had made their tour of the Hebrides in 1773, events in Europe had dramatically increased the number of travellers determined to find at home the vital elements which had once

been associated with a continental Grand Tour. Scotland, like North Wales and the Lakes, had its catalogue of beauty spots; Scott had romanticised its history; Turner had painted its light-washed mountains; and Burns and Wordsworth had both written about it extensively. If, as seems likely, Brown's handbook was the *Traveller's Guide through Scotland* (sixth edition, 1814),[2] he would have found its five hundred pages crowded with well-known points of interest, suggested routes, and information about places to stay.

Yet even Brown would feel stared into strangeness by the end of their journey. Keats, who was wearing a fur hat, plaid, and an old jacket with leather buttons and belt, looked weird enough. Brown appeared more peculiar still. He wore a thick tartan suit, had a plaid slung over his shoulder, carried an oilskin in case it rained and a white hat to shield his bald head from the sun, and had his spectacles balanced on the end of his nose: Keats would later christen him 'The Red Cross Knight'. Even though walking tours carried no social stigma, since they were often chosen by travellers rather than forced on them by economic necessity, they still broke the familiar codes of custom and placement. After only a few days' tramping, Brown noted they were 'not taken for gentlemen' – and thereafter were mistaken as 'Spectacle vendors, Razor sellers, Jewellers, travelling linen drapers, spies, Excise Men, and many things else'.[3]

There were moments, in his occasional fits of depression or exhaustion, when Keats would find this lack of precise identity bewildering. It made him feel merely one of the masses. More often, though, he found it liberating. Not to be fixed, not to be tagged, meant enjoying in everyday terms the kind of opportunities he demanded for the imagination. It was this, mingled with his fondness for Brown and his unaffected delight in things seen, felt, heard and discovered, that sustained him as he grappled with his continuing worry about Tom, and with the misery of George's absence. In prospect, the four-month tour (in fact it only lasted half that time, and covered less than half of the 2,000 miles that Brown had originally proposed) was a chance to overcome loss, and to concentrate a sense of freedom that he had never felt before. It was a time for burrowing into the self while travelling away from the self.

AFTER TRAVELLING TWENTY-FIVE miles, the brothers' coach stopped for dinner at the village of Redbourne, near St Albans, where Keats's former room-mate Henry Stephens was now practising as a doctor.

Keats sent him a message from the coaching inn, and Stephens dashed over to have a few words with them after dinner. His memories, recorded later, are brief but telling. He was impressed by Georgiana, and by Keats's pleasure in introducing her. She had 'something original about her', Stephens felt; 'she had the imaginative poetical cast'. It was a canny judgement, not least because it implied that Keats recognised something of himself in his sister-in-law. By identifying with her, he was able to feel that he was sending a part of himself away with George.

The coach rumbled on north-west, rain falling intermittently, the Welsh mountains standing suddenly clear of cloud, then vanishing again. By the following afternoon, 23 June, the travellers reached Liverpool. Before leaving London, they had not known exactly when George and Georgiana were due to sail – the ships leaving for America had no predetermined timetables. When they arrived, therefore, and checked into the Crown Inn, they spent more time finalising their plans than they did 'catch[ing] up their sleep'. Finalising and saying goodbye. In the late evening, they were together for the last time. Keats gave no description of their parting, and his silence, like his silence on all other intimate family matters, is eloquent of his strong feeling. Eventually he and Brown went upstairs to their rooms. They left Liverpool the next morning, before his brother and Georgiana were awake.

Three days later, Keats wrote to them at the Crown Inn, not knowing whether they would still be there. In fact they had already left. Scouring the local papers for details of sailings, they had seen vacant berths advertised in the 'fine first class American ship *Telegraph*', which was 'a regular trader, coppered and copper-fastened, built in Boston and registered in Philadelphia'. The *Telegraph* had been docked in Liverpool since May, and had recently been loaded with her cargo, which was mostly iron. She had been cleared for sailing on 22 June, the day the Keatses left London, but continued to lie in the Mersey and take passengers on board while waiting for a favourable wind. George – who was impressed by the *Telegraph*'s reputation for speed (she had previously crossed the Atlantic in eight weeks) and comfort (she boasted 'very superior' accommodation) – booked a cabin for £90 and finally led his wife on board on 25 June. Records show that they took with them 'Beds Bedding & five packages'[4] which doubtless contained items that Birkbeck had recommended as essential: warm clothing, cooking utensils and playing cards, as well as letters of introduction. Ten days later, on 5 July, they set sail.

By this time Keats and Brown had already left the Lake District and reached Newton Stewart, over the Scottish border. Their journey proper had begun at Lancaster, where they arrived by coach from Liverpool in the early afternoon of 24 June. With the rain falling softly, and the skies low, the steep streets and ruinous castle looked forbidding. In recent years the town had expanded rapidly, becoming (in the words of a contemporary *Gazetteer*) 'a port of some importance; the trade to the Baltic and the West Indies being considerable'.[5] It was, in fact, the first industrial town Keats had seen at close quarters, and although he did not describe it in any detail, he was obviously moved by what he found. For the next several weeks, even when travelling through beautiful scenery to the north, he would be vexed by images of poverty and by questions about its origin and cure. The shuttles of the Lancaster mills, he said, were '[the] most disgusting of all noises'.

Lancaster affected him deeply in other ways as well. When he and Brown arrived they found the town crowded and excited. It was the eve of the Parliamentary election, and Henry Brougham, the Whig lawyer who had defended Hunt in his second libel action, was standing against the Tory incumbent, Lord Lowther. Lowther's family had represented the area for many generations, but as the local industrial population had grown, and with it the need for factory and franchise reform, their continued tenure at last seemed in doubt. Lowther, in fact, now not only feared for his seat but for his safety – and had persuaded the government in London to send up troops to keep order. These, tangling with the mass of political agents hurrying hither and thither, buying and selling votes, meant that Keats and Brown were drawn into a mêlée at precisely the moment they expected to begin a solitary reverie. Entering an inn, they were told they would have to wait two hours for supper, and must look for somewhere else to sleep. Eventually, after slogging round the wet and busy streets until late in the evening, they took a room in a private house, promising each other they would leave as early as possible the next morning.

When they woke at four o'clock, the rain was falling more heavily. They decided to delay their start, ordering breakfast and then (as though it might teach them patience) reading *Samson Agonistes* for three hours. When the rain finally thinned into what Keats called 'a Scotch mist', they left for Bolton-le-Sands four miles away. Here they had a second breakfast and were once more held up by the rain. When it eventually cleared, and they set off for Burton-in-Kendal, they found another

version of the confusion they had seen in Lancaster. The Green Dragon, where they had expected to dine, was full of soldiers, so they decamped to the King's Arms, ended their meal hurriedly, and toiled on through the drizzle to Endmoor. A local landlady took them in, explaining that since she was in the middle of white-washing, all her customers would have to squeeze into one small parlour-kitchen. They found themselves shoulder to shoulder with the pub bore, an ex-soldier called Richard Radshaw. Keats was able to shrug him off, amused by his drunken guess that Brown was a spectacles salesman. He was also brought up short. Radshaw was the second person in two days to raise the question of their identity; in Lancaster a factory worker had jeered at them for being 'gentlemen with nothing better to do than make work for themselves'.

The next morning the skies cleared as they walked through Kendal, the squat ruin of its castle much less spectacular than the massive John of Gaunt gateway they had seen in Lancaster. Hitherto Keats's revelations had all had something to do with people rather than nature. As he and Brown climbed above Bowness, with the air brightening and larks singing overhead, he found what he had hoped for: a long view of Lake Windermere, the surrounding mountains ridged with cloud, and small islands glistening in the silver water. It was a view which brought passages of Wordsworth's poetry vividly to life, as well as recalling some of his own – parts of 'Calidore', for instance. 'How can I believe that?' Keats asked Brown, staring down, then insisted that it beat anything they might find in Italy. It was a spontaneously enthusiastic remark, but it touched on his recent preoccupations. The landscape formed a counterpart to those he had tried to create in *Endymion* and proposed to show in 'Hyperion'.

It also gave him his first experience of the sublime – something that his reading in Wordsworth and elsewhere had nerved him to expect, but which is in fact strikingly absent from his subsequent descriptions. In all his writing the word only appears twenty-one times, usually implying 'only some sort of elevation',[6] rather than the feeling of exhilarated 'terror' that Burke had analysed in his famous essay. The reason is simple but significant. Whereas Burke imagined the sublime as something which produced either a form of self-forgetting ('a great power' which 'anticipates our reasonings, and hurries us on by an irresistible force'), or a clear division of feelings ('There is nothing which I can distinguish in my mind with more clearness than the three states, of indifference, of pleasure, and of pain'), Keats seizes on grand scenery as a

means of discovering the simultaneity of different experiences. On Ben Nevis he would later acknowledge some of the 'obscurity' that Burke deemed essential 'to make anything very terrible'; certain other sights 'surpass' his 'expectations' so completely that he becomes speechless. But for most of the time he concentrates on a different set of goals. His purpose is not to embrace the rapture of 'terror'; it is to increase his 'knowledge'. He does not want simply to enlarge his sensations; he tries to subtilise them.

After Keats and Brown had finally turned downhill into Bowness, they found a tall, white-painted inn by the Lake – the White Lion (now the Royal Hotel). It was more expensive than they would have liked, and Brown felt awkward. 'We thought', he said, 'the many luxuries, together with the cold, civil, professional formality attending them, but ill accorded with the view from the window.'[7] He soon found that there were compensations. In the early afternoon, they 'took an oar to one of the islands to take up some trout for dinner, which they keep in porous boxes'. After they had eaten, they walked five miles along a path edged with dripping bracken and foxgloves to the Salutation Inn at Ambleside, sometimes gazing at the darkening water which flanked them on one side, sometimes twisting round to watch the mountains rising behind them.

That evening Keats recited to Brown his 'beautiful and pathetic poem of "Isabella" ', then left him talking to a fellow tourist in the parlour while he went upstairs to write to Tom. Before setting out from Well Walk he had promised to send back regular bulletins about his progress, partly to entertain his brother with 'the nimbleness of [his] quill', partly to create a set of impressions that he might draw on later in his poems. This dual purpose helps to explain the tone of everything he sent to Tom over the next few weeks. For all their chatting and joshing, his letters have an element of calculation which does not appear in those he sent to his friends. They deliberately try out effects; they self-consciously record and report. Even at his most carefree, Keats never forgot the advice Haydon had given him. He was not merely touring but collecting. (Tom and others received their letters remarkably soon after they were written. Mail coaches had been in operation in Scotland since 1784, and by Keats's day nearly fifty routes were open. A letter posted in Edinburgh reached London within forty-three hours. Costs – which were usually met by the recipient – were high, and charged by the sheet as well as the mile.)

Keats had begun this first letter to Tom the previous day, but abandoned it after six lines. This evening he rapidly developed the thoughts about 'time and space' which had struck him at 'Winander' (Windermere). 'The two views we have had', he said, 'are of the most noble tenderness – they can never fade away – they make one forget the divisions of life; age, youth, poverty and riches; and refine one's sensual vision into a sort of north star which can never cease to be open lidded and steadfast over the wonders of the great Power. The disfigurement I mean is the miasma of London.' This passage anticipates two of his greatest late poems – 'Bright Star' and the 'Ode on a Grecian Urn' – as it celebrates an image which stands outside time. It also makes clear that the need to transcend, and the instinct to escape, are conditioned by material circumstances. Keats goes on: 'I do suppose [London] is contaminated with bucks and soldiers, and women of fashion – and hat-band ignorance.' More precisely, his thoughts are shaped by his continuing preoccupation with Wordsworth. When Keats arrived in Bowness, he tells Tom, he asked someone serving in the inn whether he knew the poet, and received a demoralising answer. 'He said . . . that [Wordsworth] had been here a few days ago, canvassing for the Lowthers. What think you of that – Wordsworth versus Brougham!! Sad – sad – sad – and yet the family has been his friend always.'

This final phrase pulls back from outright condemnation, but Keats's disillusionment is evident. So is the fact that Tom needed no detailed commentary on the contest. The brothers had obviously discussed it before Keats left Hampstead. Brougham's stand for the Whigs was the first challenge the Lowthers had received to their inherited authority, and their supporters had rounded fiercely on their opponents. This in turn had led to anti-Lowther rioting in Kendal and elsewhere earlier in the year, and the local press had eagerly dramatised the divisions. The *Carlisle Patriot* supported the Tory 'Yellow boys', and the *Kendal Chronicle* backed Brougham and the Whig 'Blue boys'. Wordsworth thought that Brougham (who had already gained a reputation as a radical by opposing the slave trade and pressing for Parliamentary reform) was little more than a 'demagogue and a rabble rouser', and decided to do everything he could to defeat him. 'The best that can be said', Wordsworth's latest biographer says glumly, 'is that having joined the battle he fought to win. Even-handedness, dignity, and propriety were abandoned. He gave the Lowthers a breakdown of the political allegiances of friends and acquaintances. He dined out, listened, and

reported back. He attempted to browbeat the editor of the *Kendal Chronicle*, advising Lord Lonsdale about the possibility of suborning the paper entirely by buying it out, and finally assisting in setting up a rival paper, the *Westmorland Gazette* [which Thomas de Quincey would later edit].'[8]

Keats had no way of knowing what pains Wordsworth had taken to show his support for the Lowthers, though the memory of the poet trussed in a frilly shirt and knee breeches, about to dine with the Comptroller of Stamps in London, had already led him to fear the worst. A week after telling Tom about the latest developments, his views were echoed by Hunt in the *Examiner*, who said that his friend Brougham 'has an interest in [the] welfare [of his fellow countrymen] compatible with their old liberties', and attacked Wordsworth for taking part in 'the literary drudgery of the patronage'.[9] Yet Keats does not end his letter by repeating his condemnation; he says that he and Brown will soon be walking on to Rydal, where they hope to see Wordsworth. It is at this point that his previous remarks about the 'divisions of life' become particularly significant. In planning to visit Wordsworth, Keats is not reneging on his principles or betraying his friends. He is proving that the effect of the landscape he has just seen is to 'make all disagreeables evaporate'. When he had first begun to formulate his thoughts about 'negative capability', Keats had framed them largely in terms of art and aesthetics; here they become organic. After telling Tom about the Ambleside waterfall – Stock Ghyll Force – with a deliberately Wordsworthian thunder, he describes how he moved gradually 'a space' away from it, and 'saw nearly the whole more mild, streaming silently through the trees'. He goes on:

What astonishes me more than any thing is the tone, the coloring, the slate, the stone, the moss, the rock-weed; or, if I may so say, the intellect, the countenance of such places. The space, the magnitude of mountains and waterfalls are well imagined before one sees them; but this countenance or intellectual tone must surpass every imagination and defy any remembrance. I shall learn poetry here and shall henceforth write more than ever, for the abstract endeavour of being able to add a mite to that mass of beauty which is harvested from these grand materials, by the finest spirits, and put into ethereal existence for the relish of one's fellows. I cannot think with Hazlitt that these scenes make man appear little. I never forgot my stature so completely – I live in the eye; and my imagination, surpassed, is at rest.

The next morning, when Keats visited 'Rydal, the Residence of Wordsworth', the house was empty. (Wordsworth was at Appleby, awaiting the results of the poll.) Keats wrote a note which he 'stuck . . . up over what I knew must be Miss Wordsworth's Portrait'. Then, contenting himself with the poet's landscape since he could not see the poet himself, he and Brown took in the view from the parlour window and visited two waterfalls in Rydal Park before striding on to Grasmere. They put up for the night at the Nag's Head in Wythburn. It was, Brown said, 'a pretty place' by the water's edge, but when they returned to their rooms, they suffered the final disappointment of their day. 'Much rain' had fallen in the area recently, and 'many fleas were in the beds'.

Keats postponed having to keep them company by beginning a letter to George and Georgiana. For the first two dozen lines he keeps up the same reserve he had shown in Liverpool, confining himself to a sketch of things seen and places visited. When his restraint finally weakens, it is only to give the most guarded glimpse of how he feels. 'I have a great confidence', he says, 'in your being well able to support the fatigue of your Journey, since I have felt how much new Objects contribute to keep off a sense of Ennui and fatigue.' No sooner has he made this half-admission of sadness to his brother than he turns to his 'sister', showing the same 'disinterestedness' that he admired in her, and composing a verse acrostic on her new name: Georgiana Augusta Keats. To start with, this is simply and beguilingly light-hearted:

> Give me your patience, sister, while I frame
> Exact in capitals your golden name,
> Or sue the fair Apollo, and he will
> Rouse from his heady slumber and instill
> Great love in me for thee and Poesy.

Within a few lines, however, the mood becomes more complicated. This is partly due to Keats's difficulty in finishing the formal task he has set himself; more importantly, it is to do with the thoughts that had troubled him over the past few days. Ushering Georgiana into his depleted family, he says that the name 'Keats' has been 'Enchanted . . . the Lord knows where'. The phrase is meant to sound at once proud and throw-away. It also seems rueful – referring to worries about rootlessness and questions of identity.

By the end of this same letter, Keats has found his balance again,

reeling off eight lines ('Warm the nerve of a welcoming hand . . .') which cheerfully look forward to a reunion in America. The switch in his feelings completes a pattern he would repeat in many subsequent letters to Georgiana – reaching towards her with a tender openness, then retreating into a no less affectionate but more reserved style. She was his brother's wife, and therefore someone with whom he could feel intimate only in a qualified sense. She was also one of the few women he knew whose womanliness he felt no need to reproach.

Once Keats had set aside his letter, he and Brown resumed their headlong progress. They walked eight miles to Keswick before breakfast, then skirted Derwentwater – ten miles including a detour to see the Falls of Lodore – then juddered up and down hills for another three miles in the evening to see a prehistoric stone circle near the Vale of St John. They spent the night, 'rather fatigued', in Keswick, probably at the then fashionable Oak Inn, now the Royal Oak Hotel. Pausing here at midday, before setting off to Derwentwater, they had been amused to see 'a yawning dandy [come] from his bed-room, and [sit] at his breakfast reading a bouncing novel'. Their own pace remained not much short of furious. At four o'clock on the morning of 29 June they set off to 'mount Skiddaw' in weather that 'promised all along to be fair', and had reached the summit – just over 3,000 feet – by half past six when a heavy mist rolled in and blotted out the view. Keats had found the climb hard going but thrilling, with such views across the Irish Sea and into Scotland that he felt 'that same elevation, which a cold bath gives me – I felt as if I were going to a Tournament'.

By the evening they had reached Ireby. Brown referred to it as 'a dull, beggarly-looking place'. If Keats shared his opinion, or was worn out by his recent exertions, he did not show it. For as long as he had been moving through Wordsworth's country, there had been a note of self-consciousness in even his most excited descriptions. From Ireby onwards, he seems to have felt less constrained, more alert to individuals and details. In the 'remarkably clean and neat' Sun Inn at Ireby itself, for instance, he and Brown heard 'obstreperous doings over our heads' during their dinner, which turned out to be a travelling dancing master giving a class to the children of a local farmer. Keats was entranced by the energy of the dancing and its novelty. 'It was indeed,' he told Tom, with a reference to Burns, ' "no new cotillon fresh from France". No they kickit & jumpit with mettle extraordinary, & whiskit & fleckit, & toe'd it & go'd it, & twirld it, & wheel'd it, & stampt it, & sweated it,

tattooing the floor like mad; The differenc[e] between our country dances & these scotch figures, is about the same as leisurely stirring a cup o' Tea & [b]eating up a batter pudding, I was extremely gratified to think, that if I had pleasures they knew nothing of[,] they had also some into which I could not possibly enter[.] I hope I shall not return without having got the Highland fling, there was as fine a row of boys & girls as you ever saw, some beautiful faces, & one exquisite mouth. I never felt so near the glory of Patriotism, the glory of making by any means a country happier. This is what I like better than scenery.'

This little hymn to the demotic ends on a note that Keats would later strike repeatedly. Throughout the remainder of his tour he would insist 'descriptions are bad at all times', that to 'run over the Ground we have passed . . . would be merely as bad as telling a dream', that 'I cannot write about scenery and visitings', and that 'I hate descriptions'. On the face of it, these remarks amount to a rejection of the advice he had taken from Haydon, and had started by adopting so enthusiastically. In fact they are a deepening and a recasting of that advice. As Keats shakes off the shadow of Wordsworth, he is free to accept that – as he put it to Reynolds on 13 July – 'Fancy is indeed less than a present palpable reality, but it is greater than remembrance.'

In this sense Ireby marks the end of the first stage of Keats's tour: the loss of his innocence as a traveller, and the strong beginnings of his wish to investigate the concealed values of new experiences, rather than making do with surfaces. Before the second stage properly began, he had to deal with a number of small disappointments. When he and Brown arrived in Carlisle, walking via Wigton, they found 'nothing interesting', and felt 'a little weary in the thighs, & a little blistered'. Moreover, their hopes of meeting Bailey were dashed. Although their friend was due to be ordained deacon shortly in the Cathedral, he had not yet arrived. (He was in London trying to persuade Taylor to publish some of his religious meditations, and leaving a copy of Livy's *Roman History* for Keats to collect on his return.) It was the last in a succession of missed opportunities; the two men never saw each other again.

To recover their energy and good spirits, Brown and Keats decided not to walk the next forty-odd miles, and caught the coach north over the border to Dumfries. As they sped forward, and no doubt prompted by thoughts of Bailey, Keats began to read Dante. The sense that he was taking a journey-in-parallel, a sympathetic quest, returned to him as the countryside changed. Like Brown, he felt on arriving in Dumfries that it

'might be difficult to define in what the distinction lies', but there was no doubt that he had at last stepped into 'a foreign country'. The borders lay behind them. Ahead stretched the future he had laboured so hard to discover and was determined to enter.

TWENTY-THREE

As SOON AS Keats and Brown reached Dumfries they went to visit the tomb of Robert Burns, who was buried in St Michael's churchyard. (Burns had been buried elsewhere in the same churchyard in 1791, but in 1815 his remains had been moved from a simple grave to their new site after money had been raised by public subscription.) Although Burns belonged to Scotland's 'foreign' culture, and although there were aspects of his personality which seemed dissimilar (his notorious libertinism, for instance), he exemplified virtues that Keats regarded as essential. Both were poets whose identity depended on notions of put-upon, self-creating genius – one was a 'ploughman', the other a 'pestleman'. Both opposed received authority. Both believed that native literary traditions formed a vital part of 'patriotism'. Both – in varying degrees – associated moral health with the struggle to admit and thereby overcome the hardships of existence. In all these respects, the older poet that Burns most nearly resembled in Keats's conception was Chatterton; the contemporary who came closest to developing his ethos was John Clare – as Keats would realise in a couple of years' time.

When Keats reached St Michael's late on 1 July, he was rested by travelling in the coach but disturbed by what he had read on his journey: Dante's description of the descent into hell in Canto Four of the *Inferno*, and his account of the lovers' suspended anguish in Canto Five. The two episodes silently replayed themselves as he stood by the grave – which he found 'not very much to [his] taste'. Later that same evening, his feelings of dissociation gave him a starting point for a sonnet 'On Visiting the Tomb of Burns'. The churchyard is remembered as 'beautiful, cold – strange – as in a dream / I dreamed long ago', and precipitates a small crisis in his thoughts about how a life devoted to art must accept the full reality of suffering if it is to give an adequate account of 'Beauty':

> All is cold Beauty; pain is never done
> For who has mind to relish, Minos-wise,

> The real of Beauty, free from that dead hue
> Fickle imagination and sick pride
> Cast wan upon it!

There is no doubting the direction of Keats's argument here, but his lines are so compressed they cannot help seeming disappointed. Dante's huge narrative of human crimes and their punishments, George's attempts to find a future away from home, Tom's efforts to secure a future of any kind, his own doubts about his talents and opportunities: all these things threaten to turn a poem of homage into an introspective elegy. Eventually, the poem sinks into self-recrimination: 'Great shadow, hide / Thy face! I sin against thy native skies.'

Keats genuinely admired Burns and partly identified with him. As his feelings emerged in his sonnet, however, they became oddly unstable. They tried to establish a connection which was both 'excessive and perfunctory'[1] – as though Keats could hardly wait, once he had arrived in Scotland, to seize upon an emblem of its 'native' identity and make it a metaphor for his own sorrows. Over the next few days, as he and Brown strode onwards, his sense of being in a 'strange mood, half asleep' intensified. He felt caught between acceptance and evasion, sympathy and prejudice. The effect is immediately noticeable in his letters. While the journal that Brown kept concurrently is taken up with appreciations of how 'neat, clean and snug-looking' the Scottish villages seem, Keats veers between celebration and condemnation – especially condemnation of the Kirk. Yet the more he tries to unify his thoughts about his surroundings, his past, and his future ambitions, the more difficult he finds it to mediate between 'fidelity to concrete detail and the continually idealising demands of the imagination'.[2] His effort to immerse himself in everyday details, which had been the original purpose of his trip, is gradually transformed. He discovers that his imagination is most actively engaged by registering 'contraries' in a single moment, rather than by delivering preconditioned judgements. This was, of course, something he had planned to do in letters written over the past several months. The gap between his aspirations and his achievements was beginning to shrink remarkably.

The sense that he was coming into his own excited him – and distressed him, since it meant realising all the more acutely that 'pain is never done'. While he and Brown left the border further behind them, first making a short visit to the ruin of Lincluden Abbey, then

heading west towards the coast, he came across more and more evidence of Scotland's rural poverty. He beadily described the barefoot men and women on the road, carrying their shoes and stockings to 'look smart in the Towns', and the 'plenty of wretched Cottages, where smoke has no outlet but by the door'. To set against this, he commemorated the pleasures of drinking whisky ('called here *whusky*'), and the happy associations of the scenery with Walter Scott's novels. Early in the morning of 3 July, after spending the previous night at Dalbeattie, they walked eight miles while Brown recounted the plot of Scott's *Guy Mannering*, passing on the way the 'little spot' where 'without a shadow of doubt, old Meg Merrilies had often boiled her kettle and, haply, cooked a chicken'. At breakfast in Auchencairn, Keats cheerfully added to the story in a letter to his sister. After a brisk résumé of their progress, written in the faintly dutiful manner he generally adopted with Fanny at this time but which would later become more relaxed and confiding, he snaps into the short ballad 'Old Meg she was a gypsy':

> Her brothers were the craggy hills,
> Her sisters larchen trees –
> Alone with her great family
> She lived as she did please.

Keats seems to present Meg as a perfectly comfortable child of nature. In the context of George's recent departure, his mention of 'brothers' and 'sisters' raises the possibility that her life is in fact not a form of ideal freedom. Living 'for herself alone' has its rewards, but its lack of responsibilities, as Keats had been saying more or less continuously since leaving London, is a disadvantage. The poem has no intention of making this point weightily, nor does the letter as a whole. Once breakfast was finished, Keats tucked the pages into his knapsack and set off to walk the ten miles to Kirkcudbright, with a two-mile detour to see Dundrennan Abbey. He and Brown were both delighted by the 'stately' grey stone ruins, and by the gently sloping views towards the 'winding bay'. When they reached their lodgings in the evening, as rain began to fall, Keats caught their rising mood by 'scribbling' another poem for Fanny, 'A Song About Myself'. It has the same lightness, and the same discreet life of contrasts, as his poem about 'old Meg' – although he wrote it, he said, feeling 'so fatigued

that when I am asleep you might sew my nose to my great toe and
trundle me round the town like a Hoop without waking me':

> There was a naughty boy
> And a naughty boy was he,
> He kept little fishes
> In washing tubs three
> In spite
> Of the might
> Of the maid,
> Nor afraid
> Of his granny-good,
> He often would
> Hurly burly
> Get up early
> And go,
> By hook or crook,
> To the brook
> And bring home
> Miller's thumb,
> Tittlebat
> Not over fat,
> Minnows small
> As the stall
> Of a glove,
> Not above
> The size
> Of a nice
> Little baby's
> Little finger –
> O he made
> ('Twas his trade)
> Of fish a pretty kettle
> A kettle –
> A kettle,
> Of fish a pretty kettle,
> A kettle!

Only at the very end of this poem does Keats skip into something more
serious. The lines 'he stood in his shoes / And he wondered, / He
wondered, / He stood in his / Shoes and he wondered' are a jokey echo of

the conclusion to 'When I have fears . . .', which he had written six months earlier: 'then on the shore / Of the wide world I stand alone, and think / Till love and fame to nothingness do sink'. In the sonnet his puzzlement stemmed from a sense of frustration, the feeling that he would never have time or talent enough to do justice to his experience. In the doggerel, he realises that even when he steps outside his familiar life ('He ran away to Scotland / The people for to see'), the conditions of existence are, beneath superficial differences, the same as those he knows at home.

The poem is too light-hearted to be specific about this. It shows more clearly in another letter to Tom that Keats began writing soon after he had said goodbye to Fanny, and had left Kirkcudbright for Creetown via the hill-top village of Gatehouse-of-Fleet. Even though the country around seemed 'very rich – very fine – and with a little of Devon', he was more preoccupied by its 'very primitive' conditions. 'Very few South-rens [pass] these ways,' he said, noticing that 'The children jabber away as in a foreign language.' When he approached Creetown itself, his sense of strangeness increased as he met 'an emigration' of people returning from their daily bath in the sea. Brown wished the 'custom . . . was more general in all countries'. Keats took it as a sign of impoverishment.

They spent the night of 4 July, a Saturday, in the Barholm Arms, realising they now had a chance to make a detour to Ireland. It is not known when they first considered this, but once Keats had seen the chance to make a comparison between the two countries, he was eager. By the following evening he and Brown had travelled through Newton Stewart, where he posted his letter to Fanny, and reached Glenluce, where they dined 'on dirty bacon dirtier eggs and dirtiest Potatoes with a slice of salmon'. The following morning, as the skies suddenly cleared and hot sunlight beat down on them, they paused briefly to look at the remains of twelfth-century Glenluce Abbey ('they were scarcely worth the while') before toiling on towards Portpatrick. Tired and overheated, they were just beginning to regret their diversion when a post horn blasted on the road behind them, announcing the coach on its way to collect the Irish mail. They hailed it, travelled on swiftly to the small craggy harbour of Portpatrick, then immediately caught the ferry which took them across twenty-one miles of rough water to Ireland. After they had set sail, two ancient fellow travellers began singing ballads, one a 'very poor' romance, one about the Battle of the Boyne, and one about Robin Hood (or ' "Robin Huid" as they call him').

Keats and Brown gave each other one main reason for crossing to Ireland: they wanted to see the Giant's Causeway. When they disembarked at Donaghadee, they were relieved to find their goal was not 'as we supposed . . . 70 miles [away] . . . it is only 48 miles – so we shall leave one of our knapsacks here, . . . take our immediate wants and be back in a week'. Planning to leave for Belfast in the morning, they booked into 'a nate inn kept by Mr Kelly'. Keats was immediately impressed by the mood of the place, and after chatting with his chambermaid, used her conversation as the basis for a general theory about the difference between his present surroundings and the country he had just left. He expounded it that same evening in his letter to Tom, sounding as vehement as he had done when speaking to Bailey about the Bishop of Lincoln, or when writing the beginning of Book III of *Endymion*:

A Scotch Girl stands in terrible awe of the Elders – poor little Susannas – They will scarcely laugh – they are greatly to be pitied and the kirk is greatly to be damn'd. These kirkmen have done scotland [no] good they have made Men, Women, Old Men Young Men old Women, young women boys, girls, and infants all careful – so that they are formed into regular Phalanges of savers and gainers – such a thrifty army cannot fail to enrich their Country and give it a greater appearance of comfort than that of their poor irish neighbours – These kirkmen have done Scotland harm – they have banished puns and laughing and kissing (except in cases where the very danger and crime must make it very fine and gustful).

Over the next two days, these distinctions became much more complicated. In the first flush of his excitement, however, Keats broadens his theme to include some of the thoughts which had hovered in and around his sonnet to Burns. Mulling over the reception and fate of the 'Great shadow', Keats had turned Burns into an emblem of everything that repressive Scotland could not tolerate. 'Poor unfortunate fellow', he bursts out to Tom, '– his disposition was southern – how sad it is when a luxurious imagination is obliged in self-defence to deaden its delicacy in vulgarity, and not in thing[s] attainable that it may not have leisure to go mad after thing[s] which are not.' This is a self-sufficient point for Keats, connecting his ideas about the life of sensations with his anxieties about hostile critics. It is also a stage in a developing argument. The particular example of Burns becomes a part of a large social observation, as Keats insists that sensuality and

'abstracted Pleasure', like 'thrift' and emotional generosity, are insepar-
able elements of human experience. 'All I can do is by plump contrasts –
Were the fingers made to squeeze a guinea or a white hand? Were the
Lips made to hold a pen or a kiss? And yet in Cities Man is shut out from
his fellows if he is poor, the Cottager must be dirty and very wretched if
she be not thrifty – The present state of society demands this and this
convinces me that the world is very young and in a verry ignorant state –
We live in a barbarous age. I would sooner be a wild deer than a Girl
under the dominion of the kirk, and I would sooner be a wild hog than
the occasion of a Poor Creatures pennance before those execrable elders.'

Keats's faith in 'plump contrasts' remained unchanged, even though
this quick affection for the Irish was soon mixed with something more
perturbing. As he and Brown began walking down the Belfast road, they
realised they had been misled about distances. The '48 miles' to the
Giant's Causeway were 'Irish ones which reach to 70 English ones'.
They found the friendliness of Donaghadee quickly giving way to scenes
of horrendous poverty and despair. The hovels they passed made a
'Scotch cottage' where the 'Smoke has no exit but at the door' seem like
'a palace'. Every turn brought 'too much opportunity to see the worse
than nakedness, the rags, the dirt and misery of the poor common Irish'.
Three miles outside Belfast, they passed through a 'dreary, black, dank,
flat and springy' peat bog which was home to 'poor dirty creatures and a
few strong men'. When they reached the outskirts of the city itself, they
heard 'that most disgusting of all noises worse than the Bag pipe, the
laugh of a Monkey, the chatter of women *solus* the scream of [a] Macaw –
I mean the sound of the Shuttle'. Had Keats travelled elsewhere in
Ireland, he would have seen similar scenes, but nothing quite so
desperate. Since the turn of the century, rural poverty and the effects of
the Industrial Revolution had sucked so many people into Belfast that its
population had expanded by nearly 50 per cent. Unemployment was rife
and poverty widespread. A recent outbreak of typhus had made things
worse still: over the next three years 7,000 weavers and large numbers of
the general population would die of the disease. The city was like a scene
from Dante.

Keats was only in Belfast for twenty-four hours – but it was long
enough for him to feel deeply disturbed by the suffering he saw. He told
Tom: 'What a tremendous difficulty is the improvement of the condition
of such people – I cannot conceive how a mind "with child" of
Philosophy could gra[s]p at possibility – with me it is absolute despair.'

Though he does not mention it in his letter, he had a particular reason for feeling so thwarted. During the few hours he spent making his desolate inspection of the city, the *Belfast Newsletter* published news of Lowther's election victory in the Lake District. There was, apparently, no hope that the old order might give way; no chance that reforming furies might reduce 'misery'.

Keats's despair, more than the distance, persuaded him not to continue to the Giant's Causeway. Early on the morning of 8 July, he and Brown turned on their heels and fled back towards Donaghadee. On the way, they encountered a more gruesome sight than any they had yet seen: a huge, old, derelict heap of a woman lumbering along their road in 'a dog-kennel Sedan'. Keats later said that of all the horrors he had encountered in Ireland, this was 'what I can never forget'. In his letter to Tom, he identified her as a Spenserian monstrosity, 'The Duchess of Dunghill':

It is no laughing matter tho – Imagine the worst kennel you ever saw placed upon two poles from a mouldy fencing – In such a wretched thing sat a squalid old Woman squat like an ape half starved from a scarcity of Biscuit in its passage from Madagascar to the cape, – with a pipe in her mouth and looking out with a round-eyed skinny lidded, inanity – with a sort of horizontal idiotic movement of her head – squab and lean she sat and puff'd out the smoke while two ragged tattered Girls carried her along.

The description is full of compassion and curiosity, as well as disgust: Keats finally turns away from the Duchess by saying 'What a thing would be a story of her Life and sensations'. He had set out on his travels to 'find' poetry in landscapes which corresponded to his epic purposes. He was also discovering new ways of thinking about suffering.

TWENTY-FOUR

KEATS AND BROWN left Donaghadee with 'a fair breeze', returned to Portpatrick where a letter from Tom awaited them, then on 9 July walked the twenty-seven miles north to Ballantrae. As they travelled through Stranraer into Ayrshire, in fine clear weather, the road curved steeply uphill along the coast, giving views which Brown, in his plain way, called 'both grand and beautiful'. It marked the beginning of a new stage in their journey. Listening to the waves thrashing on rocks below

them, and to the echoes in sea caves, they passed through wooded glens towards the Vale of Glenap, and entered what Brown referred to as 'an enchanted region . . . another world'. They 'strode along, snuffing up the mountain air, – more exhilarating to those who have been long trudging on a plain'.

The climax to this magical elevation was, appropriately enough, 'a sight [that] . . . came upon us like something supernatural': the huge, snub dome of Ailsa Craig, rising to 940 feet, seventeen miles out to sea. Both men had expected it, but neither was prepared for its weird magnificence. 'The strangeness of appearance', Keats said, 'was occasioned by its seeming to possess an invisible footing above the sea', adding that he was 'really . . . a little alarmed' by how even at such a distance it 'seemed close upon us [and] . . . struck me very suddenly'. As had happened on Skiddaw and elsewhere, he felt at a loss for words, not so much conscious of his smallness as of having to live entirely 'in the eye'. The following day, beginning a new letter to Tom once they had reached Girvan, he explored his dumbfoundedness in a sonnet, transferring his own sensations to the Craig itself:

> Thou answer'st not; for thou art dead asleep.
> Thy life is but two dead eternities –
> The last in air, the former in the deep,
> First with the whales, last with the eagle-skies.

In this same letter to Tom, Keats also wrote a pastiche of Burns's 'Ah! ken ye what I met the day'. The forty-odd lines are an apparently flippant description of a wedding party that he and Brown had seen as they came into Ballantrae – a kind of vernacular companion piece to 'A Song of Myself'. Like that recent doggerel, they tip towards seriousness in the closing lines:

> Ah! Marie they are all gone hame
> Fra happy wedding,
> Whilst I – Ah! is it not a shame? –
> Sad tears am shedding.

Glancing as it is, this poem shows yet again that Keats could not shake off his sense of alienation. His brother had sailed off into marriage, while he trekked into solitude – greeted at every turn by signs of his

foreignness. Hitherto he had kept such thoughts largely silent or good-humoured. Now, nearly three weeks into his journey, their pressure started to tell. For the first time, he began writing a letter to a friend, Reynolds, rather than to his family, and for the first time he lowered his guard.

Keats begins his letter by saying he will 'not run over the Ground we have passed' because it would be 'merely as bad as telling a dream'. He then suggests that his present mood is in fact distinctly dream-like. After leaving Girvan for Kirkoswald on the morning of 11 July he had visited the 'very fine' ruins of Crossraguel Abbey, the less impressive stump of Baltersan Castle, then travelled on to Maybole. This had brought him to the Brig o' Doon ('the sweetest river I ever saw overhung with fine trees as far as we could see') and into Burns country, moving towards Alloway and 'the cottage [Burns] was born in'. It is here that the letter gets into its stride, or rather, starts its characteristic rush. 'I am approaching Burns' Cottage very fast,' Keats writes, saying breathlessly that the countryside is much less 'desolate' than he had expected, then plunging into the village as though Reynolds were actually speeding along beside him. The fact that his friend is many miles distant provokes one of Keats's occasional eruptions about the difference between speaking and writing. 'My head', he says, 'is sometimes in such a whirl in considering the million likings and antipathies of our Moments – that I can get into no settled strain in my Letters.' This frustration is transmuted into a more substantial rage about the cottage itself, and the poem that Keats writes there:

I wrote a sonnet for the mere sake of writing some lines under the roof – they are so bad I cannot transcribe them – The Man at the Cottage was a great Bore with his Anecdotes – I hate the rascal – his Life consists in fuz, fuzzy, fuzziest – He drinks glasses five for the Quarter and twelve for the hour, – he is a mahogany faced old Jackass who knew Burns – He ought to be kicked for having spoken to him. He calls himself 'a curious old Bitch' – but he is a flat old Dog – I sho^d like to employ Caliph Vatheck to kick him – O the flummery of a birth place! Cant! Cant! Cant! It is enough to give a spirit the guts-ache – Many a true word they say is spoken in jest – this may be because his gab hindered my sublimity. – The flat dog made me write a flat sonnet.

Later in the letter, Keats blames his failure on a lack of interest in descriptive writing. It has just as much to do with depression. During his tour, he had gradually promoted Burns to the status of a 'Presider', but at

the shrine of the birthplace, he suddenly saw him as an admonitory rather than an exemplary figure, someone who died rejected and miserable. The result is a poem which achieves identification only through suffering. The first and best line emphasises this by means of an uncanny premonition. 'This mortal body of a thousand days' may have been intended as a purely rhetorical phrase; we cannot read it without realising that Keats died almost exactly a thousand days after writing it:

> Yet can I stamp my foot upon thy floor,
> Yet can I ope thy window-sash to find
> The meadow thou hast trampèd o'er and o'er
> Yet can I think of thee till thought is blind,
> Yet can I gulp a bumper to thy name –
> O smile among the shades, for this is fame!

Keats confines himself to discussing Burns's misery in terms of drink and literary reputation. As his letter to Reynolds continues, though, it becomes clear he was also disturbed by the role that women played in his hero's life. Knowing Reynolds was engaged to be married, he is careful when first raising the issue. Then, as soon as he has wondered 'what [Burns's] addresses [were] to Jean in the latter part of his life' he says: 'I should not speak so to you – yet why not – you are not in the same case.' It sounds as though Keats is about to unburden himself candidly. In fact what follows is compressed and contradictory. He wishes his family and friends well in their marriages, admits to his special fondness for Georgiana, but presents his own feelings as a painful tangle of desire and doubt. Sometimes, he confesses, his confusion has been so deep it has made him feel suicidal:

– I have spoken to you against Marriage, but it was general – the Prospect in those matters has been to me so blank, that I have not been unwilling to die – I would not now, for I have inducements to Life – I must see my little Nephews in America, and I must see you marry your lovely Wife – My sensations are sometimes deadened for weeks together – but believe me I have more than once yearned for the time of your happiness to come, as much as I could for myself after the lips of Juliet. – From the tenor of my occasional rhodomontade in chitchat, you might have been deceived concerning me in these points – upon my soul, I have been getting more and more close to you every day, ever since I knew you, and now one of the first pleasures I look to is your happy Marriage – the more, since I have felt the pleasure of loving a sister in Law. I did not think it

[283]

possible to become so much attached in so short a time – Things like these, and they are real, have made me resolve to have a care of my health – you must be as careful –

From certain previous letters, notably those written to Bailey after leaving Oxford, we know that Keats tended to justify his views about women and marriage by saying that writing could not be reconciled with a settled domestic existence. As time passed, however, and especially since meeting and admiring Georgiana, he realised that his explanation was inadequate. Within a week of writing to Reynolds, he develops his thoughts further in another letter to Bailey. It is an extraordinary document, not least because it makes connections between childhood traumas and adult expectations in a way that anticipates psychoanalytic procedures which would only become commonplace a century or so later:

I am certain I have not a right feeling towards Women – at this moment I am striving to be just to them but I cannot – Is it because they fall so far beneath my Boyish imagination? When I was a Schoolboy I though[t] a fair Woman a pure Goddess, my mind was a soft nest in which some one of them slept though she knew it not – I have no right to expect more than their reality. I thought them etherial above Men – I find the[m] perhaps equal – great by comparison is very small – Insult may be inflicted in more ways than by Word or action – one who is tender of being insulted does not like to think an insult against another – I do not like to think insults in a Lady's Company – I commit a Crime with her which absence would not have known – Is it not extraordinary? When among Men I have no evil thoughts, no malice, no spleen – I feel free to speak or to be silent – I can listen and from every one I can learn – my hands are in my pockets I am free from all suspicion and comfortable. When I am among Women I have evil thoughts, malice spleen – I cannot speak or be silent – I am full of Suspicions and therefore listen to no thing – I am in a hurry to be gone – You must be charitable and put all this perversity to my being disappointed since Boyhood – Yet with such feelings I am happier alone among Crowds of men, by myself or with a friend or two – With all this trust me Bailey I have not the least idea that Men of different feelings and inclinations are more short sighted than myself – I never rejoiced more than at my Brother's Marriage and shall do so at that of any of my friends – . I must absolutely get over this – but how? The only way is to find the root of evil, and so cure it 'with backward mutters of dissevering Power'[.] That is a difficult thing; for an obstinate Prejuduce can seldom be produced but from a gordian complication of feelings, which must take time to unravell and care to keep unravelled – I could say a good deal about this but I will leave it in hopes of better and more worthy dispositions – and also content that I am wronging no

one, for after all I do think better of Womankind than to suppose they care whether Mister John Keats five feet hight likes them or not. You appear[e]d to wish to avoid any words on this subject – don't think it a bore my dear fellow – it shall be my Amen –

Keats resists the temptation to pass off his own opinions as general rules. He wants to leave room for his brother, Bailey, Reynolds and other friends to marry and be content. At the same time, he knows that his own chances of happiness with a woman are compromised by the bookish idealism he learned at school, by his sense of inferiority ('tender of being insulted' about his looks, height, background and ambitions), and by his 'being disappointed since Boyhood'. No adult experience could disguise or break the pattern of abandonment which shaped his early years. Highly sexed but nervously proud, he realises that he has been turned by 'circumstance' into someone who instinctively distrusts most women. He admits this is 'perverse', but understands that changing himself (supposing he could) would make him seem even more hungrily needful of family, friends, lovers, audience, fame, security. It would also deprive him – and he is inevitably less self-aware about this – of the subject which in the next eighteen months would impel him to greatness. 'La Belle Dame', 'Lamia', and several of the Odes all depend in various ways on precisely what he criticises in himself. They all struggle to allow, or at least to understand, a movement from love to loss, from generosity to grief.

KEATS'S EXPERIENCE OF suffering in Ireland, combined with his reflections on Burns's decline and death, had driven him so far into himself that he had been forced to examine the very foundations of his feelings. It was not the journey he had anticipated when he left England, but it was to reward him more than 'scenery and visitings'. By telling Reynolds that 'Things like these' had made him resolve 'to have a care of my health', he indicated that he meant to look to the future with an even stronger sense of responsibility. While saluting Burns's achievement, and sympathising with his fate, he understood that he must create himself in a different image.

He and Brown swung down from Kilmarnock and Kingswells towards Glasgow, which they reached on 13 July. Over supper at Kingswells they met 'a Traveller' who had seen Kean act but was hopelessly confused about which of Shakespeare's characters appeared

in what plays; in the Glasgow suburbs they were accosted by a drunk they could only shake off by mentioning 'the word Officer and Police'. Had Keats been feeling less well supported by his new resolution, he might have found that both encounters added to his 'oppression'. As it was, he turned them into comic cameos for Tom, and made them the highlight of a letter which explores the differences between Ireland and Scotland. Once again, it is only in the closing lines that he lets his darker feelings show, urging Tom to 'Make a long lounge of the whole summer', and urging 'Take care of yourself'. His vow to look after his own health, he fearfully implies, might have a better chance of success.

After visiting Glasgow Cathedral, he and Brown left the city and headed along the shore of Loch Lomond towards Tarbet, walking slowly because Brown was breaking in a new pair of shoes. The weather improved steadily, and Keats enjoyed the more relaxed regime. He was soon telling Tom that the banks of the Clyde were 'extremely beautiful', and the north end of Loch Lomond was 'grand in excess'. The next day, not even an exhausting misunderstanding could quell his optimism. Rising at four o'clock to walk fifteen miles before breakfast to what their Itinerary called the 'Rest and be Thankful', they found that what they had imagined to be an inn was in fact a cold stone seat. Two days later, Keats proved his good spirits were still intact by dashing off for Tom fourteen quatrains about the 'cursed Gad flies' which had 'been at me ever since I left the Swan and two necks'. Like the doggerel written for Fanny, part of their pleasure lay in their reference to shared opinions. In this case, to political opinions about the Lowther election, which Keats knew his brother would have read about in the *Examiner*:

> O Lowther, how much better thou
> Hadst figured t'other day
> When to the folks thou mad'st a bow
> And hadst no more to say,
>
> If lucky gad-fly had but ta'en
> His seat upon thine arse
> And put thee to a little pain
> To save thee from a worse.

Keats was obviously remembering his experiences in Westmorland and Belfast. More recent sights had reinforced their lessons by less drastic means. Travelling up from Carindow through Glen Kinlas, then

approaching Inverary on 17 July, he had passed the edge of the Duke of Argyle's estate. Peering at the enormous turreted castle, he had felt his suspicions about inherited authority bubbling once more to the surface of his mind. On this occasion, though, he confined his reaction to a few double-edged remarks about the 'very modern magnificent' building, then veered into comedy by expatiating on 'the horrors of [hearing] a solo on the Bag-pipe'. Its withering blast was as nothing compared to what followed. When the travellers eventually reached Inverary, Brown decided on an early night (his new shoes had blistered him), and Keats went to a performance of Kotzebue's *The Stranger* in the local theatre. He had little hope of being diverted – Reynolds had reviewed the play in London for the *Champion* and had panned it – but even his lowest expectations were destroyed by a piper before, during, and after the performance. 'O Bagpipe', Keats wailed in a mocking Miltonic sonnet for Tom:

> O Bagpipe, thou didst steal my heart away –
> O Stranger, thou my nerves from pipe didst charm –
> O Bagpipe, thou didst re-assert thy sway –
> Again, thou Stranger gav'st me fresh alarm!

'Alas! I could not choose', Keats ended, implying that this was the unacceptable face of deciding to live among opposites.

The next morning a heavy thunderstorm rolled above the town as they had breakfast. Brown, whose feet were still sore, was glad to postpone their departure, and Keats seized the chance to catch up with his letters. It was now that he wrote to Bailey, from whom he had found a letter waiting in Glasgow. As well as developing his thoughts about women and marriage, he also touched on other, related issues. Recognising that 'I carry all matters to an extreme – so that when I have any little vexation it grows in five Minutes into a theme for Sophocles', Keats surrounds his central argument with reflections on his friends and family, and, once again, his wellbeing. 'I shall be prudent', he says, perhaps thinking of Burns's rakish life and early death, 'and more careful of my health than I have been.'

As the thunder cleared, Keats put away his letter to Bailey unfinished, and tramped on with Brown to Cladich, at the north-east end of Loch Awe, where they spent the night. Their food at this latest inn was so 'coarse' that Keats felt 'not . . . at all in cue to write', and the next day

was little better. 'Trudging' for twenty miles south and west, they found each 'new and beautiful picture' only a partial recompense. 'No supper but Eggs and Oat cake,' Keats complained that evening, '– we have lost the sight of white bread entirely – Now we had eaten nothing but Eggs all day – about 10 a piece and they had become sickening – .' On 21 July, bending north-west towards Kilmelfort, the views were even more impressive and the food slightly better – a 'small Chicken' and even 'a good bottle of Port'. To their left they could see the sea inlets of the jagged coast; to their right, the flat black water of Loch Awe, broken by wooded islands, and ringed by low heather-covered hills. 'Indolent' eagles floated above them 'without the least motion of wings'; larks bounced out of the bracken beside them and sang invisibly overhead; the warm sun shone on their backs. It was lulling and isolating at the same time. Lulling because everything about them seemed remote, hushed, self-sufficient; isolating because they were 'for the first time in a country where a foreign Language is spoken – they gabble away Gaelic at vast rate'.

This mixture of moods survived until the evening, when they reached the small, white-washed inn at Ford, which Keats told Tom was 'by far the best house in the immediate neighbourhood'. Later that evening[1] he wrote some 'Lines' which aimed to repair the disappointment he had felt when visiting Burns's house. 'There is a joy in footing slow across a silent plain', they began, lolloping good-naturedly: 'There is a joy in every spot made known by times of old, / New to the feet, although the tale a hundred times be told'. For the next twenty-odd lines, the poem pays its conventional homage, remembering once again that although Burns was 'great through mortal days' he died 'of fame unshorn'. Yet as the concentration builds, the mood complicates. The reverence that Keats conveys at the outset starts to consume the visible world on which it depends, creating an intense abstraction which seems like the threshold of insanity:

> the forgotten eye is still fast wedded to the ground,
> As palmer's that, with weariness, mid-desert shrine hath found.
> At such a time the soul's a child, in childhood is the brain;
> Forgotten is the worldly heart – alone, it beats in vain.
> Ay, if a madman could have leave to pass a healthful day
> To tell his forehead's swoon and faint when first began decay,

He might make tremble many a man whose spirit had gone forth
To find a bard's low cradle-place about the silent North!

At this halfway stage, Keats's tone is still balanced – a compound of knowing exaggeration and genuine unease, which reflects the ambivalences of the past several days. Then his poise deserts him. The swinging march of his rhythm changes into something eerily indefinite, as if he were walking in a dream. A journey begun in the spirit of pilgrimage becomes a series of steps 'beyond the bourn of care', 'Beyond the sweet and bitter world'. It is, movingly, the mention of 'brother's eyes' and 'sister's brow' which quickens this change, producing a moment which recalls the sudden melancholy descent of the Epistle he had sent to Reynolds from Teignmouth. Commitment to others becomes a form of vulnerability; the desire to concentrate experience is transformed into a death instinct:

> O horrible! to lose the sight of well-remembered face,
> Of brother's eyes, of sister's brow, constant to every place,
> Filling the air, as on we move, with portraiture intense,
> More warm than those heroic tints that fill a painter's sense,
> When shapes of old come striding by, and visages of old,
> Locks shining black, hair scanty grey, and passions manifold.
> No, no, that horror cannot be, for at the cable's length
> Man feels the gentle anchor pull and gladdens in its strength –
> One hour, half-idiot, he stands by mossy waterfall,
> But in the very next he reads his soul's memorial.

By the time Keats signed off to Bailey as his 'affectionate friend', he and Brown had left Ford and walked on through heavy rain towards Oban. To their west lay the Isle of Mull, with Iona and Staffa veiled in mist beyond it. These were places their Itinerary recommended they should visit, but the bad weather and high cost of the detour (seven guineas) made them abandon the idea. They found lodgings in Oban overlooking the harbour, and decided to walk on the next day towards Fort William. When they woke, however, the weather had improved a little, and before leaving the inn they were introduced to a guide who offered to save them money by taking them on a direct route across Mull, which would allow them to see the 'curiosities' on Iona and Staffa more cheaply. They accepted gladly.

It seemed a small decision, compared to many others that Keats had taken in recent weeks, but it turned out to be crucial. Sailing by ferry from Oban to the island of Kerrara, and then on to Mull 'in forty minutes with a fine Breeze', Keats embarked on the most demanding part of his tour. During the next two days he trudged thirty-seven miles, was saturated by rain, exhausted by stumbling through bogs, chilled by sleeping in bleak huts, drained by the effort of merely continuing. Within hours of returning to the mainland he began worrrying about his health more anxiously than ever before; within days he started contemplating an early departure for London. When he finally reached Hampstead he immediately began nursing his brother, exposing himself to a highly infectious illness. Previously, when he had cared for Tom, he had been robust enough to keep his own good health. This autumn he could not remain immune so easily. It was on Mull that his short life started to end, and his slow death began.

TWENTY-FIVE

THEY LANDED AT Grasspoint, close to the now ruined Drover's Inn, on the early afternoon of 22 July. From here they set off inland, at first along the Drover's Road, surrounded by thin barriers of silver birch and brambles which shielded them from the wind, then coming on to a bare track. Keats described this to Tom as though, once again, something he had been reading in Dante had come to life. The road, he said, 'is the most dreary you can think of – between dreary Mountains – over bog and rock and river with our Breeches tucked up and our Stockings in hand'.

By eight in the evening, with Glen More behind them, their guide led them to a shepherd's hut, a 'horrid place', Keats said, lived in by a Gaelic-speaking family who, though 'very kind', were not able to offer much in the way of hospitality. Keats slept on the floor in wet clothes, as the smoke from the peat fire billowed round the room and out through the low door.

The next morning they toiled stiffly onwards for six miles before breakfast, wading through 'rivulets up to the knees' and bog 'up to the ankles'. Eventually they reached a house named 'Derry-na-Cullen' ('The House under the Waterfall'), but known throughout Glen More as 'The Mansion'. Today it is a ruin: thick stone walls and a roof open to the sky. But the large empty window-frames, and slivers of slate lying in the

surrounding bracken, suggest that while it was never a 'mansion', it was a great deal more comfortable than their previous lodging. Comfortable enough, anyway, for Keats to begin another letter to Tom, saying that he had enjoyed hearing their guide sing a 'Jacobin' song 'on Charles Stuart', and to add that Brown's spectacles were still provoking a good deal of curiosity: 'they hand[le them] as we do a sensitive leaf'.

Their trials continued next day. 'A most wretched walk' through Bunessan and the Ross of Mull brought them at last to Fionnphort, where they caught a ferry to Iona. Here, thirteen centuries previously, St Colomba had founded the first Christian settlement in what eventually became Great Britain, and throughout the Dark Ages the island had been used as the burial place for the Kings of Scotland. After Keats had been shown over the ruins of the cathedral by an elderly schoolmaster, he recreated what he had seen for Tom. For the first time, he obviously relied on Brown's Itinerary, paraphrasing passages to give a compressed account of 'the most interesting Antiquities', the history of the 'Church', the etymology of 'Colomba', and the details of 'the churchyard where they say 61 kings are buried'. Inevitably, his reliance on the guidebook makes him sound a little stilted. He has nothing to say about the extraordinary beauty and atmosphere of Iona, and nothing about how its historical layerings relate to his recent 'Lines'. Instead there are facts, figures, and a rapid switch of attention to Staffa, to which he and Brown continued in the afternoon – after he had pocketed some pebbles from the cathedral to take home to Fanny.

Even though tourists regularly sailed from the mainland to Staffa, admiring its basalt columns rising sheer out of the water, and peering into the echoey cathedral of Fingal's Cave, the sea swell meant that they could only occasionally set foot on the island. Keats and Brown, who had been dogged by bad weather for much of their tour, were in luck. Their boat deftly landed them in a small cove, and they walked 'along the side of the cave on the pillars which are left as if for convenient stairs', then groped their way into its vaulted darkness. (The name of the cave would have appealed to Keats: Finn, called Fingal by Macpherson in his Ossianic poems, was celebrated as a defender of the oppressed and a righter of wrongs – a kind of Celtic Robin Hood.)

The island made a profound impression on Keats. Writing about it later, he abandoned his recent experiment with guidebook sobriety, justifying the hope that his tour would 'give me more experience, rub off more Prejudice, use me to more hardship, identify finer scenes[,] load

[291]

me with greater mountains, and strengthen more my reach in Poetry'. The bleak hillsides, perilous seas, moving waters, and 'grand pillars of basalt standing together as thick as honey combs', are not just relished as aspects of an epic geography. They are a means by which Keats dramatises his historical sense:

Suppose now the Giants who rebelled against Jove had taken a whole Mass of black Columns and bound them together like bunches of matches – and then with immense Axes had made a cavern in the body of these columns – of course the roof and floor must be composed of the broken ends of the Columns – such is fingal's Cave except that the Sea has done the work of excavations and is continually dashing there . . . the roof is arched somewhat gothic wise and the length of some of the entire side pillars is 50 feet – About the island you might seat an army of Men each on a pillar – The length of the Cave is 120 feet and from its extremity the view into the sea through the large Arch at the entrance – the colour of the columns is a sort of black with a lurking gloom of purple ther[e]in – For solemnity and grandeur it far surpasses the finest Cathedrall – At the extremity of the Cave there is a small perforation into another cave, at which the waters meeting and buffetting each other there is sometimes produced a report as of a cannon heard as far as Iona which must be 12 Miles –

Keats realised that Staffa would be valuable for his poems as soon as he first saw 'the pillars . . . rising immediately out of the crystal', although it was not until he began 'Hyperion' that he connected their physical appearance with a metaphorical value. In the short term, he jotted down some doggerel which uncomfortably proves his contention that 'it is impossible to describe' the Cave, and which moves from gazing on its 'rugged wonder' to condemning the 'fashion boats' which bring tourists to 'unweave / All the magic of the place'.

He and Brown left Staffa late on 24 July, taking a ferry through Loch na Keal to Mull;[1] the following morning they ended their visit to the Hebrides when they returned to Oban. Keats knew that after a month of searching he had found the strange grandeur which matched his expectations. Contemplating the rain-smoothed effigies on Iona, walking the cobblestones of the path down which the royal dead had been carried to burial, then gazing at the immense columns round the Cave, he had forgotten himself more completely than ever before on his journey. He had also made himself more fragile. 'I have a slight sore throat,' he told Tom soon after reaching Oban, indicating that he meant to remain there for a few days. In his enforced 'indolence' he shifted

uneasily from subject to subject: wondering whether George had been in touch; telling Tom he missed Well Walk; admitting that he was 'happier than when I have time to be glum'; suggesting that he might soon begin writing for the theatre; referring nervously to his state of health. It is a plaintive catalogue, mixing gains with losses, desires with depression. As he gathered himself for what turned out to be the final stage of his journey, he was taking pains to comfort his brother by seeming resolute. No amount of self-control could conceal the anxieties which came surging back once the visit to Staffa had ended.

WHILE BROWN CAUGHT up with his journal, Keats languished; his throat showed no sign of improving. After two or three days, they went to see a doctor, who suggested that 'if, when we reached Inverness, [Keats] should not be much better', the friends should 'part'. Brown was impatient, as well as concerned, and when they finally walked out of Oban through Ballachulish to Fort William on 1 August, Keats was still in pain. The next day, as if setting himself a test that he knew would bring matters to a crisis, he agreed to accompany Brown on a climb up Ben Nevis, the highest mountain in Scotland. Describing the ascent to Tom the following day, Keats admitted 'I am heartily glad it is done – it is almost like a fly crawling up a wainscoat', and went on to ask him to 'Imagine the task of mounting 10 saint Pauls without the convenience of Stair cases'.

This humour evaporates as soon as Keats starts to give details of their climb – which started at five in the morning, brought them to 'the first Rise' after 'much fag and tug and rest and a glass of whisky apiece', then led to another 'obstinate fag' through snagging heather and across dangerous scree slopes. Before they had reached halfway, a thick mist descended, so that as they approached the summit, many of the deep chasms which lay around them, and which were 'the finest wonder of the whole', seemed to steam menacingly. When they eventually reached the top, their view was mysterious and tantalising:

After a little time the Mist cleared away but still there were large Clouds about attracted by old Ben to a certain distance so as to form as it appear[e]d large dome curtains which kept sailing about, opening and shutting at intervals here and there and everrywhere; so that although we did not see one vast wide extent of prospect all round we saw something perhaps finer – these cloud-veils opening with a dissolving motion and showing us the mountainous region beneath as through a loop hole – these Mouldy loop holes ever varrying and

discovering fresh prospect east, west north and South – Then it was misty again and again it was fair – then puff came a cold breeze of wind and bared a craggy chap we had not yet seen though in close neighbourhood – Every now and then we had over head blue Sky clear and the sun pretty wa[r]m.

In the much calmer, suburban environment of Hampstead, Keats had exploited such feelings of ambiguous eminence in one of his most successful early poems, 'I stood tip-toe . . .' Then he had delivered grave self-commands. On Ben Nevis, as if deliberately mocking thoughts of the sublime, Keats turned himself into a 'stunt-man poet',[2] dangling his feet in a precipice as he composed the sonnet 'Read me a lesson, Muse', and complaining that the mist has made the world and his ambitions 'vaporous':

> Here are the craggy stones beneath my feet –
> Thus much I know, that, a poor witless elf,
> I tread on them, that all my eye doth meet
> Is mist and crag, not only on this height,
> But in the world of thought and mental might.

Even though the sonnet is 'reflective', it manages to sustain a sociable tone. It is written to suit a chatty journal-letter, and does not want to get caught taking itself too seriously. Not until the closing couplet, anyway. Here Keats abruptly becomes straight-faced, reminding himself that his 'blindness' in the mist is not a disability but a gain, a creative obscurity, in which the mind is free to speculate. (The comparisons with his recent sonnet 'To Homer' are obvious.) In the letter he wrote to Tom shortly afterwards, Keats makes the same sort of point. He says that 'the most new thing of all is the sudden leap of the eye from the extremity of what appears a plain into so Vast a distance'. The letter is also shy of being too serious. Its first duties are to cheer Tom, and to conceal Keats's own condition – which it does by sheering off into an absurd rhyming conversation between a chubby mountaineer, Mrs Cameron, and Ben Nevis itself. It describes – among other things – how a man (mountain) feels compelled to shake off a woman (climber):

> O, pain! – for since the eagle's earliest scream
> I've had a damned confounded ugly dream,
> A nightmare sure. What, Madam, was it you?
> It cannot be! My old eyes are not true!

Red Crag, my spectacles! Now let me see!
Good Heavens, Lady, how the gemini
Did you get here? O I shall split my sides!
I shall earthquake –

Before beginning his descent from Ben Nevis, Keats clambered on
to the 'handsome pile of stones done pointedly by some soldiers of
artillery' at the very pinnacle of the mountain. Then the descent
began, a slithering clamber so 'vile' that by the time he reached Fort
William in the evening he felt shaken 'all to pieces'. If there had been
any hopes of his recovering from his sore throat, this effort destroyed
them. The next morning, Monday 3 August, he and Brown worked
slowly north-east through Letterfinlay and Laggan, where they would
have seen Laggan Lochs, the engineering masterpiece of Thomas
Telford, under construction. The following day, as they continued
along the east side of Loch Ness, they saw 'more work of the wizard of
the Caledonian Canal',[3] but Keats was too bleary to mention it when
he eventually added to his letter, and Brown preferred to concentrate
on natural beauties in his journal. At the Falls of Foyers, Brown wrote
dutifully: 'I must mention my having seen the grandest fall of water in
Europe.'

They reached Inverness on 6 August, after following the shore of
Loch Ness for more than twenty miles. Keats was still hoping he might
recover, and be able to follow their original plan. But he realised the
chances were slim. Thanking Tom for sending three letters to their poste
restante in the town (there were others from Fanny and Dilke), he
admitted, 'My sore throat is not quite well', and said he intended
'stopping here a few days'. Writing to Georgiana's mother, Mrs Wylie,
he also confessed that he had 'got a sore throat' and was 'rather tired'.
Brown knew they must soon come to a final decision and, within hours of
reaching Inverness, he insisted that Keats should see another doctor.
Their worst fears were confirmed. The doctor decided Keats was too ill
to continue, and should return at once to London. Brown passed the
news to Dilke on 7 August: 'He caught a cold in the Island of Mull,
which far from leaving him, has become worse, and the Physician here
thinks him too thin and fevered to proceed on our journey. It is a cruel
disappointment. We have been as happy as possible together. Alas! I
shall have to travel thro' Perthshire and all the Counties round in
solitude! But my disappointment is nothing to his; he not only loses my

company, (and that's a great loss,) but he loses the country. Poor Charles Brown will have to trudge by himself – '4

On 8 august 'Poor Charles Brown' – an 'odd fellow', as he called himself to Dilke, and 'moreover an odd figure' – travelled with Keats by coach to Cromarty, from where a boat was soon due to leave for London. On the way they stopped at Beauly Priory, a roofless shell surrounded by gravestones, some of which were decorated with carvings of skulls and crossbones. They walked among them gingerly, eyeing the moss-filled sockets and weathered joints, then headed for the coast. The near-embarrassment of their parting was depressing, and while they waited at an inn for the boat to arrive, they tried to amuse themselves by composing some 'Stanzas on some skulls in Beauly Abbey'. It was the prototype of the later and much more ambitious collaboration – *Otho the Great*, which they worked on together the following May. Their briskly rhyming 'Burns stanzas', most written by Brown, made a joke of mortality, turning Hamlet's graveyard address to Yorick into a series of cameos before coming to a clanging finale:

> Enough! why need I further pore?
> This corner holds at least a score,
> And yonder twice as many more
> Of Reverend Brothers;
> 'Tis the same story o'er and o'er –
> They're like the others!

It was a heavily weighted conclusion, for all its mockery. During the last six weeks, Keats had enjoyed and endured experiences which were designed to make him as unlike 'others' as possible. He had seen land- and seascapes which would give his poems their epic scale. He had discovered rural and industrial poverty which consolidated his reformist principles. In his homage to Burns he had contemplated the tangled web of his own feelings about poetry, women, sex, and reputation. He had thought deeply about both his brothers. But in spite of its many revelations, his tour had been a kind of limbo. He had walked a zig-zag line between past and present, north and south, illness and health, solitude and company. As the fishing smack the *George* at last entered Cromarty harbour, his time of suspension ended. (The irony of the boat bearing his brother's name could hardly have been lost on him.) He knew

that in a sense his early return was a failure. In other, more important ways, he had triumphed. His increased self-knowledge had prepared him to take a decisive step towards the next 'chamber' of his existence.

TWENTY-SIX

SHORTLY AFTER KEATS had left Inverness, a letter arrived there from Dilke, urging him to return to Well Walk. Tom's health had collapsed. Keats sailed towards his brother in ignorance, preoccupied by his own illness and the rigours of the journey. Bumping through the choppy seas off Northumberland, he struggled against sea-sickness, eating a little beef, as he had often longed to do on his travels, but pushing aside the 'thick Porridge' which his fellow passengers scooped up with 'large awkward horn spoons'. By the time he reached London, sailing into the Thames on 18 August, ten days after leaving Cromarty, he was in good spirits. His throat was better though not entirely cured; he was full of stories to tell; he was eager to see his brother and friends. Once he had disembarked, he decided to treat himself to a coach out to Hampstead, rather than tramp the remaining few miles home. He alighted in Pond Street, near Dilke's house, late in the evening, thinking that he would surprise his friends before walking up the hill to his brother.

Dilke himself was away in Brighton, so it was Maria Dilke who welcomed him into Wentworth Place. Keats, she said, was 'as brown and as shabby as you can imagine, scarcely any shoes left, his jacket all torn at the back, a fur cap, a great plaid, and his knapsack'. After greeting her, he immediately sank into a comfortable chair. 'Bless thee, Bottom, bless thee', he said gleefully, quoting from *A Midsummer Night's Dream*, 'thou art translated!'[1] Then the room hushed, and Keats realised that all was not well. He hardly needed to be told what had happened, but Mrs Dilke explained anyway. She added that she was not surprised to see him, because four days previously a letter had arrived from Brown saying that 'cheerful, good-tempered, clever [Keats]' had abandoned his tour and was already on his way south.

Keats left immediately, without hearing any of Mrs Dilke's other news, or meeting the neighbours who had been living in Brown's half of Wentworth Place during his absence: Mrs Brawne and her family. What he found at Well Walk horrified him. Tom was in bed: emaciated, exhausted, feverish, looking much older than his eighteen years, and

hurting in his sides and shoulders. Whenever he coughed, his phlegm was flecked with blood. 'Softened tubercular matter was now passing into his bronchial tubes . . . [and as] the cavities in the upper lobes of his lungs became ulcerated, so the lower portion gradually became tubercular too.'[2] In the spring, it had been just possible to imagine that Tom might recover, even after he had haemorrhaged on the road from Teignmouth to London. Now it was obvious there was no hope for him. Keats unpacked his knapsack and began telling his stories, knowing that the next time he left his lodgings for any length of time, his brother would be dead.

For the next month he was hardly out of Tom's sight – except for a day in late August when he visited Abbey and also the Reynolds sisters, whom he found 'in a sort of talking' about Mrs Reynolds's niece, Jane Cox, who was staying with them. He heard how Mrs Bentley, the landlady, had kindly nursed his brother, and how he had relied on friends like Dilke, Haslam and Severn. (Haydon, Rice, Reynolds and Taylor were all out of town during August, and Tom had felt too unwell to see the Reynolds sisters, who had offered to call on him.) Keats felt pitifully anxious – one day underlining the words 'poor Tom' when he was reading *King Lear* – and also guilty. He was desperate to begin writing poems again, but knew it would seem selfish. 'If I think of fame of Poetry it seems a crime,' he told Dilke. 'Yet I must do so or suffer.' In a letter to his sister, written on 19 August, the same thought reappears. Shouldering his responsibilities as head of their small, afflicted family, he kept news of their brother to a bare minimum, partly because he found the truth hard to bear, and partly to spare his sister Fanny's feelings. 'Tom has not been getting better since I left London,' he said, 'and for the last fortnight has been worse than ever – he has been getting a little better these last two or three days.'

Keats is typically reticent in this letter; he is also uncharacteristically preoccupied by his own health. Explaining to Fanny that he has returned from Scotland 'so soon' because he had a 'bad sore throat . . . caught in the island of Mull', he adds that he is now suffering from 'a confounded tooth ache', then ends abruptly: 'My tooth Ache keeps on so that I cannot writ[e] with any pleasure.' The condition he describes is obviously not quite the same as that which had forced him to end his tour, and other letters written during the next month suggest its likely cause. On 21 September, for instance, he tells Dilke that he has been afflicted with 'a nervousness proceeding from the Mercury', indicating

that he had been dosing himself with it for some time, and accepting that it had certain side-effects. Morbid excitability was one. Another was aching gums. But why was he taking mercury if all he had was a severe cold? 'The most likely explanation'[3] is that when he returned from Scotland, he and Dr Sawrey became concerned that his sore throat should not turn out to be a syphilitic ulcer – a re-emergence of the disease he had caught in Oxford. His remark to Tom that 'with respect to Women I think I shall be able to conquer my passions hereafter better than I have yet done', let alone his cogitations about marriage, show that he had recently been worrying about his sexual health. Other letters, written to his men friends in the weeks to come, suggest that it continued to trouble him. It was not until the end of the last week in September that he finally decided his condition was 'undangerous', and let it fade to the back of his mind.

As Keats tried to adjust to his role as nurse, he encountered another, more predictable problem: Abbey. Abbey had kept Fanny in the dark about Tom's relapse, and Keats now campaigned for her to visit Hampstead and see her brother. Abbey was slow to give permission, and when he eventually relented, used the flimsiest excuse to rule out further contact. He complained that Keats had introduced her to some of his friends, and that the codes governing the behaviour of young ladies had therefore been violated. At the end of October, Keats wrote to her protesting about these constraints, acknowledging that if they were going to find a way round her guardian, she would have to be more discreet. 'I do not mean to say you did wrongly in speaking of [meeting my friends], for there should rightly be no objection to such things: but you know with what People we are obliged in the course of childhood to associate; whose conduct forces us into duplicity and fa[l]s[e]hood to them.'

Compared to – say – his letter to Bailey about the Bishop of Lincoln, this sounds cannily moderate. In a sense the reasons are obvious. Abbey was a permanent feature of their lives, and present difficulties needed to be solved without creating others for the future. But there is another explanation for his seeming tight-lipped. As Keats sank under the weight of his own ill-health, Tom's sickness, and other domestic burdens, the long-threatened articles on his work were starting to appear in the Tory press. On 1 September the August issue of *Blackwood's* was published, and on 27 September the delayed April number of the *Quarterly Review* came out – at the same time as the June issue of the

British Critic also appeared. The reservations of his letter to Fanny are at least partly the result of these three desolating reviews.

Ever since 'Z' (Lockhart, egged on by Wilson) had printed his 'flaming attack' on Hunt and the 'Cockney School' the previous year, Keats had been bracing himself for a drubbing. 'I shall have the Reputation of Hunt's élève', he had told Bailey. Ironically, much of the material for *Blackwood's* new assault came from Bailey himself. When he had eventually reached Scotland after being ordained deacon in July, Bailey had met Lockhart in the house of Bishop Gleig (Bailey's future father-in-law), and had heard him abuse 'poor Keats'. He had responded by trying to dissociate his friend from Hunt, of whom he disapproved, and by giving 'an outline of Keats's history – that he had been brought up as a surgeon and apothecary; & though not highly, that he was respectably educated'. Far from deflecting Lockhart, this gave him the angle he had been looking for, the chance to mingle sneers at Keats's social origin with jeers at his poetic aspirations. The result was a horribly well-sustained defamation. It begins by saying that 'The just celebrity of Robert Burns and Miss Baillie has had the melancholy effect of turning the heads of we know not how many farm-servants and unmarried ladies', then focuses on Keats by insisting that 'Mr John' has now 'caught the infection, and that thoroughly'. In the remainder of the piece, remarks about his circumstances are mixed with criticisms of his style. Because Keats's background is lowly, Lockhart says, his writing is inevitably self-indulgent and overwrought – struggling to emulate superiors and only managing to produce 'Cockney' rhymes which travesty Pope.

'Cockney' here, as in the previous attacks on Hunt, refers to a multitude of vices. Combining social disapproval with political objection and aesthetic hostility, Lockhart seized on Keats's rejection of the idea that 'a complete couplet [should] enclose a complete idea', on his lavish sensuality, and on his deliberately digressive narrative as proof that he lacked any kind of 'decorum'. The subversions of his style, he implied, were not just a sign of his ignorance and immaturity, but evidence of vulgarity, effeminacy, and prurience, and also of his suburban pushiness and (worse still), radical and 'seditious' sympathies which he had learned at school and cultivated as an adult. In all these respects, Lockhart continued, the 'defects of [Hunt's] system are tenfold more conspicuous in his disciple's work than in his own'. Then he ended brutally: 'It is a better and a wiser thing to be a starved apothecary than a

starved poet; so back to the shop, Mr John, back to the "plasters, pills, and ointment boxes" &c. But, for Heaven's sake, young Sangrado, be a little more sparing of extenuatives and soporifics in your practice than you have been in your poetry.'

The *Quarterly Review* took a similar line. Although Taylor had previously called on the notoriously cold-blooded editor, William Gifford, to say that he hoped *Endymion* would not be 'automatically condemned because of its politics',[4] he had merely been told that matters were out of his control: the review had already been written. When Taylor discovered that its author was John Wilson Croker, whom Hazlitt scornfully called 'the talking potato', he knew what to expect. Croker opened his barrage by saying that in spite of efforts 'almost as superhuman as the story appears to be', he had only been able to read the first book of the poem. 'The author', he went on, 'is a copyist of Mr Hunt; but he is more unintelligible, almost as rugged, twice as diffuse, and ten times more tiresome and absurd than his prototype.' Like Lockhart, he was most exasperated by the vulgar and subversive style of the poem: he refers to 'what has been somewhere called Cockney poetry' as 'the most incongruous ideas in the most uncouth language', describes Hunt as 'the hierophant', accuses Keats of playing 'an immeasurable game at *bouts-rimés*', and says he cannot find any 'meaning' in his lines. These remarks are less obviously class based than Lockhart's, but are fired by the same snobbish motives and lead to the same conclusion. Keats is a 'smaller poet' than Hunt (in *Blackwood's* personally insulting phrase), and his work is not simply bad, it is 'nonsense'. The *British Critic* was just as explicit about what kind of nonsense. Pushing aside the 'flimsy veil of words', its reviewer singles out various 'immoral images' to argue that social inferiority inevitably results in bad taste. 'We will not', the author says, 'disgust our readers by retailing to them the artifices of vicious refinement, by which, under the semblance of "slippery blisses, twinkling eyes, soft contemplation of faces, and smooth excess of hands", he would palm upon the unsuspicious and the innocent, imaginations better adapted to the stews.'

The political bias of these reviews has been acknowledged ever since they appeared. It is less often noticed that their terms were in fact extremely restricted. Keats is condemned for the most general kinds of transgression, and his association with Hunt is used as a shorthand for subversions which are unspecified. There is no detailed account of his 'patriotism' or his social and sexual liberalism; no estimation of his

attitude to ideas of legitimacy and power; no proper evaluation of the way his couplets deliberately challenge conventions; no comment on his use of Greek myths to suggest an ideal commonwealth. In these respects, they hardly amount to a 'political' attack at all. They are, rather, a broadly social denigration. The difference is crucial, not least because it helps us to estimate Keats's reaction to them. For one thing, he was familiar with the terms in which contemporary critics carried on their debates and accustomed to seeing others flayed unmercifully. (In 1812 Coleridge had described most contemporary reviewing as 'personality and political gossip, where insects as in Egypt [are] worshipped and valued in proportion to the venom of their sting'.) For another, he had more reason to feel disappointed that the depth and scope of his beliefs were unappreciated, than he did to feel entirely misrepresented. In the wake of the onslaught, however, this distinction was drowned by howls of sympathetic outrage, and the popular idea developed that Keats had been desperately or even fatally injured. Shelley, in Italy in 1820, said that 'Poor Keats was thrown into a dreadful state . . . [and] the agony of his sufferings at length produced a rupture of a blood-vessel in the lungs [which led to] the usual process of consumption.' Haydon later concluded in his journals that Keats was 'a victim of personal abuse and want of nerve to bear it'. In *Lord Byron and some Contemporaries* (1828), Hunt said that 'the hunters had struck [Keats]; and a delicate organisation, which already anticipated a premature death, made him feel his ambitions thwarted by these fellows; and . . . [this] preyed on his mind'.[5]

These verdicts were all given after Keats had died, by people who needed a martyr to inspire them. They are not reliable, as we can see at once by looking at the evidence of friends who were better placed to evaluate his immediate response. Taylor, for instance, saw that Keats greeted the reviews with 'remarkable resilience', and also felt that he subsequently began 'to assert a special kind of exclusiveness about the poetic mind'.[6] Fanny Brawne, too, insisted that from the time of her first meeting with Keats, later this same autumn, she never saw 'anything in his manner to give the idea that he was brooding over any secret grief or disappointment'. James Hessey went further than either of them, pointing out that Keats 'does not seem to care at all about *Blackwood*, he thinks it is poorly done'. He had good reason for believing this. He had Keats's own word for it:

I begin to get a little acquainted with my own strength and weakness. – Praise or blame has but a momentary effect on the man whose love of beauty in the abstract makes him a severe critic on his own Works. My own domestic criticism has given me pain without comparison beyond what Blackwood or the Quarterly could possibly inflict. [A]nd also when I feel I am right, no external praise can give me such a glow as my own solitary reperception & ratification of what is fine . . . [*Endymion*] is as good as I had power to make it – by myself – Had I been nervous about its being a perfect piece, & with that view asked advice, & trembled over every page, it would not have been written; for it is not in my nature to fumble – I will write independently. – I have written independently *without Judgement* – I may write independently *& with judgement* hereafter. – The Genius of Poetry must work out its own salvation in a man: It cannot be matured by law & precept, but by sensation & watchfulness in itself – That which is creative must create itself – In Endymion, I leaped headlong into the Sea, and thereby have become better acquainted with the Soundings, the quicksands, & the rocks, than if I had stayed upon the green shore, and piped a silly pipe, and took tea & comfortable advice. – I was never afraid of failure; for I would sooner fail than not be among the greatest –

This magnificently self-possessed letter is conclusive proof that Keats was not – in Byron's famous phrase – 'snuffed out by an article'. He interpreted the ferocity of the attacks on him as a kind of tribute to his own equally defiant beliefs; he enjoyed challenging those he regarded as his natural enemies; and he was proud to be identified as a spokesman for a liberal 'set'. Hunt, admittedly, had become a comparatively remote and problematic friend in recent months; there were others whom Keats was proud to call kindred spirits. Not just friends like Reynolds (who defended Keats in the *Examiner* on 11 October), and John Scott (who wrote to the *Morning Chronicle* on his behalf), and Woodhouse (who assured him that 'many . . ., tho' personally unknown to you, look with the eye of hope & anticipation to your future course'), but also less intimate acquaintances like Hazlitt, who in the same issue of *Blackwood's* that contained the assault on Keats, had himself suffered a mauling in 'Hazlitt Cross-Questioned'. He responded to this by taking legal action (he was eventually paid £100 in an out-of-court settlement), and by composing a furious 'Reply to Z'. This came much closer to expressing Keats's own feelings than anything Shelley and others invented on his behalf.

This should not be taken to mean that Keats simply shrugged off the reviews. In certain respects they hurt him deeply. On 23 October Hessey

wrote to Taylor saying that the row was provoking interest in *Endymion* ('there is nothing like making a stir for it'), and reporting that six copies had been sold to one customer alone. Early the following year, however, business came to a standstill. In 1822, Taylor and Hessey were still £110 out of pocket, and the volume was eventually remaindered. (Edward Stibbs, a bookseller, bought the stock and sold it slowly, charging one shilling and sixpence a copy.) Keats's dream of making his living by writing was exploded. In its place, there remained the familiar anxiety of how to stretch out his small inheritance, and the need to discover other money-making schemes – by writing for the theatre, for instance.

The reviews also sharply affected Keats's thoughts about the nature of the poetic imagination. Rather than attacking those who had savaged him, or appealing to his background as either a justification or a refuge, he returned with a fresh sense of urgency to the ideas he had recently explored in his letters. Writing to Taylor, Woodhouse, Dilke and his brother George over the next few weeks, he insists that he does not care whether a poet is an apothecary or an aristocrat. The important thing is to be a 'chameleon'; someone whose ego is subordinate to a sensuous intelligence. As he reiterated this belief, he once again accelerated the development of his work. Convincing himself more strongly than ever that 'axioms in philosophy' had to be 'proved upon our pulses', he stepped back from the polemical style of some of his previous poems, while at the same time confirming his 'interest in human affairs', and his emphasis on liberty, community, and moral health. 'Hyperion' is triumphant proof of this. Its fundamental allegiances are the same as those he had always espoused; its resonances are immensely greater. Far from cudgelling him to death, his reviewers helped to bring him to mature poetic life.

SHELLEY WAS THE PRINCIPAL cause of misunderstandings about Keats and his critics. Biographers have also made their contribution, often supposing that because he hardly left Well Walk immediately after *Blackwood's* and the *Quarterly Review* had appeared, and for three weeks wrote no surviving letters, he was sulking and sighing. In fact he was recovering his health, and nursing his brother.

By the middle of September Keats was feeling better, and Tom also seemed 'more cheerful', making no objection when Keats said that he wanted to start seeing friends again. On Monday the 14th, he went to dinner with Hessey at 93 Fleet Street, and met Woodhouse and Hazlitt.

(Taylor was ill, and recuperating at his family home in Nottingham-shire.) Hessey later described Keats as being in 'excellent spirits' – though he remembered him working himself into a 'rhodomontade' at one point, insisting that he did not intend to publish in the foreseeable future, and doubted whether there was anything 'original . . . to be written in poetry', since 'its riches were already exhausted, & all its beauties forestalled'. This eruption has often been taken as further proof of the harm that Lockhart and Croker had done to him. But in the context (drinking with friends, enjoying his recovery), and in the light of his earlier remarks about 'the mighty dead', it is evident that he was not suggesting he might abandon poetry altogether. Excited by the presence of Hazlitt, who was one of the few people he regarded as an intellectual superior, he was showing that he was impatient to continue his progress. Woodhouse, uncharacteristically, missed the point, and subsequently wrote Keats a worried letter: 'For my part I believe most sincerely, that the wealth of poetry is unexhausted & inexhaustible.' Hessey was more shrewd. He had always thought that Keats was emotionally volatile, but had also always appreciated his exceptional single-mindedness. 'He is studying closely,' he wrote soon afterwards, 'recovering his Latin, going to learn Greek, and seems altogether more rational than usual – but he is such a man of fits and starts he is not much to be depended on. Still he thinks of nothing but poetry as his being's end and aim, and sometime or other he will, I doubt not, do something valuable.'

A week after Hessey wrote this, Keats vindicated his publisher's trust by turning at last towards 'Hyperion'. He found it gruellingly difficult to make any headway. In a letter to Dilke which says 'My throat has become worse after getting well', he admitted that Tom's 'identity presses upon me so all day that I am obliged to go out'. A month later he told Woodhouse: 'When I am in a room with People . . . the identity of everyone in the room begins to press upon me.' To George and Georgiana he said that his sister Fanny – who was now fifteen years old – has a character which 'is not formed', and that therefore 'her identity does not press upon me as yours does'. These remarks describe a growing sense of claustrophobia – a 'smothering and confinement' as he put it in one of his marginal notes to *Paradise Lost*. It was produced by a conflict between his responsibilities as a brother and his duties to himself, and it meant that when he finally began writing he felt none of the new energy he had stored for so long – only a sense of waste, guilt and desperation. 'Although I had intended to have given some time to study

alone,' he said to Dilke on 21 September, 'I am obliged to write, and plunge into abstract images to ease myself of [Tom's] voice and feebleness – so that I live now in a continual fever – it must be poisonous to life although I feel well.' The next day, writing to Reynolds, he said much the same thing. 'This morning poetry has conquered – I have relapsed into those abstractions which are my only life – I feel escaped from a new strange and threatening sorrow. – And I am thankful for it – there is an awful warmth about my heart like a load of Immortality.'

WHEN KEATS TOLD Reynolds 'poetry has conquered', he associated his 'escape' not just with Tom, but with 'the voice and shape of a woman [who] has haunted me these two days'. This woman was Jane Cox, the niece of Mrs Reynolds, whom he had heard the Reynolds sisters discussing when he had called on them at their home in Little Britain, on the western edge of the City, on 1 September. Her father had worked for the East India Company, and following his early death she had become her grandfather's heir. For some now obscure reason, the old man had quarrelled with her, and Mrs Reynolds had offered her a temporary home. It was a kind gesture, but soon led to difficulties. Jane Cox made the Reynolds sisters feel inferior and therefore resentful. She was prospectively a woman of substance – beautiful and self-assured.

Keats was introduced to Jane Cox on 19 September when he again visited Little Britain. He had returned from Scotland determined to keep women at arm's length; as soon as he saw her, his resistance wavered. If further proof were needed of his inexperience with women, this sudden fascination provides it. At the same time, it shows how thoroughly his feelings about women had changed since his early days in London, when he had treated them with contemptuous flippancy, or misty-eyed adoration. Even though Jane Cox appealed to him as immediately as the unknown 'lady' he had seen in Vauxhall Gardens, he did not respond to her as a sentimentally idealised beauty. He saw her as a complex and particular personality. Writing to George and Georgiana, he criticised the Reynolds sisters for their jealous sniping, then continued:

from what I hear she is not without faults – of a real kind: but she has othe[r]s which are more apt to make women of inferior charms hate her. She is not a Cleopatra; but she is at least a Charmian. She has a rich eastern look; she has fine eyes and fine manners. When she comes into a room she makes an impression the

same as the Beauty of a Leopardess. She is too fine and too conscious of her Self to repulse any Man who may address her – from habit she thinks that nothing *particular*. I always find myself more at ease with such a woman; the picture before me always gives me a life and animation which I cannot possibly feel with anything inferiour – I am at such times too much occupied in admiring to be awkward or on a tremble. I forget myself entirely because I live in her. You will by this time think I am in love with her; so before I go any further I will tell you I am not – she kept me awake one Night as a tune of Mozart's might do – I speak of the thing as a passtime and an amuzement than which I can feel none deeper than a conversation with an imperial woman the very 'yes' and 'no' of whose Lips is to me a Banquet. I don't cry to take the moon home with me in my Pocket no[r] do I fret to leave her behind me. I like her and her like because one has no *sensations* – what we both are is taken for granted – You will suppose I have by this had much talk with her – no such thing – there are the Miss Reynoldses on the look out – They think I dont admire her because I did not stare at her – They call her a flirt to me – What a want of knowledge? she walks across a room in such a manner that a Man is drawn towards her with a magnetic Power. This they call flirting! they do not know things. They do not know what a Woman is. I believe tho' she has faults – the same as Charmian and Cleopatra might have had – Yet she is a fine thing speaking in a worldly way –

'I forget myself entirely because I live in her.' Jane Cox edged Keats further into the selfless but self-filled world of 'Hyperion', where the resourcefulness of the imagination depends on its full possession of negative capability. The brevity of their meeting, her reputation as a flirt, the fact that his brother George and two of his friends (Reynolds and Bailey) were recently engaged: all these things might have persuaded Keats to maintain his fundamental prejudices about women. By 'greeting' Jane Cox in a way which was both sensuously alert yet without '*sensations*', he discovered a rare moment of balance.

Georgiana had obviously set one kind of precedent. Isabella Jones was a more complicated case. By chance, Keats met her again two or three weeks after he was introduced to Jane Cox. It was eighteen months since he had first 'warmed' with Isabella in Bo Peep. This autumn he described their latest encounter to George as another little drama of sexual suspense. Admitting that she had 'always been an enigma to me', he says they bumped into each other when he was walking from Bedford Row to Lamb's Conduit Street, strolled up from Holborn to Islington together, and then turned south to her lodgings in 34 Gloucester Street (now Old Gloucester Street). There, Keats says, in a voice which is humorous and intent, 'our walk ended' – or rather:

– not exactly so for we went up stairs into her sitting room – a very tasty sort of place with Books, Pictures a bronze statue of Buonaparte, Music, aeolian Harp; a Parrot a Linnet – A Case of choice Liquers &c &c. she behaved in the kindest manner – made me take home a Grouse for Tom's dinner – Asked for my address for the purpose of sending more game – As I had warmed with her before and kissed her – I though[t] it would be living backwards not to do so again – she had better taste: she perceived how much a thing of course it was and shrunk from it – not in a prudish way but in as I say a good taste – she cont[r]ived to disappoint me in a way which made me feel more pleasure than a simple kiss could do – she said I should please her much more if I would only press her hand and go away. Whether she was in a different disposition when I saw her before – or whether I have in fancy wrong'd her I cannot tell – I expect to pass some pleasant hours with her now and then: in which I feel I shall be of service to her in matters of knowledge and taste: if I can I will – I have no libidinous thoughts about her – she and your George are the only women à peu près de mon age whom I would be content to know for their mind and friendship alone –

Given what Keats had recently written about Jane Cox, it is surprising her name does not appear alongside Isabella's and Georgiana's. Either Keats had already dismissed her from his mind, or he felt awkward about suddenly showing so much interest in women. Yet even without mentioning her specifically, Keats continued to explore the thoughts she had provoked. His remarks about Isabella confirm that he was finding it easier to appreciate certain women as companions. At the same time, they imply that women whom he regarded as sexually available remained a threat. Cold qualifications dart between the lines of his warm evocations. He still could not imagine falling in love without losing his sense of himself or his purpose. He still supposed that love would be inadequate, if it were born into a life preoccupied with death.

Keats ended his description of Isabella by saying that his thoughts formed 'a barrier to matrimony which I rejoice in'. A few days later he glanced again at his reasons for 'rejoicing' – in an incomplete translation of a sonnet by Ronsard. (Woodhouse had recently lent him Ronsard's poems, but he 'had not the original by [him] when [he] wrote it, and did not recollect the purport of the last [two] lines'.) It is a poem which simultaneously registers the 'beauty' of 'Cassandra', and admits its dangers. When she eventually descends from 'the Heavens' she pours 'her beauty into my warm veins', and fills him with 'only burning pains'.

The form and classical reference of the sonnet, let alone the fact that it

is a translation, give these contradictions a sense of distance. No sooner had Keats abandoned it than his feelings were fanned into more violent life than they ever had been with Jane Cox or Isabella Jones. Tom, growing 'weaker every day', told Keats that he believed the onset of his disease had been caused by his love for 'Amena', the French admirer who had written to him in Teignmouth. Keats reacted angrily, fuming to George that it was a 'wretched business'. Part of him knew that he was overreacting. Another part genuinely believed that matters which he found vexing enough were proving fatal for his brother. In eighteen months' time, when he was in love and dying himself, they haunted him even more painfully. Rather than pouring its 'beauty into my warm veins', 'Love' became a hand begging that 'in my veins red life might stream again'.

TWENTY-SEVEN

SEVERAL TIMES IN the past, Keats had found life becoming especially unstable whenever he wanted to begin a new and significant piece of work. It had happened in Margate when he wrote his Epistles, and on the Isle of Wight when he started *Endymion*. The obstacles to 'Hyperion' had grown in proportion to his expanding hopes for the poem. He had toured Scotland to collect material. He had worked hard to refine his interpretation of poetic identity. He had ranged widely and deeply in a large number of sources, from Dante to Godwin, from Homer to Tooke.[1] In particular, he had saturated himself in Milton, reading and rereading *Paradise Lost* since he had taken it with him to Teignmouth. It was the poem which best illustrated and most sharply focused his own ambition. He soaked up its cadences so that his own style would become more 'naked and grecian'. He also wanted to reflect its political colouring. Milton's epic sweep was exemplary and thrilling: as far as Keats was concerned, every line was dyed with an unfading liberalism.

Keats's early reading had made him familiar with the whole narrative of the Hyperion story; he decided to treat it selectively. Jumping over the war between the old pre-Hellenic gods (the Titans) and their offspring (led by Jupiter) who established the rule of the Olympian gods, and omitting the saga of the failed counter-revolution, he opens his poem at the moment when the Titans are pondering their overthrow. Some

O speak your counsel now, for Saturn's ear
Is all a hunger'd. Thou Oceanus
Ponderest high and deep; and in thy face
I see astonied that severe content
Which comes of thought and musing. Give us help!
So ended Saturn and the God o' the Sea,
Sophist and sage, from no Athenian grove, phrase
But cogitation in his watery watery ~~foam~~
Rose with locks not oozy, and began,
In murmurs, which his first endeavouring tongue
Caught infant-like from the far-foamed sands.
O ye whom wrath consumes whom passion ~~stings~~ sting
~~Shut up your senses~~
Writhe at defeat, and nurse your agonies
Shut up your senses, stifle up your ears,
~~My~~ voice is not a bellows unto ire.
Yet listen ye who will, whilst I bring proof
How ye perforce must be content to stoop:
 will I give
~~Healthy content~~
and in the proof much comfort ~~may be felt~~
If ye will take that comfort in its truth.
We fall by course of Nature's law, not force
Of thunder or of Jove. Great Saturn thou
Hast sifted well the atom-universe;
But for this reason that thou art the King
and ~~being~~ blind from sheer supremacy
One avenue was shaded from thine eyes-
Through which I wandered to eternal truth.
And first, as thou wast not the first of Powers
So art thou not the last; it cannot be:
Thou art not the beginning nor the end.
~~Darkness was first and then a light there was~~;
~~From Chaos came the Heavens and the Earth~~
~~the first grand Powers~~
From Chaos and parental Darkness came
Light, ~~'twas the first~~ of all the first fruits of that intestine broil
That sullen ferment, ~~gained unto the height~~ which for wan years ends

believe they should try to re-establish their supremacy; others, like Oceanus, are philosophical about their downfall. As the debate continues, it builds a huge vaulted argument round the central characters of the poem: Hyperion (the sun-god and the one Titan who is still a ruler), and Apollo (the new god of the sun, music, healing and prophecy). Keats's purpose is self-evident. By lopping off the beginning of the received story, and bringing forward its conclusion, he is able to concentrate on dissolution as well as growth. He shapes his two main figures to reflect elements of himself – Hyperion being the embodiment of his 'old . . . morbid fears and forebodings', and Apollo being his new identity: confident, enlightened, humanist.

He also combines the poem's self-exploration with a more 'disinterested' political and historical theme. This has usually been discussed simply in terms of the shift in power between generations. In Hyperion and the Titans, Keats 'portrays the illness of a whole society that has gone awry',[2] using diverse images of sickness as he contemplates existence with 'a "healthy deliberation" born of philosophical "knowledge" '.[3] The old gods, delivering their speeches in sequence, struggle to accept that their cycle of power has closed. As they describe their own overthrow, they define the superiority of their successor, Apollo. Oceanus, in Book II, says: 'We fall by course of Nature's law, not force / Of thunder, or of Jove', and then reiterates the point, arguing that progression is a perfectly natural thing. He compares himself and his companions to trees in a 'proud forest':

> our fair boughs
> Have bred forth, not pale solitary doves,
> But eagles golden-feathered, who do tower
> Above us in their beauty, and must reign
> In right thereof. For 'tis the eternal law
> That first in beauty should be first in might.

In broad narrative terms, the plan of 'Hyperion' is clear. But as these famous lines indicate, its emotional appeal is often less precise. Critics have debated their meaning since they first appeared in Keats's 1820 volume, usually concluding that by 'beauty' Keats means 'essence' – in much the same way as he does at the end of the 'Ode on a Grecian Urn'. That's to say, Oceanus's speech links the poem's public, revolutionary theme of 'sorrow and disorder'[4] with the more intimate subject of self-

possession. 'Hyperion' is as concerned with the struggle to integrate personality as it is with the operation of power. Saturn and the Titans once symbolised a culture which was personally and socially 'beautiful'; now Saturn, like the outcast King Lear he so often resembles, can only understand his condition in purely personal terms. Replying to Thea early in Book I, he is fretfully introspective. He is a 'Man of Power', overthrown by the Apollonian 'Man of Genius', and his 'strong identity' has been undone by an opposing philosophy of negative capability:

> Who had power
> To make me desolate? whence came the strength?
> How was it nurtured to such bursting forth,
> While Fate seemed strangled in my nervous grasp?
> But it is so; and I am smothered up,
> And buried from all godlike exercise
> Of influence benign on planets pale,
> Of admonitions to the winds and seas,
> Of peaceful sway above man's harvesting,
> And all those acts which Deity supreme
> Doth ease its heart of love in. – I am gone
> Away from my own bosom; I have left
> My strong identity, my real self,
> Somewhere between the throne and where I sit
> Here on this spot of earth.

Because Keats pushes these personal and social themes to the foreground of 'Hyperion', what Hunt called its 'transcendental cosmo-politics' have often been oversimplified or undervalued. The month after starting the poem, Keats told George that 'Politics' were at the present 'only sleepy because they will soon be wide awake', and he found his belief confirmed week by week in the *Examiner*. Logging the details of bankruptcies, clamouring for reform, and railing against unemployment and poverty, Hunt echoed thoughts that had preoccupied Keats during his tour of Scotland, and related them to international issues and figures. To Ferdinand VII of Spain, for instance ('whose name', Shelley said, 'is changed into a proverb of execration'[5]). To the repressive measures of the Holy Alliance in general. To Napoleon – 'whose life was so extraordinary', Hunt said, 'that his death is expected to be miraculous'.[6]

In some respects, 'Hyperion' connects with these contemporary

concerns very directly. It is possible to draw parallels between characters in the poem, and figures on the international stage. But whereas Keats had often been content to let these connections speak for themselves in his earlier poems, or to insist on the need for particular reforms, in 'Hyperion' he develops a philosophy which is at once more complete and less specific. He defines a goal of renovation by promoting 'the disinterested exertions of art'[7] rather than by proposing precise social solutions. In this respect, he complements Shelley, whose *Prometheus Unbound* also argues for the revitalising role of aesthetic creation. His poem is both a gigantic elegy (for the ideal past, for Tom, for all helpless victims) and a hymn to the future. It insists on the need to replace a rigid divine order by a natural and humane dispensation. It proposes that art should influence worldly affairs. It campaigns for the elevation of value over use. Where these thing mingle most closely, in Book I and parts of Book II, they create the poem's greatest strengths: it blends immense moral sympathy with dynamic imaginative and intellectual energy. Even when the intensity slackens in the second half of Book II, and in the unfinished Book III, his purpose remains the same. When Apollo reads the 'silent face' of Mnemosyne immediately before his final transformation, he discovers ideal 'knowledge'. His essential beauty is at once poetic and political, transcendent and familiar:

> Knowledge enormous makes a God of me.
> Names, deeds, grey legends, dire events, rebellions,
> Majesties, sovran voices, agonies,
> Creations and destroyings, all at once
> Pour into the wide hollows of my brain,
> And deify me, as if some blithe wine
> Or bright elixir peerless I had drunk,
> And so become immortal.

By the time Keats wrote this passage, he suspected that he would never complete 'Hyperion'. The argument that he had hoped would sustain him through the whole length of the poem was already fully developed. The language of the last several dozen lines proves the point. It is exhausted because the task Keats had set himself was already finished. When Apollo makes his final speech, the poetry is still articulate, but its argument has too palpable a design on us. In this sense, 'Hyperion' might be described as a fragment within a fragment.

Although Keats came to regret the 'Miltonisms' of the first half of his poem, they had helped to control and pace his language. His descriptions are governed by marvellously extended Miltonic images. His figures have the evocative 'stationing' he admired in *Paradise Lost*. His dramatisation of the contest between Apollo and the fallen gods allows his ideas about progress and evolution to achieve new depth and scope. Writing under conditions of extreme personal difficulty, he magnificently achieves the fresh start he had predicted for himself. He had finally dispensed with Hunt's 'rapid slipper-shuffle', and even outgrown the 'almost jaunty' note of *Endymion* and 'Isabella'.

IN MID-OCTOBER KEATS received his first letter from George and Georgiana, written soon after they had landed in America. He was delighted to read that Georgiana was pregnant; the news that none of his letters had so far reached them gave him 'a great deal of pain'. Throughout the remainder of the month, he replied to them intermittently in a long letter-journal, interrupting his résumé of recent weeks with brief accounts of his unhappiness. At the outset he refers cavalierly to his 'sort of abstract careless and restless Life'. When he mentions Tom his tone darkens, and he warns them they must 'bear up against any Calamity for my sake as I do for your's.' These few phrases give a pitifully clear picture of his mood. Weary and frightened, and clinging to the still healthy members of his family as a refuge from the wider world, he overcomes his usual reluctance to speak openly about his fears. 'Ours are ties,' he says, 'which independent of their own Sentiment are sent us by providence to prevent the deleterious effects of one great, solitary grief. I have Fanny and I have you – three people whose Happiness to me is sacred.'

As usual, Keats links their suffering to the condition of the world at large, struggling to find some comfort. He tells George and Georgiana: 'It does annul that selfish sorrow which I should otherwise fall into, living as I do with poor Tom who looks on me as his only comfort – the tears will come into your Eyes – let them – and embrace each other – thank heaven for what happiness you have and after thinking a moment or two that you suffer in common with all Mankind hold it not a sin to regain your cheerfulness.' Valiantly, he immediately struggles to reinforce his argument, calling Georgiana 'not only a Sister but a glorious human being', and saying that Haslam has been 'a most kind and obliging and constant friend', whose nursing of Tom 'has endeared

[314]

him to me for ever'. The names of other friends then follow in quick succession, Dilke, Reynolds, and Severn among them, before he gives his account of Jane Cox and Isabella Jones. His descriptions of these two women are surrounded and separated by political talk. This begins with a reference to his reviews, spurring him to a celebrated cry of self-confidence – 'I think I shall be among the English Poets after my death' – which indicates how well he understood the nature of their attack. 'It does me not the least harm in Society to make me appear little and r[i]diculous,' he says. 'I know when a Man is superior to me and give him all due respect – he will be the last to laugh at me and as for the rest I feel that I make an impression upon them which insures me personal respect while I am in sight whatever they may say when my back is turned.' These distinctions are a preparation for the more detailed report of contemporary politics that follows his evocation of Jane Cox. (The passage about her is not a digression but an elaboration: she is someone with whom he 'cannot possibly feel . . . inferior'.) This focuses on the comfortable slothfulness of the ruling classes, the ineptitude of the Tory government which has 'nothing manly or sterling in any part', the absence of anyone like 'Milton [or] . . . Algernon Sidney' who is selflessly 'prepared to suffer in obscurity for their country', then rises to two general pronouncements. The first is about the international situation. Keats could not agree with some of his fellow liberals that Napoleon had 'advanced the "life of Liberty"': the worst thing he has done is, that he had taught [the divine right Gentlemen] how to organise their monstrous armies'. The second is about America, which Keats – echoing Robertson again – feels cannot be 'the country to take up the human intellect where [E]ngland leaves off'. Its national heroes (Franklin, Washington) are 'great but they are not sublime Man'.

Keats hopes that one of George and Georgiana's children might compensate for this by becoming 'the first American poet'. He then repeats his wish in the softly jingling lullaby 'Tis "the witching time of night" '. It is a prayer for the future and a transformation of the present – a delicate stretch towards the 'sublime'. Its theme returns at the end of the letter. After reverting to other mutual friends and family members (the Wylies, Haydon, Mr Lewis – a neighbour in Well Walk who regularly gave Tom 'some fruit of the nicer kind'), Keats moves via his account of Isabella Jones to insist 'My Solitude is sublime'. This phrase triggers the extraordinary final section of the letter, in which his dedication to 'The mighty abstract Idea I have of Beauty' mixes with

horror that he might be 'stifled' by 'the more divided and minute domestic happiness'. 'I feel more and more every day,' he says, 'as my imagination strengthens, that I do not live in this world alone but in a thousand worlds.' As Keats expands on this idea, arguing that 'According to [his] state of mind' he is 'with Achilles shouting in the Trenches', or with 'Theocritus in the Vales of Sicily', or with Troilus 'staying for waftage', he becomes more than simply defensive about women. He is actually dismissive of them. 'The generality of women', he says, 'appear to me as children to whom I would rather give a Sugar Plum than my time.'

In the past, Keats's biographers have defended this remark by pointing out that the whole last part of his letter is full of depressed hyperbole. Yet Keats says himself that 'therre is nothing spleenetical in all this': it is a clear statement of belief. Georgiana, Isabella Jones and Jane Cox had in their different ways all helped to complicate and mature his feelings about women; they had done nothing to change his opinion that the 'powers for poetry' were incompatible with marriage and domestic life.

Keats finished this long journal-letter on his twenty-third birthday. It had brought him to yet another vantage point – one from which he could tell how to move forward by looking back. Tom's final illness, the relics of family, the pressure of contemporary politics, his attraction to and worries about women, his Apollonian passion for the 'beautiful': as Keats swerved from subject to subject, striking each into brilliant life, he established links which give him a structure without damaging his spontaneity. He is headlong but carefully self-defining. He writes in a voice of complete naturalness, but is always conscious of the parallel imaginative life where his arguments might be repeated in 'a finer tone'. He is 'nerved' for the next stage of his 'march of passion and endeavour': the 'living year' in which he wrote his most important poetry.

TWENTY-EIGHT

KEATS SPENT TWO and a half weeks amassing his 8,000-word journal to George and Georgiana. It is one of his most profound meditations, and also one of his most sustained. Yet the other demands on his energy were enormous. He sent his sister the 'good news' from America. He spent an evening with Brown (now back from Scotland) and Dilke. He saw

Haydon, Hunt, Rice, and Hessey. He dined with Georgiana's mother and brother Henry. He met Hazlitt and walked with him from Fleet Street to Covent Garden. He quarrelled with Abbey about Fanny's visits to Well Walk and about the amount he had to live on. (On 27 October, Abbey grudgingly dispensed £20.) At the same time, he continued to look after Tom, who could no longer perform even the simplest tasks for himself, and tried to make headway with 'Hyperion'.

Inevitably his work on the poem meant continuing to search for more 'knowledge' in books. Dante and Milton remained the two authors he turned to most often, but he also concentrated on Shakespeare. Reading to himself and Tom from his folio edition, he worked through *King Lear* and *Troilus and Cressida*, adding marginalia as he went, and letting their images and ideas dominate his imagination. In his letter to George, they form an important part of his argument against marriage; in 'Hyperion', elements from Ulysses' famous speech on 'degree' in Act 3 of *Troilus and Cressida* are incorporated into Oceanus's speech to Saturn about evolutionary progress.[1]

As always, Shakespeare affected Keats's thinking about poetry as deeply as it did the contents of his poems themselves. The remarks he had made to George about 'the principle of Beauty' are one sign of this. Others appear in his dealings with Woodhouse. On 21 October, the assiduous lawyer-reader wrote to console Keats for his reviews. Two days later Woodhouse contacted his cousin Mary Frogley, whom Keats had first met with Mathew in 1816, and who may have been what Gittings calls 'an old flame'. She had read and admired *Endymion*, but had recently found herself 'in a company' where Keats needed defending, and had written to Woodhouse saying that she missed his advocacy. His reply was heated by friendship, and taut with the arguments of 'a deliberate opinion':

– In all places, & at all times, & before all persons, I would express, and as far as I am able, support, my high opinion of his poetical merits – Such a genius, I verily believe, has not appeared since Shakespeare & Milton: and I may assert without fear of contradiction from any one competent to Judge, that if his Endymion be compared with Shakespeare's earliest work (his Venus & Adonis) written about the same age, Keats's poem will be found to contain more beauties, more poetry (and that of a higher order) less conceit & bad taste and in a word more promise of excellence than are to be found in Shakespeare's work –

Although Keats never saw this heart-warming letter, he valued the

support that Woodhouse gave him directly. Replying to his friend on 27 October, he was anxious to correct any false impressions which might have been given by his recent 'rhodomontade' at dinner with Hessey, and to reassure Woodhouse of his 'great satisfaction' at his 'friendliness'. Sentence by sentence, he winnows the ingredients of his journal to George, which was written concurrently:

As to the poetical Character itself (I mean that sort of which, if I am anything, I am a Member; that sort distinguished from the wordsworthian or egotistical sublime; which is a thing per se and stands alone) it is not itself – it has no self – it is every thing and nothing – It has no character – it enjoys light and shade; it lives in gusto, be it foul or fair, high or low, rich or poor, mean or elevated – It has as much delight in conceiving an Iago as an Imogen. What shocks the virtuous philosop[h]er, delights the c[h]amel[e]on Poet. It does no harm from its relish of the dark side of things any more than from its taste for the bright one; because they both end in speculation. A Poet is the most unpoetical of any thing in existence; because he has no Identity – he is continually in[forming] – and filling some other Body – The Sun, the Moon, the Sea and Men and Women who are creatures of impulse are poetical and have about them an unchangable attribute – the poet has none; no identity – he is certainly the most unpoetical of all God's Creatures. If then he has no self, and if I am a Poet, where is the Wonder that I should say I would write no more? Might I not at that very instant [have] been cogitating on the Characters of saturn and Ops? It is a wretched thing to confess; but is a very fact that not one word I ever utter can be taken for granted as an opinion growing out of my identical nature – how can it, when I have no nature? When I am in a room with People if I ever am free from speculating on creations of my own brain, then not myself goes home to myself: but the identity of everyone in the room begins [so] to press upon me that, I am in a very little time an[ni]hilated – not only among Men; it would be the same in a Nursery of children: I know not whether I make myself wholly understood: I hope enough so to let you see that no dependence is to be placed on what I said that day.

Woodhouse immediately realised the significance of what he had received, and copied it into his Keats 'letter book'. Subsequent Keatsians have shared his view. They have also celebrated the following and final paragraph of the letter, though not always with a sense of how it related to its predecessors:

In the second place I will speak of my views, and of the life I purpose to myself – I am ambitious of doing the world some good: if I should be spared that may be the work of maturer years – in the interval I will assay to reach to as high a summit in Poetry as the nerve bestowed upon me will suffer. The faint

conceptions I have of Poems to come brings the blood frequently into my forehead – All I hope is that I may not lose all interest in human affairs – that the solitary indifference I feel for applause even from the finest Spirits, will not blunt any acuteness of vision I may have. I do not think it will – I feel assured I should write from the mere yearning and fondness I have for the Beautiful even if my night's labours should be burnt every morning and no eye ever shine upon them.

This is a complex passage. By insisting on his 'solitary indifference' to 'applause even from the finest Spirits' Keats wants to define his poetic integrity. He cannot help revealing his wounded feelings. Rejected by the critics, he promotes his 'fondness' for 'the Beautiful' to the point at which he realises that he may be tempted to 'lose all interest in human affairs'. Such phrases have often been cited by readers who want to deny that Keats engaged with the life of his times. Or to argue that while Keats may not have been fatally injured by his reviewers, he moderated his opinions in his later work. Even one of his shrewdest historicising critics has said 'The whole point of Keats's great and (politically) reactionary [1820 volume] was not to enlist poetry in the service of social and political causes – which is what Byron and Shelley were doing – but to dissolve social and political conflicts in the mediations of art and beauty.'[2]

This judgement leads to the heart of questions about Keats's politics, and about his poetic development. In his early work, Keats sympathises openly with radical causes. Questioning ideas of legitimacy, scorning absolute monarchs, praising liberal heroes, redefining patriotism, exploring a notion of power which is based on community and loving-kindness, he advances arguments which are supported by the structure and language of his poetry. He rejects the orthodoxy of closed forms, he is deliberately 'excessive' in his sensuality, and he is seditiously 'suburban' in his treatment of nature. When his first two books were attacked, he undoubtedly felt that his existence as a writer was more seriously jeopardised than Byron or Shelley did when they were vilified. Without the security of their aristocratic background, he reacted in a way which more nearly aligns him with Hazlitt, who felt that the assaults of *Blackwood's* threatened his entire livelihood.

It is hardly surprising, therefore, that he should have listened carefully to those friends – including Woodhouse, Taylor and Hessey – who told him to calm things down once *Endymion* had been published. However, the changes in his work were not simply the result of political

[319]

and commercial expediency. It is possible that he thought the recent polemical work of Hunt, Shelley and Byron represented a form of social criticism which had run its course: urgent as it was, it repetitively denounced the opposition while insisting on its own superior values.

If Keats had felt this, he would once again have shared Hazlitt's views. When Hazlitt collected his political writings in 1819, just before the Peterloo Massacre, he wrote a Preface which defined his beliefs in a way which is at once defiant and valedictory.[3] Furthermore, the evolution of Keats's poetic 'axioms' had persuaded him to look for ways of diversifying himself into his subjects more generally. (His dislike of being associated with Hunt, his reservations about Shelley, and his growing antipathy to Byron undoubtedly accelerated his thinking.) By exploring the opportunities of 'the drama', he intensified the intimacy of his work and broadened its scope. He did not 'dissolve social and political conflicts in the mediations of art and beauty', but made the arguments part of the mediations. While curbing the excess of his 'luxury', he remained resolutely 'pagan', as the voluptuousness of 'The Eve of St Agnes' demonstrates. While declining to mention particular contemporary events, he criticised financial dependencies (in 'Isabella', 'Lamia') and orthodox codes of power (in 'Hyperion'). While exploring the temptation to escape time and its ravages (in the odes), he registered the weight of history, reporting on its unavoidable cruelties and appealing to a more exalted idea of order.

Woodhouse understood how Keats's politics survived in his mature poems. Soon after hearing from him, he drafted a letter to Taylor which proves this. By referring to 'annihilation' and 'Essences' he invokes the spirit of Shakespeare, whom he says distils 'the very idea of a poet' for Keats. (He wittily glosses this by saying that Keats 'has affirmed that he can conceive of a billiard Ball that it may have a sense of delight from its own roundness, smoothness[,] volubility & the rapidity of its motion'.) By mentioning Byron's self-absorbed sensualities, he describes a type of writing which depends too much on 'identity'. It is an antithesis which summarises everything Keats had recently discussed, and which shows how fast and far his thinking had developed since leaving for Scotland at the beginning of the summer. It confirms that 'the chameleon poet' was still intent on 'doing the world some good'.

As the balance of Keats's poetical mind became more poised, the conditions of his daily life worsened steadily. He was desperate for

Fanny to visit Tom, and by 5 November had visited Abbey three times in as many weeks to get permission. He found his duties as a nurse increasingly upsetting. He was frustrated by his inability to see friends. A surprise gift of £25 from a 'P. Fenbank' of Teignmouth touched and embarrassed him, but could do nothing to quicken his progress with 'Hyperion', of which he was now producing only about ten lines a day.[4]

It was a desolate time, and took a heavy toll on him. When friends such as Rice and Severn visited, they found him withdrawn and fatigued. Haslam was particularly worried, and agreed with the others that Keats's writing, which generally helped to 'relieve' him, was now making him 'feverish'. Complaining bitterly about the interruptions to his poem, Keats spoke at one moment of beginning a 'tale in prose', and at another of writing more occasional pieces. The prose was never begun, but the short poems came comparatively easily – four of them in quick succession: 'Welcome joy and welcome sorrow', 'Song' ('Spirit here that reignest'), 'Where's the Poet', and a fragment called 'The Castle Builder'. They were hardly distractions. The first three all find ways of investigating how pleasure combines with pain, and also give a miniature summary of his thoughts about the poetic character. The poet, he says, is 'the man who with a man / Is an equal, be he king, / Or poorest of the beggar-clan'.

'The Castle Builder', as a satire on opportunists who promote temporary fashions, is neither sharp nor finished enough to fulfil its purpose – which is to criticise stock romantic attitudes. As a piece of inadvertent self-revelation it is fascinating. Keats dissolves himself in its other existence as a relief from watching Tom die, in much the same spirit that he worked on another unfinished satire, 'The Cap and Bells', at the end of his own life. At the same time, he relishes and recasts several of the details he had recently noticed on his visit to Isabella Jones's rooms in Holborn. In other words, the poem catches him at a moment of ambivalence, half inside the world, half outside it. Another short poem written at the same time, 'And what is love?', contains the same mixture. It repudiates love as a 'doll dressed up', but cannot help admitting it is the source of 'agony'. Why was Keats raking over his worries about love when his daily existence was filled with thoughts of death? Did his long watch at Tom's deathbed remind him of similar scenes he had suffered with his mother eight years previously? The parallels were impossible to ignore, making him especially vulnerable to the idea that if he now allowed another woman into his life, she might also leave him. Writing

this clutch of short lyrics, erecting what he called theoretical 'barriers to matrimony', and insisting that his love for his brothers was 'passing the love of women', he was protecting himself against women and also, unconsciously, engaging in a kind of preparation.

His recently finished letter to George and Georgiana confirms this. He had written about Jane Cox, whose oriental beauty had challenged the promises he had made to himself in Scotland. He had discussed Isabella Jones, whose re-emergence in his life was inseparable from his most profound period of self-definition as a poet. He had addressed his sister-in-law Georgiana with frank fondness. Of the three, Isabella Jones has been given most credit by Gittings for forcing his thoughts to a crisis. He calls her 'a visitant from another world', an ideally 'fit subject for poetry', and interprets the few details of their relationship as evidence of a love affair which lasted through the winter of 1818 until March of the following year. It is a conjecture which cannot be supported by fact. We know they often met during this time; we know Keats found her attractive, and we know she suggested he write 'The Eve of St Agnes' and 'The Eve of St Mark'. To argue for a greater intimacy is to indulge in a wishful fantasy – and also muddles the history of the sonnet 'Bright Star'. Pointing to the poem's echoes of *Troilus and Cressida*, and emphasising that it 'chimes with much in "Hyperion" and in Keats's poetic thought at the time',[5] Gittings at first suggested that it was written this October and was inspired by Isabella Jones. Eventually his ideas changed. He accepted the authenticity of a transcript that Brown made of the poem and dated '1819', allowed that it could have been written 'at almost any time between now [October] and April [1819]', and agreed that it must also have something to do with Keats's later and much more celebrated love affair with Fanny Brawne. 'It is probably nearest the truth', he says cautiously, 'to regard the sonnet as addressed not specifically to one or the other, but as a summing-up of [his] conflicting thoughts . . . on the claims of life and love on the poet's being.'[6]

Even this more flexible argument is flawed. The literary echoes that Gittings discovers are not nearly as definite as he suggests. 'Out of some thirty parallels, all told, which [he] finds between ["Bright Star"], "Hyperion", *Troilus and Cressida* and Keats's letters of October 1818, only eight [establish] links between the sonnet and its supposed sources.' Of these eight, five also appear 'at many other points' in his work, and the remaining three 'may be found – if they must be found somewhere – in a

passage from the second Book of *Endymion*'.[7] Other echoes, in fact, lead us to connect the poem with quite different periods of Keats's life. There are two alternatives. The first links the poem to July 1819, when Keats tells Fanny Brawne that he 'will imagine you Venus tonight and pray, pray, pray to your star like a Heathen. Your's ever, fair Star.' This is suggestive but inconclusive: Keats is talking about the North Star, not Venus the evening star. The second takes us to October/November 1819, when Fanny Brawne transcribed 'Bright Star' in the copy of Cary's translation of Dante which Keats had given her, and when Keats also wrote other poems to her which in form ('The day is gone . . .') and tone ('I cry your mercy . . .') resemble 'Bright Star'. This means that much of what Gittings says about the poem is hard to credit. All the same, his conjectures do have a general value. They recognise the strong association between love and death which existed in Keats's mind as he nursed his brother. They emphasise genuine uncertainties about the precise nature of his relationship with Isabella Jones. And they rightly suggest that while we can speak with authority about Keats's feelings for Fanny Brawne, we do not know exactly how and when they met.

FANNY BRAWNE'S OWN account of her first meeting with Keats was given twenty years after it had taken place, and is muddled. However, she implies that it happened after Brown had come back from Scotland, when her family had left Wentworth Place and rented Elm Cottage, which stood near by at the corner of Red Lion Hill and Downshire Hill. (She mentions visiting 'the house of a mutual friend, not Leigh Hunt's'.) She indicates that Tom, though seriously ill, was still alive. Keats's conversation, she says, 'was in the highest degree interesting, and his spirits good, excepting at moments when anxiety regarding his brother's health dejected them'. This suggests November. It also makes clear that although Keats would soon call Fanny a 'Minx' and christen her 'Millamant' (he was thinking of the heroine of Congreve's *The Way of the World*), he at least began their life together by talking to her seriously. He was drawn to her by her first name – which was his mother's and his sister's – and by certain similarities in their backgrounds.

Samuel and Frances Brawne had lived at a number of addresses in and around the north of London since the end of the eighteenth century. Fanny had been born on 9 August 1800 in the hamlet of West End, near Hampstead, and in 1810 (by which time she had a six-year-old brother Sam, and an infant sister Margaret) she was in Kentish Town. This same

year her father had died, and Mrs Brawne had taken her children to a new home near Hampstead Heath – liking the area for the same sorts of reasons as Keats did. It was healthy, and suited her station in life. Fanny's paternal grandfather, like Keats's, had been a stable-keeper; he owned an inn off the Strand called the Coach and Horses, and had property out of London at Twyford, and a small agricultural business in Kilburn. John and Alice Jennings had died believing their descendants would be able to invent their lives as they chose. So did grandfather Brawne – and his confidence proved just as unfounded. Only one of Samuel Brawne's relatives achieved any kind of eminence: George ('Beau') Brummell was the son of one of his grandfather's sisters. The rest, like Samuel himself, swayed on the edge of polite society. He was, a contemporary said, a businessman of 'no commercial reputation', and died leaving debts which his executors were instructed to pay off from Fanny's legacy at the rate of £50 a year. The money which had come to the family through Mrs Brawne's connections was only a little more secure. Her parents had been West Indian administrators and City merchants, and when her brother John (Ricketts) had died in 1816, her legacy was modest.

Fanny and her family had other reasons for feeling precarious. A second sister, Jane, and a second brother, John, had both died in infancy, and her father had died of consumption – the same disease that struck down her aunt and, eventually, her brother. Even if she and Keats were not immediately magnetised, they would certainly have recognised one another. They were linked by a shared sense of family suffering, and by similar kinds of social and financial insecurities. Only because it was larger and predominantly female did her family seem unlike Keats's; and in these differences it was a perfect complement.

WHEN FANNY FIRST met Keats she was unformed, frisky, and quick-tongued: conventional in her tastes; vehement in her enjoyments. She spoke and read French as well as German, and although 'by no means a great poetry reader',[8] was a passionate admirer of Shakespeare and Byron, and had a voracious appetite for 'trumpery' novels. Her conversation was 'animated, lively, and even witty', and she was 'wont to discuss' politics 'with fire and animation', not only with her English neighbours, but with the French exiles who had clustered round Orel House in Hampstead during and after the French Revolution. In so far as her gender and class allowed her to feel a part of the wide world, she

engaged with it energetically: in later life she published in *Blackwood's*, when its Tory rage had faded, and also translated German fiction. Her sense of humour was sharp (she once said men were 'so stupid' they could not even be trusted to post a letter); she loved card-playing, dressmaking and dancing; and she was a diligent student of fashion.

Fanny was pretty rather than beautiful. She had delicately pale skin, blue eyes, and dark brown hair which she sometimes wore piled on top of her head (as in the silhouette of 1829) and sometimes gathered in plaits over her ears (as in the miniature of 1833). In later years, she became exotically continental-looking. In the one surviving ambrotype we have of her, dating from the 1850s, she sits with one half-closed hand raised to her chin. Her dark hair is pulled back in a heavy swag, her face full, her expression dreamy. Even though Keats had been dead for thirty-odd years when the picture was taken, we can still catch a glimpse of the woman he saw: someone who in her youth was slight but sensuous (Severn said that she looked like the draped figure in Titian's 'Sacred and Profane Love' in the Borghese Palace in Rome); another contemporary described her as 'not conventionally good-looking but . . . everything that is meant by the word unusual'. Nine months after first meeting her, when writing *Otho the Great*, Keats himself confirmed just how 'unusual':

> Deep blue eyes, semi-shaded in white lids,
> Finished with lashes fine for more soft shade,
> Completed by her twin-arched ebon brows;
> White temples of exactest elegance,
> Of even mould felicitous and smooth;
> Cheeks fashion'd tenderly on either side,
> So perfect, so divine that our poor eyes
> Are dazzled with the sweet proportioning,
> And wonder that 'tis so – the magic chance!
> Her nostrils, small, fragrant, faery-delicate;
> Her lips – I swear no human bones e'er wore
> So taking a disguise . . .

When Keats first mentioned Fanny, in another long letter to George which he began writing on 16 December, he took trouble to seem unimpressed. He starts by briskly dismissing one of her friends, a Miss Robinson whom he reckoned was 'a downright Miss', and whom he

'drove away' by 'behaving badly'. Then he says Fanny is 'about my height' so that he can cut her down to size:

– Shall I give you Miss Brawne[e]? She is about my height – with a fine style of countenance of the lengthen'd sort – she wants sentiment in every feature – she manages to make her hair look well – her nostrills are fine – though a little painful – he[r] mouth is bad and good – he[r] Profil is better than her full-face which indeed is not full [b]ut pale and thin without showing any bone – Her shape is very graceful and so are her movements – her Arms are good her hands badish – her feet tolerable – she is not seventeen [in fact she was eighteen and five months] – but she is ignorant – monstrous in her behaviour flying out in all directions, calling people such names – that I was forced lately to make use of the term *Minx* – this is I think no[t] from any innate vice but from a penchant she has for acting stylishly. I am however tired of such style and shall decline any more of it –

Keats is protesting too much here. For the past several years, and especially in the last few months, he had spoken about love to his brother and friends like the young Benedick – congratulating them politely on their marriages and engagements while insisting on his own freedom. What would they think if he suddenly contradicted himself? In the months ahead, he continued to guard his feelings very closely: even when sailing to Italy with Severn at the end of his life, he said nothing which suggested that he had 'more than a common acquaintance with this lady'.[9] His reticence was more than a defence against mockery. It was also designed to prevent anyone around him feeling jealous. Although some of his friends reacted kindly to Fanny – Haslam, for instance, said that she showed Keats a 'kindness that cannot be described' – others saw her as a threat. Reynolds referred to her later as the 'poor idle Thing of womankind to whom [Keats] has so unaccountably attached himself', and Brown had to be ordered by Keats to treat her well. Never mind that others had already formed attachments elsewhere. Because Keats was generally thought to be the most gifted of his 'set', his change of heart inevitably raised difficult questions. How could he love Fanny without compromising his genius? How could he avoid breaking the framework of his old loyalties?

Even if keats had wanted to, he had no time to begin courting Fanny immediately. Throughout November 1818, Tom slipped steadily further into weakness and misery. He coughed blood repeatedly; he deliriously confused day with night; he asked to see his sister and was denied by Abbey. Keats knew this final stage of the illness could not last long. He sometimes sent brief reports to his sister and friends, optimistically recording any slight improvement; more often, he traced the sad curve of an inevitable decline. 'I cannot give any good news of Tom', he told Rice on 24 November, six days after Tom had passed his nineteenth birthday. His nursing kept him so busy, and so distressed, that he was incapable of replying in person to the 'kindness' of a Hampstead neighbour, a Mrs Davenport, and sent a formal note of thanks instead. At the end of the month things were so bad that when his sister at last received permission from Abbey to visit, on 30 November, he put her off. He knew it would upset her too much, and agonise Tom. Keats wrote her a note warning that their brother was 'in a dangerous state', and asked her pathetically to 'keep up your spirits for me'.

The next morning, 'early', Keats left Well Walk, made his way downhill to Wentworth Place, let himself into Brown's half of the house, and woke his friend by taking hold of his hand. He told him that Tom had died at eight o'clock, 'quietly & without pain'. Brown immediately took charge, writing to Woodhouse and others to break the news. He realised that Keats was not simply heart-stricken and worn out, but scared. 'Popular belief' of the time held that 'anyone who spent long hours in the room of a dying consumptive was liable to be attacked by the same disease'.[1]

There were other worries too. Where was Keats to live? The lodgings in Well Walk were larger than he now needed, were full of dismal associations, and cost more than he could afford. Moreover, he could not imagine tolerating the interruptions of the Bentley family in the future. Once again, Brown was resourceful: he invited Keats to move into Wentworth Place and share his half of the house. The suggestion was not entirely altruistic. Although Brown is generally described as a 'gentleman of property and leisure',[2] he had only felt comparatively secure since inheriting 'Legacies' from his brother James in 1815, and was still keen to supplement his income whenever possible. He asked Keats to

pay him £5 a month for his board, and said that he would keep 'a running account' of other expenses. Part of this survives, suggestively detailing '*Examiners* £20.10.0d. Half Wine and Spirits bill – £5.9s.6d. boot-makers bill £3.6s.6d.'

Dilke had described the two halves of Wentworth Place as mere 'cottages' when they were first built. This was modest. Keats and Brown had a bedroom each on the first floor (Keats's faced away from the Heath), two sitting rooms-cum-studies on the ground floor, and a wine cellar and kitchen, where the maid slept, in the basement. It was a compact, pretty, white-painted house. The tall ground-floor windows looked across a well-tended garden which contained a plum tree as well as a mulberry tree, and was separated from the lane by a hedge of laurustinus. Beyond the lane, along which water ran in a brick conduit, two other houses were being built, so slowly that Keats later said they seemed to be 'dying of old age before they were brought up'. Like Wentworth Place itself, they were a sign of the rising popularity of the area. Outlined against the Heath, they described a Londoner's dream of the country, the 'Cockney poets'' Arcadia.

Keats and Brown lived together for seventeen months, and they soon found a way of combining quiet domesticity with 'cheerful' visiting around their 'set'. 'They disliked being outpunned at Novello's, agreed on Miss Robinson's ugliness, were bored by Davenport's chatter, cursed like Mandeville and Lisle over the stoppage of mail, and damned parsons. They played cards, held claret feasts, railed at one another [or at least Keats railed at Brown when he seduced the maid] over making "more feet for little stockings", engaged in drawing contests, wrote Spenserian stanzas against one another . . ., attended the theatre, read together, and often sat opposite one another all day "authorising".'[3] Initially, however, such cheerful closeness was impossible. In the week between Tom's death and his burial in the Keats family church of St Stephen's, Coleman Street, on 7 December, Keats remained in the desolate silence of Well Walk. His brother had filled a large part of his world and he missed him terribly. Everything Keats held valuable had turned out to be useless. His medical expertise had been of no avail. The 'healing' role he described for poetry had made no difference. The fact that he had 'scarce a doubt of immortality of some nature o[r] other' brought him little comfort. In his misery, he could not even bring himself to contact George, but asked Haslam to write instead. In a life full of reticence about strong feelings, this was his most resonant silence.

[328]

Once the funeral was over, he worked hard to recover his old vivacious self. 'I have been everywhere,' he announced ten days later. He saw his sister with Mrs Dilke, and did whatever he could to comfort her. He called on the Reynoldses, who invited him to spend Christmas with them. He visited Haydon, who tactlessly badgered him for a loan. He even saw Hunt, and was predictably disappointed. After a joint visit to the Novellos Keats pronounced Hunt 'disgusting in matters of taste and of morals', and when he received Hunt's recently published *Literary Pocket Book* he said it was 'full of the most sickening stuff you can imagine'. With Dilke, he spent some time shooting blue tits in the garden of Wentworth Place. With other friends he went to see Kean in a new tragedy at Covent Garden. With yet others he travelled down to Crawley Hunt in Sussex, to watch two famous boxers, Randall and Taylor, slog their way through a thirty-four-round bare-knuckle contest.

Keats was trying to distance himself from his grief, and also to seal it inside himself, in the same way that he had done after saying goodbye to George, and would eventually do again with Fanny Brawne. By the end of the year, when he had begun living more calmly again, he realised that his exertions had only had a temporary effect. For the remainder of his life, he continued to value his friends highly and to see them often, but his contact with them became less exuberant, and he was more willing to admit to feeling anti-social. He also became noticeably more interested in philosophising his experience, not so much to create theories which explain his practice as a poet, as to make sense of ill health and suffering. The twenty-six months that remained to him, even those in which he was not knowingly ill, are strikingly darker and more isolated. His 'living year' was sustained by an unshakeable preoccupation with death.

IN THE COMPARATIVE peace of his new home, Keats tried to free himself as he had often done before, by writing shorter pieces which might build his confidence. The result was two 'specimens of a sort of rondeau': 'Fancy', and 'Bards of Passion and of Mirth'. The first, written as he glanced into the cold garden of Wentworth Place, argues that 'Fancy' improves on reality: 'She will bring, in spite of frost, / Beauties that the earth hath lost'. The latter, expanding on the theme of 'Lines on the Mermaid Tavern', reverts to the 'favourite Speculations' he had mentioned to Bailey a year earlier, when he had said that 'we shall

enjoy ourselves here after by having what we call happiness on Earth
repeated in a finer tone':

> Thus ye live on high, and then
> On the earth ye live again;
> And the souls ye left behind you
> Teach us, here, the way to find you,
> Where your other souls are joying,
> Never slumbered, never cloying.
> Here, your earth-born souls still speak
> To mortals, of their little week;
> Of their sorrows and delights;
> Of their passions and their spites;
> Of their glory and their shame;
> What doth strengthen and what maim.
> Thus ye teach us, every day,
> Wisdom, though fled far away.

In their complementary ways, both poems respond to Tom's death by
implying that Keats wished his work to be an active manipulation of
experience rather than merely a convulsive reaction to it. 'Hyperion'
stubbornly refused to prove his point. The Miltonisms which had
energised Book I had begun to pall in Book II.[4] When he finally started
Book III they congested individual lines, and weakened his narrative. In
fact Keats abandoned his story altogether when he eventually reached
the final, unfinished section of the poem early the following year. He
compressed the evolution of Apollo into a few sentences, and decorated
them with language which is reminiscent of *Endymion*:

> Soon wild commotions shook him, and made flush
> All the immortal fairness of his limbs –
> Most like the struggle at the gate of death;
> Or liker still to one who should take leave
> Of pale immortal death, and with a pang
> As hot as death's is chill, with fierce convulse
> Die into life: so young Apollo anguished.
> His very hair, his golden tresses famed
> Kept undulation round his eager neck.

As Keats grieved for Tom, he worried about his own health. By the

third week of December he had developed a bad cold, and when this cleared up his throat remained painfully sore. He had originally planned to accompany Brown to Chichester for the new year, and to stay there with the Snook family, but decided that this would be impossible. Perhaps, he told Brown, his solitude would at last allow him to make definite progress with 'Hyperion'. It was a forlorn hope. Adding odd lines and paragraphs to his manuscript, he knew that his poem belonged to a different era of his existence. Occasionally his confidence surged back, as when he told Woodhouse of his wish to treat 'the dethronement of Hyperion, the former god of the sun, by Apollo – and incidentally of those of Oceanus by Neptune, of Saturn by Jupiter, etc., and of the war of the Giants for Saturn's re-establishment – with other events, of which we have but very dark hints in the mythological poets of Greece and Rome'. Even this apparently sensible scheme was unrealistic. Keats had already modified its details in the Books he had written since the previous November. In mid-April, when he finally set aside the poem for what he supposed was the last time, he felt full of disappointment.

Other short poems, also written in mid-December, lie around the monumental ruin of his hopes. One is an apparently straightforward 'Song' ('I had a dove'), which Keats described as 'a little thing I wrote off to some Music as it was playing'. (It was probably done when he was listening to Charlotte Reynolds at the piano.[5]) Its innocence is complicated by its associations. As a 'sweetly' plaintive elegy, it provides a certain release for Keats's feelings about Tom, whose 'last days', he now told George, 'were of the most distressing nature', even though 'his last moments were not so painful, and his last was without a pang'. Referring to 'green trees', the poem laments the destruction of the ideal life he had already mourned in 'Robin Hood'. Questioning the purpose of grief, it presents a version of the question Apollo seeks to answer in 'Hyperion':

> I had a dove and the sweet dove died;
> And I have thought it died of grieving.
> O, what could it grieve for? Its feet were tied,
> With a silken thread of my own hand's weaving.
> Sweet little red feet! why would you die –
> Why should you leave me, sweet bird! why?
> You lived alone on the forest-tree,
> Why, pretty thing, could you not live with me?

I kissed you oft and gave you white peas;
Why not live sweetly, as in the green trees?

The second 'Song' Keats wrote in December, 'Hush, hush! tread softly!', contains ambiguities of a different kind. Once again, it is linked to Charlotte Reynolds, who reported that 'It was to a Spanish song that the song . . . was composed', and once again it contains little echoes of 'Hyperion'. In the second verse, for instance, which remembers the opening lines of his epic: 'No leaf doth tremble, no ripple is there / On the river – all's still, and the night's sleepy eye / Closes up, and forgets all its Lethean care, / Charmed to death by the drone of the humming mayfly'. These parallels give the 'Song' a surprising gravity, without compromising the simplicity of its subject. Such obscurities as the poem contains are not thematic; they are contextual. Gittings, keen to find evidence for Keats's continuing affair with Isabella Jones, points out the reference to 'sweet Isabel', and to the 'jealous old bald-pate' (her possessive sugar daddy O'Callaghan) and so turns the poem into a playful love lyric. As always when discussing Isabella, he overstates the case. Although the references cannot be denied, they do less to suggest that Keats is proving his loyalty to one woman than weaving his way among several. Fanny Brawne copied out the poem within a month of its composition (on 21 January 1819), a task which Keats would hardly have encouraged if he had intended the poem for someone else. The association with Charlotte Reynolds has a similarly diffusing effect. Even allowing for the irritation which Keats now sometimes felt with her and her sisters ('Ennui always seizes me' at Little Britain, he said in December), and for their ignorance of his feelings for Isabella, it would have been out of character for him to exploit his 'spleen' so deliberately. While the 'Song' obviously enjoys playing with the idea of Isabella, and admits to finding her sexy ('I kiss to the melody, aching all through') it keeps its options open. It is as much a poem about coming back to life as it is about love.

Shortly before Christmas, Bentley delivered Keats's books from Well Walk, staggering down the hill to Wentworth Place with the volumes piled in a laundry basket. It was the signal for Keats to stop looking for diversions. He told George that he suddenly felt 'smothered' – frustrated by his stop-starts with 'Hyperion', dissatisfied with his short lyrics, and fed up with 'traipsing'. He was 'completely tired' of Hunt (who 'does one harm by making fine things pretty and beautiful things hateful'), and had

turned down a chance to meet Jane Porter, an admirer of *Endymion* who was known to Woodhouse through Mary Frogley. He added that if the 'beautiful and elegant, graceful, silly, fashionable and strange' Fanny Brawne had not recently 'behave[d] a little better', he would have 'sheered off' from her as well.

Once again, he found that his wishes were not his to command. He had his sister to consider. (He would visit her three times in ten days during her Christmas holidays with the Abbeys in Walthamstow.) He had to deal with a painter called Archibald Archer, who had figured in the Mathew set, recently jilted Caroline Mathew, and 'pestered Keats more than once in Wentworth Place, ostensibly with some business concerning Haydon'.[6] In his latest, steadily expanding letter to George, he worried how he might make more money by writing.

His concern was not shared by his friends. Most of them assumed that Tom's funds would leave him comfortable for the foreseeable future. Until recently, Keats himself had shared their confidence. He had told Haydon that he would soon be sufficiently well off to do nothing but travel and study for the next three or four years. When the importunate painter stepped up his demands for a loan, Keats uncomplainingly went to see Abbey, found the office closed, and borrowed £30 from Taylor instead. But as the year drew to a close, he discovered that he had no grounds for optimism. His only resources were those his grandmother had left him. When he had first worked out what would come to him from Tom's share, he had mistaken capital for cash; now he discovered that he was entitled to some £550, rather than the £700 he had originally expected. It would not be enough to finance the life he imagined, especially after the slump of 1819 had reduced it still further. (His Chancery fund contained over £800 'and considerable interest',[7] but he still had no knowledge of its existence.)

Keats tried to play down his disappointment to George, but he could not shake it off. He had begun 1818 with a definite circle of friends, an about to be published poem he hoped would make his name, one brother at his side and another he still expected to recover. He ended it 'in too huge a Mind for study', exasperated with Hunt and Haydon, peeved by the Reynolds sisters, spurned by reviewers, financially unstable, grieving for Tom, missing George, and with his own health uncertain. Month by month, the year had brought a desolate sequence of failures and deprivations. Yet it had created opportunities as well. The lectures given by Hazlitt had stimulated new ideas and developed existing

theories. The tour of Scotland, while it exhausted him, had filled him with images and ambitions for future work. 'Hyperion' was stalling, but it contained several hundred lines of the best work he had produced. He had met Fanny Brawne, the person who would soon mean more to him than anyone else, and who would focus his troubled reflections on women and marriage. It had been a destructive but also a vitally cohesive time.

THIRTY

As CHRISTMAS APPROACHED, Keats was still suffering from the sore throat which had prevented him from leaving with Brown for Chichester. His friends surrounded him with offers. Mrs Reynolds had already asked him to spend the holiday with her family, but his feelings for her daughters were now so ticklish that he decided to accept a rival invitation – from Mrs Brawne, in Elm Cottage. The decision led to considerable difficulties, as well as great pleasure. The Reynolds sisters felt snubbed, and like their mother became scathing about Fanny Brawne. Fanny herself remembered this Christmas as 'the happiest day I had ever then spent'. This does not mean that she and Keats now became secretly engaged. But it indicates that Keats had already revised his first impressions of her. We do not know what they said to each other. Neither do we know what presents they exchanged – though immediately after Christmas Keats began sealing his letters with a 'Tassie gem' engraved with a Greek lyre which has half its strings broken, and is circled by the motto 'Qui me néglige me désole'. If this was given to him by Fanny, he soon responded with a gift of his own: a copy of Hunt's *Literary Pocket Book*. He had disparaged it to others, but it contained the only examples of his own poetry that he had printed since *Endymion*.

Writing to George, Keats insisted that his meetings with Fanny still amounted to no more than 'a chat and a tiff', and only inadvertently implied that this might not be the whole truth. 'I never forgot you,' he wrote, 'except after seeing now and then some beautiful woman.' It was a half-admission which he then disguised still further by launching into an attack on Mary Tighe, 'who once delighted me', and by saying that 'the Dress Maker, the blue Stocking and the most charming sentimentalist differ but in a Slight degree, and are equally smokeable'. He was more straightforward about other contacts: his radical friend David Lewis,

who had recently brought him some American newspapers; Mrs Dilke; Haydon. On 27 December Keats dined with Haydon, giving him the £30 for which he had been agitating, and seeing some engravings by Carlo Lasinio of the frescoes in the Campo Santo at Pisa.[1] These images, which include an extended 'allegory of Pleasure and Life opposed to the reality of Pain and Death',[2] were a beautiful distillation of themes which had obsessed him for the last several months. As he waited for his health to improve, the pictures worked their way deeply into his imagination.

He had practical as well as personal reasons for delaying his departure. He was worried about his sister – anxious about her schooling, and about not spending more time with her – and still fretting about his finances. During the first week of the new year, notes whizzed to and fro between Wentworth Place and Haydon, as the painter tried to settle terms for borrowing a larger amount of money from Keats over a longer period – partly because he needed funds to finance an exhibition of work by his pupils William Bewick and Charles and Thomas Landseer. 'I shall get my bond ready for you,' Haydon wrote on 7 January, 'for that is the best way for me to do.' Keats became increasingly jaded during this flurry of correspondence, though he took the trouble to compliment Haydon on the 'improvement' he had made to the 'architectural part' of 'Christ's Entry'. He knew now that he could ill afford the loans he had already been jostled into giving, and plaintively referred to his 'plaguy sore throat' as a reason for not visiting Haydon – however warmly Haydon thanked him for his kind efforts: 'The "agonie ennuyeuse" you talk of be assured is nothing but the intense searching of a glorious spirit; & the disappointment it feels at its first contact with the muddy world – but it will go off – & bye & bye you will shine through it with "fresh legerity".'

Such back-slappings did little to reassure Keats. Although Tom's money would see him through the next few months, his longer-term prospects remained bleak. Whenever he called on Abbey, he was warned that the new year would see the movement for liberal reform reaching a crisis, which would inevitably damage the money markets. Keats resented the implications of this, but agreed with the analysis. He may have come to dislike Hunt's poems and to distrust his personality, but he had not lost his faith in the ideas put forward by the *Examiner*. Its weekly editorials made clear that the industrial protest which had burst out in 1817 (the Spa Fields assembly, the Pentridge Rising in June, the suspension of Habeas Corpus, and the trial of the radical William Hone

and others) was about to erupt again. Far from containing the mood of dissent, the government's gagging measures – such as the Six Acts – had strengthened it, creating a tension which many believed could only be resolved by conflict. This conflict came the following September, at the notorious 'Massacre' at Peterloo, near Manchester, and while it would be foolish to say Keats's life in the months leading up to that tragedy were precisely shaped by premonitions, it would also be wrong to suggest he knew nothing of the growing emergency.

As HIS DELAY in London lengthened, Keats once again rehearsed several of his poetic theories for George. It was a way of preparing for the work he hoped soon to produce, and laid particular emphasis on the idea that 'thoughts' should be a function of 'sensations'. 'Recollect', he told his brother, 'that as Man can live but in one society at a time – his enjoyment in the different states of human society must depend upon the Powers of his Mind.' And again, self-deprecatingly: 'I have thought so little that I have not one opinion upon any thing except in matters of taste – I can never feel certain of any truth but from a clear perception of its Beauty.' When Keats had discussed these notions previously, in letters to Woodhouse and elsewhere, he had always stressed that they were not an argument for rejecting the world and its politics, but for transfiguring it. He does so just as vehemently in this letter to George. After copying out his new poem 'Fancy', he quotes Hazlitt's opinion of Godwin's novel *St Leon*, which argues that the artist is 'a limb torn off from society'. He then follows this by transcribing 'Bards of Passion', a poem which asserts that the imagination is 'more real', and knows its business is to reconcile 'Heaven' with 'Earth' rather than separate them. To emphasise the point, he closes the letter by referring to the elections at Westminster, to the character of Cobbett, to the 'discovery of an African kingdom', and to the 'affairs of Europe'. None of his reflections on these things is developed: they are interspersed with purely local and personal news about Mrs Dilke's cat, and about a 'battle with celery stalks'. But they give a definite picture of his loyalties and interests. Even though much of his recent experience 'in the world' had been painful or thwarting, he could not and would not relinquish his hold on it. His perception of 'Beauty' depended on a clear sense of what 'Beauty' had to encompass.

Keats thought well enough of his two latest poems eventually to include them in his 1820 volume; in fact they did more to define his

ambitions than to fulfil them. After telling Haydon that he had been 'writing a little now and then lately', he added that what he had produced was 'nothing to speak of – being as it were discontented and as it were moulting'. Then a more promising idea presented itself. On one of his trips into London to see Haydon, he called on Isabella Jones. Isabella, whose 'tastes tended to the fashionable quarter of the Gothic novel and the romantic legend',[3] pointed out that 20 January was the eve of St Agnes – the time, according to legend, when young women were able to see their future husbands in a dream. Might it make a suitable narrative for a romance?

Since Tom's death, Keats had become powerfully sensitised to romantic tales, for several reasons. He felt lingeringly tender about Isabella. He was falling in love with Fanny. He was frustrated with 'Hyperion'. He wanted to dramatise his 'perception of Beauty'. He was anxious to refract his most miserable feelings about his family. In 'Hush, hush!' he had already created a miniature and mildly satirical version of the story he would soon tackle in 'The Eve of St Agnes'. His lyric had described the successful entry of a young lover into the house and heart of his 'dear', dodging a 'jealous old bald-pate' to possess 'those lips, and a flowery seat'. It was a part-watchful, part-dreaming poem, full of possibilities that could be explored in greater detail on the canvas Isabella stretched out for him.

The longer he thought about her suggestion, the more attractive it seemed. It offered him the chance to dissolve himself as Shakespeare had done in his plays, and also to release him from 'Hyperion' while continuing to address its subjects in a different language. The rolling organ notes of Milton could be replaced by the more intimate cadences of Chatterton. The idea of progress from one generation to the next could be turned into a love story where youth triumphs over age. The theme of self-fulfilment could be taken from Apollo and given a quasi-human embodiment. All these things made him impatient to start work on the poem; others held him back. His reaction to Hunt's *Pocket Book* had been harder than it deserved, but its sentimental pages had reminded him that the pitfalls of 'romances' were as dangerous as the temptations of 'fashion'. He had no wish to betray the grave insights into human nature that he had gained during the last few months, and no wish either to trivialise or overexpose his feelings about Isabella. There was something inherently 'mawkish', he felt, about story-poems.

KEATS WAS WELL enough to leave Wentworth Place for Sussex on 18 or 19 January. He saw Abbey shortly before boarding the coach, and squeezed another £20 from him to help cover his expenses. As always when preparing to leave London, he felt excited and optimistic – and no longer in two minds about his new poem. He expected to work on it with the same determination he had shown when writing his Epistles in Margate, or *Endymion* on the Isle of Wight.

This time, the strangeness of being away from home would be more comfortable. Brown would be with him, and he looked forward to meeting his hosts: Dilke's parents, who lived in Chichester, and their daughter Letitia Snook, who was married to John Snook. The two families had originally been brought together by Dilke's father. During his time in the Navy Pay Office, he had worked with corn merchants along the south coast. One of these merchants was John Snook senior, who had spent his early life at Portsea, then bought a mill at Bedhampton, between Chichester and Portsmouth. When John senior died, his son – by now already married to Letitia Dilke – had taken over the mill. He was on good terms with his parents-in-law, often visiting them in their house in Eastgate Square, in Chichester.

Brown had arranged to visit the Dilkes first, and when Keats's coach finally trundled into Chichester after crossing the South Downs, he met him full of enthusiasm. He knew Keats would enjoy the city. Its narrow red-brick streets, built during recent decades as the city had prospered from 'the Government bounty on the export of corn',[4] swarmed within the ancient walls and pressed close round the cathedral and its free-standing bell tower. Everything realised scenes Keats had already imagined. On the road south from London, he had begun preparing the medieval background for his new poem. He alighted and found it true.

Keats started thinking about his poem even more seriously soon after reaching the Dilkes' house, though he did not actually begin writing it until he travelled on to Bedhampton on 23 January.[5] As he did so, he synthesised his surroundings with other sources. These included memories of Spenser (the poem is written in the stanza Spenser used for *The Faerie Queene*), Shakespeare, Burton, Coleridge, M. de Tressans's three romances ('Flores et Blanche-Fleur', 'Cléomades et Claremonde', and 'Pierre de Provence et la Belle Maguelone'),[6] and John Brand (whose *Popular Antiquities* described how 'On the eve of [St Agnes] . . . many kinds of divination are practised by virgins to discover their future husbands'). Mingling with his recollections of Chatterton and various

Gothic tales, they gave him the dramatic plan he wanted. He devised the story of Madeline, a young 'Lady' who has heard 'old dames' recount the legend of St Agnes' Eve. On the appointed night she leaves a party that her family has organised for 'a thousand guests' in her chilly mansion, to dream of her intended in the safety of her room. Before she gets there, her admirer Porphyro (who is spurned by her family: the debts to *Romeo and Juliet* are clear) has been smuggled upstairs by her nervous old maid Angela, and concealed himself in a 'closet'. When Madeline eventually reaches her room, Porphyro watches her pray, undress, and fall asleep. He then produces a 'sumptuous' meal, wakes her by playing 'an ancient ditty' called 'La belle dame sans mercy', and gets into bed with her. This produces a crisis as the lovers wonder what is 'spiritual' and what is real, and the poem ends, elegantly changing its tense from present to past, with them fleeing 'like phantoms' into the storm which has been raging round their still-cold mansion, their family, and its dying and decrepit servants.

A sober summary of the plot makes it sound preposterous, and any account of the poem which accentuates its narrative is bound to emphasise its Gothic parentage in a seriously disabling way. Not just disabling; distorting. Although the mood and resolution of 'The Eve of St Agnes' depend on fantastical elements, Keats's handling opens a gulf between the story ('a quest romance'[7]) and its treatment. The former is knowingly derivative, far-fetched, even ridiculous. The latter is highly original, intimate and intense. Yet even in the treatment there is a curious ambiguity. While the difference between Gothic 'narrative' and poetic 'writing' generally involves a distinction between a self-conscious and a 'chameleon' approach, much of the 'writing' is in fact extremely artful. As in 'Isabella', it is usually designed to illustrate a series of contrasts. From the first stanza onwards, light is played against dark- ness, warmth against cold, fulfilment against frustration, youth against age. The chilly owl, the limping hare, the numb Beadsman, the 'palsy- twitched' maid Angela, and the 'sculptur'd' dead in the chapel – these speak of exclusion and mortality. In due course they are balanced against the 'poppied warmth' of Madeline's sleep, the glow of the 'shielded scutcheon' in her bedroom, Porphyro's 'heart on fire' with love, the excitement of his 'close secrecy' in Madeline's 'chamber', and so on.

At the climax of the poem, when Porphyro steps out of his chamber and 'melts' into Madeline's 'dream', these oppositions seem to be resolved:

Her eyes were open but she still beheld
 ↑²
/ The vision of her sleep / now wide awake
 a
There was ~~some~~ painful change, that nigh expelled
The Blisses of her dream so pure and deep:
At which ~~the ~~~~~~ fair Madeline began to weep,
witless ↑²
And moan forth little words with many a sigh
While still her gaze on Porphyro would keep
Who with an aching brow and ~~~~~~ eye
Feared to move or speak she looked so dreaming
 ↑²⁵
 ~~as ~~ she speaks, "Ah Porphyro but
 ~~Ah Porphyro ~~~~ ~~she but~~ even now
 was
 Thy voice ⁀at sweet tremble by in mine ear
 Made tuneable by every sweetest vow
 And thy kind eyes were spiritual and clear
 how
 How changed art thou ~~pallid~~ chill and drear
 Give me that voice again my Porphyro!
 Those looks immortal ~~and not~~
 Those complaining dear
 O leave me not in this eternal woe
 Ah! if thou diest my Love I know not
 where to go!

10 From 'The Eve of St Agnes'; Keats's draft.

passion'd far beyond a mortal man /
As these voluptuous ~~words~~ accents he arose
thereal, ~~lisblid~~ and like a throbbing star
~~Was either~~ the saphline heavens deep repose
 Seen mid
~~Into her~~ ~~bright~~ dream he melted as the rose
Blendeth her ~~soft~~ ~~odour~~ with the violet.

† ~~As e~~ ~~Solution~~ sweet. Meantime the frost wind blew

 Like love's alarm pattering the sharp sleet
~~Against the Casement~~ ~~foam~~ windows — St. Agnes moon
~~Against the Casement~~ windows dark. had set.

† 'Tis dark — still pattereth the foam blown sleet
~ This is no dream my Bride — my Madeline
'Tis dark the iced gusts still rave and beat
~ No dream Alas! Alas! and woe is mine
 Porphyro will leave me here to fade and pine
~~As~~ cruel! what traitor could thee hither bring?
 I curse not for my heart is lost in thine
Though thou ~~forsakest~~ a deceived thing —
 elfin storm leave Porphyro
~ A ~~dove forlorn and lost~~ with sick unpruned
 wing

Her eyes were open, but she still beheld,
Now wide awake, the vision of her sleep –
There was a painful change, that nigh expelled
The blisses of her dream so pure and deep.
At which fair Madeline began to weep,
And moan forth witless words with many a sigh,
While still her gaze on Porphyro would keep;
Who knelt, with joinèd hands and piteous eye,
Fearing to move or speak, she looked so dreamingly.

'Ah, Porphyro!' said she, 'but even now
Thy voice was at sweet tremble in mine ear,
Made tuneable with every sweetest vow,
And those sad eyes were spiritual and clear;
How changed thou art! How pallid, chill, and drear!
Give me that voice again, my Porphyro,
Those looks immortal, those complainings dear!
O leave me not in this eternal woe,
For if thou diest, my Love, I know not where to go.'

Beyond a mortal man impassioned far
At these voluptuous accents, he arose,
Ethereal, flushed, and like a throbbing star
Seen mid the sapphire heaven's deep repose;
Into her dream he melted, as the rose
Blendeth its odour with the violet –
Solution sweet. Meantime the frost-wind blows
Like Love's alarum pattering the sharp sleet
Against the window-panes; St Agnes' moon hath set.

In fact, as Keats approaches the end of his poem, he does not so much
reconcile the contrasts which exist in its earlier sections as recast them.
Not surprisingly, this has licensed a host of different critical readings.
'The Eve of St Agnes' has been discussed as an allegory of identity,[8] in
which the narrative action dramatises the role of the poetic imagination.
It has been called a 'heap of substitutes',[9] where the lovers explore
various kinds of falsehood in order to discover their authentic selves. It
has been described as a 'hymn to the risen body'[10] which proves that the
ardour of physical passion can burn away the imperfections of the
familiar world. In all such interpretations – and many others as well – the
three stanzas describing Madeline's and Porphyro's love-making are
central. They define the moment at which Keats simultaneously buries

his conflicting feelings about women, and lifts them into clear view. He confronts difficult questions about Porphyro (is his 'Solution sweet' welcomed by Madeline or is it a rape?); about Madeline (is her comparative remoteness in the poem a sign of her self-absorbed excitement at the prospect of seeing her lover, or evidence of her uncertainty about the whole venture?); about sex in general (is it a form of transcendence or a false paradise?); and about adolescent passion in particular (is it admirably intense or dangerous in its urgency?). These questions are complicated in themselves. Keats makes them even more demanding by surrounding them with other uncertainties. As he transforms Porphyro's initial, voyeuristic excitement (his peeping cupboard love) into a reality which is at once palpable and 'Beyond a mortal man', we are left wondering whether Porphyro's 'melt[ing]' with Madeline is 'true' or imaginary. And is it a celebration of mutual physicality, or does its manifest inventedness imply a preference for something solitary?

Keats, allowing himself the freedom of the poet who has no fixed identity, asks these questions without giving a final and definitive answer. He remains non-committal during the last six stanzas of the poem, too, in which the lovers flee the castle. In one sense, their escape allows them to discover an ideal: they enter a realm where love never fades, where death has no dominion, and which is beyond the reach of social conflict. At the same time, Keats tells us that they are 'gone' into a 'storm': the word suggests the dangers of their isolated interdependency, and the difficulties they are likely to encounter in their new world – even though Porphyro promises Madeline that he has a 'home' for her:

> And they are gone – ay, ages long ago
> These lovers fled away into the storm.
> That night the Baron dreamt of many a woe,
> And all his warrior-guests, with shade and form
> Of witch, and demon, and large coffin-worm,
> Were long be-nightmared. Angela the old
> Died palsy-twitched, with meagre face deform;
> The Beadsman, after thousand aves told,
> For aye unsought for slept among his ashes cold.

Reading 'The Eve of St Agnes' in this way means stressing that it is as deeply concerned with the resources and responsibilities of the

imagination as it is with the pleasures and perils of love. But while Keats had long been preoccupied by these themes, it would misrepresent the poem to make it seem merely a 'logical' and straightforward development in his work. On the one hand, its voluptuousness makes it one of his mos characteristic pieces of work – gorgeously extending the imaginative reach of anything he had done before. On the other, its artfulness, and the ironical attitude it takes to its own narrative, mean that it stands at a slight remove from his previous writing. In every stanza, Keats achieves the 'chameleon' character he had long imagined, triumphantly closing the gap between his 'axioms' and his practice. 'The Eve of St Agnes' is abundantly revealing of his self and his ideas, but also ingeniously diversifies his theories and his psychological imperatives.

THE TONE OF 'The Eve of St Agnes', at once detached and engrossed, had its natural counterpart in the life Brown now shared with Keats. For 'a few days' at the Dilkes' house in Eastgate Square, Keats felt 'nothing worth speaking of happened' except that they 'went out twice . . . to old Dowager card parties'. In fact, although the Dilkes were gentle and retiring, he had more fun than he implied. He explored the old town of Chichester, inspected the Gothic cross in the town square, and visited the magnificent twelfth-century cathedral – where he took a letter from Fanny, which reached him soon after he arrived, to read in private. He also watched, amused, as Brown fell into what his friends reckoned was his regular habit of buttering up old ladies. One of those he met, a Miss Mullins, who was queen of the card-playing set, even persuaded him to shave off the whiskers he had sported for the past several years. The transformation convinced Keats to make a change in his own appearance. Maria Dilke had warned her parents-in-law that they would find Keats 'a very odd young man, but good tempered and very clever indeed'. What she meant by this 'oddness' is a matter for conjecture. It obviously has something to do with his decision to give his life to poetry rather than more practical affairs as her husband had done. It also – and more simply – implies something about his appearance. On his walk round Scotland Keats had appeared 'strange' because he was trussed up in plaids and ragged coat. Once back in London, and even when performing his wretched tasks at Tom's bedside, he had reverted to wearing the loosely knotted handkerchief and open-necked shift that was deemed 'liberal' and 'Byronic'. In Chichester, and perhaps acting on a recommendation from Fanny, he now abandoned this style for

something more conventional: a 'neckerchief . . . up to my eyes', as he described it with mock outrage.

On 23 January Keats and Brown left their elderly hosts and walked through cold clear weather to the Snooks' old mill house at Bedhampton, thirteen miles away. The medievalism of Chichester immediately became enriched: a mill had been recorded in Bedhampton in the Domesday Book. From the outside, the building looked robustly beautiful – a sturdy cube sheltered from the sea winds by a semicircle of trees, and with a dark stream running immediately outside the front door. Inside it was functional but spacious (there were four bedrooms), and well furnished with legends that suited 'The Eve of St Agnes'. At one time it was supposed to have been a priest's house, and had a 'secret' cupboard which doubled as a serving hatch, like Porphyro's hideaway.

Brown said that even before they arrived at Bedhampton Keats's sore throat was 'much better, owing to a strict forbearance from a third glass of wine' with the Dilkes. His new hosts made him more cheerful still. John Snook, like his father before him, was 'a man of real worth and unaffected piety',[11] liberal in his politics, forthright in his manner, and unpretentious in everything. His small talk about religion, farming and current affairs created a less glamorous but more pragmatic version of the world Keats knew in Hampstead. On Sunday the 24th, the morning after he and Brown had settled in, Keats's pleasure bubbled over in a letter to Mrs Dilke, written jointly with Brown. It fizzes with *risqué* puns and private jokes, with jibes about each other's recent shavings and redressings, with boasts about how much they had eaten, and, in Keats's handwriting, with a request to be remembered to 'Elm Cottage – not forgetting Millamant [Fanny]'. It was many months since Keats had sounded so carefree.

His mood soon quietened. Even though he was in a beautiful place, even though the weather did not imprison him as it had done in Teignmouth, he spent most of the next nine or ten days indoors, working on 'The Eve of St Agnes' and 'averaging about thirty-five to forty lines a day'.[12] One of his few excursions turned out to be a surprising kind of encouragement. On 25 January, he set off with Brown, Snook, and Snook's small son, to travel by chaise a few miles inland to Stansted Park, a large Queen Anne mansion, in the grounds of which a chapel was to be dedicated. It was a surprising destination, given that all three men were freethinkers, but the very oddity of the occasion was its chief attraction.

Stansted Park was renowned for standing 'in one of the finest

situations in the kingdom'. A contemporary guidebook says: 'from the windows in the drawing-room there is a compleat view of Portsmouth, Isle of Wight, the ships at Spithead, etc. The gardens are very pleasant, the walks in the park are extremely rural, and the many vistas in them, which terminate in some agreeable prospect, so judiciously planned, that though art has conducted the whole process, she lies concealed, and only nature strikes the eyes.'[13] This epitome of aristocratic elegance, so unlike everything they had seen since leaving London, had recently been inherited and made unique by Lewis Way. Way was rich, eccentric, and driven. The whole expensive purpose of his life was to convert Jews to Christianity. He had already persuaded 'the Powers at Aix-la-Chapelle in 1818 to add a clause to their protocol promising tolerance';[14] he hoped to found a college for likely candidates for conversion; and he had adapted a former hunting lodge on his estate to be his centre of operations. It was the dedication of this place that Keats came to witness, on a day chosen by Way because it marked the Feast of the Conversion of St Paul.

Winding uphill from the coastal plain, through thick belts of leafless trees, Keats and his companions found the chapel standing a few hundred yards in front of the main house, joined to a small grey-stone cottage. It seemed conventional enough: Elizabethan red brick, stepped gables, a slate roof. Inside it was a weird combination of Regency Gothic (triple-arched windows featuring scutcheons of the Fitzalan family) and Way's individualism. The painted east window had been thickly decorated with Jewish symbols and inscriptions; it was then, and still is, 'the only window in a Christian place of worship that is wholly Jewish in design and symbolism'.[15]

It was several years since Keats had renounced his Christian faith, and his attention wandered during the long service. Forgetting details of the dedication, he found material for his poem: the arched windows, 'All garlanded with carven imag'ries', the 'panes of quaint device', the 'stains and splendid dyes' (actually predominantly grey and yellow) which blossomed as winter sunlight broke through and dappled the congregation, the 'shielded scutcheon' which 'blush'd with blood of queens and kings'. As the images gathered in his mind, they combined with memories of the Campo Santo frescoes he had seen with Haydon before leaving home, and also with other memories from Spenser, the recently derided Beattie and Mary Tighe, Chatterton, and the Gothic stories recommended by Isabella Jones. Each new fusion expanded the

parameters of a poetic world which was both richly plausible and highly synthetic.

THIRTY-ONE

THE DAY AFTER visiting Stansted Park, Brown returned to Wentworth Place. It seems likely that Keats had originally intended to go with him, but his health had suddenly deteriorated. For part of the next week he was housebound with a sore throat, spending his days writing on 'thin genteel sheets' of paper that Haslam had given him for his letters to America, his evenings discussing 'religion and politics' with the Snooks, whom he continued to like 'very much'.

Early in February he felt well enough to return home, a draft of his complete poem tucked into his luggage. It had begun with a suggestion from Isabella Jones, and ended by becoming a coded epithalamium, an account of rapturous love ending with an elopement. It is a complex tribute – not only because it draws on Keats's feelings about two different women. The plot contains elements of brutality and banality: it is clear that as Keats found ways of making the poem keep pace with his life, accommodating immediate impressions of places and people, he had also revenged himself on his past. He had punished the romance genre, to which he had once been so indebted, by exposing its mawkish absurdities. He had only been away from Hampstead for a fortnight or so, but he returned, as always, feeling that in important respects he had changed.

His homecoming was difficult. Worries about his sister weighed on his conscience, and he soon wrote to remind her that he felt himself 'the only Protector you have. In all your little troubles think of me with the thought that there is at least one person in england who if he could would help you out of them.' His health still troubled him. 'I have not been entirely well for some time,' he told William Mayor, a pupil of Haydon's, on 4 February. In the same note, he asked Mayor, who was also a friend of Charles Cowden Clarke's, to give his old mentor 'my particular greeting', and 'the assurance of my constant idea of him'. It was a touching reminder of how the London life to which Clarke had first introduced him was now tattered and dispersed, and also of how Clarke himself had become a comparatively remote friend. Since moving to be near his father in Ramsgate in 1817, he only visited London occasionally.

He remained an exemplary figure for Keats – a kind heart and a kindred spirit – but he was no longer the intimate 'Daintie Davy' that Keats had once known.

Keats soon felt as marooned between worlds as he had done two months previously. Brown was partly to blame. When first welcoming him into Wentworth Place, he had simply offered a home and companionship. Now his protective instincts were more controlling, especially as far as Fanny Brawne was concerned. Although Brown liked to cultivate a raffish image, visiting prostitutes and talking lasciviously about girls with his men friends – when not chatting up old ladies – he had little time for affection between the sexes. Like Reynolds, he quickly became jealous of Fanny, and rather than trying to tease Keats out of his feelings, or straightforwardly criticising them, he began undermining Fanny by flirting with her himself. He wanted to prove to Keats that she was just like all the other women he disparaged: at best silly and susceptible, at worst false and promiscuous. When he sent Fanny a Valentine card on 14 February, possibly provoking Keats to write the 'Gripus' fragment which speaks of marriage as 'no light affair', he created a situation from which no one could emerge with much credit. His own tone of lecherous badinage was ill judged (he said Fanny should be 'whipped for being naughty'). Fanny seemed tainted by joining in the joke. Keats felt embarrassed.

He abruptly turned inwards, withdrawing so deeply that the next two months have been called 'the blankest and most puzzling period of [his] creative life'.[1] The roots of his unhappiness fed on confused feelings about love, yet they cannot easily be separated from his other worries. By admitting that he might be falling for Fanny, Keats had to confront his various shortcomings as a suitor. He was ill, perhaps with a sexually transmitted disease. He was devoted to a calling and a career which so far had brought him little but abuse. He was liked by Mrs Brawne, but reckoned by her to be a 'mad boy'. His finances were in dire shape. Just how dire, he discovered in mid-February, when for the first time in nearly three weeks he walked into London to see Abbey. Writing to Haydon a few days later he said that the meeting inaugurated a series of 'interviews'. They left him reasonably confident that he could 'perform . . . my promise' of lending Haydon money, but doubtful that he would see any of Tom's inheritance 'before my Sister is of age'. This meant waiting another six years. It is hard to tell whether Abbey was being obstinately legalistic, or actually mean, in breaking the news to him. He

had already given Keats enough evidence to suspect the worst, but it is just possible that, since he was now sole trustee of the estate, he felt obliged to act with extreme caution. He allowed Keats to withdraw £20, and referred him to Walton, the lawyer who had drawn up Alice Jennings's original deeds of inheritance. Keats, with his customary reluctance to inquire closely into his finances, made a bad situation worse. Walton was by now an old man living outside London near Epping Forest, and if Keats called on him, or visited his offices in London, he made no mention of it. His neglect lost him more than the chance to question Abbey's interpretation of the will. Had he spoken to Walton he might also have heard about his second and – to him – still unknown trust fund, buried in the bewildering depths of Chancery.[2]

Even if we try to interpret Abbey's administration of the estate charitably, all sympathy for him evaporates when we look at his other interventions. During Tom's last weeks he had prevented Fanny Keats from visiting her brother as often as she wanted. Now he told her that she was seeing too much of Keats himself. Keats first received this news in Bedhampton, and had responded with the 'hurt' letter in which he called himself her 'only Protector'. Knowing that it would irritate Abbey still further, and therefore probably make access to Tom's money even more difficult, he continued to write to her regularly, and to protest about their plight. On 27 February he told her that she should 'pay no attention' to Mrs Abbey, and on 13 March he tried to comfort her by turning details of their present situation into a vision of a contented future. His letter described a shared life they had never had, a life which in subsequent weeks he would try to create in replica by sending her presents of seeds, by answering her questions about points of religious order, by chatting about Tassie gems and coach timetables, friendships and family matters:

Tell me also if you want any particular Book; or Pencils, or drawing paper – any thing but live Stock – Though I will not now be very severe on it, remembring how fond I used to be of Goldfinches, Tomtits, Minnows, Mice, Ticklebacks, Dace, Cock salmons and all the whole tribe of the Bushes and the Brooks: but verily they are better in the Trees and the water – though I must confess even now a partiality for a handsome Globe of goldfish – then I would have it hold 10 pails of water and be fed continually fresh through a cool pipe with another pipe to let through the floor – well ventilated they would preserve all their beautiful silver and Crimson – then I would put it before a handsome painted window and shade it all round with myrtles and Japonicas. I should like the window to open

onto the Lake of Geneva – and there I'd sit and read all day like the picture of somebody reading –

Keats ended his series of meetings with Abbey feeling angry and trapped. Such family as remained to him were barred by one means or another. The money which had kept him since leaving Guy's was almost exhausted, and he had no clear idea of how to find alternative funds. Would his reputation as a poet suddenly flower? It seemed unlikely, and the more deeply he regretted this, the more inclined he was to brood on the harm done to him by *Blackwood's* and the *Quarterly*. Should he consider returning to medicine? It would be a way of doing 'some good' in the world, yet also represented a personal failure. Should he submit to his feelings for Fanny? Glancing round his friends, there seemed plenty of evidence to suggest he would be well advised to 'sheer off' from her for good. Reynolds was being lured further and further away from poetry by his fiancée, and Bailey – he discovered this month – was behaving in a way which made love itself seem inevitably foolish and manipulative. He heard during a visit to Little Britain that Bailey had become engaged to Hamilton Gleig, the daughter of the Bishop of Brechin. Keats felt offended by the fact that he also knew that Bailey had, in quick succession, disappointed Thomasina Leigh and Marianne Reynolds, and had also canvassed three or four other young women in the past two years, nosing his way up the slopes of society. There was, Keats knew, no danger that he might be accused of making 'a catch' himself if he got engaged to Fanny, but the whole business of courtship seemed tarred by Bailey's antics. He could see no reason for Bailey turning to Hamilton Gleig 'except that of a Ploughman who wants a wife'. The thought compounded Keats's sense of human frailty. It quickened his wish to remain independent.

His mood only lightened occasionally as the long winter continued. Once was during a return from Pancras Lane, when he unexpectedly came across Woodhouse, staring myopically into a shop window. They went off and drank a bottle of claret together, and Keats confided some of his hopes and fears to the man who was beginning to act as his unofficial chronicler. Among other things, they discussed his early sonnets to Alice Jennings, and to the lady seen in Vauxhall Gardens. Woodhouse later included what Keats had told him in his specially bound notebook. Another London meeting this February was even more productive. When Keats finished transcribing 'The Eve of St Agnes' he took it to

Isabella Jones, the 'onlie begetter' of its narrative, and she suggested that he follow it by tackling the story of the eve of St Mark. Like the narrative of 'The Eve of St Agnes', this companion piece combines medieval Gothic with superstitious elements, telling how someone who watches in a church porch for three years in succession on the appropriate date (24 April) will see the ghosts of all those due to die in the following twelve months. One source for the story, John Brand's *Popular Antiquities* (1813 edn.), goes on: 'When any one sickens that is thought to have been seen in this manner, it is presently whispered about that he will not recover, for that such, or such an one, who has watched St Mark's Eve, says so. This superstition is in such force then, if the patients themselves hear of it, they almost despair of recovery.'[3] It is this aspect of the story which most strongly distinguishes 'The Eve of St Mark' from 'The Eve of St Agnes'. The earlier poem enjoys imponderables, and nimbly keeps its questions unanswered. The later poem concentrates on various kinds of doom. It is predicated on experience which cannot be altered.

Or rather, it would be if Keats had written more than the first hundred-odd lines. When he copied them out some months later for his brother in America, he was careful to insist that they were occasional and fragmentary. He described the poem as 'a little thing', and said 'I think it will give you the sensation of walking about an old country Town in a coolish evening'. It is easy to see why. In the opening paragraph a 'staid' and 'pious' congregation processes to evensong through streets similar to those Keats had recently seen in Chichester. The town is settled and peaceful; the surrounding country cold but promising warmth:

> on the western window panes,
> The chilly sunset faintly told
> Of unmatured green valleys cold,
> Of the green thorny bloomless hedge,
> Of rivers new with spring-tide sedge,
> Of primroses by sheltered rills,
> And daisies on the aguish hills.

Within the town, but distanced from its society, we meet Bertha: her name is taken from Chatterton's 'Aella'. Although she lives 'in the old minster Square', she is not attending 'even-song, and vesper prayer', but reading 'A curious volume' which tells her the legend of St Mark's Eve. As Keats pours into his poem the details he had recently collected from

the wide world (from Stansted chapel, from Isabella's rooms in Gloucester Street), he narrows the focus of his attention. The town becomes the book, the voice of the modern poetic mediator is subsumed into a medieval pastiche. In this little and rapidly shrinking space, Bertha starts to submit to a condition she cannot alter. Not only have her 'two eyes' been 'taken captive', she is a 'poor cheated soul' deprived of daylight to read by. Her innate 'brightness' is soon dwarfed by her glowering shadow 'As though some ghostly Queen of Spades / Had come to mock behind her back, / And dance, and ruffle her garments black'. Even before she reads about the legend of St Mark's Eve, Bertha is associated with actual as well as readerly self-loss. Her transfixion is a kind of death, as well as a form of imaginative fulfilment.

Keats would soon return to this theme with much more composure: it is the abiding concern of his great odes. In the bleak early part of the new year, he could not develop his ideas. Perhaps the form of the poem, wonderfully well turned as it is, associated it with others he judged 'too smokeable'. Perhaps the emotions which surrounded its conception were more complicated than he could or wanted to admit. In any event, it was abandoned on 17 February, less than a week after he had begun writing, in the middle of a line. At the same time as he gave it up, Isabella Jones abruptly dropped out of his life.

On 14 February Keats had begun yet another long letter-journal for George and Georgiana, spending the first few pages bringing them up to date with his doings since Christmas before mentioning 'the Lady I met at Hastings', and saying that she 'has lately made me many presents of game'. The implication is that he expects to meet Isabella shortly. In fact he was never to mention her in a letter again. If her disappearance had coincided with a marked increase in the number of his references to Fanny Brawne, Keats's silence might be explained as a simple switch in his affections. But he has nothing to say about Fanny for the next several weeks, and seems not to have written to her directly. (His first surviving letter to her was not written until July 1819.) Does this mean he was seeing both women but not telling anyone? Was he rejecting Isabella because he knew that his chance of making a future with Fanny, though precarious, was a better bet? Was he hardening his heart against Fanny by having an affair with Isabella?

Or does it simply mean that Keats was not seeing either woman? Given the lack of other evidence, this seems the most likely explanation, especially when we consider the state of mind suggested by his letter to

George. Compared to his last communication, it is jaded and shadowed. The opening résumé is broken by irritated asides. At one point he lashes out at Hazlitt's son, 'that little Nero'; at another he says he is 'almost tired of Men and things'. As he gets into his angry stride, he continues to lay about him, criticising his neighbour Lewis for calling him 'quite the little Poet' ('You see what it is to be under six foot and not a lord', he tells George), restlessly considering a trip with Brown to Brussels later in the year, admitting his jealous dislike of Byron as he reports that the latest canto of *Childe Harold* has sold 4,000 copies, and slowly broadening his exasperation until it touches on large matters of state and church. The recent imprisonment of Richard Carlile for publishing radical pamphlets is a reason to lambast the government. The account of his visit to Stansted becomes the occasion for an attack on clergymen: 'I begin to hate Parsons . . . A Parson is a Lamb in a drawing room and a lion in a Vestry – the notions of Society will not permit a Parson to give way to his temper in any shape – so he festers in himself.'

Returning to the letter after a four-day gap, Keats is still festering in his own self, even taking a swipe at Dilke for his obsession with 'educating his son' and for talking 'of nothing but the elections of Westminster'. Yet as he gathers speed again, the complexion of his melancholy changes. Conscious that George might think his morbidity is making him self-destructive, he tells his brother, 'I never drink now above three glasses of wine – and never any spirits and water.' This reassurance is the prelude to a lip-smacking toast to claret:

– now I like Claret whenever I can have Claret I must drink it. – 't is the only palate affair that I am at all sensual in – Would it not be a good Speck to send you some vine roots – could [it] be done? I'll enquire – If you could make some wine like Claret to d[r]ink on summer evenings in an arbour! For really 't is so fine – it fills the mouth with a gushing freshness – then goes down cool and feverless – then you do not feel it quarreling with your liver – no it is rather a Peace maker and lies as quiet as it did in the grape – then it is as fragrant as the Queen Bee; and the more ethereal Part of it mounts into the brain, not assaulting the cerebral apartments like a bully in a bad house looking for his trul[l] and hurrying from door to door bouncing against the waistcoat; but rather walks like Aladin about his own enchanted palace so gently that you do not feel his step – Other wines of a heavy and spirituous nature transform a Man to a Silenus; this makes him a Hermes – and gives a Woman the soul and immortality of Ariadne for whom Bacchus always kept a good cellar of claret – and even of that he could never persuade her to take above two cups –

[353]

On 21 April 1821, Haydon would refer to Keats's fondness for 'the "delicious coolness of claret in all its glory" – his own expression', and make it the basis for an assertion that for 'six weeks' during this period Keats was 'scarcely sober'. At a later date, Haydon took seriously, or possibly even invented, a story that Keats 'once covered his tongue and throat as far as he could reach with cayenne pepper', to stimulate his appreciation as he drank. Previous biographers of Keats have always pointed out that the 'ill-ordered thing' Haydon, as Charles Cowden Clarke called him, was unreliable in several of his reminiscences of Keats: quick to score points, and jealously prone to exaggeration. They are perfectly right to do so. Although Keats enjoyed claret greatly, we never hear of him becoming more than 'a little tipsy', except in Haydon's account. And when he has stopped enthusing about the 'gushing freshness' to George, he turns at once to game birds as another 'palate-passion', making what might in other contexts sound like an addiction appear no more than a moment of exuberance.

It was a moment which seemed exceptional in these dark weeks. In the second half of February, Keats made a determined effort to rouse himself by walking into town to call on friends. He visited the Wylies. He met Taylor, and ended up staying two nights with him in Fleet Street, prevented from returning home by a heavy snowfall. He dined with Rice, Reynolds and Dilke (on a pheasant provided by Isabella Jones). He went to the British Museum with Severn. He asked his sister's advice about how to dance, then went to a party given by Georgiana's cousin Mary Millar, and found it 'an empty thing'. He half welcomed and half suffered the attentions of Haydon. He celebrated the birthday of Dilke's son. In the midst of this party, he heard news that made his future seem even more perplexing. The Dilkes planned to move to Westminster in April, to be nearer their son's school, and would soon be letting their half of Wentworth Place. His new neighbours would be the Brawnes.

His misery persisted. Haydon was bombastic. The Reynolds sisters were carping. He was confused about Fanny and Isabella. Abbey was obdurate. His sister and surviving brother gave him constant anxiety. His grief for Tom burnt sullenly. No matter how energetically he tried to vary the background of his unhappiness, nothing could alter it. No matter how hard he tried to fix the blame on other people and occasions, nothing could shift the focus away from himself – on his hopes for the future, on his failure to complete 'Hyperion' (and now 'The Eve of St Mark' as well), and on his growing resentment about the reception given

to *Endymion*. Gradually Keats showed George how wounded he felt. On 19 February he admitted heavily 'my poem has not at all succeeded', then immediately rallied and asserted 'in the course of a year or so I think I shall try the public again'. This in turn led him to attack 'the Reviews' openly, saying they had 'enervated and made indolent men's minds', and were 'getting more and more powerful and especially the Quarterly'. Three pages later, he entered a more controlled mood, which allowed the first 'speculative' element of the letter to take shape. But it is a speculation which ends with another resentful dig at Byron, whose success (social, sexual and financial) he uses as an emblem of all that he lacks himself. 'They are very shallow people,' he says, taking his cue from some critical remarks he has made about Bailey's treatment of women, 'who take everything literal. A Man's life of any worth is a continual allegory – and very few eyes can see the Mystery of his life – a life like the scriptures, figurative - which such people can no more make out than they can see the hebrew Bible. Lord Byron cuts a figure – but he is not figurative – Shakespeare led a life of Allegory; his works are the comments on it.' Although it is full of resentments, this passage strikes a more stalwart philosophic note than any Keats had managed since returning from Chichester. By distinguishing between 'a figure' and 'figurative', he briefly recovered the central article of his poetic faith. His identity depended on his having no fixed identity. The reviewers could not hurt him because they had not harmed 'the Mystery of his life'.

This slender shoot of optimism grew with painful slowness. Throughout late February and early March, his renewed sense of purpose was almost exactly matched by feelings of deficiency. 'I see by little and little more of what is to be done,' he wrote to Haydon, 'and how it is to be done, should I ever be able to do it.' Then again, on 8 March: 'I have come to the resolution never to write for the sake of writing, or making a poem, but from running over with any little knowledge and experience which many years of reflection may perhaps give me – otherwise I will be dumb.' And again to his brother five days later: 'I know not why Poetry and I have been so distant lately. I must make some advances soon or she will cut me entirely.'

As he created these courageous ambivalences, Keats became more frankly robust in other respects. Charles Cowden Clarke, making one of his now intermittent visits to his old friend, described how Keats had recently come across a butcher's boy tormenting a kitten in the street, and had fought and beaten him. Continuing his journal to George, Keats

interrupted the thought that he might 'go to Edinburgh & study for a physician' (Edinburgh accepted applicants who had not been to Oxford or Cambridge) by saying 'it is not worse than writing poems, & hanging them up to be flyblown on the Reviewshambles'. A few lines later, pointing out that he had been attacked by the same critics who had bad-mouthed Hazlitt, he copied out a long extract from the latter's 'Letter to Gifford' which bolstered his own sense of himself. Revealingly, he turns from his transcription to give a miniature self-portrait, as if to prove that the partial recovery of his inner identity is matched by a renewed sense of his outer one. 'The fire is at its last click,' he says, ' – I am sitting with my back to it with one foot rather askew upon the rug and the other with the heel a little elevated from the carpet.' He then adds: 'Could I see the same thing done of any great Man long since dead it would be a great delight: as to know in what position Shakespeare sat when he began "To be or not to be" – such thing[s] become interesting from distance of time or place.' Clearly, the new month had not brought him a wholly new kind of determination. But it had renewed his contact with the convictions which had always strengthened him in the past.

IT IS POSSIBLE that Keats's sudden interest in picturing had been spurred by Severn, who painted the famous miniature of his friend during this February or March. Keats himself had ambivalent feelings about the portrait. Although he admired its formal dexterity, he discouraged Severn from entering it for a Royal Academy exhibition at the end of March because he thought it would be 'vain' to encourage the idea, and because he felt that his low reputation might harm its reception. He knew, in other words, that the miniature told a simple truth about its subject. It is a picture of unrealised ambition – of wide eyes which look ardently to the future, of a sensual mouth which is hungry for success, of a little body crouched inside a too-large coat.

Given Severn's uncritical admiration of Keats, it seems likely that he intended to present a less complicated image. But by mingling the shapes of vulnerability with the lineaments of genius, he showed his friend trapped by circumstances while gazing beyond them. Haydon, in particular, upset and distracted him. For the past several weeks he had been nagging Keats about the possibility of borrowing £500 for two years; soon he began positively to beg, telling Keats on 10 March that he felt 'the want of your promised assistance'. Partly to fulfil his obligations, and partly to meet his own needs, Keats braced himself for further

meetings with Abbey, still 'nearly confident' that the recent reinterpretation of his grandmother's will was a 'Bam', or trick. Far from making any headway with his former guardian, Keats found himself thrust once more into the role of dependent petitioner. In the middle of the month Abbey gave him a lecture on the merits of joining a hat-making business, and allowed him to withdraw £60; on 25th he doled out a further £10; on 3 April he handed over all that remained of the £500 George had deposited the previous summer: £47 7s 7d. By the time Keats had squared some of his own outstanding debts, and paid Brown for his lodging, there was very little to spare.

Haydon was angry and dismayed, implying that Keats had deliberately misled him. 'Why did you hold out such delusive hopes every letter on such slight foundations?' he wrote on 12 April. ' – You have led me on step by step, day by day, never telling me the exact circumstances; you paralysed my exertions in other quarters.' Keats replied within twenty-four hours, saying: 'I find myself possessed of much less than I thought for', and pointing out that over the years he had already lent almost £200 to other friends – an amount 'which I have but a chance of ever being repaid or paid at a very distant period'. It is a letter written with less hope of saving a friendship than of retaining integrity, and if Haydon had not been so self-obsessed he would have sympathised with Keats rather than attacking him. Pressing Abbey to divulge more information than he had been able or willing to give earlier in the year, Keats had discovered that 'if I had all on the table all I could do would be to take from it a moderate two years subsistence and lend you the rest'. Telling Haydon, with dignity, that he 'should [do] me the justice to credit the unostentatious and willing state of my nerves' when tackling money matters, he confessed that he felt 'maimed' by his accusations.

No matter how Keats tried to prove that he was more financially 'hurt' than Haydon, their friendship was deeply damaged. They continued to see each other occasionally, and after an interval of six months they began writing to each other again. But the intensity was gone. At their first meeting in 1816, Haydon had added passion and theatricality to the ideas that Keats discussed with Hunt: he had urged Keats to cultivate high ideals and to collect experience, he had educated him in Shakespeare and the classics, he had shown him the Elgin Marbles, and he had encouraged a sensual monumentality in his writing. Often extravagant and sometimes overbearing, he had blazed through the most impressionable part of Keats's life, flicking colour on to the advice of

more calculating friends. He was their thrillingly creative complement: a large-minded man who sometimes just blustered; a big-hearted friend who was sometimes crabby. The fact that his later reminiscences of Keats are spoiled by jealousies should not obscure the importance of their early association. Haydon's generous affection for Keats, like his gusto-filled diary, is an impressive memorial to a difficult man. Both things brimmed with the human qualities he longed and failed to capture in his paintings.

As Haydon's disappointment rumbled towards its climax, Keats continued to combat other 'devils'. When he returned to his journal-letter to George, the day after giving his self-portrait in March, he was perfunctory and prickly. After a cursory mention of their sister and their friend Haslam, whose father was gravely ill, he once again got Hazlitt to do his arguing for him, copying out a further section of the 'Letter to Gifford'. This fulfilled a double purpose. It attacked a common enemy, and quickened his returning interest in those questions of poetic identity which had owed so much to Hazlitt in the first place. 'I affi[r]m, sir,' he reports Hazlitt as saying, 'that poetry, that the imagination, generally speaking, delights in power, in strong excitement, as well as in truth, in good, in right, whereas pure reason and the moral sense approve only of the true and the good.'

Keats ends his quotation by celebrating the energy of Hazlitt's style, 'the force and innate power with which it yeasts and works up itself'. The phrase registers its admiration by showing a sympathetic vigour, as if Keats were using Hazlitt to express his own ideas, and to revive his spirits. The day after completing the transcription, however, he sank back into himself, saying that he felt 'an[n]ihilated'. The change began modestly enough. On 14 March Keats visited his neighbours the Davenports in Church Row, and after dinner 'had a nap'. His weariness turned out to be the prelude to several days of what he described to George as 'uneasy indolence'. On Monday the 15th he said he did not 'know what I did . . . nothing – nothing – nothing', and although he followed this by busily calling on Abbey, inviting Taylor and the painter William Hilton to dinner – and afterwards walking them back 'as far as Cambden Town and [smoking] home a Segar' – he could not shake off his lassitude and bitterness. Referring to the recent murder of the writer Kotzebue, whose play *The Stranger* he had seen in Scotland, he said coldly that Kotzebue was a 'traitor to his country'. A mention of Dilke produced one of his contemptuous outbursts against children. The

thought of reviewing Reynolds's spoof 'Peter Bell' reminded him that 'Hyperion' was stuck, and that his freelance days were numbered. 'I am still at a stand in versifying,' he said. ' – I cannot do it yet with any pleasure – I mean however to look round at my resources and means – and see what I can do without poetry – to that end I shall live in Westminster [like Dilke] – I have no doubt of making by some means a little to help on or I shall be left in the Lurch – with the burden of a little Pride.' His self-promptings were of no avail. On the 17th he stayed in bed until ten o'clock in the morning. On the 18th he took himself off to play cricket on the Heath with Brown, was hit in the face by the ball 'and got a black eye'. On the 19th, after Brown had applied leeches to the bruise, his mood suddenly softened. Writing drowsily to his brother, he said: 'My passions are all asleep from my having slumbered till nearly eleven and weakened the animal fibre all over me to a delightful sensation about three degrees on this side of faintness – if I had teeth of pearl and the breath of lilies I should call it languor – but as I am I must call it Laziness.'

Keats is deliberately literary here: his letter incorporates allusions to Thompson's 'Ode to Indolence' and Wordsworth's 'Vernal Ode', among other poems. Even though his subject is inertia, this suggests a mood of greater curiosity and creativity than any he had known for weeks. And as his letter spreads over the next several pages, his depression continues gradually to shift, making room for a marvellous tumble of thoughts. It begins with a further reflection on his idle 'state of effeminacy', a reflection which is prompted by an etching he had recently seen, one of Piranesi's *Vasi, candelabri, cippi . . .*, and which anticipates the 'Ode on Indolence' that he would write in two months' time. 'Neither Poetry, nor ambition, nor Love have any alertness of countenance as they pass by me,' he says. 'They seem rather like three figures on a Greek vase – a Man and two women – whom no one but myself could distinguish in their disguisement.' Keats immediately identifies this as his 'only happiness', his mind spiralling outwards so that it touches on related ideas of disinterestedness, instinctiveness, heroism, 'the pious frauds of religion', identity, and energy. Recalling, perhaps, his recent thrashing of the butcher's boy, he says:

I am however young writing at random – straining at particles of light in the midst of a great darkness – without knowing the bearing of any one assertion of any one opinion. Yet may I not in this be free from sin? May there not be

superior beings amused with any grateful, though instinctive attitude my mind m[a]y fall into, as I am entertained with the alertness of a Stoat or the anxiety of a Deer? Though a quarrel in the streets is a thing to be hated, the energies displayed in it are fine; the commonest Man shows a grace in his quarrel – By a superior being our reasoning[s] may take the same tone – though erronious they may be fine – This is the very thing in which consists poetry; and if so it is not so fine a thing as philosophy – for the same reason that an eagle is not so fine a thing as a truth – Give me this credit – do you not think I strive – to know myself?

Keats may be 'young writing at random', but his thoughts have a powerful logic. They are all concerned with the relationship between feeling and knowledge, and all loosely linked to his ideas about the chameleon poet. Finally, and with a sense of slow inevitability, they issue in a poem – the first he had written for more than a month.[4] Keats acknowledges the connection in a brief introduction. 'My sonnet', he tells George, 'will show you that it was written with no Agony but that of ignorance; with no thirst of any thing but knowledge when pushed to the point though the first steps to it were throug[h] my human passions – they went away, and I wrote with my Mind – and perhaps I must confess a little bit of my heart':

> Why did I laugh tonight? No voice will tell:
> No God, no Demon of severe response,
> Deigns to reply from Heaven or from Hell.
> Then to my human heart I turn at once –
> Heart! thou and I are here sad and alone;
> Say, wherefore did I laugh! O mortal pain!
> O Darkness! Darkness! ever must I moan,
> To question Heaven and Hell and Heart in vain.
> Why did I laugh? I know this being's lease
> My fancy to its utmost blisses spreads;
> Yet could I on this very midnight cease,
> And the world's gaudy ensigns see in shreds.
> Verse, Fame, and Beauty are intense indeed,
> But Death intenser – Death is Life's high meed.

Keats never collected this poem, yet its existence is a landmark. It shows him recovering his poetic concentration, and renewing his need to accept 'Darkness' as a part of 'Life'. The effects were immediate, as well as long term. No sooner had he transcribed it for George than he

abandoned his letter-journal for almost a month. Instead, he turned back to 'Hyperion', struggling to include the thoughts about 'knowledge' and 'experience' that he had recently reawoken. Greatly as he regretted having to confront the 'Miltonisms' he had produced, and much as he disliked creating a 'fragment' rather than a complete work, he was able to interpret the shortcomings of his 'grand poem' as proof that in the four months since Tom's death he had taken another large step towards self-definition. It was a step, he realised, which could not have been made without the further sorrows he had suffered. These had 'nerved' his 'spirit', and deepened his understanding of long-standing themes and methods. Surrounded with problems, and riddled with uncertainties, he finally emerged into the spring of 1819 with his abilities more nearly equivalent to his insights than they had ever been.

The achievement made strenuous demands on him. It required great mental and spiritual effort to convert the brutal facts of life into perceptions which might 'do the world some good'. This effort depended not just on his fortitude but on his health. ('Why did I laugh' suggests that illness was still preying on his mind.) It is likely that his lassitude in mid-March was at least partly produced by laudanum, which he took to alleviate the pain of his black eye. Before and after suffering this accident, his symptoms were of a different order, and much more worrying. His sore throat had continued to trouble him into January and February, by which time he was also suffering from hoarseness and insomnia. At the end of March he was still haunted by fears about the origin of his symptoms.

Keats only accepted at the end of his life that he was doomed to die of tuberculosis. Without stethoscopes and X-rays he could not be certain of his condition; without the knowledge that tuberculosis was infectious, he could not even be sure that his nursing of Tom had been dangerous – though like most of his contemporaries he suspected that it might be hereditary. Yet in the months after his brother's death he frequently took precautions which were specifically designed to resist the onset of the illness. He refers in his letters to the perils of 'night air'; he insists on the need for moderate exercise; he talks about the advantages of a vegetarian diet; he discusses the possibility of taking a sea voyage as the surgeon on an Indiaman. At the same time, he repeatedly uses images of smothering or suffocation ('the violence of my temperament continually smothered down', he said to George on 19 March). These things make an important

[361]

contribution to the story of his approach to greatness. Overarching all his other concerns about family, money, social position, friends and love, and threatening all his hopes for poetry, they created the final and governing paradox of his life. What encouraged him to fulfil himself also destroyed him. The simultaneous apprehension of pleasure and pain, which he had long regarded as ideal, became a reality that was both magnificent and torturing.

THIRTY-TWO

Ever since his mother had returned home to die after her disastrous second marriage, Keats had felt he was losing a race against time. At school he had gorged on books and set himself enormous tasks of learning and translation. At Guy's he had rejected short-term security as a doctor while hurrying to find permanent fame as a poet. In his early days with Hunt he had fretted about quickening the pace of political change. In his poems he had asked urgent questions about progress.

Since his savaging by the reviewers, his sense of himself in the world had changed. His haste was aggravated by worries about his health and his finances; the route to his central preoccupations had become less direct. This was more a result of poetic conviction than practical necessity: in the unfinished 'Hyperion', and the wonderfully replete 'The Eve of St Agnes', he had deepened his arguments by diversifying them. Now, as he embarked on the next – and, as it transpired, last – stage of his evolution, the relationship between his fast-moving interior world and the steady march of external events became even more complex. Compared to the life he had led until his friendship with Hunt had faltered, his existence after the spring of 1819 seems enclosed. He was less obviously agitated by large events, and more concerned to reflect them in a complete philosophy of art. Long before he wrote about the abundant stillness of autumn, he had started to build the foundations of that peerless poem.

Before the spring was over, these changes were abruptly accelerated. Charles and Maria Dilke finally completed their move from Wentworth Place to Westminster (they held a 'claret feast' to mark the occasion), and the Brawne family became Keats's new neighbours, separated from him by no more than a thin dividing wall.[1] Since moving to Hampstead, and especially since Tom's death, Keats had grown increasingly close to the

Dilkes. Charles may sometimes have seemed rigidly idealistic and unimaginative, but he was a humane and warm-hearted friend. So was his wife. Together with Brown, they had done a great deal to help Keats recover from his loss. They were a surrogate family who never seemed unduly patronising or indulgent.

Yet Keats made no mention of missing them when they had gone; he just continued to dismiss Dilke's obsession with 'my Boy' as a 'farce'. This says something about his stubborn reluctance to discuss personal matters, and something about the way he saw children as an embodiment of the threats posed by domestic existence. It also implies that Fanny Brawne had now eclipsed everything else in his life. Until the end of June, when Brown planned to take his summer holiday and once again let his half of Wentworth Place, Keats expected to see her virtually every day. The afternoon after she had moved in next door, he took his Wylie brothers-in-law to dine with her, and the fact that he wrote no letters for the next ten days suggests that he was often in her company. Gittings, controversially, argues that Keats now revised the sonnet 'Bright Star' for her. More certainly, Keats lent Fanny books, discussed with her his own reading: Dryden – not so much the political invectives and satires as the addresses, odes and translations; and Robert Burton's *The Anatomy of Melancholy*.[2]

On the face of it, both were surprising choices. It was only two years since Keats had published in 'Sleep and Poetry' a vitriolic attack on the 'wretched rule / And compass vile' of Augustan writers, hoping to win Hunt's approval. Since his enthusiasm for Hunt had faded, and Hazlitt had recommended Dryden's translations of Boccaccio – calling him 'a bolder and more varied versifier than Pope' – he had redefined his opinions.[3] The attraction to Burton was puzzling in different ways: the *Anatomy* seethed with misogynistic prejudice that appeared to deny the validity of Keats's feelings for Fanny. That, however, seems to have been its attraction. Watching Fanny stroll in the gardens, hearing her moving and murmuring next door in Wentworth Place, Keats matched his pleasure in her closeness with his need for independence. As soon as he had read through the *Anatomy*, which Brown had given him, he went back to the beginning again, expanding the first notes he had made on the endpapers into a more detailed response.

Previous biographers, and especially Gittings, have rightly made much of these annotations – which are more local than is sometimes implied. Keats added almost no comments on the first two 'Partitions' of

the *Anatomy* but concentrated on the third, 'Love-Melancholy'.[4] Although his remarks are impossible to date precisely, they have a striking consistency. During this spring, and for much of the remainder of his life, he used the *Anatomy* as a highly selective kind of diary – a private and often extremely bilious grumble-book. Sometimes his remarks are self-goading or self-lacerating, as when he misquotes a line of Tasso – 'Cogliam la rosa d'amore' (let us pluck the rose of love) - beside some verses by Ausonius, then adds and heavily underlines 'ubique' (everywhere). (Perhaps he was half admitting that his visits to prostitutes did not end when he fell in love with Fanny.) More often, this mixture of vengefulness and remorse produces a sourer intolerance of women than any he had shown in his previous letters to Bailey or Reynolds. 'Aye aye', he writes at one point, beside one of Burton's attacks on marriage, underlining the sentence 'The hand of marriage is adamantine; no hope of loosing it; thou art undone.' Beside the passage 'An old, a grave, discreet man is fittest to discourse of love matters, because he hath likely more experience' he added: 'I could relate here a story or two about old women – Old men are innocents – old women are herodesses in these matters. Old Men let them pass with half attention but (not impiously I say it) old women like Mary lay out these things and ponder them in their hearts.' Similar thoughts flash and flare throughout the Partition. In the section 'Honest Objects of Love' Keats underlines 'Italian blaspheming, Spanish renouncing' and adds 'O that he had gone thr[o]ugh all the nations'. In 'How Love Tyraniseth over Men' he underlines 'That ferall melancholy which crucifies the soule in this life'. At the conclusion of Subsection Two, 'Love's Beginning, Object, Definition, Division', his rage overflows in a diatribe which summarises all these opinions. Combining self-loathing with suspicion, self-doubt with defiance, self-protection with hostility, it is the acid fruit of his 'certainty' that he did not have 'a right feeling towards Women':

Here is the old plague spot, the pestilence, the raw scrofula. I mean that there is nothing disgraces me in my own eyes so much as being one of a race of eyes nose and mouth beings in a planet call'd the Earth who all from Plato to Wesley have always mingled goatish, winnyish, lustful love with the abstract adoration of the deity . . . Has Plato separated these loves? Huh! I see how they endeavour to divide – but there appears to be a horrid relationship.

Several of these annotations, including this most violent outburst, date from a time when Keats's illness and his love for Fanny were both

more agonising. While it would therefore be wrong to say he lashed himself into a fury about women precisely as Fanny moved into the middle of his life, it is nevertheless clear that he armed himself against her arrival. His reaction exposes the tensions which had characterised the start of their relationship, and anticipates the worse clashes to come. Burton's view of melancholy was ornately presented but simple in essence: he saw the world in starkly binary terms, and promoted an idea of love 'madness' as a contagion. Keats's view of human nature was much more subtle, yet he sometimes found a bitter comfort in Burton's remarks. They offered the easy but unfulfilling option of living without negative capability.

Keats made no reference to Fanny in his letter to George. He could just as easily avoid mentioning her to his 'set'. Rice was ill, and the Saturday Club no longer met regularly. Haslam, like Reynolds, was kept busy by his work as a lawyer. Haydon was sulking and struggling to complete 'Christ's Entry'. In their place, Keats sought out others who were not likely to ask him difficult questions. Hunt came to dinner, and Brown invited their neighbour Davenport to meet him. (Davenport 'never ceased talking and boring' but Hunt took it as a compliment.) Two days later Keats met Hunt again, in Sir John Leicester's newly opened gallery in central London, where he encountered Haydon's pupil Bewick, and Novello's painter friend Hilton. That afternoon he dined with Dilke, and the following day went out again, this time to a party given by Dr Sawrey.

During this same burst of 'racketing' Keats also went to spend a day with Taylor and Woodhouse, saw a 'new dull and half damn[e]d opera', inspected a panorama of a polar expedition in Leicester Square and, unexpectedly but memorably, met Coleridge. Walking on 11 April 'towards Highgate' – where Coleridge had lived since 1816 – he entered Millfield Lane 'that winds by the side of Lord Mansfield's park' at Caen Wood, and found the poet 'in conversation' with Joseph Green. Green, who would eventually become one of Coleridge's literary executors, had been a demonstrator at Guy's, but even this could not prevent Keats from feeling that he might be an unwelcome interruption. He told George that he inquired 'by a look whether it would be agreeable' to join them, then ambled with them at Coleridge's 'alderman-after-dinner pace for near two miles'. In the course of this walk, Keats said, Coleridge 'broached a thousand things – let me see if I can give you a list

– Nightingales, Poetry – on Poetical sensation – Metaphysics – Different genera and species of Dreams – Nightmare – a dream accompanied by a sense of touch – single and double touch – A dream related – First and second consciousness – the difference explained between will and Volition – so m[any] metaphysicians from a want of smoking the second consciousness – Monsters – the Kraken – Mermaids – southey believes in them – southeys belief too much diluted – A Ghost story – Good morning – I heard his voice as he came towards me – I heard it as he moved away – I heard it all the interval – if it may be called so. He was civil enough to ask me to call on him at Highgate Good Night!'

Keats is amused and respectful here – aware that Coleridge was his poetic senior (he was twenty-four years older than Keats), and impressed by his powerful physical presence: corpulent, broad-shouldered, his hair grey and receding, his pale pudgy face expressing a striking mixture of melancholy and introspection. Coleridge later gave two accounts of the meeting, neither of which quite tallies with Keats's version. In one he is condescending, aware of his own celebrated genius, and describes Keats as 'A loose, slack not well-dressed youth'. Coleridge continues: 'He was introduced to me and stayed a minute or so. After he had left us a little way, he came back and said "Let me carry away the memory, Coleridge, of having pressed your hand".' Once Coleridge has established himself at the centre of his story, he becomes more concerned about Keats. He shakes him by the hand, watches him walk off, then turns to Green and says: 'There was death in that hand.'

Coleridge closes by saying: 'This was, I believe, before consumption showed itself distinctly.' His second account, recorded in conversation with John Frere in 1830, has the same general shape as the first and significantly intensifies his sense of foreboding. Coleridge is drawn into a very revealing and intelligent exploration of the idea that Keats had been killed by his reviewers:

Coleridge: Poor Keats, I saw him once. Mr Green . . . and I were walking out in these parts, and we were overtaken by a young man of very striking countenance whom Mr Green recognised and shook hands with, mentioning my name; I wish Mr Green had introduced me for I did not know who it was. He passed on, but in a few moments sprung back and said, 'Mr Coleridge, allow me the honour of shaking your hand.' I was struck by the energy of his manner, and gave him my hand. He passed on, and we stood still looking after him, when Mr Green said, 'Do you know who that is? That is Keats, the poet.' 'Heavens!' said I, 'when I

[366]

shook him by the hand there was death!' That was about two years before he died.

Frere: But what was it?

Coleridge: I cannot describe it. There was a heat and a dampness in the hand. To say that his death was caused by the Review is absurd, but at the same time it is impossible adequately to conceive the effect which it must have had on his mind. It is very well for those who have a place in the world and are independent to talk of these things, they can bear such a blow, so can those who have a strong religious principle; but all men are not born Philosophers, and all men have not those advantages of birth and education. Poor Keats had not, and it is impossible I say to conceive the effect which such a Review must have had upon him, knowing as he did that he had his way to make in the world by his own exertions, and conscious of the genius within him.[5]

Coleridge's memories of Keats were dominated by the sense of impending death. In fact their meeting coincided with a sudden improvement in Keats's health.[6] When Keats began writing to George again four days later, on 15 April, the depressed lassitude and effortful cogitation of mid-March had disappeared. He was brisk and braced, opening with a rapid summary of his recent socialising, including a warm reference to Reynolds, whose 'skit' on Wordsworth's 'Peter Bell' was soon to be published. Brown's nephews, who had been staying in Wentworth Place, are dismissed with a curt 'I shall not be sorry when they go'. Even a sudden rush of grief for Tom is filled with a more fierce passion than Keats had previously dared to show – though admittedly for a very particular reason. On a visit to Mrs Bentley in Well Walk, Keats had found the fake love letters sent by 'the degraded [Charles] Wells', alias the 'French admirer, Amena', to his brother Tom in Teignmouth. 'It is a wretched business,' Keats tells George. 'I do not know the rights of it – but what I do know would I am sure affect you so much that I am in two Minds whether I will tell you anything about it.' As he says this, the gloom of recent weeks becomes painfully stark, but rather than continuing to sap his identity, it goads and galvanises him. 'Any thing tho' it be unpleasant, that calls to mind those we still love, has a compensation in itself for the pain it occasions – so very likely tomorrow I may set about coppying thee whole of what I have about it: with no sort of a Richardson self satisfaction – I hate it to a sickness – and I am affraid more from indolence of mind than any thing else I wonder how people exist with all their worries.'

Keats was as good as his word. The next evening he read through the

whole correspondence between 'Amena' and Tom for the first time, and pronounced it a 'cruel deception' and a 'diabolical scheme'. 'It was no thoughtless hoax,' he said, repeating himself furiously, 'but a cruel deception on a sanguine Temperament, with every show of friendship. I do not think death too bad for the villain – The world would look upon it in a different light should I expose it – they would call it a frolic – so I must be wary – but I consider it my duty to be prudently revengeful. I will hang over his head like a sword by a hair. I will be opium to his vanity – if I cannot injure his interests – He is a rat and he shall have ratsbane to his vanity – I will harm him all I possibly can – I have no doubt I shall be able to do so – Let us leave him to his misery alone except when we can throw in a little more – '

Keats is never angrier than this in any of his letters, and although he did not carry out his threat to 'throw in a little more' misery on Wells – in fact he never mentioned him again – his rage was diverted into other channels. The 'Bam' had whipped his protective feelings into a frenzy. In the weeks and months to come, they would help to shape his growing resentment of his reviews, and his thoughts about love. The reviews were a false literary account: he could not bear to see their damage recreated in different terms. His feelings about Fanny were more solidly based than Tom's had been for 'Amena', but they created similar risks. The more Keats saw of Fanny, the more powerfully his worries about her power over him combined with his excitement about her nearness.

KEATS KNEW THAT his rage – exacerbated, perhaps, by his developing illness – was dangerously violent, and he dampened it with impatience and determination. Turning from his final word on Wells with no more than a dash, he suddenly told George: 'The fifth canto of Dante pleases me more and more', then introduced a sonnet on Paolo and Francesca that he had recently written. After the dearth of recent weeks, it was the latest of several poems he had produced in the past few days – all of them signs that his mood had altered significantly, and all (though he could not have realised it at the time) helping to prepare him for an extraordinary flowering of his genius. These recent poems had been occasional. 'Faery Bird's Song' was written at Brown's request to accompany a tale he was writing at the time, 'The Faery's Triumph'. It was a flimsily constructed story of loss and regeneration, and although Keats supported the progress of Brown's narrative in his lyric, it meant cutting across the grain of his feelings about Tom. 'Shed no tear!' he wrote, 'O, shed no

tear! / The flower will bloom another year.' In its companion piece, 'Faery's Song', the split between the demands of Brown's story and his own feelings is less marked. In a few slight lines, Keats at least allows himself to accept the inevitability of death.

'When they were come unto the Faery's Court', a longer piece written in rhyming couplets which owe something to Dryden, is the third in the series. Keats himself described it as 'a little extempore', elaborating on the characters Brown had created in his tale: an Ape, a Fool, a Dwarf and a Princess. It has been variously interpreted as a re-examination of his poetic conscience (the Princess representing Poetry, the Ape Words-worth, and the Fool Coleridge), or as a family joke (the Princess Georgiana, the Ape George, the Fool Tom and Keats the Dwarf). Both readings are justifiable. Emotionally speaking, the main interest of the poem lies elsewhere: in the fact that the Princess is vain, fashionable and peremptory, and that the male characters are all punished for breaking trivial social rules. 'Extempore' as they are, the lines relate to Keats's growing obsession with Fanny. The longing for revelation and the dread of reprisals are wound closely round each other:

> While the Dwarf spake the Princess all for spite
> Peeled the brown hazel twig to lily white,
> Clenched her small teeth, and held her lips apart,
> Tried to look unconcerned with beating heart.

Two other poems written at the same time are more knowing about their disclosures, and both continue to show the outline of serious anxieties through a veil of comedy. The first is an adaptation of Wordsworth's poem about Dover ('Dover! – who *could* write upon it?'). Taking its catalogue form as a model ('Haydon's great picture, a cold coffee pot / At midnight when the Muse is ripe for labour, / The voice of Mr Coleridge'[7]) Keats makes space to complain about the tensions in Wentworth Place – the reference to 'A damned inseparable flute and neighbour' is another snarl at Brown's irritating nephews. The sequel is a lighthearted retaliation against Brown himself for 'writing some spenserian stanzas against Mrs [and] Miss Brawne and me'. Keats understood that his friend enjoyed flirting, and appreciated that it was an aspect of his gusto. At the same time, he wanted to protect his own more tender feelings. He gently rebuffs Brown as he defines him by opposites, silently drawing on the thoughts which had been provoked

[369]

by the Valentine card Brown had sent to Fanny two months earlier:

> Ne with lewd ribbalds sat he cheek by jowl,
> Ne with sly Lemans in the scorner's chair,
> But after water-brooks this Pilgrim's soul
> Panted, and all his food was woodland air
> Though he would oft-times feast on gillyflowers rare.

In the poem about Paolo and Francesca, which Keats transcribed for George on the same day that he wrote out the 'Character of Charles Brown', these ambivalences show much more clearly. It is not one of his most perfectly realised sonnets, but is certainly one of his most compelling – a shapely space in which thoughts about Fanny, Brown, Wells, George and Georgiana all combine to produce an honest confusion of desire and dread. The influence of Coleridge is once again obvious. Even though Keats had not mentioned 'Kubla Khan' in the list of subjects covered during their 'conversation' on the Heath – though Coleridge had touched on dreams and nightmares – Keats certainly knew the poem, and had seen it harshly reviewed as 'nonsense' by Hazlitt in the *Examiner*. Indeed, his own poem seems to have begun with a laudanum-inspired dream – a dream he had 'enjoyed' after 'many [recent] days' of labouring on his lyrics 'in rather a low state of mind'. On one of these days he had visited Fanny and read with her the fifth Canto of the *Inferno*, dwelling on the lines that had inspired Hunt's *Rimini*, in which Dante describes Paolo and Francesca falling in love as they read the story of Launcelot and Guinevere. When he went back to his half of Wentworth Place and fell into a dream-filled sleep, all his tensions were briefly resolved. 'The dream', he told George, 'was one of the most delightful enjoyments I ever had in my life – I floated about the whirling atmosphere as it is described with a beautiful figure to whose lips mine were joined [as] it seem'd for an age – and in the midst of all this cold and darkness I was warm – even flowery tree tops sprung up and we rested on them sometimes with the lightness of a cloud till the wind blew us away again – I tried a Sonnet upon it – there are fourteen lines but nothing of what I felt in it – o that I could dream it every night –

> As Hermes once took to his feathers light
> When lulled Argus, baffled, swoon'd and slept
> So on a delphic reed my idle spright

So play'd, so charm'd so conquer'd, so bereft
The dragon world of all its hundred eyes
And seeing it asleep so fled away: –
Not to pure Ida with its snow cold skies,
Not unto Tempe where Jove grieved that day,
But to that second circle of sad hell,
Where in the gust, the whirlwind and the flaw
Of Rain and hailstones lovers need not tell
Their sorrows – Pale were the sweet lips I saw
Pale were the lips I kiss'd and fair the fo[r]m
I floated with about that melancholy storm – '[8]

Keats was disappointed by the differences between his dream and his poem.[9] The transition from experience to art provokes a storm of literary associations, and his slumbering 'lightness' is weighed down with conscious memories of Shakespeare (*Measure for Measure*), Coleridge ('Kubla Khan'), Hunt (*Rimini*), Dante himself, and his own sleet-spattered lovers in 'The Eve of St Agnes'. In another sense, however, the disparity turns out to be valuable: it gives him the chance to subtilise the 'delight' of the original experience. This is immediately noticeable in the reference to Hermes and Argus. While alluding to the deceitful liaison between Io and Jove,[10] Keats omits the details of the seduction, creating a sense of withheld excitement which feeds on his desire for Fanny and on the fear that his feelings will be discovered. This becomes more obvious when the poem moves to Paolo and Francesca themselves. The opening lines dramatise the danger of the hundred-eyed 'dragon world', and therefore quicken Keats's flight into an alternative, imaginative realm where 'lovers need not tell / Their sorrows'. Yet the pleasure of secrecy and of kissing 'the sweet lips' is precarious. Francesca had been condemned to the second circle of hell by Dante for committing adultery with the brother of her husband. Keats might sympathise with her, but he knows she cannot alter her situation or evade her punishment. Her lips are 'pale', and the enfolding storm is 'melancholy'. She inhabits a world of guilt, as well as gratification.

And a world of death as well as life. In this respect, Keats's sonnet anticipates the next poem he wrote, 'La Belle Dame Sans Merci'. These are separated by five days in which he was swept up by a 'whirlwind' of a different sort – a hectic social round which seemed more likely to shatter

his concentration than focus it. He went with Reynolds and Rice to see Daniel Terry's opera *The Heart of Midlothian*. He called on Taylor and Woodhouse and handed over a manuscript of 'Hyperion', 'The Eve of St Agnes' and 'The Eve of St Mark'. He went with Brown to a card party given by Mrs Wylie. On the 19th he saw Reynolds again, this time at Wentworth Place, and was persuaded to ask Hunt whether he could review the parody 'Peter Bell' in the *Examiner*. By the time he picked up his letter to George and Georgiana again, on 21 April, he said that he was 'so fat[i]gued' that he 'could not write a line'. Within a few moments, he was transcribing one of the most loved and celebrated poems he ever composed:[11]

> O what can ail thee, knight at a[r]ms,
> Alone and palely loitering?
> The sedge is withered from the Lake,
> And no birds sing!
>
> O what can ail thee, knight at a[r]ms,
> So haggard and so woe begone?
> The squirrel's granary is full
> And the harvest's done.
>
> I see a lilly on thy brow
> With anguish moist and fever dew,
> And on thy cheeks a fading rose
> Fast Withereth too –
>
> I met a Lady in the Meads
> Full beautiful, a faery's child
> Her hair was long, her foot was light
> And her eyes were wild –
>
> I made a Garland for her head,
> And bracelets too, and fragrant Zone
> She look'd at me as she'd did love
> And made sweet moan –
>
> I set her on my pacing steed
> And nothing else saw all day long
> For sidelong would she bend and sing
> A faerys song –
>
> She found me roots of relish sweet
> And honey wild and manna dew

And sure in language strange she said
 I love thee true –

She took me to her elfin grot
 And there she wept and sigh'd full sore
And there I shut her wild wild eyes
 With kisses four.

And there she lulled me asleep
 And there I dream'd Ah Woe betide!
The latest dream I ever dreamt
 On the cold hill side

I saw pale kings and Princes too
 Pale warriors death pale were they all
They cried La belle dame sans merci
 Thee hath in thrall.

I saw their starv'd lips in the gloam
 With horrid warning gaped wide
And I awoke and found me here
 On the cold hill's side

And this is w[h]y I sojourn here
 Alone and palely loitering;
Though the sedge is wither'd frome the Lak[e]
 And no birds sing – –

Like 'A Dream', 'La Belle Dame Sans Merci' reverberates with literary echoes: of Alain Chartier's medieval French poem, which provides the title; of Dante; of Spenser; of Thomas Browne; of Burton; of Voltaire; of Wordsworth; and, once again, of Coleridge. These have been extensively explored over the years,[12] but whereas some parts of 'A Dream' are made obscure by its bookish references, 'La Belle Dame' is clarified by them. Always admitting that it belongs within the traditions of a quasi-mythical romance, and invoking well-established images of women-temptresses and pale victims, it creates surfaces of beguiling simplicity, through which readers peer into states of great emotional complexity. These states become more definite if we approach the poem not through an account of Keats's reading, but through his recent remarks about 'uneasy indolence' and sexual uncertainty. It is the climax of his effort to control his depression by allowing its subconscious sources to reveal themselves, a process which was

stimulated by laudanum in 'A Dream', and is now developed by different means.

All the same, the conscious structure of 'La Belle Dame' is carefully organised. In the first three stanzas Keats introduces the 'haggard' and 'woe begone' knight: whatever 'harvest' might have been collected in his surrounding landscape is 'done'. In the next nine stanzas the knight himself speaks, answering, in so far as he can, his own and his creator's questions about the reasons for this condition. Announcing (with no sense of surprise) that he met 'a lady' who was also 'a faery's child', he remembers that during their encounter he behaved as though he controlled his own fate. 'I made a Garland', he says, and 'I set her on my pacing steed'. The lady then takes the initiative, finding him 'roots of relish sweet', telling him she loves him, taking him to her 'elfin grot', and lulling him into a dream. Before he goes under, he briefly asserts himself again – or possibly colludes with his fate – by shutting her 'wild wild eyes / With kisses four'. In his dream, he sees those whom the lady has previously enthralled, trooping in a 'death pale' melancholy procession. When he wakes, agitated by feelings which combine mortal horror with sexual jealousy, he finds himself in the bleak present from which the whole poem is spoken, 'Alone', as he had said at the outset, and 'palely loitering'.

By echoing the opening of the poem at its close, the knight implies that he has reached a desolate conclusion. 'And this is why I sojourn here', he says, implying that he is giving a plain explanation. But it is an explanation which raises as many questions as it solves: questions about his state of mind, about the reason why he continues to 'loiter', and about why he has pursued his 'Lady' in the first place. Since the poem is self-evidently a story (a dramatisation of something internal), it is difficult to address these issues without thinking how they apply to the narrator, as well as to the knight.

Some of its preoccupations are relatively clear. The narrative of love-sickness, thralldom and doomed waiting depends to a great extent on Keats's feelings about Fanny, on his memories of Tom (as the victim of Wells's hoax, and as a patient), and on worries about his physical condition. It has become a commonplace for critics to associate the pale knight with the ailing poet, and the lady with Fanny, or with Keats's mother, or with love, or with death.[13] When the knight-writer meets the lady he confronts the forces which both inspire and blight him. By squaring up to the 'great central themes of love, death and immortal-

ity',[14] Keats undertakes the same journey into maturity that he regularly makes in his letters.

These readings of the poem all tend to the same conclusion. They suggest that its final purpose is to register dismay at the wasting power of sexual attraction and love, and they describe a corresponding enslavement of the poet by his muse. This accentuates Keats's belief that suffering cannot be avoided; it also implies that the poem cannot look beyond self-pity. Like Saturn and Hyperion, and possibly like Lycius in the later 'Lamia', its narrators recognise but cannot embrace the truth of the human condition. They cannot 'die into life', or become the kind of creator-physician which *Endymion* and 'Hyperion' both hold up as their ideal.

Interpreting 'La Belle Dame' in this way emphasises the consistency of Keats's poems: the knight is a descendant of Calidore, a questing solitary whose purpose becomes more definite as his experience increases. As it does so, however, it draws our attention away from the different kind of deliberation which appears in the fourth, fifth and sixth stanzas of the poem, and then again – briefly – in the eighth. If we grant these stanzas the significance they deserve, the knight no longer appears a merely passive sufferer, seduced and enthralled. He becomes someone who creates his own fate.

His intention might be simply to accept a loss which, though melancholy, is comparatively content with the terms of its discontent. However, the desolation of the poem is too palpable for this to seem a safe conclusion, and the knight's state of knowledge too partial. It is more revealing, and more sympathetic to the mood of the poem, to argue that the knight acts with greater deliberation. He pursues the lady not in the vague hope that he might possess her happily where other 'pale' predecessors have been disappointed, but in the certain knowledge that he is bound to fail. He provokes his suffering, so that he can become one of those who know that love is an illness, and that women are either a fantasy or a bad dream.[15] This makes the knight's final explanation – 'And this is why I sojourn here' – more comprehensible and more resolute. It suggests that he has devised his suffering not just to acquire experience, but so that he can feel confidently an outcast. The torments of isolation from women are preferable to the agonies of involvement with them.

This reading of 'La Belle Dame' makes it seem much more cynical than is generally supposed. It also casts a revealing light on its main

inspiration: Keats's indecision about Fanny Brawne. The poem does more than express grim anxieties about the identity-sapping powers of love. It seeks to escape them entirely. In the weeks and months after finishing the poem, Keats certainly tried to do this himself – removing himself from Wentworth Place, on one occasion refusing to see Fanny when he briefly returned to London, and all the time devoting himself to the writing which he feared his thralldom would compromise or crush. In a sense, therefore, 'La Belle Dame' is a prognosis as well as a diagnosis. It is invariably treated as a form of superior mystery story, focusing on the identity of the lady. It is, just as importantly, an inquiry into the character of the knight.[16]

THIRTY-THREE

NO SOONER HAD Keats written out 'La Belle Dame' for George and Georgiana, than he skipped away from it, joking about its 'kisses four', then immediately transcribing another poem, the 'Song of Four Fairies'. Its couplets describe a much less intense world than his ballad – but, for all that, certain similarities exist. Burton, who had been one of the sources for the earlier poem, appears here too, as Keats blends the spirits of fire, air, earth and water with the humours discussed in *The Anatomy of Melancholy*. While the 'faeries' reveal their individual characters, and the ways in which their elements complement or cancel each other, they create a little allegory of sympathies: a story of how people find the lover to suit them. Dusketha (earth), for instance, says to Salamander (fire):

> By thee, Sprite, will I be guided!
> I care not for cold or heat;
> Frost or flame, or sparks, or sleet,
> To my essence are the same –
> But I honour more the flame.

Although Keats offered this poem to his brother casually, it confirms that his days of lassitude were over. In the opening lines he is even self-confident enough to quote cheerfully from a poem by Byron, the poet who had dogged him during his depression. When he dropped into prose again, his energy still blazed fiercely. Harking back to the last sustained instalment of his letter, in which he had wondered whether poetry 'is not

so fine a thing as philosophy', he produces a short essay on human progress – an essay fuelled by his recent rereading of Robertson's *The History of America* and Voltaire's *Le Siècle de Louis XIV*.

Keats begins by sounding embattled. Robertson, he says, reckons the experience of emigrants is 'lamentable' because even when they have escaped the 'injuries' of an oppressive regime at home, they are 'destined to hardships and disquietudes of some other sort. If [Man] improves by degrees his bodily accommodations and comforts – at each stage, at each ascent, there will be waiting for him a fresh set of annoyances'. Like the corresponding evidence that Voltaire gives of life under Louis XIV, this reinforces Keats's doubts about 'perfectability'. At the same time, it reminds him to explore the purpose of suffering:

Call the world if you Please 'The vale of Soul-making'[.] Then you will find out the use of the world (I am speaking now in the highest terms for human nature admitting it to be immortal which I will here take for granted for the purpose of showing a thought which has struck me concerning it) I say '*Soul making*' Soul as distinguished from an Intelligence – There may be intelligences or sparks of the divinity in millions – but they are not Souls till they acquire identities, till each one is personally itself. I[n]telligences are atoms of perception – they know and they see and they are pure, in short they are God – how then are souls to be made? How then are these sparks which are God to have identity given them – so as ever to possess a bliss peculiar to each ones individual existence? How, but by the medium of a world like this? This point I sincerely wish to consider because I think it a grander system of salvation than the chrystian religion – or rather it is a system of Spirit-creation – this is effected by three grand materials acting the one upon the other for a series of years – These three Materials are the *Intelligence* – the *human heart* (as distinguished from intelligence or Mind) and the *World* or *Elemental space* suited for the proper action of *Mind and Heart* on each other for the purpose of forming the *Soul* or *Intelligence destined to possess the sense of Identity*. I can scarcely express what I but dimly perceive – and yet I think I perceive it – that you may judge the more clearly I will put it in the most homely form possible – I will call the *world* a School instituted for the purpose of teaching little children to read – I will call the *human heart* the *horn Book* used in that School – and I will call the *Child able to read, the Soul* made from that *school* and its *hornbook*. Do you not see how necessary a World of Pains and troubles is to school an Intelligence and make it a soul? A Place where the heart must feel and suffer in a thousand diverse ways! Not merely is the Heart a hornbook, It is the Minds Bible, it is the Minds experience, it is the teat from which the Mind or intelligence sucks its identity – As various as the Lives of Men are – so various become their souls, and thus does God make individual beings, Souls,

[377]

Identical Souls of the sparks of his own essence – This appears to me a faint sketch of a system of Salvation which does not affront our reason and humanity –

During his time at Guy's, Keats had groped towards understanding the reasons for suffering. With Bailey in Oxford, studying Bishop Butler's *The Analogy of Religion*, he had discovered concepts and phrases which never ceased to echo within him. (Butler's idea that 'Our nature corresponds to our external condition' reverberates in this very letter.[1]) Listening to Hazlitt he had cultivated the idea of disinterestedness. Reading Dante and Milton he had enlarged his understanding of 'fine energies' in 'eternal fierce destruction'. Together with other influences, including Hunt's and Haydon's, these things had coalesced into speculations which sustained him while he 'strain[ed] at particles of light in the midst of a great darkness'. As he summarised them for George in this letter, they may not have had the same precisely political application that he envisaged in his earliest poems. But they embodied all his original liberal sympathies, turning away from a fixed and schematic 'notion' of organised religion to promote a 'system of Salvation' which made individuals responsible for their own destinies.

Keats says these ideas are especially valuable for 'the Salvation of children': he was thinking of their shared schooldays, and of the 'little nephews' that would one day constitute his family across the Atlantic. He then expands his thoughts further, emphasising the connection between 'soul-making' and 'identity'. ' – I mean, I began by seeing how man was formed by circumstances – and what are circumstances? but touchstones of his heart – ? and what are touchstones? – but proovings of his hearrt? – and what are proovings of his heart but fortifiers or alterers of his nature? and what is his altered nature but his soul? – and what was his soul before it came into the world and had These provings and alterations and perfectionings? – An intelligence – without Identity – and how is this Identity to be made? Through the medium of the Heart? And how is the Heart to become this Medium but in a world of Circumstances?'

In 'La Belle Dame' Keats had recently brought a poem full circle so as to confirm that it was packed with ambiguities. Here he draws his argument back on itself in order to define the clear trajectory of his thought. Marking another distinct phase in his life, he prepares for another deliberate step forward. He had worked his most painful feelings

about Tom into a mature philosophy of suffering. He had achieved a precarious stability in his thoughts about love. He had accepted, by the end of the month, that he had outgrown 'Hyperion' and was ready for a new challenge.

THE NEXT FOUR poems that Keats wrote were different kinds of preparation for what turned out to be his main effort: the 'Ode to Psyche', which he described as the 'first' and 'only' poem 'with which I have taken even moderate pains'. They were sonnets, variations on the same form that he had used in Margate and the Isle of Wight as a means of steadying himself. The first, 'To Sleep' (written in late April) seems to refer to the indolence he had mentioned to George the previous month. In fact it describes a completely different mood – one which looks forward to 'divine forgetfulness' rather than a creative trance. In a sense, though, it does so ambiguously. It hankers after a calm nowhere, accepting that the pains of 'curious conscience' cannot be deferred indefinitely. The form animates this two-mindedness. For all the delicious drowsiness of the lines, their rhymes work hard to modify the Shakespearean form, avoiding the final couplet to convey a sense of irresolution and openness:

> Then save me, or the passèd day will shine
> Upon my pillow, breeding many woes;
> Save me from curious conscience, that still hoards
> Its strength for darkness, burrowing like the mole;
> Turn the key deftly in the oilèd wards,
> And seal the hushèd casket of my soul.

The second sonnet, 'If by dull rhymes', addresses the issue of form more directly, as Keats pointed out before transcribing it for George. 'I have', he said, 'been endeavouring to discover a better sonnet form than we have. The legitimate [Petrarchan sonnet] does not suit the language over-well from the pouncing rhymes – the other kind [the Shakespearean] appears too elegiacal – and the couplet at the end of it seldom has a pleasing effect.' Keats sounds here as though his aim is to find a middle way – which is reasonable enough, since for all its impatience with convention, the poem in fact continues to use five rhymes, as does a Petrarchan sonnet proper. Its argument, however, is more radical. Adapting the images of binding from 'La Belle Dame', Keats deplores

[379]

the fact that 'our English' has been 'chained', and the sonnet form 'fettered', hinting that there is a connection between literary and social liberty. He had made the same association in earlier poems which sought to promote Hunt's 'new Renaissance', and in his next two poems, both called 'On Fame', he develops complementary thoughts about audience and reputation. The first promotes the idea that Fame is counter-suggestive, resisting any direct approach and only rewarding those 'she likes'. The second looks with slightly scornful wonder on 'the man' who 'vexes all the leaves of his life's book' to pursue something unbiddable:

> It is as if the rose should pluck herself,
> Or the ripe plum finger its misty bloom,
> As if a Naiad, like a meddling elf,
> Should darken her pure grot with muddy gloom.

In these lines, Keats confirms his ambition (his appeal to posterity became increasingly emphatic as he failed to find short-term success), and asserts his necessary independence. If he is to make his name as a poet, he says, it will be because he develops his individual gifts, rather than adapting them to suit the expectations of a 'fierce miscreed'. He pledges his loyalty to an aesthetic which is highly personal, rather than one which is determined by conventional readers or specific social forces. Not merely personal, indeed, but erotic. As we realise this, we discover a connection in the poem between his thoughts about the reception of his work in general, and his thoughts about the reception of his self in particular.[2] Fame in the first sonnet is 'a wayward girl' who is 'coy' to those who are 'slavish'. She is a 'gipsy', Keats says, and a 'jilt' who turns her pursuers into 'madmen': 'Ye artists lovelorn! madmen that ye are, / Make your best bow to her and bid adieu – / Then, if she likes it, she will follow you.' In theory, it should be possible for him to comfort himself at this point by saying that because a woman depends on him for pleasure, she confirms his dominance. In fact he is more concerned that 'she' – and indeed all his women readers, including Fanny – will deny his authority by refusing him. The poem contains more dread and resentment than it does ambition. It is written by a 'knight' who finds little reward in his isolation. The second sonnet confirms this. Here the dependency on fame produces illness: the man is 'fevered', imitating certain masturbatory self-fingerings. It is a condition which Keats regards as distinctly unnatural ('But the rose leaves

[380]

herself upon the briar'), and finally convinces him to reassert the conclusion of the first sonnet. It is only by resisting the temptation to tease 'the world for grace' that poets can achieve their ambitions. Identity depends on calm self-possession.

These poems once again show Keats insisting on the need for negative capability. A letter to his sister Fanny, written within a few days of their completion, makes the same point much more lightly. He sympathises with her polite confinement at Walthamstow, and promises that when the weather allows he will 'put on a pair of loose easy palatable boots and me rendre chez vous', collecting some 'seasonable plants' for her from 'the tottenham nursery'. The prospect leads to an outburst of affectionate rhyming, a piece of doggerel which, after pattering lightly over worries about money and the Abbeys, ends with a confirmation of the link between natural and creative life. It is a little gathering of every-day pleasures which is also a trove of delightful subjects:

> Two or three smiles
> And two or three frowns –
> Two or three miles
> To two or three towns –
> Two or three pegs
> For two or three bonnets –
> Two or three dove's eggs
> To hatch into sonnets.

THIRTY-FOUR

KEATS HAD FINALLY shaken off his depression. He felt well. His appetite for work had returned. So had his pleasure in living. During the first week in May, his high spirits overflowed in another letter to his sister. 'O there is nothing like fine weather,' he said, 'and health, and Books, and a fine country, and a contented Mind, and Diligent habit of reading and thinking, and an amulet against the ennui – and, please heaven, a little claret-wine cool out of a cellar a mile deep – with a few or a good many ratafia cakes – a rocky basin to bathe in, a strawberry bed to say your prayers to Flora in, a pad nag to go you ten miles or so; two or three sensible people to chat with; two or th[r]ee spiteful folkes to spar with; two or three odd fishes to laugh at and two

or three numskuls to argue with – instead of using dumb bells on a rainy day – '

After skittishly taking his leave of his sister, Keats briefly disappeared from his family and his friends' lives. ('Good bye I've an appoantment – can't stop pon word – good bye – now dont get up – open the door myself – go-o-o d bye – see ye Monday.') Only four brief notes survive from the whole month of May – two of them also to Fanny Keats, one to Haslam and one to his publisher. His silence was not a sign of inactivity. Before closing his letter to George on 3 May, he had already composed his 'Ode to Psyche'. It was the first of a series of poems he produced during the next four weeks, poems which would eventually win him the immortal fame he longed for.

Keats himself felt some measure of indifference to his odes. After they were done, he reverted to more obviously argumentative, dramatic, and narrative styles, as though what he had written failed to fulfil his ambitions. Yet in their different ways, the odes are all concerned with the same ideas that dominate his earlier and later work.[1] They investigate the value and nature of the creative process and the role played by negative capability. They explore the relation between conscious and unconscious forces, between art and life, and between 'philosophy' and 'sensation'. They parallel sexual feelings with mental activity. They struggle to transcend time, and are fully aware of being written within time. As their themes mingle and clash, they create an extraordinary combination of inwardness and sociability. Contemplating Psyche, examining the Grecian urn, listening to the nightingale, investigating melancholy, analysing indolence, Keats defines his individual self while registering his dependence on surrounding conditions. His pursuit of 'beauty' and 'truth' is both a lament for lost ideals and a celebration of their transfigured continuance. His attraction to flight is grounded in his determination to work out a salvation. His dreams are gorgeous and seductive, but are finally judged to be dangerous or actually 'deadly'.[2]

Rehearsing these common properties suggests that the odes comprise some kind of 'sequence'.[3] This is justifiable, since Keats's thoughts develop distinctly from poem to poem – but the idea needs careful handling, since we do not know precisely the order in which they were written.[4] Their formal properties give some clues. Following the 'Ode to Psyche', which we see from Keats's letter to George was written between 21 and 30 April, the stanza form of the 'Ode to a Nightingale' has a shorter eighth line than the 'Ode on a Grecian Urn', the 'Ode on

Ode To Psyche

O Goddess! hear these tuneless numbers, wrung
 By sweet enforcement, and remembrance dear,
And pardon that thy secrets should be sung
 Even into thine own soft-conched ear!
Surely I dreamt to day; or did I see,
 The winged Psyche, with awaken'd eyes?
I wander'd in a forest thoughtlessly,
 And on the sudden, fainting with surprise,
Saw two fair Creatures couched side by side,
In deepest grass, beneath the whispering fan
Of leaves and trembled blossoms, where there ran
 A Brooklet scarce espied:

'Mid hush'd, cool-rooted flowers, fragrant eyed,
 Blue, silver-white, and budded syrian,
They lay, calm-breathing on the bedded grass,
 Their arms embraced and their pinions too,;
Their lips touch'd not but had not bed adieu,
 As if disjoined by soft handed slumber,
And ready still past kisses to out number
 At tender ~~dawning~~ eye-dawn of amorian Love —
The winged Boy I knew:
But who wast thou O happy happy dove?
 His Psyche true!

O latest born, and loveliest vision far
 Of all Olympus' faded Hierarchy!
Fairer than ~~Phœbe's~~ sapphire-region'd Star,
 Or Vesper amorous glow worm of the sky;

11 'Ode to Psyche'; Keats's draft.

Fairer than these though Temple thou hast none,
Nor Altar heap'd with flowers;
Nor Virgin Choir to make melodious moan
Upon the midnight hours;
Nor voice, nor lute, nor pipe, nor incense sweet
From chain-swung Censer teeming,
Nor Shrine, nor grove, nor Oracle, nor heat
Of pale-mouth'd Prophet dreaming.

O Bloomiest! though too late for antique vows
Too, too late for the fond believing Lyre,
When holy were the haunted forest-boughs,
Holy the air, the Water, and the Fire:
Yet even in these days so far retir'd
From happy Pieties, thy lucent fans,
Fluttering among the faint Olympians,
I see, and sing by my own eyes inspired.
O let me be thy Choir and make a moan
Upon the midnight hours;
Thy Voice, thy lute, thy Pipe, thy incense sweet
From thy swinged Censer teeming;
Thy Shrine, thy Grove, thy oracle, thy heat
Of Pale mouth'd Prophet dreaming!

Yes, I will be thy Priest and build a Fane
In some untrodden Region of my mind,
Where branched thoughts, new grown with pleasant pain
Instead of Pines shall murmur in the wind.
Far, far around shall those dark-cluster'd trees
Fledge the - wild ridged mountains steep by steep;
And there by Zephyrs, streams, and birds and Bees
The moss-lain Dryads shall be lull'd to sleep.
And in the midst of this wide Quietness
A rosy sanctuary will I dress
With the wreath'd trellis of a working brain,
With buds and bells and stars without a name,
With all the gardener Fancy e'er could feign,
Who breeding flowers will never breed the same
~~Who plucking a thousand flowers and never plucks the same~~
~~So bower'd a Goddess while I was but then~~

And there shall be for thee all soft delight
That shadowy thought can win,
A bright torch, and a casement ope at night
To let the warm Love glide in.

Melancholy' and the 'Ode on Indolence', suggesting that it precedes them. However, the 'Nightingale's' reference to the musk-rose as 'mid-May's eldest child', and to hawthorn, seems to undermine this evidence, and suggest a later dating.[5] In the absence of any further proof, it seems sensible to follow the logic of evolving thought, rather than anything else. The poems form a sequence which does not quite deserve the name. They are a fluid narrative of self-definition which, like everything else Keats wrote, depends for its sense of progress on each step forward being questioned, contradicted, and modified.

While 'Psyche' has a clear place in the series, its mythical references have become obscure to many readers. Keats himself anticipated this, introducing the poem to George and Georgiana by saying that the 'pains' he had taken with it made it 'read the more richly', and hastily reminding them: 'You must recollect that Psyche was not embodied as a goddess before the time of Apuleius the Platonist who lived after the A[u]gustan age, and consequently the goddess was never worshipped or sacrificed to with any of the ancient fervour – and perhaps never thought of in the old religion – I am more orthodox tha[n] to let a he[a]then Goddess be so neglected.' Although Keats does not say so, it is probable that he had turned back to Lemprière for this information – Lemprière who describes Psyche as 'a nymph whom Cupid married and carried into a place of bliss', who was condemned to death by Venus because she 'had robbed the world of her son', and who was 'granted immortality by Jupiter at the request of Cupid'.[6] She 'signifies', Lemprière continues, '*the soul*', and is usually represented as a butterfly to 'imitate the lightness of the soul', whereas Cupid (and here Keats relies on Spence, another of his schoolboy sources) is identified with Eros and generally depicted as a child. In his earlier treatment of the myth, in 'I stood tip-toe . . . ', Keats had concentrated on the apotheosis of Psyche. In the ode he assumes that she is already a goddess,[7] embodying ideas which Keats had recently developed in his remarks about 'fellowship with essence' and the vale of soul-making. Her travails – 'left alone', as Apuleius says, 'weeping and trembling on the toppe of the rocke'[8] – exemplify the kind of suffering which can 'school an intelligence and make it a soul'.

When the poem first introduces Psyche and Cupid, they are 'calm-breathing', suspended as the lovers on the Grecian urn soon will be:

> Their arms embraced, and their pinions too;
> Their lips touched not, but had not bade adieu,

As if disjoinèd by soft-handed slumber,
And ready still past kisses to outnumber
 At tender eye-dawn of aurorean love.

Compared to these luxuriating figures, the poet-narrator seems troubled
– conscious that his words are 'tuneless', worried that he might seem like
a voyeur, and concerned that his creative 'thoughtlessness' should have
been interrupted by a sight which leaves him 'fainting with surprise'.
Briefly, he recovers his composure by saying that he recognises Cupid,
then asks himself a question – 'Who wast thou, O happy, happy dove' –
to which he perfectly well knows the answer: 'His Psyche true'. It is a
delaying tactic, and in the second stanza it allows him to reflect that while
his initial identification was with Cupid, his deeper association is with
the goddess:

O latest born and loveliest vision far
 Of all Olympus' faded hierarchy!
Fairer than Phoebe's sapphire-regioned star,
 Or Vesper, amorous glow-worm of the sky;
Fairer than these, though temple thou hast none,
 Nor altar heaped with flowers;
Nor virgin-choir to make delicious moan
 Upon the midnight hours;
No voice, no lute, no pipe, no incense sweet
 From chain-swung censer teeming;
No shrine, no grove, no oracle, no heat
 Of pale-mouthed prophet dreaming.

Psyche is presented here, and correctly according to Apuleius, as a
latecomer whose lack of traditional honouring Keats seeks to recom-
pense. He implies, too, some correspondence between her being the
'latest born' of the goddesses, and her being the 'loveliest'. He then
repeats the idea at the beginning of the third stanza, calling her
'brightest'. It is too banal to suggest that Keats is simply thinking about
Fanny, saying that her beauty is more remarkable than any he has known
previously. It is more revealing to say that he develops the connection
between Psyche and his own identity. Keats sees himself, like the
goddess, as a kind of arriviste, struggling to find a place in the 'hierarchy'
of poetry without the 'privileges of birth and education', as Coleridge
called them. By becoming Psyche's 'choir' in the third stanza, Keats

[387]

makes this association explicit, pointing up their shared vulnerability. He also accepts that he and the goddess are engaged on a similar purpose: to bring the 'happy pieties' of the Classical past into the degenerate present, and to recreate a time 'When holy were the haunted forest boughs'. In *Poems* (1817), Keats had imagined these 'pieties' as essential to a second literary Renaissance. In *Endymion*, though, he had woven them into a more complex social vision, an ideally integrated community whose beliefs represented an appeal over the head of the present to a liberal and humane past. Because Psyche has been born 'too late for antique vows', she prizes these ancient virtues with particular urgency. Her lack of fixity makes her all the more exemplary.

Once these links are established, Keats is 'nerved' to enter the centre of his poem, internalising Psyche's classical functions in its enthralling final stanza:

> Yes, I will be thy priest, and build a fane
> In some untrodden region of my mind,
> Where branchèd thoughts, new grown with pleasant pain,
> Instead of pines shall murmur in the wind:
> Far, far around shall those dark-clustered trees
> Fledge the wild-ridgèd mountains steep by steep;
> And there by zephyrs, streams, and birds, and bees,
> The moss-lain Dryads shall be lulled to sleep;
> And in the midst of this wide quietness
> A rosy sanctuary will I dress
> With the wreathed trellis of a working brain,
> With buds, and bells, and stars without a name,
> With all the gardener Fancy e'er could feign,
> Who breeding flowers, will never breed the same:
> And there shall be for thee all soft delight
> That shadowy thought can win,
> A bright torch, and a casement ope at night,
> To let the warm Love in!

In certain respects, this last stanza is a revision of the first. The remembered bower, with its tenderly loving couple, becomes an inner shrine where the priest takes on some of the character of Cupid. This second sanctuary offers more than private pleasures. Like the troubled 'centre of repose' described in 'Hyperion' (I, 243), it is a palpable mind, a 'working brain' such as Keats had studied as a doctor, and which he

presents in complicatedly detailed and physical terms.[9] He turns the nowhere of the imagination into an anatomical somewhere – virgin but possessed, mysterious but lit. His brilliantly managed combination emphasises the ambiguities of the opening stanza, in which it is not clear whether Keats has seen the lovers in a dream or with 'awakened eyes'. It drags readers down through details of the scene, concentrating their attention on the elements that Keats and Psyche have in common. Just as Psyche creates herself by her actions and their often painful consequences, so Keats authorises himself by his efforts as a poet. Both are self-made. Both define themselves as novelties in order to amass the burden of an admired past. Both are soul-makers.

Saying this makes it sound as though the 'Ode to Psyche' is broadly optimistic. It implies a successful penetration of the darkness which lies beyond the chamber of maiden thought, and a happy pairing of body and spirit, nature and fancy. The closing lines of the poem, however, with their reference to 'shadowy thought', are ambiguous. By building a 'fane' to Psyche 'In some untrodden region of my mind', Keats creates a tribute which is valuable because it is absolutely sincere, but at the same time incomplete because it is not 'real'. Its essential character is also its limitation. This contradiction is confirmed by the texture of the writing itself. It is marvellously 'warm' but always consciously artful, and has led some readers to feel that it exemplifies 'brio' rather than something more authentically Keatsian.[10] One might equally well say that its 'new' language is something Keats had laboured to produce all his writing life. The lines may lack the blushful waywardness of *Endymion*; they still seem to surprise themselves and their author. They are too packed with ambivalences to do otherwise.

THE 'Ode on a Grecian Urn' makes a more calculated inquiry into the function of art – and of its relation to life. Like 'Psyche', it dramatises its effort by continuing the formal experiments that Keats had announced in his April sonnets, alternating between hymn and argument, and introducing two voices to dramatise its dialectic. Also like 'Psyche', it combines general truths with personal experience, concentrating on the relationship between what is real and what is ideal, on what can be endured in life and what can be compensated for by the imagination. The title and publication history of the poem help to clarify this. An ode 'on' rather than 'to' a Grecian urn suggests that Keats's 'first hypothesis about aesthetic experience . . . is that art tells us a story'.[11] By first

[389]

printing the poem in the *Annals of the Fine Arts*, in January 1820, Keats placed it in a context which reinforced this idea. The magazine was renowned in its day for promoting the Romantic notion that Keats already knew well from Haydon and others – the idea that Greek art embodied an ideal version of Beauty, its formal perfections representing a supreme artistic triumph which mirrored the virtues of the society that produced it. In this sense, one might say that his poem intensifies the argument he had already rehearsed in *Endymion* and in his sonnets on the Elgin Marbles, and simultaneously rebuts Hazlitt, who in 'On Poetry in General' had said that Greek statues were incapable of moving the imagination.

Both of these things affect our consideration of whether or not Keats had a particular Greek vase in mind when he wrote the poem. We know that at some stage he made a drawing of the Sosibios Vase from Henry

12 'Ode on a Grecian Urn'; first published in the *Annals of the Fine Arts*, XV (January 1820).

Moses's *A Collection of Antique Vases, Altars, Paterae* (1814). We know that he was impressed by other vases, paintings, and pieces of statuary in the British Museum and elsewhere: the Townley Vase, the Borghese Vase, the Holland House Vase, the Elgin Marbles, Claude's picture of 'The Sacrifice to Apollo' and Poussin's 'Polyphemus'.[12] We know that he relied on several literary sources, including Burton's *Anatomy*, which Gittings says gave him 'the main theme',[13] and Wordsworth's sonnet 'Upon the Sight of a Beautiful Picture' (1815). We also know that the poem has another kind of derivation. On 2 and 9 May, Haydon had published two articles in the *Examiner* which discussed Raphael's cartoon 'The Sacrifices at Lystra', and contrasted him with Michelangelo. The ode echoes several of Haydon's phrases: for instance, his remark that in the cartoon 'all classes were crowding to the sacrifice'. Even though Keats's recent row with Haydon about money meant that relations between them were cool, Keats still sympathised with his ideas. Later in the summer, when they got back on better terms, they walked together in Kilburn Meadows and Keats recited the 'Ode to a Nightingale' to his friend 'with a tremulous under tone'.

These influences are important, but they should not obscure the fact that Keats's urn is his own invention. As its title and its place in the *Annals* indicate, he offers it as a perfect example of a perfect type – an emblem of how art can give consolation in the face of suffering. (This theme is taken up again in the 'Ode to a Nightingale' and the 'Ode on Melancholy'.) To put this another way: the 'Grecian Urn' is less concerned to justify or condemn an escapist aesthetic, than to demonstrate the powers of the imagination in general, and of negative capability in particular. Its foundations rest on the ideas he had uncovered in 'Psyche', expanding on his thoughts about soul-making, and on the gradations of self-knowledge. However, this is not to say that it has a plain and simple argument. For one thing, it tells a story which cannot be developed. Celebrating the transcendent powers of art, it creates a sense of imminence, but also registers a feeling of frustration. For another, which follows from this, it holds the knowledge of human sorrow at bay, even while it accepts that suffering must be included among familiar experiences. There is guilt as well as pleasure in its exploration of the relationship between art and reality. The attention of the speaker, who keeps the tone of explication steady, is divided between human and unearthly values. He is engaged in a 'mad pursuit' of the urn's meaning, while at the same time calmly savouring its emblematic value.

These tensions remind us that while Keats wants to explore the ways in which art can overrule time, he cannot deny that his poem exists within history. By fashioning the urn to represent a particular reading of the past, he reveals his own particular beliefs and impressions. Just as 'Psyche' reflects feelings of exclusion from the 'happy pieties' of the 'faint Olympians', so the 'Grecian Urn' embodies a sense of isolation. Its subtle subjectivity is a kind of social and historical loneliness, its ambiguities are outward signs of withheld insecurities. These themes appear in the very first line of the poem, 'Thou still unravished bride of quietness'. When the poem was first printed in the *Annals*, a comma appeared after the word 'still', making it into an adjective (meaning 'motionless') rather than an adverb implying that the urn is only untouched by damage or interpretation for the time being. Its days are numbered. This turns the speaker into someone who celebrates its virginal survival while simultaneously acting as an agent of the historical process ('woe'), which the urn itself (a 'Sylvan historian') seems to resist. Or does it? The 'leaf-fringed legends' which 'haunt' its 'shape' belong to the same world that the 'faint Olympians' occupied in 'Psyche'. They also describe an 'ecstasy' which is not just 'wild' but violent. 'What men or gods are these?' Keats asks, emphasising the distinction. 'What maidens loth? / What mad pursuit? What struggle to escape?'

The second stanza lowers the temperature, setting the opening questions against the silence of the urn itself – a silence which does not resolve contradictions, but holds them in settled equanimity. It depicts a world in which the 'Bold lover' is thwarted because he can 'never, never . . . kiss', and is rewarded because the woman 'cannot fade'. The longer Keats contemplates this stasis, the less satisfactory it seems – as the following stanza makes clear. The compensations of denying 'bliss' are greater than the rewards of embracing it:

> Ah, happy, happy boughs! that cannot shed
> Your leaves, nor ever bid the Spring adieu;
> And, happy melodist, unwearièd,
> For ever piping songs for ever new;
> More happy love! more happy, happy love!
> For ever warm and still to be enjoyed,
> For ever panting, and for ever young –
> All breathing human passion far above,

That leaves a heart high-sorrowful and cloyed,
 A burning forehead, and a parching tongue.

Developing these thoughts, Keats has led himself away from the urn itself. In the fourth stanza he is prompted into a new series of questions about its story: who is 'coming to the sacrifice', what and where is the 'green altar', and why is the 'little town' deserted? The scenes have the same eerie suspension as those he saw in the first stanza, but their effect is different – almost opposite. The hymn to 'happy love', which seems to encourage escape from the 'high-sorrowful and cloyed' world, has in fact convinced him that the 'silence' of the scene is a 'desolate' sterility. Its immortality is a kind of inhumanity. In the final stanza he attempts to reach a conclusion:

 O Attic shape! Fair attitude! with brede
 Of marble men and maidens overwrought,
 With forest branches and the trodden weed;
 Thou, silent form, dost tease us out of thought
 As doth eternity: Cold Pastoral!
 When old age shall this generation waste,
 Thou shalt remain, in midst of other woe
 Than ours, a friend to man, to whom thou say'st,
 'Beauty is truth, truth beauty, – that is all
 Ye know on earth, and all ye need to know.'

Critics have long debated the question of who speaks these last two lines. In Brown's transcript, the penultimate line reads: Beauty is Truth, – Truth Beauty, – That is all, and the *Annals* text has: Beauty is Truth, Truth Beauty, – That is all. Neither has the quotation marks round 'Beauty . . . beauty' that appear in the third authoritative text – the 1820 volume. Keats himself saw this through the press, which would be a good reason for retaining its punctuation. Yet given the lack of an original manuscript, and Keats's sickly and distracted state when reading his proofs, it cannot be taken as entirely reliable. Printing the last thirteen words of the poem as they appear above must therefore be regarded as just one among several options,[14] one which is justified by the fact that elsewhere in the poem Keats identifies himself with mankind ('us', 'ours'), and so can be thought to have the urn addressing mankind ('ye') in his finale.

There is another kind of justification as well. The version printed above distances Keats from what the poem suggests is a too-tidy summary. By resisting the escapist consolations of the urn's silence, and by criticising it as a 'Cold Pastoral', he indicates that the virtues of its durability are outweighed by the disadvantages of its being separated from life. Its chastity is a form of denial. Its power to 'tease us out of thought' is less valuable than the effects of a 'working brain'. Even if the thoughts produced by this brain are 'branched' and 'shadowy', they are nevertheless a proof of engagement with the world. They permit growth as well as proving dislocation, 'warm love' as well as loss.

Love is a troubling means to an end in the 'Grecian Urn', as well as an end in itself. Instead of exploring a gratefully reciprocal relationship, as 'Psyche' does, it describes a drama of imminent or actual ravishment. While Keats is obviously excited by the thought that he might possess the urn as he explicates it, he also knows that his actions might lead only to bafflement or disappointment. It is this prospect which compels him finally to stand back from his own creation. The urn's concluding remarks about 'beauty' and 'truth' might appear to be apt and interchangeable; they do not in fact summarise all the moods and inquiries of the poem, nor do they represent Keats's last words on the relationship between art and life. They are evidently not all that mankind knows on earth or needs to know, and neither do they adequately encapsulate Keats's artistic ambitions. Taken as a whole, rather than as a set of five stanzas which lead to a final clinching 'explanation', the poem reminds us that art is simultaneously like life and unlike it. In order to fulfil himself as a beauty-loving and truth-telling poet, Keats must remain faithful to the world of experience, and suffer the historical process which constantly threatens to extinguish his ideal, rather than opt for a world of substitutes and abstractions.

Keats begins the 'Ode on a Grecian Urn' by seeming rapt and susceptible. He ends it sounding sensibly ironical. In the 'Ode to a Nightingale' he delves more deeply into his reasons for refusing the solace of its 'cold' perfection. Brown, who implied that the 'Nightingale' was written very soon after 'Psyche' and before the 'Grecian Urn', gave a celebrated account of its composition:

In the spring of 1819 a nightingale had built her nest near my house. Keats felt a tranquil and continual joy in her song; and one morning he took a chair from the

breakfast table to the grass-plot under a plum-tree, where he sat for two or three hours. When he came into the house, I perceived he had some scraps of paper in his hand, and these he was quietly thrusting behind the books. On inquiry, I found these scraps, four or five in number, contained his poetic feeling on the song of our nightingale. The writing was not well legible; and it was difficult to arrange the stanzas on so many scraps. With his assistance I succeeded, and this was his 'Ode to a Nightingale', a poem which has been the delight of everyone. Immediately afterwards I searched for more of his (in reality) fugitive pieces, in which task, at my request, he again assisted me. Thus I rescued that *Ode* and other valuable short poems, which might otherwise have been lost. From that day he gave me permission to copy any verses he might write, & I fully availed myself of it. He cared so little for them himself, when once, as it appeared to me, his imagination was released from their influence, that it required a friend at hand to preserve them.

Brown sounds understandably proud here, slipping happily into the role of right-hand man. As he makes his claim to the stanzas and their inspiration ('my house', 'our nightingale', 'I rescued'), he disguises the extent to which they depend on imaginative and literary sources as well as familiar ones. Nightingales flicker everywhere in the foliage of Romantic poetry, embodying the freedom and necessary shyness of artistic creation. (Coleridge had reminded Keats of this during their recent encounter on Hampstead Heath.) Keats combines various memories of these literary sightings in his own poem, mixing them with other ideas derived from Dryden and Hazlitt, whose notion of poetry as a 'movement' from personal consciousness to an awareness of suffering humanity it perfectly illustrates. Their final resolution is to resist final resolution, insisting more openly on the same ambiguities that emerge at the end of the 'Grecian Urn'.

The 'Nightingale' begins as naturally as a bird in a tree, with Keats 'aching' as though he had swallowed hemlock or 'some dull opiate' while he listens to the nightingale singing 'of summer in full-throated ease'. This reference to hemlock, which recalls the suicide of Socrates, seems to introduce an escapist impulse which has often been said to dominate the poem. By turning away from drugs and poison towards alcohol as the means of achieving union with the nightingale and leaving 'the world unseen', Keats in fact begins his poem as he ends it – confronting a drastic solution, and then trying to moderate it. As he reaches the third stanza, he seems bound to fail:

Ode to the Nightingale

My Heart aches and a drowsy numbness pains
My sense, as though of hemlock I had drunk,
Or emptied some dull opiate to the drains
One minute past and Lethe-wards had sunk:
'Tis not through envy of thy happy lot,
But being too happy in thine happiness,
That thou light-winged dryad of the trees
In some melodious plot
Of beechen green, and shadows numberless
Singest of summer in full-throated ease.
O for a draught of vintage that has been
Cooling an age in the deep-delved earth
Tasting of Flora, and the country green
Dance, and Provencal song and sunburnt mirth
O for a Beaker full of the warm south,
Full of the true and blushful Hippocrene
With clustered bubbles winking at the brim
And purple stained mouth,
That I might drink and leave the world unseen
And with thee fade away into forest dim—
Fade far away dissolve and quite forget
What thou among the leaves hast never known
The weariness, the fever and the fret
Here, where Men sit and hear each other groan
Where palsy shakes a few sad last grey hairs
Where youth grows pale and thin and dies

13 'Ode to a Nightingale'; Keats's draft.

Where but to think is to be full of sorrow
and leaden eyed despairs—
Where Beauty cannot keep her lustrous eyes
Or new Love pine at them beyond tomorrow.

Away—Away—for I will fly to thee
Not charioted by Bacchus and his pards
But on the viewless wings of Poesy,
Though the dull brain perplexes and retards
already with thee! tender is the night
And haply the Queen-moon is on her throne
Clustered around by all her starry fays—
But here there is no light
Save what from heaven is with the breezes blown
Through verdurous glooms and winding mossy ways—

I cannot see what flowers are at my feet
Nor what soft incense hangs upon the boughs
But in embalmed darkness guess each sweet
Wherewith the seasonable month endows
The grass the thicket and the fruit tree wild
White Hawthorn and the pastoral eglantine
Fast fading violets covered up in leaves
And mid may's eldest child
The coming musk rose full of sweetest wine
The murmurous haunt of flies on summer eves

Darkling I listen; and, for many a time
I have been half in love with easeful death
Call'd him soft names in many a mused rhyme
To take into the air my quiet breath
Now more than ever seems it rich to die.
To cease upon the midnight with no pains
While thou art pouring thus thy soul abroad
In such an Extacy—
Still would thou sing and I have ears in vain
~~But in vain~~
For thy high requiem, become a sod—

Thou wast not born for death, immortal Bird
No hungry generations tread thee down,
The voice I hear this passing night was heard
In ancient days by Emperour and Clown
Perhaps the selfsame ~~voice~~ song that found a path
Through the sad heart of Ruth, when sick for home
She stood in tears amid the alien corn
The same that oftimes hath
Charm'd the ~~wide~~ magic casements opening on the foam
Of ~~perilous~~ perilous seas in faery Lands forlorn

Forlorn! the very world is like a bell
 To tolt me back ~~here one~~ from thee unto myself
Adieu! the fancy cannot cheat so well
 As she is fam'd to do, deceiving elf!
Adieu! Adieu! thy plaintive anthem fades
Past the near meadows, over the still stream,
Up the hill side, and now 'tis buried deep
In the next valley glades.
Was it a vision real or waking dream?
 Fled is that Music — do I wake or sleep?

> Fade far away, dissolve, and quite forget
> What thou among the leaves hast never known,
> The weariness, the fever, and the fret
> Here, where men sit and hear each other groan;
> Where palsy shakes a few, sad, last grey hairs,
> Where youth grows pale, and spectre-thin, and dies;
> Where but to think is to be full of sorrow
> And leaden-eyed despairs;
> Where Beauty cannot keep her lustrous eyes,
> Or new Love pine at them beyond to-morrow.

Even here, Keats limits his wish for 'flight', and for identification with the nightingale in its greenwood. Because the bird has 'never known' the facts of suffering, it cannot seem entirely exemplary – at least it cannot to the poet who doubted that 'beauty' is 'truth', and who does not think that immortal 'new Love' is adequately 'warm'. This thought makes Keats restless, and in the fourth stanza he shifts to another kind of 'dissolving' (his 'Away! away!' refers to his dismissal of 'Bacchus and his pards' as well as to the fact that the bird is beginning to move away from him). Charioted now by poetry itself, he enters a 'verdurous' twilight which is both densely realised and a region of the mind. Too 'winding' to resemble the bowers into which he habitually retreated in his early poems, it is a place where the imagination creates what cannot be seen in fact ('the flowers . . . at my feet') knowing that its productions are unreal. Its beauties are delicious but untenable, its paradoxes diluted by wishful thinking.

In the sixth stanza this prompts a moment of philosophical stock-taking:

> Darkling I listen; and, for many a time
> I have been half in love with easeful Death,
> Called him soft names in many a musèd rhyme,
> To take into the air my quiet breath;
> Now more than ever it seems rich to die,
> To cease upon the midnight with no pain,
> While thou art pouring forth thy soul abroad
> In such an ecstasy!
> Still wouldst thou sing, and I have ears in vain –
> To thy high requiem become a sod.

As Keats contemplates quitting the world altogether, his grief about the loss of its mixed blessings comes to seem greater than his pleasure in evading its sufferings. Realising this, he understands that the nightingale (and therefore art itself) can no longer be said to embody an idea of immaculate permanence. As an individual entity, the bird is 'born for death' like every other living creature. It is only as a symbol that it can avoid being trodden down, which in turn means that it must partake of the 'coldness' that he had rejected in the 'Grecian Urn'.

Keats emphasises the need to accept suffering by presenting it as a set of palpable facts rather than theories. Bidding 'Adieu' to the nightingale in the final stanza, presenting himself as 'forlorn', 'sole', and solitary in every sense, he implies that he would not have it any other way. Whether the song was a vision of poetic achievement or a 'waking dream' of human possibility, the conclusion is the same: its rewards can only be felt within real time and actual conditions. It is a part of the poem's achievement to make these conditions seem intimate without telling us anything very precise about his own state. His memories of Tom may have given weight to his view of the world as a place where 'youth grows pale, and spectre-thin, and dies'. (When he had underlined the words 'poor Tom' in *King Lear*, he had found them in Edgar's sentence: 'The foul fiend haunts poor Tom in the voice of the nightingale.') His ambivalent feelings about Fanny may have created a context for his lines about love. His experience as a doctor may have fed his apprehension of 'The weariness, the fever, and the fret'. His depression in the early part of 1819 may have solidified his assertion that 'but to think is to be full of sorrow / And leaden-eyed despairs'. His reference to the 'hungry generations' may have depended on his jaundiced view of contemporary politics. But these and other autobiographical elements in the ode are constantly transmuted. They protest that their 'truth' is for all lives and all times. They compel us to read the poem as an account of historical tribulations, not just as an evocation of a particular poet's heart and mind.

THE BALANCE THAT Keats strikes in the 'Grecian Urn' and the 'Nightingale' is recreated in the 'Ode on Melancholy'. In melodramatic terms. Its philosophy is much more explicit, and its sensations are feverishly heated. Keats evidently realised this might damage the harmonies he was seeking to create, and when he revised the poem he cancelled the original opening stanza, in which a strenuous attempt to

'find' melancholy is mocked as Gothic foolishness: 'Though you should build a bark of dead men's bones, / And rear a phantom gibbet for a mast, / Stitch creeds together for a sail, with groans / To fill it out, blood-stained and aghast; / Although your rudder be a dragon's tail / Long sever'd, yet still hard with agony, / Your cordage large uprootings from the skull / Of bald Medusa, certes you would fail / To find the Melancholy – whether she / Dreameth in an isle of Lethe dull'.

Keats curbed the ironies of 'Melancholy' by deleting these lines: curbed them, but did not obliterate them. Even as it stands, the opening of the poem pulsates with the same kind of exaggeration that he had admired in its principal source: Burton's *Anatomy*. This means that when he provides the antidote to melancholy in the second stanza, he also has to be over-emphatic, creating a crisis of glutting, 'emprison-[ing]', and feeding 'Deep, deep'. Only in the third and final stanza does he start to sound more poised:

> She dwells with Beauty – Beauty that must die;
> And Joy, whose hand is ever at his lips
> Bidding adieu; and aching Pleasure nigh,
> Turning to poison while the bee-mouth sips:
> Ay, in the very temple of Delight
> Veiled Melancholy has her sovran shrine,
> Though seen of none save him whose strenuous tongue
> Can burst Joy's grape against his palate fine;
> His soul shall taste the sadness of her might,
> And be among her cloudy trophies hung.

This figure of Melancholy looks forward to the monumental forms Keats would include in his revised 'Hyperion'. She is welcome yet dreadful, pleasure-giving yet embodying the same cautionary philosophic truth that Keats had previously offered at the end of the 'Grecian Urn' and the 'Nightingale'. In certain obvious respects, these combinations are admirable. They describe the simultaneous apprehension of pleasure and pain which Keats had long since regarded as his ideal. But Melancholy cannot entirely resolve the instabilities which appeared in the first cancelled stanza of the poem. Her consolations only exist within the confines of art (a picture, a poem, an image), or within the most provisional sort of capture ('emprison her soft hand'). While she summarises the argument of the whole group of odes ('Ay, in the very

temple of delight . . .'), she also signals a kind of collapse. The opposing elements of her personality are so supercharged that the reconciliations she prizes seem impossible. The poem's axioms do not feel proved upon the pulses; they are argued by the intellect.

'Psyche', the 'grecian urn' and the 'Nightingale' all extend personal experience to describe a general truth. 'Melancholy' restricts its impact by resorting to extremes. Shortly after completing it, Keats composed the 'Ode on Indolence', which shows a different but equally significant shift in his mood and methods. He gives some idea of the change in a letter he wrote on 9 June to Sarah Jeffery, one of the sisters that he and Tom had befriended during their stay in Teignmouth. 'I have been very idle lately,' he tells her, 'very averse to writing; both from an overpowering idea of our dead poets and from abatement of my own love of fame. I hope I am a little more of a Philosopher than I was, consequently a little less of a versifying Pet-lamb . . . You will judge of my 1819 temper when I tell you that the thing I have most enjoyed this year has been writing an Ode to Indolence.'

Keats is wearily self-deprecating here, implying that all his recent writing, let alone 'Indolence' itself, matters less to him than his abandoned 'grand Poem' and his extended narratives. But his letter cannot help promoting his latest creation. Simply by mentioning it, he suggests that it clarifies the personal drama which is transfigured in his other odes. He was right to do so. 'Indolence' is the only one of the group to centre on his poetic self, and the only one to use an image he had created inwardly rather than discovered in the external world. It was the image that he had first used two months earlier when writing to George and Georgiana about the death of Haslam's father (among other things). 'This is the world', he had said, ' – [and] we cannot expect to give way many hours to pleasure – circumstances are like Clouds continually gathering and busting – While we are laughing the seed of some trouble is put into the wide arable land of events – while we are laughing i[t] grows and suddenly bears a poison fruit we must pluck.' As Keats had tracked away from this general observation to his own particular depressed 'state of effeminacy', he had emphasised that what he felt was not a blank despair but a kind of creative lassitude. 'Neither Poetry, nor Ambition, nor Love have any alertness of countenance', he had said, 'as they pass by me: they seem rather like three figures on a greek vase – a Man and two women – who no one but myself could distinguish in their

disguisement. This is the only happiness; and is a rare instance of advantage in the body overpowering the Mind.' In the easy flow of this letter, the figures seem both impressive and obscure – purely personal projections. In 'Indolence' itself, they still appear laden with subjective associations, but are more organised, and deployed to serve a specific argument. This has certain advantages. It makes the figures seem substantial, and evidently supportive of the ideas Keats had already tackled. At the same time, it means that Keats has less room to imagine. Like 'Melancholy', the poem is too articulate for its own poetic good.

'Indolence' begins by reminding us of 'Psyche': it shows that his obsession with 'flight' is at least partly produced by a sense of inferiority. Introducing the 'three figures' in the first verse, he says 'they were strange to me, as may betide / With vases, to one deep in Phidian lore'. In his sonnet on Chapman's Homer, feelings of exclusion had prompted him to create an imaginative substitute for what he had been denied by 'birth and education'. Now they only distress him. They force him to regard indolence as the privilege of the leisured class to which he did not belong. After identifying one of the figures as 'my demon Poesy' – the other two are 'Love' and 'Ambition' – he brings his thoughts to a crisis:

> They faded, and, forsooth! I wanted wings.
> O folly! What is love! and where is it?
> And, for that poor Ambition – it springs
> From a man's little heart's short fever-fit.
> For Poesy! – no, she has not a joy –
> At least for me – so sweet as drowsy noons,
> And evenings steeped in honeyed indolence.
> O, for an age so sheltered from annoy,
> That I may never know how change the moons,
> Or hear the voice of busy common-sense!

This is where the theme of escape makes its most urgent return, arousing other and by now familiar issues about the function of the poet, the role of poetry, and the need for an audience. (In the final stanza Keats picks up the theme of his Fame sonnets and says 'I would not be dieted with praise, / A pet-lamb in a sentimental farce'.) Given that the poem closes a sequence which would eventually bring Keats the immortality he craved, it is a profoundly ironical conclusion. The 'Ode on Indolence' is a pre-emptive strike, warding off the possibility that he might

disappoint himself and his readers. It is a poem of banishment ('never more return!' he ends) and of resignation: Keats would not begin another poem for nearly a month.

In two of his May odes, 'Melancholy' and 'Indolence', Keats defined themes common to the whole group with such fierce candour that he restricted their imaginative power. His identity had prevailed. In 'Psyche', the 'Grecian Urn' and the 'Nightingale', the hopes to which he bids 'farewell' are magnificently realised. He had struck the balance he imagined when speaking about negative capability, and also undertaken the journey he had supposed would lead him from the chamber of maiden thought. He had embraced the 'difficulties' of life in his work, without losing the fine point of his soul. He had found a way of celebrating the triumph of art while reflecting – and admitting the need to endure – the harsh facts of historical time. For all these reasons, he had no justification in feeling that his greatest achievements lay elsewhere, in other forms and in different types of narrative. At the same time, he was right to suppose that the odes raise disturbing questions. Read in the sequence given above, they show a steady evaporation of negative capability. Striving to reconcile opposites, to balance 'thought' with 'sensation', and to explore the relationship between art's powers of consolation and life's unavoidable hardships, they demonstrate that force of circumstance was exerting an irresistible pressure on Keats's imagination. How, in the future, could he prevent the conditions which had created them from overwhelming him?

THIRTY-FIVE

Endymion had been hurried by the clamour of worldly business. The shock waves of tragedy had shattered 'Hyperion'. The sequence of odes ran a more natural course, but even they were squeezed by the demands of 'busy common-sense'. As May went by, Keats became increasingly worried about his health, about Fanny Brawne, and about money. And about his family. His sister was still guarded by Abbey, and seeing her was difficult: he could not afford to visit by coach; he did not want to risk getting caught in the rain if he walked to Walthamstow. George's situation was more perturbing still. On 12 May, Keats had told his sister that he had 'at last' received his first letter from America, and that it

contained, 'considering all things, good news'. George and Georgiana had reached Louisville safely, and had met up with Charles Briggs, 'an old Schoolfellow of ours'.

This letter from George is now lost, but it seems to have disguised the difficulties he had endured since leaving Liverpool on the *Telegraph* eleven months previously. He and Georgiana had reached Philadelphia on 26 August 1818, and registered as emigrants – Georgiana with her name misspelt, and George with his occupation 'not given'. Their intention had been to join Birkbeck's settlement in Illinois, even though George's training with Abbey meant that he had no practical experience which might suit the life of a backwoodsman. At some unknown point on their journey west, they had changed their minds. Possibly they discovered that all the allotments near where Birkbeck had his own cabin were already sold. Possibly the journey itself had influenced them: it had given them a graphic idea of the hardships that lay ahead. George had bought a wagon to cross the Alleghenies, but he and Georgiana had found themselves on a terrible road with little more than rum and water to help them keep up their spirits.

When they reached Pittsburgh, the wagon was sold and the horses sent overland to Cincinnati, while George and Georgiana took a more comfortable route, sailing down the Ohio river on a flat-bottomed keelboat. George had not anticipated the expense of the first stage of his journey, nor the cost of the six-hundred-mile river trip ($75, shared equally among all passengers). Yet there were compensations. Before they left Philadelphia, he had already begun to enjoy the surprises of living in a strange place – he had sent home an excited description of a 'black sitting on a dock eating a water melon'.[1] Now the slow current of the Ohio delighted him. He and Georgiana 'floated tranquilly on through a succession of beautiful lakes, sometimes in the shadow of some lofty bluff, sometimes by the side of widespread meadows, or underneath the graceful overhanging branches of cotton wood or sycamore. Sometimes, while the boat floated lazily along, the young people would go ashore and walk through the woods and across a point around which the river made a bend. All uncertain as their prospects were, they could easily, amid the luxuriance of nature, abandon themselves to their enjoyment of the hour.'[2]

George's movements immediately before and after reaching Cincinnati are uncertain. It is possible that he and Georgiana stopped in Shawneetown in October, where there was an English settlement which

was the home of George Flowers, a liberal pioneer like Birkbeck. It is also possible that George left his wife with Flowers's daughters in the flourishing port of Hendersonville, Kentucky, while he scouted round other nearby settlements. Evidently none of them appealed to him, perhaps because he was 'put off by their primitiveness',[3] perhaps because he was advised to switch his attention from land investment to commerce by an acquaintance he made in Hendersonville: John James Audubon. George and Georgiana may in fact have lodged with Audubon for some time; if a surviving anecdote is anything to go by, Audubon certainly encouraged him to think twice about plunging into the wilderness. 'One day, [George] was trying to chop a log, and Audubon, who had watched him for some time, at last said, "I'm sure you will do well in this country Keats. A man who persists, as you have been doing, in chopping that log, though it has taken you an hour [to do] what I could do in ten minutes, will certainly get along here." '

Audubon, who had not yet started work on the bird drawings which would make him famous, was a man of 'Micawberlike optimism'.[4] He already owned a (financially unsound) grist and lumber mill at Hendersonville, and had ambitious plans to make more money by ferrying merchandise in a steamboat up and down the Ohio. When he invited George to become a partner in this business, and to invest the bulk of his savings in a new boat, he appeared to offer short-term financial solutions, and to appeal to deep-rooted loyalties. (George's remote relations had been coastal traders.) The result was a disaster, for reasons which are now hard to give precisely. Audubon never alluded to the episode when he first published his journals, though in a later edition he guiltily referred to seeing 'the ghost' of 'Mrs Keats the wife of George Keats of London', on a subsequent visit to England. George's grandson John Gilmore Speed later interpreted events as George himself did at the time. He alleged that when Audubon arranged the partnership, he knew the steamboat was already 'at the bottom of the Mississippi river'. More recent investigations suggest that the story was a little more complicated:

Using what was left of his own money and what he could raise from others, including George Keats, Audubon purchased a boat and resold it to another group of men at what he thought was a good profit. With his usual carelessness, he accepted their notes without checking their credit. The notes proved to be worthless, and the papers were apparently drawn up improperly. For once he could take direct physical action to solve a business difficulty. With a skiff and

[407]

two negroes as rowers, he chased the boat all the way to New Orleans, where he tried to have it attached. His efforts to regain his money proved fruitless.[5]

George was effectively bankrupted by Audubon: he already owed money to a number of other new American friends, including Audubon's nephew Thomas Bakewell. When he eventually left Hendersonville, he was therefore desperate to find some way of recouping his losses. Cincinnati, the 'metropolis of the mid-West',[6] seemed a good place to start his search, but whatever business he pursued there is not known. Contemporary directories make no mention of him or of Georgiana, neither does the leading newspaper of the day, the *Western Spy*. According to his grandson, George briefly considered joining another liberal settlement, the Robert Dale Owen Colony at New Harmony, Indiana, then decided to move on to Louisville. At first he seems to have used the town as a centre for exploring the neighbourhood. There are records of him staying briefly at two different hotels: Allen's Washington Hall, and then Gwathney's Indian Queen. Soon, though, he abandoned all thought of living in the backwoods, and made another attempt to establish himself in business. As in Cincinnati, he found that most openings were in transport and milling, things which in the last few decades had turned Louisville into 'a capital of the country' with a rapidly growing population (4,000 in 1819, of whom 1,000 were slaves, rising to 10,000 in 1828). Initially George seems to have had some further involvement with shipping (in November 1820 he speaks of 'a boat that can't be sold'), but after a while his attention switched to forestry. Entering into partnership with friends who had originally worked in iron foundries in the West, he bought a share in a sawmill on the banks of the Ohio, spending much of his time in the forests surrounding Louisville, overseeing the felling of trees.

It was a gruelling, insecure existence. The mill owned by 'Geo Keats and Co.' was sparsely financed, and Louisville itself, though burgeoning, was still 'a drab little town with box-like houses of wood or brick', with streets which were 'mud puddles' in winter, and precious few resources. (There were three churches, three banks, and one library.[7]) Eventually George would prosper, build himself a fine house, and father eight children, the eldest of whom was born in June 1819. When he first made contact with his brother, however, he felt stretched, anxious and isolated. Only a few years earlier, the English pioneer Henry Feardon had described Louisville in terms which movingly suggest its depriva-

tions. Far from being a liberal Arcadia, it was graceless, toughly competitive, and greatly dependent on slave labour. 'I have to regret that so much remains to be done for the habits of the people,' Feardon said, 'and to feel from my soul the most sincere sorrow, that men who can form a theoretic constitution, in which it is declared that "men when they form a social compact are equal" . . . can in their practice continue, and even boast of the most demoralising habits, treat their fellow-creatures worse than brute beasts, and buy and sell human beings like cattle at a fair.'[8]

NEWS OF GEORGE'S most serious losses with Audubon did not reach Keats until September. But even the story of his initial expenses was enough to trigger a crisis. It forced Keats to realise that his offer of 'all the financial help he could give' was almost no use: his grandmother's legacy was virtually exhausted, and so was the £500 that George had left him and Tom the previous June. It also reminded him that if he allowed his feelings for Fanny Brawne to develop, he would soon have to answer questions about his eligibility. Mrs Brawne knew that he had no income to support a wife, and also believed, as he did himself, that he could not expect to gain much by continuing to devote himself to poetry. To make matters worse still, his sore throat returned as May drew to a close, and the fine weather of recent weeks gave way to 'quakerish' skies. His brief spell of diligent indolence was over. He could neither support his brother, nor please himself.

He cast around glumly for solutions. Late in the month, he called on his sister and Abbey, who, although surprisingly 'gracious', was unable to offer any practical advice. Keats sorted out his papers and belongings, searching for some means of reorganising his future. As he did so, he came across a bundle of letters from the Jeffery sisters in Teignmouth, noticing that he had not answered the most recent of them. Impulsively, he wrote to Sarah on 31 May, apologising for his silence, giving a tight-lipped account of the losses he had suffered since their last contact, and asking her to 'Enquire in the villages round Teignmouth if there is any Lodging commodious for its cheapness'. His immediate reason for asking was that Brown was shortly to leave for his summer holiday, which meant that Keats himself would soon have to move out of Wentworth Place. He did not refer to this. Instead, he told Sarah that he was facing a choice of 'poisons'. One was to take up medicine again, possibly as a surgeon on a ship 'voyaging to and from India for a few

years', which would have the advantage of taking him to a warmer climate while he earned some money. The other was to lead 'a feverous life alone with Poetry'. As he implied, this second option would risk bringing ill-health, as well as loneliness. Although he tried to make light of the decision, urging Sarah not to tell 'the Newfoundland fishermen' that he might be about to take to the waves, he could not conceal how vulnerable he felt. 'My brother George always stood between me and my dealings with the world,' he said regretfully, then immediately gathered himself. 'Now I find I must buffet it – I must take my stand upon some vantage ground and begin to fight – I must choose between despair & Energy – I choose the latter.'

Keats sounds understandably self-absorbed here, yet it is obvious that none of his 'poisons' was intended to take him out of the world. Neither was a third possibility. Writing briefly to Dilke soon after he had posted his letter to Devon, he said that he might travel to South America. This has sometimes been regarded as no more (or less) than a desperate remedy, but Keats did not simply mention South America because it was sufficiently far from home for him to escape his troubles. He meant that he was thinking of fighting in the wars of liberation which at that time were raging in Chile, and which had been widely reported in the *Examiner*. (Between 1818 and 1821, Thomas Cochrane, tenth Earl of Dundonald, led a daring and victorious campaign in the Chilean War of Independence. His name became synonymous with 'decisive action'.[9]) In other words, as Keats's money worries provoked anxieties about love, writing and family responsibility, they also emphasised his desire 'to do the world some good' – either as a doctor, or as a liberal poet, or an actual revolutionary.

Keats's plans for India and South America soon faded. But they had stirred ideas which stayed with him, waiting to find a voice in 'Hyperion', should he return to it, or in new work that he was waiting to begin. He soon realised this new work would not emerge in Devon. On 9 June, after he had received a letter from Sarah Jeffery suggesting he might find lodgings near to her in the village of Bradley, he wrote saying that he felt 'a little aversion to the South of Devon from the continual remembrance of my brother Tom'. He went on to explain that these memories also made it impossible for him to solve his problems by accepting an invitation from the Bentleys to return to Well Walk. The Isle of Wight on the other hand, which James Rice had proposed they visit together, was a less troubling alternative. His stay there in 1817 had

proved frustrating so far as *Endymion* was concerned, but it was not so closely associated with loss.

All the same, it had drawbacks. Rice was in such poor health that he was bound to remind Keats almost as vividly of Tom as living in Devon would have done. The prospect of separating from Fanny was even more troubling, and Keats responded to it dramatically. Rather than consoling himself with thoughts of a reunion at the end of the summer, he began hardening his heart against her. The process began as a form of defence, but soon became aggressively assertive, spurred by Brown's jealous goadings,[10] and reinforced by the influence of Burton's *Anatomy*, which Keats now began reading again obsessively. As he annotated and underlined, he furiously worked up his 'not right feeling[s] about Women', identifying with Burton's horror of sex and of smothering domesticity. This would have profound implications for his relationship with Fanny during the rest of the year; in the short term, though, its impact was restricted. Keats not only hid the violence of his thoughts from Fanny; he concealed the fact that they were changing at all, pleading that he could not dally with her because he had so much else to do. He finished tidying up Wentworth Place so that it was ready for its summer visitor – an acquaintance of Brown's named Nathan Benjamin. He sent a copy of the 'Ode to a Nightingale' to James Elmes, the editor of the *Annals of the Fine Arts*, who had heard about it from Haydon. He gave Rice money, probably the last few pounds that he had been left by George, to pay for their lodgings on the Isle of Wight. And on 16 June he made another visit to Abbey. He hoped, obviously, that he would be able to persuade him to release some of Tom's estate; what he discovered was a new obstacle to its release.

The meeting got off to a comparatively cheerful start. Abbey told Keats that Georgiana had given birth to a daughter. Then the mood darkened. Abbey explained that he had recently heard from the widow of Keats's uncle Midgley Jennings. Ten years previously, she had threatened to take an action which might gain her access to Keats's money in Chancery. Now she was thinking of starting another suit, in order to possess some of the capital left by old Mrs Jennings to her grandchildren. Her argument, Gittings says, 'must have been that since [all the] grandchildren had shared in this [original] bequest, this gave [Midgley's children] a claim on the estate of the dead Tom'.[11] This is a sensible supposition, though it implies that the widow Jennings had rights to the whole estate. In fact, even if she had persevered with her

suit, which seems to have been abandoned later in the year,[12] she would only have been able to touch the share of money that had been transferred to Alice Jennings after Midgley's death. In other words, Abbey misled Keats, compounding his deception by saying that the expense of fighting the suit would have to be met out of his (Abbey's) own pocket. Keats had no power – and possibly no inclination – to command this. The meeting ended with Abbey insisting that he had to freeze the estate in its entirety. Keats went back to Wentworth Place almost literally penniless.

Brown, who had so often played a fatherly role, once again came to his rescue. He was not in a position to offer more than a small loan himself, but he was able to make other suggestions. One was to propose that rather than seeking 'a situation with an Apothecary', Keats should 'try the press once more' – by publishing journalism as well as poems, and by collaborating with him on a play. If he provided the narrative for each scene, would Keats like to turn the story into verse? Precedents suggested it might be worthwhile, as Keats appreciated. Brown had once written successfully for the theatre himself. Coleridge had made nearly £400 when his play *Remorse* had been performed at Drury Lane in 1813.[13] Byron had written verse dramas. Wordsworth and Shelley had also tried to profit from the same market. So, more recently, had a new young poet named B. W. Proctor, writing under the pseudonym Barry Cornwall. (Reviewing his *Dramatic Scenes* in the *Examiner*, Hunt had said that it reminded him 'of the young poet Keats'.[14])

Brown's idea was exciting as well as practical. He had known for some time that Keats believed his 'chief attempt' would be 'in the Drama'. He also appreciated that Keats had a special respect for Edmund Kean. (He had seen him in at least five roles: Richard III, Hamlet, Macbeth, Othello, and Timon.) When Brown outlined the plot he had in mind, a tale of passion and deception set in the reign of Otho the Great, the first of the Holy Roman Emperors, Keats immediately envisaged Kean in the title role: a model of nobility who suffered betrayal, madness and early death. Before Keats left for the Isle of Wight, he and Brown had already begun their collaboration.

Brown's other advice was more functional. He realised that over the past few years Keats had lent as much as £200 to friends, and urged him to ask for these debts to be repaid. Overcoming his reluctance to seem needy or ungenerous, Keats first wrote to Haydon, requesting the return of £30. Haydon, who recorded in his diary that his 'pecuniary

difficulties' were 'now more dreadful than ever', refused to co-operate. Inevitably, Keats's feelings of embarrassment increased, and damaged his friendship with Haydon still further.

Had Keats not been about to go to the Isle of Wight, he would reluctantly have persevered with other debtors. As it was, he had to content himself with Brown's loan. He was determined to seem optimistic. Insisting 'I have not run quite aground yet I hope,' he told his friends that he had *Otho the Great* to look forward to, and also a new narrative poem that had been suggested by his recent reading of the story of Lamia and Lycius in Burton.[15] He hoped to make a start on it at the same time as he worked on *Otho*. By combining worldliness and fantasy, he believed that he might be able to attract a 'dramatic' audience as well as general readers – some of them, perhaps, the same people who had recently been gripped by accounts in the *Examiner* and elsewhere of a 'fair Circassian'[16] who had been brought to London earlier this year, and who was now living in the Persian embassy, glamorously concealed behind curtains and attended by eunuchs.

THIRTY-SIX

WHEN KEATS FINALLY LEFT Wentworth Place on 17 June he was determined to look 'on fine phrases', rather than on Fanny herself, 'like a lover'. His journey south immediately showed how difficult this would be. Shivering on the roof of the coach in a storm of unseasonably cold rain, he found himself surrounded by 'common french travellers'. He told his sister: 'There was a woman among them to whom the poor Men in ragged coats were more gallant than I ever saw gentlemen to Lady at a Ball – When we got down to walk up hill – one of them pick'd a rose, and on remounting gave it to the woman with "Ma'mselle – voila une bell rose".'

By the time Keats had taken the ferry across to Newport, and caught another coach to Shanklin in the south-east corner of the Isle of Wight, his sore throat had returned and he was running a temperature. Rice, who had travelled down a few days earlier to prepare their lodgings, tried to make him comfortable, but there was not much he could do. His own health was depressingly frail. Within a short time Keats was complaining that he and Rice 'made each other worse by acting on each other's spirits. We grow as melancholy as need be.' He added, thinking of Tom:

'I confess I cannot bear a sick person in a House especially alone – it weighs on me day and night.'

In April 1817, when Keats had last visited the island, he had reckoned Shanklin a prettier 'spot' than Carisbrooke, but had not been able to find lodgings he could afford. Now nothing about the place pleased him. The air was 'remarkably mild',[1] yet he felt ill and 'irritable'. His room – in a white-painted cottage at the southern end of the High Street – was cheap but the size of 'a little coffin'. Nevertheless, it was only home for the time being, and after 'talking briefly'[2] with Rice, he solemnly shut himself away to write. His first task was to work up some of the material Brown had sketched for *Otho*, and to begin 'Lamia'. In the next fortnight he completed the first act of his play and wrote the first half of his poem – some 400 lines. This has rightly been called 'one of [his] greatest feats of concentrated writing',[3] and as he met its challenge, his mind also moved in two other directions. One was towards 'Hyperion', which he would soon start thinking how to revise. The other was to Fanny Brawne in Wentworth Place.

Before leaving Shanklin on 10 September, forty-four days after arriving, Keats wrote to Fanny five times, passionately exploring the conflict in his feelings for her. On the morning of 1 July, in the earliest of his surviving letters to her, he tells his 'dearest Lady', the 'beautiful Girl whom I love so much', that he had written to her the previous evening but torn up his pages because they were 'too much like . . . Ro[u]sseau's "Heloise" '. Even though his second attempt wants to appear less obviously like the start of 'a correspondence', it has its own kind of deliberation. Keats used his separation from Fanny as a chance to dramatise his anguish. He is utterly sincere, but always mindful of the attitudes he strikes.

It is the candour of the letters which has made them so powerful for successive generations of readers. Reading them now, we live in Keats's own rapturous and bitter present, fascinated by his convulsive contradictions, infected by his fever, 'tossed to and fro' by his passionate longings and tormented doubts. But even when identifying with him most particularly, we are always aware that his unique sufferings raise large issues of dependency. By making Fanny 'the prototype of the woman reader',[4] his letters play out anxieties about a female audience in general. This is why Keats is so often concerned to resist Fanny's attempts to contribute to the shape of their relationship. 'Do not accuse me of delay,' he says at one point, and at another: 'You say you must not

have any more such Letters as the last' (in which he had spoken of his 'swooning admiration of your Beauty'). In both these instances, and in many others besides, he masks all sorts of inferiorities as he asserts his male superiority as a lover. He is desperate to present himself as an accepted poet, not as a 'weaver's boy'.[5] He wants to test his 'wings of independence' in the widest sense.

When the letters to Fanny were first published, in 1878, this 'inferiority' provoked a furious argument. Arnold and Swinburne, in particular, were shocked by Keats's 'entire want of tone'. Arnold found one letter especially perturbing – the one in which Keats told Fanny 'You have absorbed me'. 'It has', Arnold said, 'in its relaxed self-abandonment something underbred and ignoble, as of a youth ill brought up, without the training which teaches us that we must put some constraint upon our feelings and upon the expression of them. It is the sort of love letter of a surgeon's apprentice which one might hear read out in a breach of promise case, or in the divorce court.'[6] This remarkable outburst comes close to echoing the attack on *Endymion* by *Blackwood's* and the *Quarterly*. Speaking from the heartland of Victorian respectability, it insists that Keats's passion for Fanny was disgracefully extreme – a vulgar excess, vulgarly expressed.

In his first letter to Fanny, the oscillations between surrender and restraint are painfully clear. Trying to play down the drama of his dilemma, Keats only emphasises it by once again casting himself as a real-life Benedick. He tells Fanny that he has destroyed his first draft because 'I would not have you see those Rhapsodies which I once thought it impossible I should ever give way to, and which I have often laughed at in another, for fear that you should [think me] either too unhappy or perhaps a little mad.' Within a few lines, his defences seem thoroughly broken down. He portrays his need for Fanny not simply as a matter of desire and admiration, but as a poultice for his damaged self. 'I do not know how elastic my spirit might be,' he says, 'what pleasure I might have in living here and breathing and wandering as free as a stag about this beautiful Coast if the remembrance of you did not weigh so upon me. I have never known any unalloy'd Happiness for many days together: the death or sickness of some one has always spoilt my hours – and now when none such troubles oppress me, it is you must confess very hard that another sort of pain should haunt me. Ask yourself my love whether you are not very cruel to have so entrammelled me, so destroyed my freedom. Will you confess this in the Letter you must write

[415]

immediately and do all you can to console me in it – make it rich as a draught of poppies to intoxicate me – write the softest words and kiss them that I may at least touch my lips where yours have been. For myself I know not how to express my devotion to so fair a form: I want a brighter word than bright, a fairer word than fair.'

There is something tenderly emollient in the tone here, something half-joking which takes the edge off Keats's complaint. This note would fade in the weeks to come, as he repeatedly stressed the ambiguities of love and liberty. Fanny the lover would become at once inspiring and smothering; Fanny the physician would be required to heal him even as she increased his fever. (In this role she is also sometimes seen as a surrogate mother, soothing Keats but likely to abandon him.) 'You say you perhaps might have made me better,' he says to her in mid-July, when she is herself suffering a minor illness. 'You would then have made me worse: now you could quite affect a cure: What fee my sweet Physician would I not give you to do so.' Elsewhere he tells her, 'your letters keep me alive'; 'You cannot conceive how I ache to be with you: how I would die for one hour'; and 'I have two luxuries to brood over in my walks, your Loveliness and the hour of my death. O that I could have possession of them both in the same minute.'

None of Fanny's letters to Keats survives, and we have no first-hand evidence of her response to him. We can see in his own letters, however, that she made occasional efforts to assert her independence, and these are enough to suggest she felt a version of the stifling that Keats himself suffered. When Keats meant to be giving he often sounded exaggerated. When he wished to seem protective he usually sounded jealous. When he tried to promise a shared future, he invariably reminded her of how much he would have to sacrifice, 'bod[ing] ill like the raven'. Only a few months previously he had called her 'Millamant', giving the impression that she was flirtatious and giddy. Now he asked her to consider problems, and to endure the storm of his 'not right feelings', in ways which demanded her adult devotion. It was a profound change – one which tacitly pays tribute to the extraordinary maturing of Fanny's own personality.

KEATS CONCEALED THE deep sources of his anguish from Fanny. In other letters written on the Isle of Wight he was only a little less guarded. On 6 July, a little over a week into his visit, he told his sister that he had 'received another Letter from George – full of as good news as we can

expect'. Once again, he was shielding her from the details of his own and their brother's financial problems. (These are sketched in a letter Keats wrote to Abbey on 16 July, in which he says that George is 'of the opinion that I can afford to lend him money of my own', and asks Abbey to contact Fry, the co-trustee who was living in Holland, to grant him power of attorney.) He assured her that even if his new attempt 'to try the fortune of my pen' proved a failure, he would still be able to help George and make ends meet. 'Believe me, my dear sister,' he said, 'I shall be sufficiently comfortable, as, if I cannot lead that life of competence and society I should wish, I have enough knowledge of my gallipots to ensure me an employment & maintainance.'

This reference to 'gallipots', a word that Lockhart had used when reviling *Endymion*, indicates that while pressing ahead with his new poem Keats was continuing to brood about the reception given to his last. On 11 July he admitted as much to Reynolds, saying that he had 'great hopes of success' with 'Lamia', 'because I make use of my Judgement more deliberately than I have yet done'. While this 'Judgement' gave him a clear sense of the future, it could not keep him free from distractions. Towards the end of his first three weeks on the island, his rate of writing began to slow down. Fanny was pressing him to return to Hampstead, perhaps for her nineteenth birthday on 9 August. ('I will say a month,' he told her on 15 July, ' – I will say I will see you in a month at most, though no one but yourself should see me; if it be but for an hour.') Rice, whose illness continued to make him 'rather a melancholy companion', was getting on his nerves. His lodgings made him feel squeezed. Shanklin and the 'very great lion' of the Chine were horribly crowded with tourists. More disturbing still, his health was deteriorating. His throat was sore, and in the middle of the month he told Fanny that he was in 'so irritable a state of health these last two or three days, that I did not think I should be able to write this week'. His frustration increased his worries about having to woo an audience. Telling Fanny that he had 'been reading lately an oriental tale of a very beautiful colour', he first mentioned that he 'applied [it] to you', then turned quickly to his need to create something equally appealing:

I cannot say when I shall get a volume ready. I have three or four stories half done, but as I cannot write for the mere sake of the press, I am obliged to let them progress or lie still as my fancy chooses. By Christmas perhaps they may appear, but I am not yet sure they ever will. 'Twill be no matter, for Poems are as

common as newspapers and I do not see why it is a greater crime in me than in another to let the verses of an half-fledged brain tumble into the reading-rooms and drawing room windows.

The mood here, determined but resentful, is even more obvious in his next letter, written ten days later. Paradoxically, Keats's confusion is all the greater for having spent much of the interval trying to clarify his thoughts. Taking Fanny back to their first meeting, he tells her (which he never told his men friends at the time) that he had fallen in love with her immediately. His sigh of affection soon turns into a squeal of jealousy:

If you should ever feel for Man at the first sight what I did for you, I am lost. Yet I should not quarrel with you, but hate myself if such a thing were to happen – only I should burst if the thing were not as fine a Man as you are a Woman. Perhaps I am too vehement, then fancy me on my knees, especially when I mention a part of you[r] Letter which hurt me; you say speaking of Mr Severn 'but you must be satisfied in knowing that I admired you much more than your friend.' My dear love, I cannot believe there ever was or ever could be any thing to admire in me especially as far as sight goes – I cannot be admired. I am not a thing to be admired. You are, I love you; all I can bring you is a swooning admiration of your Beauty. I hold that place among Men which snub-nos'd brunettes with meeting eyebrows do among women – they are trash to me – unless I should find one among them with a fire in her heart like the one that burns in mine.

Keats wrote this letter to his 'sweet girl' on 25 July. It is the most tortured of all his letters from Shanklin, although it was written soon after his situation on the island had changed. Brown had arrived two days previously, accompanied by the publisher John Martin, who also brought his sister and three friends: they lodged near by. After two days of chat and card parties, Martin and his entourage then took the sickly Rice back to London. Keats was finally 'at liberty' with his closer friend, wanting to begin the next stage of his 'necessary' work. Brown's main purpose was to help with *Otho*, but he also gave Keats other kinds of support. He brought first-hand news of Fanny, and assured Keats that her recent 'ill health' was not serious. He listened to and admired the first part of 'Lamia'. He handed over the manuscript of 'Hyperion', which Keats had asked him to bring from Woodhouse, who had now finished making a copy. It was three months since he had given Woodhouse the poem, telling him that he was so dissatisfied that he could not imagine

developing its original plan to include the overthrow of the individual gods, the 'main conflict'[7] between Apollo and Hyperion, and the second war of the giants against the gods. He knew that persevering with this story would have brought him closer still to *Paradise Lost*, which in Books 5 to 8 contains the history (narrated by Raphael) of the war in Heaven and other events that precede the creation of Adam and Eve. As he looked at his fragment again, encouraged by Woodhouse's opinion that it had 'an air of calm grandeur that is indicative of true power', he began contemplating an alternative structure.

His renewed reading of the *Inferno*, which Brown probably also brought from Wentworth Place, gave him clues about the way forward. By introducing himself into the poem, as Dante had introduced himself with Virgil, Keats realised that he could combine Milton's philosophic nobility with a greater degree of intimacy. At the same time, he could make room for questions which had absorbed him since beginning the poem, but which he felt had been underdeveloped in his first attempt. With Brown to steady him, he began thinking he could start the poem again when he finished 'Lamia', redeeming the past and validating the future at a stroke.

First he had to finish his play. As they had done during their tour of Scotland, Keats and Brown quickly settled their time into a pattern. By 31 July, when they wrote a joint letter to Dilke, they were 'pretty well harnessed again to our dog-cart', spending much of each day sitting either side of a narrow table – Brown sketching a prose outline of each scene, then passing it over for Keats to transform into verse. Brown himself later described their methods: 'The progress of the work was curious; for while I sat opposite to him, he caught my description of each scene, entered into the characters to be brought forward, the events, and everything connected with it. Thus he went on, scene after scene, never knowing nor enquiring into the scene which was to follow, until four acts were completed.'

Brown's plot had strong associations for Keats. One of its sources was William Fordyce Maver's *Universal History, Ancient and Modern*, which he had read at school. Like other authorities, such as Gibbon and Voltaire, Maver gave an adequate account of the general context that Keats needed: the Hungarian uprisings of 953–4, during which Ludolph and his brother-in-law Conrad, Duke of Franconia, unsuccessfully revolted against Otho I (936–73). Unlike them, he gave suggestive details about the relationship between kingly father and rebellious son,

and about Ludolph's passionate but doubtful love for Auranthe. Holding Maver's book in his mind, Keats felt connected to the very start of his life as a writer, and able to address issues which had troubled him ever since.

The play was first printed in 1848, and readers judged it harshly for the first hundred-odd years of its life. (It was not produced until 1950.) Francis Jeffrey, for instance, said it was a 'great failure' and Amy Lowell called it 'dull beyond belief'.[8] More recently, critics have struggled to be kind, favouring the 'rich flavour' of its 'physical impression',[9] but often feeling that it is hastily written and feebly sub-Shakespearean. Many of these criticisms are valid. As overcrowded scene follows overcrowded scene, *Otho* gives little development of character, and only occasional glimpses of Keats's most powerful language. Most of these occur in the last act, which he wrote after leaving Shanklin 'in accordance with his own mind', and feeling 'heap'd to the full, stuff'd like a cricket ball'. By this time Ludolph, rather than his father Otho, has become the centre of attention, and the original intentions of the play have altered. At the outset Keats seemed to want to write a history, addressing some of the public issues he also intended to include in his revised 'Hyperion'. He ended up trying to produce a tragedy (the resemblances to *King Lear* are obvious), as his jealous addiction to Fanny overwhelmed him.

Ludolph is first introduced at the end of Act I, then only appears in two scenes of the next three acts before dominating Act V, where he raves about the deceit of his lover Auranthe. Until this point, dramatic incidents are few and far between. Characters deliver long speeches, action switches between the German and the Hungarian camps, the prevailing themes of jealousy and deception flicker intermittently. Generally speaking, there is little poetic decoration, and what exists is comparatively austere: 'In wintry winds the simple snow is safe, / But fadeth at the greeting of the sun'. This plainness is attractive, but indicative of weaknesses elsewhere. Keats sticks to the details of his plot too rigidly for his governing ideas to seem fully imagined. 'I strove against thee and my hot-blooded son', says Otho at one point, with typically reductive bluntness. 'Dull blockhead that I was to be so blind, / But now my sight is blind; forgive me lady'. Even though Keatsians might enjoy discovering familiar images (eagles, gold, and medicine – victory, for instance, is a 'physician' to Otho and the world is 'feverous' to Gessa, the Prince of Hungary), it is hard to imagine play-goers in general finding much to divert or grip them.

The eventual focus on Ludolph changes this, not just because he is a painfully deceived lover, but because his outbursts are fuelled by larger kinds of social concern. At various points in the first four acts, Keats raises issues of kingship and government which recall his earliest and most overtly political poems. Even though Keats is usually critical of Otho's style of kingship, he does at one point in Act I Scene 2 make him hostile to absolutism. 'I know', says Otho, 'how the great basement of all power / Is frankness, and a true tongue to the world; / And how intriguing secrecy is proof / Of fear and weakness, and a hollow state'. In the following scene Ludolph reinforces this, pointing out that his disguised defence of his father (who at this stage still thinks he is a 'rebel') was 'done in memory of my boyish days, / Poor cancel for his kindness to my youth, / For all his calming of my childish griefs, / And all his smiles upon my merriment'. As Ludolph says this, he refers to his own position as an 'outcast'. It is, he says later, a 'fair disgrace' because it allows him to express his true feelings without anyone supposing that he is motivated by mere expediency. The parallels with Keats's own position are obvious. Rejected by the authority figures of *Blackwood's* and the *Quarterly*, and battling to survive by writing alone, he feels at once isolated and proud. Admitting to the 'necessity' of writing the play, he spurns the idea that he must flatter an audience, in much the same way that Ludolph rejects the 'prodigious sycophants' surrounding his father. The central issue, for author and main character, is one of 'clear honesty' – of 'truth'.

The last act redefines and intensifies this theme. It shows Ludolph so enthralled by the duplicitous Auranthe that other characters suspect he has been 'bewitched' by 'love philtres'. (As if he, like the knight in 'La Belle Dame Sans Merci', were a figure in 'old romance'.) It is a state which allows Keats to release his most neurotic fears about Fanny. 'Poor cheated Ludolph' sees his love not as a 'cure' but as a kind of death-in-life. Any recollection of Auranthe's 'extremest beauty' ('Her nostrils, small, fragrant, faery-delicate') only makes him feel 'a fool'. Any reminder of her faithlessness excites his angry guilt as well as his despair:

> She stings me through! –
> Even as the worm doth feed upon the nut,
> So she, a scorpion, preys upon my brain!
> I feel her gnawing here!

Ludolph is denied his final revenge on Auranthe. She dies before he – 'Half-mad' – can reach her with his dagger to 'finish it'. The climax gives the play its only moment of real dramatic power, which goes some way towards justifying Keats's 'dog-cart' labours. It is also, for all that, disappointing. By confessing that his murderous feelings are an 'excess', Ludolph indicates that Keats himself knew he was being melodramatic. The play's madness, unlike Lear's, is not something which has grown inevitably from suffering, or from the social themes to which it is obviously connected. It is simultaneously too convulsive (a realisation of Keats's worst anxieties) and too calculating (an attempt to write something suitable for Kean).

Keats had explained repeatedly that his main reason for attempting 'the drama' had been to achieve the negative capability he admired in Shakespeare above all others. (*Otho* contains over forty borrowings from seventeen of Shakespeare's plays.) In the event, he created more pastiche than passion, and made himself what he least wanted to be: his own main character. His violent agitation about Fanny is the thinly disguised theme of his most impressive scenes, and also the reason why the play as a whole is a failure, even though it works hard to relate love-madness to wider issues of giving and control. Before Ludolph succumbs to Auranthe, he behaves in ways which expose the structure of his father's kingship. While he means to be patriarchal, Otho embraces the absolute power of monarchy, dispatches his army to achieve settlement rather than choosing to negotiate, and promotes an idea of mercy which is clearly inadequate. At virtually every turn, he ignores the social needs which a culture must recognise if it is to survive. He is too individualistic and too hierarchical to preside over the ideal state that Keats had envisaged in *Endymion*, and to which he had also appealed in more recent poems.

There is no indication that Keats discussed these things with Brown, and nothing to suggest that he confided his most painful feelings about Fanny. On the contrary: sheer labour occupied most of their time (they completed the first three acts by the end of July), and when not confined to their 'coffin', Brown was determined to seem cheerful and busy. He flirted with the local girls, and especially with one named Jenny Jacobs – 'open daylight! he don't care', Keats told Dilke. He braved the throngs of tourists to explore the local scenery. He let Keats challenge him to a 'trial of Skill' with 'Pencil and Paper'. The sketch that Keats produced of Brown has not survived. Brown's drawing of Keats is eloquent and

accomplished; it shows him with his cheek resting on a large clenched fist, and his slightly narrowed eyes fixed on the distance. There is an element of idealisation: the loosely drawn jacket, deep cuff and tightly curled hair are romantically done, and contradict Coleridge's impression of a 'loose, slack, not well-dressed youth'. On the other hand, the full mouth and wide nostril have a particular sensuality. The drawing conveys the impression of a man in two minds – worldly yet speculative, adamant yet adrift.

Brown was a much more sympathetic companion than Rice, yet even he soon began to agitate Keats. If the local Jenny Jacobses were so easily beguiled, how might Fanny be behaving alone in town? She had recently responded to one of his demanding outbursts by telling him that she was enjoying dances at home and in London, especially those at the Royal Artillery Mess in Woolwich. Keats was hardly in a position to complain about this, since there was no formal arrangement between them; but he could not prevent his jealousy from returning even more fiercely than it had done in the past. When he wrote to her again on 5/6 August he promised to 'flit' to her in the near future, as much to reassure himself as to enjoy seeing her.

Nothing came of this plan: Keats was following too closely on a 'trail of writing' that he 'fear[ed] to disturb'. Several all-night sessions on *Otho* had brought him towards the end of Act IV, and as he began to contemplate the next part of 'Lamia', he realised that he needed a library to supply him with necessary details. There was nothing suitable on the island, and when he and Brown looked at the map of the mainland, they decided on Winchester as the nearest place most likely to meet his needs. Brown would stay there for a month or so, he said, then travel on to visit the Snooks at Bedhampton. Keats had never been to Winchester before, but knew it would be congenial. The cathedral, the pretty medieval streets, the churches and college buildings, were part of the world yet detached from it. He imagined that among their ancient stones and hushed shadows he would be able to continue 'a dream among my Books – really luxuriating in a solitude and silence you [Fanny] alone should have disturb'd'.

By the time Keats left Shanklin on 12 August, his dissatisfaction with the place had turned into dislike. A brief separation from Brown, who had spent 'a couple of days . . . gadding over the country with his ancient knapsack', had ended with him breaking into Keats's concentration 'like a Thunderbolt'. Keats still liked his friend's 'society as well as any Man's', but the coffin-cottage brought them too close together for comfort. 'The very [door] posts' were hateful, he complained soon after leaving. 'The voice of the old Lady over the way was getting a great Plague – The Fisherman's face never altered any more than our black tea-pot.'

When Keats told Fanny about these things from Winchester, he realised they made for a 'flint-worded letter' which did not accurately reflect the change in his circumstances. This had begun with a little adventure. Sailing out of Cowes towards the mainland, he saw the Prince Regent's yacht anchored near by, and a fleet of small boats sailing to greet it. Keats suppressed his disapproval of the Regent himself as he enjoyed watching the regatta, and the skill of the ordinary sailors in avoiding a serious accident when a sloop cut across their bows, catching its mast in their bowlines. 'In so trifling an event I could not help admiring our seamen,' he told Fanny. 'Neither Officer nor men in the whole Boat moved a muscle – they scarcely notic'd it even with words.' It was the kind of imperturbability he wanted to discover in himself. During the weeks ahead, he would often cast himself in the role of a naval officer or a soldier as he stiffened his 'resolution for his work'.[1]

His first impressions of Winchester were also inspiring. After travelling west along the new turnpike into Hampshire, he and Brown came to the gentle hills overlooking the city. Below lay the long hull of the cathedral, the water meadows either side of the river Itchen, and the track winding across them to the twelfth-century hospital of St Cross – 'a very interesting old place', he would later say shrewdly, 'both for its gothic tower and alms-square and for the appropriation of its rich rents to a relation of the Bishop of Winchester'. As Chichester had done, everything seemed to suit the mood of his medieval romances. So did the house in which they found lodgings. It has since been destroyed, but seems to have been either in the High Street, or possibly at the junction

of Colbrooke Street and Paternoster Row. It looked out on 'a beautiful – blank side of a house', standing within easy distance of the Market House, the Guildhall, ancient college buildings, and the cathedral itself.

Before long, Keats was calling Winchester 'the pleasantest Town I ever was in'. It was small (the population was only a little over 2,000), sympathetically associated with King Alfred, 'beautifully wooded', and healthy. Compared to the mists which had sometimes cloaked him in Shanklin, Keats felt the air was worth 'sixpence a pint'; after the tourist-covered downs and packed Chine, its streets and surrounding country seemed miraculously peaceful. An evening walk soon became part of his daily routine: across the garden at the back of his lodgings, around the cathedral yard, through 'one of the old city gates' into College Street, where Jane Austen had died two years previously,[2] and then along the banks of the 'beautifully clear', chalk-bedded, trout-filled Itchen towards St Cross. The landscape was delightfully new, and in a sense familiar. As well as seeming to realise scenes from his poems, it reminded him of his childhood in Enfield – fishing for sticklebacks in the New river, losing himself among warm fields.

Within a short time, serpents had slithered into this paradise. Keats had gathered from recent conversations with Brown that none of their attempts to collect his debts had proved successful; his independence was bound to end soon. Worse still, his separation from Fanny grew more distressing. In his first letter to her from Winchester, written four days after he had arrived, he struggled to keep his unfounded suspicions of her faithfulness in check, and to justify his previously harsh tone. The louder he insisted 'I would not write so now', and the nearer he came to apologising for what he called his 'simple innocent childish playfulness', the more he fell victim to 'The thousand images I have had pass through my brain'. His writing, he protested, gave him a quality of 'iron' which made him seem selfish, but it was unavoidable. 'You see how I go on – like so many strokes of a Hammer – I cannot help it – I am impell'd, driven to it. I am not happy enough for silken Phrases, and silver sentences – I can no more use soothing words to you than if I were at this moment engaged in a charge of Cavalry – Then you will say I should not write at all – Should I not?'

After posting this letter to Fanny, Keats seems not to have written to her again until he returned briefly to London in mid-September.[3] He kept his doubts about her to himself, or diverted them into his work. The last act of *Otho*, which he began soon after settling into his new lodgings,

is proof of the 'torments' that boiled beneath the surface of his apparently calm life:

> Must I stop here? Here solitary die?
> Stifled beneath the thick oppressive shade
> Of these dull boughs – this oven of dark thickets –
> Silent – without revenge? Pshaw! – bitter end –
> A bitter death – a suffocating death –
> A gnawing – silent – deadly, quiet death!
> Escaped? – Fled? – Vanished? Melted into air?
> She's gone! I cannot clutch her! No revenge!
> A muffled death, ensnared in horrid silence!
> Sucked to my grave amid a dreary calm!
> O, where is that illustrious noise of war,
> To smother up this sound of labouring breath,
> This rustle of the trees!

Keats felt that his 'labouring' was only endurable so long as his writing justified itself, and his other less intense needs seemed in order. When he had finished *Otho* he wrote immediately to Taylor, meaning to make a straightforward request for funds. As his letter continued, his suppressed worries gradually overwhelmed him. By admitting his poverty, he revealed his loathing of seeming dependent – on social divisions he scorned, on friends, on the woman he loved, and on an audience he could not do without:

Am I not right to rejoice in the idea of not being Burthensome to my friends? I feel every confidence that if I choose I may be a popular writer; that I will never be; but for all that I will get a livelihood – I equally dislike the favour of the public with the love of a woman – they are both a cloying treacle to the wings of independence. I shall ever consider them (People) as debtors to me for verses, not myself to them for admiration – which I can do without. I have of late been indulging my spleen by composing a preface *at* them: after all resolving never to write a preface at all. 'There are so many verses,' would I have said to them', [sic] give me so much means to buy pleasure with as a relief to my hours of labour – You will observe at the end of this if you put down the Letter 'How a solitarry life engenders pride and egotism!' True: I know it does but this Pride and egotism will enable me to write finer things than any thing else could – so I will indulge it – Just so much as I am hu[m]bled by the genius above my grasp, am I exalted and look with hate and contempt upon the literary world – A Drummer boy who holds out his hand familiarly to a field marshall – that Drummer boy

with me is the good word and favour of the public – Who would wish to be among the commonplace crowd of the little-famous – who are each individually lost in the throng made up of themsel[v]es? is this worth louting or playing the hypocrite for? To beg suffrages for a seat on the benches of a myriad aristocracy in Letters? This is not wise – I am not a wise man – T is Pride – I will give you a definition of a proud Man – He is a Man who has neither vanity nor wisdom – one fill'd with hatreds cannot be vain – neither can he be wise –

Keats realised that his publisher would be perturbed by this rhodomontade, and asked that Taylor 'pardon' him for 'hammering instead of writing'. So did Brown, who added a postscript which explained Keats's financial situation in more measured terms. (Taylor was not reassured: he forwarded the letter to Woodhouse, asking for an explanation.) The next day, when Keats wrote to Reynolds, he was a little calmer. He admitted to being still in a 'state of excitement', but attributed it to his commitment to being a 'fine writer', which he called 'the most genuine being in the world'. 'I am convinced more and more day by day', he said, 'that fine writing is next to fine doing the top thing in the world', and added that 'the best sort of Poetry' is 'all I care for, all I live for'. Both remarks show that he was still thinking about his place in the world, and also about how to give his work the social dimension ('fine doing') he felt it needed. In the end, they insist that to make a successful reach outwards, a writer must remain apart, delving inwards. 'My own being which I know to be becomes of more consequence to me than the crowds of Shadows in the Shape of Man and woman that inhabit a kingdom. The Soul is a world of itself and has enough to do in its own home.' (The arguments here expand on statements he had made to Bailey ten days previously, when he had told his more distant friend that 'One of my Ambitions is to make as great a revolution in modern dramatic writing as Kean has done in acting – another to upset the drawling of the blue stocking literary world.')

Predictably, he was gentler and more guarded with his sister. Writing to her on 28 August, he told her how much he liked Winchester, said that although not well enough to go swimming he was enjoying 'fine Weather as the greatest blessing I can have', and assured her a touch disingenuously that his seclusion meant he could 'pass a summer very quietly without caring much about Fat Louis, fat Regent or the Duke of Wellington'. Yet even this letter is shadowed. Before signing off 'affectionate[ly]', Keats admits to his fears for George, to his hatred of Abbey's co-executor Hodgkinson ('a name I cannot bear to write'), and

to his suspicions of Abbey himself. More troubling still, he reveals that he is losing faith in his ability to make money from play-writing. Shortly after starting the letter, he had read in the newspaper that Kean was planning an American tour. This meant there was no chance of *Otho* being performed at Drury Lane until the following season; Covent Garden, the other possible outlet, he dismissed as simply 'execrable'. All the work he had done over the summer to solve his financial problems seemed wasted. He could not even see any point in continuing with the second play he was already planning.[4]

This sequel was called *King Stephen*. When Brown first outlined the plot, which involved Stephen's seizure of the English crown in 1135, and his eventual defeat by the Empress Maud at Lincoln in 1141, Keats had responded enthusiastically. 'He was struck', Brown said later, 'with the variety of events and characters', but insisted that he must have greater control over their development than had been the case with *Otho*. ' "The play must open", [Brown said], "with the field of battle, when Stephen's forces are retreating" – "Stop!" [Keats] said, "Stop! I have been already too long in leading-strings. I will do all this myself." He immediately set about it, and wrote two or three scenes, about 130 lines.'

These few scenes do in fact show Keats taking Brown's advice. Like its predecessor, *Stephen* opens on a 'field of battle', with Stephen himself speaking first:

> If shame can on a soldier's vein-swollen front
> Spread deeper crimson than the battle's toil,
> Blush in your casing helmets! for see, see!
> Yonder my chivalry, my pride of war,
> Wrenched with an iron hand from firm array,
> Are routed loose about the plashy meads,
> Of honour forfeit.

After this bold beginning, *Stephen*'s power is diluted by the same sense of haste that weakened the earlier play. In so far as Keats focuses an argument at all, he addresses issues of self-justification, and a woman's (Maud's) right to govern. Stephen may be a usurper, but seeks to become heroic in his determination to go down fighting: 'Farewell my kingdom, and all hail / Thou superb, plumed, and helmeted renown'. Maud may be an agent of natural law, but she is gloomily severe: ' 'Tis not for worldly pomp I wish to see / The rebel,

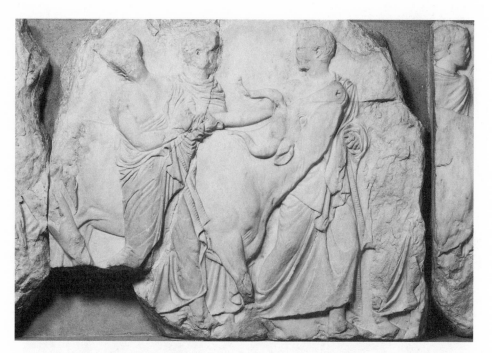

43 The Elgin Marbles, South Frieze, slab XL: 'Who are these coming to the sacrifice? / To what green altar, O mysterious priest, / Lead'st thou that heifer lowing at the skies?'

By John Keats.

44 Drawing or tracing by Keats of the Sosibios Vase.

45

46

45 High Street, Belfast, c. 1820. Keats and Charles Brown walked from Donaghadee to
Belfast on 7 July 1818. 46 Ailsa Craig, 1823, by William Daniell. In a journal-letter to his
brother Tom written 10–14 July 1818, Keats said: 'The effect of Ailsa with the peculiar
perspective of the Sea . . . and the misty rain then falling gave me a complete Idea of a
deluge – Ailsa struck me very suddenly – really I was a little alarmed . . .'

47

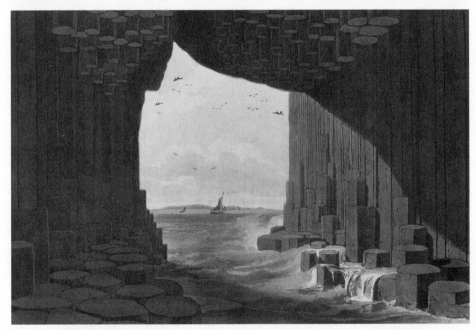

48

47 The birthplace of Robert Burns, c. 1840, by D. O. Hill. Keats wrote his sonnet 'This mortal body of a thousand days' at Burns's cottage on 11 July 1818. 48 Fingal's Cave, Staffa, by William Daniell, 1823. On 24 July 1818 Keats wrote to his brother Tom: 'I am puzzled how to give you an Idea of Staffa. It can only be represented by a first rate drawing'.

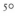

51

49 John Gibson Lockhart by Sir Francis Grant. In his review of *Endymion* in *Blackwood's Magazine* in August 1818, Lockhart, writing under the signature 'Z', urged Keats to abandon poetry and go 'back to . . . "plasters, pills, and ointment boxes," &c' 50 John Wilson Croker (1780–1857), by William Owen, 1812. Croker began his review of *Endymion* in the *Quarterly Review*: 'We have made efforts almost as superhuman as the story itself appears to be, to get through it; but . . . we have not been able to struggle beyond the first of the four books . . .'. 51 Francis Jeffrey (1773–1850), by William Bewick. Jeffrey was the editor of the *Edinburgh Review*; although he praised Keats's 1820 volume, he was slow to defend *Endymion*, which Keats considered 'cowardly'.

52

53

52 'To Henry Hunt': an aquatint made on 16 August 1819, showing the Massacre at
Peterloo. 53 Wentworth Place, Hampstead, in half of which Keats lived with Brown from
the end of 1818.

54 Well Walk, Hampstead, where Keats lived with his brothers 1817–18.

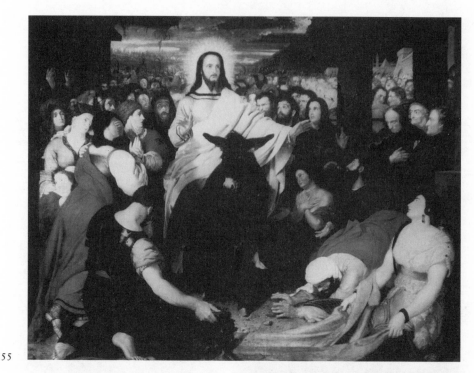

55

56

57

55 'Christ's Entry into Jerusalem', by Benjamin Robert Haydon, completed in 1820. Keats appears in profile between the two pillars on the right, just behind the bowed head of Wordsworth, and talking heatedly to Haydon's pupil William Bewick. 56 Sketches of Keats by Benjamin Robert Haydon, taken from his journal, November 1816; they show him beginning to evolve the portrait of Keats that appears in 'Christ's Entry into Jerusalem'. 57 Detail of Keats's portrait in 'Christ's Entry into Jerusalem'.

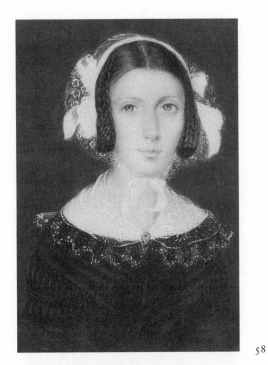

58

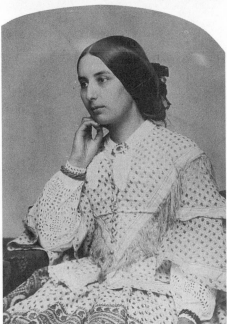

60

58 Fanny Brawne (1800–1865),
a miniature by an unknown
artist, c. 1833. 59 Fanny
Brawne, an ambrotype taken c.
1850 60 Fanny Brawne aged
twenty-eight. The silhouette was
cut by Augustin Edouart
between January and June
1829.

59

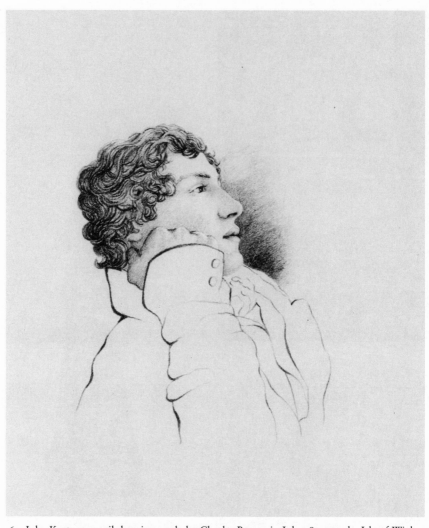

61 John Keats, a pencil drawing made by Charles Brown in July 1819 on the Isle of Wight.
OPPOSITE: 62 A silhouette of Keats made by Marianne Hunt in 1820. 63 Dr George
Darling (?1782–1862), by Haydon, 1826–30. Darling was one of several doctors who
attended Keats in Hampstead and Kentish Town. 64 John Keats by Joseph Severn: a
posthumous portrait (1823), which shows him reading in Wentworth Place.

62

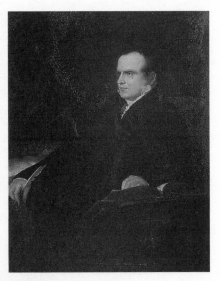

63

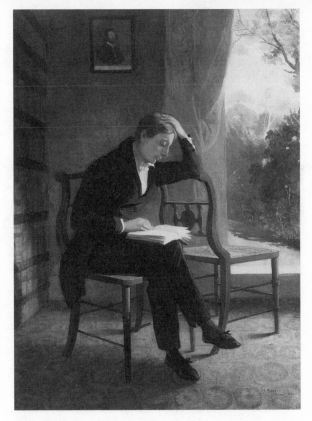

64

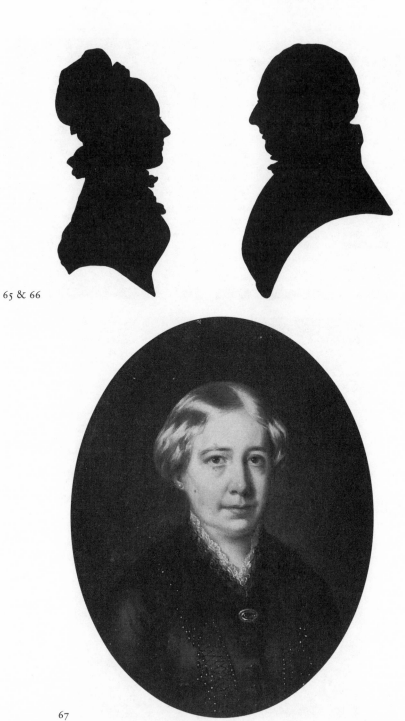

65 & 66

67

65 & 66 Silhouettes of Georgiana and George Keats, c. 1830.
67 Fanny Llanos (née Keats), by her son Juan Llanos, c. 1860.

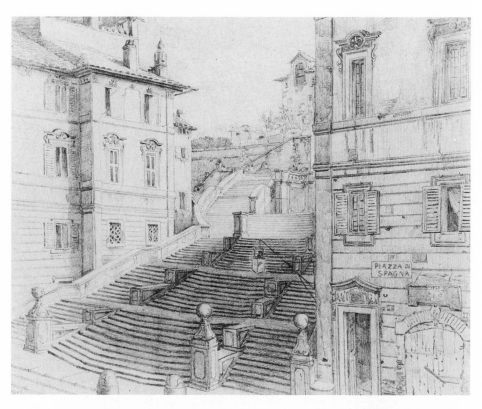

68 Keats's house in Rome, No. 26 Piazza di
Spagna, 1819; front door bottom right.
69 Dr James Clark (1788–1870), by Hope James
Stewart, 1848. Before Keats left England for Italy
he told Brown 'I am to be introduced . . . to a
Dr Clark, a physician settled at Rome, who
promises to befriend me in every way'.

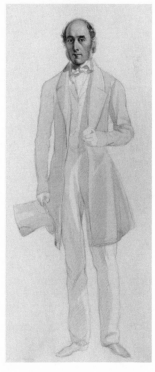

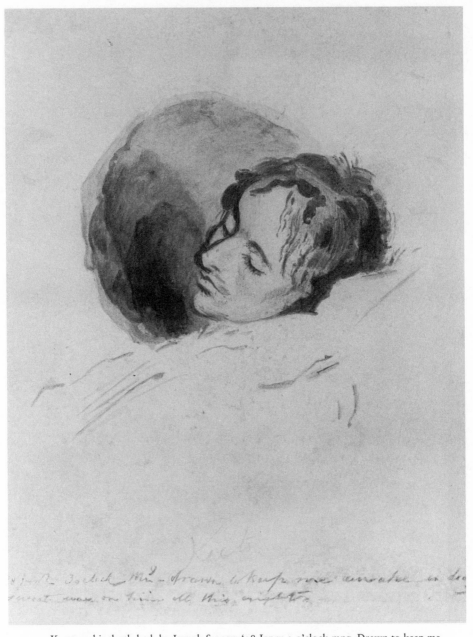

70 Keats on his death-bed, by Joseph Severn: '28 Janry 3 o'clock mng. Drawn to keep me awake – a deadly sweat was on him all this night'.

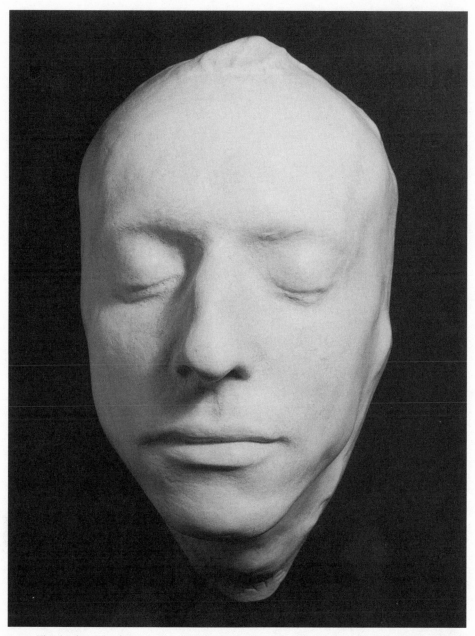

71 The death-mask of Keats, taken by Gherardi on 24 February 1821, the day after Keats died.

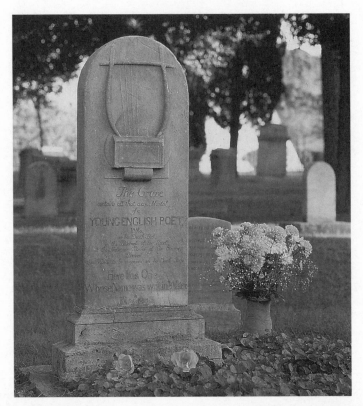

72

73

72 Keats's grave in the Protestant Cemetery, Rome. 73 The Protestant Cemetery in Rome,
by Samuel Palmer, showing the Pyramid of Cestius.

but as dooming judge to give / A sentence something worthy of his guilt.'

It is easy to see why these themes appealed to Keats. They describe political ideals and antagonisms that he had cherished all his life; they reflect his sense of being a writerly 'usurper'; they recast his resistance to and respect for Fanny; and they embody his wish to make a mark on posterity. But even supposing he had received less dismaying news about Kean (which anyway turned out to be false), and had found time and energy to finish the play, it seems unlikely that the piece as a whole would have proved successful. Like *Otho*, *Stephen* is too frankly derivative, too quick in its narration, and too stiffly theatrical. Within the tense lyrical structures of the odes he was able to release himself more potently. Within the monumentally moulded world of 'Hyperion' he could feel the pulse of philosophy more clearly. Within the flowing narrative of 'The Eve of St Agnes' and the fragmentary 'The Eve of St Mark', he discovered a form which was intimate as well as sociable. In his plays, he addresses his readers too obviously. He wanted to create worlds which were hotly imagined and yet rigorously speculative, but he delivered them with a headlong rush which was fatal to both ambitions.

LUDOLPH IS BEWITCHED by a beautiful enchantress who turns out to be other than she seems; he sinks from adoration to mania. Although 'Lamia' also describes a movement from entrancement to devastation, it is enriched by ambiguities which are quite absent from *Otho*. Keats began the second part of the poem in late August, when his disappointment about Kean might easily have broken his concentration and damaged his sense of continuity. (Part I had been completed more than a month before.) In fact the integration and development of the poem are among its most striking features. Possibly Keats's delay had worked to his advantage. For all their shortcomings, his plays had at least explored compatible themes. Abandoning *Stephen* meant that he could deploy ideas and energies which were already well rehearsed.

Other kinds of preparation had been more deliberate. He had come to Winchester with the express purpose of plundering the city libraries and, while working on his plays, he had researched the 'background colour'[5] of his poem in John Potter's *Archaeologia Graeca*, which Haydon had recommended to him earlier in the year, and which he had fortunately discovered in a local bookshop. He had also continued to read Dante, whose *Inferno* influenced his sense of Lamia as a half-

human, half-demon lover, and Dryden, whose tautly colloquial style would affect the general tone of his couplets, and shape particular moments more precisely. Within a matter of days, he had the details he needed, and was ready to flesh out the structure derived from Lemprière and Burton. When he first printed 'Lamia' in his 1820 volume, he accompanied it with the following passage from the *Anatomy* to acknowledge at least this one of his several debts:

Philostratus, in his fourth book *de vita Apollonii*, hath a memorable instance in this kinde, which I may not omit, of one Menippus Lycius, a young man 25 years of age, that going betwixt Cenchreas and Corinth, met such a phantasm in the habit of a gentlewoman, which taking him by the hand, carried him home to her house, in the suburbs of Corinth, and told him she was a Phoenician by birth, and if he would tarry with her, he should hear her sing and play, and drink such wine as never any drank, and no man should molest him; but she being fair and lovely, would live and die with him, that was fair and lovely to behold. The young man, a philosopher, otherwise staid and discreet, able to moderate his passions, though not this of love, tarried with her a while to his great content, and at last married her, to whose wedding, amongst other guests, came Apollonius; who, by some probable conjectures, found her out to be a serpent, a lamia; and that all her furniture was like Tantalus gold, described by Homer, no substance, but meer illusions. When she saw herself descried, she wept, and desired Apollonius to be silent, but he would not be moved, and thereupon she, plate, house, and all that was in it, vanished in an instant: many thousands took notice of this fact, for it was done in the midst of Greece.

By publishing this extract, Keats advertised his wish that 'Lamia' should seem disinterested. He had already let Reynolds know that his poem made more 'use of my judgement than I yet have done', and would soon tell Woodhouse that whereas 'Isabella' was 'too smokeable', there was 'no objection of this kind to Lamia'. Later still, he showed his confidence in the poem by placing it first in his 1820 volume. All these things imply something instantly appealing about 'Lamia'. In fact readers have often found it confusing. Sometimes they have tried to gloss it with biographical interpretations which can never be made to fit exactly. (Gittings wonders if Lamia is Fanny or Isabella Jones, Middleton Murry casts Brown as Apollonius.) More frequently, they have supposed that Keats's 'judgement' was designed to produce clear-cut answers. In fact, 'Lamia' delights in complications. As it advances the claims of living 'in one mind', it celebrates the necessity of being in several.

In spite of this fascinating openness, there is no doubt that the poem's arguments all close on questions about love. Is it a revelation or a delusion? Does it fulfil the self or is it destructive? What power does it have to counter or include philosophy? How can it accommodate the demands of the material world? Keats prepares the ground for these thoughts by opening with the pre-history of Lamia, which is not mentioned by Burton.[6] This prelude tells the story of Hermes (Mercury) who 'left / His golden throne, bent on amorous theft' of a 'sweet nymph'. As he flits 'From vale to vale, from wood to wood' he discovers 'a palpitating snake' complaining that she longs to 'move in a sweet body fit for life':

> She was a gordian shape of dazzling hue,
> Vermilion-spotted, golden, green, and blue;
> Striped like a zebra, freckled like a pard,
> Eyed like a peacock, and all crimson barred;
> And full of silver moons, that, as she breathed,
> Dissolved, or brighter shone, or interwreathed
> Their lustres with the gloomier tapestries –
> So rainbow-sided, touched with miseries,
> She seemed, at once, some penanced lady elf,
> Some demon's mistress, or the demon's self.
> Upon her crest she wore a wannish fire
> Sprinkled with stars, like Ariadne's tiar;
> Her head was serpent, but ah, bitter-sweet!
> She had a woman's mouth with all its pearls complete;
> And for her eyes – what could such eyes do there
> But weep, and weep, that they were born so fair,
> As Proserpine still weeps for her Sicilian air.

After Hermes has listened to Lamia's story – she tells him that she 'was a woman' and is now in love with 'a youth of Corinth' – she promises to direct him to his 'nymph' if he will release her from her 'wreathed tomb'. The twin freedom follows immediately: Hermes and his lover disappear 'Into the green-recessed woods', and Lamia erupts like a firework, becoming a 'full-born beauty new and exquisite'. It is a transformation which crackles with sexual excitement, and with the intellectual thrill of a scientific experiment. The intense pleasure of self-realisation is fizzily mingled with the pain of the process:

But the God fostering her chilled hand,
She felt the warmth; her eyelids open'd bland;
And she, like new flowers at morning song of bees,
Bloom'd, and gave up her honey to the lees.
Into the green-recessed woods they flew;
Nor grew they pale, as mortal lovers do.

Left to herself, the serpent now began
To change; her elfin blood in madness ran,
Her mouth foam'd, and the grass, therewith besprent,
Wither'd at dew so sweet and virulent;
Her eyes in torture fix'd, and anguish drear,
Hot, glaz'd, and wide, with lid-lashes all sear;
Flash'd Phosphor and sharp sparks, without one cooling tear.
The colours all inflam'd throughout her train;
She writh'd about convuls'd with scarlet pain:
A deep volcanian yellow took the place
Of all her milder-mooned body's grace;
And, as the lava ravishes the Mead,
Spoilt all her silver mail, and golden brede;
Made gloom of all her freckelings, streaks and bars,
Eclips'd her crescents, and lick'd up her stars:
So that, in moments few, she was undrest
Of all her sapphires, greens, and amethyst,
And rubious-argent: of all these bereft,
Nothing but pain and ugliness were left.
Still shone her Crown; that vanish'd, also she
Melted and disappeard. as suddenly;

14 From 'Lamia', Part I; Keats's fair copy.

 her elfin blood in madness ran,
 Her mouth foamed, and the grass, therewith besprent,
 Withered at dew so sweet and virulent;
 Her eyes in torture fixed, and anguish drear,
 Hot, glazed, and wide, with lid-lashes all sear,
 Flashed phosphor and sharp sparks, without one cooling tear.
 The colours all inflamed throughout her train,
 She writhed about, convulsed with scarlet pain:
 A deep volcanian yellow took the place
 Of all her milder-moonèd body's grace;
 And, as the lava ravishes the mead,
 Spoilt all her silver mail, and golden brede;
 Made gloom of all her frecklings, streaks and bars,
 Eclipsed her crescents, and licked up her stars.
 So that, in moments few, she was undressed
 Of all her sapphires, greens and amethyst,
 And rubious-argent; of all these bereft,
 Nothing but pain and ugliness were left.

For Hermes, the revelation of love means finding immortal pleasure. Lamia's convulsions are more disturbing. Her infatuation with Lycius cannot conceal the fact that she is a 'shape-shifter'.[7] It means that she must enter a world in which she is bound to be vulnerable because she is continually threatened with discovery. Keats registers his mixed feelings by combining wonder with revulsion when he describes her physical change; in the narrative that follows, both aspects of his response are developed equally. The function of the prelude, in other words, is to establish ambiguities which govern the poem as a whole. Hermes is propelled by love but acts as a materialist, striking deals and trading favours. Lamia is sincere but slippery. Because we have seen her as a snake, we cannot ignore her unreality in everything she does. Neither can we forget that love is bound up with self-interest, and abstract longing with actual circumstances.

With financial circumstances in particular.[8] When Lamia goes to Corinth to find Lycius, she approaches a city renowned for its 'immensely profitable trade', leaving 'the golden age for an age of gold'.[9] Emotions in the city are just as likely to be bartered as goods. Her own value changes accordingly. In the original classical realm of the poem, she may have been physically imprisoned, but was free to exchange favours with Hermes in ways which did no immediate

damage. In Corinth she is physically liberated but cannot engage innocently with her lover or his society. Feelings which began by proving the triumph of the imagination therefore become sinister. Lamia is turned from someone who enjoys her desires into someone who casts spells. She is no longer a suddenly beautiful mythical creature; she is a 'Belle Dame'.

When Lamia encounters Lycius, Keats keeps her function as a charmer as vividly in mind as her charm itself. Lycius's eyes 'drink her beauty up', even though he fears that she might be unreal – that she might 'vanish', or be 'a Naiad of the river'. Ironically, she quickens her seduction by appealing to him as 'a scholar' who 'must know / That finer spirits cannot breathe below / In human climes, and live'. In so teasing him (and speaking in language that Keats had previously used in *Endymion*: she asks 'What taste of purer air hast thou to soothe / My essence?'), she impels a change in keeping with her own. 'Wakening' Lycius from 'one trance . . . into another', she makes him her victim, 'tangled in her mesh', and destroys his sense of what is 'true' and 'real'.

By couching his seduction in these terms, Keats narrows the gap between his hero and himself. Lycius is a type of the Romantic artist, preoccupied by issues of identity:

> she whispered in such trembling tone,
> As those who, safe together met alone,
> For the first time through many anguished days,
> Use other speech than looks; bidding him raise
> His drooping head, and clear his soul of doubt,
> For that she was a woman . . .

This passage leads towards the poem's central ambiguity. Although Lamia's 'whisperings' are a deception, they persuade Lycius that he and his lover are united by similar feelings. Sensing that 'the self-same pains / Inhabited her frail-strung heart as his', he realises that they share a longing to become fully human. For Lamia this means concealing her serpentine nature; for Lycius it means either altering or transcending the existence he has led in Corinth – the existence which is defined in the remainder of Part I. As he leads Lamia back to his 'pillared porch, with lofty portal door', he begins to feel that losing 'his heart' means finding greater rewards than any he has known. Not only is Lamia's beauty a more valuable 'gold coin' than any he has handled as a trader. It is a

challenge to his discipleship with Apollonius, his 'trusty guide / And good instructor'.

When they pass Apollonius in the street, Lamia shudders, reminding us that she is liable to being unmasked. By now, however, the original balance of Keats's sympathies has shifted. His tacit identification with Lycius has brought him under Lamia's spell. She is no longer merely a fake, but someone whose deceptions are deemed to have a humanising function. The implications are developed throughout Part II, where the lovers are first sealed in amorous privacy. Their pleasure might represent a kind of escape; it also allows them to fulfil themselves, denying any chance to 'breed distrust and hate'. Indeed, when they become conscious that their time is limited – that they cannot survive in the world by concealing themselves from it – it is Lamia and not Lycius who introduces the idea. This confirms that the original order of the poem has been reversed. In Corinth, it is Lycius who precipitates a catastrophe. Using the language of power and money that dominates the city, he tells Lamia that he wants a public marriage, something 'majestical' and triumphalist. Arguably, this hubris is another aspect of Lamia's trickery: she has generated feelings in her lover which lead to his downfall. At the same time, he behaves with a degree of cruelty ('passion . . . / Fierce and sanguineous') which ensures that she keeps our sympathy.

By making Lycius proud and domineering, and Lamia fearful and sensitive, Keats locks the final paradoxes of his poem into place. As architect of the magical wedding banquet, Lycius is 'senseless' and a 'Madman'. Unlike Lamia and the forewarned reader, he cannot see that Apollonius will destroy their 'warm cloistered hours':

> Do not all charms fly
> At the mere touch of cold philosophy?
> There was an awful rainbow once in heaven:
> We know her woof, her texture; she is given
> In the dull catalogue of common things.
> Philosophy will clip an Angel's wings,
> Conquer all mysteries by rule and line,
> Empty the haunted air, and gnomèd mine –
> Unweave a rainbow, as it erewhile made
> The tender-personed Lamia melt into a shade.

These notorious lines have often been read as an instance of Keats stepping outside the poem to speak in his own voice. They echo Hazlitt's opinion that 'the progress of knowledge and refinement has a tendency to circumscribe the limits of the imagination', and to 'clip the wings of poetry', and recall the 'Immortal Dinner' with Haydon, at which Keats had toasted 'confusion to mathematics'. In the context of the poem, they seem knowingly extreme. Keats is not saying that all philosophy is necessarily 'cold'. He is suggesting that the seclusion of the lovers makes them vulnerable to its 'mere touch'. They are equally but differently to blame: Lamia has wanted to escape from society because her incomplete humanity puts her in danger; Lycius wanted to boast to the world without thinking how he needed to integrate its material demands with his private feelings. Neither of them has sufficient negative capability; neither has married sensations with thoughts.

Nevertheless, the final unmasking of Lamia by Apollonius at the wedding banquet seems brutal – especially since feasting in Keats's poems is usually a prelude to gratification. (In *Endymion*, 'The Eve of St Agnes', *Otho* and elsewhere.[10] Apollonius's gaze into Lamia's eyes ignores her 'lovelorn piteous appeal', he 'absorbs' her 'loveliness', he is 'ruthless', a 'wretch', and a 'contemptuous' sophist. The paradox is elaborate. By exposing Lamia as a serpent and causing her to vanish, Apollonius preserves his pupil Lycius and at the same time destroys him. He becomes a form of the evil he banishes. He cannot appreciate that Lamia's two natures might be reconciled. His 'magic' does not take account of what cannot be known.

The outcome at once validates and confounds Keats's opinion that he showed more 'judgement' in 'Lamia' than in anything else he had written. Its final scenes of destruction justify the warnings about deception that he has given in the opening lines, and offer themselves as an allegory of the opposition between poetry and scientific rationalism. The whole middle part of the poem, however, has complicated the relationship between cause and effect. Deception, which is originally a pure wickedness, becomes part of the machinery of pleasure. Lamia, who is at first a manipulator, is finally 'tyrannised' by Lycius. Philosophy, which first seems an absolute good, is eventually shown to be baleful. Bargaining, which in its emotional and material forms is initially deemed to be corrupting, is at last considered necessary.

The tone of the poem changes as its argument alters. The playfulness of the opening, though it finds a parallel in lavishly sensual descriptions,

gives way to bitterness and sarcasm. Inevitably, this makes us wonder about the connection between Keats's theme and his own circumstances. In so far as the poem is an attempt to resolve his feelings about Fanny, it proves that he cannot do without her – which suggests that it might be read as a poem of concession. It also embodies two kinds of elegy. One is to do with the imagination. Keats's many references to and reversals of *Endymion* amount to a departure from the Classical world he had always promoted as his ideal. In the prelude, and in Corinth itself, he criticises the antique fictions which had been his lifeblood, and allows Lycius's eventual fate to seem a form of liberation from them. The other is personal. The love commemorated in the poem, which is at once nourished and damaged by the 'not right feelings' which originated in his boyhood, is not merely illusory or defective. It is the prelude to death itself.

THIRTY-EIGHT

KEATS FINISHED 'LAMIA' feeling briefly confident that he had at last written something which honoured his poetic principles and would also prove popular. 'There is', he said, 'a fire in it which must take hold of people in some way.' He immediately set about thinking how he might revise other recent poems to make them equally appealing. Turning to 'The Eve of St Agnes' before August was over, he wrote one entirely new stanza, and several new lines, to make it clear that Madeline and Porphyro become lovers, and to describe the beadsman's death in more detail. When Woodhouse and Taylor saw these changes, they thought Keats had gone too far, and told him that he was bound to alienate readers rather than attract them. Keats was adamant. His alterations, he said, suited his mood and his aims. He could not accept that they were merely sensational, rather than full of sensation.

These disagreements lay a little in the future. As Keats was working on his revisions, Taylor was still worrying about the 'pride and egotism' Keats had shown in his letter of 23 August. Woodhouse had done what he could to settle things down, pointing out that Keats's word 'Pride' meant 'nothing more than literary Pride'. In order to feel properly reassured, Taylor – who was still recuperating in Retford – needed to hear again from Keats himself. Encouraged by Brown, Keats wrote to his publisher a second time, apologising for his recent histrionics and

Brown is going to Chister and Bedhampton a visiting — I shall be alone here for three weeks — expecting accounts of your health

Winchester Sept 5th —

My dear Taylor,

This morning I received yours of the 2nd and with it a letter from Hessey enclosing a Bank post Bill of 30£, an ample sum I assure you — more I had no thought of. You should have delayed so long leading an inactive life in Fleet Street; breathing poison: you will find the country air do more for you than you expect. But you must be proper ... you must choose a spot ...

15 Keats's letter to Taylor, written on 5 September 1819; the first page.

struggling to seem moderate. 'I am in want of a Month's cash,' he said, then hurriedly insisted 'I do not apply to you as if I thought you had a gold Mine.' His self-control soon had the desired effect. On 5 September, when Keats was down to his last 'few shillings' and was living 'in fear of the Winchester Jail', he received £30 from Hessey, £20 from Woodhouse, £30 from a friend of Brown's, and the repayment of a £40 loan he had made to Haslam. Keats wrote to Hessey with embarrassed gratitude ('to be a complete Midas I suppose someone will send me a pair of asses ears by the wagon'), and to Taylor as well.

This third letter to Taylor includes some lines from 'Lamia' – an extract later cancelled from the second part of the poem. They were obviously intended as evidence of his summer's marvellous creativity. Rather than proving any such thing, however, they show Taylor had been right to feel worried by Keats's recent vehemence. Like his remarks about 'pride and egotism', they are crudely strenuous. Their satire has more in common with 'The Cap and Bells', which Keats would begin writing the following winter, than with the controlled opulence of 'Lamia' as a whole:

> Swift hustled by the servants: – here's a health
> Cries one – another – then, as if by stealth,
> A Glutton drains a cup of Helicon,
> Too fast down, down his throat the brief delight is gone.
> 'Where is that Music?' cries a Lady fair.
> 'Aye, where is it my dear? Up in the air?'
> Another whispers 'Poo!' saith Glutton 'Mum!'
> Then makes his shiny mouth a knapkin for his thumb.

Although Keats did not make the connection himself, the rest of his letter to Taylor explains why he chose to send these lines. As he came to the end of 'Lamia', his poetic balance began to break up very rapidly. He found that the world he had managed to transfigure in the past few weeks was now too much with him. His short-term financial situation had improved, but he was still fretting about what he called elsewhere 'the poisonous suffrage of a public'. He was worrying more than ever about his health. Knowing that Taylor himself was poorly, he called on memories of his medical training to recommend country air. 'What sort of a place is Retford?' he asked anxiously. 'You should live in a dry, gravelly, barren, elevated country open to the currents of air, and such a

place is generally furnish'd with the finest springs.' It was the sort of advice that he realised he should be taking himself, and when he returned within a few dozen lines to brooding once more on 'money matters', he said that he wanted his 'worldly non-estate' put in order 'in case of my death'. It was the first time he had mentioned the possibility so openly.

BROWN FINALLY LEFT Winchester to visit John and Letitia Snook in Bedhampton on 6 September. Keats remained alone in their lodgings, knowing it was his last chance to complete the 'immense' task he had set himself during the summer. He continued to tell himself that his solitude was bound to be productive, and that his jealousy of Fanny was under control. His dread of 'dissolving' had abated. His independence had been redefined – partly by his continuing refusal to write to her.

He decided to continue developing the future by redeeming the past. As soon as he had finished with 'The Eve of St Agnes', he turned back to the manuscript of 'Hyperion'.[1] For some time he had been reading Dante again, and as he redrafted the opening section of his 'grand poem' he studied the *Inferno* more closely, reading it in Italian with Cary's translation as a guide. He not only wanted to humanise the Miltonic idea that good and evil exist 'together in the field of the world'.[2] He intended to create a different framework for his discussion of poetic identity – even if this meant repudiating the old myths he had previously held so dear, and embracing new kinds of indebtedness. (These are particularly obvious in the similarities between Keats's and Dante's poet-guides, and in the approach to the altar of Moneta, the goddess of Knowledge and Memory, previously called Mnemosyne.) Beginning where the first 'Hyperion' ended, with Apollo's cry that 'Knowledge enormous makes a god of me', Keats identifies himself with the god who is the agent of poetry and healing, and fixes his attention on 'the deifying power of the artist'.[3] This makes the poem more urgent and more distinctly contemporary – self-evidently concerned with the conditions and consciousness of the modern writer:

> Fanatics have their dreams, wherewith they weave
> A paradise for a sect; the savage too
> From forth the loftiest fashion of his sleep
> Guesses at Heaven: pity these have not
> Traced upon vellum or wild Indian leaf

Here is what I had written for a sort of induction

Fanatics have their dreams wherewith they weave
A Paradise for a Sect; the savage too
From forth the loftiest fashion of his sleep
Guesses at Heaven: pity these have not
Trac'd upon vellum, or wild indian leaf
The shadows of melodious utterance:
But bare of laurel they live, dream, and die
For Poesy alone can tell her dreams,
With the fine spell of words alone can save
Imagination from the sable charm
And dumb enchantment.

Now for all this you two must write me a letter apiece - for as I know you will each read one another. I am still writing to Reynolds as well as yourself. As I say to George I am writing to you but at your Wife - and dont forget to tell Reynolds of the fairy tale Undine - Ask him if he has read any of the American Brown's novels that Hazlitt speaks so much of - I have read one call'd Wieland - very powerful - something like Godwin - Between Schiller and a Godwin - a Domestic he prototype of Schiller's Armenian. More clever in plot and incident than Godwin - A strange american scion of the German trunk. Powerful genius - accomplish'd horrors - I shall proceed tomorrow. Wednesday - I am all in a Mess here - embowelled in Winchester. I wrote two Letters to Brown one from said Place, and one from London, and neither of them has reached him - I have written him a long one this morning

6 'The Fall of Hyperion', beginning of Canto I; included in a letter Keats wrote to Woodhouse on 21 September 1819.

The shadows of melodious utterance.
But bare of laurel they live, dream, and die;
For Poesy alone can tell her dreams,
With the fine spell of words alone can save
Imagination from the sable charm
And dumb enchantment. Who alive can say,
'Thou art no Poet – mayst not tell thy dreams'?
Since every man whose soul is not a clod
Hath visions, and would speak, if he had loved,
And been well nurtured in his mother tongue.
Whether the dream now purposed to rehearse
Be Poet's or Fanatic's will be known
When this warm scribe my hand is in the grave.

Keats wrote these lines less than a year after beginning the first 'Hyperion'. His wish was to answer many of the questions he had asked himself during this extraordinary time; his achievement is to deepen their resonance. He proposes a role for the poet, as healer and/or philosopher, which is admired but not fully realised. He imagines an existence within history which cannot be confident of progress. He opposes dreaming and poetry without feeling sure that one can do without the other. These doubts dominate the first grand scene in the poem. Keats enters a 'bower' (it recalls his progress from the 'chamber of maiden thought' to the 'thoughtless' chamber), where he finds the 'refuse' of a feast on which he feeds 'deliciously' before 'swooning' into a profound slumber. As so often in his poems, this gorging is the 'parent' to a vision. Nothing the narrator has seen 'upon the earth' resembles his new surroundings (even though they are described in images which clearly derive from Keats's walking tour). Their focus is a 'shrine' which appears both fatal and death-defying, in much the same way that Moneta, who finally speaks to him from behind 'white fragrant curtains', sounds at once daunting and enlightening. 'If thou canst not ascend/ These steps', she says, 'die on that marble where thou art'. Her invitation seems just as likely to produce actual death as death-in-life:

I heard, I looked: two senses both at once,
So fine, so subtle, felt the tyranny
Of that fierce threat, and the hard task proposed.
Prodigious seemed the toil; the leaves were yet
Burning – when suddenly a palsied chill

Struck from the pavèd level up my limbs,
And was ascending quick to put cold grasp
Upon those streams that pulse beside the throat.
I shrieked; and the sharp anguish of my shriek
Stung my own ears – I strove hard to escape
The numbness, strove to gain the lowest step.
Slow, heavy, deadly was my pace: the cold
Grew stifling, suffocating, at the heart;
And when I clasped my hands I felt them not.
One minute before death, my iced foot touched
The lowest stair; and as it touched, life seemed
To pour in at the toes.

In the dialogue which follows, the narrator draws Moneta towards as
clear a definition of her role as she or he can manage. She begins by
assuring him that 'None can usurp this height . . . / But those to whom
the miseries of the world / Are misery, and will not let them rest'. This
confirms the argument of the introduction to the poem, in which Keats
had insisted on the poet's responsibility to 'purge off' his mind's 'film'
and embrace the suffering of the world. As Moneta expands her
argument, however, it becomes obscure. Is she a judge or a redeemer?
The confusion is both beguiling and unsettling. When the narrator
wonders why he stands alone at the shrine, Moneta answers:

'They whom thou spak'st of are no visionaries,
 . . . – They are no dreamers weak,
They seek no wonder but the human face;
No music but a happy-noted voice –
They come not here, they have no thought to come –
And thou art here, for thou art less than they –
What benefit canst thou do, or all thy tribe,
To the great world? Thou art a dreaming thing,
A fever of thyself. Think of the Earth;
What bliss even in hope is there for thee?
What haven? Every creature hath its home;
Every sole man hath days of joy and pain,
Whether his labours be sublime or low –
The pain alone; the joy alone; distinct:
Only the dreamer venoms all his days,
Bearing more woe than all his sins deserve.
Therefore, that happiness be somewhat shared,

[443]

Such things as thou art are admitted oft
Into like gardens thou didst pass erewhile,
And suffered in these temples; for that cause
Thou standest safe beneath this statue's knees.'

Perhaps the difficulties here would have been resolved if Keats had lived long enough to revise his poem. As they stand, they show how intense the 'conflicting inclinations of his sensibility'[4] had become, and suggest that he had not finally decided what he thought about the relationship between poetry and suffering. Accepting that the source of the poet's power depends on learning to combine pain with pleasure, he implies that his art and his conscience may lead in different directions. These uncertainties exist, though, in the confused heart of the poem; at the surface level of narrative and conscious argument, things are more nearly reconciled. Keats plainly insists that suffering is a source of insight, and is grateful to Moneta (her words are 'propitious') for clarifying his sense that 'a poet is a sage, / A humanist, physician to all men'. She says, in some of the most famous lines Keats wrote: 'The poet and the dreamer are distinct, / Diverse, sheer opposites, antipodes. / The one pours out a balm upon the world, / The other vexes it'. Keats responds to this with an excitement that is out of keeping with the rest of the poem, differentiating himself from the 'mock lyricists' and 'careless hectorers in loud bad verse'. It is a moment in which we hear sharp echoes of many recent remarks in his letters – remarks in which he had criticised more successful poets than himself (such as Byron), and had emphasised his wish 'of doing the world some good'.

In the remainder of Canto I, the mood settles again. Moneta sketches the recent history of the rebellion which has left her 'supreme / Sole priestess' of the 'desolation' following Saturn's fall, then draws aside the veils which have hitherto concealed her face. It is the signal for one of Keats's finest achievements. Revealing herself as an emblem of complete disinterestedness, like the ideal poet, Moneta shows that she is able to contain and endure suffering, and to transmit its terrible but essential lessons. 'Beaming like the mild moon', she shows how far Keats has travelled in his imagination since writing *Endymion*. Her accents are not those of a heavenly lover but of a 'mother' who is at once familiar and strange. She is not an agent of supernatural religion,[5] but a humanist who is simultaneously terrifying and compassionate. She is not someone

who liberates Keats from reality, but a guide who explains that his 'dream' is a repetition of reality:

> Then saw I a wan face,
> Not pined by human sorrows, but bright-blanched
> By an immortal sickness which kills not;
> It works a constant change, which happy death
> Can put no end to; deathwards progressing
> To no death was that visage; it had passed
> The lily and the snow; and beyond these
> I must not think now, though I saw that face –
> But for her eyes I should have fled away.
> They held me back, with a benignant light,
> Soft-mitigated by divinest lids
> Half-closed, and visionless entire they seemed
> Of all external things – they saw me not,
> But in blank splendour beamed like the mild moon,
> Who comforts those she sees not, who knows not
> What eyes are upward cast.

These magnificent lines occur towards the centre of Canto I; they are in effect the conclusion to the introduction. When the narrator reacts to them by saying that he aches 'to see what things the hollow brain / Behind enwombèd', he does not mean that he wants a more complete revelation of Moneta's theme, but to understand more of her past. He is asking for history, not philosophy. To provide this, the poem switches to its original version, stripping out 'Miltonisms' as it reintroduces the recumbent Saturn, repeats his discovery by Thea, and describes the aftermath of the rebellion. Most critics have regretted Keats's revisions to this part of 'Hyperion', pointing out that his originally dense descriptions become either excessively determined or strangely 'timorous'.[6] The overall purpose remains clear. Because Saturn no longer addresses Thea, he indicates that her support is no longer useful to him. He is powerless – which Keats emphasises by cancelling his original passage about progress, which is now represented entirely by the new gods. The old gods may be tragic, and therefore in some respects sympathetic, but their fall is inevitable. Moneta's demanding wisdom has proved it.

Virtually every one of Canto II's sixty lines also reworks the first 'Hyperion' (I, 158–204), again emphasising the sickness of the fallen

world. (Hyperion's 'ample palate takes / Savour of poisonous brass and metals sick'.) When the fragment finally ends, there is no evidence of weakening power, such as appeared in the earlier version. Like Hyperion himself, it 'flares' into empty space, still weighted with the load of its original vision, then is abruptly 'given up'. There is a practical explanation for this. On 21 September, Keats had to abandon work on the poem in order to deal with various problems: his own and his brother's finances among them. There are also other and more complex reasons why he found it impossible to continue writing – reasons which emphasise the poem's strengths as well as its weaknesses, and which help to explain their sources.

When Keats began his revision, he meant to create a clearly argumentative structure, and to identify closely with his narrator (a poet, not a shepherd, a knight-warrior, or a lover). As he worked forward, he failed to become either 'consistent [or] inclusive'.[7] His own circumstances kept undermining his conviction that poetry could alleviate suffering. These tensions are concentrated in the figure and speech of Moneta. As the only remaining representative of the Saturnian age, she embodies 'the survival of the archaic way of thought – imagination rather than discourse',[8] but everything she says makes her 'less *human* than the discourse of "philosophy" which Keats, with his tentative evolutionism, was trying to accept as a necessary human development'.[9] This means that the poem sometimes feels confused even when its argument is most logical. As the goddess of Memory, Moneta distils an abiding truth: suffering is unavoidable, and true poets know that it cannot be separated from pleasure and fulfilment. As someone whose very name insists that systems of knowledge are dominated by practical considerations – Burton refers to her as 'queen money' – she teaches the poet-narrator that his arguments cannot be separated from history.[10] Significantly, Keats affirmed his belief in progress three days before abandoning the poem, telling Reynolds in a letter that 'all civi[liz]ed countries become gradually more enlighten'd and there should be a continual change for the better'. Moneta's vision contradicts this, even as it insists on the need for human understanding which makes progress possible. Her losses entitle her to shape the identity of the poet, and inspire Keats to the status of a prophet. At the same time, she reminds him that his role cannot be so easily attained in an age of materialism and revolution as it was in the classical past.

Saying this does justice to the grandeur of the poem. It does not

entirely explain its peculiarly unstable mood. As it moves from blossom-heavy bowers to immense and desolate halls, and then advances again to the altar of Moneta, it unveils thoughts which are both disinterested and inevitably self-revealing. In 'Lamia', Keats had created a serpent-seducer who embodied his contradictory thoughts about women. Moneta is ambiguous in a different way. At a pinch, we could relate her to Georgiana, and suggest that Keats's anxiety about human evolution had been triggered by the birth of his niece a few months before he began his revision. More plausibly, we can say that Moneta's criticism of the narrator connects her with Fanny, who had recently reproached Keats for identifying her with his 'abstract idea . . . of Beauty'. This rightly emphasises that Moneta is an admonitory and judgemental figure, but it denies the extent to which she is consoling and inspiring. She is not someone who embodies 'sheer female power [so much] as equivocality about that power'.[11] Although her first appearance is alarming, she gradually becomes obliging, open and readable. Specifically, she becomes maternal.

The change is deeply significant. Writing a poem which identifies its central character as a 'mother' immediately after he had finished one about a 'bride' ('Lamia'), Keats implies a link and possibly even a development between the two. It suggests that when he fell in love with Fanny, he discovered buried feelings for his dead parent (whose name she shared). Feelings of grief, and of reconciliation. As he did so, he made explicit the loss which had given his whole adult life its defining shape. In his letters he had sometimes come close to admitting this: when writing to Bailey from Scotland, for instance. In his poems, he had always fed on his deprivation unconsciously, frequently creating narrators who wake to find themselves painfully alone.

By looking squarely at his mother in the revised 'Hyperion', Keats energised his poem – but at the same time endangered his whole imaginative effort. He reads the fact of his own orphaned childhood in Moneta's face, and the shock of recognition produces some of the best lines he ever wrote. Simultaneously, it deals a blow to his powers as a chameleon poet. It would be absurd to say that the effect was instantly destructive. For one thing, he wrote two great poems ('To Autumn' and 'Bright Star') around the same time that he abandoned his 'dream'. For another, his remaining fourteen months were more cruelly dominated by physical illness than psychic shock. All the same, the association of Moneta with his mother connects the waning of his powers with the

explicit recognition of what had done more than anything to develop them in the first place. 'Lamia' describes a surrender to married love and imagines an appalling price. The revised 'Hyperion' looks beyond love in the present and associates it with abandonment in the past.

THIRTY-NINE

KEATS NEVER GAVE his reasons for abandoning 'The Fall of Hyperion' in these terms. His mother's influence on his imaginative life occurred unconsciously. Besides, a host of other problems stood between him and completion, some practical, some literary. On Friday 10 September, when he had been working on the revision for four or five days, he received news from Louisville which required him to leave Winchester immediately. Partly as a result of Audubon's irresponsibility, and partly because a recent financial panic had led to the collapse of many Western pioneer banks, George was almost entirely out of money. He asked his brother to raise what he could, and forward it at once.

Keats caught the first coach to London, travelling all night. On the way, he realised that Abbey was unlikely to help him, and for a moment or two considered leaving Taylor for John Murray. Since Murray had done so well with Byron, might he not also transform the reputation of 'Pestleman Jack'? He knew the answer as soon as he asked the question. Byron was a household name, notorious but securely popular. Keats was a nobody. He rejected the plan instantly, realising that it would anyway mean betraying the trust that Taylor and Hessey had placed in him.

By the time his journey was over, Keats understood there was no alternative: he must try Abbey. When he rushed to the offices in Pancras Lane early on Saturday morning, he found Abbey was about to leave for Walthamstow for the weekend. They arranged to meet on the following Monday. Keats then walked to see his publishers in Fleet Street and explained his plight to Hessey (Taylor was still in Retford). He said that he had enough new work to form a volume, and wanted to publish it at the end of the year. Hessey hesitated. He reminded Keats that the firm was still £100 down on *Endymion*, and said that he would have to talk to his partner. Keats was bitterly disappointed.

As he left the building, Keats also spoke briefly to Woodhouse, who was tidying up some publishing business before travelling to Bath the following afternoon: they agreed to have breakfast before he set off. This

was comfort of a kind; but it still left Keats with empty time in which to contemplate his failure. Trudging through the hot streets of the city, he felt that London was not his home – it was a gigantic symbol of his isolation. It could not offer him money or readers; it could not distract him with friends. Reynolds and Dilke were away on holiday. Haydon was in Hastings 'sea-bathing for his health'.[1] Briefly, he wondered whether to call on Fanny in Hampstead. Even though he had planned to 'flit' to her a month earlier, when his jealous addiction had been almost unbearable, he now felt that seeing her would destroy the self-control he had so painfully built up. It would threaten his chances of continuing to work if and when his other worries were settled.

Eventually he sought out Rice in Poland Street, and they spent the evening together in Covent Garden. The next morning, after staying over with Rice, he made his way to Woodhouse in the Temple. Here at last his mood began to alter. The young lawyer was full of a new enthusiasm for Provençal poetry, reading Keats some examples and suggesting they visit France together the following year. Keats in turn read him 'Lamia', in a chanting mumble which made parts of the poem inaudible. Woodhouse was 'much pleased with it' but puzzled. He could not understand why Lamia should marry Lycius, since it meant losing her immortality. Keats replied that 'women love to be forced to do a thing, by a fine fellow'.

There were other disagreements, too. As Keats outlined the shape of his new collection, Woodhouse was astonished to hear him say that he meant to exclude 'Isabella'. Woodhouse protested that the poem was likely to prove popular, only to be told by Keats that he considered it 'mawkish'.[2] As they turned to 'The Eve of St Agnes' their argument became even more heated. Keats showed his revisions to the poem, and Woodhouse felt they introduced 'a sense of pettish disgust' and 'a "Don Juan" style of mingling up sentiment & sneering'.[3] As he argued his case, abusing the changes 'for "a full hour by the Temple clock" ', Woodhouse delivered a judgement he would later repeat to Taylor. The revisions, he said, 'will render the poem unfit for ladies, & indeed [will] scarcely [allow it to be] mentioned to them among "the things that are" '. Faced with these objections, Keats worked himself into a resentful fury, saying he did not 'want ladies to read his poetry: that he writes for men . . . [and] that he sh[d] despise a man who would be such an eunuch in sentiment as to leave a maid, with that Character about her, in such a situation. & sh[d] despise himself to write about it &c &c &c'.

[449]

Keats's friendship with Woodhouse was easily able to contain the ferocity of his argument. Yet while the two men parted affectionately, Keats knew their conversation had disturbed some of his most sensitive feelings. His defence of the revisions to 'The Eve of St Agnes', in particular, reflected his confusion about Fanny:

> See, while she speaks his arms encroaching slow,
> Have zoned her, heart to heart, – loud, loud the dark winds blow!
> For on the midnight came a tempest fell;
> More sooth, for that his quick rejoinder flows
> Into her burning ear; and still the spell
> Unbroken guards her in serene repose.
> With her wild dream he mingled, as a rose
> Marrieth its odour to a violet.
> Still, still she dreams, louder the frost wind blows.

It is debatable whether these lines are in fact less 'decent' than those Keats had originally written, and which he was finally persuaded to reinstate. What is certain, however, is that as he sought to protect himself by coarsening the grain of his narrative, he produced poetry which oversimplifies the situation it describes. Taylor concentrated on the commercial folly of the revision, denouncing the idea that Keats was only writing for men as conceited. Woodhouse, while agreeing that it was foolish, also knew what poetic price Keats was paying. Challenging his changes, he encouraged him to rediscover the balances and vulnerabilities which characterised his best work.

Keats understood what Woodhouse meant, but could not easily take his advice. His problems seemed overwhelming, though as always he tried to conceal them. After he had left the Temple to visit George's mother-in-law in Westminster, he did not even refer to his brother's or his own difficulties. Admiring a lock of his niece's hair, bantering with the Wylie brothers, he kept George's letter to himself and concentrated on chatting and 'quizzing' before returning to sleep in Fleet Street. The following morning he made a different kind of suppression. Unable to dismiss Fanny from his mind altogether, he wrote her a jittery note which began by asking 'Am I mad or not?', then told her he loved her 'too much to venture to Hampstead'. As he briefly expanded on his reasons, he rushed into a confession that evidently pained him, and must have been deeply troubling for Fanny. 'Knowing well that my life must be

passed in fatigue and trouble,' he said, 'I have been endeavouring to wean myself from you: for to myself alone what can be much of a misery? As far as they regard myself I can despise all events: but I cannot cease to love you.' Keats admitted that he 'scarcely [knew] what [he was] doing' in this note, which he did not post for several hours. It was the first time Fanny had heard from him for a month. Was she to suppose their informal 'understanding' was now ended? Was she to feel that Keats was acting selfishly or protectively? She had no way of knowing. He left for Winchester the day after she received his letter; all surviving evidence suggests that she did not see or hear from him again for another month.

As Keats sealed his letter, he accused himself of behaving 'like a coward' because he 'could not bear the pain of being happy'. He could hardly expect the opposite – unhappiness – to be more easily endured. By chance, he soon found himself reflecting on this in ways he had not anticipated. Returning from a short visit to his sister in Walthamstow on Monday morning, and bracing himself for his meeting with Abbey in the late afternoon, he reached London at the same time as Henry Hunt, the radical orator, made a spectacular and 'triumphal entry'.[4] In Winchester, cut off from his liberal friends, he had been able to do no more than read about Henry Hunt's recent history in the *Examiner*. He knew that taxes recently imposed by the government on tea, malt and spirits were 'designed' to fall most heavily on those who could least afford to pay them. He also knew that opposition stood little chance of success in an unreformed Parliament. Henry Hunt had urged this point repeatedly, organising a series of mass meetings in the industrial centres of northern England. Although these meetings were generally peaceful, Keats had already come across signs of the government's nervousness. At the start of their Scottish walking tour, he and Brown had seen soldiers in the streets during the Lowther election campaign, and he had sorrowfully discovered that Wordsworth supported the idea of covering 'the whole island . . . with a force of this kind'. Furthermore, he understood from the *Examiner*, and from his political discussions with friends like Dilke and Snook, that this unrest was connected to wider issues. The burden of the national debt had oppressed the disenfranchised classes at home, and had financed the creation of the Holy Alliance overseas. Absolutist monarchs such as Ferdinand of Naples had resumed their thrones after the defeat of Napoleon, and perpetuated the model of kingship that Keats most despised. Only recently, in 'Isabella' and 'Lamia', he had condemned the hardships created by brutally materialist cultures, and

the union of what Leigh Hunt would soon call 'power with money-getting';[5] in *Otho* he had presented a court run by 'corrupt and entrenched grandees'[6] who had traded in violence and hysteria; and in the two versions of 'Hyperion' he had philosophised the need to confront these things.

Earlier in the year, Keats had predicted to George that the country was ready to erupt. A month before his financially motivated visit to London, he had been proved right. At a mass meeting on St Peter's Fields outside Manchester, where 'Orator' Hunt had been pressing the need for reform, the local Yeomanry, backed by a troop of Hussars, had charged into the crowd with sabres drawn, wounding 400 people and killing eleven men and women. Even the Tory press was horrified – *The Times* published a shocked eye-witness account. For radicals, it was proof of barbarism they had long condemned. The *Examiner*, which had always been ambivalent about Henry Hunt in the past, reported the 'atrocities' in detail, and the *Champion* spoke of 'ANARCHISTS IN MILITARY UNIFORM'. Immediately and permanently, the Peterloo Massacre became a definition of government brutality, one famously commemorated by Shelley in 'The Mask of Anarchy':

> I met Murder on the way –
> He had a mask like Castlereagh –
> Very smooth he looked, yet grim;
> Seven blood-hounds followed him:
>
> All were fat; and well they might
> Be in admirable plight,
> For one by one, and two by two,
> He tossed them human hearts to chew,
> Which from his wide cloak he drew.

Parliament responded to Peterloo by passing the notorious 'Six Acts', but while this guaranteed a crushing kind of order, it fuelled popular rage and sympathy with Henry Hunt. When Hunt arrived in London a month after the Massacre, 30,000 people lined the streets from Islington to the Strand. It was 'the greatest triumphal entry the city had seen. At the head of the procession came chariots and barouches drawn by red-ribboned bay horses with red-cockaded outriders, followed by bands playing, men bearing oak branches, a red flag with the motto "Universal Suffrage", a blue flag reading "A Free Press", a white flag emblazoned

"Trial by Jury", and rank after rank of marchers; then at last, riding in a landaulet with a banner proclaiming "Liberty or Death", came Hunt himself, looking pale and tired, bowing gravely to the throngs.'[7] In the city itself, the scenes were just as chaotic. Climbing down from the Walthamstow coach, Keats was surrounded by a turbulent mob – as though Haydon's familiar canvas had come to life. He was exhilarated and outraged, and aware that everything he saw provided a dismally telling context for his interview with Abbey. The reasons for the unrest were more severe, but essentially similar, to those which had existed in 1817, when he had published his first book and ignored Abbey's advice. Now that he was contemplating what would turn out to be his last volume, he was more vulnerable than ever to the censure of his former guardian. He felt a victim among victims, someone whose appeal to an alternative and potentially transcendent culture had failed.

In fact the meeting with Abbey was not as hostile as Keats feared. During the summer, Abbey had written a letter to the Isle of Wight in which he had seemed more conciliatory than usual. As he sat Keats down to tea at seven o'clock this Monday evening, and read the grim note that George had asked his brother to pass on, he became positively helpful. He promised to raise some money from Tom's estate and forward it to America, and added that he would get Walton's partner, Gluddon, to sort out Mrs Midgley Jennings's questionable appeal to Chancery. But he could not resist chiding Keats himself. Before their conversation ended, he picked up a magazine and quoted a passage from Byron which attacked the 'folly of literary ambition'.[8] 'Some liken it to climbing up a hill, / Whose summit, like all hills, is lost in vapour.' Given Keats's views about Byron, the reference was an unkind cut. He left the office wounded by Abbey's remark that Byron 'does say true things now and then'.

As Keats walked out of Pancras Lane up Cheapside he remembered that his letter to Fanny was still in his pocket, and turned back to the Lombard Street post office. Passing through Bucklersbury, he encountered Abbey again, and they strolled on towards the Poultry together. Whether or not Abbey knew that he had hurt Keats, he continued to recommend a steadier kind of employment than writing, saying that he could arrange for Keats to work in a hatter's shop if he wanted.[9] Keats thought this a horribly comic possibility, though he persuaded himself that Abbey meant well.

As soon as Keats had parted from Abbey for a second time, his

wounded feelings were aggravated again. Faced with the prospect of a solitary evening, he sought out Haslam, and went with him to see the second part of *Blue Beard: or Female Curiosity* at Covent Garden. The performance stirred his thoughts about male domination and female power, and so did his friend. Haslam had recently got engaged, and in the days to come Keats would make several remarks which suggest that he felt the arrangement was a trap. He told George, for instance, that Haslam showed him a miniature of his fiancée which Severn had painted, and said, 'Nothing strikes me so forcibly with a sense of the ridiculous as love – A Man in love I do think cuts the sorryest figure in the world – even though I know a poor fool to be really in pain about it, I could burst out laughing in his face – His pathetic visage becomes irrisestible.' The more eagerly Keats adds phrase to phrase here, the more obviously he writes about himself – mocking his own extravagances, yeasting his guilty conscience, and anticipating difficulties which lay ahead. When he eventually climbed on to the coach back to Winchester, the best he could say about his visit to London was that he had fended off disaster. He knew that he could not expect to keep his freedom for much longer.

FORTY

Keats reached winchester on Wednesday 15 September. As he settled back into his lodgings, and tried to resume his daily routine of working and walking, he found it impossible to recover his concentration. After two days of 'reading, writing, and fretting', he began another long letter to 'My dear George', in which his own and his brother's difficulties are intricately combined. He told him that he had finished *Otho*, which he hoped would improve their 'very low estate', and pluckily argued that 'Your wants will be a fresh spur to me'. Once again, he related their particular situation to larger issues. This was partly because he knew they shared a similar set of political beliefs, and partly because he was still thinking about Henry Hunt's arrival in London. Several paragraphs before mentioning 'the proceedings in Manchester', he describes himself as someone who has 'not been well treated by the world', and who is sinking in 'the mire of a bad reputation'. The blame, he says, lies particularly with the 'literary fashionables' – with the same Tory press that was opposed to Hunt's campaign for reform.

His only means of defending himself was to emphasise his devotion to writing, and insist that this required a retired life. Two years previously, he had withdrawn from London confident that he would be able to collect copy and 'get knowledge'. Now he struggles to sound resolute – even light-hearted – but knows that his situation is precarious. 'Whenever I find myself growing vapourish', he says, 'I rouse myself, wash and put on a clean shirt brush my hair and clothes, tie my shoestrings neatly and in fact adonize as I were going out – then all clean and comfortable I sit down to write. This I find the greatest relief – Besides I am becoming accustom'd to the privations of the pleasures of sense. In the midst of the world I live like a Hermit. I have forgotten how to lay plans for enjoyment of any Pleasure. I feel I can bear any thing, any misery, even imp[r]isonment – so long as I have neither wife nor child.' Keats did not explore the wider implications of these remarks until the following day, 18 September, when he offered to 'give' George 'a little politics'. What he provided was a homily on liberty and progress. Arguing that 'there should be a continual change for the better' in 'all civilised countries', he says that 'Three great changes have been in progress – First for the better, next for the worse, and a third time for the better once more':

The first was the gradual annihilation of the tyranny of the nobles. when kings found it [in] their interest to conciliate the common people, elevate them and be just to them. Just when baronial Power ceased and before standing armies were so dangerous, Taxes were few. kings were lifted by the people over the heads of their nobles, and those people held a rod over kings. The change for the worse in Europe was again this. The obligation of kings to the Multitude began to be forgotten – Custom had made noblemen the humble servants of kings – Then kings turned to the Nobles as the adorners of the[i]r power, the slaves of it, and from the people as creatures continually endeavouring to check them. Then in every kingdom therre was a long struggle of kings to destroy all popular privileges. The english were the only people in europe who made a grand kick at this. they were slaves to Henry 8th but were freemen under william 3rd at the time the french were abject slaves under Lewis 14th The example of england, and the liberal writers of france and england sowed the seed of opposition to this Tyranny – and it was swelling in the ground till it burst out in the french revolution – That has had an unlucky termination. It put a stop to the rapid progress of free sentiments in England; and gave our Court hopes of turning back to the despotism of the 16 century. They have made a handle of this event in every way to undermine our freedom. They spread a horrid superstition against all inovation and improvement – The present struggle in England of all the

people is to destroy this superstition. What has rous'd them to do it is their distresses – Per[h]aps on this account the pres'ent distresses of this nation are a fortunate thing – tho so horrid in the[i]r experience. You will see I mean that the french Revolution [put] a temporry stop to this third change, the change for the better – Now it is in progress again and I thin[k it] an effectual one. This is no contest beetween whig and tory – but between right and wrong. There is scarcely a grain of party spirit now in England – Right and Wrong considered by each man abstractedly is the fashion. I know very little of these things. I am convinced however that apparently small causes make great alterations.

'I know very little of these things,' Keats ends modestly. In fact his peroration proves his wide reading[1] and his deep thinking about the historical process – not only about recent events like the Massacre at Peterloo and 'the business about [Richard] Carlile the bookseller' (who had recently been indicted for publishing 'seditious' literature), but about repressive governments as a whole. Although he never dwells on details of his own problems for long, they intensify everything he says. His financial 'distresses' mean that he shares the same sense of inequality and exclusion as 'the people'. His reviewers, like Parliament, have suppressed 'the rapid progress of free sentiments' in his poems. In other words, while protesting that he 'lived like a Hermit' after his return to Winchester, he in fact continued to write and think in the same terms he had always done. The romantic medievalism of his surroundings may have set him apart from history; they also provided him with an 'eagle's perch' from which he could examine its ravages.

His main task was to continue with 'The Fall of Hyperion', which would combine public and private history in a steadily deepening vision of progress. As he resumed work, his mind skittered and fidgeted. He picked up Dante, who confirmed the anxieties inherent in his main theme. He read Burton, who quickened his worries about the 'rediculousness'[2] of lovers. After lingering over Burton's statement that 'every lover admires his mistress, though she be very deformed of herself', he underlined the sentence and then dashed off a piece of rhyming which elaborated the point: 'Pensive they sit, and roll their languid eyes, / Nibble their toast and cool their tea with sighs; / Or else forget the purpose of the night, / Forget their tea, forget their appetite.'

These lines, with their echoes of Milton and Pope (whom Keats quoted three times in his letters this summer), suggest that while Keats re-entered the world of 'The Fall', his mind bounded nervously through a wide landscape of books, not just those closest to hand. As it did so, he

[456]

began thinking about Chatterton again, whose criticisms of Milton's poetic language were similar to his own. Occasionally this encouraged borrowings – for instance, in the climactic scene where Moneta shows her face. (The line 'That made my heart too small to hold its blood' has been said to recall Chatterton's 'Comme, wyth acorne-coppe and thorne, / Drayne mie harty's blodde awaie.'³) It also created the context for a poem which Keats wrote at the same time as he wrestled with his larger scheme – a poem for which he had made no self-conscious long-term preparation, but which expressed his ambitions and his identity more powerfully than any other he wrote: 'To Autumn'.

Keats introduced the ode, and its connection with Chatterton, in a letter he wrote to Reynolds on 21 September. 'How beautiful the season is now – How fine the air. A temperate sharpness about it. Really, without joking, chaste weather – Dian skies – I never lik'd stubble fields so much as now – Aye better than the chilly green of the spring. Somehow a stubble plain looks warm – in the same way that some pictures look warm – this struck me so much in my sunday's walk that I composed upon it. I hope you are better employed than in gaping after weather. I have been at different times so happy as not to know what weather it was – No I will not copy a parcel of verses. I always somehow associate Chatterton with autumn. He is the purest writer in the English Language. He has no French idiom, or particles like Chaucer – 'tis genuine English Idiom in English words.' Chatterton's appearance in this letter has crucially shaped the reception of 'To Autumn'. By presenting Chatterton's work as a kind of ideal opposite to 'Miltonic intonation', Keats suggests that it has no sense of strain, no evident difficulty in realising its purpose. But Chatterton was not simply a model of settled Englishness for Keats – one peculiarly well suited to Winchester, with its 'door steps always fresh from the flannel', its 'Cathedral yard', 'gardens', and 'clear river'.⁴ He was also an emblem of the outcast poet, crushed by neglect, and of suffering youth generally. (Keats had last read him while nursing Tom during his brother's final illness.) When Keats said that he 'associat[ed] Chatterton with autumn', therefore, he meant that the season's mixture of fulfilment and finality mirrored the same element in the career of the 'marvellous boy'. And in 'To Autumn' itself, Keats similarly enlarges a sense of abundance by blending it with the certainty of decline and loss:

[457]

Season of Mist and mellow fruitfulness
 Close bosom friend of the maturing sun;
Conspiring with him how to load and bless
 The Vines with fruit that round the thatch eves run
 To bend with apples the mossd Cottage trees
 And fill all fruits with ripeness to the core
 To swell the gourd, and plump the hazel shells
 With a white kernel; to set budding more
 And still more, later flowers for the bees
 Until they think warm days will never cease
 For Summer has o'erbrimm'd their clammy cells

Who hath not seen thee? ~~for thy haunts are many~~ ~~If anxious thy stores?~~
Sometimes whoever seeks ~~for thee~~ abroad may find
Thee sitting careless on a granary floor
Thy hair soft lifted by the winnowing wind
 ~~While bright the sun slants through the barn;~~
 ~~or sound asleep in a half reap'd field~~
 ~~or sound asleep in a half reap'd field~~
 ~~Dosed with red poppies; while thy reaping hook~~
 ~~Spares from some slumbrous minutes while thy cross~~
Or on a half reap'd furrow sound asleep
 Dos'd with the fume of poppies, while thy hook
 ~~Spares the next swath, and all its twined flowers~~
 ~~Spares for some slumbrous minutes the next swath;~~

And sometimes like a gleaner thou dost keep
 Steady thy laden head across the brook;
 Or by a Cyder-press with patent look
 Thou watchest the last oozing hours by hours

Where are the songs of Spring? Aye, where are they?
 Think not of them. Thou hast thy music too—
While a ~~barred~~ clouds ~~bloom~~ the soft dying day
 and Touching the the stubble plains with rosy hue—
 Then in a wailful quire the small gnats mourn
 among the river sallows, ~~on the~~ borne aloft
 Or sinking as the light wind lives and dies;
 ~~Thar~~ full grown lambs loud bleat from hilly bourn,
 Hedge crickets sing; and now again full soft
 The Redbreast whistles from a garden croft;
 ~~And now flock still~~ ~~tired of streaming~~ Swallows twitter in the Skies—

Original manuscript of John Keats
Poem to Autumn— Presented to
Miss A Barker by the authors Brother.
 ~~in~~ Nov 15. 1839.

 Given to my Grand daughter
 Elizabeth Ward May 14th 96.
 ~~from~~ H. B. Ward

Season of mists and mellow fruitfulness,
 Close bosom-friend of the maturing sun,
Conspiring with him how to load and bless
 With fruit the vines that round the thatch-eves run;
To bend with apples the mossed cottage-trees,
 And fill all fruit with ripeness to the core;
 To swell the gourd, and plump the hazel shells
 With a sweet kernel; to set budding more,
And still more, later flowers for the bees,
Until they think warm days will never cease,
 For Summer has o'er-brimmed their clammy cells.

Who hath not seen thee oft amid thy store?
 Sometimes whoever seeks abroad may find
Thee sitting careless on a granary floor,
 Thy hair soft-lifted by the winnowing wind;
Or on a half-reaped furrow sound asleep,
 Drowsed with the fume of poppies, while thy hook
 Spares the next swath and all its twinèd flowers;
And sometimes like a gleaner thou dost keep
 Steady thy laden head across a brook;
 Or by a cider-press, with patient look,
 Thou watchest the last oozings hours by hours.

Where are the songs of Spring? Ay, where are they?
 Think not of them, thou hast thy music too –
While barrèd clouds bloom the soft-dying day,
 And touch the stubble-plains with rosy hue:
Then in a wailful choir the small gnats mourn
 Among the river sallows, borne aloft
 Or sinking as the light wind lives or dies;
And full-grown lambs loud bleat from hilly bourn;
 Hedge-crickets sing; and now with treble soft
 The red-breast whistles from a garden-croft;
 And gathering swallows twitter in the skies.

At every turn, 'To Autumn' seems easily to balance forces of life and
death, and to combine a sense of natural growth with individual effort.
The process begins at once, with the lines about the heavy vines, ripe
fruit, plumped shells and overflowing honeycombs. These things are
delicious – perfect versions of themselves – but also the product of
unseen yet discreetly acknowledged labour (the bees have been

persuaded into working overtime), and shadowed with a sense of immanent decay ('And fill all fruit with ripeness to the core'). As Keats responds to their ambivalence, he achieves a sympathetic poise in the tone of his writing. It is at once detached and involved – capable of describing things in ways that are picturesque and statuesque, but at the same time taking them to heart. (He had struck the same note in his letter to Reynolds when saying 'Somehow a stubble plain looks warm – in the same way that some pictures look warm'.)

In the second stanza, which may have been written last,[5] Keats deepens the feeling of penultimacy – but now using half-human, half-mythical terms. The figure imagined 'sitting careless on a granary floor', or 'Drowsed' among the harvest, combines a sense of completion with one of satiety. The same is true of the image of the gleaner – who is 'steady' but burdened – and of the scene at the cider press, where Autumn is 'patient', watching a process that always seems on the point of ending ('Thou watchest the last oozings hours by hours'). In the final stanza, where Keats switches from what has been called the 'peculiar non-narration'[6] of the first twenty-two lines to a more obviously sequential style, these ambivalences become even more tense and telling. The 'soft-dying' light suspends the poem between day and night. The 'barrèd clouds' and fluctuating wind give intimations of mortality while seeming to resist it. It is the same in the final four lines: the 'full-grown lambs' are a fleecy oxymoron; the 'gathering' swallows (not 'gathered' as they were in the first draft of the poem, still less departed) are ready to leave. They are the reminder of a coming absence which is also a promise of new life elsewhere.

Because 'To Autumn' holds its balances so expertly, it has often been called Keats's 'most . . . untroubled poem'.[7] This, combined with its great fame and familiarity, can make it seem unassailable – 'warm' but strangely impenetrable, 'a very nearly perfect piece of style [with] . . . little to say'.[8] To register the full force of its achievement, its tensions have to be felt as potent and demanding – just as the presiding figure of Chatterton must also be seen as challenging. Keats wrote the poem when his precarious freelance life was finally coming to an end, when his poor health was becoming unignorable, when he realised that he could not continue to postpone some sort of resolution with Fanny, when he felt gloomy about the reliability of his 'set', and when his worries about his brother and sister-in-law were acute. Line by line, stanza by stanza, 'To Autumn' draws upon these conflicts and transmutes them into its own

terms. But there is nothing complacent about the process. What Keats (speaking of Milton) called the 'stationing' of his figures might align them with a familiar and comfortable pastoral tradition, but we are constantly reminded of their instability. (Their penultimacy cannot last.) The surfaces of the poem might seem painterly and therefore static, but in fact they too are disturbed: a critical moment is about to arrive; autumn is about to turn into winter.

And there are other means, too, by which Keats makes sure that none of his balancing acts seems entirely safe or sustainable. As well as feeding on various personal kinds of distress, 'To Autumn' also refers to the social anxieties which had dogged him all his adult life, and had been brought to an unexpected crisis during his recent visit to London. It would oversimplify the case to say that because the poem was written in the aftermath of Peterloo, it is precisely concerned with the Massacre. This ode, like the others that Keats had written earlier in the year, is ambitious to transmute or escape history. At the same time, it cannot and does not want to escape its context – which it registers in a number of subtle but significant ways. It has been suggested that the word 'conspiring', in the third line, both embraces and deflects the plotting that Keats knew surrounded Henry Hunt's recent activities.[9] The reference to the gleaner is more certainly charged with contemporary references. Gleaning had been made illegal in 1818, and although the figure is obviously part of an appeal to the world of Classical fulfilment, and a refracted expression of Keats's wish to glean his teeming brain, it also refers to his sympathy for the denied and the dispossessed.[10] So does his description of the bees. They are a reminder of the miserable facts of labour that Keats had condemned during his walking tour in Scotland, and had mulled over in recent letters to George.

The point of emphasising these moments in 'To Autumn' is not to characterise it as a 'historical' poem in a narrow and neglected sense. (Nor is it meant to suggest that Henry Hunt and Peterloo represented all the history that Keats knew.) It is to stress that its individual 'truth' is founded on a knowledge of past suffering – knowledge which depended on political engagement, as well as personal experience. It is also to insist that the poem anticipates a future in which political and personal grief, and the value of great art, will continue. 'To Autumn' is a magnificent portrait of an integrated imagination, haunted by the fear of rejection, suppression and failure.

FORTY-ONE

W<small>HEN KEATS TOLD REYNOLDS</small> he had written 'To Autumn' he also
announced that he had 'given up Hyperion'. Chatterton, who had done
so much to release the ode, was also implicated in the abandonment of
the epic. Although Chatterton's language was elaborately antiquated,
Keats felt that it made Milton's seem artificial, inflexible, and self-
conscious. (Coleridge made a similar point when he said 'Milton himself
is in every line of the *Paradise Lost*'.) 'Miltonic verse', Keats said,
'cannot be written but in an artful or rather artist's humour. I wish to
give myself to other sensations. English ought to be kept up.'[1]

His self-criticism was directed against the narrative of 'Hyperion', as
well as the language. Its argument had rested on Apollo and the new
generation of gods, but his imagination had been captured by the Titans.
By shifting his attention so decisively to the poet-narrator in 'The Fall',
he had made it virtually impossible to deal satisfactorily and at length
with the tribulations of the old gods. This is why he stepped back from
his poem so calmly. Of course the fragmentation was a disappointment.
Of course he regretted that Moneta had not become a magisterially
impersonal figure. Of course he continued to make sporadic efforts to
'remodel' what he had done. But his sense of defeat was offset by an
equally strong feeling of liberation. In one version or another,
'Hyperion' had preoccupied him for much of his great creative year and
had proved an enormous lesson in self-discovery. His failure was
evidence of how much knowledge he had gained.

In this sense, 'To Autumn' is the reward of his epic labours. So, in
their different ways, are the spring odes and 'Lamia'. Their investigation
of human and artistic endurance is buttressed by the work which
surrounds them. Keats understood this, even though he never made
large claims for his achievement. In the weeks after completing 'To
Autumn' he said several times that he felt ready to enter another stage of
his writing life. 'I wish to devote myself to another sensation,' he told his
brother, just as he had said to Reynolds: 'I wish to give myself up to other
sensations.'

He realised that his chances were slim. All summer he had been
steeling himself for his eventual return to London and the difficulties
which awaited him there. He had finally succeeded in recouping some of
his debts, but the money was not enough to solve his larger worries. So

long as he was engrossed in revising, he was able to suppress the feeling that a crisis was inevitable. As soon as he set the poem aside, he knew that he must face it. He could no longer live by poetry alone. He had no choice but to find other ways of earning his living.

The prospect profoundly damaged his sense of himself, socially as well as poetically. 'I am all in a mist', he told George, then illustrated his confusion by referring to Byron. 'There is this great difference between us,' he said. '[Byron] describes what he sees – I describe what I imagine – mine is the hardest task.' Before finishing his letter to Reynolds, he made a similar point in different terms. He told his friend a wry little anecdote which emphasised that life placed obstacles in his path whichever way he turned. It was a true story, but – as Keats realised – full of symbolic significance. 'In my walk today,' he said, referring to the fact that roads laid with rails for wagons snaked over the surrounding countryside, 'I stoop'd under a rail way that lay across my path and ask'd myself "Why I did not get over" Because, answered I, "no one wanted to force you under".'

Immediately after closing his letter to Reynolds, Keats wrote to Woodhouse in Bath, trying to make light of his worries but unable to conceal them altogether. He said that he had recently stood outside a blacksmith's 'shop', admiring it 'till I was verry near listing for one'; he described the well-fed coachman who had driven him down to Winchester and speculated: 'Perhaps I eat to persuade myself I am somebody.' As the letter continued, with transcriptions of 'To Autumn' and a part of the revised 'Hyperion', he found it increasingly difficult to make such oblique references to questions of his future. 'I am all in a Mess here,' he said, ' – embowell'd in Winchester', then added: 'I have determined to take up my abode in a cheap Lodging in Town and get employment in some of our elegant Periodical Works.' His plan was to live in Westminster, near Dilke, and 'enquire of Hazlitt how the figures of the market stand', perhaps asking him to recommend him to the *Edinburgh Review.*[2]

On the same day that he wrote to Woodhouse, Keats also contacted Brown and Dilke. To Brown, whom he reckoned lived 'for others more than any man I know', he confessed that he no longer had any expectation of seeing *Otho* performed, and castigated himself for his lack of decisiveness in the past. 'In no period of my life have I acted with any selfwill', he said, exaggerating unhappily, 'but in throwing up the apothecary-profession.' His hopes, he reiterated, lay with literary

journals – though he emphasised that he would only write for those which supported the radical cause. Brown would not have expected less. Neither would Dilke, to whom Keats wrote in a similar vein: 'Yea I will traf[f]ic . . . I hope sincerely that I shall be able to put a Mite of help to the Liberal side of the Question before I die.'

Keats did not post this letter to Dilke. Instead, he sent a more functional note which asked him to hire rooms near Westminster – 'A Sitting Room and bed room for myself alone', he specified, lest Dilke should think he was planning an elopement. The decision to destroy his original letter conveys a sense of embarrassment – an embarrassment he also tried to conceal in other letters written during these few days. On 23 September, for instance, he wrote to Brown again, insisting 'I am as far from being unhappy as possible. Imaginary grievances have always been more my torment than real ones.' By the time he wrote this, he had decided to leave Winchester as soon as possible and lodge with Rice until Dilke had found him what he required. He soon received advice from Brown which persuaded him to change his mind. Brown knew that Rice's illness had upset Keats on the Isle of Wight, and was bound to do so again. He also felt that Keats needed time to prepare for the momentous changes he was contemplating. In the past, Keats's impetuosity had created as many problems as it had solved. In the present and most acute crisis, Brown understood that steadiness was all.

He was asking for the impossible. Since the summer, when Keats had felt unable to live either with or without Fanny, he had learned to govern his feelings. Yet he knew that the slightest disturbance was likely to shatter his control. He wrote haltingly to Brown: 'If you live at Hampstead next winter – I like [Miss Brawne] and cannot help it. On that account I had better not live there.' There was also the question of poetry itself. Although he had spoken contemptuously of the reading public to Dilke, his devotion to writing was still absolute. 'To Autumn' proved it. The decision to 'prose' for a while confirmed it. At the same time, his experience with 'The Fall of Hyperion', and his recent broodings on liberal politics, suggested that his faith in his own 'march of passion and endeavour' had been badly shaken. It was not that he had entirely lost confidence in the idea of progress, but that his thoughts about how to embrace the facts of suffering in his work had grown more complicated. 'To Autumn' represented one kind of response: character-ising a distinctly modern and isolated sensibility, without seeming in the least polemical. 'The Fall' also conceived of history as an ominous force,

while looking towards a different kind of poetic resolution. It made Keats wonder whether its themes needed to be cast in more positive terms. Was it possible for him to keep more obviously in step with contemporary events? Could the inward-delving imagination be reconciled with a wish to speak on 'the Liberal side of the Question'?

Keats had ended the most recent instalment of his letter to George by looking back – copying a long extract from a previously unsent part of his Scottish journal, transcribing 'The Eve of St Mark', and chatting about the recent antics of their friends and relations: Haydon, Brown, Haslam and the Wylies. As he began his last few days in Winchester, he was at pains to show how different he now felt. Remembering from his medical training that the human skin is 'fresh-material[e]d' every seven years, he says: 'From the time you left me, our friends say I have altered completely – am not the same person . . . seven years ago it was not this hand that clench'd itself against Hammond.' Within a few lines he has turned this personal point into a poetic one, saying that he had recently started to teach himself Italian, but knows 'the immense difficulties of the times' will prevent him from finding an easy 'thoroughfare for all my thoughts'. He added: 'Some think I have lost the poetic ardour and fire 't is said I once had – the fact is perhaps I have: but instead of that I hope I shall substitute a more thoughtful and quiet power. I am more frequently, now, contented to read and think – but now & then, haunted with ambitious thoughts. Quieter in my pulse, improved in my digestion; exerting myself against vexing speculations – scarcely content to write the best verses for the fever they leave behind. I want to compose without this fever.'

On 27 September these 'present misfortunes' became even more acute. He received a letter from George, asking why no money had arrived from England. Keats tried to reassure his brother, saying that it now looked as though Kean would not be leaving the country after all, and suggesting that George might be able to rely on his neighbours for a little longer. 'In a new country whoever has money must have opportunity of employing it in many ways,' he wrote 'affectionately' but 'anxiously'. Soon he was in an even worse 'mess'. Brown travelled down from London, which meant that Keats no longer felt so lonely, but his arrival coincided with the publication of the latest issue of the *Examiner*: it reported that Kean, who had been performing in Manchester ('to audiences shouting "Peterloo" '[3]), was still planning to break his contract and go on tour in America. Realising that this ended

his hopes of seeing *Otho* performed at Drury Lane, Keats immediately confirmed his other plans. He wrote asking Haydon to get him a reader's ticket for the British Museum. Only recently he had told George that his friendship with Haydon was 'at an end'; now he could not afford to ignore any available sort of help. Disguising the fact that he needed the ticket at least partly to help him with research for journalism, he said simply: 'I feel every day more and more content to read. Books are becoming more interesting and valuable to me – I may say I could not live without them.'

Although Keats and Brown enjoyed their reunion, it was a nervous, unconfident time. The 'Dian skies' of the previous month were clouded over. Each walk along the 'most beautifully clear river' to St Cross reminded Keats that his long withdrawal from the world was coming to an end. Since leaving Hampstead on 27 June he had written some of his greatest poetry, without receiving any proof that it would make his name. When he finally packed up his small parcel of manuscripts and other belongings on 8 October, the future seemed to offer little apart from failure.

FORTY-TWO

KEATS REACHED LONDON three weeks after abandoning 'The Fall of Hyperion' and only one week after asking Dilke to find him rooms. The lodgings that his friend arranged for him, in 25 College Street, had a comforting air of continuity. They were near Dilke himself, who lived in Great Smith Street, and their surroundings – overlooked by Westminster Abbey – seemed to recreate the calm of Winchester. He was living alone in London for the first time, but he was sequestered.

He still had to collect his belongings from Wentworth Place. He had not seen Fanny since June, and had been in touch with her only once since 16 August, nearly two months previously. At their last meeting, they had shown each other an equal tenderness, even though Fanny had all the uncertainties of youth, and he had his own doubts about commitment. In the interval, his reservations had grown as his desire increased, resulting first in tormented accusations, and finally in a self-protective silence. This had confused and hurt Fanny, and had also made her resolve her own feelings. When she opened the door to Keats on 10 October, two days after he had arrived in town, she was no longer

the half-adolescent whose affection might be mistaken for flirting. She was a suddenly mature young woman who had been pained by the threat of losing her love. Uncertainty had persuaded her that she wanted to devote herself to Keats.

Keats fell immediately into a 'complete fascination'. He was 'dazzled' by Fanny's beauty and tenderness, and when Brown teased him 'with a seemingly true story against [him]',[1] he could not help exonerating himself in a way which showed his true feelings. Inevitably, the revelation meant reviving his old worries about independence. As he and Fanny snatched a few moments alone, his reasons for hesitating were dissolved. 'When shall we pass a day alone,' he wrote the following morning. 'I have had a thousand kisses, for which with my whole soul I thank love – but if you should deny me the thousand and first – 't would put me to the proof how great a misery I could live through.'

Referring to Fanny's 'threat[s]' in this way, and admitting that he was 'at [her] mercy', meant rekindling the argument of their mid-summer letters. In two poems he wrote around the same time as he first saw Fanny again – poems which inaugurate a short series of lyrics – Keats returned to it more openly. The first, a sonnet beginning 'The day is gone . . .', dwells on the delicious pleasures of the moment: 'Sweet voice, sweet lips, soft hand, and softer breast, / Warm breath, light whisper, tender semi-tone, / Bright eyes, accomplished shape, and languorous waist!' The second poem, 'What can I do . . .', describes more familiar territory. While he insists that his 'liberty' as a poet depends on his remaining 'above / The reach of fluttering Love', he connects his own situation to broader issues of independence. Particularly the independence of his brother and sister-in-law. The highly strung, irregular couplets abruptly became horrified as he contemplates their life in America:

> Where shall I learn to get my peace again?
> To banish thoughts of that most hateful land,
> Dungeoner of my friends, that wicked strand
> Where they were wrecked and live a wreckèd life;
> That monstrous region, whose dull rivers pour,
> Ever from their sordid urns into the shore,
> Unowned of any weedy-hairèd gods;
> Whose winds, all zephyrless, hold scourging rods,
> Iced in great lakes, to afflict mankind;

[468]

Whose rank-grown forests, frosted, black, and blind,
Would fright a Dryad; whose harsh-herbaged meads
Make lean and lank the starved ox while he feeds;
There flowers have no scent, birds no sweet song,
And great unerring Nature once seems wrong.

There are moments when 'What can I do . . .' seems more like a private act of self-scourging than a fully achieved work. This central section is exceptional, drawing a picture of Keats's anxieties which is unrivalled anywhere in his work. It also gives a fascinating glimpse of the 'other sensations' he wanted to encompass after giving up 'The Fall'. It contains a despairing appeal to the Classical order he had always espoused, but shows his old loyalties had been eroded. 'Enough! Enough!' it ends in anguish. 'It is enough for me / To dream of thee!'

Keats left Fanny on 10 October knowing that his plans for the future had failed. He spent the next several days trying to revive them. He arranged his rooms in College Street. He tried to persevere with his reading. He made fair copies of his new poems. He possibly went to see Hazlitt in York Street to inquire about writing for liberal magazines. If he did, he would have found the 'dark-haired critic' confirming the impression he gained elsewhere. Hazlitt only needed to point to his own predicament to prove that journalism was a thankless task. In recent months he had been 'muzzled, libelled, underpaid and unceremoniously dismissed'.[2]

When Hazlitt later recorded his impressions of Keats,[3] he said that he lacked 'masculine energy' and 'hardy spirit'. Given the emphasis that Keats's other friends place on his pugnacity and resolution, the description seems unjust, unless we suppose that Hazlitt was only remembering how Keats appeared at this particularly agonised time. During his weeks in Winchester, he had made significantly few references to his health. Was he feeling better than he had done all summer, or was he simply hiding the truth? Severn, who also saw him during these College Street days, was struck by his weakness. When they met on 24 October, to discuss the submission of Severn's painting 'The Cave of Despair' for the Royal Academy historical painting competition, Severn said that Keats seemed 'in high spirits' but had not been done 'much good' by his absence from London. In the coming weeks, Keats continued to avoid mentioning his health. His mood suggests it was deteriorating fast. He was almost continuously depressed and distracted.

The harder Keats tried to concentrate on his work, the more consumed he felt by Fanny. His letters show that she had even begun to dominate his most sacred loyalty: to 'the principle of Beauty in all things'. He uses her looks as an absolute (seeking to 'assure you by your Beauty'), and he tells her: 'The Beauties of Nature have lost their power over me.' The result was not so much a sense of eclipse as of collapse, and his fretting about 'liberty' soon turned into complaints about imprisonment – about being the 'emprison[er]' of Fanny, and of living in a kind of gaol himself. As his illness grew worse, this conceit grew into a dreadful reality. Fanny became confused in his mind with the reasons for his approaching death.

On 11 October Keats told Fanny that he had arranged for Mrs Dilke to accompany him on his next visit to Hampstead, so as to lend an air of propriety to their meeting. If he hoped that this would help him to control his feelings, he soon realised he was helpless. 'I cannot exist without you,' he told Fanny in his next letter, recalling the words of the poet before Moneta's shrine in 'The Fall'. 'I am forgetful of every thing but seeing you again – my Life seems to stop there – I see no further. You have absorb'd me. I have a sensation at the present moment as though I was dissolving.' In their extreme frankness, these phrases come perilously close to sounding histrionic, and as Keats continued writing he obviously feared as much. Briefly restraining himself, he introduced a new element into his letter, one which gives it an apparently more solid framework, but in fact only emphasises Fanny's dominance. 'Do not threat me even in jest,' he told her. 'I have been astonished that Men could die Martyrs for religion – I have shudder'd at it – I shudder no more – I could be Martyr'd for my Religion – Love is my religion – I could die for that – I could die for you. My Creed is Love and you are its only tenet.'

The language here echoes the religious references of his two recent poems, which speak of 'love's missal' and of 'heresy and schism'. It has led one biographer to speculate that Keats was 'contemplating a formal engagement leading to the sacrament of marriage'.[4] This is reasonable, as long as we realise that Keats still did not view marriage as a safe haven. He had regarded it suspiciously for many years – along with the other 'pious frauds of religion'. Now there were better reasons than ever for doing so. Given this, the letter seems to say more about the contraction of Keats's world than it does about the contract of marriage. Not only was Fanny the focus of his faith in Beauty, she was also replacing other

systems of order and control. She was becoming his whole universe in miniature.

Two days after writing this letter, on 15 October, Keats returned to Wentworth Place for yet another visit. Rather than helping to clarify his thoughts about the future, it only complicated them. Whether Fanny realised it or not, his recent remarks about the church had awoken deep memories which were connected with his love for her. When Tom had died the previous winter, a few hundred yards away from where they were talking, Keats had angrily refused to 'enter into any parsonic comments on death'. And when he had recently thought of George in America, he imagined him without even the consolations of myths or nature. Whirling 'in a tremble', he told himself again and again that Fanny was bound to make him suffer, as well as succouring him. Writing about Moneta, he had confronted the image of his dead mother. Adoring his lover, he could not help envisaging absence and loss.

Several years after his death, Fanny was asked whether 'Keats might be judged insane'[5] during the last year or so of his life. She was at pains to say that 'he could have never addressed an unkind expression, much less a violent one, to any human being'. But she also admitted that while giving himself to her, he 'seemed . . . to turn on himself'. It is striking that she never seemed to have felt intimidated by this. Perhaps the part of her that enjoyed 'trumpery novels' made her feel that any love affair was likely to seem a little unreal – like the plot of a romance come to life. Perhaps the strong current of her own feelings simply swept away the thought that there was anything excessive in Keats's protestations. In any event, her steady acceptance was remarkable: a proof of her devotion, and also of her mature composure. By remaining in one mind herself, she guided Keats through the contradictions of his own thoughts towards a final decision. Returning to College Street after the 'three hours dream' of his visit, he told Mrs Dilke that he would soon not be needing his lodgings any longer. He was planning to return to live with Brown in Wentworth Place.

THE DECISION DID nothing to solve his 'mess'. On 19 October, shortly before leaving College Street, Keats ended a letter to Fanny by saying 'I cannot tell what I am writing', then began a sonnet which breathlessly combined an appeal for 'mercy' with a demand for complete possession:

O! let me have thee whole, – all, all, be mine!
 That shape, that fairness, that sweet minor zest
Of love, your kiss – those hands, those eyes divine,
 That warm, white, lucent, million-pleasured breast –
Yourself – your soul – in pity give me all,
 Withhold no atom's atom or I die.

The sonnet seems set on extending its catalogue until the final full stop. As the conclusion approaches, Keats recognises that if Fanny does not return his feelings she will make him, like the knight in 'La Belle Dame', her 'wretched thrall'. It is a prospect which breaks his rush by turning desire into despair. He realises that he risks being neither a satisfied lover nor a self-fulfilled writer:

Or living on perhaps, your wretched thrall,
 Forget, in the mist of idle misery,
Life's purposes – the palate of my mind
Losing its gust, and my ambition blind!

It is likely that Keats wrote another and much better known poem within a short time of completing this sonnet: 'Bright Star'. Precise dating is difficult, but among the various possibilities,[6] at least one fact links it to October 1819. In lines 7/8 the sonnet refers to 'the new soft-fallen mask / Of snow', and on 22 October an unusually early and heavy snowstorm had swept across London. The other reasons for supposing that Keats wrote it this month are equally persuasive. The poem resonates with phrases and ideas that Keats had used in his recent letters to Fanny:

Bright star! would I were steadfast as thou art –
 Not in lone splendour hung aloft the night
And watching, with eternal lids apart,
 Like nature's patient, sleepless Eremite,
The moving waters at their priestlike task
 Of pure ablution round earth's human shores,
Or gazing on the new soft-fallen mask
 Of snow upon the mountains and the moors –
No – yet still steadfast, still unchangeable,
 Pillowed upon my fair love's ripening breast,
To feel for ever its soft swell and fall,

Bright Star, would I were stedfast as thou art—
Not in lone splendor hung aloft the night
And watching, with eternal lids apart,
Like nature's patient, sleepless Eremite,
The moving waters at their priestlike task
Of pure ablution round earth's human shores,
Or gazing on the new soft-fallen masque
Of snow upon the mountains and the moors.
No—yet still stedfast, still unchangeable,
Pillow'd upon my fair love's ripening breast,
To feel for ever its soft swell and fall,
Awake for ever in a sweet unrest,
Still, still to hear her tender-taken breath,
And so live ever—or else swoon to death.

18 'Bright Star!'; Keats's autograph in Severn's copy of Shakespeare.

> Awake for ever in a sweet unrest,
> Still, still to hear her tender-taken breath,
> And so live ever – or else swoon to death.

The poem's longing for steadfastness develops the appeal of 'I cry your mercy . . .'. Its reference to the waters' 'priestlike task' reminds us that Keats had recently called love his 'religion'. The 'ripening' breast, at once erotic and maternal, recalls the 'dazzling breast' in 'What can I do . . .', and 'That warm, white, lucent, million-pleasured breast' in 'I cry your mercy . . .'. For all these similarities, 'Bright Star' is crucially distinct from other poems written to Fanny. Instead of panting and gasping, filling its lines with irregular rhythms and snatched glances, it struggles to maintain the discipline of a strict form, a steady antithesis, and an evolving idea. In these respects, it is a poem which at once recognises and masters Fanny's destabilising power – so long as Keats keeps his attention fixed on the heavens, where 'great unerring Nature' is

exemplary and conciliatory. In the sestet, though, where Keats switches to Fanny herself, the poem's control begins to loosen. The 'steadfast' and 'unchangeable' attributes of the star can only be maintained in 'lone splendour'. Once Keats is 'pillowed' on his lover, he is condemned to 'sweet unrest', as the nervous and triple repetition of 'ever' cannot but emphasise. This raises a troubling question. Do the star's qualities in fact 'matter'[7] to Keats as much as he implies? Or rather, do they matter because they describe a condition he cannot emulate? At the beginning of the poem, they trigger a line of thought which is not completed, and at the end they seem admirable but remote – neither intimately supportive nor integrated. This is why the last phrase of the poem, 'or else swoon to death', seems to carry more weight than all the accumulated reassurances of the preceding lines. Even if 'death' punningly connotes sexual satisfaction rather than actual mortality, it still suggests that the 'ever' Keats wants is an impossibility.

KEATS FINISHED 'Bright Star' knowing that one kind of steadfastness had gone, and another kind had yet to be confirmed. On 18 October, twelve days before his twenty-fourth birthday, he finally asked Mrs Dilke to let Fanny know that he was returning to live with Brown. The following day, he told her himself, asking soon afterwards that their 'understanding' should now become a formal arrangement, and probably giving her a garnet ring.[8] It was a momentous decision, but they did their best to keep it secret, and agreed that Fanny should not wear the ring in public. They had several reasons. Keats knew that he could not afford to get married in the foreseeable future. He also realised that Mrs Brawne did not approve. She still liked Keats, but understood that his prospects were dismal, and hoped that the plan would 'go off'[9] in due course. Moreover, he distrusted the reaction of his family and friends – rightly, as it turned out. He said nothing to his brother and sister, or to Brown, Taylor, Woodhouse, Severn and Rice. Dilke and Reynolds both soon discovered what had happened. Dilke wrote in private, 'God help them. It's a bad thing for them',[10] and Reynolds jealously disparaged the 'unhappy . . . connection'.[11]

It was not only the disapproval of others that troubled Keats as he settled back into Wentworth Place. Living under the same roof as Fanny brought obvious 'pleasures'; it aggravated his 'torments' as well. He had already told Fanny that he 'must impose chains' on himself if he was to endure living so close to her, and now he was as good as his word.

Great Smith Street

My sweet Fanny,
 Tuesday Morn

On awakening from my three days dream
("I cry to dream again") I find one and another astonish'd
at my idleness and thoughtlessness. I was miserable
last night — the morning is always restorative. I
must be busy, or try to be so. I have several things
to speak to you of tomorrow morning. Mrs Dilke
I should think will tell you that I purpose living at
Hampstead — I must impose chains upon myself. I shall
be able to do nothing. I should like to cast the die for
Love or death. I have no Patience with any thing
else — if you ever intend to be cruel to me as you
say in jest now but perhaps may sometimes be
in earnest be so now — and I will — my mind is
in a tremble, I cannot tell what I am writing.

 Ever my love yours
 John Keats

19 Keats's letter to Fanny Brawne, written on 19 October 1819.

Following the advice of Burton's *Anatomy*, which insisted that meat-eating increased physical desire, he put himself on a vegetarian diet, telling his sister that he hoped it would mean 'my brains may never henceforth be in a greater mist than is theirs by nature'.[12]

Brown was only a little reassured by these signs of self-discipline. Keats seemed more decided than he had done in Winchester, but he was still demoralised and introspective. His plans to live as a journalist had come to nothing, and his poetry was stalled. Brown did all he could to encourage him, seizing eagerly on a report in the *Examiner* which revealed that Kean had decided to honour his contract with Drury Lane, and would be remaining in London throughout the winter. He urged Keats to make a few small revisions to *Otho*, and said he would send it to Elliston, the theatre manager. Keats agreed to make the changes, though gloomily refused to give his name as author, fearing that his low reputation would damage the chance of getting a fair reading. He was equally pessimistic about other possibilities. He temporarily set aside the thought of publishing a new volume, discouraged, perhaps, by Taylor's angry reaction to Woodhouse's report of his revisions. ('If he will not so far concede to my wishes as to leave the Passage [in 'The Eve of St Agnes'] as it originally stood,' Taylor had written, 'I must be content to admire his Poems with some other Imprint.') He got out the manuscript of *King Stephen* and abandoned it after a few scenes. It is probable that the fragment beginning 'This living hand . . .' was part of his effort, and it gives a bleak glimpse of his mental state. Spoken anonymously, the lines turn their appeal for sympathy into something like blackmail:

> This living hand, now warm and capable
> Of earnest grasping, would, if it were cold
> And in the icy silence of the tomb,
> So haunt thy days and chill thy dreaming nights
> That thou would wish thine own heart dry of blood
> So in my veins red life might stream again,
> And thou be conscience-calmed – see here it is –
> I hold it towards you.

Nothing that Keats tried,[13] and nothing that Brown suggested, made any difference to his mood. On 10 November he described himself to Severn as being still 'lax, unemployed, unmeridian'd, and objectless',

This living hand, now warm and capable
Of earnest grasping, would, if it were cold
And in the icy silence of the tomb,
So haunt thy days and chill thy dreaming nights
That thou would wish thine own heart dry of blood
So in my veins red life might stream again,
And thou be conscience-calmed – see here it is
I hold it towards you

20 'This living hand . . .'; Keats's draft.

knowing that however he might blame the world at large for his plight, the source of his greatest misery lay very close to home. He was living only a few feet away from Fanny, yet prevented by circumstances from marrying her, and by convention from making love to her. Every day was filled with excited frustration – frustration that Brown, in spite of his kindness, continually made worse. During the summer a new live-in maid had come to work at Wentworth Place: a pretty, fiery, semi-literate young woman named Abigail O'Donaghue, whose family came from Killarney in Ireland. Shortly after returning from Winchester, Brown began sleeping with her, and soon made her pregnant. 'Normally, with the manners of the age, this would be something that Keats would have no difficulty in accepting.'[14] He had, after all, recently joked about Severn 'either getting a bastard or being cuckolded into accepting one as his'.[15] Now it only fuelled his rage and disappointment.

Keats's sexual longing dramatised his other feelings of failure: poetic as well as professional and financial. Shortly after moving back into Wentworth Place he borrowed some more money from Brown. This soon ran out, forcing him to ask for loans from Haslam and other friends. How was he to help his brother, let alone himself? Making a reluctant visit to London, to see Mrs Wylie, he once again managed to conceal the extent of his difficulties. In a letter to his sister he admitted that 'George's affairs perplex me a great deal', and accepted that he would

soon have to start visiting Abbey again. When the first of these visits took place, it only brought further discouragement. Although Mrs Midgley Jennings's appeal to Chancery had recently been dismissed, the value of stocks was very low. Abbey advised him not to sell.

Then at last came better news. Fry, the co-trustee of Tom's estate who was living in Holland, wrote to Abbey and gave Keats the power of attorney he had recently requested. Although the market was still performing badly, Keats knew where his duties lay. He sold a part of Tom's inheritance, realising £100 which he sent to America immediately. He closed the deal feeling that he had at last done something valuable – but within a few weeks it became clear that even this success was a kind of failure. The ship on which the money travelled across the Atlantic, the *William*, was delayed by storms and did not reach its destination until the New Year. By this time George had decided that his brother needed help in sorting out their affairs, and had left for England. The round trip would cost him almost £200; he felt it would be worth it if he could return home with even double that amount.[16]

Keats's efforts to improve his own situation were not so unlucky. Realising a further £200 of Tom's money (it was the first instalment that he had collected since his brother's death), he paid off his debts, sent £100 to his sister, and squared his lodging arrangements with Brown. This gave him a breathing space – for a little while, and in a limited sense. Through no fault of his own, his recent transactions had increased the distance which was opening between himself and his friends. When he next saw Dilke, for instance, at the Naval Pay Office in Somerset House, he impatiently denied that George would have done better to join Birkbeck's settlement than set up business in Louisville. Dilke, who was doing his best to support Keats by concealing his doubts about Fanny, was put out. 'The very kindness of friends was at this time oppressive to [Keats],' he said later. 'From this period his weakness & his sufferings, mental & bodily, increased – his whole mind & heart were in a whirl of contending passions – he saw nothing calmly or dispassionately.'

Keats sank further and further into himself, fidgeting with *Stephen* and adding only a few lines, desperate for news of *Otho* and hearing nothing. When Hazlitt began a new series of lectures, on Elizabethan drama, at the Surrey Institution in early November, he did not attend. He could not face the seven-mile tramp from Wentworth Place, or the pitying faces he would see when he got there. When Severn invited him to see his painting hung in the Royal Academy, he deflected him

awkwardly. When he wrote to George and Georgiana he was unable to give news of his sister ('I have not been to see [her] since my return from Winchester'), and supplied only the sketchiest information about mutual friends. 'Our Set', he said, 'still continue [to] separate as we get older, each follows with more precision the bent of his own mind.' Rice was ill, he added, and Reynolds 'in Lodgings . . . and . . . set in for the Law'. As he went on to mention Dilke and Severn, he could not avoid giving the impression that he, and not they, had become solitary; his 'cavalier days' were long gone. It was the kind of confession that he had previously spared his brother, and which soon became explicit. 'I have been endeavouring to write lately,' he said pitifully, 'but with little success as I require a little encouragement, [and] little better fortun[e] to befall you and happier news from you before I can wr[i]te with an untrammell'd mind. Nothing could have in all its circumstances fallen out worse for me than the last year has done, or could be more damping to my poetical talent.'

FORTY-THREE

EVER SINCE TAYLOR had first met Keats, he – like Hessey – had known him to be a man of 'fits and starts'. But when he heard about this latest depression, he sensed that it marked the beginning of a more settled misery. On 15 November he tried to rally him by inviting him to dinner with the painter William Hilton, to discuss plans for a new collection of poems. (One of the few social calls that Keats had made in recent days was to the house in Percy Street that Hilton shared with Peter de Wint; Hilton had sketched Keats, possibly intending the drawing to serve as a frontispiece for the book.) Their conversation only confirmed the gloom that Taylor hoped to lift. Keats wrote to him two days later saying: 'I have come to a determination not to publish any thing I have now ready written.' In the same letter, he suggested that Taylor's encouragement had done some good: it had revived his hopes of tackling 'other sensations'. 'As the marvellous is the most enticing and the surest guarantee of harmonious numbers,' he said, 'I have been endeavouring to pursuade myself to untether Fancy and let her manage for herself – I and myself cannot agree about this at all. Wonders are no wonders to me. I am more at home amongst Men and Women. I would rather read Chaucer than Ariosto.'

It is possible that someone other than Taylor himself helped Keats to define this difference: John Clare. Throughout the previous two months, Taylor had been negotiating with his cousin Edward Drury, a printer and bookseller in Stamford, to publish Clare's first book in London. Taylor deeply admired Clare's poems, and also hoped to cash in on the contemporary fashion for 'peasant poets' such as Bloomfield and Bamford: it is highly likely that he mentioned him over dinner. At first glance, Keats and Clare do not appear to have much in common beyond a few facts. They would eventually share the same publisher. The same doctor, George Darling, would one day attend them both. When Keats revised 'Lamia' in Taylor's Fleet Street office in the spring of 1820, he wrote on the back of an envelope containing a letter from Clare. This was as close as they came to each other. They did, however, comment on each other's work. Clare thought that *Endymion* was 'a very original, ingenious and elegantly written poem',[1] but felt that 'when [Keats] speaks of woods Dryads & Fauns are sure to follow & the brook looks alone without her naiads to his mind yet the frequency of such classical accomplishment makes it wearisome to the reader where behind every rose bush he looks for a Venus & under every laurel a thrumming Appollo'.[2] Keats, in turn, thought that Clare's 'Images from nature are too much introduced without being called for by a particular Sentiment', and that 'the Description overlaid and stifled [what] . . . ought to be the prevailing Idea'.

This suggests that Keats and Clare came from strictly separate worlds, and wrote in utterly distinct styles – one urban and allusive, the other earthy and unadorned. It is not as simple as that. Although Clare was agricultural working class, and Keats was a suburban 'Cockney', although their experience was so different and their response to authority so divergent, although they had reservations about each other's work, they recognised that they had something in common. This is evident in the letters that Clare wrote to Taylor, referring to Keats as 'Friend'[3] and as 'a brother wanderer in the rough road of life'.[4] Their fraternity depended not just on their sense of belonging to a poetic brotherhood, but on similar feelings of exclusion. In their different ways, they were both rejected by an establishment they felt compelled to infiltrate, subvert and, in Clare's case, finally abandon. At no previous time in his life had Keats been more likely to respect this kinship than during this meeting with Taylor. Clare's whole poetic enterprise endorsed the appetite Keats now felt for 'Chaucer [rather] than Ariosto'.

As Keats revealed his doubts about 'Miltonisms' in his letter to Taylor, he also gestured towards the poems he had recently written to Fanny. He had no intention of publishing these – they were too personal – but they had initiated a more rough-hewn technique, and a differently expressive kind of language. They allowed him to feel that another new beginning was still possible. Before signing off to Taylor, he sketched it in outline: 'The little dramatic skill I may have as yet however badly it might show in a Drama would I think be sufficient for a Poem – I wish to diffuse the colouring of St Agnes eve through a Poem in which character and Sentiment would be the figures to such a drapery – Two or three such Poems, if God should spare me, written in the course of the next six years, would be a famous gradus ad Parnassum altissimum – I mean they would nerve me up to the writing of a few fine Plays – my greatest ambition.'

Keats immediately deflated this little bubble of optimism by saying that he felt ambition 'very seldom'. But his letter proves he was at least able to contemplate some means of restoring the connection between suffering and creating that had been so painfully broken in recent weeks. His difficulties variously solidified his intentions, as well as threatening them. His money worries forced him to tangle more closely with the familiar world, as well as making him resent it. His engagement to Fanny encouraged him to write with greater directness, even as he struggled to defend himself.

Taylor was only briefly reassured by this flare of ambition. Within hours of finishing his letter, Keats was acting in 'fits and starts' again, scrapping the plans he had just outlined, and deciding to prepare his book for publication after all. While he began sorting his papers, he also started work on a new poem that aimed to achieve something much more practical than the 'other sensations' he had mentioned after finishing 'To Autumn'. It was begotten by despair upon the need to make money, took jealousy and oppression as its central subjects, and illuminated them with the bright glare of satire rather than 'the colouring of St Agnes'.

Brown, now acutely anxious about Keats, was always protective of the new poem. Sometimes he implied that he had originally intended to have a hand in its creation, saying he 'knew all' the 'intended construction', and helped form 'the machinery of one part'. More often, he protested it was nothing more than a form of 'relaxation' for Keats. It was started, he later told Richard Monckton Milnes, 'By

chance' when 'our conversation turned on the idea of a comic faery poem in the Spenser stanza, and I was glad to encourage it . . . It was to be published under the feigned authorship of Lucy Vaughan Lloyd, and to bear the title of The Cap and Bells, or, which he preferred, The Jealousies.' (The plot obviously owes something to *A Midsummer Night's Dream*, as well as to Brown's fantasy 'The Faeries' Triumph', for which Keats had previously written three songs.)

As Keats rushed ahead with the poem, sometimes writing as many as twelve stanzas in a single morning, his haste became more and more disruptive. At the outset, his main purpose seems to have been to satirise the Prince Regent (Elfinan) – not, as has sometimes been said, for attempting to bring his wife Caroline (Bellanaine) to trial for adultery, which he did not do until the following year, but for his cruelty and self-absorption.[5] This much is evident in the opening scenes of the poem, which show Elfinan hungering after a human woman, Bertha Pearl, while consenting to marry his faery Princess. As Keats reports on these divided loyalties, he revels in his impatience with the Regency court, combining Byronic sarcasm with a more belligerent form of satire. Elfinan's greed is reprehensible because it is selfish, and because it corrupts the entire structure of government and society. His capital city Panthea is described, in the poem's best single line, as 'shutter[ed] with a moody sense of wealth'; the prisoners in his gaols are not subject to the due process of law but to fits of temper:

> He rose, he stamped his foot, he rang the bell,
> And ordered some death-warrants to be sent
> For signature – somewhere the tempest fell,
> As many a poor felon does not live to tell.

When the Chancellor Crafticanto is dispatched to bring Bellanaine to Panthea, Elfinan arranges for Eban, his slave 'of colour', to fetch the 'soothsayer' Hum: together, they plot the seduction of Bertha by magic. Once these plans have been arranged, Elfinan sets off for Bertha's house in Canterbury, leaving space for a long digression by Crafticanto about his return journey to Panthea with Bellanaine and her maid Coralline – during which we see him taking pot-shots at a moth, flying above the Gobi Desert, and lighting torches to scare off a griffin. When they eventually arrive at the court, they find Elfinan has already departed, Hum is drunk, and the whole place is in chaos. At

which point, after running for nearly 800 lines, the poem breaks off.

By this time, the focus of Keats's attention has shifted. In order to broaden his attack on despicable systems of authority, he has combined his assault on the Regent with a censure of contemporary literary life. As several commentators have pointed out,[6] Eban has certain similarities with Hazlitt, Hum with Leigh Hunt, and Elfinan with Byron. (Keats even quotes Byron, and refers to the notorious separation from Annabelle Millbanke, when Elfinan bows to Bellanaine and says: 'Poor Bell! / Farewell, farewell! and if for ever! still / For ever fare thee well!' The original, 'Fare Thee Well', had been printed by Hunt in the *Examiner* in April 1816.) Crafticanto is even more bluntly satirised. The 'running, lying, flying foot-man', who is Elfinan's 'great state-spy militant', is a compound of Southey, Wordsworth and Coleridge, all of whom Keats criticised for losing faith with their youthful radicalism. Crafticanto is at once a victim of the state, and the pompous representative of its injustice:

> Show him a mouse's tail, and he will guess,
> With metaphysic swiftness, at a mouse;
> Show him a garden, and with speed no less,
> He'll surmise sagely of the dwelling house.

It has sometimes been argued that the poem ranges 'Byron and Hunt on one side and the Lake Poets on the other, with Hazlitt as the sardonic outsider'.[7] This does justice to Keats's respectful feelings for Hazlitt, but it plays down the ferocity of his attack on time-servers, and misrepresents the way in which he regards individual actions as part of a larger malaise. It also proposes a clearer scheme for the poem than it in fact possesses. As Keats extended his canvas to include courtiers as well as Emperor, poetics as well as politics, he allowed his own particular circumstances to impinge on his narrative. The alternative titles of the poem admit this. One suggests a social criticism; the other something more personal. So does 'the feigned name of Lucy Vaughan Lloyd'. On the one hand it is a dig at Wordsworth, the author of the 'Lucy poems', and his Lakeland neighbour Charles Lucy, whose writing had recently been reviewed in the *Examiner*.[8] On the other, it disparages contemporary women poets, the 'blue-stockings' that Hazlitt had also criticised in one of his lectures. In both cases, Keats's intention is to reprimand bigots – and while his reasons for satirising Wordsworth might seem

sympathetic, his sneers at women writers tell us more about himself than they do about his subject. The pseudonym, in fact, connects with all his previous remarks about women as authors and readers. It wants to establish male authority and to strike against those who have failed to buy his poems.

Other elements in the poem make the same sort of point. Occasionally these emerge as angry outbursts which speak directly of his feelings for Fanny: 'Poor Elfinan! whose cruel fate was such, / He sat and cursed a bride he knew he could not touch.' More frequently, they are dramatised by various kinds of interaction – between mortals and immortals, between those from the 'lowland' and those from the 'highland'. These transgressions are woven into the fabric of the writing, which is sometimes harshly ironic, and sometimes has an authentically Keatsian sensuality. Often, and most revealingly of all, these stylistic veerings lead Keats to parody his own previous poems. We can hear echoes of 'The Eve of St Agnes' when he asks, speaking of Bertha, 'what crime can it be to glide / About the fragrant pleatings of thy dress'; and at another point he makes specific mention of 'The Eve of St Mark', in which the name Bertha also appears.

Keats's readers have often wondered why his final effort to write a long poem should have produced something so uncharacteristic – inverted and heavy-hearted when it means to be outward-going and light-footed. Its flaws and misfirings, however, have a painfully progressive logic. In 'The Fall of Hyperion' he had treated large spiritual and poetic questions with complete seriousness; in 'The Cap and Bells' he handles them with bitter humour, more intent on making money than he is on diversifying his problems by reimagining them. The expectation was too great, and the requirement too foreign to his poetic nature. Of all the poems written in his maturity, 'The Cap and Bells' is the most disappointing. It is simultaneously a last gasp and a broken cry of doubt about all he had believed in, done, and written.

KEATS EVENTUALLY ABANDONED 'The Cap and Bells' early in the new year. So long as he continued writing it, he was engrossed – as Brown had hoped he would be. Whenever he set the manuscript aside, he cast about busily for an equivalent distraction. 'In the evenings, at his own desire,' Brown said, 'he was alone in a separate sitting-room, deeply engaged in remodelling his poem of "Hyperion" into a "Vision".' He added, at the

most, fifty lines to the poem, and managed only a small number of alterations.

News about *Otho* was suddenly a little more cheering, though not precisely what Keats and Brown wanted to hear. Elliston, the manager at Drury Lane, wrote to Brown saying that he would put on the play, but not until the following spring, since he wanted to devote the winter to comedy. This boosted Keats's confidence, yet did nothing to solve his immediate financial difficulties. Accordingly, Brown threatened to send the manuscript to Covent Garden. Keats hesitated, pleased that Kean had liked the prospect of playing Ludolph, and eager to make further small changes. For the first time in months it seemed as though the current of life was running in his favour. He had a production to look forward to, he had recently seen the 'Ode to a Nightingale' in the *Annals of the Fine Arts*, and the 'Ode on a Grecian Urn' was soon to follow, and his new book of poems was due to appear in the spring. 'My hopes of success in the literary world are now better than ever,' he told his sister, genuinely believing what he wrote, rather than merely wishing to comfort her.

There were other encouragements too. In the second week of December he learned that Severn's painting 'The Cave of Despair' had won the Gold Medal at the Royal Academy. It was the first time the prize had been awarded for twelve years, and Keats was delighted. (When he later heard his friend attacked at dinner with de Wint and Hilton, he angrily left the room.) Almost simultaneously, he discovered that Abbey's partner Hodgkinson, who had recently married, was thinking of expanding his tea-broking business. He wanted to know if Keats was interested in becoming a partner. When Keats heard further details about the job, he and Abbey both decided against it, but for a brief while it seemed attractive. He felt that safety was at hand, if he chose to reach for it.

None of these things could affect the worry that underlay them all: his fears about his health. Closing a letter to his sister on 20 December, he reassured her that he was looking after himself. 'I have had a wa[r]m Coat made', he said, 'and have ordered some thick shoes.' In the same week, he told Rice that he was still extremely distressed, then immediately regretted seeming self-pitying, and hurried to entertain his friend with 'a true story':

There was a Man and his Wife who being to go a long journey on foot, in the course of their travels came to a River which rolled knee deep over the pebbles – In these cases the Man generally pulls off his shoes and stockings and carries the woman over on his Back. This Man did so; and his Wife being pregnant and troubled, as in such cases is very common, with strange longings, took the strangest that ever was heard of – Seeing her Husband's foot, a han[d]some on[e] enough, look very clean and tempting in the clear water, on their arrival at [the] other bank she earnestly demand[ed] a bit of it; he being an affectionate fellow and fearing for the comeliness of his child gave her a bit which he cut off with his Clasp knife – Not satisfied she asked another morsel – supposing there might be twins he gave her a slice more. Not yet contented she craved another Piece. 'You Wretch['] cries the Man, [']would you wish me to kill myself? take that!' Upon which he stabb'd her with the knife, cut her open and found three Children in her Belly two of them very comfortable with their mouth's shut, the third with its eyes and mouth stark staring open. 'Who would have thought it' cried the Wid[ow]er, and pursued his journey –

Keats turns away from this story as soon as he has told it, ending his letter flippantly: 'Brown has a little rumbling in his Stomach this morning.' But its significance – whether conscious or unconscious – is unmistakable. In one way, it links to Brown and the pregnant Abigail O'Donaghue – and possibly to George and Georgiana as well – indicating that Keats was fearful about the demands that a mother and children make on a father. In another, it dramatises questions about his own future. What burdens would marriage to Fanny place on him? Would he be able to support her? Would his wish for self-preservation lead him to destroy her? Behind these interpretations, and connected with them as surely as Fanny merges with his past in the figure of Moneta, lies another possibility. The woman represents his mother, the two healthy children are himself and George, and the third is his dead brother Tom. However it is decoded, the story connects dependencies in the past to others in the future. It shows Keats dragging the whole intact weight of his neuroses through the most chance-filled time he had known for many weeks.

For a while these chances continued to hearten him, leading him away from the seclusion of Wentworth Place and back into the company of his friends. He even visited Hunt, for the first time in many months, and discussed shared financial problems as well as his returning faith in poetry. If a poet added to a legend, he told Hunt, then this authorised him as a Classicist. He called on the Dilkes too, accompanying them to a

speech day at Westminster School, then dining with Dilke's parents in Great Smith Street on Christmas day. He was high-spirited and self-confident. When Dilke and Brown challenged each other to write a fairy story, with the loser buying the winner a beefsteak supper, Keats volunteered to be one of the judges. He left the party feeling confident that his 'set' was gathering round him again. His relationship with Abbey had improved. His help – so he supposed – had reached George. The spring would see his reputation rising. He was only twenty-four. He still had time to come into his own.

FORTY-FOUR

KEATS HAD ALWAYS BELIEVED that present pleasures implied future troubles. The new year, 1820, proved him disastrously right – and once again his own difficulties reflected and sometimes connected with tensions in the world at large. On 3 January George III died, ending a long period of political uncertainty, but freeing the Regent, now George IV, finally to sever his ties with reformist Whigs and pursue a simply reactionary course. On 23 February, a week after a day of national mourning for the dead king, a group of conspirators plotting to assassinate the entire cabinet was arrested in Cato Street. It was an event that even radicals like Shelley judged harshly, but its extremity was in a sense inevitable. It was the last act of a tragedy which had begun at Peterloo, and, rather than attracting support to the liberal cause, it handed the initiative back to the government. The repressive measures which had been introduced in preceding years were confirmed and strengthened; five of the conspirators were hanged and decapitated at Newgate on 1 May. The *Examiner* wrote: 'It is a bloody catastrophe, and yet, we are sure, it will be far from answering the expectations of the promoters. The machinery is too apparent.'[1]

Even before news of the conspiracy scorched through the country, Keats's hopes of making an untroubled start to the new year were dashed. Early in January, when he was trapped in Wentworth Place by several days of bad weather, in which heavy snow alternated with freezing fog, he received a letter from George for Mrs Wylie. It was full of surprises. Georgiana was pregnant again. The money that Keats had forwarded earlier in the winter had not arrived. George was coming to England. He reached London almost as soon as his letter, staying with

the Wylies to be near Abbey. By the end of the first week in January, he had made his way to Hampstead. It was eighteen months since the brothers had last seen each other, and although in some respects their lives had run in parallel, they had been affected by them very differently. George was hardened by his trials; he wanted his money, he resented the delays, he demanded to return to his family as soon as possible. Keats was wounded and nervous: his plans vague, and his ambitions clouded. Their delight at seeing each other soon gave way to disillusion.

George was a little exasperated to find his brother so evidently ill. Why had he not told him? Just looking at Keats was enough to awaken fears that the 'family disease' was working in him. His face was drawn and had lost much of its eagerness. His hair was thinner. His hands were 'faded and swollen in the veins'.[2] When Keats looked at George, the contrast was painful. Wearing the 'high white stock, close-fitting trousers and frock coat that he favoured',[3] he seemed decisive, worldly, and urgent. Everything about him reminded Keats of how he had once relied on him for support – as a reader, a guide, a defender and a financial adviser. 'Although his reception of me was as warm as heart could wish,' George later told Dilke, 'he could not speak with his former openness and unreserve, he had lost the reviving custom of venting his griefs.'

As George listened to friends like Reynolds, who thought that Fanny was 'an artful bad hearted girl', he became suspicious of her. He felt fond enough of his brother to suppose that she must have certain good qualities, but felt that she treated her sister unkindly and was rude to her mother. It is possible that Fanny only struck George in this way because she was made abrupt by his scrutiny. In any event, she resented his judgement, and his interference. 'He is no favourite of mine and he never liked me,' she said later. 'When his affairs did not succeed and he had a wife and one child to support, with the prospect of another, I cannot wonder that he should consider them first and as he could not get what he wanted without coming to England he unfortunately came – By that time his brother wished to marry himself, but he could not refuse the money.'

Fanny was not the only one who doubted George's financial motives. Brown was immediately distrustful of him, and later came to believe that he had arrived in England with the express purpose of draining the Keats estate entirely. In fact George's aims are difficult to calculate precisely. After a number of visits to Pancras Lane,[4] he divided what he supposed was the whole of Tom's inheritance: not more than £1,300. George claimed that Tom had outstanding debts of £250, and when these were

paid, the amount was reduced to approximately £1,100. Keats had already withdrawn money from this: £100 for himself, £100 for his sister, and £100 for George. This left between £800 and £1,000, of which a third belonged to Fanny Keats. According to Gittings, 'Keats took only £100 of [the remaining third to which he was entitled] and let George have the rest'.[5] By his own account, George returned to America with £700.

When George defended his actions to Dilke, in a letter written on 10 April 1824, he said that £100 of this £700 was given to him by Abbey, 'part of it as a gift, part as a loan, and another part presumably for a personal investment or speculation by Abbey himself'. This seems unlikely, since Abbey had persistently refused to advance George money via Keats. Even if it were true, it still leaves unanswered the question of whether George was entitled to all the money he took. He claimed to Brown that part of it (£160) was a legitimate repayment from the £500 he had left with his brother in June 1818, but this is difficult to prove, since the brothers had kept no accounts in the intervening months, and were habitually 'at sixes and sevens'. Keats himself evidently regarded the £500 'not as a loan but as a gift; it was some compensation for the way both George and Tom had drawn on him for their own purposes after he was twenty-one, for the trip to Paris . . . for instance, and for the debts that George had spoken of owing him in the spring of 1818'.[6]

It seems probable that George believed he was acting fairly, but because he never adequately explained his calculations, his transactions will always seem suspicious. Maybe he wanted to protect Keats from the grim reality of their situation. Maybe he thought his brother was adequately provided for. (Before returning to America he said to Keats: 'You, John, have so many friends, they will be sure to take care of you.') Maybe he interpreted something that Keats only intended as a loan to be a squaring of accounts. In years to come, he would act generously in paying his brother's debts, which suggests that he had originally been motivated by real need, and baffled by genuine confusions, rather than by the wish to deny or injure Keats. But the result of his actions was hurtful to them both. George was subsequently abused by most of Keats's friends, except Dilke. Keats was left insufficient money to pay his debts. 'That was not fair, was it,' he said to Brown. 'He ought not to have asked me.'

Most of these recriminations took place after George had gone back to America, and they became particularly fierce when, in the mid-1820s, he

discovered and claimed the Chancery fund that Keats had never known about. In the short term, Keats said nothing to his brother (though he did complain to Brown), and disguised his disappointment by accompanying him on a frantic social round. They went to the Wylies. They saw *The Comedy of Errors* and *Harlequin* at Covent Garden. They went to a 'pianoforte hop' given by the Dilkes. They had a dinner with Taylor – at which the fairy story competition was judged, and Dilke unanimously declared the winner. (Keats, feeling weary, left early to spend the night with the recently married Haslam.)

Nothing could help Keats and his brother recover their old closeness. Beginning a long letter-journal to Georgiana on 13 January, Keats said: 'I fear I must be dull having had no good natured flip from fortune's finger since I saw you.' He felt blocked and bitter: too poor to visit America, too disillusioned to feel he had a future at home. The prospect of a new nephew or niece prompts him to think of *King Lear* and say: 'If my name had been Edmund I should have been more fortunate.' Each face he evokes, each party he remembers, reminds him of how isolated and antisocial he feels. When he says that he has met an American named Hart with the Dilkes, he reports that he told him, 'I hated Englishmen because they were the only Men I knew'. When he speaks of Dilke himself, he says 'I fell foul of Politics. 'T is best to remain aloof from people and like their good parts without being eternally troubled with the dull processes of their every day Lives. When once a person has smok'd the vapidness of the routine of S[o]ciety he must have either self interest or the love of some sort of distinction to keep him in good humour with it. All I can say is that standing at Charing cross and looking east west north and south I can see nothing but dullness.'

Four days after starting this letter to Georgiana, Keats made a greater effort to seem companionable. Continuing to discuss 'our old set', he says that Rice, Reynolds and Richards are 'three witty people all distinct in their excellence', then launches into a piece of comic extravagance suggesting the word 'Amen' should be 'scratched out' and replaced with 'T wang-dillo-dee'. The fantasy is full of exuberance, but only confirms the impression he had given in the earlier part of his letter. The world which used to delight him is now troublesome or actually despicable. 'I must be silent,' he ends, sinking back into 'entrammell'd' seriousness. 'These are dangerous times to libel a man in, much more a world.'

While writing this letter, Keats was concealing a particular reason for his depression. Elliston, the manager of Drury Lane, had contacted

Brown and said that he would not be rushed into producing *Otho*. Keats had quickly finished his final revisions and agreed that the manuscript should be sent to Covent Garden, where he hoped that Macready would take the part of Ludolph. It was sent back to Wentworth Place almost immediately, apparently unread.

He was still determined to play down his anxieties. On Saturday 22 January he took George to the 'beefsteak dinner' that Brown, as the loser of the fairy tale competition, had to buy Dilke, and for the next few days they saw each other as much as possible. Keats continually avoided the subject of his poverty, and made reassuring noises about his prospects as a poet. When, at six in the morning of 28 January, he helped his brother into the coach which would take him to Liverpool and thence to America, George carried with him a notebook of poems that he had found time to copy, and a present of Hazlitt's *Political Essays*. Both things were meant to prove the brothers' continuing sympathy; nothing could disguise how disappointing their time together had been. There is no record of the last words they exchanged, nor of how George felt as he watched his brother's small suffering figure fade into the distance. They never saw each other again.

FORTY-FIVE

As GEORGE TRAVELLED NORTH, Keats realised that he had forgotten to give his brother the letter he had been writing to Georgiana. He rushed back to Wentworth Place and scribbled a few last cheerful words, assuring her that he soon meant to 'retire into the Country', as he had done in previous years, to work 'where there will be no sort of news'. 'I shall not be able to write you very long Letters,' he warned. In the event, even this turned out to be an understatement. His postscript ended the last letter he sent to America.

The reasons have a great deal to do with his illness, and with his wish to prevent further worry. His silence is also a sign of growing disillusion. The longer he thought about his brother's financial dealings, the angrier he became. He felt personally cheated, and also believed that George had betrayed larger family loyalties. Although Fanny Keats was separated from them by years and temperament, as well as distance, she still formed a part of the responsibility that Keats cherished. During his three weeks in London, George had not seen her once. In a letter sent

from Liverpool on the morning of 30 January, he said it was simply a 'misfortune' that he had failed to take 'a final leave' of her. For the rest of her life, and not surprisingly, she coldly criticised him.

Practically speaking, George's return to America was a success. Using the money brought from England, he paid off his debts, invested in a new boat to trade on the Ohio river, and financed the completion of a sawmill on First Street in Louisville. Within a couple of years he was able to tell his sister that his 'energy and application [were] the marvel of more lethargic Kentuckians'. In 1823 he bought a flour mill, and in 1830 he took over a thriving timber business. In addition, he and a partner named Felix Smith began dealing in real estate: by 1840 they owned forty-nine properties in the commercial area of Louisville. Almost inevitably, the expansion meant diluting the radical ideals which had taken him to America in the first place. In the context of the town and the times, he did not seem exceptionally reactionary. Even though he kept slaves at home and at work, even though he came to disapprove of 'Jacobins' and to 'fear universal suffrage',[1] he also persisted in supporting some liberal causes. He served on the town council for several years, he was a member of the committee which drafted the first town Charter, and he promoted a revision of the school system that involved the abolition of tuition fees. He was well known for his lack of snobbery, and once outraged his neighbours by helping a drunken woman home on a Sunday, while others preferred to continue their way to church.

As soon as George had started to make money, he had begun living in style. In February 1824, after lodging for a while with a family called Peay, he bought 'a House that exactly suits me, situated most pleasantly on a high Bank looking onto the Falls of the Ohio'. The following year he built a large grey stone mansion, later fronted with a monumental portico, on Walnut Street, which then stood at the edge of town near Jacob's Woods. It was a superior version of his Enfield childhood, and a tangible proof that he, unlike his brother, had managed to invent himself as he wished. He had a library of 300 books (including titles by Coleridge, Wordsworth, Shelley, Johnson, Scott and Cobbett), and some fine furniture: a valuable bureau, a French clock, and a Brussels carpet. His furnishings at his death were valued at more than £2,000.

In due time this house became known as 'the Englishman's Castle', and George himself was renowned for his business prowess and for his contribution to local culture. He was a member of the Kentucky

Historical Society, and entertained several notable speakers, including Howard Payne, the author of 'Home Sweet Home'. He drew round him a 'cultivated circle'[2] of kindred spirits who met regularly to hear recitals, discussions, and readings of poetry, including poetry by his brother. They may have parted awkwardly, and then lost touch with each other, but George kept a miniature of Keats over his fireplace, surrounded by portraits of Shakespeare and Beaumont and Fletcher (as well as others of Tom, Wellington, and Napoleon). Faithfully copying out his brother's poems for interested readers, he helped to establish Keats's reputation in America before it was secure in England.

A number of contemporaries left grateful accounts of his hospitality. A visitor to Louisville in the 1830s wrote in the *Lady's Companion* that she had 'attended few parties in better taste' than those given at 'The Englishman's Castle'.[3] 'It is rare to find cordiality and unpretending elegance more attractively blended . . . There was no ostentation of literature, no attempt at conversational parade about Mr Keats; he was manly, but modest; and rather disclaimed the least pretension to any regard, excepting as a mere man of business, and as a person deeply devoted to the best interests of his adopted country. It was not until some time after that I discovered, and that from a third person, that he was the brother of John Keats the poet of England; and when I conversed with him upon the subject, I found him ardently attracted to the memory of the gifted but ill-starred enthusiast.'[4]

George's more frequent guests agreed. Fortunatus Crosby (Jnr), for instance, a Yale graduate and minor poet who was headmaster of a local boarding school and would eventually become one of George's executors, praised his liberal sympathies. James Freeman Clarke, a Unitarian minister, author, and editor of the *Western Messenger*, praised him to several of the leading intellectuals of the day. He described him to Margaret Fuller as 'one of the best men in the world', and told Ralph Waldo Emerson that he and George often discussed Shakespeare and Carlyle together, as well as Keats. Others confirmed that George was 'decidedly an intellectual man' whose 'remarks at meetings [of the Louisville Literary Society] were to the purpose and acute, judicious and modest'. It was 'strange', they said, 'to find, on the banks of the Ohio, one who has successfully devoted himself to active pursuits, and yet retained so fine a sensibility for the rarest and most evanescent beauties of ancient song.'[5]

Georgiana, 'the most disinterested person' Keats had known, and of

whom he was 'very fond', remains a more obscure figure. It is clear from Keats's letters to her that she initially found America crude, alarming and unlikeable, but as George prospered and their family increased (they eventually had six daughters and two sons, of whom all but two lived beyond their twenties), she settled comfortably into her new life. In the process, she changed from being what Dilke had called 'a pretty, lively, ignorant girl, unaccustomed to society' into an accomplished woman who busily supported all her husband's various interests. She shared his admiration for the local landscape. (In many letters George comments on 'the buckeyes in bloom', the blossoming apple and cherry orchards, the cranes on the pools close to their house, and the eagles in the woods near by.) She was proud of her new family and her original connections, hanging silhouettes of her children alongside those of her mother, brothers, and brothers-in-law. She attended meetings of the Literary Society, and compiled a large dark green, marbled scrapbook[6] in which she pasted poems cut out of magazines. These give a sharp picture of her loyal and liberal tastes. As well as pasting in extracts from Burns and Cobbett, reports of the death of Horne Took, an article on 'The Influence of Women in Politics', and poems in favour of political reform, she copied several poems by Keats himself, newspaper references to his work, and an account from the *Morning Chronicle* on the publication of Shelley's *Adonais*. The scrapbook is a record of intelligence and devotion, the touching emblem of an affection which was both fed and frustrated by distance.

Throughout the 1830s, George and Georgiana felt their gamble had paid off. They were independent and happy. In spite of his success, however, George could not finally escape the difficulties which beset him during his first few months in America. Early in 1841, he was asked to endorse a large loan by Thomas Bakewell, the relation of Audubon who had lent him money more than twenty years previously. George did so willingly, but when the venture failed, Bakewell's creditors came down on him hard. They demanded money which took him back to the verge of bankruptcy. Almost immediately, the disaster broke his health. Within months, he had contracted tuberculosis. On 21 December he made his will, and three days later, on Christmas Eve, he died. He had lived for forty-three years, eighteen more than his elder brother, with whom he was closely linked by obituarists. The *Louisville Daily Journal* wrote: 'Mr Keats was a younger brother of John Keats, the distinguished British poet, and possessed with much genius and all the

philosophy, benevolence and enlarged philanthropy of the lamented bard. The suavity of his manners and the charm of his conversation endeared him to all who knew him, and his enterprise and public spirit rendered him an estimable member of society. There is not a man in our community whose death would not be more deeply and universally mourned.'[7]

Georgiana, suddenly poor again, and with seven surviving children to support, lacked the means to fend for herself. A little over two years later, on 5 January 1843, she married John Jeffrey, a twenty-six-year-old Scotsman who worked in Louisville as an engineer. (He later built the town's first gas works.) The marriage began badly, as Georgiana later revealed in a long letter to her brother-in-law, complaining about her husband's unfaithfulness, but in time it found its balance. Jeffrey was kind to his stepchildren, tried to build up George's surviving business interests, and continued the defence and promotion of Keats. George had often lamented that no biography of his brother existed, and when Richard Monckton Milnes eventually began collecting material in the mid-1840s, Jeffrey copied (and sometimes miscopied) many letters and manuscripts. He lived into old age, eventually dying in 1881, two years after his wife. Like her two husbands, Georgiana was buried in Cave Hill Cemetery on the outskirts of Louisville. According to the local paper she was 'a woman of the most sprightly mind, and, in her later years, the most caustic wit [. She] . . . retained the unusual qualities of mind that made her famous among Kentucky women to the very last.'[8]

FORTY-SIX

GEORGE WAS NOT killed by the collapse of his hopes, but his failure sapped his spirit, and opened the way for illness to make a swift advance. Keats's disappointment grew more slowly, and his health weakened by more painful degrees. The days leading up to George's departure affected him especially badly: he was exhausted by worry, and shocked by the second parting. Shortly after George had left, it was discovered, probably by Abigail O'Donaghue, that Keats was regularly taking 'a few drops of laudanum'. When the news was relayed to Brown, he made Keats promise 'never [to] take another drop without my knowledge'. Keats did as he was told, sinking into deeper misery. He no longer spent his evenings tinkering with 'The Fall of Hyperion'. He made no

concerted effort to persevere with 'The Cap and Bells'. He had little inclination to stir outside the house, or to see people other than Brown and Fanny.

Then, in the first few days of February, the freezing weather of recent weeks at last relented, and he began to think about his future and other friends once more. On the third day of the month, a Thursday, he went into town on some unknown business, and caught the late coach back to Hampstead. He had left his new thick coat at home, not realising that the nights were still cold, and as usual travelled on top of the coach to save money. By the time he climbed down at Pond Street he was chilled and feverish, and when he staggered into Wentworth Place, Brown at first thought he was drunk. A moment later he realised the truth. 'What is the matter,' he asked. 'Are you fevered?' Keats replied 'Yes. Yes', then added contradictorily 'I was severely chilled – but now I don't feel it. Fevered! – of course, a little.' Brown ordered Keats to go straight to bed, and went to the kitchen to fetch a glass of spirits. When he carried it up the narrow stairs, he found that Keats had already changed into his nightgown and was just 'leap[ing] into bed. On entering the cold sheets, before his head was on the pillow, he slightly coughed, and I heard him say, "That is blood from my mouth." I went towards him; he was examining a single drop of blood upon the sheet. "Bring me the candle, Brown; and let me see this blood." After regarding it steadfastly, he looked up in my face, with a calmness of countenance that I can never forget, and said, "I know the colour of that blood; – it is arterial blood; – I cannot be deceived in that colour; – that drop of blood is my death warrant; – I must die".'

Keats realised that he had suffered a small lung haemorrhage.[1] He lay back, knowing that a second attack might soon follow. It did: a massive 'rush of blood . . . to my Lungs that I felt nearly suffocated'. All he could think about was Fanny, and 'the love which has so long been my pleasure and torment'. After settling him as best he could, Brown sent for the nearest doctor – not Sawrey, who had treated both Keats and Tom previously, but George Rodd, who lived in the High Street. Rodd arrived within minutes, and started to bleed Keats. By five in the morning, the immediate crisis was passed, and Keats was asleep. Brown crept back to his own room.

Rodd's treatment seems extraordinary. Keats had already lost a copious amount of blood, and to drain more was bound to debilitate him further. In fact he was doing what any contemporary doctor would have

done. He was a well-educated and widely respected surgeon, who shared the popular belief that bleeding (venesection) would remove poisoned blood, and reduce pressure on the cardiovascular system. In the days to come, the only other cures he was able to recommend were 'Quietness of mind and fine weather', and a starvation diet which also only increased Keats's feebleness. (Tom had written pathetically to Dilke in the summer of 1818 that 'invalids are suposed to have delicate stomachs; for my part I should like a slice of underdone sirloin'.)

It is possible, anyway, that Rodd did not believe Keats had consumption (then also known as 'phthisis', and more recently as tuberculosis). One of the five other doctors who subsequently treated him, Robert Bree, certainly thought the illness was largely nervous and concentrated on the stomach. (Bree, 1759–1839, was a Fellow of the Royal College of Physicians, and a specialist in respiratory diseases.) Keats himself, in spite of saying that the 'drop of blood' on his pillow was his 'death warrant', was also slow to admit that he had consumption.[2] This was in keeping with his behaviour since the winter of 1818, when he had probably been infected by Tom. He had, admittedly, avoided bathing on the Isle of Wight. He had worried about good climates and cold weather. But he had never complained of more than a sore throat,[3] and generalised feelings of 'feverishness'.

Were these refusals deliberate or ill informed? As far as Keats himself was concerned, the answer is comparatively simple. He had enough professional and family knowledge to recognise consumption when he saw it, but his wish to protect himself and his friends led him to mount a heroic deception. His doctors' behaviour is more problematic. They had inherited a body of opinion about consumption which was voluminous and confused. Hippocrates, writing around 400 BC, had been the first to use the term 'phthisis', which he defined as 'a diminution or shrinking of the body, following incurable illness of the lungs accompanied by a small fever'.[4] In succeeding centuries, there had been a great deal of medical discussion about the disease, and precious little progress in discovering its origins. Everyone agreed that it killed large numbers of people – Bunyan called consumption 'The Captain of all these men of death' in *The Life and Death of Mr Badman* – but the only thing that had been certainly established was its gross pathology. One doctor working at the end of the eighteenth century had summarised the findings as follows: 'The phthisis begins as a respiratory catarrh, with chest pains, increasing malaise and a dry cough yielding yellow sputum',[5] adding that it also

produced a raised temperature, a rapid pulse, and sweating. These symptoms may be described in contemporary terms as the result of a patient inhaling micro-organisms known as tubercle bacilli, which inflame and corrode the lungs. 'If, in the course of the destruction, a blood vessel in the lungs chances to be opened, the patient coughs up blood.'[6] Rodd, like Keats's other doctors, had no such knowledge and no such language. He did not have a stethoscope with which to examine his patient – Laënnec had published his epoch-making book on the examination of the lungs with a stethoscope in 1815, though this was largely unknown in England until 1821. He would not even have been certain that the disease was infectious: the tubercle bacillus was not definitively characterised until 1882, when Robert Koch published a paper identifying its aetiological agent. This was followed by Röntgen's discovery of X-rays in 1885, and later by the introduction of vaccine and a whole range of effective drugs.

Rodd's ignorance is all the more poignant for persisting through a time when concerted efforts were being made to vanquish the disease. In 1818, for instance, William Woolcombe published a lengthy analysis of all available data, proving that consumption had spread rapidly since the seventeenth century, when it had been responsible for 20 per cent of all deaths, and was 'now so high as almost to exceed belief'.[7] The effect was only to elaborate the description of symptoms, rather than to identify causes. This meant that most people continued to regard consumption as hereditary, and to apply the traditional cures of bleeding, dieting and resting. It also meant that 'respectable' ideas had to compete with those offered by cranks and quacks. One early nineteenth-century doctor claimed that 'butchers are seldom consumptive'.[8] Another recommended patients to 'Buy a cow, drive the cow to the mountains, and live off the cow'.[9] A third advised wearing flannel next to the skin.

All these treatments, sensible and otherwise, have been tellingly described as nothing more than 'a meditation on death'.[10] In two respects, however the picture had recently clarified. It is evident from contemporary books about Hampstead, let alone guides to Margate, Teignmouth and the Isle of Wight, that the healthy effects of fresh air and a dry climate were widely recognised. In the years after Keats's death, their benefits were institutionalised: in 1840 George Boddington of Sutton Coldfield published 'An Essay on the Treatment and Cure of Pulmonary Consumption' which led to the creation of many 'open-air' hospitals. Doctors also agreed that patients should 'by all Careful ways,

industriously lay aside Care, Melancholy, and all poring of [their] Thoughts, as much as they can'.[11] James Clark, who would later treat Keats in Rome, was especially emphatic on this point. Ironically, he argued that the advantages of a 'change of climate' would be undone by the emotional demands of 'a long journey'.[12] At the same time, he also spelt out what every one of his contemporaries knew to be the case: 'Respecting the treatment of Consumption, we must admit the humiliating truth, that there is no reason to believe that the physicians of the present day are more successful than their predecessors were ten, nay, twenty centuries ago.'[13]

Respecting the treatment. Diagnosis was another matter. It is clear from Clark's remarks, and from books by other contemporaries, that Keats's doctors in fact had no reasonable grounds for doubting what was the matter with him. They kept him in the dark either because they were colluding with his deception, or because they were incompetent. The second possibility would make them seem reprehensible, were it not for the fact that their treatment of him, wisely or ignorantly, turned out to include all known 'cures'. Each one did the best they could for him, which was also the worst. This left Keats free to hope that he might recover, and at the same time plunged him into confusion. If he anticipated having a future, he supposed that he might be deluded. If he told himself that he was dying, he was tormented by the various misconceptions surrounding tuberculosis.

It has become conventional to glamorise the consumptive artist. As the sad roll-call of victims is recited (Sterne, Schiller, Voltaire, Emily and Anne Brontë, Elizabeth Barrett Browning, Katherine Mansfield, D. H. Lawrence), and as the symptoms are listed ('white pallor and red flush, hyperactively alternating with languidness'[14]), suffering becomes confused with sensitivity, and illness with intensity. Lord Sligo, visiting Byron in Patras in 1810, told an anecdote which suggests that such conflations were common in Keats's day too. Moore describes Byron looking into a mirror and saying 'I look pale . . . I should like to die of a consumption.' When asked why, Byron replied: 'Because all the ladies would say "Look at that poor Byron, how interesting he looks in dying".'[15] The story of Keats's own life, when it became generally known, added to the power of this image. In *Adonais*, Shelley promoted Keats as someone whose achievement could not be separated from agony, who was 'spiritualised' by his decline, and who was forced to live at a rapidly accelerated rate. Although not 'a consumptive type', he

was simply too fine-tuned to endure the buffetings of the world.[16]

Shelley had already made the same connections to Keats himself. Writing from Italy in July 1820, he said that he had heard 'you continue to wear a consumptive appearance', as though this were proof of Keats's enduring delicacy of spirit. Keats was more concerned with other aspects of his illness. Although medical opinion often made out that consumption was hereditary, or at least innocently contracted in childhood, it also suggested that it was linked to certain kinds of personal 'weakness'. A comparatively innocent kind was the weakness of love. (The theory continued into recent times. In *The Magic Mountain*, Thomas Mann writes: 'Symptoms of the disease are nothing but a disguised manifestation of the power of love; and all disease is only love transformed.'[17]) Keats himself registers this in his letters to Fanny, repeatedly referring to his love for her as an originally noble power which has been transformed by its own excess. In doing so, he conformed to a pattern which Michel Foucault, among others, noticed running throughout the nineteenth century: 'A man, in becoming tubercular, in the fever that hastens and betrays him, fulfils his incommunicable secrets. That is why chest diseases are of exactly the same nature as diseases of love: they are the Passion, a life to which death gives a face that cannot be exchanged.'[18]

This argument implied a special degree of susceptibility in the patient – one which flouted all the available evidence, but which fed the Romantic archetype. To someone as concerned about his independence as Keats, this was dismaying enough. There was another aspect to the equation as well. The more eagerly doctors emphasised the link between tuberculosis and love, the more inclined they were to suppose that 'increase[d] sexual desire'[19] was not simply a sign of the disease, but a cause of it. A number of classical authors, Celsus and Hippocrates among them, had been especially concerned about the debilitating effects of masturbation, and their ideas were enthusiastically endorsed by subsequent generations. S. A. Tissot, for instance, a widely translated Swiss doctor who has had the distinction of being called 'clearly the [eighteenth century's] most influential authority on masturbation',[20] pronounced that 'the loss of too much semen [by masturbating] . . . gives rise to a dorsal consumption, indolence, and various other disorders, which are connected with these'.[21] Later authorities took a grisly delight in confirming and elaborating his prejudices. One, for example, referred in 1848 to the case of the teenage 'Miss R', who told

her doctor 'I am evidently in a rapid consumption, which was brought on by the habit of onanism, that I contracted when very young.'[22]

There is no evidence to prove that Keats himself regarded masturbation as a form of destructive self-abuse. There is plenty to suggest that the sadistic climate of public opinion would have associated it with his disease. Like other consumptives of his time, he was not only stricken but stigmatised – possibly as a masturbator, certainly as a helplessly obsessed lover. This is important because it helps to explain one possible reason why he was so anxious to deny the nature of his illness: he refuses to give it a name in his letters, and defiantly attaches no meaning to it. He refers to it simply as a given state, over which he has no control and of which he claims no understanding. Several critics, however, have found ways of making the connections that he denied, at least as far as their characterisation of his poetry is concerned. It has become a commonplace to connect his efforts at self-creation with self-pleasuring. Byron was one of the first to do this. Although he originally took against Keats for attacking Pope, he soon turned from literary issues to more personal ones, reviling the yeastings of Keats's imagination as a form of solipsism. In one letter he called Keats's early verse 'the Onanism of poetry', and Keats himself a 'miserable Self-polluter of the human mind'; in another he said that his poetry was 'a sort of mental masturbation – he is always f-gg-ng his *Imagination*.'

Byron wrote these things in the autumn of 1820, after he had heard that Keats was consumptive. When the news reached him the following spring that Keats was dead, he told Shelley: 'I should have omitted some remarks upon his poetry, to which I was provoked by his *attack* upon *Pope*, and my disapprobation of *his own* style of writing.' Although this meant that his criticism then shrank back into its original terms ('Mr John Ketch' was 'vulgar'), his outburst referred to a popular supposition. It hypothesised that the 'Cockneyism' of Keats's poetry was inseparable from the deficiency of his moral character – a deficiency that Keats feared others would also comment on or condemn as his illness took hold.

Brown had often criticised Fanny Brawne to Keats. Now he had Rodd's opinion, as well as the weight of popular superstition, to back him up. Love was both the symptom and the agent of consumption: therefore Keats must suppress his feelings. He must also, Rodd said, avoid all other kinds of excitement as well, including writing. Keats found this comparatively easy, for the next several days at least. Fanny was a different matter. She was his neighbour – unavoidable – and anyway he had decided weeks ago that he could not resist her. All he could do was try to meet her without arousing Brown's criticism. 'I think you had better not make any long stay with me when Mr Brown is at home,' he told her. 'Whenever he goes out you may bring your [sewing] work.'

He first tried to see her the day after his haemorrhage, and was told that she had gone to town. Waiting for her return, he wrote to her reassuringly: 'The consciousness that you love me will make a pleasant prison of the house next to yours.' No sooner had he finished his note than he discovered Brown had been lying. Fanny had stayed at home all day, waiting for news on the other side of the thin wall that divided them. Brown realised at once that he would find it impossible to keep them apart, and reluctantly agreed to a more tolerant regime. During the next six weeks, Fanny visited Keats almost every day, and he wrote her twenty-two short letters.

By 6 February he was feeling a little better. Mrs Reynolds and his Wylie brothers-in-law came to see him; he sat up in bed reading the *Examiner*; and he wrote to his sister. (He still regarded himself as her 'only Protector': she was just sixteen years old.) He told her that he had simply 'caught [a] cold which flew to my lungs' because he had 'imprudently [left] off my great coat in the thaw'. He promised to 'ask Abbey's permission' to let her see him 'if I should be confined long'. It is a courageous letter, searching for news which would comfort them both, but shows that his world had immediately shrunk to the little he could see from his window. 'The grass looks very dingy,' he says, 'the Celery is all gone, and there is nothing to enliven one but a few Cabbage s[t]alks that seem fix'd on the superannuated list.' When he moved downstairs two days later, and lay wrapped in blankets on a sofa in the front parlour, most things that he saw continued to speak to his condition. In a second

letter to his sister he described seeing 'a Pot boy', 'Old women . . . creeping about the heath', 'Gypsys after hare skins and silver spoons', a man carrying a clock which chimed endlessly, and 'the old french emigrant (who had been very well to do in france) with his hands joined behind on his hips, and his face full of political schemes'. Even when he reported on it cheerfully, the entire landscape reminded him of age, of time passing, of vagrancy, and of exclusion.

On 10 February he reported that he was 'a little more verging towards improvement', and had been able 'to walk for a quarter of an hour in the garden'. As his strength returned, so did his need for Fanny Brawne. Hours without a note or a visit passed desperately slowly, leaving him time to fret about when they would next meet, and how he might have hurt her in the past. Hours with her only reminded him that their engagement was a mockery. If he survived he had no security to offer; if he remained ill he would trap her in a prison of responsibilities. The longer he considered this, the more obvious it seemed that he should break off their agreement. The prospect was terrible, but he felt he had no option. Accordingly, he asked her to consider herself free of him – only to find that this wounded her pride by seeming to ignore her own feelings. It was precisely the reaction he had hoped for, and scarcely believed possible. With a mixture of relief and excitement, he told her that 'Whenever I have at any time written on a certain unpleasant subject, it has been with your welfare impress'd upon my mind. How hurt I should have been had you ever acceded to what is, notwithstanding, very reasonable! How much the more do I love you from the general result!'

Keats ended this letter by raising his original doubts about Fanny in order to reject them. 'My greatest torment since I have known you', he said, 'has been the fear of you being a little inclined to the Cressid; but that suspicion I dismiss utterly and remain happy in the surety of your Love, which I assure you is as much a wonder to me as a delight.' This implies that Keats had once again persuaded himself his jealousies were a thing of the past. He was wrong. During the next few weeks his old worries returned in battalions, as we can see from the only poem he wrote this February: 'To Fanny'. It begins with a desperate challenge to the advice that he should avoid writing, describing 'verse' as an illness which 'Physician Nature' must cure by bleeding. Initially he is sickened by not having a 'theme'; when one emerges, it only produces a crisis. He imagines Fanny beyond his reach, at a party where 'The current of [her] heart' flows towards rival suitors:

Save it for me, sweet love! though music breathe
 Voluptuous visions into the warm air,
Though swimming through the dance's dangerous wreath,
 Be like an April day,
 Smiling and cold and gay,
 A temperate lily, temperate as fair;
 Then, Heaven! there will be
 A warmer June for me.

By this fourth stanza, the poem is beginning to show the same signs of strain that had appeared in his earlier lyrics to Fanny. Its form is wrenched and battered, and the sense of audience is confused. Are the lines addressed to Fanny or a wider readership? Or are they meant only for Keats himself? Briefly, in the fifth stanza, Keats tries to impose order by offering his condition as evidence of a general truth. ('Must not a woman be / A feather on the sea, / Swayed to and fro by every wind and tide'.) In the final two stanzas, this control breaks down disastrously:

I know it – and to know it is despair
 To one who loves you as I love, sweet Fanny!
Whose heart goes fluttering for you everywhere,
 Nor, when away you roam,
 Dare keep its wretched home.
 Love, Love alone, has pains severe and many:
 Then, loveliest! keep me free
 From torturing jealousy.

Ah! if you prize my subdued soul above
 The poor, the fading, brief, pride of an hour,
Let none profane my Holy See of Love,
 Or with a rude hand break
 The sacramental cake;
 Let none else touch the just new-budded flower;
 If not – may my eyes close,
 Love! on their last repose.

In 'The Cap and Bells' Keats had cannibalised and criticised his earlier beliefs openly. In 'To Fanny' the self-recrimination is more disguised and also more drastic. The poem describes 'the exact negative counterpoint'[1] to the 'Ode to a Nightingale', withering into a contrast between desire and self-possession which it admits to finding irreconcilable.

Finally, it recasts the closing phrase of 'Bright Star' ('or else swoon to death') in a couplet which denies itself the comfort of a punningly dual meaning.

The manuscript of 'To Fanny' provides touching evidence of the state in which it was written. Initially large and wild, with several letters hastily unformed, Keats's handwriting eventually slackens and splays. He was obviously worn out. The fact that it was the last poem he wrote makes this all the more moving. But in what sense does it prove that his career was cruelly cut short? Four months before his sickness and his doctors' orders made writing virtually impossible, Keats had produced a poem which indicates that he was on the point of beginning a new and significant phase: 'To Autumn'. Its disinterestedness brings his development through the narrative poems and the previous odes to a triumphant climax, and shows how his wish to explore 'other sensations' might have evolved in the future. The poems and fragments he wrote after completing the ode can only show these ambitions in a series of broken and distorting mirrors. The lyrics to Fanny are made shrill by his distress, and 'The Cap and Bells' becomes strident in its wish to strike a popular satirical note. For all this, they reflect his hopes of continuing to combine profound investigations of the self with deliberations about politics and society – the things he was planning to tackle in his career as a liberal journalist.

The question of how the language of his poems would have developed is harder to answer. In the five and a half years between the 'Imitation of Spenser' and 'To Autumn', Keats had moved from directly polemical writing to something much richer and more oblique, from hot-handed intensity to a graver though still warmly sensuous kind of imaginative 'stationing'. In the process, and especially during 1819, his performance as a chameleon poet sometimes grew troublingly uncertain. The two halves of his poetic self, the imagining heart and the explicating intellect, became more and more obviously at odds – as 'Melancholy', 'Indolence' and parts of 'The Fall of Hyperion' show to their disadvantage. Would the 'other sensations' he wanted to embrace after completing 'To Autumn' have finally denied him possession of negative capability altogether? It is impossible to say – only to emphasise that it is singularly lacking in the poems to Fanny and in 'The Cap and Bells', where its disappearance is 'hastened' by his illness and other worries. This means that any judgement about the premature end to his poetic life has to say two things simultaneously. It must lament the lack of a future that Keats

himself only envisaged in theory, and say that if it had followed the pattern of 'To Autumn', it would have placed him even more securely 'with Shakespeare'. At the same time, it should admit that 'To Autumn', in whatever sense it marks an end as well as a beginning, closes a career which feels remarkably intact. In his astonishing youth, in his phenomenal energy and impatience, in his marvellous integration of social and personal forces, he created a unified imaginative world, and a coherent artistic development. The *Collected Poems* possibly contains everything the Keatsian Keats had to give.

KEATS CLUNG TO THE thought that he might be counted 'among the English poets' after his death. While his illness took hold, his hopes were constantly eroded by doubts about the value of what he had achieved. The good opinion of his friends counted for little in the wide world. It could not cancel the hostility of reviewers, and it could not inspire a wide and remunerative audience. Even posthumous fame seemed unlikely. 'If I should die,' he told Fanny, 'I have left no immortal work behind me – nothing to make my friends proud of my memory – but I have lov'd the principle of beauty in all things, and if I had had time I would have made myself remembered.' A little later he wrote to her again: 'Let me have another opportunity of years before and I will not die without being remember'd.'

As his confidence collapsed, Keats became increasingly aware that his situation in Wentworth Place reversed the fears he had often expressed to Fanny. He had dreaded losing his poetic identity to love; in fact he was losing it to sickness, and love became his whole existence. He had thought that he would be a prisoner of domestic cares; he had become a gaoler as well. 'Let me not longer detain you from going to Town,' he wrote to Fanny, 'there may be no end to this emprisoning of you.' As the first half of February crawled by, he repeatedly tried and failed to acclimatise himself to his dependency. 'I must be patient,' he said; and later: 'All we have to do is be patient.'

Keats could not see Fanny without thinking of how death would separate them. He could not be apart from her without realising that death would prevent them from reuniting. His agitation grew daily more acute – so much so, that it almost becomes possible to sympathise with Bree for thinking his sickness was predominantly 'nervous'. 'I was very disinclined to encounter the Scuffle' of London, Keats wrote to his sister, 'more from nervousness than real illness.' Later he told her: 'I am

too nervous to enter into any discussion in which my heart is concerned.' And later again, in August: 'I am excessively nervous: a person I am not quite used to entering the room half choaks me – 'T is not yet Consumption I believe.'

He did what he could to control the chaos of his feelings. He told himself not to mind when Fanny went into town. He advised her not to worry about the opinion of their friends: 'they think and speak for the best', he said, 'and if their best is not our best it is not their fault.' He arranged that Fanny should send him a note each night to put under his pillow. They agreed that he would watch from the parlour window to see that she got his messages safely. They tried to avoid talking about the time to come. When other friends called, Keats felt bound to stare ahead more searchingly. On 13 February Reynolds came to visit, looking so tired and hungry that Keats regretted not offering him dinner. When Keats wrote to him afterwards, he selflessly tried to engage with Reynolds's travel plans (he was shortly to visit Brussels), and with literary prospects. He said that the young poet B. W. Procter – 'Barry Cornwall' – had sent two collections of poetry which 'teas[ed]' him, but which he admired for their suggesting 'he likes poetry for its own sake not his'.[2] A letter to Rice, written the day after Reynolds's visit, begins by making the same effort to seem optimistic. Its opening promise to 'follow your example in looking to the future good' soon wavers. 'I may say', Keats admits, 'that for 6 Months before I was taken ill I had not passed a tranquil day – Either that gloom overspre[a]d me or I was suffering some passionate feeling, or if I turn'd to versify that acerbated the poison of either sensation.' As the letter continues, he rallies again:

How astonishingly does the chance of leaving the world impress a sense of its natural beauties on us. Like poor Falstaff, though I do not babble, I think of green fields. I muse with the greatest affection on every flower I have known from my infancy – their shapes and coulours [are as] new to me as if I had just created them with a superhuman fancy – It is because they are connected with the most thoughtless and happiest moments of our Lives – I have seen foreign flowers in hothouses of the most beautiful nature, but I do not care a straw for them. The simple flowers of our sp[r]ing are what I want to see again.

This was the note that Keats's friends associated with him, played in a minor key. It was only two weeks since his haemorrhage, but he was starting to reaffirm his first principles of Beauty. For the final part of February he continued to recover 'gradually', telling his sister that

'quietness of mind and fine weather will restore me'. The days filled with trivial incidents, all persuading him that he was once more a part of the life around him. He watched Brown copying a 'methodist meeting Picture' by Hogarth, which later gave him 'a horrid dream'.[3] He reported on the benefits of his restored vegetarian diet. He wrote to his sister, sympathising that Abbey would not increase her pocket money. He lent Fanny books. He even began to think again about preparing his poems for publication, encouraged by Taylor and Woodhouse, who had recently shown some to Cary, the translator of Dante. By early March he was almost his old self. Writing to Dilke, he retailed news of Reynolds and Rice, called Hunt 'a very neglectful fellow' for failing to send him Procter's book, joked about Brown's efforts as an artist, and discussed the chances of the radical Cobbett being elected as member of Parliament for Coventry in the General Election which was to be held shortly. (Cobbett, as the *Examiner* reported, had recently returned from America.) In its abbreviated way, the letter has the same heart-warming gusto as those he had written when he was well, and the same determination to criticise 'the slovenly age we live in'.

As Fanny watched him improve, she insisted that she still wanted to marry him. Greatly as this helped to restore Keats's confidence, it also challenged Brown's possessive control. This meant that while one kind of tension lessened in Wentworth Place, another kind increased. Brown was reluctant to alter his first impressions of Fanny, and he resented having her in the house where she was bound to meet the heavily pregnant Abigail, and judge him accordingly. By now, however, nothing could daunt or deflect her. She gave Keats a ring as proof of her love. She became more and more involved with his dreams of recovery. 'Health is my expected heaven,' he said, 'and you are the Houri – this word I believe is both singular and plural – if only plural never mind – you are a thousand of them.'

A relapse was inevitable. On 6 March Keats suddenly suffered what Brown called 'violent palpitations at the heart', and went back to bed for two days. He was unable to continue revising his poems, and unwilling even to open a letter. The 'wretchedly depressed' Brown arranged for Dr Bree to visit, believing that his expert knowledge of asthma might do some good. In his popular book on the subject, Bree had devoted a section to 'psychosomatic or hysterical symptoms', and as he explained these to Keats, he confirmed that he believed anxiety was largely to blame for the deterioration. Brown was deeply relieved. Two days later

he wrote to Taylor: 'I am happy to tell you that we are now assured there is no pulmonary affection, no organic defect whatever, – the disease is on his *mind*.' He added that he and Keats hoped, 'if the weather remain[ed] kindly, . . . [to] go to the coast of Hants' later in the year. In the meantime, Brown brought Keats downstairs to the front parlour once more, sometimes accompanying him on short walks round the garden.

Bree's reassurance, combined with the fact that he took Keats off the strict diet that Rodd had suggested, and prescribed sedatives (small doses of opium 'to abate sensibility of slight irritations')[4] meant that Keats entered a calmer and more self-possessed period of his illness. He began revising his poems again, sending Taylor 'The Eve of St Agnes' with its original text restored. He restarted his correspondence with Fanny.[5] He started to sleep better, and to put on weight. He even felt able to mock his condition – and his size: 'My Mind has been the most discontented and restless one that ever was put into a body too small for it.'

By 13 March he felt strong enough to tell Brown that he wanted his poems published 'as soon as [was] convenient' to Taylor, and impatiently asked that he might be allowed to take the fair copy of 'Lamia' to Fleet Street himself. Brown told him that he must not think of doing so until the weather improved, but on the following day he went anyway, dining with Taylor in his offices and possibly once more discussing Clare with him. (Taylor had just published Clare's first book.) Returning to Wentworth Place, he continued to insist that he felt 'much better'. Although he feared that his 'palpitations' might begin again at any moment, and hated Fanny leaving him alone for as much as a morning, he joked with her that he was 'too prudent for a dying kind of Lover. Yet, there is a great difference between going off in warm blood like Romeo, and making one's exit like a frog in a frost.'

He began reaching out to the wider world, as well. He worried about his sister, who had recently complained that Mrs Abbey objected to her keeping a pet spaniel, and arranged for the dog to be moved to a relation of Mrs Dilke's – probably her brother-in-law William Dilke, who lived near by in Wentworth House. He received a letter from Charles Wylie, and wrote to Mrs Wylie to reassure her about George, from whom no one had heard since his departure. ('Louisville is not such a monstrous distance,' he said. 'If Georgiana lived at york it would be just as far off.') At the end of the month he gathered himself for another visit to London. Haydon, who had at last finished 'Christ's Entry into Jerusalem',

exhibited the painting at a private view in the Egyptian Hall, Piccadilly, on Saturday 25 March. It had formed the backcloth to their entire friendship, and even though their feelings about each other were still cool, Keats was determined to show that his loyalty to Haydon as an artist had not diminished even though he had recently lost a lot of blood and been on a starvation diet, and had to walk five miles to reach the exhibition.[6]

Haydon had widely publicised the unveiling of what he considered his masterpiece, and a large crowd of painters, writers and celebrities milled in front of the canvas, which measured thirteen feet by fifteen, and hung in an ostentatious frame weighing 600 lb. Initially, the reaction was muted. Hazlitt whispered that the central figure of Christ was feebly done, and the Academician James Northcote told Haydon 'the ass is the saviour of your picture'.[7] Then, the actress Mrs Siddons cut a swathe through the onlookers, silencing everyone for a moment before announcing 'in her solemn and sublime tone' that the painting was 'completely successful'.[8] Everyone relaxed immediately, and Haydon believed that his reputation was made. The *Examiner* later described the day as 'one of triumph to the British school',[9] and when the painting subsequently went on tour to Edinburgh and Glasgow, it was seen by more than 50,000 people, who paid nearly £5,000 for the privilege. (Its reputation later declined rapidly. In 1831 it was bought by the American painter Henry Inman and the engraver Cephas Childs for $1,200, then passed in the 1840s to the Archbishop of Cincinnati. It hung briefly in the cathedral before being removed to the local museum, and then to St Mary's Seminary in Ohio, where it remains.)

Haydon felt 'singular . . . glorious . . . [and] oppressed with a roar of sensations'. Keats, by all accounts, was also 'exhilarated'.[10] Picking his way through the throng, he talked to Lamb, met Procter for the first time, and sought out Hazlitt. We do not know what he thought of Haydon's 'masterpiece', but while it seems likely that he admired its ambition, he could not help looking at it sorrowfully. It showed him as a passionate rising talent, his face in profile, pressing towards a companion (Haydon's pupil William Bewick). Framed by two dark pillars, with the bald and bowed head of Wordsworth immediately in front of him, and Hazlitt, Voltaire and Newton elsewhere in the crowd, he is flushed and intense – excitedly arguing a point. Now he was sick and penniless. The contrast was painful, and painfully obvious to everyone around him.

Keats tramped back to Hampstead, from where he wrote to tell Fanny

and his sister that his excursion proved he was still 'steadily improving'. But this only created new problems. For one thing, Bree began insisting that in order to make a complete recovery, Keats would have to travel abroad – to Rome, perhaps, where Keats could live in the 'English colony', and benefit from the better climate. The prospect of living under 'skies Italian' had obvious attractions; the thought of leaving Fanny was more than he could endure. He forced it to the side of his mind, hoping that the English spring would make his journey unnecessary. At the same time, Brown started thinking about letting Wentworth Place during the summer, as he always did, while he went off on another walking tour round Scotland. Because Abigail was soon to have their child, and his resources had been drained by caring for Keats,[11] he decided that this lease would have to begin sooner rather than later. Brown made various suggestions to his friend. One was that he should take Keats to stay with Dilke senior in Chichester, but when Fanny's brother Sam insinuated that Brown wanted to inherit the old man's money, the idea was shelved. Another was to appeal to Abbey, but Abbey believed there was no more inheritance to distribute, except to Fanny Keats, and did not answer his letter. A third was to write to George, as if from Keats himself, asking for money for the journey to Italy, without specifying that the total expense would be in the region of £200.

Brown told George that he did not envisage Keats leaving England before the autumn, and left open the question of whether he would accompany him. (In fact his mind was already made up. With his various business interests to supervise, and a young child about to enter his life, he knew that he would have to remain in Hampstead.) As he pressed ahead with his plans, soon arranging to let his half of Wentworth Place from the end of the second week in May, Rodd suggested a much more drastic solution. He recommended that Keats might accompany Brown on his forthcoming tour of Scotland. At least, according to Brown he did. Given that Rodd had recently told Keats he should not travel even as far as Walthamstow to see his sister, it seems more likely[12] that he meant Keats should consider taking a sea voyage off the north-east coast. For all his affection and 'disinterestedness', Brown's actions during this time were stained by an element of selfishness. Guiltily preoccupied by Abigail, and resentful of Fanny, he colluded too readily with the doctors who told Keats that he was mending. It is also possible that Brown felt badly about not being able to solve all Keats's financial worries himself,

and let his disappointment curdle into harshness, as it later did in his dealings with George. In any event, his decision to leave Wentworth Place was decisive. It destroyed the comparative optimism of recent days.

In so far as he could, Keats concentrated on his poems. He finally completed his fair-copying on 27 April, and presented Taylor with the complete manuscript soon afterwards. Partly because the effort had wearied him, and partly because he was afflicted with chronic doubt about the success of his book, he seemed almost indifferent to its contents and order. This has led to certain editorial confusions. Did Taylor and Woodhouse have a say in the final selection? In subsequent weeks, Keats made various remarks which suggest that the final choices were his own, but Taylor's role should not be underestimated. Taylor had, after all, recently exercised a decisive influence on Clare's first collection.

Keats was due to leave Wentworth Place in less than a month, and still had no idea about where he might go. The 'exhilaration' of recent days continued to evaporate, and he kept himself to himself, stewing in nervous uncertainty. He stopped writing to Fanny. He told his sister that he was 'affraid to ruminate on any thing which has the shade of difficulty or melancholy', but knew that he had no option. His problem was twofold. He needed a roof over his head, and wanted to remain within easy reach of Fanny. Hampstead itself seemed out of the question – during the summer months, the rent for lodgings in the village rose prohibitively. So when the chance rose to stay near by, he seized it gladly. At his last meeting with Hunt, he had discussed his financial difficulties, and had found that Hunt's affairs were also in a critical state. This had revived some sympathy between them, and so had the recent toings and froings with Procter. Soon after the unveiling of Haydon's picture, Hunt had brought Procter to see Keats, and offered his help. ('I never encountered a more manly and simple young man', Procter later said. 'His face might be termed intellectually beautiful . . . It was such a face as I never saw before or since. Anyone who had looked on it would have said "That is no common man".') Hunt explained that he had been forced to abandon his four-year lease of York Buildings, and was now living more cheaply at 13 Mortimer Terrace, in Kentish Town, which he described to Novello as 'most convenient and cheerful'. Would Keats like to live in the same neighbourhood? He would be only a mile from Hampstead, and would also be able to call on the Hunt family in

emergencies. Keats was touched by this thoughtfulness, and impressed by Hunt's efficiency. (Inevitably, it reminded him of their earliest days together, bearing out Charles Cowden Clarke's contention that in spite of their difficulties Hunt 'never varied towards Keats'.[13]) Within a matter of days, it was arranged that Keats should take lodgings in 2 Wesleyan Place, a few doors away form Hunt, for a lower rent – one guinea a week – than he had been paying Brown.

Keats moved on 4 May, and Brown paid the first week's rent, as well as writing off what Keats owed him for the previous six weeks. Brown also borrowed £50 from his lawyer, Robert Skynner, and lent it to Keats to cover his expenses during the summer. Even if guilt formed a part of his motive, it was still a generous settlement, and Keats was grateful. He knew that he could not have survived without Brown's help as nurse and benefactor during the last three months. Partly to show his appreciation, and partly to give himself a blast of fresh and healing air, he accompanied his friend on the first stage of his journey to Scotland. They travelled together down the Thames as far as Gravesend, then he sailed back to London alone on the in-coming tide.

FORTY-EIGHT

TWO WESLEYAN PLACE was a narrow, grey-brick house at the edge of the 'half-suburb'[1] of Kentish Town – 'a long street going up towards Highgate, and chiefly composed of hunting boxes and lodging houses for the inhabitants of London'. Keats immediately felt lonely. The conventions of the day made it impossible for Fanny to see him by herself, and she seems never to have visited with a chaperon either. The Hunt household was friendly but off-putting. It was full of squalling children, and Hunt was bothered by his wife's ill health, felt sickly himself, and was distracted by money worries and the business of editing two weekly papers: the *Examiner* and the *Indicator*, which he had founded the previous year, and which he advertised as reflecting his 'private' and non-political interests, rather than his 'public' concerns. Other friends were not much better placed to help. Dilke, in Westminster, was absorbed by political work and his son's schooling. Reynolds was away. Rice was too poorly to visit. Haslam was engrossed in his recent marriage. Haydon was obsessed by 'Christ's Entry'. With no energy or inclination to work, and long hours of solitude in which to

[513]

LA BELLE DAME SANS MERCY.

Ah, what can ail thee, wretched wight,
 Alone and palely loitering;
The sedge is wither'd from the lake,
 And no birds sing.

Ah, what can ail thee, wretched wight,
 So haggard and so woe-begone?
The squirrel's granary is full,
 And the harvest's done.

I see a lily on thy brow,
 With anguish moist and fever dew;
And on thy cheek a fading rose
 Fast withereth too.

I met a Lady in the meads
 Full beautiful, a fairy's child;
Her hair was long, her foot was light,
 And her eyes were wild.

I set her on my pacing steed,
 And nothing else saw all day long;
For sideways would she lean, and sing
 A fairy's song.

I made a garland for her head,
 And bracelets too, and fragrant zone:
She look'd at me as she did love,
 And made sweet moan.

She found me roots of relish sweet,
 And honey wild, and manna dew;
And sure in language strange she said,
 I love thee true.

She took me to her elfin grot,
 And there she gaz'd and sighed deep,
And there I shut her wild sad eyes—
 So kiss'd to sleep.

And there we slumber'd on the moss,
 And there I dream'd, ah woe betide,
The latest dream I ever dream'd
 On the cold hill side.

I saw pale kings, and princes too,
 Pale warriors, death-pale were they all;
Who cried, " La belle Dame sans mercy
 Hath thee in thrall!"

I saw their starv'd lips in the gloom
 With horrid warning gaped wide,
And I awoke, and found me here
 On the cold hill side.

And this is why I sojourn here
 Alone and palely loitering,
Though the sedge is wither'd from the lake,
 And no birds sing.

 CAVIARE.

21 'La Belle Dame Sans Merci', first published in the *Indicator* on 10 May 1820.

reflect on the ruin of his hopes, Keats sank swiftly into a deep depression. During the whole of his seven weeks in Wesleyan Place he wrote to Fanny only a handful of times, notes which show that his jealousies had swelled into something like paranoia. In one he wrote: 'Hamlet's heart was full of such Misery as mine is when he said to Ophelia "Go to a Nunnery, go, go!" Indeed I should like to give up the matter at once – I should like to die.'

Comforts came rarely, and were often compromised. On 10 May, Hunt published 'La Belle Dame Sans Merci' in the *Indicator*, but rather than give his own name as the author, Keats signed the poem 'Caviare'. This pseudonym's allusion to *Hamlet*[2] suggests a mildly disparaging attitude to the readership of the magazine; its uncharacteristic haughtiness also registers a grave self-doubt. A similar sort of unsettledness shows in the text of the poem – but is better controlled. Keats had revised the stanzas since first transcribing them for George in April 1819, possibly following the advice of Hunt and Woodhouse that they might be considered sentimental. His changes did more than meet this danger. At the outset, the 'knight-at-arms' becomes a distinctly Spenserian 'wretched wight'. The conclusion runs:

> She took me to her elfin grot,
> And there she gaz'd and sighed deep,
> And there I shut her wild sad eyes –
> So kiss'd to sleep.
>
> And there we slumber'd on the moss,
> And there I dream'd, ah woe betide.
> The latest dream I ever dream'd
> On the cold hill side.
>
> I saw pale kings, and princes too,
> Pale warriors, death-pale were they all;
> Who cried, 'La belle Dame sans mercy
> Hath thee in thrall!'
>
> I saw their starv'd lips in the gloom
> With horrid warning gaped wide,
> And I awoke, and found me here
> On the cold hill side.

And this is why I sojourn here
 Alone and palely loitering,
Though the sedge is wither'd from the lake,
 And no birds sing.

This version of 'La Belle Dame' was the only one Keats oversaw; neither was included in the 1820 volume, and when Milnes first collected the poem in 1848, he preferred the earlier text, apparently drawing on a copy made by Brown. Most subsequent editors have followed his example. But while there are good reasons for thinking that many of Keats's second thoughts about other poems were inept (in 'The Eve of St Agnes', for instance), the revisions to his ballad are more rewarding. In purely literary terms, they toughen and discipline the poem, making it resonate with a creative kind of self-consciousness.[3] Biographically speaking, they help to explain his state of mind during his last months as a poet. By existing more obviously and ironically within the ballad tradition, they create a degree of detachment.

This possibly reflects a fresh effort by Keats to distance himself from Fanny. In the past, separation had often made him challenge her rather than seek reassurance; now it only proved his dependence. His first surviving letter to Fanny from Wesleyan Place, written some time in late May, is a long howl of recrimination and tortured tenderness. He had discovered that she had 'go[ne] to town alone', and even though it turned out that her expedition had been entirely innocuous – she had been to visit Mrs Dilke – the news reawoke all his old 'torments'. 'Do not live as if I was not existing,' he demanded. 'Do not forget me.' Struggling to recover his self-control, he immediately added: 'But have I any right to say you forget me? Perhaps you think of me all day', then gave way to his grief again. As his sentences tumbled after each other, swinging between adoration and blackmail, piling contradiction on contradiction, they built to an agonised conclusion:

I see *life* in nothing but the cerrtainty of your Love – convince me of it my sweetest. If I am not somehow convinc'd I shall die of agony. If we love we must not live as other men and women do – I cannot brook the wolfsbane of fashion and foppery and tattle. You must be mine to die upon the rack if I want you. I do not pretend to say I have more feeling than my fellows – but I wish you seriously to look over my letters kind and unkind and consider whether the Person who wrote them can be able to endure much longer the agonies and uncertainties which you are so peculiarly made to create – My recovery of bodily hea[l]th will

be of no benefit to me if you are not all mine when I am well. For god's sake save me – or tell me my passion is of too awful a nature for you. Again God bless you
 J.K.
No – my sweet Fanny – I am wrong. I do not want you to be unhappy – and yet I do, I must while there is so sweet a Beauty – my loveliest my darling! Good bye! I kiss you – O the torments!

By the time Keats next wrote to Fanny, she had told him that she would never do anything which 'it would have pained him to have seen'. She had also explained it was perfectly natural for her to want some relief from a situation that Keats himself knew was a 'prison', and unreasonable of him to believe the malicious gossip of 'enemies' such as the Reynolds sisters. This had filled Keats with remorse. He knew that his illness goaded him to rages which were almost insane, proving that his life was no longer his own. 'People are revengeful,' he said to her early in June, ' – do not mind them – do nothing but love me – if I knew that for certain my life and health will in such event be a heaven, and death itself will be less painful.' Once again, Fanny did her best to reassure him. Her reward, eventually, was to make him 'bitterly sorry that I ever made you unhappy', but it was a confusing kind of consolation. It did nothing to alter Keats's 'spirit of Wretchedness' which remained when the storm blew over.

Neither did contact with his other friends. In a conversation with Hunt, he discussed Scott's novels, and ended up 'touch[ing] especially on Balfour and Burley and the scene in the cave'[4] from *Old Mortality*, where Scott describes a man *in extremis*. When he saw Dilke he had to listen to yet more rumours about Fanny's unreliability. When he thought of his brother – on 18 June he heard from him for the first time since their parting – he had to read about 'unending miseries'. When he wrote to Brown, he felt bound to excuse himself for 'behav[ing] badly' after hearing about Bailey's recent marriage. 'It is to be attributed to my health, spirits, and the disadvantageous ground I stand on in society,' he said, realising that his diagnosis was no recompense. 'I would go and accommodate matters, if I were not too weary of the world.'

Keats also gave Brown bleak news about his writing. He said he was continuing 'to improve slowly', but did not dare persevere with 'The Cap and Bells' 'in case of a relapse'. As far as his book was concerned, he warned that it was 'coming out with very low hopes, though not spirits on my part', and would be his 'last trial . . . [N]ot succeeding, I shall try what I can do in the apothecary line'. His doubts were partly prompted

[517]

by continuing editorial disagreements with his publisher. Taylor was insisting that the first 'Hyperion' be included; Keats was loath to see it appear in an unfinished state. In addition, Taylor was concerned about parts of 'Lamia' (the extract that Keats had sent him from Winchester had already been excised), and so was Woodhouse. Woodhouse thought it contained formal inaccuracies and 'vulgarity' which *Blackwood's* and the *Quarterly* would be quick to criticise. Accordingly, he queried the scansion of Greek names, made various small editorial changes,[5] and tidied up the punctuation. (Keats gave him a free hand, saying 'Stop this as you please'.) At the same time, he discussed the order in which the poems should appear. Keats was anxious that the 'weak-sided' 'Isabella' should not be the first poem in the book, and persuaded Taylor and Woodhouse that 'Lamia' must lead off, even though he realised that its couplets were bound to draw the fire of critics who had objected to the versification of *Endymion*.

A final version of 'Lamia' was in proof by the end of May; the remaining poems were typeset during the first two weeks in June. Once the flurry of thinking and rethinking was over, Keats sank back into lonely gloom, hunkering indoors as frequent rain storms trailed across London, and making brief excursions whenever he had the energy. Sometimes he walked on the Heath with Severn. Once he went to a 'famous exhibition' at the British Institute to see a show of 'the old English portraits by Vandyke and Holbein, Sir Peter Lely and the great Sir Godfrey [Kneller]'. On another trip into town he met Monkhouse, who invited him to supper with Wordsworth. Keats declined, thinking that his health was too frail 'to risk being out at night', and possibly feeling embarrassed by his association with Reynolds, the author of the parody 'Peter Bell'. (Wordsworth in fact had recently shown his continuing interest in Keats by referring to him as 'a youth of promise too great for the sorry company he keeps', and earlier this year had written two poems which owe debts to the 'Nightingale' ode, which he had read in the *Annals*.[6]

Keats knew that any change would be for the worse. The letter from George, and further complaints about Abbey which followed soon afterwards, hit him particularly hard. His first haemorrhage had immediately followed his brother's departure; this new contact with his family undermined him again. On 22 June, as he set off to catch the coach which would carry him to see his sister in Walthamstow, his mouth suddenly filled with blood. Bree's assertion that he was merely

'nervous' was clearly false. Although Keats continued to keep the plain fact of his consumption to himself, he knew that his illness had him in its thrall.

He headed back to his lodgings, woozy and panicky, then decided he had to be with friends in case he suffered a second full-blown haemorrhage. There was no one near by except Hunt, and he entered 13 Mortimer Terrace cautiously, trying to disguise his condition. Hunt noticed nothing unusual, but later in the afternoon another visitor arrived, and immediately saw that a crisis was imminent. Maria Gisborne, a dark-haired, handsome woman of fifty-four, had hovered on the fringe of Hunt's circle for many years. Originally a friend of Godwin's (who had proposed to her), she had lived with her second husband in Rome since 1801, and in Livorno since 1815. In Livorno she had met Shelley, soon becoming his friend, confidante, and – in the 'Letter to Maria Gisborne' – inspiration. She had evidently heard of Keats before making her visit to London, and had therefore presumably also listened to Shelley expounding his views on *Endymion*. In September 1819 Shelley had told Ollier that 'the author's intention appear[ed] to be that no person should possibly get to the end of it. Yet it is full of some of the highest & the finest gleams of poetry; indeed every thing seems to be viewed by the mind of a poet which is described in it. I think if he had printed about 50 pages of fragments from it I should have been led to admire Keats as a poet more than I ought, of which there is now no danger.'[7]

The opinion might have led Maria Gisborne to look on Keats condescendingly; in fact she showed him nothing but friendly concern. She later remembered talking about music with Hunt, and discussing the famous soprano castrato Farinelli who sang 'alternately swelling and diminishing the power of his voice like waves'. Keats, whose own chest felt tight with sickness, and whose mouth tasted of blood, commented 'in a low tone' that 'this must in some degree be painful to the hearer; as when a diver descends into the hidden depths of the sea you feel an apprehension lest he may never rise again'.[8] He was plainly describing his own condition, and proved almost at once how acute it had become. In the early evening, after Keats had left Hunt's house and returned to Wesleyan Place, the haemorrhage that he had feared suddenly struck him down. Desperately, he called out to his landlady for help. This woman, whose name we do not know, immediately went to Mortimer Terrace, and Hunt in turn sent for his own doctor,

William Lambe. Like the three other doctors who had already seen Keats, Lambe was well qualified. He was a Fellow of the Royal College, had a thriving practice in Bedford Row, and was the author of a respected work on *The Cure of Constitutional Diseases*. Also like the others, he could do little except help Keats to bed, bleed him, put him on a strict diet, and agree that he should spend the winter in Rome. He also suggested that Keats should leave his solitary lodgings and move in with Hunt, which he did on 23 June. For the next few days he lay weak and terrified, still spitting blood, while Hunt alerted other friends and, on Haydon's recommendation, summoned yet another doctor: George Darling. Darling was already known to Keats. He had previously attended Taylor and Hazlitt on a number of occasions, and belonged to 'that little group which focussed . . . in the back parlour'[9] of 93 Fleet Street. He too did nothing that had not already been tried. He bled Keats, and said that he should travel to Italy as soon as possible. Keats had many personal reasons for wanting to resist the idea, and many medical reasons for doubting its value. But he could not resist the combined weight of others' opinion.

He kept to his bed, trying to ignore the noise of Hunt's five unruly children rampaging through the house, and wishing that he did not find Hunt's wife exasperating. (Brown later wrote: 'Hunt was very kind to Keats last summer, and I cannot forget it. If Keats could not like his wife, that is nothing to the purpose.')[10] Adding to his discomfort, the cool weather of recent days gave way to exceptional heat: on 26 June the temperature in London reached eighty-seven degrees. Ever since first falling ill, Keats had felt he was 'dissolving'. Now he seemed literally to be melting, unable to bear the thought of seeing his friends, let alone Fanny. 'I shall not expect to see you yet,' he told his 'dearest girl' as soon as she had heard news of his relapse. 'It would be so much pain to part from you again.' Hunt, who during this time was complaining about a migraine as well as his other disorders, gave what support he could. While he made his final preparations for his own latest volume, a translation of Tasso's *Amyntas*, he dedicated it to Keats as a proof of their enduring friendship. He asked him for more contributions to the *Indicator*, and eventually published the Dante sonnet as well as an extract from 'The Cap and Bells'. When he prepared an article on the hot weather for the issue of 28 June, he invited Keats to supply him with suggestions. One that Keats offered shows his mind reeling away from the present into childhood, glimpsing its health through a mist of grief.

'Now rooms with sun upon them become intolerable; and the apothecary's apprentice, with a bitterness beyond aloes, thinks of the pond he used to bathe in at school.'

Watching Hunt work, Keats could not help asking himself painful questions about his own writing. What sort of life could he expect to lead as a journalist, supposing he recovered? How could he hope that his new book would prosper since his critics were so powerful and well prepared? Would his attempts to involve political arguments in meditations on art mean that he escaped censure? Hunt later remembered him saying that the 'critical malignity' of *Blackwood's* weighed on him heavily as publication approached, and wrote two letters – one to Severn, one to Shelley – which helped to foster the impression that Keats actually blamed his reviewers for his illness. It would have been more accurate to say that their hostility combined with his other worries to make his recovery seem hopeless – but most of his friends were only too glad to be able to blame those who had always been their enemies. Although Bailey had recently slithered some way towards joining the establishment, he told Reynolds that 'poor Keats attributed his approaching end to the poisonous pen of Lockhart'.[11] Others claimed to remember him poring over the critics' bitter denunciations.

THE NEW BOOK finally appeared on 1 July, in an edition of 500 copies costing seven shillings and sixpence.[12] By this time, Keats's depression was so severe that he thought even his friends wanted to damage him. Taylor had prefaced the poems with an Advertisement which said that 'Hyperion' had been included 'contrary to the wish of the author', and had originally been 'intended to have been of equal length with *Endymion*, but the reception given to that work discouraged the author from proceeding'. Keats, who had not been consulted about the Advertisement, reckoned that it would only excite the malice of those it was meant to appease. In a copy given to his acquaintance Burridge Davenport, a Hampstead banker, he later furiously scratched out Taylor's words and wrote 'I had no part in this; I was ill at the time.' Beside the reference to *Endymion* he added 'This is a lie.'

There was another problem, too, which also persuaded Keats that the whole world was against him. His book was published at the same time as George IV tried to drag his Bill of Pains and Penalties through Parliament – the Bill which was designed to let him assert that his wife Caroline had committed adultery, and could therefore be sued for

This is none of my doing – I was ill at the time.

ADVERTISEMENT.

—————

IF any apology be thought necessary for the appearance of the unfinished poem of HYPERION, the publishers beg to state that they alone are responsible, as it was printed at their particular request, and contrary to the wish of the author. The poem was intended to have been of equal length with ENDYMION, but the reception given to that work discouraged the author from proceeding.

This is a lie.

Fleet-Street, June 26, 1820.

22 The Advertisement for *Lamia, Isabella, The Eve of St Agnes, and Other Poems* (1820), cancelled and annotated by Keats.

divorce. This created an uproar which reduced the space available in newspapers and journals for matters of literary interest, and distracted those who might otherwise have given Keats an audience. Nevertheless, he was still able to see that his new collection was better received than its predecessors had been. In all, twelve reviews appeared during the two months after publication, two by friends, six largely favourable, and four hostile. His friends wrote as Keats expected. Woodhouse, anonymously, picked out 'Hyperion' in the *Sun* for special praise, and Hunt printed two pieces in the *Indicator*, the first appreciative, and the second little more than a description of contents. His enemies were equally predictable. The *Monthly Review*, for instance, echoed the earlier judgement of *Blackwood's* and the *Quarterly* by calling him 'laboriously obscure', and by claiming that he still owed damaging debts to the 'affected school of our metropolitan poets'.

The less partisan pieces were especially encouraging. Charles Lamb, who admittedly knew Keats a little, said in the *New Times* that he thought 'Isabella' was 'the finest thing in the volume', and that 'Lamia' was also 'of as gorgeous stuff as ever romance was composed of'. The influential *Edinburgh Review*, which in spite of its Whig sympathies had failed to defend *Endymion* in 1818, was still more sympathetic. It at last came to the defence of the beleaguered epic, and praised the new poems warmly, in spite of their 'extravagance and irregularity'. 'They are flushed all over with the rich lights of fancy,' wrote the editor Francis Jeffrey, 'and so coloured and bestrewn with the flowers of poetry, that even while perplexed and bewildered in their labyrinths, it is impossible to resist the intoxication of their sweetness, or to shut our hearts to the enchantments they so lavishly present.'[13] John Scott, the liberal editor of the *London Magazine*, was more particular. While insisting that Keats was 'not a political writer' in a narrow sense, he said there was 'nothing more truly unprincipled' in 'the whole history of criticism' than the earlier attacks in *Blackwood's* and the *Quarterly*. The damage done to Keats's work by the 'selfishness of political party', Scott said, was 'one of the worst signs of . . . the worst times which England, we are afraid, has ever seen'.[14]

This same month *Blackwood's* itself made a 'half-ashamed'[15] reference to the new book. But not even this, combined with the good opinions which had appeared elsewhere, could generate the readership Keats wanted. The reception given to his last two volumes had always made it unlikely that he would have a sudden success, and he understood

that his fundamental beliefs were still challenging. He might have become a less obviously seditious and vulgar Cockney, but his idiom and versification were still dangerously unorthodox, his 'paganism' was still undimmed, his vision of Classicism was still critical of present conditions, and his treatment of the theme of progress still defiantly liberal. All the same, he was bitterly disappointed by his sales. (Three months after publication, Taylor told Clare that he would have trouble shifting the whole of the first edition; eight years later copies were still available at the original price.) By failing to make money Keats was condemned to remain in his 'prison'. Writing to Brown, he tried his best to seem optimistic, but could not help suggesting that he had only managed to preach to the converted. 'My book has had good success among literary people,' he said, 'and, I believe, has a moderate sale.' Severn, for instance, said, 'I have been delighted with the volume', and wishfully added that he thought it 'would please the million'. Reynolds told Taylor 'His book looks like an Angel & talks like one too.' Taylor himself believed 'for Poetic Genius there is not his equal living, and I would compare him against anyone with either Milton or Shakespeare for Beauties'.

Shelley, too, offered a kind of support. When Maria Gisborne returned to Italy later in the year, she took a copy of the book with her and gave it to him. As soon as Shelley had read it, he wrote to Hunt's wife Marianne: 'The fragment called Hyperion promises for [Keats] that he is destined to become one of the finest writers of the age.' Even though the letter qualified this praise elsewhere ('his other things are imperfect enough'), it ended generously. 'Where is Keats now?' Shelley asked. 'I am anxiously expecting him in Italy where I shall take care to bestow every possible attention on him. I consider his a most valuable life & am deeply interested in his safety. I intend to be the physician both to his body & his soul, to keep the one warm & to teach the other Greek and Spanish. I am aware indeed in part that I am nourishing a rival who will far surpass me and this is an additional motive & will be an added pleasure.'[16]

In the weeks surrounding publication of his book, the voice of future fame sounded too faintly for Keats to hear. Ever since his second haemorrhage, his doctors Lambe and Darling had repeated their opinion that he must spend the winter in Italy. He knew that it would be impossible, practically speaking, and for reasons of convention, for Fanny to come with him; he could not endure the thought of leaving her behind. ' 'T is certain I shall never recover if I am to be so long separate from you,' he told her at the end of the first week of July, pitifully revealing that he was still wracked with jealousies. 'Yet with all this devotion to you I cannot persuade myself into any confidence of you. Past experience connected with the fact of my long separation from you gives me agonies which are scarcely to be talked of.'

Merely mentioning the possibility of departure meant allowing the dreadful tide of his feelings to sweep him away. Keats tortured himself once more that Fanny had been 'in the habit of flirting with Brown', and said that he felt done 'to death by inches'. He avoided telling his friends what he was thinking, but whenever he was caught off-guard, he was cruelly exposed. Hunt, at around this time, noticed him staring out of the window of Mortimer Terrace with 'a manner more alarming than usual', and suggested they go for a drive in a coach for a while. When they reached Hampstead, they climbed down and Keats rested on a bench in Well Walk, under the full-leaved trees near the house where he had nursed Tom. They sat in silence for a few moments, then Keats suddenly covered his face with his handkerchief. After he had composed himself, he told Hunt that he was dying of a broken heart. There was no mention of Fanny, and Hunt was bewildered as well as horrified. 'He must have been wonderfully excited to make such a confession,' he said later, 'for his spirit was lofty to a degree of pride.'[1]

When Maria Gisborne saw Keats again on 12 July she described him as being 'under sentence of death'. Keats himself still tried to disguise his illness by associating it with things other than the medical facts. Writing to Fanny in mid-August, he said: 'I am more and more concentrated in you; every thing else tastes like chaff in my Mouth.' He then spelt out the ironies of his situation once more, in terms which seemed designed to prick her conscience while striving for her sympathy. 'I feel it almost impossible to go to Italy – the fact is I cannot

leave you,' he said. 'To be happy with you seems an impossibility! It requires a luckier Star than mine.' His existence, he implied, was a frozen moment of grief and suspicion which made death itself seem welcome. It was the last letter he would write to Fanny, and denied all that he had once held precious and inspiring:

If my health would bear it, I could write a Poem which I have in my head, which would be a consolation for people in such a situation as mine. I would show some one in Love as I am, with a person living in such Liberty as you do. Shakespeare always sums up matters in the most sovereign manner. Hamlet's heart was full of such Misery as mine is when he said to Ophelia 'Go to a Nunnery, go, go!' Indeed I should like to give up the matter at once – I should like to die. I am sickened at the brute world which you are smiling with. I hate men and women more. I see nothing but thorns for the future – wherever I may be next winter in Italy or nowhere Brown will be living near you with his indecencies – I see no prospect of any rest. Suppose me in Rome – well, I should there see you as in a magic glass going to and from town at all hours – I wish you could infuse a little confidence in human nature into my heart. I cannot muster any – the world is too brutal for me – I am glad there is such a thing as the grave – I am sure I shall never have any rest till I get there[.] At any rate I will indulge myself by never seeing any more Dilke or Brown or any of their Friends. I wish I was either in your a[r]ms full of faith or that a Thunder bolt would strike me.

There was nothing more his friends could do for Keats in London: he was beyond their reach.[2] When Marianne Hunt did a silhouette of him, propped in one chair with his legs resting on another, he was depressed and withdrawn. A visit from Dilke brought 'more pain than pleasure'. When Horace Smith sent a carriage to bring him to his new house in Elysium Row, Fulham, to drink 'some quite undeniable Chateau Margaux', he sat silently under the sunlit trees in the garden. 'Do you see that man,' said another guest to his young daughter, ' – that's a poet,' and pointed to the invalid as though such a thought were impossible. Any greater demands on his energy were frankly irritating. Haydon, who nagged him for the return of a book, seemed selfish. A letter from Shelley, offering to look after him in Italy, confirmed his dependency – especially since Shelley tactlessly combined his suggestion with further blasé criticisms of *Endymion*, saying it contained 'treasures poured forth with indistinct profusion'. His sister's continuing tribulations with Abbey only reminded him that he was powerless to 'extricate' her.

Another crisis was inevitable. On Friday 12 August, a messenger brought a note from Fanny to Keats at Mortimer Terrace. Marianne

Hunt received it, but was busy with the children, and asked the maid to pass it on to Keats himself. This maid, who had recently given notice, never handed it over. It was discovered the next day by Hunt's ten-year-old son Thornton, with the seal broken. Keats was distraught, and began weeping wretchedly, furious that his privacy had been violated, and convinced that he was not welcome in the house. Within a few hours he had decided to return to the Bentleys in Well Walk, though this meant living where Tom had died. He packed his few books and belongings, tottered out into the warm evening, and set off towards Hampstead. Maybe he reached Well Walk and found the Bentleys out. Maybe he decided to visit the Brawnes on the way. In any event, he arrived at Wentworth Place as dark was falling. Mrs Brawne invited him in, and after hearing that he had left Hunt, told him that he was welcome to stay with her. It was not just a kind but also a brave offer: for Keats to live under the same roof as Fanny, even with her mother in the house as well, meant repudiating conventional ideas of decorum. But Mrs Brawne realised that Keats was helpless and his case hopeless. He did not leave Wentworth Place again until he began his journey to Italy.

DURING THE NEXT few weeks, Keats felt more safely at home than he had done for months, and happier, he said later, than he had ever been in his whole life. Nevertheless, his new situation piled irony on irony. He knew it would have been impossible for him to live in the same house as Fanny if he had been well. In this sense, their proximity was proof that he – and their love – was doomed.

He began by trying to put his affairs in order. He apologised to Hunt and asked for 'patience at my lunes [lunatic outbursts]'. (Hunt replied generously, pointing out, 'you must have seen by this time how much I am attached to yourself'.) He wrote twice to Taylor, once to complain 'This Journey to Italy wakes me at daylight every morning and haunts me horribly', then to inquire about the likely cost of the voyage, to ask for help in finding a ship, and to send a short unofficial will. He left all his assets to Taylor and Brown, and – in a perfect iambic pentameter, his last line of poetry – instructed: 'My Chest of Books divide among my friends'. He also wrote briefly to Haydon, saying, 'I am affraid I shall pop off just when [my] Mind is able to run alone', and to Brown, with a muted request for financial help. He replied to Shelley, too, thanking him for his suggestion that they meet in Italy, and responding to the criticism of *Endymion* with some advice of his own: 'You I am sure will

23 Keats's letter to Shelley, written on 16 August 1820.

a copy of the Cenci, as from yourself from Hunt. There is only one fault of it I am judge of; the Beauty, and dramatic effect, which by many I think now a days is considered the maximum. I also deem worth it it said must have a tie-taste, which may be the God — an artist must have a tie-taste, which may be the God — an artist must have self concentration "selfishness" perhaps. You I am sure will forgive me for sincerely remarking that you might curb your magnanimity and be more of an artist, and 'load every rift' of your subject with ore. The thought of such discipline must fall like cold chains upon you, who perhaps never sat with your quill for six Months together. And is not this extraordinary talk for the writer of Endymion? whose mind was like a pack of scattered cards. I am pick'd up and sorted to a pip. My Imagination is a Monastery and I am its Monk — you must explain my metap'cs to yourself — I am in expectation of Prometheus every day. Could I have my own will for its artist effects you would have it still in manuscript — or be but now

feeling and such to the second act. I remain her that advising me not to publish my first-flights, on Tiptoe — I am returning advice upon your hands. Most of the Poems in the volume I send you have written above two years, and would never have been publish'd but for a hope of gain; so you see I am inclined enough to take your advice now; I must express once more my deep sense of your kindness, adding my sincere thanks and respects for Mrs. Shelley. In the hope of soon seeing you

I remain

most sincerely

yours

John Keats

forgive me for sincerely remarking that you might curbe your magnanimity and be more of an artist, and "load every rift" of your subject with ore.' It was a fine, compressed defence of the methods on display in his own recent book, a defence which insisted that 'sensation' was compatible with 'philosophy'. 'Is not this extraordina[r]y talk for the writer of Endymion?' he went on, wryly insisting that he had developed a long way since their last meeting in London. '[Then my] mind was like a pack of scattered cards – [now] I am pick'd up and sorted to a pip. My Imagination is a Monastery and I am its Monk.'

In all these letters, Keats is vulnerable but determined, casting himself not as a patient but as a soldier. In one he says he has 'the sensation of marching up against a Battery', and elsewhere that he is like 'a soldier march[ing] up to a battery'. Another note, written to Haydon, says, 'At some future time I shall reborrow your Homer', as though he were planning to begin work again. By 18 August, when he saw Taylor to go over their plans, he had slipped back into all his old uncertainties. As Taylor explained that he would be borrowing money from his brother James to finance the journey to Italy, Keats protested that he was not strong enough to set out. He could not, he said, expect to survive if he left London, even though it was the site of his disappointments. 'If I die,' he burst out at one point in their conversation, 'you must ruin Lockhart.'[3]

Later in the month, Keats sent a letter to Brown which makes clear that he said nothing to Taylor about Fanny. In fact she was bound up with every aspect of his life. Even the 'very slow' sale of his poems was associated with her – or, at least, with the dependence on women which she crystallised. He wrote: 'One of the causes, I understand from different quarters, of the unpopularity of this new book, and the others also, is the offence the ladies take at me. On thinking that matter over, I am certain that I have said nothing in a spirit to displease any woman I would care to please: but still there is a tendency to class women in my books with roses and sweetmeats, – they never see themselves dominant.' Brown annotated this letter, pointing out that in 'Isabella' women were 'dominant to an extreme', that 'his other poetic women' were 'mentally dominant', and that even the uncollected 'The Cap and Bells' contained nothing 'but to the honour of women'. Though well-intentioned, these protestations do not address the origins of Keats's feelings or encompass their scope. Recognising that there are passages in his work which identify women with the liberalising and self-fulfilling power of love, they fail to register other and more contradictory

elements. They do not adequately appreciate that, for Keats, 'identity' required control, and that self-giving entailed self-preservation. As the 'cold winds' of late summer began 'to blow low towards evening', and the time of his departure drew close, the ambiguities which had always troubled Keats became more and more sharply defined. Instead of energising him, as they had once done, they became the almost complete definition of his 'prison'.

The fact that Keats mentioned women to Brown at this time is a proof of their closeness. As his companion in Scotland, and then as his landlord, co-author and confidant, Brown had persuaded Keats that no other male friend understood him better or was more willing to give him help. In the final emergency, however, Brown was absent. He was driven away by his jealousy of Fanny, his involvement with Abigail and her child – a son, Carlino, it soon transpired – and his guilt at letting his friend down. When he returned to Wentworth Place after Keats had departed, he sifted through his feelings miserably. Salving his conscience, he told himself and others that he had never wished or intended to go to Italy in the first place, that Keats was 'in good hands', that his illness was 'on his mind', and that 'Little could be gained, if anything, by letting my house this time of year, and the consequence would be a heavy additional expense which I cannot possibly afford.' Proving the depth of his affection, he wrote letters protesting that Keats 'is present to me everywhere and at all times – he now seems sitting by my side and looking hard in my face . . . Much as I have loved him, I never knew how closely he was wound about my heart.' Eventually these warm but injured feelings hardened into a tormented defensiveness. He was desolated by stories of Keats's final days. He overcame his dislike of Fanny and cared for her as Keats had asked him to do. He denounced George's financial dealings. He collected Keats's papers. He lectured on his poems and defended his reputation – accusing Hunt, for instance, of being 'too impressed by his illness'. In everything he did, he behaved with an exemplary loyalty, but also betrayed his lingering self-criticism. His memorialising, which he could never finalise in a biography, was protective as well as proud. When he died in 1842, shortly after emigrating to New Zealand with his son, he was buried outside New Plymouth under a stone inscribed: 'The Friend of Keats'.

It was not just companionship that Keats wanted from Brown. As the plans for Italy continued to take shape, he became increasingly anxious about money. Taylor had offered to help with the cost of the journey –

but how would he survive when he reached Rome, with no means of helping himself? Knowing that it was unlikely to do him any good, he appealed to Abbey, who offered to give a 'small personal gift'⁴ if Keats visited the offices in Pancras Lane. (When Keats arrived, he had the satisfaction of discovering that Hodgkinson had loaned George £50 more than he should have done, and had thereby hurt Abbey's business.) Only with his sister did he continue to sound 'dauntless', consoling her for some minor recent illness and advising her: 'Do not suffer Your Mind to dwell on unpleasant reflections – that sort of thing has been the destruction of my health.' With everyone else he gave up pretending. He could not face writing to his brother, so asked Haslam to break the news of his departure. When Haydon called on him and offered some Christian comfort, Keats spurned it by saying that he would cut his own throat if he did not recover soon – leaving Haydon with the impression that he was 'going out of the world with a contempt for this and no hopes of the other'. He spent long hours dozing or staring out of the window, or talking with Fanny about the life they would never share. This quietness could not save him. At the end of August he suffered a third serious haemorrhage and went back to bed. He was too ill to see anyone except his adopted family. He did not have the strength to write even short letters.

Taylor continued to press ahead with arrangements. By early September he had found a ship, the *Maria Crowther*, which was leaving for Naples in the middle of the month, and which had room for Keats and a companion. He had contacted an English doctor, James Clark, who would take charge when Keats reached Rome. ('I am not fond of living in cities,' Keats told his sister in a letter dictated to Fanny Brawne, 'but there will be too much to amuse me, as soon as I am well enough to go out, to make me feel dull.') Although Taylor was going through a lean patch, he also made a final and generous publishing settlement. He had already paid £100 for the copyright of *Endymion*, and a further £100 for *Poems* (1817) and the 1820 volume. After deducting the advances owed since he had signed up Keats, he announced that Keats was £30 in credit. At the same time, he put £150 into a bank in Rome, the money to be regarded as an advance on whatever Keats might publish in the future.

This left the problem of who was to accompany Keats. Brown, in spite of his squirmings, remained the obvious choice, but he was still away in

Scotland and could not be contacted easily. Most of Keats's other close friends were simply not able to go with him. Reynolds was 'limed' in the law, and so was Woodhouse. Haslam was busy, and his wife was expecting their first child. Taylor had his business to run. Rice was too ill. Hunt and Haydon were variously preoccupied and unsuitable. It was unthinkable that Fanny might travel alone with him. This left Severn. Severn had known Keats for four years, and deeply admired him. In their frequent discussions of poetry and painting, they had recognised each other as kindred spirits, although Keats had not told him about his feelings for Fanny, or about his engagement to her. Yet everyone in their circle feared that Severn might do Keats as much harm as good. He seemed younger than his years (he was a few weeks short of his twenty-seventh birthday). He was often nervous and excitable.

He was, however, free and willing to travel. Since winning the Gold Medal at the Royal Academy with his picture 'The Cave of Despair', he had felt more confident about his vocation as a painter, and therefore about the value of further study. When Haslam called on him, four days before Keats was due to depart, he played on these aspirations, suggesting that Severn might produce another painting in Italy which he could enter for the Academy's travelling scholarship. Severn later gave two accounts of the conversation and, like much that he subsequently wrote about Keats, they are a little economical with the truth. 'Haslam said to me,' he reports in the more plausible version, ' "As nothing can save Keats but going to Italy, why should *you* not try to go with him, for otherwise he must go alone, and we shall never hear anything of him if he dies. Will you go?" I answered, "I'll go." "But you'll be long getting ready," [Haslam] added; "Keats is actually now preparing. When will you be ready?" "In three or four days", I replied, "and I will set about it this very moment." '[5]

Within a short space of time Severn had collected £25 owing to him for a miniature he had recently completed, and had visited Sir Thomas Lawrence, who gave him an introduction to the Italian sculptor Antonio Canova. His domestic affairs took longer to sort out. Severn's father was an overprotective man who feared that by choosing to become a painter his son had set out on a life of impossible hardships. When Severn told him about the journey, the old man panicked. He rose up from his chair 'in an apparent passion of madness'[6] and 'struck' Severn 'to the ground'. Another of his children, the nineteen-year-old Tom, eventually restrained him, but he would not relent. As Severn left the house, there

was 'no sign of a remonstrance or a reconciliation'.[7] The parting gives a clear picture of the two selves that Severn would show in the following weeks. One part of him was devoted, willing to nurse Keats in very painful and dangerous circumstances, and always showing him deep kindness. (Severn himself said that he had 'the virtue of the donkey – obstinacy – in the highest degree'.) Another part was prone to 'agitation and trembling nerves', hysterical outbursts, and intense self-pity. His letters from the *Maria Crowther*, and from Italy, form the only substantial record of Keats's last months. To see Keats clearly, it is necessary to distinguish between Severn's sympathetic distress and his twitchy dramatising.

Severn spent his last 'three or four days' in England scurrying and providing. Keats hoarded the hours miserably, nerving himself for the ordeal of the journey, and for his parting from Fanny. In the last month, his jealousies had been soothed by her constant company: she had become a lover who was also a replacement for the mother who had twice abandoned him. But this had merely shifted the burden of his anxieties. Once he had laboured under the burden of doubts. Now he grieved that the proven fact of her love could not be separated from the certainty of its destruction. It was the last in a long series of ironies, and the grim realisation of a truth that his poems had always worked to emphasise. In the hastily built temple of his delight, he embraced melancholy. Possession and loss were inseparable.

Fanny and Keats agreed that if he returned from Italy they would marry and set up house with her family. Mrs Brawne gave her permission knowing that such an outcome was extremely unlikely. Fanny tried to show Keats that she believed in the future. She promised to begin a correspondence with his sister, passing on news and comforting her in her isolation. (Soon after Keats left, she sent a lock of his hair, saying: 'I have some [myself] that was cut off two or three years ago I believe, and there is no difference in the colour.') She gave him presents which were practical, and would also remind him of her love. She sewed a new silk lining into his travelling cap to keep him warm on the journey. She gave him a pocket diary and a paper knife in a silver case. She also, perhaps, gave him the white cornelian that Keats was later seen passing from hand to hand on his deathbed. Since Keats never mentioned this in writing, its source, as well as its exact nature, remains mysterious. One of his biographers[8] thinks it may have been a Tassie seal, depicting a broken lyre – which would help to explain why Keats

asked that the same image be carved on his gravestone. Severn, however, insisted that it had no crest and was unset.

Keats had little to add to the few gifts he had already given Fanny during the twenty-three months they had known each other. There were copies of some of his poems. There was his ring. (He gave her younger sister Margaret an amethyst brooch which may have belonged to his mother.) There was the lock of hair. There was the miniature Severn had painted. There was the red-covered *Literary Pocket Book* for 1819, and other, better loved volumes, including his Dante and his folio Shakespeare. There was the edition of Spenser with certain passages underlined.[9] Fanny realised these underlinings were meant to instruct her in Spenser's 'beauties'; as she turned over the pages they seemed to spell out a different purpose: almost every passage that Keats had marked emphasised the folly of ambition and the frailty of fame.

Although Keats knew which day the *Maria Crowther* was due to sail, the precise time would depend on wind and tide. He therefore had to spend his last English hours in London rather than Hampstead – with Taylor, so that he could reach the river quickly if need be. Ever since childhood Keats had responded to great emotional crises by becoming 'awkward' and tight-lipped. The only surviving report of his departure from Wentworth Place was provided by Hunt, and it describes a supreme effort of self-control. Leaving Mrs Brawne, Margaret and Sam on the doorstep of the house on the morning of Wednesday 13 September, and with Hunt carrying his small bundle of luggage, Keats walked with Fanny to the coach stop in Pond Street. In just under six weeks' time he would scrawl at the bottom of a letter to Mrs Brawne: 'Good bye Fanny! god bless you!' Today he could barely bring himself to speak. Hunt copied his restraint when remembering the final 'most trying moments'. 'Neither of them entertained a hope to see each other again in life,' he said, 'yet each endeavoured to subdue the feelings of such a moment, to the retention of outward composure.'[10]

Fanny returned to Wentworth Place and wrote numbly in her copy of the *Literary Pocket Book*: 'Mr Keats left Hampstead.' Keats himself travelled the short distance to Fleet Street and waited in his publishers' office while his friends made final arrangements. Haslam went to Severn's house to check that he was ready, then to the ship's agent to confirm the second berth. While he was there, he discovered that the *Maria Crowther* would not be ready to sail until Sunday morning. Fearing that his resolve might break if he returned to Hampstead, Keats

agreed to stay with Taylor, checking through the financial proposals, assigning his copyright, chatting to friends who came to say their last farewell, and on at least one occasion going out himself, to see Dilke. He was not at home. Hunt, who had already said goodbye in person, went back to Mortimer Terrace, where he wrote an emotional article for that week's *Indicator*. 'Ah, dear friend, as valued a one as thou art a poet – John Keats, – we cannot, after all, find it in our hearts to be glad now thou art gone away with the swallows to seek a kindlier clime.' Woodhouse, loyal and pragmatic as ever, drafted a letter which he planned to give Keats as he boarded the *Maria Crowther*, offering to continue to supply him with money from his own modest income. Taylor reminded him of his faith in the 'genius' of the new book, and said that while he had not been able to 'ruin Lockhart' he had at least had words with Blackwood, and told him that the review of *Endymion* was 'done in the spirit of the devil'.[11] If any of these friends believed there might be some advantage for Keats in leaving Fanny, they kept the thought to themselves. Only Reynolds was tactless enough to raise the possibility. He sent a letter to Woodhouse saying that the journey meant their friend would be able to escape 'one or two heartless and *demented* people, whose opinions and conduct could not but silently influence the bearings of his Thoughts & Hopes. Absence from the poor idle Thing of woman-kind, to whom he has so unaccountably attached himself, will not be an ill thing.'

There is embarrassment as well as jealousy here. In 1818, and intermittently throughout the following year, Reynolds and Keats had shared a closeness which depended on their being exclusive male literary colleagues. Reynolds's work for the law, his engagement, and his waning talent had done nothing to shake his faith in Keats, but had destroyed their intimacy. So had his sisters. Realising that their place in Keats's affections had been usurped by Fanny, they had encouraged their brother's aggrieved feelings. Yet it would misrepresent Reynolds's friendship with Keats if his thoughts at their parting were made to seem definitive. As a poet and critic he continued to honour Keats's memory. As a lawyer he did a great deal of business for Fanny Keats and George. According to Dilke, however, he was not only incompetent but dishonest in some of his dealings, and eventually the sense of failure tainted all his work. Contented with his wife but grieving for the loss of their only child, and saddened by his dwindling poetic reputation, Reynolds eventually became Assistant Clerk of the County Court at

Newport on the Isle of Wight. According to some reports, he was a 'broken-down' man whose 'drunken habits placed him beyond the pale of society' – a judgement he tended to confirm himself. He was, he said, a 'poor, baffled thing'. When he died in 1852, however, the local paper described him as 'highly respected'. Reynolds himself was in no doubt about his happiest and most notable achievement. 'Keats will take care of me,' he wrote to Richard Monckton Milnes in the 1840s. It was the sort of loyalty that impressed Fanny, even among those who distrusted her. In her first letter to Keats's sister, written the day after the *Maria Crowther* had sailed, she said: 'I am certain [Keats] has some spell that attaches [his friends] to him, or else he has fortunately met with a set . . . that I did not believe could be found in the world.' Her words movingly echo others by Haydon: Keats 'cared not for himself, & would put himself to any inconvenience to oblige his Friends, and expected his Friends to do the same for him.'

FIFTY

IN THE FLURRY of farewell, Keats had spoken to more friends than he had met in months. His 'set' would never be so closely united again. In this sense, it was an appropriate leavetaking, though still a dismal one. Keats approached the end of his life in the same spirit that he had shown when healthy: he was an independent-minded but deeply sociable man; one for whom 'fine deeds' were as important as 'fine words'.

When the morning of his departure finally arrived, Sunday 17 September, he left Fleet Street under an overcast sky. Taylor, Taylor's assistant William Smith Williams, Haslam and Woodhouse went with him, telling him they would accompany him downriver as far as Gravesend. Apart from Williams (who would later become famous as the friend and publisher of Charlotte Brontë), they were all people who knew they would never again have such a friend to cherish, or such gifts to admire. Taylor had already told his family: 'If you knew [Keats] you would also feel that strange personal Interest in all that concerns him.' Woodhouse had said that he would do for Keats 'whatever People regret that they could not do for Shakespeare or Chatterton'. Haslam was his 'excessively' kind 'oak friend'.

They met Severn at Tower Dock, on the south side of the Thames opposite the Tower of London, and climbed on board the *Maria*

Crowther. Looking inland, they saw the two recently built bridges at Waterloo and Southwark; downstream, heavy clouds lumbered above the estuary. A storm threatened. But there was no question of their voyage being delayed. Their Captain, Thomas Walsh, was an experienced seaman, and the *Maria Crowther* was used to rough passages. She was a twin-masted brigantine – each mast had three tan-coloured, square-rigged sails – registered as weighing 127 tonnes and measuring approximately eighty feet long. Since being commissioned in 1810 she had worked mainly on the Bristol–Holyhead and the Liverpool–Cardiff runs, ploughing through the difficult waters of the Irish Sea (where she would eventually sink in 1837). More recently, since Captain Walsh had taken over command, she had sailed to various ports in mainland Europe, carrying cargoes which filled most of the space below decks. The room left for accommodation was severely cramped, as Keats and Severn immediately discovered when they went below. Divided from the hold by a narrow galley, the low-ceilinged, twelve-foot-wide, horseshoe-shaped stern had been fitted with six bunks, each of which was barred with vertical struts to stop its occupant rolling out of bed in bad weather. The cabin was like a vault. The bunks were like coffins.

Keats stowed his luggage – a bundle of clothes, his new thick coat, his presents from Fanny, some books including Shakespeare's *Works*, the first two cantos of *Don Juan*, and the manuscripts of several poems, among them, one of the sonnets he had written to George in Margate, and one 'To my Brothers'. Then another passenger arrived: Mrs Pidgeon, a jovial, middle-aged companion for their final fellow traveller, who was due to join them at Gravesend. Mrs Pidgeon was also shown below decks, and given a bunk on the opposite side of the cabin from Keats, Severn and Captain Walsh. A cloth was suspended down the centre of the little room for decency's sake, and Walsh made final preparations for departure with his half-dozen crew. At mid-morning the high tide turned, and Keats and his friends stood at the stern of the *Maria Crowther*, watching London slip away. They noticed that Severn was not with them, and called him on deck. He was drooping and melancholy, mumbling that he had been suffering from a liver complaint for the past few days, and expected he would be seasick as soon as they left the river. Keats, who had much more reason to feel wretched, took it upon himself to be cheerful. He was 'full of waggery', even after Severn revealed that he had forgotten his passport and would need to send for it when they reached Gravesend.

They arrived in mid-afternoon, in time for dinner. When they had finished eating, Haslam went ashore to sort out Severn's passport, and Keats and the other passengers stayed below decks, sheltering from the warm drizzle which was now falling. He said that he suspected he was getting a chill, and wanted an early night. Before he turned in, Woodhouse asked him whether he might cut a lock of hair from his head. Keats agreed. He had already divided up his possessions. Now he was dividing up himself.

Severn slept badly that night, continually waking and feeling disoriented. Once he imagined he was in a cobbler's shop; another time he supposed he must be in a wine cellar. As he and Keats lay in the darkness, listening to the crew changing watch and the water squelching against the ship, a smack sailed up the river towards them and moored near by. It had come from Dundee, and carried a drowsy passenger on his way back to Hampstead. It was Brown. He had no idea that Keats had already left London, and continued sleeping as his boat waited for the early tide.

The following morning, Monday the 18th, Keats sounded croaky but said he felt well. Comforted by this, Severn clambered ashore to buy various supplies that he had forgotten to bring with him. Keats asked him, in particular, to get some laudanum – in case of seasickness, Severn supposed. Captain Walsh went with him, hoping (and failing) to buy a goat which would give them a supply of fresh meat. Keats, Taylor, Williams and Haslam sat on deck when the weather allowed, chatting and looking ashore at the red-brick tower of the local church as it rose and sank on the swell. When Severn returned, he was concerned to find Keats looking 'not so well', but for the next few hours could think of little except his passport. Would it arrive in time for them to catch the evening tide? It did, at six o'clock. Two hours later their final passenger came on board: Miss Cotterell, the young woman for whom Mrs Pidgeon was due to act as chaperon. She was eighteen years old, pretty, 'very agreeable and ladylike', and tactless. As soon as she set foot on deck, Severn said, she glanced 'hesitatingly at Keats & myself and enquired which was the dying man'. Keats was wounded, but saw at once that there was no question as to which was the dying woman. Miss Cotterell was plainly consumptive.

Not that they competed for the role of invalid. Like Keats, Miss Cotterell was determined to play down her illness, entering into a kind of competition which endeared her to him over the coming weeks. 'She

[539]

insists', Severn said, 'on [being] much better than Keats – & Keats feels she is certain[ly] worse than himself.' He set about proving this at once, pouring out a stream of quips and puns as Miss Cotterell found her berth in the curtained-off part of the cabin, and reassuring her by pointing out that he was a qualified doctor. Severn began to take heart again. 'Keats is seeming and looking better,' he said as he began his first letter. 'I have the best possible hopes.'

Shortly before Miss Cotterell joined them, Keats had said goodbye to Taylor, Williams, Haslam and Woodhouse, asking them to take care of his sister. They were as good as their word. The following morning, Taylor wrote to Fanny Keats and said that her brother was 'already much improved by the Air of the River, & by the Exercises & amusement which the sailing afforded. He [is] provided with everything that could be contributed to make the Time pass agreeably, & with all that his Health required.' In closing, Taylor looked forward to Keats's 'Restoration to perfect Health'; it was a brave pretence.

THE PASSAGE OUT of the Thames into the Channel was predictably rough. Cross-currents churned the water into angry waves, and as the busy traffic pressed round them, the crew set and reset their course frantically. The previous evening, Severn had stayed on deck late, sketching by moonlight. When he came up into the fresh air this morning he said he wanted to watch the sunrise. In fact, like Miss Cotterell, he was already feeling unwell. Breakfast made things worse. As soon as he had eaten, he began to feel 'a waltzing on my stomach' and shortly afterwards vomited over the side. So did the others – Keats 'in the most gentlemanly manner – then the saucy Mrs Pidgeon who had been laughing at it', and then Miss Cotterell – who afterwards fainted.

All four of them decided to take to their cabin, where Keats kept rallying their spirits. He 'dictated surgically' from his top bunk 'like Esculapius of old in baso-relievo', not even 'looking pale' as the wind gathered strength and drove them round the Isle of Thanet towards Dover. Had he been on deck, he would have seen Margate slide past in the rain – a place where he had deepened his dedication to poetry. The gathering ironies only stiffened his determination not to seem self-pitying. He told his companions to drink tea to prevent them from dehydrating, and so impressed them with his resilience that Severn referred to him as 'Keats the king'.

By the following morning they were off Brighton, sailing in calm seas.

Keats knew their trials were far from over. Noticing that the wind was blowing from the south-west, he warned his companions 'a storm was breaking'. At two o'clock the gale began in earnest, pitching the ship violently, hurling their luggage across the cabin floor, and pinning them all in their bunks 'like ghosts by daylight'. Mrs Pidgeon and Miss Cotterell were 'much frightened' in spite of Keats's encouragement. Severn was uncharacteristically bold, and decided to go on deck to see what was happening. Once he was knocked down. When he finally made it, he was 'astounded – the waves were in Mountains – and washed the ship – the wat[e]ry horizon was like a mountainous Country – but the ship's motion was beautifully to the sea – falling from one wave to the other in a very lovely manner'.

Lovely but destructive. By evening the planks of their cabin walls had begun to separate. The sea poured through 'by pails-full', soaking them, their bunks, and their scattered possessions. This at last persuaded Captain Walsh they were in serious danger, and he decided to put about. With the pumps labouring to clear the water they had taken on board, the sails 'squalling', and the 'confused voices of the sailors' shouting orders, they floundered back towards Dover. It was hard going, with the *Maria Crowther* time and again skittering up enormous waves, then plunging into surly hollows. Keats remained self-possessed, but Severn was soon 'quite beside' himself, clinging for support to the man he was meant to be supporting. Eventually he was reassured: the following morning he told Haslam that 'the sea has done its worst with us', insisted that he was 'better tha[n] I have been for years', and described himself and his fellow passengers as 'a Quartet of fighting cocks'.

When the storm blew itself out they were becalmed for two days. As the emergency receded, Keats relaxed his guard. He stopped pretending that he was better than he felt, and for the first time allowed himself to regret the life he had left behind. Although he did not tell Severn how desperately he missed Fanny, he started brooding once more on the way his illness was connected with his love. To escape their fellow passengers, he and Severn put ashore at Dungeness, clattering along the stony beach in the sunlight, Keats toying with the idea that he might abandon his journey and return to London. Severn was alarmed by the thought – and even more concerned that Keats would die before the *Maria Crowther* reached Naples.[1] When they climbed back on board, his anxiety grew as Keats became increasingly fretful.

They retraced their course past Brighton, sailing so slowly that on

Wednesday 20 September, as they approached Portsmouth, Captain Walsh announced that he was going to put into harbour until the wind changed and they could make faster progress. As Keats prepared to disembark, the thought of returning to London swept through him even more powerfully; he persuaded Severn that if he got any worse there was simply no point in continuing. But whereas their landing at Dungeness had only depressed Keats, the prospect of this second landing seemed to lift him. He realised that Portsmouth was only seven miles away from John and Laetitia Snook at Bedhampton, and excitedly told Severn that he wanted to visit them. As he led the way out of the harbour, however, walking through Langstone and across the lush alluvial plain, his 'old apprehensions' returned. He knew that the mill house would remind him of happier times and disappointed hopes. When he arrived, bursting in on his friends unannounced, he felt even more tormented than he had expected. The Snooks told him that Brown was only ten miles away, staying with the elderly Dilkes in Chichester. His longing for his old existence became almost unbearable. What was the point of going to Italy if he was bound to die there? Why not end his life in England and near Fanny, no matter how much his love for her might accelerate his illness?

His friends knew that 'a word' might have sent him back to Hampstead. They advised him to persevere, and not to try and visit Brown: if he did, he might not be able to reach the *Maria Crowther* when she sailed on the next high tide. Keats thought that he had better not involve his friends in the pain of his indecision. When he left Bedhampton the following morning, John Snook wrote to Brown with news of the visit, news which Brown in turn passed on to Taylor. He said Keats was 'better than they had expected from the accounts they had previously heard, and Severn had talked cheeringly of him . . . He abuses the Captain, though he acknowledges him to be civil and accommodating. He likes one of the ladies [Miss Cotterell] and has an aversion to the other [Mrs Pidgeon].'

The *Maria Crowther* sailed from Portsmouth late in the afternoon of 29 September, reprovisioned, and with a fair wind. By the next morning Keats was passing the Isle of Wight – another place crammed with memories of earlier visitings and different prospects. Off the little port of Yarmouth, he began a letter to Brown, finishing it as he slid past the Needles. It was the first time he had felt strong enough to write since leaving London; what he had to say proved that he had been wise to keep

his feelings to himself. They were too destructive to voice aloud. 'The time has not yet come for a pleasant Letter from me,' he warned Brown, then laid himself bare to the only friend with whom he had discussed Fanny:

The very thing which I want to live most for will be a great occasion of my death. I cannot help it. Who can help it? Were I in health it would make me ill, and how can I bear it in my state? I dare say you will be able to guess on what subject I am harping – you know what was my greatest pain during the first part of my illness at your house. I wish for death every day and night to deliver me from these pains, and then I wish death away, for death would destroy even those pains which are better than nothing. Land and Sea, weakness and decline are great separators, but death is the great divorcer for ever. When the pang of this thought has passed through my mind, I may say the bitterness of death is passed . . . I am in a state at present in which woman merely as woman can have no more power over me than stocks and stones, and yet the difference of my sensations with respect to Miss Brawne and my Sister is amazing. The one seems to absorb the other to a degree incredible. I seldom think of my Brother and Sister in america. The thought of leaving Miss Brawne is beyond every thing horrible – the sense of darkness coming over me – I eternally see her figure eternally vanishing. Some of the phrases she was in the habit of using during my last nursing at Wen[t]worth place ring in my ears – Is there another Life? Shall I awake and find all this a dream? There must be[;] we cannot be created for this sort of suffering.

Keats longed to reach a point beyond memory. As the *Maria Crowther* creaked forwards towards the coast of Dorset, Captain Walsh again unwittingly forced him to confront his past by allowing his passengers ashore.[2] In Studland Bay, and possibly also at Lulworth Cove or nearby Holworth, they scrambled among the 'splendid caverns and grottos' at the water's edge – Keats behaving so courageously that he seemed 'like his former self'. Soon after they had climbed back on board again, Severn reckoned he had further evidence that Keats was recovering. While the *Maria Crowther* waited to put into the Portland Roads and head south, Keats sat on deck reading. Severn claimed to see him scribbling down the sonnet 'Bright Star' in pencil, then asked him to copy it out in ink on 'a blank leaf in a folio volume of Shakespeare's *Poems*, which had been given him by a friend, and which he gave to me in memory of our voyage'.[3]

Most of the details here are misleading. It is true that Keats was reading 'Bright Star' as he prepared finally to lose sight of England, and

also true that it was copied out in Shakespeare's *Poems*, opposite the opening of 'A Lover's Complaint'. But the sonnet had been written the previous autumn,[4] and transcribed before Keats left London. Moreover, the edition of the *Poems*, which was a quarto not a folio, and had formerly been shared by Keats and Reynolds, was not in fact 'given to Severn until the following January, as the inscription on the fly-leaf records'.[5] In spite of these mistakes, Severn's account has a sympathetic logic. 'Bright Star' was peculiarly appropriate to this moment in their voyage. It suggested that once the star-poet had become the lover-poet, he was no longer 'steadfast'. When Keats had originally composed the poem, he had anticipated his destruction. Since then, loss had become his only reality.

FIFTY-ONE

EARLY THE NEXT MORNING, 1 October, the *Maria Crowther* finally set off into the open sea. It was a fortnight since they had left Tower Dock, and Keats did not expect to reach Naples for another three weeks. The mood on board changed immediately. There was no going back; they were isolated and unprotected. For the first twenty-four hours it seemed they had nothing to fear – from the weather, at least. As they sailed round the tip of Brittany, the wind blew steadily and Keats sat on deck fingering the presents Fanny had given him. Sometimes he saw dolphins hurtling towards the ship and gambolling round the prow, and occasionally a whale. After darkness had fallen, he watched the 'ethereal syllabub'[1] of phosphorescence, and the stars growing gradually larger and clearer.

When they entered the Bay of Biscay, his peace was shattered. Another violent storm overtook them, and everyone but Captain Walsh and a watchman was driven below decks. For the next three days the sea boiled round them so fiercely that at times even the crew thought they might sink. Severn was sick and panicky, often collapsing in tears. Miss Cotterell repeatedly fainted in the foul-smelling and riotously bucking cabin. As soon as the portholes were opened to let in fresh air, it was Keats's turn to suffer: he began to cough convulsively, eventually spitting blood. Within hours he was weaker than at any time since leaving London, though still resolutely controlled. 'During the night,' Severn wrote later, 'when in the darkness the water rushing up and down

our cabin filled me with horror, I was anxious about Keats who was in the berth opposite me and who from his delicate state I was afraid might die under such a trial. – It was a long time before I could even speak the noise was so great, but when I was able at last I said "Well Keats this is a pretty music is it not?" when to my great surprise (for I really was afraid he might be dead) he answered calmly and pleasantly "Yes, it is 'Water parted from the Sea' ".'[2]

At last the skies cleared and Keats ventured on deck again. By now any 'amusement' he had once found in the journey was long gone. Everything was a vexation. Approaching Trafalgar, the *Maria Crowther* was forced to heave to by a couple of Portuguese men-o'-war, who fired a shot across the bows because they suspected Walsh was carrying revolutionaries to Spain. Keats interpreted the episode as an affront to his most dearly held beliefs. When he started reading *Don Juan* he was reduced to fury. He found himself contemplating lines which mocked poets such as himself who 'thought of wood nymphs and immortal bowers', and which capped a (dismayingly apt) scene of shipwreck with another of cannibalism. Severn remembered 'Keats threw down the book and exclaimed: "this gives me the most horrid idea of human nature, that a man like Byron should have exhausted all the pleasures of the world so completely that there was nothing left for him but to laugh and gloat over the most solemn and heart-rending scenes of human misery; this storm of his is one of the most diabolical attempts ever made upon our sympathies, and I have no doubt it will fascinate thousands into extreme obduracy of heart – the tendency of Byron's poetry is based on a paltry originality, that of being new by making solemn things gay and gay things solemn".'

Although Severn is clear that Keats was sinking ever more deeply into depression, he is muddled about the timing of the episode which best illustrates its extent.[3] At some point between leaving Biscay and arriving in Naples, Keats confessed the real reason why he had asked for some laudanum to be brought on board at Gravesend. He did not intend to use it as medicine but as a means of committing suicide. Severn was shocked. He refused to hand over the bottle, and hurriedly threw together some Christian arguments to resist Keats. He prevailed – but only in the sense that he persuaded Keats to soldier on. He could do nothing to convince him that the future held anything except pain.

As the *Maria Crowther* reached the 'beautiful lone promontory'[4] of Cape St Vincent, the wind dropped again. Keats's anger shrivelled.

[545]

Leigh Hunt, who travelled by ship to Italy eighteen months later, spoke of a similar calm in terms which chillingly recall 'The Rime of the Ancient Mariner' – the sea 'swelling, and foul with putrid substances', the crew 'employed in painting the vessel – an operation that does not look well, amidst the surrounding aspect of sickness'.[5] It is a scene Keats would have recognised, and helps to explain why his spirits lightened a little when the wind revived and carried them forwards. The 'nobler billows' of the Atlantic subsided, and the waves began working with 'a short uneasy motion, that fidget[ed] the vessel'.[6] It was 'unpleasant',[7] but any sort of movement was preferable to none. When Gibraltar appeared in the early morning light, Keats said that it glowed 'like a vast topaz', and as they continued along the coast of North Africa, Severn told himself that their progress meant there would soon be 'great changes . . . for the better'.

He was wrong. No sooner had the novelty of their renewed progress worn off, than Keats declined again. By entering the Mediterranean, he was approaching the classical world which had always been his ideal – a world Hunt would later evoke in terms they had shared, and which Keats was now too sick to enjoy: 'Countless generations of the human race, from three quarters of the world, with all the religions, and the mythologies, and the genius, and the wonderful deeds, good and bad, that have occupied almost the whole attention of mankind, look you in the face from the galleries of that ocean-floor, rising one above another, till the tops are lost in heaven . . . The mind hardly separates truth from fiction in thinking of all these things, nor does it wish to do so. Fiction is Truth in another shape, and gives as close embraces.'[8]

Keats ended his journey in misery. After two days in the Mediterranean he suffered yet another serious haemorrhage, with 'blood [coming] from his stomach, with fever at night and violent perspiration'. Prone on his bunk, the cabin walls pressing tightly round him, he drifted into wretched semi-consciousness. When they eventually reached Naples on 21 October, thirty-four days after leaving London, he found himself horribly separated from the things which might once have pleased him most. Bursting on deck as they entered the harbour, Severn was astonished and exhilarated. To their left, divided from the main enormous crescent of the Bay, lay the small harbour of Santa Lucia, and a fleet of fishing boats and larger tall-masted ships. Dead ahead stood the Norman fortress of Castel dell' Ovo, its honey-coloured walls pitted with cannon shot. To the right, rising behind hills scribbled over with

gardens and vineyards, rose Vesuvius – its 'writhing columns of smoke, golden at their sunlit fringes' and its long shadow tapering south-east towards Pompeii. Following his friend cautiously into the brightness, Keats stood gazing with 'a starved haunting expression'. This was the scene he had imagined in his 'Epistle to Charles Cowden Clarke', lying on the clifftop in Margate four years earlier. Then he had been close to the start of his poetic life, 'reclin[ing] at ease / While Tasso's page was floating in a breeze / That gave soft music from Armida's bowers, / Mingled with fragrance from her rarest flowers'. Here he was beginning his afterlife; nothing he saw could bring help or comfort or pleasure.

FEEBLE AS HE WAS, Keats felt keen to press on to the end of his journey. But as the *Maria Crowther* headed slowly towards a mooring off Castel dell' Ovo, the Bourbon authorities in charge of the harbour told Captain Walsh that no one on board was allowed to land for a further ten days: there had been an outbreak of typhus in London when the ship had left Tower Dock, and they had to complete a six-week period of quarantine. It meant a new imprisonment for Keats. Standing on deck, peering through the rigging of 'a tier of ships' held in suspension, he could see the spires and rooftops of Naples spread out ahead, beautiful but beyond his reach. The following morning he wrote to Mrs Brawne: 'Give my Love to Fanny and tell her, if I were well there is enough in this Port of Naples to fill a quire of Paper – but it looks like a dream – every man who can row his boat and walk and talk seems a different thing from myself – I do not feel in the world.'

Typically, his first instinct was to comfort his companions, passing on what he knew about the remote history of Naples, speaking of Greek galleys and Tyrrhenian traders. He also talked about the immediate past, relying on information he had gleaned from the *Examiner*. In 1814, as the Napoleonic Wars drew to a close, the joint Kingdom of Naples and Sicily had signed a Treaty of Alliance with Austria and a Convention with Britain which allowed English ships to use its port. But the incumbent King of Sicily, Joachim (Murat), who had been appointed by Napoleon, doubted that the Allies were acting in good faith. They had recently sided with Sicilian troops at Leghorn, intending to restore the exiled King Ferdinand to the throne. The suspicions were well founded: Ferdinand's regime was restored in May 1814, and Joachim fled to France.

As rightful heir to Naples and Sicily, Ferdinand could count on the

loyalty of his army. But he was an elderly, repressive ruler, and a wily one too. Within a short time he began suppressing liberal reformist movements, and filling the streets of his capital with soldiers. By the end of the 1810s the *Examiner* was regularly carrying articles which criticised his regime in the same terms that it used to harry the British government. The month Keats left Hampstead, for instance, it had reviewed Henry Matthews's *Diary of an Invalid* – a journal kept by a convalescent who had visited Naples for the same reasons that Keats was travelling to Rome. 'The inhabitants seem to increase in misery,' Hunt reported Matthews as saying, 'in proportion to the improving kindness of the climate, and fertility of the soil. I have never seen such shocking objects of human wretchedness as in this smiling land of corn, wine and oil.'[9]

This 'misery' persisted in spite of some reforms. A new ministry or 'Junta' had been created, comprised largely of men who had held office under Joachim, and Ferdinand had promised a new Constitution. As time passed, and this Constitution failed to materialise, the reformers and even some sections of the army became restless, Protestors met regularly to complain about the 25 per cent property tax and high excise duties, and in August and September outbreaks of rebellion were harshly put down. In November (by which time Keats had left for Rome), the *Examiner* carried a 'Letter from Naples' which warned: 'The cry of war increases here daily. It is quite impossible to give you a correct idea of the state of public affairs in this place: one thing, however, you may set down as certain, that if the Austrians come they will meet with a warm reception. The whole country is in arms and in the provinces nothing can possibly exceed the enthusiasm throughout.'[10]

Ferdinand clung stubbornly to the old order, calling on the British to rescue him if necessary. (In September the *Examiner* reported that 40,000 Austrian troops were waiting to invade.) During the summer they had sent a squadron to Naples harbour, and as Keats waited for his quarantine to end, he became aware of his fellow countrymen riding at anchor near by. Soon he was entangled with them. When a Lieutenant Sullivan rowed over and boarded the *Maria Crowther* with six ratings, meaning only to pay a courtesy call, the port authorities announced they were not allowed to disembark until the quarantine ended. This meant that conditions became even more uncomfortably crowded, no matter how determined Sullivan was to compensate for his mistake by seeming cheerful. (There were probably as many as eighteen people on board the eighty-foot boat.) Initially, at least, Keats responded in kind, producing

more puns, he said, 'in a sort of desperation', than he usually made in a whole year. As the long muggy days crept past, however, his energy evaporated and his anger returned. At one moment, turning aside from Sullivan's banterings (and from Miss Cotterell's brother Charles, who was a banker in Naples and had also joined them), he heard an Italian boatman jeering at the *Maria Crowther*'s cabin boy for laughing 'like a beggar'. 'Tell him he laughs like a damned fool,' Keats said, and when he was told that the phrase could not be easily translated, added that the boatman was 'not worth a damn'.[11]

His bitterness showed even more bleakly in the one letter he wrote during these ten wretched days – the letter to Mrs Brawne which ended with his despairing 'Good bye Fanny! god bless you'. He told her: 'I dare not fix my Mind upon Fanny, I have not dared to think of her', and stressed once again that he felt cut off from everything around him. 'O what an account I could give you of the Bay of Naples if I could once more feel myself a Citizen of this world.' Writing to Brown a week later, the day after he had finally reached dry land, he dared spell out that this sense of nothingness was not in fact a blank. It was a protracted moment of agony:

The fresh air revived me a little, and I hope I am well enough this morning to write you a short calm letter; – if that can be called one, in which I am afraid to speak of what I would the fainest dwell upon. As I have gone thus far into it, I must go on a little; – perhaps it may relieve the load of WRETCHEDNESS which presses upon me. The persuasion that I shall see [Fanny] no more will kill me. I cannot q——[12] My dear Brown, I should have had her when I was in health, and I should have remained well. I can bear to die – I cannot bear to leave her. Oh, God! God! God! Every thing I have in my trunks that reminds me of her goes through me like a spear. The silk lining she put in my travelling cap scalds my head. My imagination is horribly vivid about her – I see her – I hear her. There is nothing in the world of sufficient interest to divert me from her a moment. This was the case when I was in England; I cannot recollect, without shuddering, the time that I was prisoner at Hunt's, and used to keep my eyes fixed on Hampstead all day. Then there was a good hope of seeing her again – Now! – O that I could be buried near where she lives! I am afraid to write to her – to receive a letter from her – to see her hand writing would break my heart – even to hear of her any how, to see her name written would be more than I can bear. My dear Brown, what am I to do? Where can I look for consolation or ease? If I had any chance of recovery, this passion would kill me.

THE LONG INCARCERATION ended on Tuesday 31 October: it was Keats's twenty-fifth birthday. Once he and Severn had disembarked, they followed Charles Cotterell's advice and looked for lodgings near the port. Finding them too expensive, they then turned to the Guanti Nuovi district, and took rooms above the trattoria Villa di Londra, in the Vico S. Giuseppe. The street was a tight canyon, quite unlike the Italy of Keats's imagination. Grey drizzling skies veiled Vesuvius in the distance.

They slept badly, and rose early to write letters which would catch the English courier. Keats unburdened himself to Brown unwillingly but helplessly, ending: 'O, that something fortunate had ever happened to me or my brothers! – then I might hope, – but despair is forced upon me as a habit. My dear Brown, for my sake, be [Fanny's] advocate for ever. I cannot say a word about Naples; I do not feel at all concerned in the thousand novelties around me, I am afraid to write to her. I should like her to know that I do not forget her. Oh, Brown, I have coals of fire in my breast. It surprised me that the human heart is capable of containing and bearing so much misery. Was I born for this end? God bless her, and her mother, and my sister, and George, and his wife, and you, and all!'

Severn wrote to Haslam less despairingly, saying that 'Keats has become calm', insisting that '[he] thinks favourably of this place', but realising that the voyage had been a disaster. As Severn's mind travelled back over the last month he described himself as 'horror struck at [Keats's] sufferings', and the *Maria Crowther* as 'a black hole'. His memories, and the strain of pretending that Keats was more contented than he knew to be the case, soon overpowered him. He left the room abruptly, close to tears, on the pretext of needing something from their landlord. It was a gallant deception. Later in the day Keats told Severn 'much – very much' about Fanny, hoping that Severn would be able to bear his responsibilities more easily if he understood them better.

That night Keats went to bed early, slept soundly, and the next morning was 'very much better'. He even made a pun in Italian. Deciding that it would be sensible to remain in Naples a week, making plans and gathering his strength, he and Severn put themselves in the charge of Charles Cotterell, who offered to show them the sights. They drove along the margin of the bay, and went inland to the vineyards of

Capodimonte and the Ponte Rossi. They visited churches and ruins. At one point, stopping by the Capuan Gate, they watched some workmen sitting round a cauldron, eating spaghetti by the handful. Describing their excursions later, Severn bathed them in the warm glow of nostalgia; in fact even the most innocuous-seeming moments were full of dread. Keats knew that his remission was only temporary. He also found the political situation depressing. One day, dodging the heavy showers that gusted over the city, they came across a large military review being inspected by the 'goat-faced' Ferdinand in the Piazza Reale (now the Piazza del Plebiscito). Keats was angered by the display of despotic power, and by the soldiers themselves, who, he said, had 'no backbone'. (This was prescient. Four months later the army surrendered to the Austrians without a fight and Ferdinand fled. Eventually he returned only to impose an even more autocratic regime, and to execute the liberals who had risen against him.) On another day, they went to the San Carlo opera and saw soldiers posted on the stage on each side of the proscenium arch. At first Keats thought they were part of the production. When he realised they were there in case the audience began protesting against Ferdinand, he was disgusted and told Severn they must leave Naples as soon as possible. He did not, he said, want his 'bones . . . to remain amongst a people with such miserable politicks'.

For much of the remaining time in Naples, Keats kept to his lodgings, reading in the small nine-volume edition of Richardson's *Clarissa* that Severn had brought from England, watching the rain dribble down his windows, organising the next stage of his ordeal. He received a letter from Shelley, recommending that he come to Pisa, but without repeating his offer of hospitality. He wrote to James Clark in Rome, saying that he would soon be arriving and needed lodgings. Clark, who had already been in touch with Taylor, was primed to help him, and well qualified by the standards of the day. Aged thirty-two, he had lived a packed life, combining his professional career with a keen interest in music and literature. (He owned a copy of *Endymion* and the 1820 volume, and subscribed to the *Edinburgh Review*, in which he read Francis Jeffrey's review of Keats that autumn.) After training at the College of Surgeons in Edinburgh, he had worked briefly as an assistant surgeon in the navy, been wrecked off New Jersey, then returned to Scotland to receive his MD in 1817. In 1818 he accompanied a consumptive patient to the south of France, during which time he made contact with several pioneering European doctors and fell under their influence. He knew Laënnec's

colleague Dr Cayol, and used a stethoscope before most of his contemporaries in Britain; he collected material for a book on the effects of climate[1] which, with his *Cyclopedia of Practical Medicine* (1833), eventually made him famous. He settled in Rome in 1819, and was generally regarded as the leading physician in 'the English colony'.

There was no time for Clark to reply to Naples. On 6 November Keats and Severn collected their visa from the British Legation, signed with an *Otho*-like flourish by the Ambassador, G. C. de Ludolph; the following day they got a second visa from the Papal Consul General; and went to dinner with Charles Cotterell. The party ended a week of maddening compromises. Far from confirming Keats's ideal of Classical culture, Naples had dramatised the political situation he detested at home. If he took refuge in his imagination, his suffering was even more acute. On Wednesday 8 November, when he and Severn climbed into a hired carriage (a vettura), and set off along the huge uneven stones of the Appian Way towards Rome, the past seemed as forlorn as the future.

On the morning of their departure, George Keats wrote to his brother from Louisville, assuming he was still in Hampstead. 'Again, and Again I must send bad news,' he began, then went on to say that he had not been able to sell his steamboat, was constantly busy with his new sawmill, and could not send any money. It was an affectionate letter, protesting 'your distress is ours'; if Keats had received it, it would only have deepened his sense that 'despair is forced upon me as a habit'. Brown, sensing this and sending a précis to Severn, described George as 'a canting selfish, heartless swindler [who] . . . shall have to answer for the death of his brother, if it must be so'.

Severn continued to protest that it must not be so – with weakening hopes. As the vettura travelled up from the coastal plain and the sun finally appeared, glancing on the steaming hills which gathered round them, he watched Keats deteriorate. Ahead lay a journey of 140 miles which they expected to take a week, with only 'villainously coarse' food and lodgings to sustain them. Severn tried desperately to make things easier, distracting Keats by pointing out the water buffalo grazing in the fields, the vineyards, and the white villages. Sometimes he made extra space by jumping down to walk, collecting wild flowers and throwing them into the carriage.

After four days they reached Terracina, entering its gate between the medieval cathedral, and the columns of a decayed Roman villa. Ahead

lay the flat, malarial Campagna, its sluggish streams lined with bulrushes, its 'billowy wastes' stippled with flocks of goats. It was a brutal, poverty-stricken place. Lurching forwards, they passed a red-cloaked cardinal shooting songbirds: as a lure, he had tied an owl to a stick and suspended a mirror round its neck. Severn said 'it was astonishing the great number of birds he killed', though pointed out that the real skill lay in not shooting the owl by mistake. Elsewhere they saw the bleached bones of horses lying by the roadside, and gibbets dangling the bodies of bandits who had been hanged.

Compared to this, Rome seemed a salvation. But on 15 November, when Keats and Severn finally saw the crumbling rampart of the Aurelian Wall rising ahead, death continued to haunt them. The last mile of the Appian Way was lined with posts from which hung the bodies of more criminals, taken beyond the city wall for their execution. When they passed through the Lateran Gate, the 'stupendous' Colosseum loomed at them shaggily, a giant emblem of cruelty and broken power. It was 'of enormous height and extent', said Shelley, describing his own first sight of the ruin, 'and the arches built of massy stones are piled on one another, and jut into the blue air, battered into the form of overhanging rocks . . . It has been changed by time into the image of an amphitheatre of rocky hills, overgrown by the wild olive, the myrtle and the fig-tree, and threaded by little paths which wind among its ruined stairs and immeasurable galleries.'[2]

Keats and Severn asked to be taken to the Piazza di Spagna, the centre of the 'English colony', where Clark was waiting in his rooms. He had not received Keats's letter, and was writing to a friend in Naples for news of his patient when he heard the carriage arrive. His first impression of Severn was doubtful. He realised that he was 'attentive', but found him fussy and unconfident. 'I suppose', he ruefully told a friend soon afterwards, 'poor [Keats] . . . had no choice.' His feelings about Keats were more mixed. He was struck by his intelligence and resilience, and later described him as a 'noble . . . animal'. At the same time, he could see that he was gravely ill – though not, he thought initially, with consumption. Writing to a colleague twelve days later, Clark said 'The chief part of his disease, as far as I can yet see, seems seated in his stomach. I have some suspicion of the heart and it may be of the lungs . . . His mental exertions and applications have I think been the sources of his complaints – If he can put his mind at ease I think he'll do well.'

Although Clark was deeply concerned about Keats, he was as

powerless to help him as Rodd, Bree, Lambe and Darling had been in England. He told him that he would bleed him regularly, put him on a starvation diet (sometimes only 'a single anchovy and a morsel of bread' a day), and shield him from unnecessary worry. The change of climate, he hoped, would do the rest. Even after Keats's death he preserved his faith in Rome's healing powers. Writing in 1829 he said: 'No city in the south of Europe frequented by invalids, affords greater facilities for exercise in the country than Rome. In the variety and extent of its rides it indeed exceeds every other large city I have visited on the continent. This circumstance, together with the facility of egress from the town, and the immediate vicinity of the public walks to that part chiefly occupied by strangers, render Rome a far less objectionable abode for invalids than large cities generally are. The Piazza di Spagna, and streets in that vicinity, afford the best residences. The streets that run in an easterly and westerly direction are better than those running north and south, as they are less exposed to currents of cold air during the prevalence of northerly winds, and the houses have a better exposure. Both the sitting- and bed-rooms of delicate invalids should, if possible, have a southern aspect.'

The lodgings Clark had arranged for Keats and Severn, close to his own, suited these requirements almost exactly. They were in 26 Piazza di Spagna, a hundred-year-old house at the foot of the broad marble stairway (later known as 'The Spanish Steps') which leads up to the twin-towered church of the Trinità dei Monti. The white stone of the steps caught tawny reflections from the surrounding buildings. Faint sounds of the open country drifted from beyond the Trinità. Neighbouring houses were elegant – most were divided into rented apartments except for number 30, which was a saddlemaker, and number 33, which was a small stables for coaches and horses. The square was busy with stallholders selling flowers brought from the Campagna, and with artists' models who gathered for hire wearing their costumes.[3] In the centre stood – and still stands – Pietro Bernini's fountain the 'Barcaccia', a sinking boat which ceaselessly takes on water and pulses it overboard again. Here at last was the Italy Keats had imagined. He turned indoors more determined than ever that his journey – the whole journey of his life – should not have been in vain.

An englishman named Thomas Gibson lived with his French valet on the first floor of 26 Piazza di Spagna; on the top floor was a young

Irishman, James O'Hara, and his servant in one apartment, and an Italian army officer, Giuseppe d'Alia, in another. The second-floor rooms that Keats was to share with Severn had previously been occupied by a solitary English doctor; the landlady, a forty-three-year-old Venetian called Anna Angeletti,[4] briskly pointed out that they were large enough for two, and were well furnished. A tiny hall opened from the landing into a bright sitting room, fifteen feet square. Off this again was a double-windowed corner room, only eight feet wide, which led into a still smaller annexe overlooking the Steps. Severn said he would make up a bed in the sitting room, and use the annexe for his painting. This left Keats with the corner room for his bedroom. He could take in the whole panorama of the Piazza and the Steps from its two windows. Lying in bed, staring at the wooden ceiling embossed with daisies, or at the grey stone fireplace with its grotesque devil-faces, he could hear the splash of the fountain, and the murmur of voices in the square below.

The rent was higher than they had expected – nearly £5 a month. Yet Keats had neither the wish nor the energy to move elsewhere. All the same, he confided his worries to Clark, who in turn told a friend 'the Idea of his expenses operates on his mind and some plan must be adopted to remove this if possible'. Accordingly, Clark outlined a daily routine which he hoped would divert Keats without draining him. Extensive sightseeing was out of the question – it was too taxing – but Keats was encouraged to stroll on the Pincian Hill immediately north of the Trinità. Clark also hired a 'little horse' (much to Severn's dismay: it cost £6 a month), believing that riding would do Keats's stomach some good. Within a few days, the two cautious tourists had made a number of new friends on their excursions, among them Lieutenant Isaac Elton of the Royal Engineers, who was also consumptive. On one of their joint expeditions to the Pincian Hill they encountered Princess Pauline Napoleon; when she made eyes at Elton, Keats 'was very severe in his satire of this famous coquette'. He was similarly scathing when they saw Canova's partly clothed statue of the Princess in the Villa Borghese: he nicknamed it 'the Aeolian harp' because 'every wind could play upon it'.[5] Clearly his old antagonisms to women still burned in him.

Keats and Severn soon settled into a modest routine. On Clark's recommendation, Severn hired a piano (for thirty shillings a month) and borrowed a quantity of sheet music which included piano arrangements of Haydn's symphonies. These particularly pleased Keats, who told Severn that the composer was like a child 'for there is no knowing what

he will do next'. Occasionally they visited their new acquaintances for dinner. More often, they ate in their sitting room, ordering food from a nearby trattoria. (The quality improved dramatically after Keats threw one of their meals out of the window in disgust.[6] Sometimes they sat talking companionably. Sometimes they went their separate ways – Keats dawdling and loitering, Severn presenting his letters of introduction,[7] sketching the ruins in the Forum, visiting the galleries in the Vatican, and working in his annexe on the painting which would be his entry for the Royal Academy Travelling Scholarship: 'The Death of Alcibiades'.

Gradually, Keats also began to work again. He read Shakespeare's *Poems*, *Don Quixote*, and the novels of Maria Edgeworth that he had brought from London. He renewed his study of Italian, concentrating on Tasso and Alfieri. He even began thinking about a new poem – on Sabrina, the river nymph and tutelary goddess of the river Severn,[8] saying that soon he would be well enough to face the 'excitement' of composing. His subject had an element of jokery (Keats had previously inscribed his companion's copy of *Poems*, 1817, 'The author consigns this copy to the Severn with all his Heart'); it also gave him scope to explore feelings of homesickness, of patriotism, and of banished love.

As so often in recent weeks, he was showing the world a brave face while continuing to draw on griefs which remained painfully raw. Everywhere he looked, he was reminded of injustice and regrets. Watching Severn begin work on 'The Death of Alcibiades', for instance, he 'urged' him to 'lose no time in contending with . . . artistic enemies, and to confront them before they could do . . . further harm', then told him about the dinner with Hilton and de Wint at which he had defended the award of the Gold Medal. Severn was alarmed by this, though understood it said more about Keats than himself. Without mentioning *Blackwood's*, Keats showed that as his appetite for work returned, it stirred the resentments which had besieged him in London, and confirmed his feelings of powerlessness. A letter he wrote to 'My dear Brown' on 30 November, two weeks after arriving in Rome, shows this with harrowing clarity. ' 'Tis the most difficult thing in the world to me to write a letter', he began. 'My stomach continues so bad, that I feel it worse on opening any book, – yet I am much better than I was in Quarantine. Then I am afraid to encounter the proing and conning of any thing interesting to me in England. I have an habitual feeling of my real life having past, and that I am leading a posthumous existence.'

This was the note he had struck repeatedly in recent weeks, and as he went on writing he gave a beautiful and touching summary of his poetic ambitions, only to insist they were beyond his grasp. Remembering how narrowly he had missed Brown at Gravesend and Bedhampton, admitting that he could not 'bear the sight of any hand writing of a friend I love so much as I do you', he said: 'There is one thought enough to kill me – I have been well, healthy, alert &c, walking with [Fanny] – and now – the knowledge of contrast, feeling for light and shade, all that information (primitive sense) necessary for a poem are great enemies to the recovery of the stomach.' He ended, with typical solicitude, by turning to his family and friends. 'Severn is very well, though he leads so dull a life with me. Remember me to all friends, and tell [Dilke] I should not have left London without having leave of him, but from being so low in body and mind. Write to George as soon as you receive this – and also a note to my sister – who walks about my imagination like a ghost – she is so like Tom.' The sentences were not so much an appeal as a farewell, and he knew it. 'I can scarcely bid you good bye even in a letter,' he ended. 'I always made an awkward bow. God bless you! John Keats.' It was the last letter he wrote. From now on, the story of his life would depend on other people's impressions, other writers' words.

The letter from Brown to which Keats was obviously replying has not survived. It is therefore impossible to judge the extent to which Keats's thoughts were provoked by news that Brown had sent him. Did Brown, for instance, praise Severn so as to excuse his own failure to travel to Rome? He was still struggling to rationalise his decision at the end of the year, and although he told Taylor that he was 'preparing to follow very early in the spring [of 1821], and not return, should [Keats] prefer to live there', he made no reference to precise plans. Did he mention that this autumn he had decided to marry Abigail O'Donaghue? Did he add that by having a Roman Catholic wedding, which had no legal force at the time, he intended merely to gain custody of his son and send Abigail packing after a decent interval? When Brown next wrote to Keats, on 21 December, he was relentlessly jocular about his new arrangements but careful to say that 'Abby' was not 'living' with him 'in the same capacity' as previously, which 'prevent[ed] that affair from giving pain next door'. In his blustering way, Brown understood that his own situation would torture Keats. Brown was married to a woman he did not love, and continuing to live independently. Keats was separated from a woman he adored, and sunk in a 'posthumous existence'.

[557]

KEATS TOLD BROWN in this final letter that 'Dr Clark is very attentive to me; he says, there is very little the matter with my lungs, but my stomach, he says, is very bad.' For the first two weeks of December, he stuck to his rituals and routines – outwardly optimistic, inwardly despairing. Whenever he felt strong enough, he walked on the Pincian Hill.[9] Most days he kept indoors, chatting, dozing, watching Severn work, and reading. Once, after translating two lines of Alfieri as 'Unhappy me! No solace remains for me but weeping, and weeping is a crime', he broke down and put the book aside. The violent see-saw of his moods told him that the comparative ease of his first few weeks in Rome was coming to a close.

It ended on 9 December. Severn left their lodgings early in the morning to post a letter to Haslam, and shortly after he returned Keats abruptly began coughing blood, 'extremely black and thick'. Severn collected two cupfuls, then sent for Clark, who immediately did as he thought best: he drained yet more blood (eight ounces) from Keats, and told him to rest. As soon as he had gone, Keats reeled out of his little room, wild-eyed and heart-broken, whispering 'This day shall be my last'. Severn, who had already steered Keats away from thoughts of suicide once before, struggled him back to bed and swiftly went through the apartment hiding all the knives, scissors and razors, and pocketing the laudanum – which he later gave to Clark.

For a full twenty-four hours, Keats continued to 'rave',[10] flinging away the food and drink that Severn brought him, and begging Clark, whenever he visited, to tell him 'how long is this posthumous existence of mine to last?' Clark, who had been surprised by the suddenness of the collapse, could find nothing to say which gave 'any hope against the great intelligence Keats had of his own case'. Like Severn, he watched helplessly as Keats shouted that he wanted to die, then sank into silence, then panicked and argued again. The next morning, Keats had another coughing fit, losing as much blood as he had done in his last attack. Once again Clark drew a further eight ounces of blood from his arm and ordered him to keep to his bed. By midday on 10 December Keats had no choice. He was too weak to do otherwise.

Severn coaxed him back to his senses, bringing newspapers and reading to him. Keats continued to weaken. Even though his fever was high and his digestive system nearly destroyed, he complained of 'a perpetual hunger and craving', imploring Severn to bring him more than bread and anchovies. Severn had no reason to doubt Clark's advice,

and gently refused Keats. Keats pleaded with him, then gradually relented, once again showing 'generous care' for Severn in his 'isolated position'. This was partly a concern that his 'lingering death' would 'ruin' Severn's prospects of establishing himself as a painter in Rome. Keats was also determined that Severn should be prepared for what the next few weeks would bring. He explained that he would make great demands on Severn's patience, that he would suffer 'continued diarrhoea', that he would risk passing on his sickness with his dying breath. 'Little did I dream of THIS . . . in London,' Severn wrote to Brown in a 'complete tremble', but he never failed his friend. With servants refusing to wait on them for fear of contamination, he became dogsbody as well as companion, listening day and night to Keats rambling deliriously of Fanny and his family, grieved by his outbursts of persecution mania, then slipping away from the bedside to prepare tiny meals, to collect material for the fire, to order fresh sheets, to consult privately with Clark.

A week later there was still no improvement: Keats continued to cough 'large quantities' of blood, 'generally in the morning, and nearly the whole time his saliva [was] mixed with it'. Severn wrote to Brown on 17 December, 'O he will mourn over every circumstance to me whilst I cool his burning forehead – until I tremble through every vein in concealing my tears from his staring glassy eyes. – How he can be Keats again from all this I have little hope – but I may see it too gloomy since each coming night I sit up adds its dismal contents to my mind.' This was wishful thinking. By now Severn knew there could only be one outcome, and he prevailed on Clark to soften his regime. Clark said that the 'dreadful . . . torture' of hunger had to be endured since 'not a single thing will digest'. As though to prove the point, Clark went 'all over Rome' for a particular kind of fish that Keats wanted, but when Severn 'received it from Mrs C[lark] delicately prepared, Keats was taken by the spitting of blood'.

So it continued until Christmas: Clark visiting four or five times a day, Severn nursing, preparing meals, snatching small moments of rest, and tearfully writing to friends in England when he thought Keats might not see how despairing he felt. On 24 December, at four-thirty in the morning, he was caught out. As he began a letter to Taylor, Keats suddenly roused and began talking about Christianity. 'I think a malignant being must have power over us,' he told Severn, 'over whom the Almighty has little or no influence – yet you know Severn I cannot

believe in your book – the bible.' In early conversations with Hunt and Shelley, and in poems like the sonnet 'Written in Disgust of Vulgar Superstition', Keats had proudly denounced organised religion. Now the absence of 'this last cheap comfort – which every rogue and fool have' seemed like another mark of his deprivation, but also of his independence. It made him veer between defiance of Severn and a muted respect for his beliefs – asking him to find copies of Jeremy Taylor's *Holy Living and Holy Dying*, Dacier's translation of Plato, and Bunyan's *The Pilgrim's Progress*.[11] All these books were likely to revive ideas he had once discussed with Bailey, and to reawaken his thoughts about soul-making; none of them convinced him that he could look forward to 'immortality of some nature or other'. Before Severn finished writing his letter to Taylor, Keats had ordered him to tell his publisher: 'I shall soon be in a second edition – in sheets – and cold press', and later added that after his death there should be no reference to him in any newspapers, and no engravings made of his portrait. During his final days with Fanny in England 'his most ardent desire' had been 'to live to redeem his name from the obloquy cast upon it'. Dying in Rome, he claimed only to want what he felt it had been his fate to receive: nothing; his life and its effort utterly annihilated.

STILL PUZZLED BY the rapid decline, Clark asked an Italian colleague to examine Keats and give a second opinion. This doctor diagnosed a 'malformation of the chest', and agreed there was no possibility of a recovery. Keats did not have to be told that he had only a little time left. On Christmas Day, which Severn called 'the strangest and saddest' he ever spent, he proved once again that his life might as well already be over. Three letters arrived from London. One was from Hessey, full of solemn religious advice, and one was from Brown. They reminded him that his friends were following each stage of his illness with bated breath – Hessey copying and circulating Severn's letters, Brown passing on carefully edited news to the Brawnes, Haslam calling on Fanny Keats. Their loyalty was almost more than Keats could bear. The third letter was simply unendurable. It was from Fanny, and the sight of her handwriting on the envelope 'affected him bitterly'. He handed it back to Severn unopened.

His grief was compounded by knowing how much Fanny must also be suffering. When Brown visited her she was determined to seem stoical, never speaking about her engagement, but she could not help showing

that she was 'a little disappointed at not receiving a letter', and demanded that Brown show her no excessive tact. 'When you hear of his death,' she said, 'tell me immediately. I am not a fool.' In her early letters to Fanny Keats, she also tried to seem no more than a properly concerned neighbour. As time passed her control broke down; she confessed 'If I am to lose him I lose everything'. It was a grim preparation for the sorrow which stretched ahead – a vigil fraught with suspicions and silences, and with the knowledge that whatever news came from Italy was bound to be out of date. In late December she heard the favourable report that Severn had sent to Haslam early in the month, then in early January came the letter describing his relapse. Since it was obvious that Severn could not predict what turn the illness might take next, she had no option but to withdraw into herself, her dread increasing with her uncertainty.

In fact the information about Keats's latest collapse reached London as Severn tried, for the last time, to convince himself there was still reason to hope. In the quiet weeks following Christmas, with no bleeding and a slightly improved diet, Keats seemed to recover a little of his strength, on some days leaving the apartment to sit in the weak winter sunlight. But on 3 January, Clark wrote to Taylor saying that Keats was 'in a most deplorable state – the stomach is ruined and the state of his mind is the worst possible for one in his condition, and will undoubtedly hurry on an event that I fear is not far distant.' Saying this, Clark was referring to more than Keats's physical weakness. He was also concerned about a sudden eruption of financial worries. When Keats and Severn had first arrived in Rome, they had immediately withdrawn all but £30 of the £150 that Taylor and Hessey had deposited in the form of a letter of credit with Torlonia, the famous banking house. It had been explained to them that if they took out the money in small amounts, they would be liable for a fee for each transaction. Taylor did not know this, and as soon as he received the bill for £120 he had written to Torlonia to stop all further payments – partly because he feared that his friends were living beyond their means, partly because he was expecting George to send Keats more money at any moment. When Severn discovered that he could not realise the remaining £30, he panicked. How were they to live? Moreover, how was he to cope when Keats died, since their landlady had told him that because Keats was consumptive all the furniture and movables in the apartment would eventually have to be destroyed and paid for?

Severn decided that a letter to Taylor from Clark would carry more authority than anything he might say, and prevailed on the doctor to intercede. He did so immediately – and effectively. Taylor wrote to Torlonia asking them to resume payment, and also set about organising a subscription at home. Five friends promised £10 each and Woodhouse made a note of their names, modestly neglecting to mention that his own contribution was £50. A further £50 was donated by Taylor's friend the Earl Fitzwilliam. It was a generous response, but Severn did not hear of it until the end of February, by which time Keats was dead. In the meantime, he had to make do with what remained of the original advance.

It is perhaps for this reason that Severn's letters home during the early new year became increasingly fretful. 'For Three weeks I have never left him,' he wrote to Mrs Brawne on 11 January, ' – I have sat up at night – I have read to him nearly all day & even in the night – I light the fire, make his breakfast & sometimes am obliged to cook – make his bed and even sweep the room[.] I can have these things done but never at the time when they ought & must be done – so that you will see my alternative[.] [W]hat enrages me most is making a fire[.] I blow – blow – for an hour – the smoke comes fuming out – my kettle falls over on the burning stucks – no stove – Keats calling me to be with him – the fire catching my hands & the door bell ringing – all these to one quite unused and not at all capable – with the want of every proper material come not a little galling.' When Isabella Jones later read this letter, she ridiculed Severn for his 'egotism and selfishness', and one can see why. At the same time, though, it does Severn an injustice to suggest that he became merely self-absorbed in the last month of Keats's life. His letter to Mrs Brawne contained elements of self-irony as well as self-pity, and is touchingly revealing of his loyalty, fear and exhaustion.

He was more practical than he let on, too, following Clark's advice that Keats must sometimes lie on a bed in the large sitting room, and realising that this would mean eventually destroying the expensive furniture it contained, he devised ways of keeping the move a secret from Anna Angeletti. To make matters even more complicated, he also had to prevent Keats from knowing why the landlady had to be kept in ignorance: to tell him would be to admit that death was close. He therefore blocked the door to their apartment before making up a bed on the sofa, then told Keats the new arrangements had been made by a servant. Keats 'half suspected'[12] but said nothing. He was grateful for

the change of scene and admired Severn's ingenuity – just as he also admired the device that Severn created for making sure there was always a light at his bedside. Severn linked several candles with a length of cotton so that as one burnt down another would light automatically. 'Severn, Severn!' Keats once said when he saw this happening, 'there's a little fairy lamplighter actually has lit up another candle.'

On 11 January Severn had told Mrs Brawne that he still hoped to bring Keats back to England in the spring. Within a week he had finally accepted this would be impossible: Keats's face was 'sunk and pale', and 'those hazel eyes' had steadily 'become more prominent and less human'. Severn stayed at the bedside day and night, listening to Keats's teeth chattering uncontrollably, wiping the thick expectoration from his lips, fetching him clean sheets, soothing him as he was racked by hard coughs. Sometimes he spoke about his own plans for painting, and once he sketched Keats while he slept, showing his face haggard with shadows, his hair tangled and lank on his forehead. (At the foot of the drawing he wrote the date and time – 28 January, three o'clock in the morning – and added 'a deadly sweat was on him all this night'.) Sometimes he listened to him deliriously repeating that the 'many causes of his illness' lay 'in the exciting and thwarting of his passions'. Sometimes he read to him from Taylor's *Holy Living and Holy Dying* – which Hazlitt once described as 'more like fine poetry than any other prose whatever'.

Taylor's sonorities pleased Keats, but could not persuade him to hope for salvation. Throughout his adult life he had rejected orthodox religion, constructing an alternative, secular philosophy which recognised that pain and pleasure were inseparable. He was ending with suffering 'alone'. Nothing he had achieved seemed valuable. No system of belief, no literature, no individuals could cancel or compete with the brute fact of extinction. From Severn's Christian point of view, he was dying 'in horror'.

FIFTY-THREE

By 25 January, when Keats had moved back into his little corner room and lay on what Severn bluntly told Taylor was 'his death bed', his depression was unshakeable. His 'sorrow . . . border[ed] on the insane. He desir[ed] his death with dreadful earnestness'. Little acts of kindness

[563]

exasperated him – he twice threw away the coffee that Severn brought him. The glimpse of a second letter from Fanny filled him with agony. He could not even 'bear any books'. 'The fact is,' Severn said, 'he cannot bear anything – his state is so irritable – is so every way unfortunate.'

Mercifully, Clark insisted that some extra help was necessary. At first Severn resisted this, saying that his 'duty' was to remain at the bedside. But he was worn out, and did not protest for long. On 26 January an English nurse began making daily visits, and Severn seized the chance to rest, and to remind himself of his other life. He dozed on the sofa in the sitting room. He continued to chalk out 'The Death of Alcibiades' in his cramped annexe. He pursued the few contacts he had made in Rome, and occasionally brought one of them, a young English sculptor named William Ewing, to visit Keats.

As January drew to a close, Keats's mood began to alter. He was simply too sick to continue with his 'savageness', and a look of something like acceptance came into his face. His nightmares ceased, and he began sleeping more easily. His 'desire for books' suddenly returned, and when Severn 'got him all [those] on hand', including his seven-volume edition of Shakespeare, Keats piled them at his bedside as if they were 'a charm'.[1] His conversation became calmer, too, and he started discussing the arrangements for his funeral. He knew that since he was not a Catholic he would have to be buried in the Protestant cemetery outside the Aurelian Wall encircling Rome, close to the Pyramid of Cestius, and asked Severn to go and look at it. When Severn came back, and told him there were sheep and goats grazing among the graves, and early violets and daisies growing prolifically, he was satisfied. Only a little while before, seeing trees in blossom on the Pincian Hill, he had told Severn 'The spring was always enchantment to me . . . perhaps the only happiness I have had in the world – has been the silent growth of flowers.' Early in February he insisted that violets were his 'favourite[s]', and said that he could already feel the daisies growing over him as he gazed at the yellow and white flowers embossed on the ceiling of his room. Quietly and decidedly, he gave instructions for his burial. The unopened letters from Fanny were to be interred with him, along with a lock of her hair and a purse made by his sister. In due course, his headstone must be engraved with a broken lyre, and with the words 'Here lies one whose name was writ in water'.[2]

This phrase has generally been taken as a sign that Keats died without any hope of posthumous fame, especially since it was not accompanied

by his name, and was prefixed by a sentence devised by Brown – who eventually reached Rome in 1822 – which runs: 'This grave contains all that was Mortal, of a YOUNG ENGLISH POET Who on his Death Bed, in the Bitterness of his Heart at the Malicious Power of his Enemies, Desired these Words to be engraved on his Tomb Stone.' The truth is more complicated, as even Brown realised: he later referred to his addition as 'a sort of profanation', and wished that it could be erased. Although Keats had often railed against his 'Enemies' during his last few months, he had not composed the epitaph in 'Bitterness'. In fact, and with the last ounces of his energy, he had devised an inscription which adapted the translation of a Greek proverb,[3] and was characteristically ambiguous. Being written 'in' rather than 'on' water, his 'name' seemed doomed to vanish immediately, leaving nothing which might be praised. On the other hand, it made itself permanent. His poetry had come to him 'as naturally as leaves to a tree'; now it was part of nature – part of the current of history.

Keats remained steady through the second week of February, clinging to his pleasure in familiar things. Severn brought him a glass of fresh milk five or six times a day, and the smell and taste of it delighted him. Hour after hour, he handled the cool weight of the cornelian Fanny had given him. Watching the sunlight mark time across the wall of his room, he listened to the fountain in the square below, and the play of strangers' voices. Occasionally visitors called – not only Ewing, but a young Spanish novelist in exile called Valentín Llanos y Guiterez, whom Severn had met on one of his excursions.[4] On 20 February, Clark warned Severn that such calm could not last; even so, Keats continued to show glimmers of his old, considerate self. He made Severn promise to write to Hilton and ask that the deadline for the travelling scholarship be extended. He warned him what to expect when death eventually approached. Had Severn ever seen anyone die, Keats asked. 'No,' Severn replied. 'Well then,' Keats said, 'I pity you – poor Severn, what trouble and danger you have got into for me.' Drawing on his experience as a doctor, and on his memories of Tom, he added that he did not expect to convulse in his final moments.

Severn thought these moments were coming during the night of 21 February. Keats began coughing painfully, the phlegm rattling in his throat, and asked to be propped up on his pillows. When the first 'pale daylight' crept into the room, he was still alive, barely able to speak, his emaciated face set in 'a most ghastly look'. All the next day he lingered,

still able to recognise his nurse when she came to relieve Severn for a short while. Severn waited in the sitting room, writing proudly to Haslam: 'Poor Keats keeps me by him . . . he opens his eyes in great horror and doubt – but when they fall upon me – they close gently and open and close until he falls into another sleep – The very thought of this keeps me by him until he dies – and why did I say I was los[i]ng my time – the advantages I have gained by knowing John Keats – would to gain any other way have doubled and trebled the time – they could have gain'd.'

It was the same on the following day, 23 February. When the nurse returned, Severn snatched a little rest, then took his place by Keats's side in the late afternoon. As the evening darkened, Keats suddenly stirred and clutched at Severn, imploring him 'Lift me up – I am dying – I shall die easy – don't be frightened – thank God it has come.' Severn leaned across the bed and took Keats in his arms, but as the thickly taken breaths persisted, he slowly released him and straightened again, keeping hold of his left hand. They remained in silence while the last glow of the sun gave way to candlelight, the mucus 'boiling' in Keats's throat as he became too weak even to cough. At one point a cold, heavy sweat broke out over his whole body and he whispered warningly, 'Don't breathe on me – it comes like ice.' Severn kept immovable, on the verge of sleep. As eleven o'clock approached, he jolted awake and looked again at his friend. Keats was dead, his face so composed that Severn 'still thought he slept'.

SEVERN WAS DISTRAUGHT. It was four days before he could bring himself to write to Brown, and a fortnight before he dared spend any time alone. Clark took charge. He arranged for Gherardi, Canova's mask-maker, to make a cast of one of Keats's hands, another of one of his feet, and also a mask of his face. The life mask that Haydon had made four years previously had captured Keats's delicacy and eagerness; in the death mask the cheekbones are skeletally clear, the nose beaky, the eyes sunk in their sockets, the receding hair pressed thinly back. Then Clark performed an autopsy, assisted by a Dr Luby. Although this seems to have been 'a limited operation, probably confined to the thorax, so that we have no information on the state of the abdominal organs, the condition of the larynx or other organs that might have been affected by disease',[5] it told Clark what he wanted to know. Keats's lungs were almost completely destroyed; Clark pronounced it the worst case of

consumption he had ever seen. He could not imagine how Keats had lived for so long. Keats was twenty-five years and four months old.

Clark also took over plans for the funeral. As a general rule, non-Catholics not only had to be buried outside the city walls but at night, too – though occasionally by special dispensation the service was allowed to take place in the early morning. Clark gained this dispensation. Arriving at 26 Piazza di Spagna before dawn on 26 February, he led the small procession through Rome's still-sleeping streets and reached the Protestant cemetery as the sun began to rise. An English chaplain, the Revd Mr Wolff, read the service; Severn, Clark, Ewing, and half a dozen others watched as the coffin was lowered into the ground. The Aurelian Wall and the Pyramid of Cestius rose on one side of the cemetery; on the other stretched open country. Keats lay in death where he had always lived: on the edge of things, defined by exclusion. It was nine o'clock and broad daylight when the service was over. 'Put turfs of daisies upon the grave,' Clark told the gravedigger. 'This would be poor Keats's wish – could he know it.'

When Clark and Severn returned to the Piazza di Spagna, their reverie was confounded. The police were already inside the apartment, and workmen were scouring the walls, making new doors and windows, piling up the furniture to be burnt. Anna Angeletti, hovering with a bill, had covered a table with broken crockery for which she also intended to make a charge. In a fury of grief and rage, Severn pounded it to fragments with his walking stick, and accused her of trying to cheat him. She truculently backed down, warning that she would still expect almost £150 in due course. Severn recovered himself and told her that she would be paid, then put himself in the care of Clark. He slept for many hours and, when he awoke, immediately made his first visit to Keats's grave, striving to comfort himself as he stared at the mound of raw earth.

It took three weeks for Severn's letter to Brown to reach Hampstead. Ever since Keats had left for Italy, Brown had tried to persuade himself that he would see Keats again, and when he discovered that it was 'all over' he was desolate. He hurried off notes to Rice, Dilke and Abbey, but asked Taylor to tell Haslam and to publish news of Keats's death in the papers. (The following day he changed his mind and wrote to Haslam himself, asking him to tell Abbey *without delay* – lest Miss Keats should hear of it by the papers or thro' some other means'.) He was even more devastated by the thought that he must break the news to Fanny Brawne. Writing to Severn a few days later, he could not bring himself to describe

the effect, saying only that Fanny was 'now pretty well, – and thro' out she has shown a firmness of mind which I little expected from one so young'. The judgement marked a decisive change in their relations. Brown was no longer jealous and carping; he could appreciate Fanny's maturity, and had proof of her devotion. She soon fell ill, lost a great deal of weight, and had her hair cropped short. When she recovered, she went into mourning as though she had in fact been married to Keats, still anguished by the thought that 'he might have died here with so many friends to soothe him and me *me* with him'. She took to wearing a widow's black dress, and spent hours in her room rereading his letters or wandering alone on the Heath, often far into the night. Writing frequently and tenderly to Fanny Keats, she accepted that it was 'better' not to dwell on the past, even though this might outrage her enemies. 'They think I have [forgotten him],' she said. 'But I have not got over it and never shall.'

IT WAS AT LEAST three years before Fanny changed out of her mourning clothes. But Keats's death was not the last tragedy to afflict her. In 1828 her brother Sam died of tuberculosis, and her mother was burned to death in 1829 – the year that Valentín Llanos described Fanny as looking 'very thin and sadly worn'[6] when he visited her in Wentworth Place. Gradually, though, her 'dazzling . . . manner' returned 'despite her pale looks'.[7] When she began going to parties again, she still impressed her friends and irritated her detractors. On one occasion, for instance, Reynolds saw her wearing a dress decorated with little bugles and said: 'It's good to wear bugles and be heard wherever one goes'; she replied – referring to the fact that his sister Jane had married the poet Thomas Hood – 'And it's good to be a brother-in-law of Tom Hood's and get your jokes for nothing.'[8] Eventually, in 1833, she married Louis Lindo, a Sephardic Jew who later changed his name to Lindon, with whom she had two children. They spent much of their life on the Continent before returning to London in 1859. Fanny died in 1865, and was buried in Brompton Cemetery. Her husband died seven years later, and was interred in the same grave.

Throughout this time, Fanny cherished her memories of Keats: she never took off the ring he had given her. But she kept her devotion private. Only a few of Keats's friends knew of her engagement, though she herself told Fanny Keats: 'Had he returned I should have been his wife and he would have been with us.' As far as the general public was

concerned, Fanny remained unknown until 1878, thirteen years after her death, when Keats's letters to her were first published. The initial reaction was scandalised. Keats was attacked for showing the unguarded emotionalism of a 'snivelling, sensuous, badly-bred surgeon's apprentice',[9] and Fanny for seeming flighty, cold and unworthy. These accusations were reinforced by the discovery that she had first responded to news that his biography might be written by remarking: 'I may truly say that he is well-remembered by me and . . . satisfied with that I could wish no one but myself knew he had ever existed.' She added: 'The kindest act would be to let him rest for ever in the obscurity to which circumstances have condemned him.' Although objections to the letters soon evaporated, accusations of her indifference faded more slowly, and even persisted after her letters to Fanny Keats were published in 1936. The reasons for her discretion were misunderstood. Far from believing that Keats's readers should not be curious about his life, she was keen to prove that he had never shown 'weakness of character', and in the late 1820s gave Brown permission to use her name in his projected memoir of Keats. 'If his life is to be published,' she said, 'no part ought to be kept back'.[10] On the other hand, she felt that further examination of his achievement might condemn him to more ridicule – no matter how faithfully she believed in his genius herself. She could not endure the possibility that he might be as grotesquely unrewarded in his 'posthumous life' as he had been in his real one.

The immediate reaction of Keats's family and other friends to the news of his death is not recorded. Their later actions show their distress, and their undiminished, complex admiration. Fanny Keats, who had always loved her brother without knowing him well or seeing him often, lived proudly in the spreading light of his fame, and was so dismayed when Fanny Brawne married Lindo that she ended their friendship. The rupture suggests a loyalty to Keats which was distorting in its intensity. George Keats, too, remained faithful to his brother's name, publishing some of his poems in America, vilifying those who criticised them, and stoutly defending himself when Brown launched the long campaign to blacken his reputation. Brown's affection also showed in other, healthier ways. He divided up Keats's books as he had been asked to do – omitting to send one to George or to Haydon, whom he reckoned owed Keats money – and slowly gathering biographical materials for the memoir which he eventually handed over to Richard Monckton Milnes. Dilke, Rice, Reynolds, Woodhouse and Haslam[11] were more straightforwardly

faithful, as was Severn. He championed Keats for the whole of his long remaining life, rewriting the account of their time together, organising lectures and readings in honour of his friend, and entertaining admirers in Rome, where in 1861 he was appointed British Consul. After his death in 1879, friends raised a fund to have his body interred beside Keats in the Protestant cemetery, under 'a matching gravestone commemorating his devotion'.[12]

The difficulties which had sometimes divided these friends soon began to reappear. Bailey wrote to Taylor crudely describing Keats's death as 'a merciful severity'. Haydon told a friend that Keats's 'want of nerve' had contributed to his decline, and made various barbed comments about him in his journals.[13] Similar tensions were reflected in the evolving debate about his work. Although *Blackwood's* had not condemned the 1820 volume in any detailed way, it continued to snipe at him, even after the death of John Scott, who was killed in a duel defending the reputation of Keats and Hunt in the same month that Keats himself died.[14] The magazine marked the first anniversary of Keats's death by attacking his immature sensuality, misspelling his name in the process: 'Poor Keates! I cannot pass his name without saying that I really think he had some genius about him. I do think he had something that might have ripened into fruit had he not made such a mumbling work of the beds – something that might have been wine, and tasted like wine, if he had not kept dabbling his fingers in the vat, and pouring it out and calling lustily for quaffers, before the grounds had time to be settled, or the spirit to be concentrated, or the flavour to be formed.'[15] Other enemies continued to berate him in equivalent terms, combining their original political and social disapproval with sneers at what seemed to be his excessive sensitivity. After Keats's headstone had been erected in Rome, Severn reported that 'a host' of 'scoffers' had 'started up', repeating the 'silly jest': 'Here lies one whose name was writ in water, *and his works in milk and water.*' De Quincey complained that *Endymion* combined 'The very midsummer madness of affectation, of false vapoury sentiment, and a fantastic effeminacy'.[16] Byron, in *Don Juan*, gave grudging praise to 'Hyperion' but dwarfed it by converting Lockhart's notion of Keats as a Cockney bardling into an unforgettable image of feebleness:

> John Keats, who was killed off by one critique
> Just as he really promised something great

If not intelligible, without Greek
 Contrived to talk about the gods of late
Much as they might have been supposed to speak.
 Poor fellow! His was an unwonted fate;
 'Tis strange the mind, that very fiery particle,
 Should let itself be snuffed out by an article.

There were writers who flatly contradicted these views. The obituarist in the *London Magazine*, for example, said that Keats's poems 'were full of high imaginative and delicate fancy, and his images were beautiful and more entirely his own, perhaps, than any living writer whatever';[17] and the *New Monthly* said simply 'A name richer in promise England did not possess'.[18] Yet these uncomplicated enthusiasts were outnumbered by others who damaged Keats's reputation even as they meant to promote it. Hazlitt, for instance, described him as 'a bud bit by an envious worm', and confirmed the impression of delicacy by referring to him as 'a little western flower'. Hunt remembered him as sickly and put-upon.[19] Meaning only to protect Keats, they kept alive the antagonisms he had always struggled against.

In their different ways, all these critics took their lead from the single most famous and influential response to Keats's tragedy: Shelley's *Adonais*. It is clear from their final exchange of letters that at least some poems in the 1820 volume, notably 'Hyperion', had persuaded Shelley that Keats in his maturity was worthy to be considered a 'rival'. (When Shelley's drowned body was washed ashore at Viareggio in July 1822, Hunt's copy of the book was in his pocket: it was thrown on the funeral pyre.) Soon after Shelley had heard of his death, in letters from Hunt which were laden with hints that bad reviews had triggered the fatal haemorrhages, he simplified their friendship for the sake of his elegy. He forgot the difference in their backgrounds and poetic politics, he ignored the discrepancies in their temperaments, he made nothing of the fact they had never been intimate. Instead, he turned Keats into an archetype – not someone who had suffered uniquely, but someone who represented all artists oppressed by reactionary regimes.

Shelley's 'Preface' sets the tone. Claiming that his 'repugnance to the narrow principles of taste on which several of [Keats's] earlier compositions were modelled proves that I am an impartial judge', he asserts that 'The savage criticism of his *Endymion* . . . in the *Quarterly Review*, produced the most violent effect on his susceptible mind; the

agitation thus originated ended in the rupture of a blood-vessel in the lungs; [and] a rapid consumption followed.' His most recent information, he says, suggests 'the poor fellow seems to have been hooted from the stage of life'. In the poem itself, Shelley presents himself as blighted and etherealised by lack of public sympathy – he is 'A phantom among men', 'companionless', 'A pardlike Spirit beautiful and swift'. Keats appears even more terribly 'neglected and apart'. He is poisoned, cut off, circled by 'carrion kites', and 'secure' only because he is entirely removed from the world, outsoaring 'the shadow of our night' and existing where 'Envy and calumny and hate and pain, / And that unrest which men miscall delight, / Can touch him not and torture not again'. In so far as this means Keats is 'made one with Nature', it signifies revival – but the 'Nature' in the poem is either abstract ('darkness', 'light', 'loveliness') or merely pitiful: a landscape of tombs and flowers. Aiming to immortalise Keats in the same way that Milton immortalised 'Lycidas', *Adonais* emasculates him. Linking him to 'the one spirit's plastic stress', it denies his identity.

Shelley wrote *Adonais* in Pisa between mid-April and June 1821, and printed it there the following month. When copies reached England towards the end of the year, it was not widely noticed. Such reviews as did appear confirmed the impression given by the poem. Keats had been killed by his reviewers; he was a wiltingly sensitive flower; his contact with the real world proved lethal. 'It is an elegy', said the *Literary Gazette*, 'on a foolish young man, who, after writing some volumes of very weak, and in the greater part, of very indecent poetry, died some time since of a consumption: the breaking down of an infirm constitution having, in all probability, been accelerated by the discarding of his neckcloth, a practice of the Cockney poets, who look upon it as an essential to genius.'[20]

If Keats's friends had been better organised in their defence of his reputation, Shelley's distortions would not have become so quickly and firmly rooted in the popular imagination, and the comments of Hazlitt, Hunt, Byron and de Quincey would not have had such a powerfully collusive effect. As it was, efforts to provide a more accurate account of his career were confused and curtailed. At the end of March 1821, Taylor announced that he intended to write a biography, and began collecting material from Woodhouse, Bailey and others. Dilke and Hunt disliked the idea. Brown resisted it even more strongly. He accused Taylor of acting with improper haste, and castigated the publisher as a

'mere bookseller' who 'neither comprehended [Keats] nor his poetry'. Shortly afterwards, he persuaded Severn to send him all Keats's papers, saying that he meant to write a Life himself when the time was right.[21] The result was not simply to define the battle lines which had always threatened to divide Keats's friends, but to create a stalemate. Although Dilke, Severn, Reynolds, Charles Cowden Clarke and even Shelley also considered writing Keats's story, none of them succeeded.

The longer these squabbles continued, the further Keats's work sank from public gaze. Taylor complained regularly about the poor sales of Keats's books, and eventually, in 1845, he sold his copyright in the poems and unpublished manuscripts for £50. There was no single volume of Keats's work reprinted until twenty years after his death – only an edition published by Gagliani in Paris in 1829, which collected his poems with others by Coleridge and Shelley. Although this bears witness to some enduring interest in his writing at home and in America, where the Gagliani edition was pirated, the audience remained very small. When Dante Gabriel Rossetti and Holman Hunt bought copies of the 1848 biography they believed that they were almost alone in admiring Keats.

If they had scoured anthologies, or come across occasional remarks by such people as Leigh Hunt, Charles Lamb, and Reynolds's brother-in-law Thomas Hood – who was heavily influenced by Keats in 'Lycius the Centaur' (1822) and 'Lamia' (1827) – they would have known better. Yet their reaction demonstrates that, at the time, Keats's most dismal fears about his posthumous fame seemed well founded. Outside the circle of his friends, and the few influential figures they were able to impress,[22] his name was seldom mentioned, and his work generally unread.

FIFTY-FOUR

IN 1829 ARTHUR HALLAM helped to organise a debate between the Cambridge and Oxford Unions. He contended that Shelley was a greater writer than Byron, and argued that anyone who admired the author of *Adonais* must revere its subject. (Hallam told Hunt that he believed Keats was 'the last lineal [descendant] of Apollo'.[1]) Inspired by this enthusiasm, Hallam's friend Tennyson also took up Keats's cause, even though it meant sharing the burden of Tory criticism: the *Quarterly*, for instance, trashed his first book and called him 'a new prodigy of genius,

[573]

another and brighter star of the galaxy or *Milky Way* school of poetry, of which the lamented Keats was the harbinger'.[2] As Tennyson's fame grew, however, it helped to create an audience for the voice he championed. When his contemporary Richard Monckton Milnes at last collected papers from Keats's surviving friends, and published the first biography in 1848, Keats's years of neglect were almost over.[3]

Milnes shared Tennyson's view that 'there is something of the innermost soul of poetry in almost everything [Keats] wrote', but he began writing his book with only faint hopes of scoring a popular success. Yet its warm reception, and the rapidly increasing number of approving critical voices, drew Keats during the middle years of the century into the position he had always coveted. By 1853 it was possible for Clough to speak of 'the school of Keats'; Arnold decreed that he was 'with Shakespeare'; between 1851 and 1886 no fewer than twenty-seven separate editions of his poems were published. This fame, however, came at a price. For one thing, there was the question of what Victorian sensibilities would make of Keats's sensuality. Even Milnes's amanuensis, the young Coventry Patmore, ambiguously referred to the poems as 'a very splendid piece of paganism', and said that his letters 'd[id] not increase my attachment to him'. In one respect, Milnes found this easy to deal with: his book stressed 'the productions of . . . genius' rather than 'the circumstances of . . . outward life', made no mention of Fanny, and included none of Keats's correspondence with her. In other ways, he contained the danger of disapproval by ascribing to Keats the same 'magnanimity' that Moneta had required of poets in 'The Fall of Hyperion'. Although he included anecdotes and collections from friends, plundered the (still unpublished) memoir by Brown, and included sixty-seven poems and many letters, he added these things to a narrative which was determined to correct any impressions of excess. Personal excess, as well as excessive sensitivity to critics:

I saw how grievously [Keats] was misapprehended, even by many who wished to see in him only what was best. I perceived that many, who heartily admired his poetry, looked on it as the product of a wayward, erratic genius, self-indulgent in conceits, disrespectful of the rules and limitations of Art, not only unlearned but careless of knowledge, not only exaggerated but despising proportion. I know that his moral disposition was assumed to be weak, gluttonous of sensual excitement, querulous of severe judgement, fantastical in its tastes and lackadaisical in its sentiments. He was all but universally believed to have been killed by a stupid, savage article in a review, and to the compassion generated by

[574]

his untoward fate he was held to owe a certain personal interest, which his poetic reputation hardly justified.

Most of Keats's surviving friends were grateful to Milnes for restoring to them the robust Keats they had always known, and for nailing the lie that he had been 'snuffed out by an article'. Reynolds thanked him 'for the boldness and *cleanness* of your defence of him against the drunken brawl of Blackwood, and the wicked savagery of Gifford'; Cowden Clarke was 'enchanted with the way in which you have performed your labour of love'. Such praise rightly implied that the biography had managed to counter those who objected to Keats's 'ardent temperament' and his lack of 'the regulating principle of religion'. It took no account of the ways in which Milnes himself had perpetuated certain kinds of suppression – as Dilke was one of the few to admit. He greeted the biography by quoting: 'Appearances to save his only care; / So things *seem* right, no matter what they are'. Writing to Bailey in 1848 (Milnes had supposed Bailey to be dead, and received a humorous denial), Milnes said 'I felt myself compelled as distinctly as possible to dissociate Keats from . . . Hunt & the effect has been to produce an impression that his mind would have been better without such associations.' In so far as Milnes was motivated by the wish to make Keats seem 'virile' and independent-minded, this was admirable. At the same time, he denied that Keats had been at all interested in or bound up with the life of his times, and subsumed the challenge of his suburban Cockneyism by relating it to an emerging Victorian desire to escape from the harsh facts of social upheaval into leafy and respectable private luxury.

Throughout the second half of the nineteenth century, this approach was variously elaborated. Tennyson's admirers called him 'the true successor of Keats to whom all . . . political and social questions were repulsive'.[4] Browning consistently praised the purity of his style and largely ignored his ideas. The Pre-Raphaelites pictured Keats as a delicious sybarite: in Holman Hunt's 'The Eve of St Agnes', for instance, complex social issues are swept aside in the excitement of a romantic escape. Arnold, while recognising the unique imaginative weight of the poems, concentrated on the 'fascinating felicity' and 'natural magic' of their diction and concluded – without going into details – that there was less to be said for their content. Even in America where, as Severn once said, Keats 'has always had a solid fame, independent of the old English prejudices', he was celebrated as

[575]

someone who had managed to escape squalor and disturbance by creating a gorgeous 'world of the past, a world painted in lavish colours and felt intensely through the senses'.[5] He might not be 'little Keats' but he was still 'poor Keats' – a poet to be valued for his gentleness, and associated with rapturous sighs, delicious sweetness, and flowery bowers. (In the mid-century a group of cultural faddists at Brook Farm, Massachusetts, 'plucked weeds to the rhythm of Keats'.[6])

Year by year, voice by voice, the same emphasis was repeated. In *Little Dorrit* (1856) Dickens presented John Chevery as a sentimentally Keatsian 'son of a turnkey' who is 'small of stature, with rather weak legs and very weak light hair', and who delights in haunting 'groves'.[7] William Rossetti preferred Keats to Shelley because he did not advance any 'revolutionary philanthropy'. Dante Gabriel Rossetti and Christina Rossetti referred to him in similar terms. Elizabeth Barrett Browning described him in *Aurora Leigh* (1857) as 'turning grandly on his central self'. Pater, in his essay on Lamb, placed Keats above Coleridge, Shelley and Wordsworth as one of the 'disinterested servants of literature'. Swinburne referred to him as 'the most . . . absolutely non-moral of all serious writers on record'. Hopkins, although he conceded that Keats was 'made to be a thinker, a critic, as much as a singer or artist in words', complained that 'his verse is at every turn abandoning itself to an unmanly and enervating luxury'.

Hopkins had shrewder things to say about Keats than almost any other nineteenth-century writer, but his conclusion summarises their collective views: Keats 'lived in mythology and fairyland the life of a dreamer'. In the opening years of the twentieth century, the pattern remained the same: Robert Bridges lent elegant support to Arnold, and Rupert Brooke spoke for his fellow Georgians in calling Keats 'pretty'. In 'Ego Dominus Tuus' Yeats put a notoriously snobbish gloss on these impressions:

> I see a schoolboy, when I think of him,
> With face and nose pressed to a sweetshop window,
> For certainly he sank into his grave,
> His senses and his heart unsatisfied;
> And made – being poor, ailing and ignorant,
> Shut out from all the luxury of the world,
> The coarse-bred son of a livery stable keeper –
> Luxuriant song.

By the time Yeats wrote this poem, in 1915, the culture which had allowed Keats's reputation to prosper was beginning to destabilise. In the letters written to his friends and mother before the First World War, Wilfred Owen had worked up his admiration for Keats into a feverish kind of identification, seizing on him as a guiding spirit in much the same way that Keats himself had taken hold of Spenser and Shakespeare. ('His writing is rather large and slopes like mine,' he wrote to his mother in 1911.) In doing so, he personalised what was still in effect a national cult. When Owen went to write and fight in France, however, his hero-worship produced other effects. By using an avowedly Keatsian language to describe scenes more appallingly destructive than any that Keats or his heroes had imagined, he devised a way of celebrating the continuity between past and present while indicating that he belonged to a different age. Sometimes ironical, invariably elegiac, Owen's sensuality is both defiant and doomed: brambles become barbed wire, and bees are bullets draining the 'wild honey' of youth.

Owen, who died at the same age as Keats, did not live long enough to see how the implications of his work might be developed. When the war ended, Keats's poems emerged into a climate which made them seem part of a broken tradition. 'For the study of men in particular', said J. C. Squire on the centenary of Keats's death in 1921, 'we must go elsewhere . . . [He] preferred Greek legends and autumn leaves, musical sighs, a sweet melancholy, and the shining of moonlight through a window dyed azure and gules.' Modernist experiments challenged traditional formal orthodoxies, more conversational styles became conventional, and the idiom which for a hundred years had gradually been defined as 'Keatsian' seemed suddenly remote. Eliot, like John Middleton Murry, concentrated on his aesthetic achievement (Eliot said that the letters contained hardly a statement about poetry which was not 'true'). Beckett said: 'I like him the best of them all, because he doesn't beat his fists on the table. I like that awful sweetness and soft damp green richness. And weariness: "Take into the air my quiet breath".'[8] Until recently, successive generations have followed suit. Always enthusiastically, and often ingeniously, they have defended his place 'among the English poets' by removing him from time altogether.

'How long is this posthumous life of mine to last?' Keats asked Clark in Rome. He meant that he longed to die. His readers have answered him in ways he did not expect. They have made him immortal. So have the

pilgrims to his house in Hampstead, and to his lodgings in the Piazza di Spagna. Every day, visitors climb the narrow marble stairs to the room where he lay, scanning his books and manuscripts, peering at Severn's sketch of his sweat-soaked, emaciated face, gazing at the embossed ceiling and the grey stone fireplace with its grotesque heads – the same heads that stared back at Keats on his deathbed. It is intensely moving: a monument to his genius, and the profound pathos of his story. But it is also the place which defines his 'nobler life'. Even in his last desperate hours, he never embraced the 'pious frauds of religion', or betrayed his belief that suffering was a means of soul-making – for others, if no longer for himself. All his life, he had celebrated a humane and intelligent paganism, defining it as a personal salvation which was also a criticism of his 'barbarous age'. He had immersed himself in history, so as to understand better the morality of transcendence. He had refined but never abandoned his attempt to combine 'thought' with 'sensation'. This is what his friend Woodhouse realised, writing in his interleaved and annotated copy of Keats's *Poems*. His sentences do not have the surge of a resounding conclusion. Rather, they make an appropriately 'awkward bow'. They insist that Keats deserves eternal fame because the astoundingly rich world of his invention contained 'a very great deal of reality'. 'There must be', Woodhouse wrote, 'many allusions to particular Circumstances, in his poems: which would add to their beauty & Interest, if properly understood. – To arrest some few of those circumstances, & bring them to view in connexion with the poetic notice of them, is one of the objects of this collection.'

Notes

INTRODUCTION

1 Richard Monckton Milnes, *Life, Letters and Literary Remains of John Keats*, p. xiii. The phrase is from Wordsworth's pamphlet attacking biography, 'Letter to a Friend of Robert Burns'.

2 Milnes, *Life*, pp. 242–3: 'When the memoir so nearly approaches the times of the subject that the persons in question, or, at any rate, their nearer relatives, may still be alive, it will at once be felt how indecorous would be any conjectural analysis of such sentiments, or, indeed, any more intrusive record of them than is absolutely necessary for the comprehension of the real man.'

3 Though Milnes did concede 'the unpopularity of [Leigh Hunt's] liberal and cosmopolite politics', *Life*, p. 20.

4 This edition of 1917 is the culmination of a lifetime's devotion to Keats. Colvin's first biography was published in the *English Men of Letters* series in 1887, and reissued in 1889.

5 Gittings's book synthesises and expands a great deal of biographical work he had done during the previous decade.

6 Jack Stillinger, *John Keats: Poetry Manuscripts at Harvard*, p. ix.

7 Sidney Colvin, *John Keats*, p. 51.

8 Some scholars and critics – notably Kenneth Muir – had done pioneering work on Keats's politics during the 1950s. This was developed in the 1970s and 1980s by Jerome J. McGann, John Barnard, and others, and in 1986 Susan J. Wolfson edited an important collection of historicising essays: 'Keats and Politics: A Forum', *Studies in Romanticism* 25, 2 (Summer 1986). More recently, Nicholas Roe has published articles and – like Elizabeth Cook – produced an edition of Keats's poems which also explores his radical aims and achievements. In 1995 Roe edited a collection of essays, *Keats and History*, which continues the process, as does his *John Keats and the Culture of Dissent* (1997). In 1995 Stephen Coote published a biography which usefully places Keats in his context, and explores some aspects of his politics. I am happy to acknowledge my debt to these writers in general terms, and in my notes.

9 Leigh Hunt, *Lord Byron and some Contemporaries*, p.250.

10 *The Poetical Works of John Keats*, ed. William Rossetti, p. ii.

11 My assessment owes a great deal to John Barnard's 'Charles Cowden Clarke's "Cockney" Commonplace Book', *Keats and History*, pp. 65–88.

12 *Examiner*, 1 December 1816. See also Hunt's *Lord Byron*, p. 147.

ONE

1 As Gittings points out in *John Keats*, pp. 15–16.

2 Ibid., p. 638.

3 See Dwight C. Robinson, 'Notes on the Antecedents of John Keats: The Maritime Hypothesis', *Keats-Shelley Journal* XXXIV (1986).

4 Ward makes the same point.

5 Other possible relations include William Keats, a linen draper in the City; Thomas Mower Keats and his brother Joseph, who worked as hatters; and Frederick Keats, a wine merchant whose uncle was employed by Fortnum and Mason.

6 Gittings, *Keats*, p. 29.

7 Gittings explored these thoroughly, and reports on Keats's relations in detail.

8 As Gittings points out.

9 Ibid., p. 27

TWO

1 E. J. Hobsbawm, *The Age of Revolution*, p. 46.

2 Ibid., p. 13.

3 E. P. Thompson, *The Making of the English Working Class*, p. 194. It is worth pointing out, too, that in 1780, during the Gordon Riots, which lasted for four days, 100,000 troops were called out, 210 people were killed outright, and a further 71 died of their wounds.

4 E. S. Parker, *English Society*, p. 348.

5 John Rule, *The Vital Sanctuary*, p. 196.

6 Thompson, *The Making of the English Working Class*, p. 170.

7 Linda Colley, *Britons*, p. 151.

8 Hobsbawm, *The Age of Revolution*, p. 52.

9 To appreciate this figure properly, it is necessary to know the value of money then as compared to now. 'Multiplying eighteenth-century sums by sixty or eighty will give a rough 1990 equivalent. Rock bottom wages during the Georgian period were about a shilling a day, to support a family somebody needed to earn between £30 and £40 a year – a careful family could keep out of debt and away from hunger on £1 a week, the petit bourgeoisie would commonly have incomes of between £50 and £100 a year, above £300 would keep a gentleman. For most of the eighteenth century a loaf of bread cost about 4d, a pot of ale about 1d, a meal in a pub would have been 1/6, and a two-up two-down brick cottage about £100.' Parker, *English Society*, p. xv.

10 Quoted in Colley, *Britons*, p. 323.

11 Hobsbawm, *The Age of Revolution*, p. 121.

12 Quoted in Colley, *Britons*, p. 323.

13 Watkins, *Keats's Poetry*, p. 190.

14 Colley, *Britons*, pp. 182–3.

15 Quoted in Perkins, *English Society*, p. 11.

16 Pitt the Younger 1783–1801; Addington 1801–4; Pitt 1804–6; the Ministry of all the Talents 1806–7; Portland 1807–9; Perceval 1809–11; Liverpool 1812–27.

17 Quoted in Rupert Christiansen, *Romantic Affinities*, p. 187.

18 George Rude, *Hanoverian London*, p. 232.

19 Asa Briggs, *How They Lived*, p. 57.

20 Ibid., p. 233.

21 Paul-Gabriel Bouce, *Sexuality in Eighteenth Century Britain*, p. 9.

22 Rule, *The Vital Sanctuary*, pp. 223–4.

23 Not everyone, of course, could afford to travel. The cost of riding inside a coach in 1800 ranged from 4d to 6d a mile, and even the roof-top fare, which Keats usually favoured, was 2d or 3d a mile.

24 Thomas Love Peacock, *Headlong Hall* (1815), p. 4.

THREE

1 Gittings, *Keats*, p. 35. He appreciates the ethos of the school, but does not investigate it thoroughly.

2 Parker, *English Society*, p. 160.

3 On at least one occasion this institutional violence erupted into something more spectacular. In 1805, pupils at Harrow plotted to blow up their unpopular headmaster, George Boulter, and laid gunpowder under a passageway. They only decided not to ignite it when they realised it would mean destroying some panels engraved with the names of famous old boys.

4 Dorothy Hewlett, *Adonais*, p. 26.

5 Gittings, *Keats*, p. 44.

6 Nicholas Roe has written well about Keats's school. See Bibliography.

7 James Culcross, *The Three Rylands*, p. 34.

8 Richard Altick, *The Cowden Clarkes*, p. 14.

9 Ibid.

10 Culcross, *The Three Rylands*, p. 49.

11 Ibid., pp. 61–2.

12 William Newman, *Rylandia*, p. 14.

13 Ibid., p. 200.

14 See Charles and Mary Cowden Clarke, *Recollections of Writers*, pp. 12–13.

15 Altick, *The Cowden Clarkes*, p. 94.

16 Culcross, *The Three Rylands*, p. 34.

17 Newman, *Rylandia*, p. 82.

18 Ibid., p. 126.

19 John Ryland, *Plan of Education* (quoted in Newman, *Rylandia*, p. 122).

20 John A. Passmore (ed.), *Joseph Priestley's Writings on Philosophy, Science and Politics*, p. xiv.

21 Ibid., p. 36.

22 Ibid., p. xix.

23 For instance, the *Catechism for Children and Young Persons* (1781).

24 Altick, *The Cowden Clarkes*, p. 12.

25 John S. Stabling, *History of Christ Church, Enfield* (no date), p. 280.

26 Charles and Mary Cowden Clarke, *Recollections of Writers*, p. 3.

27 John Clarke was not only an admirer of Priestley but of Alexander Geddes; he was a subscriber to Geddes's translation of the Bible.

28 See Robert Ryan, *Keats: The Religious Sense*, p. 35.

29 Keats's grandmother's Bible was still among his possessions at the time of his death.

30 Newman, *Rylandia*, p. 14.

31 Charles and Mary Cowden Clarke, *Recollections of Writers*, p. 5.

32 Altick, *The Cowden Clarkes*, p. 19.

FOUR

1 Gittings, *Keats*, p. 40.

2 Ibid., p. 41.

3 Ibid., p. 47.

4 William Robinson, *The History and Antiquities of Edmonton* (1819). No page numbers.

5 See Walter Jackson Bate, 'The Stylistic Development of Keats' (1945), pp. 51–6, and p. 65.

6 Colvin, *Keats*, p. 11.

7 Charles Cowden Clarke's Commonplace Book (Brotherton Library, Leeds), p. 158.

8 Ryan, *Keats: The Religious Sense*, p. 40.

9 Gittings, *Keats*, p. 51.

10 Bate, *Keats*, p. 26. This 'other book' may have been a two-volume edition of *Paradise Lost* – a prize for his translation of the *Aeneid*.

FIVE

1 Midgley's brother Thomas had died of 'a decline' in 1796, aged fourteen.
2 Bate, *Keats*, p. 24.
3 One of Sandell's executors was John Henry Schneider (1742?–1824), also of Broad Street Buildings, who was one of London's most important fur buyers during the last quarter of the eighteenth century. Sandell, who shared the same professional address, was probably in the same line of business. Since much of the fur they imported was beaver, which was used almost exclusively for felt in hat-making, it is possible that he was linked commercially, as well as by law, to the Keats children. Certain members of the Keats family worked as hatters in London, though Keats himself refused to have anything to do with them. I am grateful to Jean Haynes for this information.
4 Gittings, *Keats*, p. 60.
5 See Gittings, *Keats*, pp. 58–9.
6 There is some uncertainty about whether Keats left his school at this time or a year later. See Gittings, *Keats*, pp. 56–7 and Bate, *John Keats*, Appendix II. Charles Cowden Clarke was adamant that Keats left in 1810; see his annotation to Milnes's *Life*, p. 6, in the Brotherton Library, Leeds.
7 Aileen Ward, *John Keats: The Making of a Poet*, p. 24.
8 Ibid.
9 Irvine Loudon, *Medical Care and the General Practitioner*, p. 131.
10 Ibid., p. 167.
11 Ibid.
12 Ibid.
13 *Examiner*, 7 September 1817.

SIX

1 Dilke wrote of Keats's 'quarrel with the surgeon as a well-known thing'. Gittings, *Keats*, p. 67.
2 Hermione De Almeida, *Keats and Romantic Medicine*, p. 131.
3 Colvin, *Keats*.
4 Ibid., p. 18.
5 De Almeida, *Romantic Medicine*, p. 37.
6 As Gittings points out. See his *Keats*, p. 65 for an analysis of Beattie's influence.
7 John Barnard, 'Charles Cowden Clarke's "Cockney" Commonplace Book', *Keats and History*, p. 65. See also Barnard's essay on the Leigh Hunt–Charles Cowden Clarke correspondence in *Romanticism* 3, 1 (1997).
8 Charles Cowden Clarke's Commonplace Book, p. 109.
9 Ibid., p. 156.
10 Ibid., p. 262.
11 Ibid., pp. 258–61.
12 As John Barnard points out in *Keats and History*.
13 John Barnard, *Keats and History*, p. 68.
14 Ibid. Leigh Hunt obviously found Clarke's poems touching but irritatingly deficient. In 1834 he wrote to him: 'What a strange fellow you are, who with such a feeling of the poetical, and a nice sense of music, can never write a dozen lines together without committing a false quantity, – leaving out some crotchets of your bar' (Leigh Hunt to Charles Cowden Clarke, 11 February 1834; in Brotherton Library, Leeds).
15 *Examiner*, 3 January 1808.

16 Blainey, *Immortal Boy*, p. 41.

17 *Examiner*, 3 January 1808.

18 Ibid.

19 Ibid.

20 *Examiner*, 9 July 1815.

21 *Examiner*, 1 June 1816.

22 *Examiner*, 21 August 1808.

23 *Examiner*, 22 March 1812.

24 Byron, *Letters and Journals*, 1 December 1813, p. 228.

25 For instance, Hunt wrote to Charles Cowden Clarke on 5 January 1814: 'As soon as you can snatch a little lesson, pray let us see you. You know our dinner hour, & can hardly have to learn, at this time of day, how sincerely I am, my dear sir, your friend and servant' (Brotherton Library, Leeds).

26 The precise date is uncertain. See Gittings, *Keats*, p. 66.

SEVEN

1 Although 'Fill for me . . .' speaks from the heart, it borrows some of its energy from a well-known contemporary poem – Byron's 'To a Beautiful Quaker'. In December 1814, Keats addressed Byron by name. On the face of it, his intention was not to develop his feelings about women any further; it was merely to praise 'sweetly sad' melodies and tales 'of pleasing woe':

> thou [Byron] thy griefs dost dress
> With a bright halo, shining beamily,
> As when a cloud a golden moon doth veil,
> Its sides are tinged with a resplendent glow,
> Through the dark robe oft amber rays prevail,
> And like fair veins in sable marble flow.

Beneath the surface of the poem, however, run currents which flow directly from his thoughts in 'Fill for me . . .', and which also connect with his subsequent and more complex thoughts about Byron. In every obvious respect, Keats and Byron seem exact opposites. One was obscure and unconfident, the other was lordly and successful – even when a focus for gossip and disapproval. Yet they were both men of exceptional self-consciousness, and while this led Byron to exploit his identity, and to evolve a style which depended on control and (increasingly) detachment, it prompted Keats to 'dissolve' himself. The fact that Byron later complained so bitterly about Keats suggests that at some level he understood the link which produced their differences. Rather than considering him simply as an antithesis, he saw him as a kind of hideous parody. Keats attacked Pope while Byron revered him, Keats was 'panting' where Byron was disdainful, and Keats was 'snuffed out by an article' when Byron's response to criticism was to drink '3 bottles of claret'. Only the 'masculine' and 'Grecian' poem 'Hyperion' escaped Byron's whipping. Otherwise he scorned 'Jack' Keats as a model of the false poet who hears 'a voice in every wind', as a pretentious and precious suburbanite, and as a narcissist who 'viciously solicited his own ideas into a state which is neither poetry nor anything but a Bedlam vision produced by raw pork and opium'. (Significantly, the *OED* credits Byron as the first person to use the word 'suburban' meaning 'having the inferior manners, the narrowness of view, etc., attributed to residents in suburbs' – in *Beppo*, stanza lxvi; the poem was published in 1817.) Writing to his publisher John Murray in 1820, Byron

marshalled his charges in a famously aggressive assault: 'The grand vulgarity of the underforms of the new school of poets is their *vulgarity*', he said. 'By this I do not mean that they are *coarse*, but "shabby genteel", as it is termed. A man may be *coarse*, and yet not *vulgar*, and the reverse . . . It is in their *finery* that the new underschool are *most* vulgar, and they may be known by this at once; as what we called at Harrow "a Sunday blood" might be easily distinguished from a gentleman . . . in this case, I am speaking of writing, not of persons.'

There is no overt reference to women in these criticisms, but they repeatedly raise the issue of sexuality. As far as Byron was concerned, Keats was a 'mankin' whose 'p-ss a bed poetry' was either solipsistic or cloyed with a repellent languor. It forced a separation between loving and writing which Byron never acknowledged himself, and which Keats later defended angrily. By 1817 he was telling Bailey: 'I am disgusted with literary Men and will never know another except Wordsworth – no not even Byron.' Two years later he wrote to his brother: 'You see what it is to be under six foot and not a lord.' There is jealousy here as well as shrewd judgement, and although Keats's early poems show the same things much less obviously, they nevertheless anticipate the development of his feelings. When Keats began to find his voice, he was motivated by a sense of inferiority as well as dedication. As he started to establish his adult place in the world, the wish to protect himself, especially from women, was inseparable from the need for definition.

2 Probably: Tom's movements during this time are obscure.
3 See Bate, *Keats*, p. 42.
4 Quoted in Donald C. Goellnicht, *The Poet-Physician*, p. 17.
5 Unlike several of his friends, notably Hazlitt, Keats did not allow his disappointment with domestic politics to convert into hero-worship of Napoleon.
6 *Examiner*, 22 May 1815.
7 Erland Anderson, *Harmonious Madness*, p. 6.
8 Ibid., p. lii.
9 Gittings, *Keats*, p. 76.
10 *Keats and his Circle*, ed. Hyder E. Rollins, I, p. 185.
11 Keats was following Wordsworth's example in disguising the name of his dedicatee by referring to her as 'Emma'. Wordsworth had addressed his sister Dorothy as 'Emma' in several poems.
12 This passage apparently moved Keats to tears when he wrote it. See Ward, *Keats*, p. 43.

EIGHT

1 De Almeida, *Romantic Medicine*, p. 22.
2 Bate, *Keats*, p. 44.
3 Gittings, *Keats*, p. 33.
4 J. Feltham, *The Picture of London for 1810*, p. 106.
5 Goellnicht, *The Poet-Physician*, p. 24.
6 De Almeida, *Romantic Medicine*, p. 5.
7 Ibid., p. 5.
8 Ibid., p. 35.
9 Ibid., p. 36.
10 For details, see George A. R. Winston, 'John Keats and Joshua Waddington', *Guy's Hospital Report* 92, 2 & 3 (1943).
11 John Flint South, *Memorials*, pp. 69–70.
12 Ibid.
13 Gittings, *Keats*, p. 80.

14 Ward, *Keats*, p. 51.

15 And some give 'vivid, picturesque and out-of-the-way details' – for instance his note to Cooper's tenth lecture on physiology, in which he records that 'the patriot K[osciusko] having had the Sciatic Nerve divided by a pike wound, was a long while before his limb recovered its Sensibility'. Quoted in Gittings, *Keats*, p. 85.

16 Gittings, *Keats*, p. 86. It is also sometimes suggested that Keats was recommended by Henry Green, who was related to Hammond by marriage, and had been brought up near the Swan and Hoop.

17 George Macilwain, *Memoirs of John Abernethy*, p. 77.

18 John L. Thornton, *John Abernethy*, p. 59.

19 De Almeida, *Romantic Medicine*, p. 63.

20 Ibid., p. 106.

21 Macilwain, *Memoirs*, p. 317.

22 Bransley Blake Cooper, *The Life of Sir Astley Cooper*, p. 95.

23 R. C. Brook, *The Life and Work of Astley Cooper*, p. 12.

24 Cooper, *Cooper*, p. 223.

25 Ibid., p. 218.

26 Ibid., p. 224.

27 Ibid., p. 225.

28 Ibid., p. 294.

29 Ibid.

30 Brock, *Cooper*, p. 111.

31 Cooper, *Cooper*, p. 30.

32 Ibid.

33 Ibid.

34 Ibid., p. 20.

35 Ibid.

36 South, *Memorials*, pp. 83–4.

37 Ibid., p. 83.

38 See also Stuart Sperry, *Keats the Poet*, p. 11 & p. 30.

39 Quoted in Ryan, *Keats: The Religious Sense*, p. 64.

40 De Almeida, *Romantic Medicine*, p. 140.

41 Quoted in Goellnicht, *The Poet-Physician*, p. 144.

42 South, *Memorials*, p. 58.

43 Goellnicht, *The Poet-Physician*, p. 29.

44 Ibid.

NINE

1 Gittings, *Keats*, p. 91.

2 Ward, *Keats*, p. 57.

3 Milnes, *Life*, p. 6: 'The sense of humour, which almost universally accompanies a deep sensibility, and is perhaps but the reverse of the medal, abounded in him.' Clarke ticked this sentence in his copy of Milnes's biography.

4 Gittings, *Keats*, p. 100.

5 We know nothing about his appearance, either: no portrait of him survives.

6 William Lucas junior was the son of the man who had taught Hammond at Guy's.

7 William Hayle-White, *Keats as Doctor and Patient*, p. 15.

8 Goellnicht, *The Poet-Physician*, p. 37.

9 Bate, *Keats*, p. 61.

10 Gittings, *Keats*, p. 108.
11 Ward, *Keats*, p. 65.

TEN

1 Gittings, *Keats*, p. 118.
2 Charles Cowden Clarke wrote a poem in praise of Margate in his Commonplace Book, p. 280.
3 George Carey, *Balnea*, pp. 29–30.
4 *Guide to Margate* (anonymous, Margate County Council, 1995), p. 19.
5 Carey, *Balnea*, pp. 6–7.
6 For discussions of this possibility see Gittings, *Keats*, p. 121, and Ward, *Keats*, p. 70.
7 Like most of his 'set' – and, indeed, like his contemporaries in general – Keats was extremely keen on puns. They were not just a proof of mental agility and ingenuity, but of Huntian 'cheer' and Shakespearean good humour. Significantly, when Keats was confined in quarantine on the *Maria Crowther* in Naples in October 1820, he made more puns, he said, 'in a sort of desperation', than he usually made in a whole year.
8 Gittings also makes this connection.
9 Also quoted in Bate, *Keats*, p. 73.

ELEVEN

1 Joanna Richardson, *Fanny Brawne: A Biography*, p. 10.
2 Ibid., p. 1.
3 John Feltham, *The Picture of London*, p. 335.
4 Ibid.
5 See Elizabeth Jones, 'The Suburban School', *The Times Literary Supplement* (27 October 1995), pp. 14–15. It is worth linking this aspect of Keats's poetry to the gardening he was encouraged to do at school in Enfield.
6 Quoted in Gittings, *Keats*, p. 137.
7 Quoted in Blainey, *Immortal Boy*, p. 37.
8 Gittings, *Keats*, pp. 125–6.
9 See Vincent Newey's essay, 'Keats, History and the Poets' in *Keats and History*.
10 Blainey, *Immortal Boy*, p. 4.
11 Ibid., p. 6.
12 Ibid.
13 Ibid.
14 Ibid.
15 Edmund Blunden, *Leigh Hunt and his Circle*, p. 47.
16 Thornton Leigh Hunt, 'A Man of Letters of the Last Generation', *Cornhill Magazine* I (January 1860), p. 85.
17 David Bromwich, *Hazlitt: The Mind of a Critic*, p. 230.
18 Colvin, *Keats*, p. 51.
19 Barnette Miller, *Leigh Hunt*, p. 617.
20 Ibid.
21 Hewlett, *Adonais*, p. 64.
22 Thornton Leigh Hunt, 'A Man of Letters', p. 88.
23 Ibid.
24 Ibid.

25 Even at the time, however, it would have seemed unusual, as we can see by comparing Keats
 to the other leading Romantic poets: Blake and Clare were both only slightly taller than him;
 Byron was five foot eight; Coleridge, Wordsworth and Burns nearly five foot nine; Southey
 five foot eleven; and Shelley six foot.
26 Blunden, *Leigh Hunt*, p. 41.
27 Amy Lowell, *John Keats*, p. 235.
28 Colvin, *Keats*, p. 79.
29 Ibid.
30 Gittings, *Keats*, p. 132.
31 Hunt, *Lord Byron*, p. 147.
32 Quoted in John Barnard, *John Keats*, p. 136.
33 Ward, *Keats*, p. 79.
34 Quoted in Hewlett, *Adonais*, pp. 89–90 and elsewhere.

TWELVE

1 Gittings, *Keats*, p. 144.
2 See *The Excursion*, Book IV, lines 847–87:

> 'Once more to distant ages of the world
> Let us revert, and place before our thoughts
> The face which rural solitude might wear
> To the unenlightened swains of pagan Greece.
> – In that fair clime, the lonely herdsman, stretched
> On the soft grass through half a summer's day,
> With music lulled his indolent repose:
> And, in some fit of weariness, if he,
> When his own breath was silent, chanced to hear
> A distant strain, far sweeter than the sounds
> Which his poor skill could make, his fancy fetched,
> Even from the blazing chariot of the sun,
> A beardless Youth, who touched a golden lute,
> And filled the illumined groves with ravishment.
> The nightly hunter, lifting a bright eye
> Up towards the crescent moon, with grateful heart
> Called on the lovely wanderer who bestowed
> That timely light, to share his joyous sport:
> And hence, a beaming Goddess with her Nymphs,
> Across the lawn and through the darksome grove,
> Not unaccompanied with tuneful notes
> By echo multiplied from rock or cave,
> Swept in the storm of chase; as moon and stars
> Glance rapidly along the clouded heaven,
> When winds are blowing strong. The traveller slaked
> His thirst from rill or gushing fount, and thanked
> The Naiad. Sunbeams, upon distant hills
> Gliding apace, with shadows in their train,
> Might, with small help from fancy, be transformed
> Into fleet Oreads sporting visibly.
> The Zephyrs fanning, as they passed, their wings,

Lacked not, for love, fair objects whom they wooed
With gentle whisper. Withered boughs grotesque,
Stripped of their leaves and twigs by hoary age,
From depth of shaggy covert peeping forth
In the low vale, or on steep mountain-side;
And, sometimes, intermixed with stirring horns
Of the live deer, or goat's depending beard, –
These were the lurking Satyrs, a wild brood
Of gamesome Deities; or Pan himself,
The simple shepherd's awe-inspiring god!'

3 Quoted in Gittings, *Keats*, p. 146. Hazlitt's review was in fact of the *Catalogue Raisonné* of the British Institution, which was 'pretty well understood to be a declaration of the views of the Royal Academy'.
4 Ibid.
5 Thompson, *The Making of the English Working Class*, p. 821.
6 Colvin, *Keats*, p. 89.
7 *Examiner*, 26 October 1817.
8 Charles and Mary Cowden Clarke, *Recollections*, p. 60.
9 Ward, *Keats*, p. 233.
10 Bromwich, *Hazlitt*, p. 182.
11 Ibid.
12 Gittings, *Keats*, p. 152.
13 Not to be outdone, Reynolds also produced a sonnet praising Haydon's 'Giant Genius'.
14 Gittings, *Keats*, p. 155.
15 There was a practical reason for the delay in seeing Abbey. Keats had to wait to receive legal proof from a former servant of his parents that he was indeed twenty-one years old in October 1815, and was therefore entitled to his inheritance.
16 De Almeida, *Romantic Medicine*, p. 12.
17 Among them: Smollett, Crabbe, Somerset Maugham, Robert Bridges, Dannie Abse.

THIRTEEN

1 Bate, *Keats*, p. 134.
2 For more information, see Ryan, *Keats: The Religious Sense*, pp. 72ff.
3 There is also, of course, a sense in which this poetic 'doctoring' justifies his decision to abandon medicine, as well as diversifying his physicianly interests.
4 Blainey, *Immortal Boy*, p. 102.
5 Elizabeth Kent made her own significant contribution to 'suburban' culture: she wrote garden manuals.
6 If *Endymion* is in part a reply to *Alastor*, it suggests that Keats may have misunderstood the (possible) irony with which Shelley regards his hero.
7 Gittings, *Keats*, p. 167.
8 *Examiner*, 7 November 1816.
9 *Examiner*, 1 September 1816.
10 *Examiner*, 16 November 1816.
11 *Examiner*, 27 October 1816.
12 Gittings tells this story differently, but see Bate, *Keats*, p. 144.
13 See Sperry, *Keats the Poet*, pp. 118–19.

FOURTEEN

1 Gittings also quotes this, *Keats*, p. 178.
2 Bate says it was 1 or 3 March; I have followed Gittings.
3 Martin Aske, *Keats and Hellenism*, p. 13.
4 Ibid., p. 17.
5 Quoted in Bate, *Keats*, p. 39.
6 Quoted in Aske, *Keats and Hellenism*, p. 119.
7 See Stephen Larrabee, *English Bards and Grecian Marbles*, pp. 204–5.
8 Bate, *Keats*, p. 30.
9 Aske, *Keats and Hellenism*, p. 117.
10 Ibid.
11 *Champion*, 25 February 1816.
12 Quoted in *John Keats: The Critical Heritage*, ed. G. M. Matthews, p. 74.
13 Ibid., p. 69.
14 Ibid., p. 73.
15 *London Magazine*, October 1817.
16 Leigh Hunt to Charles Cowden Clarke, 1 July 1817 (Brotherton Library, Leeds).
17 Gittings, *Keats*, p. 214.
18 For further information on Taylor and Hessey – and on early-nineteenth-century
 publishing generally – see Tim Chilcott, *A Publisher and his Circle* and Edmund Blunden,
 Keats's Publisher.
19 Averil Mackenzie, *Clare Novello*, p. 1.
20 Richard Ortig, *The Cowden Clarkes*, p. x.
21 Theodore Fenner, *Leigh Hunt and Opera Criticism*, p. 33.
22 Ibid.
23 Walter Armstrong, *Memories of Peter de Wint*, p. 34.
24 Ibid., p. 15.
25 Ibid., pp. 26–7.
26 *Examiner*, 6 April 1817.
27 Quoted in Newey, *Keats and History*, p. 170.
28 See Newey for further details.

FIFTEEN

1 For further details see Chilcott, *A Publisher and his Circle*, pp. 17–19, 71–2, 87.
2 Leslie A. Marchand, *The Athenaeum: A Mirror of Victorian Culture*, p. 30.
3 Ibid., p. 32.
4 Ibid., p. 28.
5 John Bullar, *An Historical and Picturesque Guide to the Isle of Wight*, p. 1.
6 Ibid., p. 10.
7 Ward, *Keats*, p. 116.
8 Aske, *Keats and Hellenism*, p. 40.
9 Watkins, *Keats's Poetry*, pp. 46–7.
10 See Newey, *Keats and History*.
11 Possibly Keats found these trees in 'a beautiful little dell near Margate called "Nash"',
 which Charles Cowden Clarke visited in October 1818. He later commemorated the place in
 a poem: 'There you may see trees . . . / All fresh and green as if they "never would / Grow
 old".' Commonplace Book, p. 280 (Brotherton Library, Leeds).
12 Gittings, *Keats*, pp. 203–4.
13 See Bate, *Keats*, p. 167 for details.

14 For a résumé of the debate see *John Keats: Complete Poems*, ed. Barnard, p. 592.

SIXTEEN

1 Gittings, *Keats*, p. 211.
2 Ibid.
3 Leigh Hunt to Charles Cowden Clarke, 1 July 1817 (Brotherton Library, Leeds).
4 Newey, *Keats and History*, p. 172.
5 See Christopher Ricks's *Keats and Embarrassment*, and also John Bayley's *The Uses of Division*.
6 Gittings, *Keats*, p. 215.
7 'John Hamilton Reynolds, James Rice, and Benjamin Bailey in the Leigh Browne-Lockyer Collection' by Clayton E. Hudnall; *Keats-Shelley Journal* XIX, p. 26.
8 Ibid., p. 27.
9 Gittings also credits the importance of this remark, *Keats*, p. 221.
10 Bate, *Keats*, p. 188.
11 Newey, *Keats and History*, p. 173.
12 Gittings, *Keats*, p. 222.
13 For details see Gittings, *Keats*, pp. 228–9.
14 *Letters* I, pp. 231–2.
15 For more information about Butler's influence on Bailey, see Gittings, *Keats*, p. 231–2.
16 See Bate, *Keats*, p. 198 for a fuller discussion.
17 Bate, *Keats*, pp. 215–16.
18 *Letters* I, p. 169.

SEVENTEEN

1 Gittings, *Keats*, p. 233.
2 As Gittings points out (*Keats*, Appendix II), Keats may have blamed himself for hastening the onset of his tuberculosis by taking mercury. If he did, this would help to explain the note of self-recrimination in many of his letters written during his last year.
3 See Gittings, *Keats*, Appendix II.
4 Ibid.
5 Gittings, *Keats*, p. 236.
6 See Newey, *Keats and History*, p. 175.
7 Bate, *Keats*, p. 191.
8 *Sibylline Leaves* was published in August 1817, and Keats asked for it from Dilke on 5, 12 or 19 November. But he had begun *Endymion* early in October, which means that these echoes of Coleridge, if they are authentic, must have been provoked by his reading of someone else's copy of *Sibylline Leaves*, before he had his own.
9 See Newey, *Keats and History*, pp. 173ff.
10 Ibid., p. 177.
11 Ibid.
12 Ibid., p. 176.
13 Bate, *Keats*, p. 191.
14 Ryan, *Keats: The Religious Sense*, p. 123.
15 Bailey was so moved by this untimely death that he wrote a Christian apologia about it. This was published, on Keats's recommendation, by Taylor and Hessey in December 1818. At several points it echoes or paraphrases Keats: see Gittings, *Keats*, pp. 263–4.

EIGHTEEN

1 Or possibly 21 November. See Bate, *Keats*, p. 229.

2 Similarly, he told Reynolds: 'Heart-vexations . . . never surprise me'.

3 Ward, *Keats*, p. 146.

4 Quoted in Bernice Slote, *Keats and the Dramatic Principle*, p. 28.

5 Quoted in Christiansen, *Romantic Affinities*, p. 235.

6 Gittings, *Keats*, p. 250.

7 Hunt, *Lord Byron*, p. 226.

8 It is in fact not clear whether Wordsworth made this remark now or later. See Gittings, *Keats*, pp. 251–2.

9 See Gittings, *Keats*, p. 252.

10 Barnard, *Keats*, p. 38.

11 It is possible that Keats read Hazlitt's *Characters* this month.

12 See Bate, *Keats*, p. 238.

13 According to Gittings.

14 John Keats to George and Tom Keats, 30 January 1818. Quoted in Christie's (New York) sale catalogue, May 1996, pp. 85–7. This letter is mentioned by Rollins (*Letters* I, p. 225n); it was also described briefly in *Harper's New Monthly Magazine*, August 1877, p. 361.

15 Haydon's reply is famous: 'Allow me to add sincerely a fourth to be proud of – *John Keats's genius.*'

NINETEEN

1 Bate, *Keats*, p. 283.

2 John Keats to George and Tom Keats, 30 January 1818. See Chapter 18, note 14, above.

3 Two slight but ebullient lyrics – 'Hence Burgundy, Claret, and 'Port', and 'God of the meridian' – show that his spirits lightened as his plans for 'Hyperion' became clearer.

4 See Ward, *Keats*, p. 163.

5 Ibid.

6 Harold Orel and George J. Worth (eds), 'Six Studies in Nineteenth Century Literature and Thought', *Romantic Studies* 33 (1962), p. x.

7 The version of the poem which appears in the letter of 30 January 1818 runs as follows: 'Souls of poets dead and gone / What Elysium have ye known, / Happy field or mossy cavern / Fairer than the Mermaid Tavern? / Have ye tippled drink more fine / Than mine host's canary wine; / Or are fruits of Paradise / Richer than those dainty pies / [O]f venison. Oh! generous food! / Dress'd as though bold Robin Hood / Would, with his Maid Marian, / Sup and booze from Horn and Can. / I have heard that on a day / Mine Host's sign board flew away, / Nobody knew whither till / An astrologer's old Quill / To a Sheepskin gave the story: / Says he saw yo[u] in your glory / Underneath a new old sign / Sipping beverage divine, / And pledging with contented smack / The mermaid in the Zodiac! / Souls of poets dead and gone / Are the winds a sweeter home, / Richer is uncellar'd Cavern / Than the new [?] Mermaid Tavern?'

8 For a full discussion of this poem see John Barnard, 'Keats's "Robin Hood"', *Proceedings of the British Academy* LXXV (1989).

TWENTY

1 John F. Travers, *The Rise of the Devon Seaside Resorts*, p. 8.
2 James Clark, *A Treatise on Pulmonary Consumption*, p. 35.
3 N. T. Carrington, *The Teignmouth Guide* (1829), p. 23.
4 Bate, *Keats*, p. 302.
5 And also a complimentary sonnet to A[ubrey] G[eorge] S[penser], a contemporary of Bailey's at Magdalen Hall.
6 Quoted in Goellnicht, *The Physician-Poet*, p. 295.
7 Rollins, in *Letters*, has 'Jeffrey', but see Gittings, *Keats*, Appendix V, p. 404.
8 Gittings, *Keats*, p. 299, says that he was 'distressed'.
9 Morris Birkbeck, *Notes on a Journey in America*, p. 5.
10 Ibid.
11 Ibid., p. 67.
12 It is likely that Rice stayed with Keats in Teignmouth from 18–20 April: see Gittings, *Keats*, p. 309.
13 Gittings makes the same point.
14 See also Keats's description of Glaucus in *Endymion*.
15 See Watkins, *Keats's Poetry*, p. 54.
16 Possibly commemorating the visit Rice may have made to Teignmouth.
17 *Complete Poems*, ed. Barnard, p. 625.

TWENTY-ONE

1 Gittings, *Keats*, p. 318.

TWENTY-TWO

1 Quoted in Bate, *Keats*, p. 346.
2 The suggestion is persuasively made by Carol Kyros Walker in *Walking North with Keats*.
3 Ibid., caption 10.
4 Ibid.
5 M. M. Schofield, *Outlines of an Economic History of Lancaster*, p. 56.
6 W. P. Albrecht, *The Sublime Pleasure of Tragedy*, p. 136.
7 Walker, *Walking North*, caption 10.
8 Stephen Gill, *William Wordsworth: A Life*, pp. 329–30.
9 *Examiner*, 5 July 1818.

TWENTY-THREE

1 John Glendening, 'Keats's Tour of Scotland: Burns and the anxiety of Hero worship', *Keats-Shelley Journal* XLI, p. 98.
2 Sperry, *Keats the Poet*, p. 38.

TWENTY-FOUR

1 Or possibly the previous evening.

TWENTY-FIVE

1 Probably at Salen.
2 Walker, *Walking North*, caption 129.
3 Ibid., caption 133.
4 This letter, stretching for comedy as a way of controlling strong feeling, gives a fine résumé of the friendship that Keats and Brown had forged during their tour. Before leaving Hampstead forty-five days previously, they had only seen each other for short visits – for dinner, for amiable afternoons. Since then, they had shared confidences which had bound them together very closely. So closely, that Keats's biographers have sometimes wondered whether Brown fell half in love with him. It is not difficult to see why. Ever since Keats had first met Brown in Hampstead, he had known him as an averagely warm-blooded man-about-town who often referred to women – as Aileen Ward says (*Keats*, p. 204) – as 'mere sexual objects'. Judging by the evidence of Brown's surviving letters, however, his tenderest sentiments during this time had in fact been reserved for Dilke's teenage nephew, Henry Snook, who was a pupil at Eton. Over the past few weeks, Brown had written several long letters to this boy. 'I have thought of you, and your brother, and my two nephews, every day on my walk,' he says in one of them. 'To have left you at all, after so long having been your companion, sometimes comes across my mind in a painful manner, and the farther I have travelled away the stronger has been the feeling. There may be many who cannot understand why I should think of you so much, but my dear boys know how much I have loved them. But let the proof of this remain till some future day, for in the meanwhile I can have nothing to offer but assurances of affection. God keep you well, My dear Boy, and believe me your more than brother-friend.' (Quoted in Ward, *Keats*, pp. 204–5.)

There is no denying that these letters are peculiarly intense, even allowing for the contemporary codes of male friendship. They suggest that Brown's outbursts against women, and his intermittent eruptions of hunger for them, were possibly signs that he was denying other longings. Equally, though, there is no evidence that Brown ever turned his loving thoughts for Henry Snook into loving actions, and no evidence that he was sexually attracted to Keats. Brown regarded himself as an admiring and solicitous 'brother-friend', and Keats responded in kind, while also sometimes seeing him as a substitute parent. If there was a homosexual component in Brown's friendship with Keats, it was repressed to the point of being entirely unconscious. In years to come, his fondness would issue as it had done throughout their tour: in proud protectiveness, loyalty, and great kindness.

TWENTY-SIX

1 Gittings, *Keats*, pp. 342–3, investigates another possible sequence for these events.
2 Stephen Coote, *John Keats*, p. 185.
3 Gittings, *Keats*, p. 343.
4 Bate, *Keats*, p. 369.
5 Hunt, *Lord Byron*, p. 257.
6 Tim Chilcott, *A Publisher and His Circle*, p. 35.

TWENTY-SEVEN

1 Other influences include Ovid, Hesiod and Ronsard.
2 Goellnicht, *The Physician-Poet*, p. 213.
3 Ibid., p. 212.

4 Sperry, *Keats the Poet*, p. 212.
5 Quoted in Watkins, *Keats's Poetry*, p. 93.
6 Ibid.
7 See Margaret Homans, 'Keats Reading Women, Women Reading Keats', *Studies in Romanticism* 29 (Autumn 1990), p. 346.

TWENTY-EIGHT

1 Gittings adds that Clymene is 'a kind of pathetic Cassandra', and Enclades is 'a kind of more moral Ajax'. *Keats*, p. 375.
2 Jerome McGann, *The Romantic Ideology*, p. 117 & p. 124. See also his *The Beauty of Inflections: Literary Investigations in Historical Method and Theory*.
3 For instance: 'This is the only politics I know; the only patriotism I feel. The question with me is, whether I and all mankind are born slaves or free. This is the one thing necessary to know and to make good: the rest is *flocci, nauci, nihili, pili*. Secure this point, and all is safe: lose this, and all is lost. There are people who cannot understand a principle; nor perceive how a cause can be connected with an individual, even in spite of himself, nor how the salvation of mankind can be bound up with the success of one man. It is in vain that I address to them what follows.' (Preface to *Political Essays* in *The Collected Works of William Hazlitt*, pp. 33–4. Or: 'The Opposition have pressed so long against the Ministry without effect, that being the softer substance, and made of more yielding materials, they have been moulded into their image and superscription, spelt backwards, or they differ as concave and convex, or they go together like substantive and adjective, or like man and wife, they two have become one flesh.' Ibid., p. 44.
4 Gittings, *Keats*, p. 384.
5 Gittings, *The Living Year*, pp. 56–8.
6 Gittings, *Keats*, p. 389.
7 Albert Gerard, 'Romance and Reality', *Keats-Shelley Journal* XI, p. 16.
8 Bate, *Keats*, p. 427. This suited Keats, who on 9 July 1819 wrote to tell Fanny that he loved her 'the more in that I believe you have liked me for my own sake and for nothing else – I have met with women whom I think would like to be married to a Poem & to be given away by a Novel.'
9 *The Keats Circle*, I, ed. Rollins, p. 145.

TWENTY-NINE

1 Jean Dubos, *The White Plague*, p. 13.
2 *The Letters of Charles Armitage Brown*, ed. Stillinger, p. 1.
3 Ibid., pp. 6–7.
4 Bate, *Keats*, p. 393, calls it 'an unparalleled advance'.
5 See *Complete Poems*, ed. Barnard, p. 642.
6 Gittings, *Keats*, p. 399.
7 Ibid., p. 398.

THIRTY

1 See *The Keats Circle* II, ed. Rollins, p. 19. Also Ian Jack, *Keats and the Mirror of Art*, p. 99.
2 Gittings, *Keats*, p. 401.

3 Ibid., pp. 402–3.
4 Ibid., p. 405.
5 It may have been a little earlier. See Bate, *Keats*, p. 437.
6 As Gittings points out, *Keats*, pp. 407–8.
7 Quoted *Complete Poems*, ed. Barnard, p. 645. Barnard gives a useful résumé of these and other sources.
8 Marjorie Levinson, *Keats's Life of Allegory*, p. 108.
9 Like Stillinger, in *The Hoodwinking of Madeline and other essays*.
10 Like Harold Bloom in *The Visionary Company*.
11 Gittings, *The Living Year*, p. 74.
12 Bate, *Keats*, p. 437.
13 J. Seagrave, *The Chichester Guide*, p. 67.
14 Gittings, *Keats*, p. 416. For much of what follows about Stansted Park, I am indebted to Gittings.
15 Ibid., p. 416.

THIRTY-ONE

1 Ward, *Keats*, p. 255.
2 Gittings, as always, is good on Keats's financial dealings, and I have relied on his evidence.
3 Quoted in *Complete Poems*, ed. Barnard, pp. 652–3.
4 *Complete Poems*, ed. Barnard, says 8 March.

THIRTY-TWO

1 The Brawnes may not have arrived in Wentworth Place until June. See Bate, *Keats*, p. 467.
2 Scholars disagree about when Keats first read Burton. Some say it was April 1818; Gittings, Colvin and Forman all say winter 1818.
3 Dryden's 'Ode to Mrs Anne Killigrew' strongly influenced Keats's 'Ode to Psyche'; his other odes helped to shape Keats's use of the same form; his sensuality coloured 'Lamia'; his translations of Ovid affected the Paolo and Francesca sonnet.
4 There are occasional underlinings in other sections of the book, and a few asides. At one point, for instance, when Burton uses the phrase 'pseudo-martyrs', Keats adds: 'The most bigoted word ever met with'.
5 *Conversation with John Frere*. Quoted in Bate, *Keats*, p. 661.
6 The meeting set a seal on the broad similarities between some of their poems. Coleridge possibly added the thought that 'mute still air / Is Music slumbering on her instrument' to 'The Aeolian Harp' after he had read 'Sleep and Poetry'. (See John Barnard, 'An Echo of Keats in "The Eolian Harp"', *Review of English Studies* 28 (1977), pp. 311–13.) Keats remembered the closing lines of 'Frost at Midnight' when completing 'To Autumn', and borrowed from *Sibylline Leaves* in some of his earlier poems, as well as combining Coleridge's ideas about 'negative faith' with Hazlitt's similar notions in his remarks about negative capability.
7 The opening parodies 'The House of Mourning' by John Scott, which Taylor and Hessey had recently published.
8 For variant readings see *Complete Poems*, ed. Barnard, p. 661.
9 See Sperry, *Keats the Poet*, p. 231.
10 In Ovid, Argus guards the lovely nymph Io from Jove, who eventually possesses her. It is Hermes's job to put Argus to sleep.

11 The text I have printed here is the one Keats transcribed for George and Georgiana, minus deletions and corrections. See *Letters*, ed. Rollins, II, pp. 95–6.
12 For a résumé see *Complete Poems*, ed. Barnard, pp. 661–2.
13 See, for instance, De Almeida, *Romantic Medicine*, p. 221.
14 Sperry, *Keats the Poet*, p. 240.
15 For an elaboration of this argument see Anne K. Mellor's essay 'Ideological Cross-dressing', *Romanticism and Gender* (1993), to which I am indebted.
16 As Mellor points out.

THIRTY-THREE

1 As Gittings points out, *Keats*, p. 449.
2 See Mellor, 'Ideological Cross-dressing', p. 97.

THIRTY-FOUR

1 For detailed discussion of the order of composition see *Complete Poems*, ed. Barnard, p. 665. I have moved my discussion of 'Psyche' to follow my remarks about the two sonnets 'To Fame', because although begun earlier it was completed later.
2 Watkins, *Keats's Poetry*, p. 286.
3 Gittings, *Keats*, p. 459.
4 Gittings ascribes 'Indolence' to 4 May 1819, 'since it describes a May morning between showers. This was the only day of such weather in a three week spell' (*Keats*, p. 313). This seems unreasonably precise, since Keats was perfectly well able to describe a May morning at any time he chose.
5 For details see *Complete Poems*, ed. Barnard, pp. 672–88.
6 Ibid., pp. 666–7.
7 Other sources for the poem include Apuleius himself, Spenser's 'Garden of Adonis' from *The Faerie Queene*, and Mary Tighe's *Psyche* (1811). For further details of pictorial influences see Jack, *Keats and the Mirror of Art*.
8 Quoted in *Complete Poems*, ed. Barnard, p. 667.
9 In the notes Keats made during Astley Cooper's anatomical and physiological lectures at Guy's, he had recorded: 'Nerves are composed on numerous Cords – this is still the Case in the smallest. They take a serpentine direction. They arise by numerous branches from the substance of ye Brain.' In *Outlines to a Course of Anatomy* (1815), Joseph Henry Green, Keats's dresser at Guy's and the friend of Coleridge, had discussed – among other phenomena of the brain – 'the Arbor Vitae'.
10 See, for instance, John Bayley, *The Uses of Division*.
11 Helen Vendler, *The Odes of John Keats*, p. 118.
12 See Jack, *Keats and the Mirror of Art*, pp. 214–44.
13 Gittings, *Keats*, p. 136.
14 For further details see *Complete Poems*, ed. Barnard, p. 676.

THIRTY-FIVE

1 Naomi Kirk, *Memoirs of George Keats*, p. 260.
2 Kirk, *The Life of George Keats*, pp. 61–2.
3 Ibid., p. 90.
4 Bate, *Keats*, p. 575.

5 Alexander B. Adams, *Audubon: A Biography*, pp. 180–2.
6 Ibid., p. 183.
7 Kirk, *Life of George Keats*, p. 104.
8 H. B. Feardon, *Sketches of America*, pp. 250–1.
9 Ward, *Keats*, p. 273.
10 Brown's jealousy of Fanny, and his leathery feelings about women generally, are reflected in a counterblast to Smart's *Song of David*, which he was writing at this time.
11 Gittings, *Keats*, p. 475.
12 Bate, in *Keats*. The action may never even have begun, but have been proposed by Abbey as a means of keeping control of the estate.
13 Slote, *Keats and the Dramatic Principle*, p. 109. 'Records of proposed remittances to the author of a tragedy in 1819 show £50 for each of the first three performances, up to a total of £350 for twenty-one nights.'
14 Quoted in Gittings, *Keats*, p. 476.
15 He was, of course, encouraged by Hazlitt's recommendation of Dryden's verse tales.
16 See Gittings, *Keats*, p. 478.

THIRTY-SIX

1 John Buller, *Guide to the Isle of Wight*, p. 25.
2 Bate, *Keats*, p. 536.
3 Gittings, *Keats*, p. 480.
4 Homans, 'Keats Reading Women', *Studies in Romanticism* 29 (Autumn 1990), p. 198. See also Wolfson, 'Keats the Letter-writer'.
5 Samuel Bamford, one of the many survivors of the Peterloo demonstration, published a collection of poems under this title the following year.
6 Quoted in George H. Ford, *Keats and the Victorians*, p. 163.
7 Gittings, *Keats*, p. 484.
8 Quoted in Slote, *Keats and the Dramatic Principle*, p. 108.
9 Ibid.

THIRTY-SEVEN

1 Ward, *Keats*, p. 303.
2 As Gittings points out. Gittings's evocations of Winchester are particularly successful. All subsequent biographies of Keats are bound to be indebted to them.
3 Dilke's grandson subsequently destroyed some of the correspondence between Keats and Fanny. The missing letters may well have been written during this period. See Richardson, *Fanny Brawne*, p. 169.
4 Bate believes Keats wrote *King Stephen* in the first two weeks of November 1819.
5 Gittings, *Keats*, p. 490.
6 Burton's descriptive writing does, however, influence Keats's treatment of the scene.
7 De Almeida, *Romantic Medicine*, p. 196.
8 For a detailed analysis of this point see Watkins, *Keats's Poetry*, pp. 176ff.
9 Levinson, *Keats's Life of Allegory*, p. 259.
10 See Ward, *Keats*, p. 309 for a fuller discussion of how this might relate to Keats's feelings about his mother.

THIRTY-EIGHT

1 For details see *Complete Poems*, ed. Barnard, p. 700.
2 Lionel Trilling, *The Opposing Self*, p. 38.
3 Ibid.
4 Sperry, *Keats the Poet*, p. 136.
5 Such as Coleridge created in his *Lay Sermons*. See Bate, *Keats*, p. 132.
6 Edward Thomas, *Keats*, p. 69.
7 Sperry, *Keats the Poet*, p. 326.
8 Frank Kermode, *The Romantic Image*, pp. 6–8.
9 Ibid.
10 Tooke's *Pantheon* also refers to Moneta's monetary associations. See also *Examiner*, 24 May 1819: 'At home we are alarmed lest the monied men should be panick-struck by the state of the finances; we tremble at the idea of the effect of the resumption of cash payments, and the consequent limitation of the issue of bank-notes, on the commercial body; we dread lest the distress in some parts of the country should drag the people into violence.'
11 Homans, 'Keats Reading Women', p. 356.

THIRTY-NINE

1 Gittings, *Keats*, p. 500.
2 When Woodhouse reported this to Taylor he glossed the word as meaning 'That [feeling] which comes upon us when anything of great tenderness & excessive simplicity is met with when we are not in a sufficiently tender & simple frame of mind to bear it: when we experience a sort of revision, or resiliency (if there is such a word) from the sentiment of expression'.
3 In using these phrases Woodhouse was speaking about Byron's poems in the same terms that Keats himself had used in recent months.
4 Gittings, *Keats*, p. 502.
5 *Examiner*, 7 November 1819.
6 Coote, *Keats*, p. 265.
7 Ward, *Keats*, p. 317.
8 Gittings, *Keats*, p. 502.
9 Abbey's offices in Pancreas Lane were close to the London hatters named Keats.

FORTY

1 In Milton, Robinson, Burdett and Voltaire especially – and also, of course, in the *Examiner*.
2 Christopher Ricks points out that this misspelling creates a pun which suggests blushing.
3 Quoted in Gittings, *Keats*, p. 504.
4 Keats's remarks about Chatterton, English, and Englishness recall his letter to Bailey from Teignmouth (13 March 1818), in which he complained that 'A Devonshirer standing on his own native hills is not a distinct object' and went on: 'I like, I love England, I like its strong Men – Give me a "long brown plain" for my Mornings so I may meet with some of Edmund Ironside's desendants – give me a barren mould so I may meet with some shadowing of Alfred in the shape of a Gipsey, a Huntsman or [a] Shepherd. Scenery is fine – but human nature is finer – The Sward is richer for the tread of a real, nervous, english foot – the eagles nest is finer for the Mountaineer has look'd into it –'
5 See M. Ridley, *Keats's Craftsmanship*, p. 282.

6 Helen Vendler, *The Odes of John Keats*, p. 261.

7 Ward, *Keats*, p. 321.

8 The phrase is Allen Tate's. See 'A Reading of Keats', *The Man of Letters in the Modern World*, p. 195.

9 See Roe's essay 'Keats's Commonwealth', in *Keats and History*.

10 See Andrew Bennett, *Keats, Narrative and Audience*, pp. 159–71.

FORTY-ONE

1 These remarks, like his request that Reynolds help him distinguish between those parts of 'Hyperion' which showed 'the false beauty proceeding from art' and those which expressed 'the true voice of feeling', are a development of others he had made while writing the poem.

2 Hazlitt had already done this for Reynolds.

3 Gittings, *Keats*, p. 518.

FORTY-TWO

1 It is not clear what the story was. Presumably Brown had teased Keats about the interest he had shown in other women during the summer.

2 Ward, *Keats*, p. 330.

3 It is also possible that Hazlitt encouraged Keats at this meeting to 'try the press once more' with his poems. A month later Hazlitt paid Keats the compliment of quoting 'Sleep and Poetry' in the first of his new series of lectures – though after Keats's death he referred to him surprisingly seldom.

4 Gittings, *Keats*, p. 521.

5 Ibid.

6 *Complete Poems*, ed. Garrod, pp. 418–19.

7 See Bate, *Keats*, p. 168.

8 See Gittings, *Keats*, p. 524, and Bate, *Keats*, p. 625.

9 Charles Dilke, *Papers of a Critic* I, p. 1.

10 Ibid.

11 Leonidas M. Jones, *The Life of John Hamilton Reynolds*, p. 115.

12 The diet was also designed to treat consumption, but there is no evidence to suggest that Keats believed he had the disease at this time, and three weeks later he was happily eating meat again.

13 He contemplated a narrative romance based on the story of Elizabeth and Leicester, but never made any progress. He scanned his edition of Holinshed for other play subjects but never found one he liked. He started compiling an index to his copy of John Selden's *Titles of Honour* but gave up after making two entries.

14 Gittings, *Keats*, p. 527.

15 Ibid.

16 As Gittings and others point out.

FORTY-THREE

1 *The Prose of John Clare*, ed. J. W. & Anne Tibble, p. 223.

2 Ibid.

3 *John Clare, Selected Letters*, ed. Mark Storey, p. 17.

4 Ibid., p. 22.
5 Stanzas XII and XVIII, which refer most directly to George IV, were added to the poem as 'an afterthought' (Gittings, *The Mask of Keats*, p. 117).
6 For instance, Gittings, *Keats*, pp. 537–40.
7 Gittings, *Keats*, p. 540.
8 *Examiner*, 3 September 1819.

FOURTY-FOUR

1 *Examiner*, 30 April 1820.
2 Hunt, *Lord Byron*, p. 246. Hunt later mentioned that Keats would often look at his hand and say 'it was the hand of a man of fifty'. The remark connects suggestively with his fragment 'This living hand . . .'.
3 See Kirk, *The Life of George Keats*.
4 Details from Gittings, *Keats*, pp. 548–9, and Bate, *Keats*, pp. 631–2.
5 Gittings, *Keats*, p. 548.
6 Ibid., p. 549.

FORTY-FIVE

1 Kirk, *The Life of George Keats*, p. 98.
2 Ibid., p. 186.
3 Ibid.
4 Ibid., p. 188.
5 Ibid., p. 190.
6 In the Houghton Library, Harvard.
7 Quoted in Kirk, *The Life of George Keats*, p. 183.
8 Ibid., p. 195.

FORTY-SIX

1 Hale-White suggests that he had already started to cough blood on the coach. *Keats as Doctor and Patient*, p. 52.
2 Ward, *Keats*, p. 390, says that Keats referred to consumption as 'the family disease'.
3 See Hale-White, *Keats as Doctor and Patient*, pp. 216–17.
4 R. Keers, *Pulmonary Tuberculosis*, pp. 1–2.
5 Dubos, *The White Plague*, p. 70.
6 Hayle-White, *Keats as Doctor and Patient*, p. 43.
7 H. D. Chalke, 'The Impact of Tuberculosis on History, Literature and Art', *Medical History* 6, 4 (1962), p. 305.
8 Thomas Young, *A Practical and Historical Treatise on Consumptive Disorders* (1815), pp. 46–7.
9 Quoted in Keers, *Pulmonary Tuberculosis*, p. 15.
10 Ibid., p. 15.
11 Richard Morton, *Phythisiologia* (2nd edn, 1720), pp. 74–5.
12 James Clark, *Pulmonary Consumption*, p. 261.
13 Ibid., pp. 224–5.
14 Susan Sontag, *Illness as Metaphor*, p. 13.

15 Quoted in Dubos, *The White Plague*, p. 58.
16 Ibid., p. 62.
17 Quoted in Sontag, *Illness as Metaphor*, p. 22.
18 Quoted in De Almeida, *Romantic Medicine*, pp. 206–7.
19 Morton, *Phythisiologia*, p. 254.
20 Arthur N. Gilbert, 'Diseases in the Nineteenth Century', *Journal of the History of Medicine* 30, 3 (July 1975), p. 219.
21 S. A. Tissot, *Onanism* (3rd edn, 1767), p. 11.
22 Gilbert, 'Diseases', pp. 226–7.

FORTY-SEVEN

1 Paul de Mann, 'Keats and Hölderlin', *Comparative Literature* 8 (Winter 1986), p. 42.
2 In fact these remarks conflated a complicated history. Procter was one of Hunt's protégés, and Hunt originally said he would send Keats a copy of his (Procter's) earlier volume, *Dramatic Scenes*, believing that it owed debts to *Poems* and to *Endymion*. During Keats's absence from London, Hunt had forgotten his promise, and Procter now sent his second volume, *A Sicilian Story*, directly to Wentworth Place. Keats discovered that the title poem of the new collection was a version of the same story that he had treated in 'Isabella'. There was no question of Procter having seen 'Isabella', but the coincidence made Keats feel that he must press ahead with the preparation of his own book, or be made to seem a plagiarist himself. It was when Keats wrote to acknowledge receipt of *A Sicilian Story* that Procter sent him *Dramatic Scenes*.
3 This picture was either Hogarth's 'Credulity, Superstition and Fanaticism', or 'The Sleeping Congregation'.
4 Quoted in Gittings, *Keats*, p. 561.
5 During the previous month, while 'turning over two Volumes of Letters written between Rousseau and two ladies' he had wondered: 'What would Rousseau have said at seeing our little correspondence'. Now, as he told Fanny 'I never felt my Mind repose upon anything with complete and undistracted enjoyment – upon no person but you', he began to relax a little. The Rousseau correspondence he meant was the one with Marie Latour de Francqueville.
6 As Gittings points out (*Keats*, p. 562). Inevitably, my account of Haydon's showing of 'Christ's Entry' owes a good deal to earlier descriptions, by Gittings and others.
7 Quoted in Ward, *Keats*, p. 355.
8 B. R. Haydon, *Autobiography*, p. 377.
9 *Examiner*, 2 September 1820.
10 Haydon, *Autobiography*, p. 377.
11 See Gittings, *Keats*, p. 563. By calling in loans, Keats managed to pay his rent to Brown until the end of March.
12 As Gittings points out, *Keats*, p. 565.
13 See Charles Cowden Clarke's annotated copy of Milnes's *Life*, p. 85 (Brotherton Library, Leeds).

FORTY-EIGHT

1 The phrase is Hogg's.
2 *Hamlet* II, ii, ll. 432–3: 'the play, I remember, pleased not the million; 'twas caviare to the general'.

3 There is a striking paradox here. While self-consciousness enriched the alterations to 'La Belle Dame Sans Merci', the same quality damaged Keats's revisions to several other poems – 'The Eve of St Agnes', notably – by making him overspecific.
4 Quoted in Gittings, *Keats*, p. 567.
5 For details see Gittings, *Keats*, pp. 574–5.
6 For details see Gittings, *Keats*, p. 577.
7 Shelley, *Collected Letters*, ed. W. S. Scott, II, p. 117.
8 Quoted in Bate, *Keats*, p. 645.
9 Lowell, *Keats*, p. 422.
10 *Letters of Charles Armitage Brown*, ed. Stillinger, p. 90.
11 *Keats Circle* II, ed. Rollins, p. 232.
12 Taylor and Hessey first thought of publishing the book as a series of pamphlets costing 2/6 each.
13 *Edinburgh Review* XXXIV, pp. 203–4.
14 *London Magazine* IX, p. 315.
15 Gittings, *Keats*, p. 592.
16 Shelley, *Collected Letters* II, pp. 239–40.

FORTY-NINE

1 Hunt, *Wishing-Cup Papers*, p. 239.
2 Clark believed that 'the sensibility of the nervous system in warm climates is naturally more exalted than in the colder, and the influence of the passions far greater in producing and modifying bodily disease'. *The Influence of Climate*, p. 125.
3 See Gittings, *Keats*, p. 588.
4 Ibid., p. 590.
5 William Sharpe, *The Life and Letters of Joseph Severn*, p. 48.
6 Hewlett, *Adonais*, p. 345.
7 Ibid.
8 See Ward, *Keats*, p. 400.
9 This may have been Brown's copy, not the one Keats purchased himself.
10 Quoted in William Howitt, *The Homes and Haunts of the Most Eminent British Poets*, p. 299.
11 Quoted in Gittings, *Keats*, p. 593.

FIFTY

1 Severn did not realise that Keats was wearing a badge of his illness, a 'blister', inside his shirt. He had put it on before leaving London.
2 Keats said he was 'in a part that he already knew', according to Severn.
3 Quoted in Gittings, *Keats*, p. 601.
4 See my dating, pp. 322–3.
5 Gittings, *Keats*, p. 601.

FIFTY-ONE

1 Hunt, *Autobiography*, p. 269.
2 The quotation is from a song which had been set by Thomas Arne.
3 See Gittings, *Keats*, p. 603.

4 Hunt, *Autobiography*, p. 271.

5 Ibid., p. 268.

6 Ibid., p. 273.

7 Ibid.

8 Ibid.

9 *Examiner*, 24 September 1820.

10 *Examiner*, 12 November 1820.

11 See Gittings, *Keats*, p. 604. The reasons for Keats's rage are similar to those which had prompted him to complain on his voyage about the 'abominable songs' sung by the sailors on the *Maria Crowther*. Then he had felt protective of 'the ladies below in the cabin . . . listening'. Now he was defensive about the fact that the cabin boy was a mere 'beggar'. In both cases, he wanted to shield in others the vulnerabilities that he felt himself.

12 Brown annotated this: 'He [Keats] could not go on with this sentence, not even write the word "quit", – as I suppose.'

FIFTY-TWO

1 See Bibliography. Clark returned from Rome to London in 1826, publishing a number of papers, including one on consumption. In 1837 he became first physician to Queen Victoria, and although he bungled the diagnosis of one of her ladies-in-waiting, he died in 1876 a well-liked and widely respected figure.

2 Quoted in Tim Hilton, *Keats and his World*, p. 147.

3 According to Gittings, *Keats*, p. 604.

4 Severn obviously found Anna Angeletti daunting, later referring to her as 'an old Cat'. A less timorous witness described her as a 'lively, smart, handsome little woman [who] has two nice daughters . . . [and] has much taste for the fine arts'. See Bate, *Keats*, p. 673.

5 Gittings, *Keats*, p. 610.

6 In old age, Severn wrote '[Keats said] "Now you'll see . . . that we'll have a decent dinner", and sure enough in less than half an hour one came, and we continued to be similarly well-treated every day.' (Sharpe, *Life*, p. 67.)

7 Clark also arranged for Severn to meet the sculptor John Gibson. When Severn entered Gibson's studio he came across Lord Colchester, who was also visiting. Gibson seized Severn by the arm and drew him forwards, treating him as an equal. Severn said later: 'If Gibson, who is a great artist, can afford to do such a thing, then Rome is the place for me.' (Sharpe, *Life*, p. 65.)

8 Keats had reread the Sabrina passage from *Comus* on board the *Maria Crowther*.

9 Keats, on one of these walks, joked that a tucked-away fountain was 'a corner watering out of revenge for watering in a corner'.

10 Gittings, *Keats*, p. 614.

11 It is possible that some or all of these books were chosen by Severn as being suitable for Keats to read or hear. *Letters* II, p. 369, makes Jeremy Taylor sound like Severn's idea.

12 Bate, *Keats*, p. 686.

FIFTY-THREE

1 Bate, *Keats*, p. 695.

2 Keats had originally asked Severn to sketch a lyre in April 1820, which suggests that he was convinced, even at this early stage in his illness, that he was bound to die. Severn did the drawing on the third page of Brown's copy of *Endymion*. He later had a brooch made of a

half-strung lyre, threaded with hair from Keats's head. He intended to give it to Fanny Brawne, but in fact presented it to his daughter as a wedding present.

3 For details see Oonagh Lahr, 'Greek Sources of "Writ in Water" ', *Keats-Shelley Journal* XXI–XXII (1972–3), p. 17.

4 Fanny Keats later married Valentín Llanos. In the 1830s, when a political amnesty had been declared in Spain, they went to live there. They had three sons and three daughters, but their eldest son and daughter died in infancy. They never returned to England. Fanny died in 1889, and was buried in Madrid.

5 Hillas Smith, *Keats and Medicine*, p. 114.

6 See Ward, *Keats*, p. 411.

7 Ibid.

8 George Keats was astonished to learn that Jane Reynolds, who had grown increasingly crabby with age, 'captivated so facetious a genius' as Hood.

9 Ward, *Keats*, p. 413.

10 Ibid.

11 For further details of Keats's less well-known friends – those whose afterlives are not sketched in my text – I am indebted to *The Letters of John Keats*, ed. Rollins.

ABBEY suffered serious financial losses before 3 June 1824, when Fanny Keats came of age, and was unable (or unwilling) to settle her estate. According to Adami, Dilke 'came to her help and dealt with Abbey firmly enough to obtain all that belonged to her' (*Fanny Keats*, p. 117). By 1827, Abbey was in debt to Fanny Keats's lawyer James Rice, and her trustee Dilke. He had left Walthamstow by 1831 and went to live in London, where he worked as a coffee and tea dealer. He died in 1837.

BAILEY ended his correspondence with Keats in August 1819, four months after he had married Hamilton Gleig. Bailey held a country parish at Dallington in Northamptonshire from 1819–22, and thereafter at Gayhurst, Stoke Goldington, and Burton-on-Trent. In 1827 his wife's bad health led him to spend a year in France. After living briefly near Margate, he became senior Colonial Chaplin in Colombo, where he was eventually appointed Archdeacon. He returned to London in 1852, and died the following year.

CHARLES COWDEN CLARKE saw Keats only occasionally after going to live in Ramsgate in 1817. He returned to London in 1821, and in 1825 began a bookselling and publishing business with Henry Leigh Hunt. This failed four years later, and Clarke began to work as a music publisher with Joseph Alfred Novello, son of Vincent. In 1828 he married Vincent's daughter Mary. From 1834–56 he was 'a popular lecturer on literary subjects' (*Letters*, I, p. 72), and, like his wife, published many volumes in the same field. In 1856 they moved to Nice, and in 1861 to Genoa, where he died in 1877.

DILKE supervised the financial affairs of Fanny Keats and Fanny Brawne after Keats's death, and also kept in friendly contact with George. He bought 'financial control' (*Letters*, I, p. 74) of the *Athenaeum* in 1828, and full control two years later, editing it until 1846. His wife Maria died in 1850, after which Dilke lived with his son in Sloane Street, central London, and wrote a number of important literary studies. He retired to Hampshire in 1862, and died there in 1864.

HASLAM moved from London to Hampshire after his wife died in 1822. He continued to work as a solicitor, married again, had a daughter, and died in 1851, 'broken by business and financial straits' (*Letters*, I, p. 76).

RICE continued to work as an attorney with his father until going into partnership with Reynolds in the early 1830s. They acted – unhappily and unsatisfactorily – as solicitor for Fanny Keats, her husband, and George Keats. Rice was never well, retired in 1832, and moved with his father to Putney, where he died aged forty.

TAYLOR set up a new publishing office at 13 Waterloo Place in April 1821, after buying the

London Magazine, leaving HESSEY to run the Fleet Street business. Their partnership was dissolved in 1825. Hessey remained a bookseller in Fleet Street until 1829, when he went bankrupt. By 1834 he was in charge of a school in Hampstead, and after retiring he moved to Wiltshire, where he died in 1870. Taylor wrote books on Junius, currency, banking and scriptural subjects throughout the 1820s and 1830s, and retired from publishing in 1853. He died in London in 1864.

WOODHOUSE added steadily to his collection of Keatsiana after Keats had died. He commissioned Hilton to paint a posthumous portrait, and Girometti to make the medallion which now hangs in Keats House in Hampstead. In 1829 he developed tuberculosis and went to the Continent, staying with Brown in Florence in 1832. He died in London in 1834, and was buried in the Temple churchyard aged forty-five.

12 Ward, *Keats*, p. 413.
13 Haydon lived until 22 June 1846, when he incompetently and painfully committed suicide.
14 For a full account of this extraordinary episode, see Jones, *The Life of John Hamilton Reynolds*, pp. 217–25.
15 *Blackwood's* XI (March 1822), p. 346.
16 Quoted in Hewlett, *Adonais*, p. 186. De Quincey was more forgiving about the 1820 volume.
17 *Critical Heritage*, ed. G. M. Matthews, p. 326.
18 *New Monthly* III, 1 (May 1821), p. 256.
19 In *Lord Byron*. Dilke called this 'a sad tweedling book', and George Keats was 'extremely sorry that poor John's name should go down to posterity with the littleness of Leigh Hunt'. For further details of Hunt's life see Blainey, *Immortal Boy*.
20 *Critical Heritage*, ed. G. M. Matthews, p. 295.
21 Dilke called the memoir that Brown eventually produced 'No memoir of Keats, but a memoir of Brown in his intercourse with Keats – or rather a dream on the subject'.
22 Such as Walter Savage Landor.

FIFTY-FOUR

1 Ford, *Keats and the Victorians*, p. 19.
2 *Critical Heritage*, ed. G. M. Matthews, p. 273.
3 The growth of Keats's reputation depended greatly on the approval of a female audience. But just as Victorian readings of his poetry denied its political charge, so they also made its pagan sensuality conform to a more sedate aesthetic. The effect, paradoxically, was to emphasise his 'effeminacy', making him seem especially sympathetic to the very readers he had gone out of his way to repudiate. The biographies written by Amy Lowell, Blanche Williams and Dorothy Hewlett show the tendency persisting into more recent times.
4 Ford, *Keats and the Victorians*, p. 44.
5 Ibid., p. 32.
6 Guy Murchie, *The Spirit of Place in Keats*, p. 251.
7 See Karl Miller, *Doubles*, p. 177.
8 Quoted in James Knowlson, *Damned to Fame: The Life of Samuel Beckett*, p. 133. John Barnard has pointed out to me that William Carlos Williams and Wallace Stevens also both admired *Endymion*.

BIBLIOGRAPHY

This is a selective bibliography. Except in especially important cases, I have excluded works by or biographies of those who appear in Keats's story.

EDITIONS

The Poems of John Keats, ed. Miriam Allott (1970, 2nd imp., 1972)
John Keats: The Complete Poems, ed. John Barnard (Harmondsworth, 2nd edn., 1976)
John Keats, ed. Elizabeth Cook (Oxford, 1990)
John Keats: Selected Poems, ed. Nicholas Roe (1995)
John Keats: Complete Poems, ed. Jack Stillinger (Cambridge, Mass. and London, 1978)

Letters of John Keats, ed. Robert Gittings (Oxford, 2nd edn., 1975)
The Letters of John Keats 1814–21, ed. Hyder E. Rollins (2 vols, Cambridge, Mass., 1958)

The Keats Circle: Letters and Papers 1816–1878, ed. Hyder E. Rollins (2 vols, Cambridge, Mass., 1948)
More Letters and Poems of The Keats Circle, ed. Hyder E. Rollins (Cambridge, Mass. 1955)

BIOGRAPHY

Bate, W. J., *John Keats* (Cambridge, Mass., 1963)
Coote, Stephen, *John Keats: A Life* (1995)
Gittings, Robert, *John Keats* (1968)
Ward, Aileen, *John Keats: The Making of a Poet* (1963)

CRITICISM AND BACKGROUND

Adami, Marie, *Fanny Keats* (1937)
Albin, John, *A Companion to the Isle of Wight* (1818)
Albrecht, W. P., *Hazlitt and the Creative Imagination* (Lawrence, 1965)
Altick, Richard, *The Cowden Clarkes* (Oxford, 1948)
Anderson, Erland, *Harmonious Madness* (Salzburg, 1975)
Armstrong, Isobel, *Victorian Poetry: Poetry, Poetics and Politics* (1993)
Ashton, Rosemary, *The Life of Samuel Taylor Coleridge* (1996)
Aske, Martin, *Keats and Hellenism* (Cambridge, 1985)
Asquith, Betty, *Keats* (1941)
Baker, Jeffrey, *Keats and Symbolism* (1986)
Barnard, John, 'Keats's Tactile Vision', *Keats-Shelley Memorial Bulletin* 33 (1982)
– *John Keats* (Cambridge, 1987)
– 'Byron's Use of *Endymion* in *Don Juan* Canto I', *Keats-Shelley Review* 3 (1988)
– 'Keats's Robin Hood, John Hamilton Reynolds, and the "Old Poets" ', *Proceedings of the British Academy* LXXV (1989)
Barrell, John, *The Idea of Landscape and the Sense of Place* (Cambridge, 1972)
Bate, W. J. (ed.), *Keats: A Collection of Critical Essays* (Princeton, 1964)
Baudry, Francis, 'A Dream, a Sonnet and a Ballad: The Path to Keats's "La Belle Dame Sans Merci" ', *Psychoanalytic Quarterly* LV, 1 (1986)
Bayley, John, *The Uses of Division* (1976)

Bennett, Andrew, *Keats, Narrative and Audience: The Posthumous Life of Writing* (Cambridge, 1994)
Birkbeck, Morris, *Notes on a Journey in America* (1817)
Birkenhead, Sheila, *Against Oblivion: The Life of Joseph Severn* (1943)
Blackstone, Bernard, *The Consecrated Urn* (1959)
Blainey, Ann, *Immortal Boy: A Portrait of Leigh Hunt* (1985)
Bland, D. S., 'Poussin and English Literature', *Cambridge Journal* (November, 1952)
Bloom, Harold, *The Visionary Company* (rev. edn, 1971)
– (ed.), *Modern Critical Views: John Keats* (New York, 1985)
Blunden, Edmund, *Leigh Hunt and his Circle* (1930)
– *Votive Tablets* (1931)
– *Keats's Publisher: A Memoir of John Taylor* (1936)
Bouce, Paul-Gabriel, *Sexuality in Eighteenth Century Britain* (Manchester, 1982)
Boulton, William, *The Amusements of Old London* (1901)
Bradley, A. C., *Oxford Lectures on Poetry* (1909)
Brannon, George, *The Pleasure-Visitor's Companion in Surveying the Isle of Wight* (Isle of Wight, 1833)
Bree, Robert, *A Practical Inquiry into Disordered Respiration* (1815)
Briggs, Asa, *How They Lived* (Oxford, 1969)
– *William Cobbett* (Oxford, 1967)
Brock, R. C., *The Life and Work of Astley Cooper* (Edinburgh, 1952)
Bromwich, David, *Hazlitt: The Mind of a Critic* (Oxford, 1985)
Brooks, Cleanth, *The Well Wrought Urn* (New York, 1947)
Brown, Charles Armitage, *The Life of John Keats*, ed. Dorothy Hyde Bodurtha (Oxford, 1937)
Burke, Edmund, *The Sublime and the Beautiful* (1756)
Burnet, W., *History of his Own Time* (2 vols, 1724 & 1734)
Bush, Douglas, *John Keats: His Life and Writings* (1966)
Bushnell, Nelson S., *A Walk After John Keats* (New York, 1936)
Butler, Marilyn, *Romantics, Rebels and Reactionaries* (Oxford, 1981)
Cameron, H. C., *Mr Guy's Hospital* (1954)
Carrington, N. T., *The Teignmouth, Dawlish and Torquay Guide* (Teignmouth, 1829)
Caudwell, Christopher, *Illusion and Reality* (1937)
Chilcott, Tim, *A Publisher and his Circle* (1972)
Christiansen, Rupert, *Romantic Affinities* (1988)
Clark, James, *A Treatise on Pulmonary Consumption* (1837)
Clarke, Charles Cowden, 'Recollections of Keats', *Atlantic Monthly* VII (1861)
Clarke, Charles and Mary Cowden, *Recollections of Writers* (1878)
Clarke, James Freeman, 'The Character of the late George Keats', *The Dial* (April 1843)
Clive, John, *Scotch Reviewers: The Edinburgh Review 1802–1815* (1957)
Colley, Linda, *Britons: Forging the Nation 1707–1837* (New Haven, 1992)
Colvin, Sidney, *John Keats* (1917)
Cooper, Bransby Blake, *The Life of Sir Astley Cooper* (2 vols, 1844)
Culcross, James, *The Three Rylands* (1897)
De Almeida, Hermione, *Romantic Medicine and John Keats* (Oxford, 1991)
Dickstein, Morris, *Keats and his Poetry: A Study in Development* (Chicago, 1971)
Dilke, Charles Wentworth, *The Papers of a Critic* (2 vols, 1875)
Dubos, Jean, *The White Plague: Tuberculosis, Man and Society* (Rutgers, 1952)
Dyer, George, *Poetics* (1812)
Edgecombe, Fred (ed.), *Letters of Fanny Brawne to Fanny Keats 1820–24* (Oxford, 1936)
Emsley, Clive, *British Society and the French Wars* (1979)

Ende, Stuart A., *Keats and the Sublime* (New Haven, 1976)

Evans, Ifor, *Keats* (1894)

Everett, Barbara, *Poets in their Time* (1986)

Evert, Walter, *Aesthetic and Myth in the Poetry of Keats* (1965)

Feardon, Henry Bradshaw, *Sketches of America* (1818)

Fenner, Theodore, *Leigh Hunt and Opera Criticism* (1972)

Finney, Claude Lee, *The Evolution of Keats's Poetry* (2 vols, Cambridge, Mass., 1936)

Ford, George H., *Keats and the Victorians* (1962)

Forman, Maurice Buxton (ed.), *Some Letters and Miscellanea of Charles Brown* (1937)

Foucault, Michel, *Power/Knowledge: Selected Interviews*, ed. Colin Gordon (Brighton, 1980)

Garrod, H. W., *Keats* (1926)

Gill, Stephen, *William Wordsworth: A Life* (1989)

Gittings, Robert, *John Keats: The Living Year* (1954)

– *The Mask of Keats* (1956)

– *The Keats Inheritance* (1964)

Goellnicht, Donald C., *The Poet-Physician: Keats and Medical Science* (Pittsburgh, 1984)

Hale-White, William, *Keats as Doctor and Patient* (1938)

Halevy, Eric, *A History of the English People in 1815* (1937)

Hamilton, James W., 'Object Loss, Dreaming, and Creativity', *The Psychoanalytic Study of the Child* XXIV (1969)

Hancock, A. E., *John Keats: A Literary Biography* (1908)

Hartman, Geoffrey, *The Fate of Reading* (Chicago, 1975)

Harvey, A. D., *Sex in Georgian England* (1994)

Haydon, Benjamin Robert, *Autobiography*, ed. Alexander Penrose (1927)

Hayter, Alethea, *A Sultry Month: Scenes of London Literary Life in 1846* (2nd imp., 1992)

Hazlitt, William, *Complete Works*, ed. P. P. Howe (21 vols, 1930–4)

Hewlett, Dorothy, *The Life of John Keats* (3rd edn., 1970)

Hilton, Timothy, *Keats and his World* (1971)

Hobsbawm, E. J., *The Age of Revolution: Europe 1789–1849* (1988)

Holmes, Edward, *The Life of Mozart* (1845)

Holmes, Richard, *Shelley: The Pursuit* (1974)

– *Coleridge: Early Visions* (1989)

Homans, Margaret, 'Keats Reading Women, Women Reading Keats', *Studies in Romanticism* 29 (Autumn 1990)

Hughes, Graham, *Robert Hall* (1961)

Hunt, Leigh (ed.), *The Examiner*, 1808–21

– *Lord Byron and Some Contemporaries* (1828)

– *Autobiography* (revised edn., 1891)

Jack, Ian, *Keats and the Mirror of Art* (Oxford, 1967)

Jones, Elizabeth, 'The Suburban School: Snobbery and Fear in the Attacks on Keats', *The Times Literary Supplement* (27 October 1995)

Jones, John, *John Keats's Dream of Truth* (1969)

Jones, Leonidas M. (ed.), *Selected Prose of John Hamilton Reynolds* (Cambridge, Mass., 1966)

– (ed.), *The Letters of John Hamilton Reynolds* (Lincoln, 1973)

– *The Life of John Hamilton Reynolds* (Hanover, 1984)

Jones, Stanley, *Hazlitt: A Life* (1989)

Kaufman, Paul, *The Leigh Browne Collection at the Keats Museum* (1962)

Keers, R. Y., *Pulmonary Tuberculosis* (1978)

Kenyon, Katherine M. R., *Keats in Winchester* (Winchester, 1946)

Kermode, Frank, *Romantic Image* (1957)

Kinkaid, John, *William Hazlitt: Critic of Power* (New York, 1978)

Kirk, Naomi J., 'The Life of George Keats', unpublished thesis (Carpenter Library, Columbia University, 1933)

– 'Memoir of George Keats', *The Poetical Works and Other Writings of John Keats*, ed. H. B. Forman and M. B. Forman (1938–9)

Kucich, Greg, *Keats, Shelley, and Romantic Spenserianism* (1991)

Larrabee, Stephen, *English Bards and Grecian Marbles* (New York, 1943)

Lau, Beth, *Keats's Reading of the Romantic Poets* (Ann Arbor, 1991)

Leavis, F. R., *Revaluations* (1936)

Levinson, Marjorie, *Keats's Life of Allegory* (Oxford, 1988)

Lowell, Amy, *John Keats: A Biography* (2 vols, 1925)

Loudon, Irvine, *Medical Care and the General Practitioner* (Oxford, 1986)

MacAlpine, Aiden and Richard Hunter, *George III and the Mad Business* (2nd edn., 1993)

Macilwain, George, *Memoirs of John Abernethy* (1853)

Mann, Paul de, 'Keats and Hölderlin', *Comparative Literature* 8 (Winter 1956)

Marquess, William H., *Lives of the Poet: The First Century of Keats Biography* (1985)

Matthews, G. M. (ed.), *Keats: The Critical Heritage* (1971)

Matthews, Henry, *The Diary of an Invalid* (1820)

McCormick, E. H., *The Friends of Keats: A Life of Charles Armitage Brown* (Victoria, 1989)

McGann, Jerome J., 'Keats and the Historical Method in Literary Criticism', *Modern Language Notes* XCIV (1979)

– *The Romantic Ideology: A Critical Investigation* (Chicago, 1983)

– *The Beauty of Inflections: Literary Investigations in Historical Method and Theory* (Chicago, 1985)

Mellor, Anne K., *Romanticism and Feminism* (Bloomington, 1988)

– 'Ideological Cross-dressing: John Keats/Emily Brontë', *Romanticism and Gender* (1993)

Miller, Barnette, *Leigh Hunt's Relationship with Byron, Shelley and Keats* (Colombia, 1910)

Miller, Karl, *Doubles: Studies in Literary History* (Oxford, 1985)

Monckton Milnes, Richard, *Life, Letters and Literary Remains of John Keats* (2 vols, 1848)

Morris, R. J., *Class and Class Consciousness in the Industrial Revolution* (1979)

Muir, Kenneth (ed.), *John Keats: A Reassessment* (Liverpool, 1958)

Murry, John Middleton, *Keats and Shakespeare* (1925)

– *Studies in Keats* (1930)

– *Keats* (1955)

Newman, William, *Rylandia: Reminiscences Relating to the Rev. John Ryland* (1835)

Owen, John B., *The Eighteenth Century* (1974)

Ortig, Richard, *The Cowden Clarkes* (Oxford, 1948)

Park, Roy, *Hazlitt and the Spirit of the Age* (Oxford, 1971)

Parrinder, Patrick, *Authors and Authority* (1977)

Passmore, John A. (ed.), *Priestley's Writing on Philosophy, Science and Politics* (New York, 1965)

Patterson, Charles I., *The Daemonic in the Poetry of John Keats* (Chicago, 1970)

Peterson-Krag, Geraldine, *The Lurking Keats* (New York, 1984)

Pirie, David, 'Keats', *The Penguin History of Literature: The Romantic Period* (Harmondsworth, 1994)

Pite, Ralph, *The Circle of our Vision* (Oxford, 1994)

Plumb, J. H., *England in the Eighteenth Century* (Harmondsworth, 1950)

Porter, Roy, *English Society in the Eighteenth Century* (Harmondsworth, 1990)

– *Mind-forg'd Manacles* (Harmondsworth, 1987)

Redpath, Theodore, *The Young Romantics and Critical Opinion 1807–1824* (1973)

Reed, Michael, *The Georgian Triumph* (1983)
Richardson, Joanna, *Fanny Brawne: A Biography* (1952)
– *The Everlasting Spell* (1963)
– *Keats and his Circle* (1980)
Ricks, Christopher, *Keats and Embarrassment* (Oxford, 1976)
Ridley, M. R., *Keats's Craftsmanship: A Study in Poetic Development* (Oxford, 1933)
Robinson, Dwight E., 'Notes on the Antecedents of John Keats: the Maritime Hypothesis',
 Keats-Shelley Journal XXXIV (1985)
Robinson, William, *The History and Antiquities of the Parish of Edmonton* (1819)
Roe, Nicholas, 'Keats's Lisping Sedition', *Essays in Criticism* XLII, 1 (January 1992)
– (ed.), *Keats and History* (Cambridge, 1995)
– *John Keats and the Culture of Dissent* (Cambridge, 1997)
Ross, Marlon B., *The Contours of Masculine Desire* (Oxford, 1989)
Rude, George, *Hanoverian London* (1971)
Rule, John, *Albion's People: English Society 1714–1815* (1992)
– *The Vital Sanctuary: England's Developing Economy 1714–1815* (1992)
Ryan, Robert M., *Keats: The Religious Sense* (Princeton, 1976)
Ryland, John, *An Address to the Ingenious Youth of Great Britain* (1792)
Sales, Roger, *Literature in History 1780–1830* (1983)
Schor, Esther, *Bearing the Dead: The British Culture of Mourning* (Princeton, 1994)
Scott, Grant F., *The Sculpted Word: Keats, Ekphrasis and the Visual Arts* (Hanover, 1994)
Sharp, Ronald A., *Keats, Scepticism, and the Religion of Beauty* (Georgia, 1979)
Sharpe, William, *The Life and Letters of Joseph Severn* (1892)
Slote, Bernice, *Keats and the Dramatic Principle* (Nebraska, 1958)
Smith, Hillas, *Keats and Medicine* (1995)
Sontag, Susan, *Illness as Metaphor* (2nd imp., Harmondsworth, 1979)
South, John Flint, *Memorials* (1884)
Southey, H. H., *Observations on Pulmonary Consumption* (1814)
Sperry, Stuart M., *Keats the Poet* (Princeton, 1973)
Spurgeon, Caroline, *Keats's Shakespeare* (1929)
Stillinger, Jack (ed.), *The Letters of Charles Armitage Brown* (Cambridge, Mass., 1966)
– *The Hoodwinking of Madeline and Other Essays* (Illinois, 1971)
– *John Keats: Poetry Manuscripts at Harvard* (Cambridge, Mass., 1990)
Thomas, Edward, *Keats* (1914)
Thompson, E. P., *The Making of the English Working Class* (London, 1963)
Thornton, John L., *John Abernethy* (1953)
Thorpe, Clarence D., *The Mind of John Keats* (Oxford, 1926)
– 'Keats's Interest in Politics and World Affairs', *The Modern Language Association of America*
 (December 1931)
Tissot, M., *Onanism, or, A Treatise upon the Disorders Produced by Masturbation* (3rd edn.,
 1767)
Trilling, Lionel, *The Opposing Self* (1955)
Walker, Carol Kyros, *Walking North With Keats* (Boston, 1992)
Wallace, Anne D., *Walking, Literature, and English Culture* (Oxford, 1993)
Wasserman, Earl R., *The Finer Tone: Keats's Major Poems* (Baltimore, 1953)
Watkins, Daniel P., *Keats's Poetry and the Politics of the Imagination* (1989)
White, R. S., *Keats as a Reader of Shakespeare* (1987)
Wilbur, George B. and Werner Muensterberger (eds), *Psychoanalysis and Culture* (New York,
 1951)
Winegarten, Renee, *Writers and Revolution* (New York, 1974)

Wingent, R. M., *The Borough and the Borough Hospitals* (1913)
Woodring, Carl, *Politics in English Romantic Poetry* (Cambridge, Mass., 1970)
Wolfson, Susan J., 'Keats the Letter-writer: Epistolatory Poetics', *Romanticism Past and Present* 6, II, 2 (1982)
– 'Keats's "Isabella" and the "Digressions" of Romance', *Criticism* XXVII, 3 (Summer 1985)
– *The Questioning Presence: Wordsworth, Keats, and the Interrogative Mode in Romantic Poetry* (1986)
– (ed.), 'Keats and Politics: A Forum', *Studies in Romanticism* 25, 2 (1986)
– 'Keats and the Manhood of the Poet', *European Romantic Review* 6, 1 (1995)
Vendler, Helen, *The Odes of John Keats* (Cambridge, Mass., 1983)
Young, Thomas, *A Practical and Historical Treatise on Consumptive Diseases* (1915)

Index

Leaf', 146; on Frances Keats, 9; friendship
with K, xix–xx, 51, 69, 87, 103, 105, 155,
188, 194, 347–8; on Haydon, 354; on
Hazlitt, 124–5; on his father's philosophy,
24; K first shows one of his poems to, 67; K
reads part of *Endymion* to, 184; on King
Alfred and Milton, 54–5; and K's
apprenticeship, 46, 49, 50–51; and K's
choice of publisher, 141; and K's
depression, 94; K's master-principle, xviii;
and K's *Poems*, 153; and K's reading, 37,
38, 39, 50–56; and K's studies at Guy's
Hospital, 80, 97; on K's tears while reading
Shakespeare, 71; the language of his poetry,
55–6; meets Hunt, 56, 62; and Milnes'
biography of K, 576; and 'On First
Looking into Chapman's Homer', 111–12;
and politics, 33, 54, 63; recommends
Margate, 99; and Richards, 140–41; on
Ryland's 'pulpit eloquence', 28; and the
search for immortal 'Fame', 55; sheltering
influence on K, 65; shows Hunt some Keats
poems, 105, 107, 108; stays with his sister
in Clerkenwell, 105; on Thomas Keats, 9;
and Vincent Novello, 158; 'Left upon
Milton's Tomb in Westminster Abbey',
55; 'The Nightingale', 55; *Recollections of
Writers*, 54, 56, 182; 'Sunset', 55
Clarke, James Freeman, 493
Clarke, John, 39; appearance, 26; atmosphere
of his school, 22–3; Charles on his father's
philosophy, 24; and K's pugnacity, 33;
liberal politics, 29; his library, 37; and
poetry, 29; and Priestley, 27; and religious
instruction, 28; retires to Margate, 100;
teaches at Northampton, 26–7
Clarke, Mary (née Novello), 159
Clarke family, 33, 34, 35, 69
Clarke's School, Enfield, *see* Enfield, John
Clarke's school
Classicism, 525; Haydon and, 118;
Wordsworth and, 121
Claude Lorraine, 107, 117, 159, 246; 'The
Enchanted Castle', 245; 'Landscape with
the Father of Psyche', 245; 'The Sacrifice
to Apollo', 391
Clerkenwell, 105, 109
Clerkenwell Volunteers, 7
Cline, Henry, 83, 84
Cline, Henry, junior, 77, 86
Clink Prison, Southwark, 74
Clough, Arthur Hugh, 574
Clyde River, 286
Coach and Horses inn, near the Strand, 324
Cobbett, William, xviii, 12, 56, 336, 492, 508
Cobbett's Political Register, 56, 117

Cochrane, Thomas, 10th Earl of Dundonald,
410
'Cockney School', 204, 300
Coldbath Fields, 61
Coleridge, Samuel Taylor, 37, 57, 86, 261,
338, 369, 373, 387, 423, 483, 492, 576; on an
'age of anxiety', 16; appearance, 366; and
Chatterton, 68; and contemporary
reviewing, 302; encounter with K on
Hampstead Heath, 365–7, 395; and Hazlitt,
123, 124; Hunt attacks, 59, 143; influences
K, 218, 370; and negative capability, 217–
18; and Pantisocracy, 241; on Priestley, 27;
and radicalism, xxi; and Taylor and
Hessey, 156; and vitalism, 82; Wordsworth
and, 219; 'Christabel', 57; 'Kubla Kahn',
370, 371; 'Ode to Dejection', 201; *Remorse*,
412; 'The Rime of the Ancient Mariner',
546; *Sibylline Leaves*, 201
College Street, London (no. 25), 467, 469,
471
Collins, Wilkie, 106, 227
Colne, Lancashire, 7, 8, 44
Colomba, St, 291
Colvin, Sidney, xx, xxi
Colyton, near Sidmouth, 187
Company of Grocers, 47
Conder, Josiah, 154
Congregationalists, 12
Congress of Vienna, 59, 68
Congreve, William, *The Way of the World*,
323
Constable, Archibald, 204
consumption (tuberculosis), 497–500, 502
Convention, the, 12
Cook, Mrs (boarding house keeper), 168, 173
Cooper, Sir Astley, xxv, 74, 77, 80, 81, 82, 83,
93, 98, 131; and Abernethy, 81, 82–3;
admired as a lecturer, 85; honours, 84–5;
influences K, 85–6; K attends his lectures,
77, 80; and Lucas, 93; and mercury
administration, 196; personality, 85;
radicalism, 83–4, 85
Cooper, Edward, 34
Cooper, George, 74, 90, 98
Cooper, William, 83
Copenhagen Fields, East London, 12
Corfe, Dorset, 4
Corn Law riots, 67
Corn Laws, xviii, 165
Cornwall, Barry (pseud. of B. W. Proctor),
115, 507, 508, 510, 512; *Dramatic Scenes*,
412
Corresponding Societies, 12
Cortez, Hernando, 112, 113
Corunna, Battle of, 35

Chatterton and, 457; Hazlitt on, 126, 227; and *Hyperion*, 309, 314, 317, 330, 361, 419; and the 'immortal dinner', 219, 220; K reads, 253, 309, 378; and Poussin, 245; radicalism, 155; and Wordsworth, 254; *Paradise Lost*, 38, 53, 305, 309, 314, 419, 463; *Samson Agonistes*, 265

Mineralogical Foundation, 18

Ministry of All the Talents, 35

Monckton Milnes, Richard, lst Baron Houghton, ix, 151, 495, 516, 569, 574–5; *Life, Letters and Literary Remains of John Keats*, xix–xx

Monkhouse, Thomas, 215, 219, 221, 260, 518

Montague, Elizabeth, 199

Moore, Sir John, 14

Moore, Peter, 235

Moore, Thomas, 59, 61, 153, 499; *Anacreon* (translation), 132

Moorfields (now Finsbury Pavement), 6–7, 21, 23

Morning Chronicle, 123, 303, 494

Morning Post, 60

Mortimer Terrace, Kentish Town (no. 13), 512, 519, 525, 526

Moses, Henry, *A Collection of Antique Vases, Altars, Paterae*, 391

Mozart, Wolfgang Amadeus, 34, 35, 159, 307

Muggletonians, 12

Mull, Isle of, 289–92, 295, 298

Mullins, Miss, 344

Murray, John, 19, 156, 448

Nag's Head, Wythburn, 270

Naples, 532, 541, 544, 546, 548, 550–2

Napoleon, Princess Pauline, 555

Napoleon Bonaparte, 10, 13, 35, 58, 59, 67, 224, 312, 315, 451, 493, 547

Napoleonic Wars, xxiii, 547

Nash, John, 16, 168

National Assembly (France), 84

National debt, 14

National Gallery, London, 18–19

Naumachia (August 1814), 64, 182

Nelson, Horatio, Viscount, 15, 35, 207

Neoclassicism, 150, 151, 160

New Monthly, 571

New Zealand, discovery of, 15

Newman, William, 37

Newmarch, Henry, 91, 144

Newport, Isle of Wight, 167–8, 413, 536-7

Newton, Sir Isaac, 219, 220, 510

Newton Stewart, Scotland, 265, 277

Nonconformist religions, growth of, 12

Nore mutiny (1797), 16

Norfolk, Duke of, 214

North, Christopher, 154

North Wales, 263

Northampton, John Ryland's school, 25–8

Northcote, James, 510

Nottingham, 12

Novello, Vincent, 19, 34, 158, 328, 365, 512; appearance, 159; background, 158; Catholicism, 159; music parties, 159; personality, 159; at the Portuguese Church, 116–17, 158

Novello family, 158, 159, 329

Oak Inn, Keswick (now the Royal Oak Hotel), 271

Oban, 289, 290, 292, 293

'Observator' (Christopher North), 154

Observer newspaper, 19

O'Callaghan, Donat, 180, 181, 332

O'Donaghue, Abigail, 477, 486, 495, 508, 511, 531, 557

O'Hara, James, 555

Ollier, Charles, 117, 130, 140, 141, 145, 146, 153, 156, 158

Ollier, James, 117, 130, 140, 141, 146, 156, 158

Orel House, Hampstead, 324

Ossian, 68

Ovid, 189

Owen, Robert, 90

Owen, Wilfred, 577

Oxford: Bailey offers K a second stay, 257; K visits, 188–9, 191, 197, 199, 299, 378

Oxford Street, London (no. 240), 158

Oxford Union, 573

Oxford University and City Herald, 258

Paddington, London, 107

Paine, Thomas, 12, 27

Paley, William, *Natural Theology*, 17

Pantisocracy, 241

Pater, Walter, 576

Patmore, Coventry, 114, 574

Payne, Howard, 493

Peace of Amiens (1802), 13

Peace of Paris (1815), 59, 63, 64

Peacock, Thomas Love, 137; *Headlong Hall*, 18

Peay family, 492

Peel, Sir Robert, 7, 22

Penn, William, 54

Pentridge Riots, 143, 335

Perceval, Spencer, 13, 22, 35, 59

Percy, Thomas, *Reliques of Ancient English Poetry*, 230

Perthshire, 295

332, 333, 354, 517
Rice, James, 119, 187, 207, 219, 221, 222, 258,
298, 317, 321, 354, 372, 423, 449, 490, 567;
career, 185; Dilke on, 185–6; friendship
with K, 185, 194, 223, 244; health, 185,
186, 194, 365, 411, 413, 417, 418, 465, 479,
513, 533; independence, 186; and the Isle of
Wight, 410, 413, 414, 417, 418; and Jane
Reynolds, 186; loyalty to K, 569–70; his
poetry, 186; Reynolds on, 186; 'Saturday
Club', 213, 365; sexual behaviour, 198; in
Sidmouth, 186; in the Zetosophian Society,
119
Richards, 490
Richards, Charles, 141, 145
Richards, Thomas, 34, 140–41
Richardson, Benjamin, 90
Richardson, Samuel, 106, 367; *Clarissa*, 552
Ricketts, John, 324
Ritchie, John, 219–20
Ritson, Joseph, *Robin Hood: A collection of all
the ancient poems, songs and ballads now
extant, relative to that celebrated English
outlaw*, 230
Robert Dale Owen Colony, New Harmony,
Indiana, 408
Robertson, William, 132, 315; *History of
America*, 38, 112, 241, 246, 377; *History of
Charles V*, 38; *History of Scotland
1542–1603*, 38
Robespierre, Maximilien de, 84
Robinson, Henry Crabb, 23, 139
Robinson, Miss (Fanny Brawne's friend),
325–6, 328
Rodd, Dr George, 496–7, 498, 502, 509, 511,
554
Rogers, Samuel, 153
Rollins, Hyder E.: *The Keats Circle: Letters
and Papers 1816-1879*, xx; *More Letters and
Papers*, xx
Romanticism, 390; and consumption, 500;
and creativity, 111, 395; Hazlitt's influence
on the early Romantic poets, 123; K's
Romantic alienation, xxi; and K's world,
xxii; Mathew and, 88; and nature, 106
Rome, 237, 520, 531, 548, 551–67; K buried
in the Protestant cemetery, 567; K's final
illness and death in, 558–66; Severn buried
in the Protestant cemetery, 570
Ronsard, Pierre de, 29, 308
Rosa (K's niece), 4
Ross of Mull, 291
Rossetti, Christina, 576
Rossetti, Dante Gabriel, 573, 576
Rossetti, William, xx, xxiv, 576
Rousseau, Jean Jacques, 'Heloise', 414

Royal Academy, 92, 123, 126, 160, 356, 469,
478, 485, 533
Royal Academy Travelling Scholarship, 556,
565
Royal Artillery Mess, Woolwich, 423
Royal College of Surgeons, 46, 66, 73, 93,
105, 144
Royal Institution, 17–18
Royal Opera House, Covent Garden, 19, 237,
329, 428, 454, 485, 490, 490
Russell, George, 54
Russell, HMS, 8
Russia: Brown in, 195, 262; collapse of
alliance with France, 14
Rydal, 269
Rydal Park, 270
Ryland, John, 23, 25–8, 38

St Bartholomew's Hospital, London, 16, 81,
82
St Botolph's Without church, London, 10
St Cross hospital, Winchester, 424, 425, 467
St George's church, Hanover Square, 9–10
St John's church, Hackney, 43
St John's Wood, London, 17
St John's Wood Barracks, London, 106
St Luke's Hospital, 7
St Margaret's church, Westminster, 257
St Mary's Seminary, Ohio, 510
St Michael's churchyard, Dumfries, 273
St Paul's Cathedral, London, 219, 293
St Paul's School, Barnes, 119
St Stephen's church, Coleman Street, 5, 7,
30, 31, 40, 65, 81, 328
St Thomas Street (No. 28), London, 74, 90,
98, 105, 161
St Thomas's Hospital, London, 74, 76, 77;
ancient foundation, 16, 75; K attends
lectures, 77; operations at, 77–8; shares
educational responsibilities with Guy's, 76
Salcombe Regis, 185
Salisbury, William, 77
Salutation Inn, Ambleside, 267
San Carlo opera, Naples, 551
Sandell, John Nowland, 43, 97
Sandemanians, 12
Sandys, George, 189
Santa Lucia, 547
Sappho, 107
Sawrey, Dr Solomon, 197, 256, 258, 299, 365,
496
Sayers, Frederick, 150
Schiller, Johann Christoph Friedrich von,
499
Scotland, 263; Brown tours, 511, 513; K's
tour, 252, 256, 258, 260, 261, 262, 265,

[633]